Janson's History of Art

THE MODERN WORLD

The second states of the second se

MCHERLE TIVACE

o portante a la construcción de la construcción Desarto de Cale Relación - Construcción de Relación de Pr De Construcción de Construcción de la construcción de la construcción de la construcción de la construcción de

Janson's History of Art

THE MODERN WORLD

Eighth Edition

Portable Edition | Book 4

PENELOPE J. E. DAVIES WALTER B. DENNY FRIMA FOX HOFRICHTER JOSEPH JACOBS ANN M. ROBERTS DAVID L. SIMON

Prentice Hall

Upper Saddle River London Singapore Toronto Tokyo Sydney Hong Kong Mexico City

Editorial Director: Leah Jewell Editor in Chief: Sarah Touborg Senior Sponsoring Editor: Helen Ronan Editorial Project Manager: David Nitti Editorial Assistant: Carla Worner Media Director: Brian Hyland Media Editor: Alison Lorber Director of Marketing: Brandy Dawson Senior Marketing Manager: Laura Lee Manley Marketing Assistant: Ashley Fallon Senior Managing Editor: Ann Marie McCarthy Assistant Managing Editor: Melissa Feimer Senior Operations Specialist: Brian Mackey Production Liaisons: Barbara Cappuccio and Marlene Gassler AV Project Manager: Gail Cocker Cartography: Peter Bull Art Studio Senior Art Director: Pat Smythe Site Supervisor, Pearson Imaging Center: Joe Conti Pearson Imaging Center: Corin Skidds, Robert Uibelhoer, and Ron Walko Cover Printer: Lehigh-Phoenix Color Printer/Binder: Courier/Kendallville

This book was produced by Laurence King Publishing Ltd, London. www.laurenceking.com

Senior Editor: Susie May Copy Editor: Robert Shore Proofreader: Lisa Cutmore Picture Researcher: Amanda Russell Page and Cover Designers: Nick Newton and Randell Harris Production Controller: Simon Walsh

Cover image: Detail. Brooklyn Bridge, New York, by John and Washington Roebling, 1867–83. © Jon Arnold Images Ltd/Alamy

Credits and acknowledgements borrowed from other sources and reproduced, with permission, in this textbook appear on the appropriate page within text or on the credit pages in the back of this book.

Copyright © 2012, 2007, 2004 Pearson Education, Inc., publishing as Prentice Hall, 1 Lake St., Upper Saddle River, NJ 07458. All rights reserved. Manufactured in the United States of America. This publication is protected by Copyright, and permission should be obtained from the publisher prior to any prohibited reproduction, storage in a retrieval system, or transmission in any form or by any means, electronic, mechanical, photocopying, recording, or likewise. To obtain permission(s) to use material from this work, please submit a written request to Pearson Education, Inc., Permissions Department, 1 Lake St., Upper Saddle River, NJ 07458

Library of Congress Cataloging-in-Publication Data

Janson, H. W. (Horst Woldemar) Janson's history of art : the western tradition / Penelope J.E. Davies ... [et. al]. -- 8th ed. p. cm. Includes bibliographical references and index. ISBN 978-0-205-68517-2 (hardback) 1. Art--History. I. Davies, Penelope J. E., II. Janson, H. W. (Horst Woldemar), History of art. III. Title. IV. Title: History of art. N5300.J29 2009b 709--dc22 2009022617

10 9 8 7 6 5 4 3 2 1

Prentice Hall is an imprint of

www.pearsonhighered.com

ISBN 10: 0-205-16115-4 ISBN 13: 978-0-205-16115-7 Exam Copy ISBN 10: 0-205-16756-X ISBN 13: 978-0-205-16756-2

Contents

Preface	X
Faculty and Student Resources for Teaching and Learning with <i>Janson's History of Art</i>	XV
	24 V
PART FOUR	
THE MODERN WORLD	
Art in the Age of the Enlightenment, 1750–1789	785

23	Art in the Age of the Enlightenment, 1750–1789	785
	ROME TOWARD 1760: THE FONT OF NEOCLASSICISM	787
	ROMANTICISM IN ROME: PIRANESI	789
	NEOCLASSICISM IN BRITAIN	790
	MATERIALS AND TECHNIQUES: Josiah Wedgwood and Neoclassical Jasperware	792
	THE ART HISTORIAN'S LENS: The Elusive Meaning of West's The Death of General Wolfe	795
	EARLY ROMANTICISM IN BRITAIN	798
	NEOCLASSICISM IN FRANCE	806
	PRIMARY SOURCES: Denis Diderot (1713-1784)	812
	PRIMARY SOURCES: Étienne-Jean Delécluze (1781-1863)	813
	ITALIAN NEOCLASSICISM TOWARD 1785	817
24	Art in the Age of Romanticism, 1789–1848	821
	PAINTING	823
	MATERIALS AND TECHNIQUES: Blake's Printing Process	827
	PRIMARY SOURCES: John Constable (1776–1837)	829
	PRIMARY SOURCES: Eugène Delacroix (1798-1863)	845
	ROMANTIC SCULPTURE	850
	ROMANTIC REVIVALS IN ARCHITECTURE	851

25 The Age of Positivism: Realism, Impressionism, and the Pre-Raphaelites, 1848–1885

REALISM IN FRANCE	860
PRIMARY SOURCES: Lila Cabot Perry (1848?-1933)	872
MATERIALS AND TECHNIQUES: Impressionist Color Theory	874
BRITISH REALISM	881
PRIMARY SOURCES: James Abbott McNeill Whistler (1834–1903)	885
REALISM IN AMERICA	887
THE ART HISTORIAN'S LENS: An Artist's Reputation and Changes in Art Historical Methodology	889
PHOTOGRAPHY: A MECHANICAL MEDIUM FOR	
MASS-PRODUCED ART	890
PRIMARY SOURCES: Charles Baudelaire (1821-1867)	896
ARCHITECTURE AND THE INDUSTRIAL REVOLUTION	897
Progress and Its Discontents: Post-Impressionism	

859

903

26 Progress and Its Discontents: Post-Impressionism, Symbolism, and Art Nouveau, 1880–1905

POST-IMPRESSIONISM	905
PRIMARY SOURCES: Paul Cézanne (1839-1906)	907
MATERIALS AND TECHNIQUES: Lithography	911
PRIMARY SOURCES: Paul Gauguin (1848-1903)	917
SYMBOLISM	917
THE ART HISTORIAN'S LENS: Feminist Art History	923
ART NOUVEAU AND THE SEARCH FOR MODERN DESIGN	927
AMERICAN ARCHITECTURE: THE CHICAGO SCHOOL	931
PHOTOGRAPHY AND THE ADVENT OF FILM	936

21	Ioward Abstraction: The Modernist Revolution,	
	1904–1914	945
	FAUVISM	946
	CUBISM	950
	THE ART HISTORIAN'S LENS: The Myth of the Primitive	951
	THE IMPACT OF FAUVISM AND CUBISM	955
	MATERIALS AND TECHNIQUES: The Woodcut in German Expressionism	958
	PRIMARY SOURCES: Vasily Kandinsky (1866–1944)	960
	PRIMARY SOURCES: Kazimir Malevich (1878-1935)	968
	MARCEL DUCHAMP AND THE ADVENT OF AN ART OF IDEAS	970
	CONSTANTIN BRANCUSI AND THE BIRTH OF	
	MODERNIST SCULPTURE	972
	AMERICAN ART	974
	EARLY MODERN ARCHITECTURE IN EUROPE	976
28	Art Between the Wars	983
	DADA	985
	PRIMARY SOURCES: Hannah Höch (1889–1978)	991
	SURREALISM	993
	ORGANIC SCULPTURE OF THE 1930S	1000
	PRIMARY SOURCES: Barbara Hepworth (1903-1975)	1003
	CREATING UTOPIAS	1003
	PRIMARY SOURCES: Piet Mondrian (1872–1944)	1007
	PRIMARY SOURCES: Le Corbusier (1886-1965)	1012
	MATERIALS AND TECHNIQUES: Reinforced Concrete	1013
	ART IN AMERICAN: MODERNITY, SPIRITUALITY,	
	AND REGIONALISM	1015
	MEXICAN ART: SEEKING A NATIONAL IDENTITY	1025
	THE EVE OF WORLD WAR II	1028

27 Toward Abstraction: The Modernist Revolution

29	Postwar to Postmodern, 1945–1980	1035
	EXISTENTIALISM IN NEW YORK: ABSTRACT EXPRESSIONISM	1036
	PRIMARY SOURCES: Jackson Pollock (1912–1956)	1038
	EXISTENTIALISM IN EUROPE: FIGURAL EXPRESSIONISM	1042
	REJECTING ABSTRACT EXPRESSIONISM: AMERICAN ART OF	
	THE 1950S AND 1960S	1044
	PRIMARY SOURCES: Roy Lichtenstein (1923-1997)	1050
	FORMALIST ABSTRACTION OF THE 1950S AND 1960S	1053
	PRIMARY SOURCES: Frank Stella (b. 1936)	1056
	THE PLURALIST 1970S: POST-MINIMALISM	1058
	THE ART HISTORIAN'S LENS: Studying the Absent Object	1059
	ART WITH A SOCIAL AGENDA	1064
	PRIMARY SOURCES: Romare Bearden (1911-1988)	1066
	LATE MODERNIST ARCHITECTURE	1069

30	The Postmodern Era: Art Since 1980	1075
	ARCHITECTURE	1077
	MATERIALS AND TECHNIQUES: Computer-Aided Design in Architecture	1085
	POSTMINIMALISM AND PLURALISM: LIMITLESS POSSIBILITIES	
	IN FINE ART	1085
	APPROPRIATION ART: DECONSTRUCTING IMAGES	1091
	PRIMARY SOURCES: Cindy Sherman (b. 1954)	1091
	MULTICULTURALISM AND POLITICAL ART	1096
	PRIMARY SOURCES: Ilya Kabakov (b. 1933)	1102
	THE ART HISTORIAN'S LENS: The Changing Art Market	1104
	GLOBAL ART	1105
	Glossary	1108
	Books for Further Reading	1116
	Index	1127
	Credits	1142

CONTENTS I

Preface

ELCOME TO THE EIGHTH EDITION OF JANSON'S CLASSIC TEXTBOOK, officially renamed *Janson's History of Art* in its seventh edition to reflect its relationship to the book that introduced generations of students to art history. For many of us who teach introductory courses in

the history of art, the name Janson is synonymous with the subject matter we present.

When Pearson/Prentice Hall first published the *History of Art* in 1962, John F. Kennedy occupied the White House, and Andy Warhol was an emerging artist. Janson offered his readers a strong focus on Western art, an important consideration of technique and style, and a clear point of view. The *History of Art*, said Janson, was not just a stringing together of historically significant objects, but the writing of a story about their interconnections— a history of styles and of stylistic change. Janson's text focused on the visual and technical characteristics of the objects he discussed, often in extraordinarily eloquent language. Janson's *History of Art* helped to establish the canon of art history for many generations of scholars.

Although revised to remain current with new discoveries and scholarship, this new edition continues to follow Janson's lead in important ways: It is limited to the Western tradition, with a chapter on Islamic art and its relationship to Western art. It keeps the focus of the discussion on the object, its manufacture, and its visual character. It considers the contribution of the artist as an important part of the analysis. This edition maintains an organization along the lines established by Janson, with separate chapters on the Northern European Renaissance, the Italian Renaissance, the High Renaissance, and Baroque art, with stylistic divisions for key periods of the modern era. Also embedded in this edition is the narrative of how art has changed over time in the cultures that Europe has claimed as its patrimony.

WHAT'S NEW IN JANSON'S HISTORY OF ART?

"The history of art is too vast a field for anyone to encompass all of it with equal competence."

H. W. JANSON, from the Preface to the first edition of History of Art

Janson's History of Art in its eighth edition is once again the product of careful revision by a team of scholars with different specialties, bringing a readily recognized knowledge and depth to the discussions of works of art. We incorporate new interpretations such as the reidentification of the "Porticus Aemilia" as Rome's Navalia, or ship-shed (p. 186); new documentary evidence, such as that pertaining to Uccello's *Battle of San Romano* (p. 538); and new interpretive approaches, such as the importance of nationalism in the development of Romanticism (Chapter 24).

Organization and Contextual Emphasis

Most chapters integrate the media into chronological discussions instead of discussing them in isolation from one another, which reflected the more formalistic approach used in earlier editions. Even though we draw connections among works of art, as Janson did, we emphasize the patronage and function of works of art and the historical circumstances in which they were created. We explore how works of art have been used to shore up political or social power.

Interpreting Cultures

Western art history encompasses a great many distinct chronological and cultural periods, which we wish to treat as distinct entities. So we present Etruscan art as evidence for Etruscan culture, not as a precursor of Roman or a follower of Greek art. Recognizing the limits of our knowledge about certain periods of history, we examine how art historians draw conclusions from works of art. The boxes called *The Art Historian's Lens* allow students to see how the discipline works. They give students a better understanding of the methods art historians use to develop arthistorical arguments. *Primary Sources*, a distinguishing feature of Janson for many editions, have been incorporated throughout the chapters to support the analysis provided and to further inform students about the cultures discussed, and additional documents can be found in the online resource, MyArtsLab. (See p. xv for more detail.)

Women in the History of Art

Women continue to be given greater visibility as artists, as patrons, and as an audience for works of art. Inspired by contemporary approaches to art history, we also address the representation of women as expressions of specific cultural notions of femininity or as symbols.

Objects, Media, and Techniques

Many new objects have been incorporated into this edition to reflect the continuous changes in the discipline. The mediums we discuss are broad in scope and include not only modern art forms such as installations and earth art, but also the so-called minor arts of earlier periods—such as tapestries, metalwork, and porcelain. Discussions in the *Materials and Techniques* boxes illuminate this dimension of art history.

The Images

Along with the new objects that have been introduced, every reproduction in the book has been reexamined for excellence in quality, and when not meeting our standards has been replaced. Whenever possible we obtain our photography directly from the holding institutions to ensure that we have the most accurate and authoritative illustrations. Every image that could be obtained in color has been acquired. To further assist both students and teachers, we have sought permission for electronic educational use so that instructors who adopt *Janson's History of Art* will have access to an extraordinary archive of high quality (over 300 dpi) digital images for classroom use. (See p. xv for more detail on the Prentice Hall Digital Art Library.)

New Maps and Timelines

A new map program has been created to both orient students to the locations mentioned in each chapter and to better tell the story of the chapter narrative. Readers now can see the extent of the Eastern and Western Roman Empires, as well as the range of the Justinian's rule (p. 236). They can trace the migration routes of tribes during early medieval times (p. 314) and the Dutch trade routes of the seventeenth century (p. 702). This enriching new feature provides an avenue for greater understanding of the impact of politics, society, and geography on the art of each period. End of chapter timelines recap in summary fashion the art and events of the chapter, as well as showing key contemporaneous works from previous chapters (for example, pp. 345 and 759).

Chapter by Chapter Revisions

The following list includes the major highlights of this new edition:

CHAPTER 1: PREHISTORIC ART

Expands upon the methods scholars (both art historians and anthropologists) use to understand artwork, including, for instance, feminist interpretations. Includes new monuments such as Skara Brae and Mezhirich. A new box explains dating techniques.

CHAPTER 2: ANCIENT NEAR EASTERN ART

This chapter is expanded to include a discussion of Jerusalem.

CHAPTER 3: EGYPTIAN ART

Now includes a tomb painting from the pre-Dynastic age, and a discussion of jewelry. A new box names the major Egyptian gods.

CHAPTER 4: AEGEAN ART

Improved images and a reconstruction of Mycenae enhance the discussion of Aegean art.

CHAPTER 5: GREEK ART

This chapter is tightened to allow space for longer discussion of Greek sanctuaries, and the inclusion of Hellenistic works outside of the Greek mainland, such as the Pharos at Alexandria. The issue of homosexuality in fifth-century Athens is addressed, as well as women's roles in life and art. A new box deals with the issue of repatriation of works of art such as the Elgin marbles.

CHAPTER 6: ETRUSCAN ART

The range of artworks is increased to include, for instance, terracotta revetments and terra-cotta portraits.

CHAPTER 7: ROMAN ART

This chapter includes new interpretations such as the reidentification of the "Porticus Aemilia" as Rome's Navalia or ship-shed. It also has been tightened to allow space for more Republican works (such as the terracotta pediment from Via di San Gregorio and the Praeneste mosaic) and a wider discussion of life in Pompeii. There is some rearrangement of art works to improve the chronological flow.

CHAPTER 8: EARLY CHRISTIAN AND BYZANTINE ART

A new section on early Jewish art is added, including three images of early synagogue wall paintings and mosaics (Dura Europos and Hammath Tiberias). Coverage of Late Byzantine art is increased, as is discussion of liturgical and social history.

CHAPTER 9: ISLAMIC ART

The relationship of Islamic art to early Jewish and Christian medieval art is accentuated.

CHAPTER 10: EARLY MEDIEVAL ART

Includes an expanded discussion and reorganization of Viking art, which is now placed later in the chapter.

CHAPTER 11: ROMANESQUE ART

Coverage of secular architecture is broadened to include the bridge at Puente la Reina on the pilgrimage route to Santiago de Compostela and a new section on the crusades and castle architecture.

CHAPTER 12: GOTHIC ART

This chapter is tightened to allow space for added focus on secular objects and buildings with the inclusion of a Guillaume de Machaut manuscript illumination and Westminster Hall from the royal palace in London. There is also expanded discussion of courtly art and royal iconography in later Gothic monuments.

CHAPTER 13: ART IN THIRTEENTH-AND FOURTEENTH-CENTURY ITALY

Organization now places less emphasis on religious architecture. Siena's Palazzo Pubblico is added. There is a more focused discussion of Tuscany, and a briefer treatment of Northern Italy and Venice. Images of key works of art, including Nicola and Giovanni Pisano and the Arena chapel are improved. Two maps in the chapter outline Italian trade routes and the spread of the plague in the 1340s.

CHAPTER 14: ARTISTIC INNOVATIONS IN FIFTEENTH-CENTURY NORTHERN EUROPE

Discussion of the *Tres Riches Heures* is enlarged, and reproductions contrasting aristocratic "labors" and the images of peasants are added. Treatment of works by Van Eyck, Van der Weyden and Bosch is revised and sharpened. A new map of centers of production and trade routes in Northern Europe illustrates the variety of media produced in the region.

CHAPTER 15: THE EARLY RENAISSANCE IN FIFTEENTH-CENTURY ITALY

Reorganized for better flow and student comprehension, chapter now begins with the Baptistery competition illustrating reliefs by both Ghiberti and Brunelleschi. It then looks at architectural projects by Brunelleschi and Alberti in Florence as a group, considering their patronage and function as well as their form. New art illustrates Brunelleschi's innovations at the Duomo, while his work at San Lorenzo is expanded to include the Old Sacristy. Section on domestic life has been revised, but it still offers a contextualized discussion of works such as Donatello's *David*, Uccello's *Rout of San Romano* and Botticelli's *Birth of Venus*. This section now includes the Strozzi cassone at the Metropolitan Museum in New York and Verrocchio's *Lady with Flowers*. The discussion of Renaissance style throughout Italy is revised for greater clarity.

CHAPTER 16: THE HIGH RENAISSANCE IN ITALY, 1495-1520

A discussion of the portrait of Ginevra de' Benci is now included, permitting a revised discussion of the *Mona Lisa*. The section on the Stanza della Segnatura is revamped to focus on the *School of Athens*. Treatment of Giorgione and Titian is reorganized and revised to reflect current discussions of attribution and collaboration. A new Titian portrait, *The Man with a Blue Sleeve*, is included.

CHAPTER 17: THE LATE RENAISSANCE AND MANNERISM IN SIXTEENTH-CENTURY ITALY

Florence in the sixteenth century is reorganized and refreshed with new images, including a view of the architectural context for Pontormo's *Entombment*. Michelangelo's New Sacristy is treated in terms of architecture as well as sculpture. Ducal Palaces of the Uffizi and the Pitti and of the Boboli Gardens receives a new focus. Cellini's *Saltceller* is discussed in its Florentine context. Treatment of Il Gesu is revamped. New images enliven the Northern Italian art section and Sophonisba Anguissola's *Self Portrait* is compared to Parmagianino's. There is a revised consideration of Palladio, and a new Titian, *The Rape of Europa*, exemplifies the artist's work for elite patrons.

CHAPTER 18: RENAISSANCE AND REFORMATION IN SIXTEENTH-CENTURY NORTHERN EUROPE

Discussion of France, as well as Spain, is revised and images are improved. Includes new images and discussions of Cranach and Baldung: Cranach's *Judgment of Paris* in New York replaces another version of this theme, while Baldung is represented by his woodcut of the *Bewitched Groom* of 1544. The discussion of Holbein is enlivened by consideration of his *Jean de Dinteville* and Georges de Selve (The Ambassadors'), allowing examination of him as an allegorist as well as a portraitist. Gossaert is now represented by the *Neptune and Amphitrite* of 1516, while a new Patinir, the *Triptych of Saint Jerome in the Wilderness*, represents the landscape specialty of that region.

CHAPTER 19: THE BAROQUE IN ITALY AND SPAIN

Chapter content benefits from insights gained through recent exhibitions and from the inclusion of new architectural image components. New illustrations better expand understanding of the Roman Baroque and the role of the Virgin in Spanish art, including a view of the Piazza Navonna that shows Bernini's *Four Rivers Fountain* and as well as Borromini's church of *S. Agnese*, a cut-away of Borromini's complex star-hexagon shaped church, S. Ivo, and one of Murillo's many depictions of the *Immaculate Conception* (St. Petersberg).

CHAPTER 20: THE BAROQUE IN THE NETHERLANDS

The importance of trade, trade routes and interest in the exotic is explored in this chapter. Gender issues—and the relationship between men and women—and local, folk traditions (religious and secular) play a role here in the exploration of the visual culture and social history. New images include: Peter Paul Rubens, *The Raising of the Cross*—the entire open altarpiece; Peter Paul Rubens, *Four Studies of the Head of a Negro*; Jacob Jordaens, *The King Drinks*; Judith Leyster, *The Proposition*; Rembrandt van Rijn, *Bathsheba with King David's Letter* and Vermeer, *Officer and Laughing Girl*.

CHAPTER 21: THE BAROQUE IN FRANCE AND ENGLAND

New scholarship from the *Poussin and Nature: Arcadian Visions* exhibition in 2008 informs a more developed discussion of this artist's work. A fuller discussion of the role of the 1668 Fire of London and the re-building of St. Paul's Cathedral, in addition to a 3-D reconstruction of St. Paul's and a modern reconstruction of Sir Christopher Wren's plan of the city of London drawn just days after the fire, expands the coverage of this architect.

CHAPTER 22: THE ROCOCO

Expresses in greater depth the concept of the Rococo, the role of Madame da Pompadour and the expansion of the Rococo style in Germany. New images include Francois Boucher, *Portrait of Madame de Pompadour* (Munich); Jean-Simeon Chardin, *The Brioche (the Dessert)* and Egid Quirin Asam, interior and altar of the Benedictine Church at Rohr. Sections of this chapter are reorganized to accommodate the removal of Élisabeth-Louise Vigéele Brun, Sir Thomas Gainsborough and Sir Joshua Reynolds to Chapter 23.

CHAPTER 23: ART IN THE AGE OF THE ENLIGHTENMENT, 1750-1789

Slightly restructured, the chapter keeps Neoclassicism and early Romanticism separated, thus making them more clearly defined. Joshua Reynolds, Thomas Gainsborough, and Elizabeth Vigée-Lebrun are placed here and into the context of Neoclassicism and Romanticism. Antonio Canova also is moved to this chapter to emphasize his importance in the development of Neoclassicism. Image changes include Joseph Wright's more clearly Romantic *Old Man and Death*; Ledoux's Custom House with the entrance to Salt Works at Arc-et-Senans; as well as the addition of Canova's tomb of Archduchess Maria Christina.

CHAPTER 24: ART IN THE AGE OF ROMANTICISM, 1789-1848

This chapter is tightened and has several new images. William Blake is now represented by *Elohim Creating Adam* and Corot by

Souvenir Montrefontaine (Oise). Frederick Church's Twilight in the Wilderness is added. The discussion of architecture is changed by placing the Empire style at the very end, thus keeping the Neoclassical revival together.

CHAPTER 25: THE AGE OF POSITIVISM: REALISM, IMPRESSIONISM, AND THE PRE-RAPHAELITES, 1848-1885

Includes a number of image changes to better focus discussions. These include: Monet, *Gare St. Lazare*; Rossetti, *Proserpine*; Nadar, *Portrait of Manet*; and Gustav, *Brig on the Water*.

CHAPTER 26: PROGRESS AND ITS DISCONTENTS: POST-IMPRESSIONISM, SYMBOLISM, AND ART NOUVEAU, 1880-1905

Now incorporates discussions of vernacular, or snapshot, photography, represented by Henri Lartigue's *Woman in Furs on the Avenue in the Bois de Bologne*, and the advent of film, represented by Thomas Edison's *Train Crossing the Brooklyn Bridge*.

CHAPTER 27: TOWARD ABSTRACTION: THE MODERNIST REVOLUTION, 1904-1914

Discussion of the formal and stylistic developments between 1904 and 1914 that culminated in abstractionism is tightened and the number of images reduced.

CHAPTER 28: ART BETWEEN THE WARS

More compact discussion structured around the impact of World War I and the need to create utopias and uncover higher realities, especially as seen in Surrealism.

CHAPTER 29: POSTWAR TO POSTMODERN, 1945-1980

Polke is placed here from Chapter 30, thus putting him within the context of an artist influenced by Pop Art. David Hammons is moved to Chapter 30. Betye Saar's *Shield of Quality* adds a woman to the discussion of African-American artists.

CHAPTER 30: THE POSTMODERN ERA: ART SINCE 1980

Architecture is reduced, and fine art is expanded. Neo-Expressionism benefits from the addition of Julian Schnabel's *Exile*. The multi-culturalism of the period receives greater emphasis, especially feminism. Barbara Kruger is placed in a more feminist context with inclusion of a new image, *We Won't Play Nature to Your Culture*. The discussion of African-American identity is broadened by the placement of David Hammons here, and by the addition of Kara Walker's *Insurrection*. Fred Wilson's *Mining the Museum* is also included. The discussion of Gonzalez-Torres now stresses his involvement with the AIDS crisis. The importance of large-scale photography for the period is reinforced by the addition of Andreas Gursky's *Shanghai*. The truly global nature of contemporary art is strengthened by the addition of El Antsui's *Dzeii II*.

Acknowledgments

We are grateful to the following academic reviewers for their numerous insights and suggestions on improving Janson:

Amy Adams, College of Staten Island Susan Benforado Baker, University of Texas Arlington Jennifer Ball, Brooklyn College Dixon Bennett, San Jacinto College - South Diane Boze, Northeastern State University Betty Ann Brown, California State University - Northridge Barbara Bushey, Hillsdale College Mary Hogan Camp, Whatcom Community College Susan P. Casteras, University of Washington Cat Crotchett, Western Michigan University Tim Cruise, Central Texas College Julia K. Dabbs, University of Minnesota - Morris Adrienne DeAngelis, University of Miami Sarah Diebel, University of Wisconsin-Stout Douglas N. Dow, Kansas State University Kim Dramer, Fordham University Brian Fencl, West Liberty State College Monica Fullerton, Kenyon College Laura D. Gelfand, The University of Akron Alyson A. Gill, Arkansas State University Maria de Jesus Gonzalez, University of Central Florida

Bobette Guillory, Carl Albert State College Bertha Steinhardt Gutman, Delaware County Community College Marianne Hogue, University of North Carolina - Wilmington Stephanie Jacobson, St. John's University Ruth Keitz, University of Texas - Brownsville Joanne Kuebler, Manhattan College Adele H. Lewis, Arizona State University Lisa Livingston, Modesto Junior College Diane Chin Lui, American River College B. Susan Maxwell, University of Wisconsin-Oshkosh Paul Miklowski, Cuyahoga Community College Charles R. Morscheck Jr., Drexel University Elaine O'Brien, California State University - Sacramento Matthew Palczynski, Temple University Jason Rosenfeld, Marymount Manhattan College Phyllis Saretta, The Metropolitan Museum of Art Onovom Ukpong, Southern University and A & M College Kristen Van Ausdall, Kenyon College Marjorie S. Venit, University of Maryland Linda Woodward, Montgomery College Ted M. Wygant, Dayton Beach Community College

The contributors would like to thank John Beldon Scott, Whitney Lynn, and Nicole Veilleux for their advice and assistance in developing this edition. We also would like to thank the editors and staff at Pearson Education including Sarah Touborg, Helen Ronan, Barbara Cappuccio, Marlene Gassler, Cory Skidds, Brian Mackey, David Nitti, and Carla Worner who supported us in our work. At Laurence King Publishing, Susie May, Kara Hattersley-Smith, Julia Ruxton, Amanda Russell, and Simon Walsh oversaw the production of this new edition.

Faculty and Student Resources for Teaching and Learning with Janson's History of Art

EARSON/PRENTICE HALL is pleased to present an outstanding array of high quality resources for teaching and learning with Janson's History of Art. Please contact your local Prentice Hall representative (use our rep locator at www.pearsonhighered.com) for more details on how to obtain these items, or send us an email at art.service@pearson.com.

my arts lab

www.myartslab.com Save time, improve results. MyArtsLab is a robust online learning environment providing you and

your students with the following resources:

Complete and dynamic e-book

Illustrated and printable flashcards

Unique "Closer Look" tours of over 125 key works of art Pre-and post-tests for every chapter of the book

Customized study plan that helps students focus in on key areas Primary Sources with critical thinking questions

Writing Tutorials for the most common writing assignments

Available at no additional charge when packaged with the text. Learn more about the power of MyArtsLab and register today at www.myartslab.com

THE PRENTICE HALL DIGITAL ART

LIBRARY. Instructors who adopt Janson's History of Art are eligible to receive this unparalleled resource containing every image in Janson's History

of Art in the highest resolution (over 300 dpi) and pixilation possible for optimal projection and easy download. Developed and endorsed by a panel of visual curators and instructors across the country, this resource features images in jpeg and in PowerPoint, an instant download function for easy import into any presentation software, along with a zoom and a save-detail feature.

CourseSmart

COURSESMART eTEXTBOOKS ONLINE

is an exciting new choice for students looking to save money. As an alternative to

purchasing the print textbook, students can subscribe to the same content online and save up to 50% off the suggested list price of the print text. With a CourseSmart eTextbook, students can search the text, make notes online, print out reading assignments that incorporate lecture notes, and bookmark important passages for later review. For more information, or to subscribe to the CourseSmart eTextbook, visit www.coursesmart.com.

CLASSROOM RESPONSE SYSTEM (CRS) IN CLASS

QUESTIONS. (ISBN: 0-205-76375-8) Get instant, classwide responses to beautifully illustrated chapter-specific questions during a lecture to gauge students' comprehension-and keep them engaged. Contact your local Pearson representative for details.

MYTEST (ISBN: 0-205-76391-X) is a commercial-quality computerized test management program available for both Microsoft Windows and Macintosh environments.

A SHORT GUIDE TO WRITING ABOUT ART. 10/e (ISBN: 0-205-70825-0) by Sylvan Barnet. This best-selling text has guided tens of thousands of art students through the writing process. Students are shown how to analyze pictures (drawings, paintings, photographs), sculptures and architecture, and are prepared with the tools they need to present their ideas through effective writing. Available at a discount when purchased with the text.

INSTRUCTOR'S RESOURCE MANUAL WITH TEST BANK

(ISBN: 0-205-76374-X, download only) is an invaluable professional resource and reference for new and experienced faculty, containing sample syllabi, hundreds of sample test questions, and guidance on incorporating media technology into your course.

Art in the Age of the Enlightenment, 1750–1789

A most remarkable change in our ideas is taking place, one of such rapidity that it seems to promise a greater change still to come. It will be for the future to decide the aim, the nature, and the limits of this revolution, the drawbacks and disadvantages of which posterity will be able to judge better than we can.

—Jean d'Alembert

HEN THE FRENCH PHILOSOPHER AND SCIENTIST JEAN d'Alembert made this prophetic statement in 1759, the Western world was indeed embarking on a revolution, one that is still unfolding today. This revolution ushered in a radically new way of viewing the world, one that would lead to the social, scientific, economic, and

political values that govern our present lives. Little did d'Alembert realize that he was witnessing the birth of the modern world.

This new world was heralded by twin revolutions: the Industrial Revolution, which began first in Britain in the middle of the eighteenth century and gradually spread worldwide in the nineteenth century; and the political revolutions of the United States and France in 1776 and 1789, respectively. Democracy, personal liberty, capitalism, socialism, industrialization, technological innovation, urbanization, and the "doctrine of progress," that is, a continuous upward march toward an improved life through science and knowledge, are just some of the many modern concepts that emerged from this period.

The force behind this transformation was the Enlightenment, a term that refers to the modern philosophy that emerged largely in Britain, France, Germany, and the United States in the eighteenth century. The foundation for this new thought lay in late seventeenth-century Britain with the philosopher John Locke (1632–1704) and the physicist and mathematician Isaac Newton (1642–1727), perhaps the two most influential thinkers of their

Detail of figure 23.22, Claude-Nicolas Ledoux. Main entrance, saltworks, Arc-et-Senans

age. Both stressed empiricism—the idea that knowledge comes from practical experience rather than abstract thought or religious revelation—as the basis for philosophy and science. For Newton, this meant proceeding from personally collected data and observation—not superstition, mysticism, religion, hearsay, or whimsy—and applying this information in a rational, logical fashion. For Locke, empiricism established experience as the only basis for formulating theory and principle. No longer could ideas be considered innate or ordained by God. Locke upset the applecart of Original Sin when he declared that all humans are born good and have a natural right to life, liberty, and property. He defined the function of government as the protection of these natural rights, and failure to do so granted citizens the license to remove their government, even if that required revolution.

What began as a trickle of influence evolved into a torrent as the basic premises behind the innovative ideas of Locke and Newton produced an explosion of treatises and theories throughout the eighteenth century. Leading this philosophical charge were the *philosophes*, as the leading French intellectuals of the time are commonly called. Among the best known are Voltaire (1694–1778), Jean-Jacques Rousseau (1712–1778), and Denis Diderot (1713–1784), who, along with d'Alembert, edited the 52volume *Encyclopédie*, the world's first encyclopedia, which in its

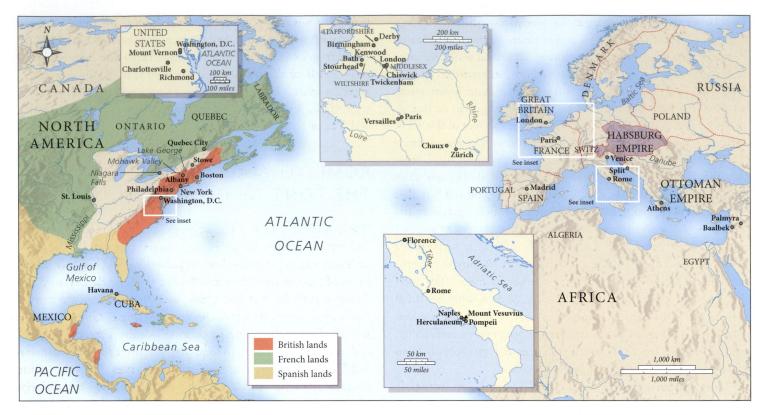

Map 23.1 Europe and North America in 1763

attempt to document the world and knowledge epitomizes Enlightenment empiricism.

In addition to establishing basic human rights and a new moral order, Enlightenment thought also ushered in modern science. Electricity and oxygen were discovered, for example, and chemistry and natural science as we know it today were established. Science helped launch the Industrial Revolution. By midcentury, the first mills were churning out yards of fabric at an unimaginable rate in the Midlands of England, and the notion of labor was redefined as the first factory workers, employed at subsistence wages, were tethered to clattering looms in enormous spaces filled with deafening noise. Miners excavated coal and ore to produce iron, permitting construction of the first metal bridge. Perfection of the steam engine by Scottish engineer James Watt from 1765 to 1782 aided the mining and textile industries and enabled Robert Fulton, in 1807, to send a steamboat chugging up the Hudson River in the face of a swift current and public incredulity, arriving in Albany from Manhattan in unimaginably quick time.

The second half of the eighteenth century was a period of transition as the world moved from the old to the modern, from rule by aristocracy and church to democracy, from agriculture to industry, and from rural to urban. The art of this time reflects this transformation, for it is often changing and complex, with several almost contradictory attitudes existing in a single work. The dominant style associated with this transitional period is **Neoclassicism**, meaning the "New Classicism," which often illustrated what were considered the virtuous actions and deeds of the ancient Greeks and Romans. As we shall see, however, not all works labeled Neoclassical are set in historical antiquity; they may be contemporary genre scenes or major events that have the look or feel of classical antiquity and that embrace similar moral values.

Neoclassicism embraced the logic and morality of the Enlightenment, which were perhaps best encapsulated in the works of Voltaire. In his plays, poems, novels, and tracts, Voltaire used logic to attack what he called "persecuting and privileged orthodoxy," mainly meaning Church and State, but any illogical institution or concept was fair game for his satire. He believed science could advance civilization and that logic presumed a government that benefitted the people, not just the aristocracy. It is from Voltaire that we get the "doctrine of progress." The models for Voltaire's new civilization were the republics of ancient Greece and Rome, which in addition to being the first democracies provided the first rationalist philosophers. Taking its vocabulary directly from ancient art, Neoclassicism would reject the sensual pastel colors and bold painterly flourishes of the Rococo and instead return to the hard line and cool paint handling of the Italian Renaissance (see Chapters 15, 16, and 17) and French Classicism (see Chapter 21).

While Neoclassicism is the style generally associated with the second half of the eighteenth century, simultaneously, a second and seemingly antithetical thread appears in art: **Romanticism**. As we shall see in the next chapter, Romanticism really comes of age about 1800, when the term was actually coined in order to describe the sweeping changes in worldview then occurring. Instead of Neoclassicism's logic and its desire to control the forces of nature through science, Romanticism values emotion and intuition and believes in the supremacy of raw, unrestricted nature. Like Neoclassicism, however, early Romanticism often stems from Enlightenment thought, in particular its emphasis on morality. Jean-Jacques Rousseau is the principal proponent of this view. which he articulated in his Discourse on the Arts and Sciences (1750). Here, he advocated a return to nature, arguing, like Locke, that humans are born good, not in sin, and that they use their innate sense or instincts to distinguish between good and bad, that is, between what makes them happy and sad. Feeling determines their choices, not rational thought, which one uses to explain choices, not to make them. Society, he believed, through its mores, values, and conventions, eventually imposes its own rationalized standards on humans, distracting them from their first true and natural instincts. Rousseau praised what he called the sincere "noble savage," steeped in nature, and he denounced contemporary Western civilization for its pretensions, artificiality, and, in general, for those social restraints that prevent us from tapping into the power of our basic emotions.

Rousseau, in turn, inspired the German proto-romantic movement known as *Sturm und Drang* and conventionally translated as "Storm and Stress," although "Passion and Energy" or "Energy and Rebellion" is perhaps more accurate. This literary movement, which centered on the Weimar region, appeared from roughly the late 1760s through the early 1780s. Its best-known representative was Johann Wolfgang von Goethe (1749–1832), author of *The Sorrows of Young Werther* (1774), one of the most widely read novels of its day. Like Rousseau, the group supported personal freedom, which in part was a reaction to the repressive despotism of the German states and of contemporary moral and social conventions. Similarly, the movement advocated powerful emotions and extreme passion as an expression of the unique, creative individual, and it likewise called for a return to nature, a pre-civilization state.

While Neoclassicism is the style generally associated with the period, we must remember that the rational and the emotional survived side by side in art, flip sides of the same Enlightenment coin. Proponents of both attitudes aggressively rejected Rococo art (see Chapter 22), which they perceived as licentious, frivolous, even immoral, and which was generally associated with aristocracy and privilege, the twin evils condemned by the Enlightenment. While there was a call for a new art, one based on Classical values, no one was sure what it should look like. Not until the 1780s, with the paintings of Jacques-Louis David and the sculpture of Antonio Canova, did the Neoclassical style crystallize. In the meantime, Neoclassicism would appear in many guises, sometimes even containing elements of Rococo elegance, a reminder that the Rococo still survived-Boucher did not die until 1771, and Fragonard and Clodion lived on into the nineteenth century. Simultaneously, the Romantic fascination with strong emotions, with the irrational and unexplainable, and with the powerful forces of nature, was developing, which

ironically would overshadow Neoclassicism by the 1790s, the decade following David's and Canova's rise as well as the French Revolution of 1789. While Britain and France dominate art in the second half of the century and are the focus of our discussion, Neoclassicism, like the Enlightenment, was an international movement, well represented in Scandinavia, Austria, Germany, and Russia.

ROME TOWARD 1760: THE FONT OF NEOCLASSICISM

Rome was the center of the art world in the eighteenth century, and virtually anyone aspiring to become a painter, sculptor, or architect wanted to study there, experiencing first hand the antiquities of Greece and Rome and the riches of the Renaissance and Baroque periods. Not just artists came to Rome, for no gentleman's education was complete without making a "Grand Tour" of Italy, including the North Country (Florence, Tuscany, Umbria, and Venice) and Naples, the jumping-off point for Herculaneum and Pompeii, perfectly preserved Roman cities that were in the process of being excavated from 1738 and 1748, respectively. These archaeological excavations, as well as those in Athens (of the Akropolis, 1751), Palmyra (1753), Baalbek (1757), Split (Spalato, 1757), and Ionia (1764), fueled an interest in antiquity and fired the imagination of artists, largely through illustrations published in lavish folio format. But the climax of the Grand Tour was Rome, which was itself one large excavation site, with antiquities dealers furiously digging for artifacts and sculpture to sell to tourists.

Equally responsible for creating a renewed preoccupation with antiquity were the writings of the German scholar Johann Winckelmann (1717-1768, see page 157), librarian to the great antiquities collector Cardinal Albani, whose Villa Albani in Rome was one of the antiquities museums-along with the Villa Borghese and the Capitoline Hill-that every gentleman on the Grand Tour had to visit. In 1755, Winckelmann published Reflections on the Imitation of Greek Art in Painting and Sculpture, and in 1765, he produced his magnum opus, History of Greek Art. The latter was one of the most widely read books of its day, which accounts for its influence. In both publications, Winckelmann elevated Greek culture to a position of supremacy it never quite held in the Classical tradition: an era of perfection that was followed only by imitation and decline. But Winckelmann did not just see beauty in Greek art; he also saw moral qualities that paralleled Enlightenment thought: "the general and predominant mark of Greek masterpieces is noble simplicity and calm grandeur, both in gesture and in expression. The expression of all Greek statues reveals even in the midst of all passions a great and grave soul [italics added]." He concludes that "the only way for us to become great, and if possible, even inimitable, is through imitation of the ancients." In response to Winckelmann's influence, the rallying cry of Neoclassicism would be the creation of moral works embodying "noble simplicity and calm grandeur."

Artistic Foundations of Neoclassicism: Mengs and Hamilton

Influenced by the revived interest in antiquity, two artists working in Rome began to lay the foundation for Neoclassicism: Anton Raphael Mengs (1728-1779) and the Scottish painter Gavin Hamilton (1723-1798). Mengs, a German who worked in Rome on and off from 1740 to 1765, gained notoriety when Cardinal Albani, at Winckelmann's urging, commissioned him to paint a ceiling fresco for the Villa Albani. Completed in 1761 and with Winckelmann assisting with the iconography, his Parnassus (fig. 23.1) depicts the cardinal as Apollo surrounded by the seven female Muses, most of whom can be identified as the cardinal's friends. The composition is based on Raphael's Vatican fresco of the same title. Stylistically, Mengs drew on Raphael, as well as ancient sources. His painting combines Raphael's planarity (objects and figures are parallel to the picture plane) and linearity (objects and figures have crisply drawn contours). The figures themselves are copied from Raphael and from the recently unearthed murals at Herculaneum and Pompeii. Apollo's pose recalls the Apollo Belvedere (see page 157), a work in the Vatican collection and made famous by Winckelmann. For the sake of planarity, Mengs dispensed with the Baroque device of an illusionistic ceiling (see fig. 19.10), one that opens up to the sky. Instead he made his ceiling look like a wall painting by Raphael, simply hung on a ceiling. He also daringly replaced the lush Rococo brushwork then in fashion (see page 766) with tight brushwork that dissolves into a smooth, hard surface. An even lighting models solid, three-dimensional forms. All of these elements—planarity, linearity, tight brushwork, even lighting, sculptural forms, and Classical figures and themes—played a prominent role in the development of the Neoclassical style.

The one element absent from Mengs's painting that would be crucial for the development of Neoclassicism is an austere, moralistic subject, such as a scene of self-sacrifice. This missing ingredient was provided by the painter and antiquities dealer Gavin Hamilton, who in the early 1760s began painting deathbed scenes, such as *Andromache Bewailing the Death of Hector* (ca. 1761), a subject taken from Homer showing Andromache bent over the body of her husband, Hector, the Trojan leader who had been killed by the Greek Achilles. The painting was reproduced in a widely circulated engraving of 1764 (fig. **23.2**), a reminder of the importance of prints in giving currency to images before the invention of photography, as well as an additional way for artists

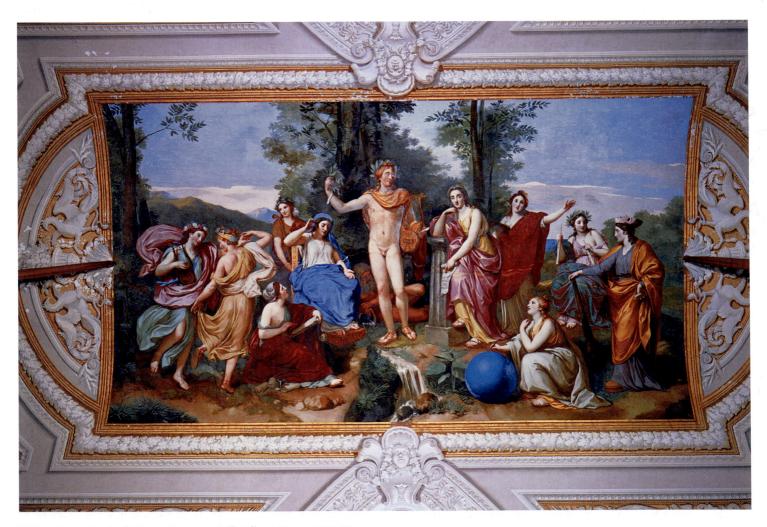

23.1 Anton Raphael Mengs, Parnassus, Villa Albani, Rome. 1761. Fresco

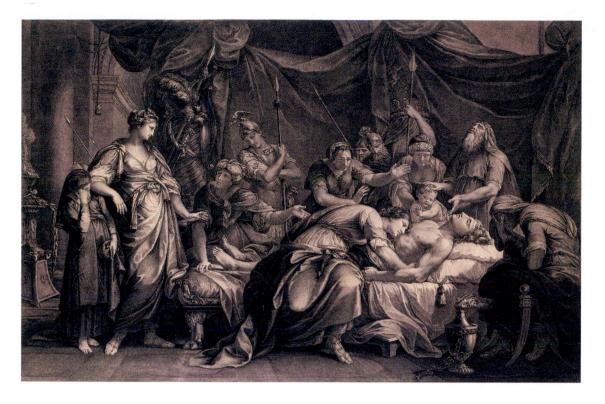

23.2 Gavin Hamilton, Andromache Bewailing the Death of Hector. 1764. Engraving by Domenico Cunego, after a painting of ca. 1761. Yale Center for British Art. Paul Mellon Collection

to earn a living. Everyone who went to Rome would have seen this picture in Hamilton's studio, since at the time he was one of the must-see painters. For those who did not get to see the work in Rome, it was available for viewing at a 1764 exhibition of the Society of Artists in London, an organization providing an annual exhibition for members and considered the premier venue in the British capital until the Royal Academy opened in 1768. This painting of mourning must have shocked eyes accustomed to Rococo gaiety, fantasy, and pleasure. Its moral is matrimonial devotion as opposed to marital indiscretion, unwavering dedication rather than titillating deception, virtue not vice. Elements of the composition were inspired by reliefs on Roman sarcophagi and sepulchral buildings, but Hamilton's prime source was Poussin's Death of Germanicus (see fig. 21.4), which was then in the Palazzo Barberini in Rome. The two pictures share the receding barrel vault on the left and the same planar composition established by the lateral spread of the bed with canopy and recumbent body. Hamilton would paint other works on the themes of virtue and moral fortitude, and while he was not the first to reintroduce themes that had been of extreme importance to artists until the advent of the Rococo, his pictures seem to have been a catalyst. Increasingly in the 1760s and 1770s, artists in all mediums turned to this kind of moralistic subject matter.

ROMANTICISM IN ROME: PIRANESI

As discussed in the introduction, Neoclassicism was not the only movement to evolve after 1750. Concurrently, the first signs of a Romantic spirit were emerging, a spirit that evoked strong emotional responses from the viewer. In Rome, the source of this

current was Giovanni Battista Piranesi (1720-1778), a printmaker who would have a powerful impact on eighteenth-century artists, especially architects, as we shall see. By the 1750s, Piranesi was renowned for his vedute, or views, of Rome, which gentlemen on the Grand Tour took home as souvenirs of their visit. (In Venice, they would buy vedute by Canaletto and other artists-see page 775.) Winckelmann's glorification of the Greeks and belittling of the Romans had infuriated Piranesi, who set out to defend his Roman heritage by producing Roman Antiquities, a four-volume work completed in 1757 and illustrated with several hundred etchings of Roman ruins. These etchings are hardly mere documentation of sites in and around Rome. Often presenting worm'seye views of the structures (fig. 23.3), Piranesi transformed them into colossal, looming monuments that not only attested to the Herculean engineering feats of the ancient Romans but also the uncontested might and supremacy of Roman civilization. The frightening scale of the monuments dwarfs the awestruck tourists who walk among the dramatically lit ruins. These structures seem erected not by mere humans, but by a civilization of towering giants who mysteriously vanished. Time, however, has taken a toll on their monuments, now crumbling and picturesquely covered by plants. Tourists such as Goethe, who before only knew Rome from Piranesi's vedute, were shocked to discover how small the ruins actually were upon seeing them for the first time.

These images embody Piranesi's own sense of awe in the face of Roman civilization and constitute a melancholic meditation on the destructive ability of time to erode that once-great empire. The prints are not intended just to inform; they are also meant to evoke a sense of astonishment, even fright. In them we see the beginnings of a sensitivity that is antithetical in spirit to the noble simplicity and calm grandeur of Neoclassicism.

79

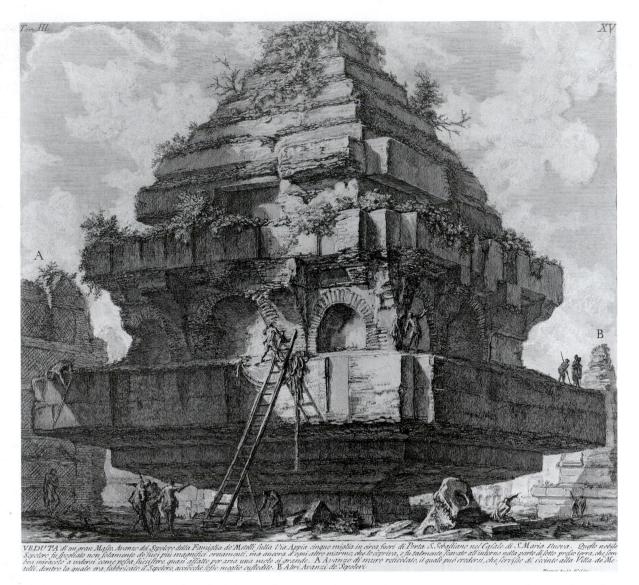

23.3 Giovanni Battista Piranesi, *Tomb of the Metalli*, plate XV from *Antichità Romane III*. ca. 1756. Etching, 16¼ × 18¾" (42.5 × 46.5 cm). Metropolitan Museum of Art, Rogers Fund, 1941, transferred from library. (41.71.3(15))

Before the eighteenth century was out, the sense of awe that Piranesi produced would be identified as being caused by what the period called the "sublime." The sublime is not a style, but a quality or attribute. Interestingly, the word became current in 1756, a year before Piranesi's publication, when the British statesman Edmund Burke (1729-1797) published a treatise titled A Philosophical Inquiry into the Origin of Our Ideas of the Sublime and Beautiful. Burke's study was directed more toward psychology than aesthetics, but its impact on the world of art was tremendous. He defined beauty as embodying such qualities as smoothness, delicacy, and grace, which produced feelings of joy, pleasure, and love. The sublime he defined as obscurity, darkness, power, vastness, and infinity, anything that generated feelings of fright, terror, being overwhelmed, and awe. The sublime, he wrote, produced "the strongest emotion which the mind is capable of feeling." As the century progressed, more and more artists embraced this quality, catering to viewers' demands to be awed or moved by paintings, sculpture, and architecture.

NEOCLASSICISM IN BRITAIN

It almost seems as though the British were predisposed to embracing Neoclassicism, not only because the birth of Enlightenment occurred in Britain but also because the nation already had an intense involvement with antiquity in literature, which dated to the opening decades of the eighteenth century. The Augustan or Classical Age of British poetry was in full bloom by then, with its leading authors, such as John Dryden, Alexander Pope, and Samuel Johnson, emulating the form and content of the writers active during the reign of the first Roman emperor, Augustus Caesar (63 BCE-14 CE), many of whose works these same British poets translated. Britain at this time was enjoying unprecedented peace and prosperity, which, in part, was responsible for the identification with Augustus Caesar's reign, similarly marked by stability, economic success, and the flourishing of culture. The liberal faction of the British aristocracy modeled itself on ancient Rome, relating the British parliamentary government

that shared power with the king to the democracy of the Roman Republic. As we shall see, by the 1720s, these liberals, who compared themselves with Roman senators, had come to desire country homes based on Roman prototypes.

Sculpture and Painting: Historicism, Morality, and Antiquity

The British were particularly receptive to the Neoclassical foundation established by Mengs and Hamilton. Hamilton's moralistic antique scenes in particular had a major impact, and the list of artists inspired by them is extensive, starting with a handful in the 1760s and extending to dozens more in the following decades. However, the taste for the classical could also be just that, a taste for a style or look, with little consideration for the underlying moral message. This was especially true in the decorative arts (see *Materials and Techniques*, page 792).

THOMAS BANKS Hamilton's impact was so great it extended beyond painting to sculpture, as seen in the work of Thomas Banks (1735-1805). From 1772 to 1779 Banks studied in Rome, where he chiseled a marble relief of *The Death of Germanicus* (fig. 23.4). Reflecting the Enlightenment emphasis on logic and credibility, Banks authenticated his scene by making his setting as real and as historical as possible, using archaeologically correct architectural details and furniture (note the klismos chair, for instance, which was especially popular in the fifth century BCE). To make his image more antique, he aligned his Classical figures in a flat, shallow frieze composition, idealizing faces and putting them in Greek profile. The unusual stance of the soldier on the far right is a mourning pose that Banks copied from Roman reliefs. As in Hamilton's Andromache Bewailing the Death of Hector, the devoted women and children express intense sorrow for the dying general, while the dedicated soldiers, with raised oath-swearing arms, probably inspired by Hamilton's 1763-64 Oath of Brutus, vow to avenge his murder. Similarly sweeping curves augment the intense emotion of both groups, although Hamilton's figures, especially Andromache, appear to imitate the explosive monumentality of Michelangelo's sibyls and prophets. As we shall see, Neoclassicism, in its climax in France in the 1780s, will abandon curvilinear design and embrace a severe geometric grid that underscores the intense moralistic resolve of the figures.

ANGELICA KAUFFMANN Angelica Kauffmann (1741–1807) was among the most important artists for the development of Neoclassicism in Britain. She was born in Switzerland, studied in Rome in the 1760s, and moved to London in 1766. She befriended Joshua Reynolds, who was to become the first president of the Royal Academy when it was founded in 1768, and she herself was a founding member. Prior to the twentieth century, she was one of only two women admitted into the academy. As a woman, she was denied access to studying the male nude, then considered critical to a history painter's success, which makes her accomplishments all the more remarkable. Of the few eighteenth-century

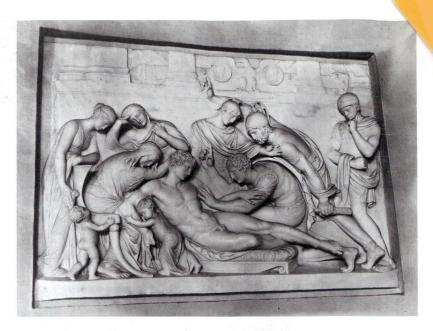

23.4 Thomas Banks, *The Death of Germanicus*. 1774. Marble, height 30" (76.2 cm). Holkham Hall, Norfolk, England. By Kind Permission of the Earl of Leicester and the Trustees of the Holkham Estate

women artists to carve out a successful career in a man's world, Kauffmann was the only one who became a history painter. The others were either still-life painters, like the Parisian Anne Vallayer-Coster (1744-1818), or portraitists, like Marie-Louise-Élisabeth Vigée-Lebrun (see page 816), who was the French queen Marie-Antoinette's favorite artist, and Adélaïde Labille-Guiard (1749-1803). Male prejudice was so strong against the latter two French women, both of whom rank among the finest painters of the period, that they were accused of employing men to make their works. Enlightenment philosophy, with its emphasis on equality, may have provided a theoretical premise for greater social, economic, and political freedom for women, but in reality female artists remained second-class citizens throughout the eighteenth century, only occasionally gaining access to the academies in London and Paris (the French Academy only allowed four women members at a time). Furthermore, male artists continued to depict women stereotypically, as wives and mothers who in addition to being fertile and pretty are helpless, passive, grieving, and immobile, as we saw in Hamilton's Andromache Bewailing the Death of Hector and Banks's The Death of Germanicus.

Like so many of her contemporaries, Kauffmann raided Greek and Roman literature for her subjects. In 1769, at the first Royal Academy exhibition, she presented *Hector Taking Leave of Andromache*, and three years later she showed *Andromache and Hecuba Weeping over the Ashes of Hector*, two pictures portraying unwavering marital fidelity. A classic example of Kauffmann's moralistic pictures is *Cornelia Presenting Her Children as Her Treasures (Mother of the Gracchi)* (fig. 23.5) of about 1785. Here she champions child-rearing and family duty over materialism. While portraying a woman as a mother, she nonetheless counters traditional male stereotyping by presenting her subject as proactive and in control. In this second-century BCE story from

Josiah Wedgwood and Neoclassical Jasperware

reflecting the rising demand in Britain for all things Classical Rwas jasperware porcelain, invented by Josiah Wedgwood and produced by the mid-1770s in his factory named Etruria in Staffordshire. Jasperware is a durable, unglazed porcelain decorated with Classically inspired bas-relief (low-relief) or cameo figures. Most jasperware is ornamented in white relief on a colored ground, especially blue and sage green. In 1775, Wedgwood hired the sculptor John Flaxman (1755-1826) to produce many of his designs, which were largely based on ancient Greek vases in the collection of William Hamilton. The Greek vases, not discovered until the middle of the eighteenth century, were considered Etruscan, hence the name Etruria for Wedgwood's plant. Hamilton's collection, housed in Naples and sold to the newly founded British Museum in 1772, was published in enormous folio volumes in the 1760s and readily available for copying.

Reproduced here is a Flaxman vase depicting *Hercules in the Garden of the Hesperides*, designed in 1785, although not produced until later. Flaxman translated the two-dimensional drawing on a Hamilton vase into the shallow three-dimensionality appropriate for jasperware. While he retained the strong contours, profiles, and basic configuration of the figures on Hamilton's vase, he subtly increased the elegance of the original Greek design, largely by simplifying the drawing and making it more graceful.

Like most Wedgwood images, the scene is not one of action, resolve, or a decisive moment reflecting nobility of character. Instead, Flaxman shows Hercules in repose in the garden where his eleventh task required him to steal the golden apple belonging to Zeus, which was protected by the multi-headed Hydra and the Hesperides, the daughters of Atlas. The image looks more like a Classical *fête galante* than a heroic act of Herculean courage and might. The prettiness of the color and delicacy of the design echo Rococo sensitivity and are a reminder that the taste for the Classical could also be just that, a taste for a style or look, with little consideration for a moralistic message, as we

saw in the Neoclassical images of Hamilton, Banks, and Kauffmann.

The rise of Wedgwood coincided with the Industrial Revolution: the company was based upon mass production. Wedgwood produced the same Flaxman design on different objects: vases, fireplace panels, plaques, medallions, and jardinières (large, ornamental flowerpot holders). With his partner Thomas Bentley, who was responsible for the firm's preoccupation with Classical art and for hiring Flaxman, Wedgwood opened a showroom in London to promote their wares and innovatively published a well-distributed catalogue of their products. The two men were not only massproducing art, they were also mass-marketing it, making highquality work available to a broad public at a reasonable price. They also fulfilled a growing public infatuation with celebrities, for their medallions included portraits of famous people, in effect anticipating the role of photography some 75

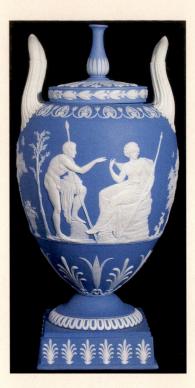

John Flaxman, *Hercules in the Garden* of the Hesperides. Designed 1785 and produced by Wedgwood ca. 1790. Jasperware, height 14" (35.7 cm). The Potteries Museum and Art Gallery, Stoke-on-Trent

years later and the mass media in the twentieth century. Flaxman designed profiles of such renowned figures as the writer Samuel Johnson and the sensation of London, the actress Sarah Siddons.

The Industrial Revolution was increasing wealth and creating an upper middle class in Britain, and Wedgwood was meeting the needs of this new clientele—art was no longer just for royalty, the aristocracy, and the church. Demand was so great that Wedgwood installed his first steam engine at Etruria in the early 1780s to make his plant more efficient.

Hercules in the Garden of the Hesperides. Illustration in Pierre-François Hugues d'Hancarville, Collection of Etruscan, Greek and Roman Antiquities from the Cabinet of the Honorable William Hamilton. 1766–67. Vol. II, Plate 127

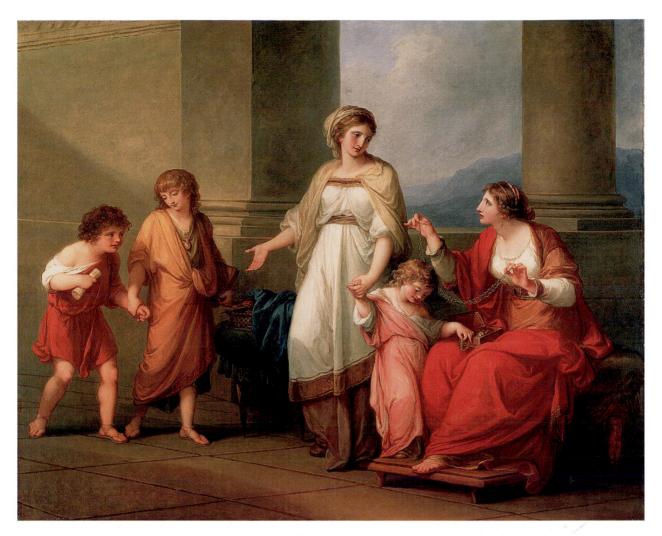

23.5 Angelica Kauffmann, *Cornelia Presenting Her Children as Her Treasures (Mother of the Gracchi)*. ca. 1785. Oil on canvas, 40 × 50" (101.6 × 127 cm). Virginia Museum of Fine Arts, Richmond. The Adolph D. and Wilkins C. Williams Fund. 75.22

Roman history, a visiting friend has just shown off her jewelry to Cornelia Gracchus. Instead of displaying her own gems, Cornelia proudly presents her children, two of whom, Tiberius and Gaius, would become great politicians. To prepare her sons for leadership, Cornelia acquired the finest tutors in the world, and it was said that she "weaned" them on conversation, not her breasts. She remained an ally and advisor to both, and in addition to her reputation for virtue and intelligence, she was one of the most powerful women in the history of the Roman Republic. Kauffmann, a woman artist struggling in a man's world, must have identified with the successful Cornelia, whose features in the painting resemble the artist's own.

In Cornelia Presenting Her Children, Kauffmann has created an austere and monumental painting that reinforces the strength and nobility of the mother. The picture is dominated by the bareness of the floor and walls, the carefully modeled statuesque figures, and a stable composition anchored by a solid triangle culminating in Cornelia. The Cornelia theme was not unique to Kauffmann, but was quite popular with other artists. Not only did it illustrate virtue, it also reflected the new interest in the importance of the family unit that stemmed from the Enlightenment teachings of Jean-Jacques Rousseau, who advocated that parents should nurture their children at home, rather than sending them off to wet nurses and nannies until they were adolescents.

The Birth of Contemporary History Painting

Enlightenment empiricism had a major impact on history painting in two ways. One was the strong emphasis on historicism—when portraying a scene set in the historical past, costume, setting, and props all had to be convincing and true to the period. The second impact affected the presentation of major contemporary events that the future would perceive as historically important. Until now, such moments had generally been shown using allegory and symbols, not by portraying the actual scene, or figures would be dressed in Classical garb in order to provide the sense of decorum and importance the event apparently required. But with the Enlightenment, paintings increasingly had to be logical and real and every bit as convincing to contemporaries as we expect period films to be today. This applied not only to the historical past but to contemporary events as well. BENJAMIN WEST The artist perhaps most responsible for popularizing contemporary history painting is Benjamin West (1738-1820), one of the most successful British Neoclassical history painters. A Quaker born and raised just outside of Philadelphia, West went to Rome in 1760 where he studied with Mengs, befriended Gavin Hamilton, and immersed himself in antiquity and the Classically influenced Renaissance masters, especially Raphael. By 1763, he had settled permanently in London, and within three years had found success, in part because of his innovative handling of Neoclassicism's emerging vocabulary. He was a founding member of the Royal Academy in 1768, and he became its president in 1792 when Joshua Reynolds died. Throughout his life, he was a mentor for many American artists, and always remained proud of his New World heritage, even supporting the American Revolution. (For a discussion of art in colonial America, see the Introduction.)

Among the pictures that established West's reputation are his Agrippina with the Ashes of Germanicus of 1768, a picture that falls into the moral category of the dedicated widow, and The Departure of Regulus from Rome from 1769, which reflects the stoic self-sacrifice of a Roman general to save his country. Employing Enlightenment historicism, the pictures are set in convincingly real ancient Roman cities, with figures aligned in relief, parallel to the picture plane, against a backdrop of Classical buildings.

West shocked the London art world in 1770 when he announced he was working on a contemporary history painting, The Death of General Wolfe (fig. 23.6), and placing the event in the realistic setting of 1759 Quebec during the French and Indian War. Wolfe won the Battle of Quebec, which became a turning point in the war and made him a national hero. Upon hearing of West's plan, King George III declared he would never purchase a picture with his soldiers shown in modern uniforms, and Reynolds frowned on the picture's breach of decorum, which required an allegorical apotheosis scene. But when exhibited at the Royal Academy, the painting was immediately applauded by the public. The costumes, setting, and Indian warrior all lend the image an air of authenticity, despite inaccuracies (see The Art Historian's Lens, page 795), and in an era before photography and film, made the audience feel as though it were indeed witnessing its great national hero at the very moment he sacrificed his life for his country.

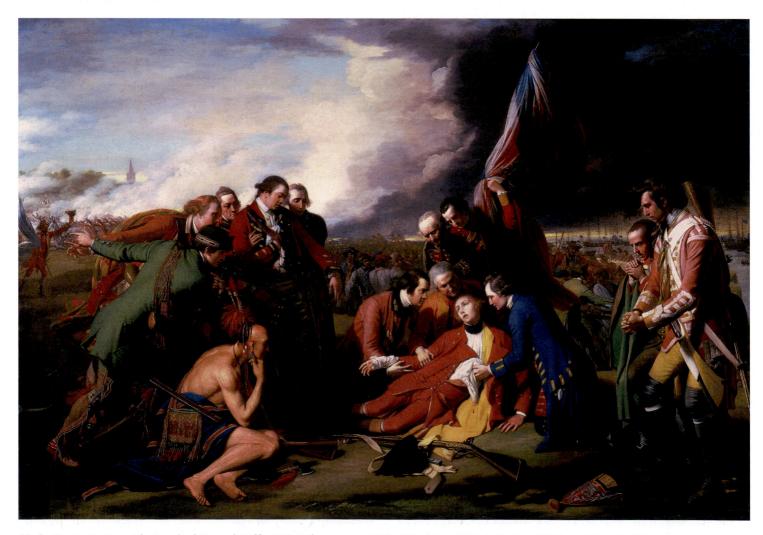

23.6 Benjamin West, *The Death of General Wolfe*. 1770. Oil on canvas, $59\frac{1}{2} \times 84$ " (1.51 × 2.13 m). National Gallery of Canada, Ottawa. Gift of the Duke of Westminster

75

The Elusive Meaning of West's The Death of General Wolfe

The history of art is filled with mysteries, and among the most common unknowns for art made before 1900 are the authorship and date of a piece, the reason it was made, and its message. Art historians are often forced to rely on speculation, a tactic filled with risk but one that has the advantage of beginning an intellectual dialogue that may lead to firm answers. Benjamin West's *The Death of General Wolfe* raises probing questions. The most obvious question is, why did West depict this particular subject? The key to the answer may be the figure of William Johnson, who is shown in a green coat to the left (see fig. 23.6). His name and a map with "Mohawk Valley" and "Ontario" on it are etched on his powder horn. These territories had been ceded to him as superintendent of Indian affairs by the Native Americans. More important, he had been the hero at the battles of Lake George and Fort

The painting was also successful because West aggrandized and classicized his figures and the event, in effect creating a modern Classical scene. Contemporary viewers recognized they were in the presence of what amounted to a traditional Lamentation scene (for instance, see fig. 14.15), and that their hero was a modern-day Christ or martyr. The surrounding "apostles" express remorse and concern, but their powerful emotions, worthy of Poussin according to contemporary reviewers, are noble and controlled, in keeping with the Classical rule of decorum. Figures strike contrapposto poses, stand in Classical profile, and have the sculptural quality of a shallow ancient relief or Raphael saint, apostle, or Greek philosopher (see fig. 16.24); they are simultaneously modern and Classical. The one unemotional figure is the Iroquois, Rousseau's "noble savage," whom West presents with the grandeur and composure of an ancient river-god. West's painting technique was influenced by that of Hamilton and Mengs, both of whom he knew in Rome, for he first drew and then colored in the figures, allowing crisp contours to ennoble them.

Grand Manner Portraiture in the Neoclassical Style: Joshua Reynolds

Portraiture dominated British painting, for it was extremely difficult to earn a living as a history painter—there just was not much demand for it. Nonetheless, it was a fashionable "face painter," as portraitists were derogatorily called, who played a major role in encouraging British artists to turn to working in a grand manner that aspired to match the great accomplishments of the ancients and their Classical heirs in the Renaissance and Baroque. This proselytizer was Joshua Reynolds (1723–1792), who studied in Rome from 1750 to 1752 and returned to London determined to elevate British art in the mold of the great masters. Working behind the scenes, Reynolds played a role in establishing the Royal Academy of Art in 1768, and as a favorite of George III, he was appointed the body's first president, a position he held until his death in 1792. From 1769 to 1790, Reynolds delivered his Niagara and therefore was a symbol of the important role that Americans played in winning the French and Indian War. Despite the picture's historicism, West's image is a fiction: Johnson had not been at Quebec, and the Indians aided the French, not the British. West made this picture on the threshold of the American Revolution (the Boston Massacre was in 1770), and his ahistorical inclusion of Johnson was perhaps designed to make the British aware of their indebtedness to the colonists, represented here by Johnson, who as faithful citizens had supported Britain, and of the need to be more conciliatory in granting the concessions they felt they had earned. This interpretation accounts for many of the unusual components in the painting, although the fact that the explanation is so logical is its only proof. Although conjecture, it certainly provides a new way to think about the picture.

Fifteen Discourses on Art, in which he laid out theories similar to those of Charles Le Brun, the first director of the French Royal Academy (see page 745). He advocated history painting in the grand manner, emulation of the great masters, and an idealization in art.

While Reynolds was financially forced to spurn history painting for portraiture, he elevated the genre by encasing his figures in Classical poses and layering the images with recondite references of the kind that could be found in great history painting. Upon returning from Rome, for example, he painted a monumental full-length portrait of Commodore Keppel (1753), which shows the subject walking on a beach after a shipwreck. But Keppel is ennobled, for his pose is clearly based on the Apollo Belvedere (see page 157), then considered one of the great monuments of Greek art that Reynolds saw during his time in Rome. In his 1765 portrait Lady Sarah Bunbury Sacrificing to the Graces (fig. 23.7), Reynolds fills his picture with Classicisms. The presentation of the Three Graces on an antique pedestal at the upper left of the picture is based on a well-known Hellenistic sculpture. Lady Sarah's gown is not contemporary dress but rather ancient drapery, pinned at the shoulder and with a band at the waist. The brazier, urn, and architecture are also antique. The sitter's pose is based on a figure in a Guido Reni painting (see page 672).

Like a history painter, Reynolds has loaded his image with symbols. Using Cesare Ripa's *Iconologia* or Andrea Alciatii's *Emblemata*, books of symbols dating to the Renaissance that were vital resources for history painters, Reynolds selected the Three Graces because they were a representation of *amicitia*, or friendship. Ripa declared that the three figures symbolize the three stages of friendship, which are the giving, receiving, and constant exchange of friendship between friends. The intertwined arms represent this exchange, and the nudity the openness of friendship. The myrtle wreath held by the central figure signifies friendship's self-propagation, while the roses on the pedestal represent its beauty and pleasure. The figure pouring a sacrificial libation has been identified as Lady Sarah's lifelong friend, Lady

23.7 Joshua Reynolds, *Lady Sarah Bunbury Sacrificing to the Graces.* 1765. Oil on canvas, 7'10" × 5' (2.42 × 1.53 m). The Art Institute of Chicago, Mr. and Mrs. W.W. Kimball Collection, 1922.4468

Susan Fox-Strangways. While little is known about the commission for this picture, scholars believe the painting is as much about the platonic dedication of the women to one another as it is a portrait of Lady Sarah.

In the 1750s and 1760s, Reynolds made countless portraits that could be described as Neoclassical, pictures filled with Classical references and executed in a style that has a strong linear quality as well as smooth modeling and even lighting that sculpturally forms figures and objects. But in his quest to emulate the Old Masters, as he advocated in his Discourses, Reynolds was a stylistic chameleon, at one moment taking his cue from Raphael, the next Guido Reni, the next Rubens, and the next Rembrandt. One artist who is lurking behind most of his pictures in some form, however, is Anthony van Dyck, the Flemish painter who ended his brief career painting royalty in London. His enormous full-lengths portraits with grandly yet elegantly posed figures (see fig. 20.8) challenged most portraitists in eighteenth-century Britain, and despite the Neoclassical look of Lady Sarah Bunbury, this almost 8-foot-high canvas, which would proudly preside in a public room of the sitter's imposing home, reflects the scale and grandeur of Van Dyck's work.

Architecture and Interiors: The Palladian Revival

In Britain, a Classical revival began much earlier in architecture than it did in painting and sculpture, and its origins date to the architectural treatises of Anthony Ashley Cooper, third earl of Shaftesbury, and of Colen Campbell, published in the 1710s. Both writers argued for a British architecture based on antiquity and Antonio Palladio's classically inspired villas, which not only evoked antiquity but projected a perfect harmony using geometry, mathematics, and logic (see pages 614–17). Sounding much like Winckelmann did when he was discussing sculpture some 50 years later, Shaftesbury, in his *Letter Concerning Art, or Science of Design* (1712), wrote that the proportions and geometry of ancient architecture reflected the nobility and beauty of the Greek and Roman soul, which have a powerful effect on the enlightened "man of taste." Architecture was beauty, not function.

The works of both Campbell and Shaftesbury reflect a British antagonism toward Roman Catholicism. In Britain, Baroque architecture was associated with two evils: papist Rome and French royalty. Shaftesbury, a patron and student of John Locke, was an advocate of individual freedom, and he equated ancient architecture with democracy. He was also a member of the Whigs, the liberal antimonarchy political party. (The Tories, the conservative promonarchy party, had backed the Roman Catholic Stuart king James II, who died in 1701.) In 1714, the Whig party came to power, ending 13 years of political turmoil. Its democratic members especially identified with Classical-revival architecture, for they saw themselves as the modern equivalent of Roman senators, who had country villas in addition to city houses. Campbell, who was virtually unknown prior to the publication of Vitruvius Britannicus (1715-25), could hardly fill singlehandedly the demand from Whigs who wanted Palladian-style country homes. His three-volume treatise consisted of dozens of his own Palladio-inspired designs, which formed a pattern book for architects for the remainder of the century. Most British architects had a copy of Campbell's Vitruvius Britannicus as well as Vitruvius' Ten Books of Architecture and Palladio's Four Books.

THE COUNTRY VILLA: CHISWICK HOUSE We can see the impact of *Vitruvius Britannicus* on Campbell's patron, Lord Burlington (1694–1753), who after a trip to Italy in 1719 became an amateur architect and eventually supplanted Campbell as the leading Palladian. In 1725, Burlington with the artist William Kent (1684–1748) designed Chiswick House (fig. 23.8), located on Burlington's estate outside of London and one of the most

23.8 Lord Burlington and William Kent. Chiswick House, near London. Begun 1725

famous Palladian-revival houses. This stately home is based on Palladio's Villa Rotonda (see fig. 17.34), which Lord Burlington had studied on his Grand Tour. The exterior staircase, however, could just as well have come from Campbell's 1715 design for the façade of Wanstead House, which appears in volume one of *Vitruvius Britannicus*.

Chiswick House is remarkable for its simplicity and logic, making it easy to understand why Lord Burlington was such a success as an architect. The building is a cube. Its walls are plain and smooth, allowing for a distinct reading of their geometric shape and the form of the windows. The Greek temple portico protrudes from the wall, again creating a simple and clear form. Even the prominent domed octagonal rotunda is geometric, as are its tripartite semicircular clerestory windows, based on windows in Roman baths. Here we have reason and logic clearly stated, and put in the service of the ideals of morality, nobility, and republican government. Like Shaftsbury, Burlington believed architecture to be an autonomous art dealing in morality and aesthetics, not function.

URBAN PLANNING: BATH Perhaps the greatest example of the Classical revival in Britain is in Bath, a resort that had been a spa town since Roman times. Local architects John Wood the Elder (ca. 1704–1754) and the Younger (1728–1782) played a major role in developing the sleepy town as it expanded to accommodate the flood of wealthy Londoners who as a result of the burgeoning economy at midcentury came to "take the waters." In

the 1740s and 1750s, John Wood the Elder, influenced by the Classical revival, aspired to evoke ancient Rome and designed an imperial gymnasium, forum, and circus. Only the last was realized with success. Built in 1764, it consists of 33 attached houses surrounding a circle and divided by three streets. The façades are identical and continuous, and resemble the Colosseum turned outside in (see fig. 7.20). John Wood the Younger upstaged his father in 1767 when he designed the Royal Crescent (fig. 23.9), a crescent-shaped space containing 30 houses. Wood the Younger used a colossal Palladian Ionic order mounted on a podium basement, giving the façade a magnificent unified grandeur. The Woods' urban planning of circuses was so innovative it would be replicated in Britain right through the nineteenth century.

THE NEOCLASSICAL INTERIOR The British taste for the Classical extended to interior design and was largely created by one man, Robert Adam (1728–1792). Adam was a wealthy Scottish architect who made the Grand Tour from 1754 to 1758. He scrambled over the Roman ruins, assisting Piranesi in measuring and documenting the deteriorating structures and reconstructing them on paper. Upon returning to Great Britain, he began practicing in London and was soon the city's most fashionable architect. Although he designed several houses, his specialty was renovating interiors and designing additions, especially for country homes. Along with Joshua Reynolds, Adam played a major role in developing a taste for the Neoclassical in London in the late 1750s.

23.9 John Wood the Younger. Royal Crescent, Bath, England. 1767-ca. 1775

A fine example of his work is the library wing at Kenwood (fig. 23.10), built in 1767–69. The ceiling of the room is a Roman barrel vault, and at either end is an apse separated from the main room by Corinthian columns. This concept comes largely from Palladio. The decoration is based on Classical motifs, which Adam could copy from the many archaeological books then being published. On the one hand, the library is quite Classical, not just because of the motifs, but also because it is symmetrical, geometric, and carefully balanced. On the other hand, it is filled with movement, largely because of the wealth of details and shapes that force the eye to jump from one design element to the next. Adam's palette is pastel in color and light in tone; light blues, white, and gold prevail. Curving circles, delicate plant forms, and graceful fluted columns with ornate capitals set a festive, elegant, and refined tone closer to Rococo playfulness than to Neoclassical morality. For the decorative wall paintings, Adam often turned to the Italian Antonio Zucchi and occasionally to Angelica Kauffmann, whom Zucchi married in 1781.

EARLY ROMANTICISM IN BRITAIN

The architect Sir John Vanbrugh was not only one of the leading figures of the British Baroque (see page 758), he was also responsible for introducing Gothic design to domestic architecture when he built his own London mansion, Claremont, in 1708, silhouetting the roofline with massive medieval crenelations. This decision to depart from the Baroque or Classical may at first seem incongruous, but within Vanbrugh are the seeds of Romantic longing for emotional experience. Vanbrugh argued not to destroy old buildings but rather to conserve them because they inspire "more lively and pleasing Reflections on the Persons who have inhabited them; on the remarkable things which have been transacted in them, or the extraordinary occasions of erecting them." This longing for exotic experience, of being transported mentally to a distant past, gradually became a prevailing sentiment in British art, surfacing in painting, architecture, and landscape design. By the closing decades of the eighteenth century,

23.10 Robert Adam. Library, Kenwood, London. 1767-69

exotic experience alone would not be sufficient; audiences would want to be awed or terrified, just as they do today when they go to see a horror film.

Architecture and Landscape Design: The Sublime and the Picturesque

We do not know precisely what motivated Edmund Burke to write his 1756 treatise *A Philosophical Inquiry into the Origin of Our Ideas of the Sublime and Beautiful* (see page 790), but he must in part have been prompted by the period's increasing desire to undergo powerful subjective experiences, an emphasis that existed alongside a strong belief in the primacy of logic and empiricism. We have already seen how Piranesi created a sense of awe and melancholy in his etchings of Roman monuments, which were popular throughout Europe and were often labeled "sublime" once the word became current. The British, however, were principally responsible for developing a taste for the sublime in the visual arts—for the experience of undergoing the most primal of emotions, those verging on terror—and it first appears in architecture and garden design.

Simultaneously, the British also developed two other concepts or principles, neither of which is a style. One is the **picturesque**.

Initially the term was used in the guidebooks to the Lake District in the north of England to mean a scenic view that resembled a landscape painting. It gradually came to mean as well that something had variety and delightful irregularities that made it interesting to look at, and the concept was offered as an alternative to, on the one hand, the sublime, which caused awe and fear, or as Burke claimed, a feeling of a need for self-preservation, and, on the other hand, beauty, which was manifest in smooth, symmetrical, and harmonious qualities that generated feelings of joy, pleasure, and love. The British writer William Gilpin, who played a major role in defining the term picturesque in several late eighteenth-century treatises, wrote that a Gothic castle would be infinitely more interesting and picturesque if it were in a state of decay, a crumbling ruin covered with vegetation. In a painting, this ruin would offer greater variety for the eye if it were executed with a large range of colors instead of just a few, and were lit with a strong light that resulted in a play of dark and light as opposed to even, uniform illumination. Although not discussed by Gilpin, this same Gothic castle could be considered beautiful if exquisitely proportioned and in perfect condition, and it would be sublime if it were enormous, dark, and foreboding, seeming to harbor unseen dangers. The picturesque, in contrast to the sublime, generated visual interest, not fright or awe.

The other major concept developed at the time was associationism, a term invented by twentieth-century historians to describe the eighteenth century's love of layering architecture and garden design with numerous associations, many exotic, that were often designed to elicit emotional responses as well as to edify. Enlightenment research and publications vastly increased the knowledge of history and the world, and this knowledge was now poured into art. Winckelmann and Piranesi, for example, gave separate identities to Greek and Roman art, which had previously been combined under the banner of Classical art; now artists could make reference to the "noble simplicity and calm grandeur" of the Greeks or to the imperial might of the Romans. We have already seen, for example, how British architects evoked republican Rome in their buildings in order to elicit a sense of democracy. While architecture had always been representational, that is, containing associations, now these associations became more extensive, precise, formal, and literary.

THE ENGLISH LANDSCAPE GARDEN Burlington and Kent landscaped the grounds surrounding the Palladian-revival Chiswick House to look natural, that is, unplanned and without human intervention. This was a radical departure from the style of the house itself and from the geometric gardens that were then in vogue, such as those at Versailles (see fig. 21.12). Winding paths, rolling lawn-covered hills, serpentine ponds, and irregular stands of trees greeted visitors making their way to the mansion. Picturesque asymmetry rather than orderly geometric symmetry prevailed. However, these natural-looking grounds were not intended to be a re-creation of untamed nature; rather, they were an idealized vision of the Classical past as if rendered in a landscape painting by Claude Lorrain (see fig. 21.8), who was

23.11 Henry Flitcroft and Henry Hoare II. Park at Stourhead, Wiltshire, England. Designed 1743, executed 1744-65, with later additions

extremely popular among British collectors. Aristocrats arriving in their carriages even had special yellow-tinted "Claude" glasses that gave the view the same warm twilight glow found in the French master's paintings. On the one hand, we can label the grounds as Neoclassical, since they are meant to evoke the Classical past as seen through the eyes of Claude. But on the other hand, they are Romantic, for they are designed to transport viewers psychologically into a lost Arcadian world, an immersion accompanied by powerful emotions.

Kent was probably responsible for most of the landscaping at Chiswick, and he became renowned as a landscape designer, rather than as an architect. He is credited with establishing the English style of landscape garden, his finest perhaps being the one he developed at Stowe in the 1740s. There, Kent sprinkled the grounds with carefully sited Classical temples and Gothic "ruins." Unfortunately, there is very little left of Kent's gardens. The best-preserved picturesque landscape garden is by two followers of Kent and Burlington, the architect Henry Flitcroft (1697-1769) and the banker Henry Hoare II (1705-1785), who started developing the grounds on the latter's estate at Stourhead in Wiltshire in 1743 (fig. 23.11). In the carefully orchestrated view reproduced here, we look across a charming bridge and artificial lake to see nestled in the distant trees a Pantheon-like structure that is a replica of the Temple of Apollo in Claude's Coast View of Delos with Aeneas, a picture based on Vergil's epic poem The Aeneid. The path around the lake is meant to be an allegorical reference to the journey of Aeneas through the underworld, for the lake itself represents Lake Avernus, the entrance to the underworld. A grotto by the lake contains statues of a nymph and rivergod. Thus, not only are there picturesque variety and views in the park at Stourhead, but there are also layers of historical and literary associations. Nor is the park limited to Greek and Roman motifs, for it includes rustic cottages, a Gothic spire, a Turkish tent, and Chinese bridges, an encyclopedic compendium reflecting Enlightenment discoveries. And there are also the sham ruins that Kent popularized at Stowe "to raise the imagination to sublime enthusiasm, and to soften the heart to poetic melancholy," as contemporaries themselves described them.

In other words, the English garden did more than just evoke the nobility of the Classical past, in which case it would simply be described as Neoclassical. It also catered to a Romantic sensibility developing at the time—a sensibility characterized by delight in the exotic as well as a desire to experience powerful emotions. It was, in fact, a Piranesian contemplation of the destructive power of time and mortality as seen in the ruins. Burke had put the word sublime into play, and, as we saw in the previous quote about sham ruins, the period was using it.

THE GOTHIC REVIVAL: STRAWBERRY HILL While the Woods were developing Bath to look like a Roman city and Palladian country houses were springing up all over Britain, a Gothic revival was also taking place. An interest in Gothic architecture-which was then perceived as a national architecture because it was believed to have originated in Britain-was sparked in part by the appearance of some of the first literature on the style, which until then had been so little studied that no one knew when the buildings were made or that they even belonged to different periods of the Gothic, each with a different style. After midcentury, books began to identify the major buildings and their dates, and to define a development of Gothic architecture. But the Gothic style's appeal in large part lay in its sublime qualities. The cathedrals were cold, dark, and gloomy, and contained vast overwhelming spaces. Gothic ruins, which could be seen everywhere, evoked associations of death, melancholy, and even horror. In 1764, the Gothic novel emerged as a genre with the publication of Horace Walpole's The Castle of Otranto: A Gothic Story, which was set in a haunted castle. The book started a medieval craze that peaked with Victor Hugo's 1831 Notre-Dame de Paris, in which the dark, foreboding cathedral is the home of the terrifying hunchbacked recluse Quasimodo.

23.12 Horace Walpole, with William Robinson and others. Strawberry Hill, Twickenham, England. 1749–77

Horace Walpole (1717–1797) also deserves credit for making the Gothic revival fashionable when, with a group of friends, he redesigned Strawberry Hill (fig. 23.12), his country house in Twickenham, just outside of London. Started in 1749, the renovation took over 25 years to complete. The house is distinctly medieval; the walls are capped with crenelated battlements and pierced by tracery windows. While Walpole may have thought of these features as eliciting a sublime quality, they are not really sublime. Instead they have a Rococo delicateness. The crenelations are petite, not massive, and the windows sit near the surface, making the walls look delicate, not fortresslike. Instead, Walpole's concept of the Gothic revival is more limited to just

23.13 Picture Gallery at Strawberry Hill

being picturesque; the L-shaped building is irregular, asymmetrical, and looks like an accretion of additions from different periods, which it actually is because the building was erected piecemeal over a long period, with each section being designed by a different person. (The Neoclassical architect Robert Adam, for example, contributed the turret.) A Rococo lightness also characterizes the interior, as in the Picture Gallery (fig. 23.13). Walpole insisted on historical accuracy for his rooms and had architectural details copied from engravings of medieval buildings that were being researched at that time. The gallery ceiling, for example, is taken from the Lady Chapel of Henry VII at Westminster Abbey (see fig. 12.54). The walls may be richly brocaded, but they look dainty, as though covered with lace-paper doilies, while the thin, gilded fan vault is elegant and lighthearted. Walpole verbally expressed the playfulness with which he approached the past when he wrote about "the charming venerable Gothic" and "whimsical air of novelty" the style lent contemporary buildings. Walpole's Gothic revival was in many respects as playful and decorative as Adam's Classical revival, a reminder that both represent a transition from the Rococo to the true Romantic revival, which would be much more somber, awe-inspiring, and even horrific, as seen in Fonthill Abbey of 1796 (see fig. 24.28).

Early Romantic Painting in Britain

Just as the Gothic revival thrived alongside the Classical revival in Britain, Romantic painting coexisted with Neoclassical. Romantic undercurrents even appeared in pictures that are essentially Classical, a paradox that underscores the limitations of labeling. Like a moth to a flame, the taste of the period was increasingly drawn to the awesome power of nature, the experience of unfettered elemental emotions and instincts, and even the wonder of the irrational. In effect, the Enlightenment at moments could deny its very foundation of logic and empiricism and permit itself to be swept away by the emotional pull of the exotic, wondrous, terrifying, and unexplainable. But we must remember that this thirst for sublime experiences stems from an identifiably Enlightenment mentality. Burke's treatise on the sublime, for example, reflects the Enlightenment inquiry into the operation of the human mind, while the cataloguing of the emotions and experiences parallels the compendious nature of Diderot and d'Alembert's Encyclopedia.

GEORGE STUBBS While we can only speculate as to whether Piranesi in his prints of Roman monuments was at all influenced by Burke's concept of the sublime, we know for sure that the treatise spurred George Stubbs (1724–1806) in the early 1760s to paint his series of approximately 21 paintings of a lion attacking either a horse or a stag, works that represent some of first examples of Romantic painting. Stubbs, who was from Liverpool, was a largely self-taught artist. He started as portrait painter in the north of England in the 1740s, and from 1745 to 1751 studied and taught human anatomy at York County Hospital. In 1754, he went to Italy, only to declare that he could learn nothing from the Greeks and Romans; nature instead would be his only source of inspiration. Upon returning to England, he moved to Lincolnshire, where he practiced this professed Enlightenment empiricism by dissecting horses in order to study their anatomy. In 1766, he published his studies in *Anatomy of a Horse*. This was after he had moved to London, where he almost instantly became the country's foremost painter of horses, portraits that often also included an owner or groom holding the horse's lead. Never before had horses been painted with such scientific precision, a quality that in part accounted for Stubbs's acclaim.

While returning via ship from Rome in 1755, Stubbs saw a lion attack a horse in Morocco. When he repeatedly painted the scene, he was clearly under the influence of Burke's treatise, as seen in a fine 1770 example (fig. 23.14). Here, Stubbs quite deliberately set out to create a horrifying natural event that would evoke a sublime emotion in a viewer. Stubbs's protagonists are animals, who, unlike humans, are immersed in nature and at one with it, virtual personifications of unleashed natural forces. We identify with the horse, which is white, a symbol of goodness and purity. Its mouth, eye, mane, and legs are taut with fear and pain. Evil is represented by the lion's dark powerful legs, which seem almost nonchalant as they rip into the horse's back, pulling the skin away to expose a skeletal ribcage. The lion's body disappears into the blackness of the landscape, identifying its evil force with a frightening darkness and elemental powers that surge from the earth. Ominous storm clouds announce the horse's fate as they threaten to cast the entire scene into dark shadow at the moment, we assume, the doomed horse expires. West, in *The Death of General Wolfe*, similarly harnessed the forces of nature to reinforce the emotional intensity and psychology of his figures.

JOSEPH WRIGHT Joseph Wright (1734-1797), born and raised in Derby in the Midlands, went to London in 1751 to study painting with a well-known portraitist, Thomas Hudson, with whom he later worked. However, Wright then returned to the Derby area, where he essentially spent his entire life. From here, he sent pictures to London, first to the Society of Artists and, after 1778, to the Royal Academy. While Wright earned his living largely from portraiture, he is best known today for his genre paintings and landscapes and has been hailed as "the first professional painter to express the spirit of the Industrial Revolution," of which he was in the middle since Derby is near Birmingham, the center of the Industrial Revolution. This acclaim is largely due to his paintings of iron forges and factories. He also made pictures of science experiments, and was himself a member of the Lunar Society, a Birmingham scientific organization that included many major figures, such as the physiologist and natural philosopher Erasmus Darwin, the grandfather of Charles Darwin. Many of

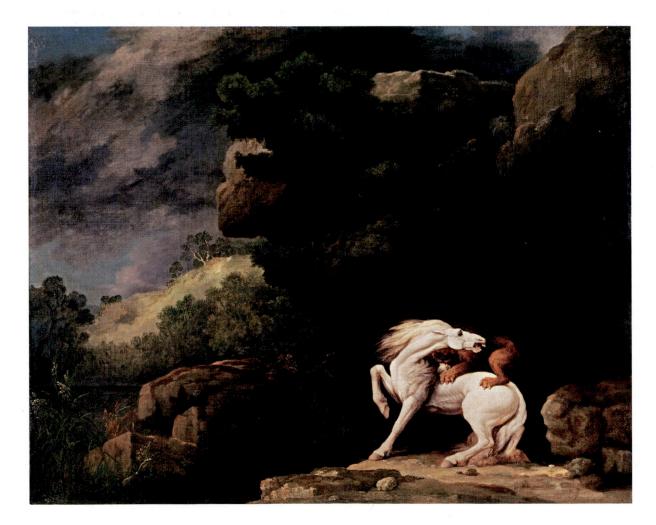

23.14 George Stubbs, Lion Attacking a Horse. 1770. Oil on canvas, 38 × 49½" (96.5 × 125.7 cm). Yale University Art Gallery, New Haven, Connecticut. Gift of the Yale University Art Gallery Associates 1961.18.34

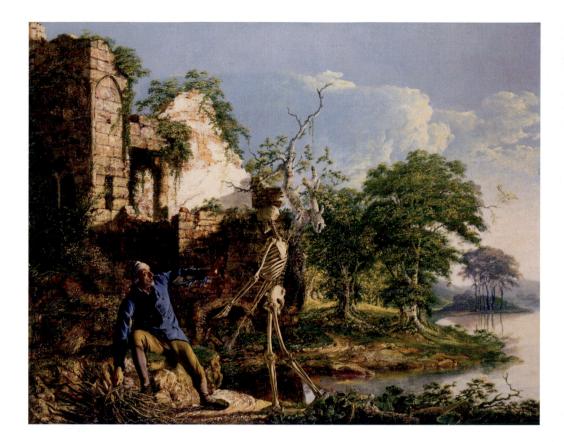

23.15 Joseph Wright, *The Old Man and Death.* ca. 1773. Oil on canvas, $40 \times 50 \frac{1}{102} \times 127$ cm). Wadsworth Atheneum, Hartford, Connecticut, The Ella Gallup Sumner and Mary Catlin Sumner Collection

Wright's images were set at night so that he could indulge in his scientific love of painting complicated light effects, which sometimes emanated from an artificial light source, including newly invented gas lamps.

In many of his images, Wright sought to create a sense of the miraculous or the unusual, thus reflecting the Romantic curiosity for new experiences and powerful emotions. A fine example of this is The Old Man and Death (fig. 23.15), painted toward 1773. The theme comes from Aesop's fables (also recounted by Jean de La Fontaine), in which an old man, exhausted from carrying his load of faggots, falls to the ground and summons Death to come and take him away so that he need not return to his labor. Death instantly appears, terrifying the wearied worker, who now insists that he is fine, picks up his bundle, and continues about his business. In his painting Wright shows us Death, in the form of a skeleton with an arrow resting in his right palm, approaching the fatigued elder, who suddenly develops the energy of a horse. Although a daylight scene, Wright blasts the startled faggotgatherer with an eerie powerful light, which seems to make him reel backwards. Adding to the sense of doom and gloom is the Gothic ruin, covered in plants, as were Piranesi's Roman ruins. Moss dangles from surrounding trees, contributing further to the lugubrious atmosphere. Employing his scientific approach to image making, Wright shuns Rococo paint handling and color, and instead carefully picks out each and every detail in the scene-every pebble on the ground, brick on the Gothic ruin, and leaf on the plants and trees. After finishing this frightening picture, Wright left for Italy, where instead of studying Greek and Roman art, he headed off to Naples. There, he watched the awesome eruption of Mount Vesuvius, which he painted, as well as sublime cavernous caves that he explored on the Bay of Naples.

JOHN HENRY FUSELI Early Romanticism in Britain culminated in the art of the Swiss-born painter John Henry Fuseli (1741-1825), whose special province was plumbing the innermost recesses of the mind and the incomprehensible forces within nature. Fuseli initially intended to be a theologian. In Zurich, he studied with the famous philosopher Johann Jakob Bodmer (1698-1783), who introduced him to the works of Shakespeare, Dante, Homer, and Milton, and to the Nibelungenlied, a medieval Norse epic that Germans believed was the northern equivalent of Homer's The Odyssey and The Iliad. He also befriended Johann Kaspar Lavater, a poet and physiognomist, who was an antagonist of rationalism despite his scientific interest in the way facial features reflected states of mind and personality. Lavater's interest in psychology heavily influenced Fuseli. As important, Lavater put Fuseli in direct contact with the German Sturm und Drang, which clearly influenced his development as an artist. He was especially captivated by the concept of the antihero, found, for example, in Goethe's The Sorrows of Young Werther (1774). The novel tells the tale of a young man, Werther, who rejects society, falls in love with a woman who spurns him, and in depression kills himself, suicide, in effect, being an extreme form of withdrawal from civilization and return to nature. The antihero was an important new kind of hero, one who established personal moral codes and followed personal passions to attain freedom and fulfill individual needs. These values would become part of the foundation of Fuseli's art.

In 1764, Fuseli moved to London. Encouraged by Reynolds, he took up painting and in 1770 went to Rome, where he became the leading figure in a circle of British and Swedish artists that included Thomas Banks. Dismissing Winckelmann's adulation of the calm grandeur and noble simplicity of Greek sculpture, as well as the perfect harmony of the High Renaissance as represented by Raphael, he gravitated to Michelangelo's colossal, twisting, muscular figures on the Sistine Chapel ceiling and especially the *Last Judgment* (see fig. 17.14). He was also inspired by the distorted anatomies of such Mannerists as Parmigianino (see fig. 17.29) and Rosso Fiorentino (see fig. 17.1).

Fuseli's selection of subjects was as unique as his style. Instead of noble, virtuous scenes drawn from the Roman historians Livy and Plutarch, he chose psychologically and physically agonizing events from Homer, Shakespeare, Milton, Spenser, and Ossian (a fake ancient Gaelic epic poet invented by James Macpherson and foisted on the public in the 1760s), many with erotic overtones. The more horrific and tortured the scene, the better, and the artists surrounding Fuseli in Rome favored similar themes. By the 1780s, Fuseli's subject matter dominated British painting, with

23.16 John Henry Fuseli, *Thor Battering the Midgard Serpent*. 1790. Oil on canvas, $51\frac{1}{2} \times 36\frac{1}{4}$ " (133 × 94.6 cm). Royal Academy of Arts, London

even the Neoclassicist Benjamin West painting lurid scenes from Shakespeare and the Bible.

Upon Fuseli's return to London in 1779, his themes and style were fixed, as we can see in Thor Battering the Midgard Serpent (fig. 23.16) of 1790. The subject comes from the Nibelungenlied, an epic tale of the doom that results in the demise of the gods and the end of the cosmos and all morality. The wolf Skoll devours the sun and his brother Hatii eats the moon, plunging the world into darkness. Earthquakes shatter the world, releasing such monsters as Jormugand, the Midgard Serpent, who arises from the sea intent on poisoning the land and sky. Gods and giants fight fierce battles with the monsters, and here Thor, the god of thunder, is charged with slaying Jormugand, although ultimately he dies from the serpent's poison. The scene radiates sublime horror, from which the boatman shrinks and the ghost-white Wotan, king of the gods, cowers. Neoclassical planarity, tight drawing, consistent lighting, and the smooth handling of paint are replaced by an explosion of light, a flurry of Baroque brushwork, and a dramatic composition. The bold elements of this composition include the tensely coiled serpent, the deep recession of both the boat and boatman, and the violent upward thrust of Thor, whose Michelangeloesque proportions seen from the low vantage point of the serpent itself endow him with an appearance of Herculean strength. The image is all blood, water, rippling flesh, the heat of the serpent's breath, and the darkness of night, and because of the serpent's-eye perspective, a viewer is immersed in nature and put directly in the midst of the violent, frightening struggle.

While Thor epitomizes courage and sacrifice, Fuseli was often interested in portraying unconventional heroes who follow personal passion and exemplify individual freedom, especially in the face of societal pressure to conform and repress desires. How else to explain Fuseli's admiration for the Satan of Milton's epic poem Paradise Lost, whom he painted numerous times within the circle of Chaos, calling up his legions to launch a futile attack on the unfallen world of the Garden of Eden? Fuseli himself exemplified artistic freedom in his unique style and unconventional subjects, as well as in highly personal images, such as The Nightmare (fig. 23.17) of 1781. The meaning of this work remains a puzzle. Clearly, sex permeates the picture, from the figure's erotic pose, to the mare's penetration of the "vaginal" parting of the curtain, and the sensual red of the fabric. But does the incubus (an evil spirit that has sexual intercourse with women while they sleep) on the woman's stomach represent her own psychotic monster or Fuseli's own repressed desires? A portrait of a woman on the back of the canvas suggests the exposed libido is Fuseli's, for although the figure is not identified, it may be of a Zurich woman who spurned the artist's offer of marriage in 1779 when he was passing through the city en route to London.

Regardless of the answer, this very personal painting is an extraordinary image, powerful, unique, and filled with sublime terror. It explores the erotic depths of the human mind and shrugs off expectations of what painting is supposed to be about. With Fuseli we have moved into the full-blown Romantic era, which begins to emerge throughout Europe toward 1800.

23.17 John Henry Fuseli, *The Nightmare.* 1781. Oil on canvas, $39\frac{3}{4} \times 49\frac{1}{2}$ " (101 × 127 cm). The Detroit Institute of Arts. Gift of Mr. and Mrs. Bert Smokler and Mr. and Mrs. Lawrence A. Fleischmann

Romanticism in Grand Manner Portraiture: Thomas Gainsborough

Just as we saw that Neoclassicism affected portraiture in the work of Sir Joshua Reynolds, so too did burgeoning Romanticism. It is best exemplified in the portraits of Reynolds's nemesis, Thomas Gainsborough (1727–1788). Gainsborough was born into a prosperous Sudbury manufacturing family, and after studying painting in London with a French Rococo painter in the 1740s, he returned to his native Suffolk, initially painting landscapes. But to earn a living, he soon turned to portraiture, and in 1759 moved to Bath to take advantage of the wealthy clientele who came there to vacation. He did not move to London until 1774, but the appearance of his works at the Society of Artists from 1761 and the Royal Academy after 1769 established him as one of the leading artists of his day.

Like Reynolds, Gainsborough took his cue from Van Dyck, and his forte was enormous, life-size, full-length portraits, the figures often having elegant proportions and poses. While Reynolds created bold, modeled forms, Gainsborough dissolved figures and objects in lush, feathery brushwork, as can be seen in his 1785 *Portrait of Mrs. Richard Brinsley Sheridan* (fig. **23.18**), the sitter being a celebrated soprano married to the playwright responsible for the comedy of manners *The School for Scandal.* Not only does

23.18 Thomas Gainsborough, *Portrait of Mrs. Richard Brinsley* Sheridan. 1785. Oil on canvas, $7'2\%" \times 5'\%" (2.2 \times 1.54 \text{ m})$. National Gallery of Art, Washington, D.C. Andrew W. Mellon Collection (1937.1.92)

Gainsborough's gossamer-thin touch give an elegance to the surface, it also animates it, making it seethe with motion and tying all of the objects together. More important, Gainsborough has integrated Mrs. Sheridan into the landscape. Her hair is windswept, following the pattern of the tree above and behind her, which forms a halo of sky around her head. Her body also echoes the thrust of the land, her drapery rippling in the same direction as the leaves, clouds, and rock. Mrs. Sheridan is steeped in nature, virtually swept away by it. Here we see demonstrated Rousseau's return to nature, the locus of innocence, beauty, and moral perfection.

NEOCLASSICISM IN FRANCE

As in Britain, the reaction against the Rococo in France first appeared in architecture, but it surfaced in the 1750s and 1760s, rather than the 1710s and 1720s. At first elegant and rational and largely based on seventeenth-century French Classical architecture, it moved into an austere, awe-inspiring, and even visionary stage by the late 1770s. This sublime phase of Neoclassicism had a profound impact on painting. Despite repeated appeals from numerous sources, including Enlightenment exponents and the government, painters were slow to meet the challenge to create a new moralistic art based on antiquity. It was not until the late 1770s that large numbers of painters took up the cause, and it was not until the 1780s, with the advent of Jacques-Louis David and his austere brand of Neoclassicism, that a new style emerged, one that thrived well into the nineteenth century.

Architecture: Rational Classicism

The first phase of French Neoclassical architecture was a reaction to the excesses of the Rococo, which had been about asymmetry, graceful movement, decorative flourishes, and curvilinear elegance. The new architecture was about rational design, and hence is often called "Rational Classicism." All components of a building had to be geometric, symmetrical, and logical in the sense that they should be essential to the structure. While this rational phase of Neoclassical architecture was theoretically based on nature, it nonetheless took its lead from seventeenth-century French Classical architecture.

THEORETICAL BEGINNINGS Launching the attack on the Rococo was the architect Jacques-François Blondel (1705–1774), who in a speech at the opening of the Royal School of Architecture in 1747 condemned the ornate flamboyance of that style. Here, and in his later publications, he called for a return to the Classicism of great seventeenth-century architects: Claude Perrault, Nicolas-François Mansart, and Louis Le Vau (see pages 748–51). Applying Enlightenment reason, Blondel demanded that buildings be logical, simple, functional, and symmetrical. They should be constructed with right angles, not curves, and there should be no superfluous ornament. Façades were to reflect interior layout and social use.

Blondel's rationalism was seconded by the influential writer Abbé Marc-Antoine Laugier (1713-1769), who in his Essay on Architecture (1753) and Observations on Architecture (1765) declared that function, not beauty, should determine the style of a building. Denouncing decorative ornament as well, his theory permitted only columns, architraves, pediments, and walls, all of which were essential and therefore natural. He condemned pilasters, niches, and any nonfunctional wall decoration or shape. Architectural components had to be based on nature, as illustrated by the famous engraving on the frontispiece of his Essay: a primitive hut, in essence the first building, consisting of four crude tree trunks dug into the ground in a rectangular configuration, with a gable roof made of twigs. This structure was the primordial forerunner of the Greek post-and-lintel system and the pedimented façade. Laugier's aesthetics also accommodated Gothic architecture, for he viewed its soaring stone columns as logical and natural, like a forest of trees, and he loved its spaciousness and light. Buttressing was structural, thus allowed.

But the theoretician who stripped rational architecture down to a barebones austerity that pointed to the future was Jean-François de Neufforge (1714–1791). Drawing on antiquity and Palladio but mostly on the British Palladians, his multivolume treatise *Basic Collection of Architecture* (1757–68) was filled with his own designs that reduced architecture to simple geometric forms: cubic houses, bare walls, severe unframed rectangular windows. Although he was otherwise virtually unknown, his treatise became a major source book for the period, one that many French architects owned and from which they lifted ideas.

A second major force for the Classical revival in architecture was the marquis de Marigny, who in 1751 became director general of buildings, a position that gave him artistic control over France, since he oversaw all royal commissions for art and buildings, as well as the French Academy. In preparation for the appointment, he went on the Grand Tour with the architect Jacques-Germain Soufflot from 1749 to 1751, receiving a Classical education that would prepare him to revolutionize French taste. Upon returning, he hired Soufflot to finish Perrault's Louvre (see fig. 21.11), which at the time was literally a ruin and slated for demolition. After the completion of the Louvre, he instructed Ange-Jacques Gabriel (1698-1782), the newly appointed first architect to Louis XV, to erect two enormous government buildings on the north side of what is today the Place de la Concorde, where they can still be seen: two huge identical façades framing the Rue Royale. Gabriel had never been to Rome, and for him Classicism largely meant seventeenth-century French Classicism. His two buildings are so similar to Perrault's Louvre they almost do not need illustrating: The major differences are that the double columns of Perrault's façade are now single, and the center pediment is removed, reappearing again at either end of the colonnade to become "bookends" framing the colonnade.

JACQUES-GERMAIN SOUFFLOT It was Soufflot (1713–1780), an ardent follower of Blondel, who designed the most famous rationalist building. Unfortunately, his masterpiece, the church of

23.19 Jacques-Germain Soufflot. Initial plan for the Panthéon (formerly Sainte-Geneviève), Paris. 1757.

Sainte-Geneviève, has been so altered, including its name and function, that its current appearance can be quite misleading. In 1755, Marigny commissioned Soufflot to design the church. Within two years, the architect had completed his initial plan, which had a clearly stated geometry: an equilateral Greek cross with a six-column portico entrance (fig. **23.19**). The wide square

center crossing would have a hemispherical dome (modeled on the Pantheon in Rome) sitting on a drum supported by narrow piers consisting of four triangles, each triangle formed by three columns. Perrault's Louvre was his model. The pedimented section of the Louvre's east façade inspired the portico, and the Louvre colonnade provided the idea for the rows of interior Corinthian columns supporting an entablature. The drum for the dome largely derives from the circular peristyle Perrault used for the dome at the Louvre chapel. But Soufflot, following Laugier's vision of combining the clarity and grandeur of the Classical with the lightness and spaciousness of the Gothic, filled his church with light. Using a daring system of hidden buttresses, he was able to remove the wall mass and open the building up with enormous vertical windows.

Unfortunately, the clergy and public attacked Soufflot's 1757 plan, and the church was heavily compromised. An apse was added and the transept extended, destroying the symmetry of the first design. To adjust to these new proportions, Soufflot had to increase the size of the dome, with the result that it looks more like the Baroque dome on Christopher Wren's St. Paul's Cathedral (see fig. 21.22). But the greatest abuses came with the French Revolution. In its ardor to erase religion and honor French heroes, the Directoire government of the new republic in 1793 declared the building a pantheon to the nation's leaders (fig. **23.20**). To convert the church into a lugubrious mausoleum, the windows were walled in and the interior ornamentation removed. Additional changes well into the nineteenth century further destroyed Soufflot's vision.

23.20 Jacques-Germain Soufflot. The Panthéon (formerly Sainte-Geneviève), Paris. 1757–90

23.21 Marie-Joseph Peyre and Charles de Wailly. Façade of the Théâtre Français (Théâtre de l'Odéon), Paris. ca. 1778–82. Designed 1767–70

The Sublime in Neoclassical Architecture: The Austere and the Visionary

French architecture started to move into a new, more austere phase in the 1770s, one less interested in following the rules of the ancients and more preoccupied with reducing architecture to elemental geometric forms that operate on a monumental scale and create a Piranesian sense of awe and power. Among the architects largely responsible for this aesthetic were Claude-Nicolas Ledoux and Étienne-Louis Boullée.

MARIE-JOSEPH PEYRE Marie-Joseph Peyre (1730–1785) was a student of Blondel's, and in 1751 he won the Rome Prize. He met Piranesi and with his new mentor surveyed the baths of Caracalla and Diocletian (see figs. 7.58 and 7.63). This determined the course of his career, for he turned his back on the rules and propriety of Vitruvius and Palladio, and instead dreamed of making monumental, sublime architecture. In 1765, Peyre published Architectural Works, which included his plans for ideal buildings and the philosophy behind them. He emphasized the importance of scale and enormous cavernous spaces, especially advocating the use of vaults and domes that reflected the engineering prowess of the Romans. Modern architecture had to aspire to the sublime, to be awesome and grand-and he used the word "sublime" as defined by Burke. Decoration and detail were to be curtailed as the architect instead relied on the monumentality of the Romans to generate powerful emotional responses-shock, fear, awe, reverence, and passion.

Peyre's Théâtre Français (the present-day Théâtre de l'Odéon, fig. 23.21), designed from 1767 to 1770 with another likeminded architect, Charles de Wailly, reflects the severity and monumentality that he advocated in his treatise, although it falls a bit short of a sense of the sublime, largely due to the practical restrictions of the commission. Nonetheless, the building seems austere compared to any eighteenth-century French building that preceded it. The façade consists of a towering two-story, unpedimented portico. Instead of elegant Corinthian or Ionic columns, Peyre used the harsh, unfluted Tuscan Doric. The only "decoration" is the striations and rustication of the stone. There are no frames around the arched doors and windows, and these openings penetrate deep within the wall, making it seem formidable and weighty. Geometry prevails in the form of circles and rectangles, and in the strong horizontals of the entablatures. Peyre's theater is a forceful block of a building, imposing in scale, awesome in its massiveness, and rational in its geometry.

CLAUDE-NICOLAS LEDOUX Even more severe than Peyre's Théâtre Français were the buildings of Claude-Nicolas Ledoux (1736-1806), also a student of Blondel. Ledoux was heavily influenced by Peyre's Architectural Works, Piranesi's publications, and Neufforge's Basic Collection of Architecture. He had no need of going to Italy. By the mid-1760s he was a fashionable Parisian architect designing many of the most prestigious hotels particuliers, as grand private homes were called, and by the 1770s, he was designing austere Palladian residences. In 1771, Ledoux became inspector of the royal salt mine at Chaux in the Franche-Comté region of southeastern France, designing many of its buildings from 1774 to 1779. The entrance portico to the gatehouse of the salt mine (fig. 23.22) was in the Tuscan Doric style, which meant columns had neither flutes nor base and instead brutally sprang directly from a platform. The wall behind these primitive columns had an enormous primordial arch made of raw, uncut stone.

At Chaux, Ledoux developed a utopian vision of architecture, one that provided for the needs of employees of every rank. He was heavily influenced by Rousseau's vision of a world without

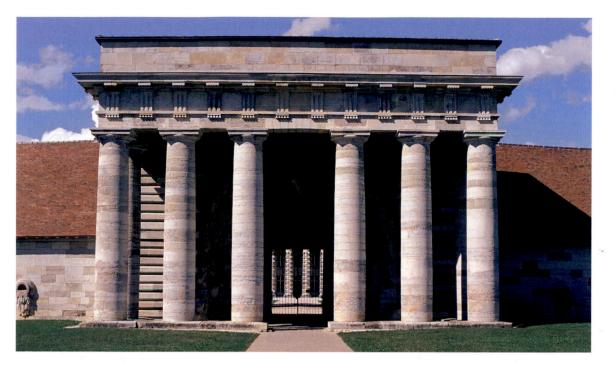

23.22 Claude-Nicolas Ledoux. Main entrance, saltworks, Arc-et-Senans. 1775–79

social barriers as well as by the social philosophy of an Enlightenment economic group called the Physiocrats, who advocated a basically agrarian economy that operated not only to benefit the proprietor class of landowners but also the productive class of laborers, thus giving workers a respected and essential position. Ideally, Ledoux wanted to lay out Chaux in concentric circles, with the most important functions symmetrically located in the center and the least farthest away. An essential component of the design had the concentric circles of buildings gradually dissolve into the surrounding countryside, thus becoming immersed in nature. Homes were often designed based on the dweller's job. The river authority's house, for example, was an enormous segment of pipe that the Chaux River would have literally run through if the house had actually been built (fig. **23.23**). Hoopmakers would reside in houses shaped like wheels. Regardless of the owner's rank, each home had an austere

23.23 Claude-Nicolas Ledoux. House of the river authority, ideal city of Chaux. ca. 1785. Bibliothèque Nationale, Paris

stripped-down geometry that gave it a sense of importance and monumentality worthy of a noble civilization. While Ledoux's visionary architecture romantically conjured up the power and might of long-gone great civilizations, it simultaneously freed itself from the architectural vocabulary of the historical past as it radically reduced buildings to abstract forms, mutating Neoclassicism from a revival of the Classical past to a futuristic vision of purity and perfection.

ÉTIENNE-LOUIS BOULLÉE Ledoux's contemporary Étienne-Louis Boullée (1728–1799) shared his quest to create a monumental architecture using a basically abstract vocabulary. Like Ledoux, he did not go to Italy and took his cue from Piranesi, Neufforge, and Peyre. After a modest career designing relatively severe Palladian *hôtels*, he retired in 1782 to teach at the Royal Academy of Architecture, which gave him considerable influence over the next generation of architects throughout Europe. He also designed and published visionary structures that were so impractical they could never be built, which he knew. They are important nonetheless because they reflect the growing taste for the sublime that was welling up in France by the 1780s and that could be expressed, if not in real buildings, then at least on paper.

One of Boullée's most famous visions is his design for a tomb for Isaac Newton (fig. 23.24). Conceived as a 500-foot-high hollow sphere resting in three concentric circles, it was meant to suggest a planet tracking three orbits. The top quarter or so of the orb was perforated with small holes to allow in light, making the ceiling from inside look like a night sky filled with stars. Below lay Newton's **cenotaph**, dwarfed by the immense scale of the structure and lost in the low lighting. The dramatic shadows and dark clouds of Boullée's drawing augment the frightening monumentality of his structure and help transform the edifice into an awesome meditation on the power of universal forces and the insignificance of human existence. How ironic that Boullée should conceive of such a sublime building using a rational, geometric vocabulary—and have meant it to honor one of the most logical thinkers of all time.

Painting and Sculpture: Expressing Enlightenment Values

There was no parallel in French history painting to the swing toward Classicism occurring in French architecture in the 1750s and 1760s. Until the 1780s, the Enlightenment emphasis on reason and morality was best presented not by history painting but by the lower stratum of genre painting. In sculpture, it appeared in portraiture.

JEAN-BAPTISTE GREUZE One artist alone created the vogue for genre painting, Jean-Baptiste Greuze (1725-1805), and from 1759 until the 1770s his scenes of everyday life were the sensation of the Paris Salons. The Salon was an exhibition of members of the Royal Academy held in the Louvre. While conceived in the seventeenth century, the show was held only a handful of times before 1737, when it was first instituted as an annual that gradually evolved into a biennial presented in the Salon carré of the Louvre, hence its name. Pictures literally wallpapered the high walls, with smaller works and landscapes appearing at eye level, above which hung portraits, and above them, enormous history paintings. A narrow staircase leading to the Salon was packed with small still lifes and genre scenes. The Salons, which opened on August 25, the feast-day of St. Louis, and lasted between three and six weeks, were attended by some 20,000 to 100,000 people, who came from all strata of society, resulting in bakers and

23.24 Étienne-Louis Boullée, Project for a Tomb to Isaac Newton. 1784. Ink and wash drawing, $15\frac{1}{2} \times 25\frac{1}{2}$ " (39.4 × 64.8 cm). Bibliothèque Nationale, Paris

blacksmiths literally rubbing shoulders with dukes and duchesses in the crowded room. With the Salons critics emerged, their commentaries, often scathing, appearing in brochures that were generally published anonymously.

Greuze emerged from a working-class background in the Lyon region and went to Paris in the mid-1750s to make his mark at the Royal Academy. A wealthy collector sponsored a trip to Italy for him from 1755 to 1759, but Greuze left Paris a genre and portrait painter and returned as one as well. Nonetheless, he became the rage of Paris with *The Village Bride* (fig. **23.25**), his submission to the Salon of 1761, which shows a Protestant wedding the moment after a father has handed his son-in-law a dowry, dutifully recorded by a notary, seated on the right. The scene seethes with virtue as the various members of this neat, modest, hardworking religious family express familial love, dedication, and respect. Here is the social gospel of Rousseau: The naïve poor, in contrast to the more cultivated, yet immoral aristocracy, are closer to nature and thus full of "natural" virtue and honest sentiment. Greuze draws a parallel between the human family and the hen and her chicks, each with one member separated, thus reinforcing the point about the natural instinct of common folk. Critics and public alike raved about the authenticity of the gestures and emotions, comparing them favorably with those of the noble figures of Poussin (see fig. 21.5). While Greuze was certainly attempting to match the intensity of emotion and gesture found in history painting, he was also inspired by contemporary _ theater, which accounts for the arrangement of the figures in a *tableau vivant* (a "living painting," when actors onstage freeze as in a painting to portray a pregnant moment) just as the father is declaiming his poignant speech about the sanctity of marriage.

Greuze was also heavily influenced by his friend Diderot, who championed him in his Salon reviews, which appeared anonymously in the *Correspondence littéraire*, a paper circulated privately throughout Europe and Russia. (See *Primary Source*, page

23.25 Jean-Baptiste Greuze, The Village Bride, or The Marriage: The Moment When a Father Gives His Son-in-Law a Dowry. 1761. Oil on canvas, 36 × 46½" (91.4 × 118.1 cm). Musée du Louvre, Paris

Denis Diderot (1713–1784)

From Salon of 1763, Greuze

Diderot's reviews of the biennial Salons, published in the outlawed newspaper Correspondence littéraire, are generally considered the beginning of art criticism. The full title of the painting discussed below is The Paralytic Succoured by His Children, or The Fruit of a Good Education, which was subsequently acquired by Catherine II of Russia, with Diderot acting as intermediary. In a setting similar to The Village Bride, Greuze placed in the painting a paralyzed old man being affectionately attended by his large family.

812.) In his painting, Greuze perfectly captures Diderot's *drame bourgeois*, the new sentimental theater that this *philosophe* developed in the 1750s and that focused on ordinary middle-class people. As important as the bourgeois settings and sentimentality supporting virtue is Diderot's Enlightenment emphasis on logic and naturalism in theater. The dialogue was to be in prose, not verse, and the actors were to be instructed to stay in character and play to each other, not to the audience, which would destroy the illusion of reality. In other words, he wanted the audience to forget they were in a theater and be transported to the world of his drama. Likewise, Greuze wanted his viewers to forget the gallery they were standing in as they became immersed in the scene he magically painted.

Largely derived from Dutch and Flemish genre painting and certainly playing to an audience that loved Chardin's illusionism (see page 769), *The Village Bride* is filled with realistic detail, including attention to textures. The figures are individualized, rather than portrayed as ideal types: They are so real that when Greuze used them again in later paintings, the public decided it was witnessing the continuation of the story of the same family. As we shall see, Greuze's realism and morality as well as his pregnant *tableau vivant* moment will figure prominently in French Neoclassicism when it emerges some 20 years later.

JEAN-ANTOINE HOUDON The French sculptor who perhaps best exemplifies Enlightenment empiricism is Jean-Antoine Houdon (1741–1828). Both Greuze and Houdon used realism in their works, but Houdon, unlike Greuze, incorporated realism into a façade of Classicism. Son of the concierge at the Royal Academy school and thus literally growing up in the academy, he had little education but was extremely hardworking. His artistic vision was not given to flights of fantasy; rather, it was firmly rooted in Enlightenment empiricism. The elegant, mythological frolics of Clodion (see fig. 22.12) and the complex allegories favored by many French sculptors were foreign to his sensibility. Instead he approached the world scientifically. While a pensioner at the French Academy in Rome from 1765 to 1768, Houdon studied realistic Roman portrait busts, not idealized Greek sculpture, and in 1767 he executed in plaster a life-size flayed male Now here is the man for my money, this Greuze fellow. Ignoring for the moment his smaller compositions ... I come at once to his picture *Filial Piety*, which might better have been entitled the *Reward for Providing a Good Upbringing*.

To begin with, I like this genre: it is a painting with a moral. Come, now, you must agree! Don't you think the painter's brush has been employed long enough, and too long, in the portrayal of debauchery and vice? Ought we not to be glad to see it competing at last with dramatic poetry in moving us, instructing us, correcting us, and encouraging us to virtue? Courage, Greuze, my friend; you must go on painting pictures like this one!

torso revealing in detail every muscle of the body while it leans against a support in perfect contrapposto, like Praxiteles' *Hermes* (see fig. 5.57).

23.26 Jean-Antoine Houdon, *Voltaire Seated*. 1781. Terra-cotta model for marble original, height 47" (119.3 cm). Institut et Musée Voltaire, Geneva

Étienne-Jean Delécluze (1781–1863)

From Louis David, son école et son temps

In the early 1820s, David related the following to his student Étienne-Jean Delécluze, who published it in his 1855 book on David. Here, David describes the impact his 1779 discovery of Caravaggio and the Caravaggisti had on him. He ends his statement, however, by renouncing Caravaggio and embracing Raphael, an attitude that reflects a shift in style in his late work.

When I arrived in Italy, the most striking characteristic of the Italian pictures I saw was the vigor of the color and the shadows. It was the quality most radically opposed to the weakness of

As would be expected of such an empirical mentality, Houdon specialized in portraits, and he became portraitist in chief to the Enlightenment, depicting virtually every one of the era's major personalities, including Diderot, Rousseau, Louis XVI, Catherine II of Russia, and Benjamin Franklin. Houdon's uncanny ability to capture both the look and essential character of his sitter is apparent in Voltaire Seated (fig. 23.26), here shown as a terra-cotta cast from the original plaster, which is lost. The sculptor classicizes his sitter by dressing him in a Roman toga and headband, and seating him in an antique-style chair. But then Houdon's empiricism takes over. He gives us the sagging folds of skin on Voltaire's neck, the sunken toothless mouth, the deep facial wrinkles, and the slumping shoulders, all of which mark the sitter's age and frailty. Simultaneously, Houdon has brilliantly seized the philosophe's sharp intellect and wit: The head is turning and the mouth smiling, and while one hand droops over the arm of the chair, suggesting age, the other grasps it firmly.

The Climax of Neoclassicism: The Paintings of Jacques-Louis David

The reign of genre painting in Enlightenment France was short, with Greuze's popularity peaking by 1765. The tide began to turn toward history painting in 1774 when Charles-Claude d'Angiviller was appointed director-general of buildings by Louis XVI. It became his personal mission to snuff out what he considered Rococo licentiousness and replace it with moralistic history painting. Beginning in 1777, he regularly commissioned "grand machines," as these enormous oils were called (they required special installation equipment), based on the noble and virtuous deeds of the ancients as well as exemplary moments from French history, which included a number of pictures set in the Middle Ages and Renaissance. The resulting paintings are largely forgotten today, but the project triggered a quest, and even a heated competition, among artists to produce *the* great history painting. The fruit of d'Angiviller's program appeared in the mid-1780s French painting; this new relationship between light and dark, this imposing vivacity of modeling, of which I had no idea, impressed me to such an extent that in the early days of my stay in Italy, I thought the whole secret of art consisted in reproducing, as had certain Italian colorists at the end of the sixteenth century, the bold uncompromising modeling that we see in nature. ... I could understand and appreciate nothing but the brutally executed but otherwise commendable pictures of Caravaggio, Ribera, and Valentin who was their pupil. There was something barbarous about my taste, my formation, even my intelligence; I had to get rid of this quality in order to arrive at the state of erudition, or purity, without which one can certainly admire the Stanze of Raphael, but vaguely, without understanding, and without the ability to profit from them.

Source: Anita Brookner, Jacques-Louis David (New York: Harper & Row, 1980)

with the emergence of Jacques-Louis David (1748–1825), whose images were so revolutionary they have virtually come to epitomize Neoclassicism, thus simplifying a very complex period and a very complicated term that encompasses much more than David's style.

It took David almost two decades to find his artistic voice, his distinctive mature style. He began his studies at the Royal Academy school in 1766. He did not win the Rome Prize until 1774, and then studied in Rome from 1775 to 1781. His progress was painfully slow, and he only seemed to find himself in 1780 after copying a painting the year before of a Last Supper by Valentin de Bologne, a French follower of Caravaggio, in the Palazzo Barberini. De Bologne's powerful naturalism and dramatic lighting, which carved out crisp sculptural figures and objects, triggered something in him (see *Primary Source* above), and in 1781 he submitted to the academy a painting of the Roman general Belisarius that incorporated this newly discovered aesthetic world. The work became his academic acceptance piece and garnered him a large following of students. It also won him his first major commission from d'Angiviller.

It took David three years to complete d'Angiviller's commission, *The Oath of the Horatii* (fig. **23.27**), which he finished in Rome in 1784. When David unveiled *The Oath* in his Rome studio, it instantly became an international sensation, with an endless procession of visitors filing through to see this revolutionary work. *The Oath* arrived in Paris from Rome a few days after the opening of the 1784 Salon, its delayed grand entrance enhancing the public clamor.

The theme for the picture comes from a Roman seventhcentury BCE story found in both Livy and Plutarch recounting how a border dispute between Rome and neighboring Alba was settled by a sword fight involving three soldiers from each side. Representing Rome were the three Horatii brothers, and Alba the three Curiatii brothers. Complicating the story, a Horatii sister, Camilla, was engaged to a Curiatii brother, while one of the Horatii brothers was married to a Curiatii sister. Only Horatius of the Horatii brothers survived the violent fight, and David was instructed by d'Angiviller to paint the moment when Horatius returns home and slays his sister after she curses him for killing her fiancé. Instead, David painted a scene that does not appear in the literature: the Horatii, led by their father, taking an oath to fight to the death. The composition is quite simple and striking: David contrasts the virile stoic men, their bodies locked in rigorous determination, with the slack, curvilinear heap of the distressed women, Camilla and the Curiatii wife, who, either way, will lose a brother, husband, or fiancé.

David was undoubtedly inspired by the many oath-taking paintings that had appeared since Gavin Hamilton had made an *Oath of Brutus* in 1764. The dramatic, pregnant moment, which David made one of the hallmarks of Neoclassical history painting, allowed him to create a *tableau vivant* championing noble and virtuous action dedicated to the supreme but necessary sacrifice of putting state before family. The severity of the Horatii's dedication is reinforced by the severity of the composition. It can be seen in the austerity of the shallow space, and even in David's selection of stark, baseless Tuscan Doric columns, which Ledoux had made fashionable in France the decade before. It also appears in the relentless planarity that aligns figures and architecture parallel to the picture plane and in the harsh geometry of the floor, arches, and grouping of the warriors. It surfaces as well in the sharp linear contours of the figures, making them seem as solid and frozen as statues. In his planarity and linearity, David is more "Poussiniste" than his idol Poussin, from whom he borrows figures. Line and geometry, the vehicles of reason, now clearly prevail over the sensual color and brushwork of the Rococo.

But it is the Caravaggesque naturalism and intensity that make this image so powerful and distinguish it from Renaissance and Baroque Classicism. Sharpening edges and heightening the drama of the painting is a harsh light that casts precise shadows, an effect derived from Caravaggio (see fig. 19.2), as is the attention to textures and such details as chinks in the floor marble. The picture is startlingly lifelike, with the setting and costumes carefully researched to re-create seventh-century BCE Rome.

23.27 Jacques-Louis David, The Oath of the Horatii. 1784. Oil on canvas, 10'10" × 13'11" (3.3 × 4.25 m). Musée du Louvre, Paris

While *The Oath* is generally perceived as the quintessential Neoclassical picture, one of several David made that came to define the style, it is filled with undercurrents of Romanticism. It is a horrific scene, one that frightened onlookers, sending chills down their spines. This is not *just* an image of moral resolve and logic, reflecting the words of Cassius when he declares in Voltaire's play *Death of Caesar* that "a true republican's only father and sons are virtue, the gods, law, and country." Under the frozen Neoclassical stillness of this scene lies the tension of the bloodbath soon to come. We see this in the father's brightly lit fingers, which echo the stridency of the swords. This enormous 13-foot painting is about the impending violence, from which the woman in the ominous background shadow tries to shield the children.

David was a rabid revolutionary once the French Revolution began in 1789, and he became a powerful figure in the new republic when it was established in 1792. He was a member of the National Convention, the legislative assembly holding executive power in the early years of the French Republic, and was in charge of artistic affairs, in effect becoming the republic's minister of propaganda. He voted to execute the king, sent the revolutionary leader Georges-Jacques Danton to the guillotine, and successfully closed the Royal Academy. He was too busy signing arrest warrants and death sentences to make much art at the time.

Two major works from the early 1790s, however, are portraits of assassinated revolutionaries and were conceived as pendants. Only one survives: *The Death of Marat* (fig. **23.28**), which was exhibited with its mate at the Louvre in May 1793, after which the

23.28 Jacques-Louis David, *The Death* of Marat. 1793. Oil on canvas, 65×50 /2" (165.1 × 128.3 cm). Musées Royaux des Beaux-Arts de Belgique, Brussels

government declared it would hang in perpetuity in the hall of the National Convention. The picture was propaganda. Marat was a deputy in the National Convention and the editor of a populist newspaper. He was a dedicated revolutionary and a defender of the people. But he was also a ruthless man, who was hated and feared. He was so despised that a counterrevolutionary from Caen, one Charlotte Corday, plunged a knife into his chest while he was writing on a portable desk laid across his bathtub, where he spent most of his time due to a lethal skin condition that grossly disfigured him.

David, who had visited Marat the day before, shows him expiring in the tub, still holding in one hand the quill with which he defended the French Republic, and in the other the fake petition Corday used to divert his attention before stabbing him. Like *The Oath*, David presented this scene with realism, attention to detail, sharp lighting, and planarity. But now he pushes the image much closer to the picture plane, almost to the surface of the canvas, with Marat's writing crate and Corday's blood-stained knife dramatically thrust into the viewer's space and the figure of Marat just inches behind.

23.29 Marie-Louise-Élisabeth Vigée-Lebrun, *Self-Portrait with Daughter*. 1789. Oil on canvas, 47²/₃ × 35¹/₂" (121 × 90 cm). Musée du Louvre, Paris

To contemporaries, this must have seemed like modern reportage. No matter that it was a propagandistic lie. Marat's bathroom was quite lavish, not the monastic republican interior seen here, which is so frugal the sheets are patched and a crate is used as a writing surface. Marat was notoriously unattractive, but here he has the physique of a Greek god and a seraphic face. The pose of the slumped arm is unmistakably that of Christ in a Deposition, Lamentation, or Pietà scene (see figs. 16.12 and 17.37), and derives from a Pietà by David's student Anne-Louis Girodet made the year before. The sheets recall Christ's shroud. The mundane writing crate is elevated to a time-worn tombstone. Like West in The Death of General Wolfe (see fig. 23.6), David appropriated religious iconography for secular glorification. He has also given the picture a personal twist, for on the crate he has written "À Marat" ("To Marat") with his signature below. Although a commission, the painting was one that David, as a member of the government, in a sense commissioned from himself, and one that he wanted to make. The dedication certainly makes the picture seem like a personal statement, almost a declaration that the powerful emotions expressed in it are particular to him as much as they are an expression of collective grief. The look of the painting has roots in a long Classical tradition going back to Poussin, Raphael, Caravaggio, and antiquity, but its personal intensity, as we shall see, is not far removed from that of the Romantic era, which is looming just around the corner and will be the subject of Chapter 24.

Neoclassical Portraiture: Marie-Louise-Élisabeth Vigée-Lebrun

The impact of David's Neoclassicism was powerful, not just on history painting but portraiture as well. We can see this impact on the 1789 Self-Portrait with Daughter (fig. 23.29) by Marie-Louise-Élisabeth Vigée-Lebrun (1755-1842). Born in Paris to a father who was a minor painter and who died when she was 12, Vigée-Lebrun, as a woman, was denied access to the Royal Academy. Consequently, she was essentially self-taught. In her teens, she began painting portraits, which were illegal since she did not have a license from the academy, which forced her to seek admission to the less prestigious Academy of St. Luke, where she exhibited in 1774. The following year, in a marriage of convenience, she wed Jean-Baptiste-Pierre Lebrun, a painter and prominent art dealer, who gave her access to powerful contacts. Her exceptional talent, vibrant personality, and sophistication soon had her circulating among the aristocracy and the wealthy, and she became a favorite of Queen Marie-Antoinette, whose portrait she painted many times, beginning in 1778. Thanks to the queen's influence, the Royal Academy in 1783 accepted her as a painter of historical allegory.

Lebrun is generally labeled a Rococo painter, her portraits having an affableness, liveliness, intimacy, and colorful palette associated with the style (see page 761). But throughout her career, Vigée-Lebrun was attuned to the latest artistic fashions, and she was a forceful arbiter in the world of couture, introducing, for example, shawls, and making "an arrangement with broad scarfs lightly intertwined around the body and on the arms, which was an attempt to imitate the beautiful drapings of Raphael and Domenichino," as she said in her memoirs. Vigée-Lebrun's 1789 portrait of herself with her daughter reflects the taste for the Classical that was then becoming pervasive in Paris. (In 1788, Vigée-Lebrun famously gave a *souper grec*, or Greek supper, considered one of the great social events of the reign of Louis XVI.) In this portrait, we see the sitters attired à *la* antique, wearing togas, Vigée-Lebrun's cinched above the waist with a scarf. The artist wears an antique headband and sports a Roman-style coiffure. Instead of a lavish Rococo interior, she and her daughter pose against an austere, although warm, wall.

Vigée-Lebrun loved her daughter, but the powerful intimacy and affectionate nature of the scene should also be seen as a reflection of the new Rousseauian attitude toward children that called for greater parental involvement in child-rearing, a quality that was increasingly apparent in portraiture in the second half of the century as young children began to be featured more frequently in portraits with their parents. But despite these Neoclassicisms and Enlightenment influences, this spectacular painting still retains an undercurrent of the Rococo, seen in its warm colors, affable glances, soft Correggioesque contours, and curvilinear patterning of arms and drapery.

ITALIAN NEOCLASSICISM TOWARD 1785

This chapter began in Rome toward 1760, and our story comes full circle by ending there as well, toward 1785, no longer looking at foreigners, such as Mengs and Hamilton, but at an Italian sculptor. It took over 20 years for Neoclassical painting to crystallize into a distinctive style in the work of David, and the same happened almost simultaneously in sculpture in the work of Antonio Canova. Canova emerged in Rome in the 1780s, and by the 1790s he was the most famous sculptor in the world, receiving commissions from all over Europe and America. He was the artist the majority of sculptors in both the Old and New World emulated and tried to equal, deep into the nineteenth century.

Neoclassical Sculpture: Antonio Canova

Antonio Canova (1757–1822) came from a family of stonecutters in the region around Venice. When he was nine his artistic talent was brought to the attention of a Venetian senator, under whose patronage he was able to study sculpture in Venice, becoming a teenage prodigy. By 1780, he was in Rome, financed by the Venetian senate, and the following year he took the city by storm with his marble sculpture *Theseus Vanquishing the Minotaur*. The work was a sensation in part because it looked Classical, like an excavated sculpture, although it was not based on a specific antique source—it was entirely Canova's creation.

We can see Canova's originality in *Cupid and Psyche* (fig. **23.30**), commissioned in 1787 by a tourist for his home in Britain. Canova first modeled the work in plaster, and then had assistants rough it out in marble. Afterward he completed the carving, which included creating an impressive variety of surface textures,

23.30 Antonio Canova, Cupid and Psyche. 1787–93. Marble, 6'1" \times 6'8" (1.55 \times 1.73 m). Musée du Louvre, Paris

23.31 Antonio Canova, *Tomb of the Archduchess Maria Christina*, Augustinerkirche, Vienna. 1798–1805. Marble, life-size

especially the remarkable cold-perfect finish for flesh that was often copied but never equaled by his many imitators. Nor did anyone match his exquisite compositions of continuous elegant contours, which in *Cupid and Psyche* are visible in the curving pattern of the sensuous arms and legs, as well as in the flowing drapery and the oval mound gently elevating the figures.

Canova delivers more than beautiful idealized Classical models, more than noble simplicity and calm grandeur—he also presents intense emotion. Here, he portrays the moment when Cupid, having fallen in love with the human Psyche, gives her a kiss that awakens her from the eternal sleep into which she has been cast by the jealous Venus. With this kiss, she becomes immortal, like Cupid. Canova captures a tenderness and passion in both expression and gestures that was unthinkable before 1780, and this reflects the interest in states of mind that preoccupied the Fuseli circle in Rome in the 1770s and consumed British artists in the 1780s. Canova was a close friend of Gavin Hamilton, who in addition to introducing Canova to the antiquities of Rome undoubtedly brought to his attention the emotional intensity that his British colleagues were exploring in their art.

We can see this emotional intensity stated in a very different way in the *Tomb of the Archduchess Maria Christina* (fig. 23.31) in the church of the Augustins in Vienna. One of the many commissions that flooded Canova's studio by the 1790s, the monument projects a chill pallor and deathly silence appropriate to a scene of mourning. Classically robed figures with bowed heads, one holding an urn supposedly containing ashes, trudge in Classical profile ever so slowly into the pyramidal tomb. The cold melancholy is reinforced by the severe geometry of the pyramid, including its austere Egyptian pylonlike post-and-lintel door. Above the door is a sculpture of two flying genii, one holding a portrait of the deceased, which is framed by a snake biting its tail, a symbol of eternity. On the right, a winged genius of war leans on a lion, representing Austria, both mourning the archduchess, while the three leftmost figures represent the Three Ages of Life. But for the most part, these symbols and allegories are subservient to the highly palpable realism of the event, so that we feel as though we are watching a real funeral procession taking place in real space and time. The scene is so convincing that we believe that the archduchess's ashes are indeed in the urn and the pyramid is the actual burial place-in fact, neither is the case, and the sculpture is only a monument. Despite Canovas's classicizing qualities of ideal beauty and drawing upon the antique, his work, like David's, contains a powerful emotional intensity that we have seen in early Romanticism and, as we will see in the next chapter, are the hallmarks of nineteenth-century Romanticism.

1725 Burlington and Kent begin construction of Chiswick House

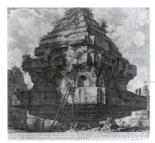

1757 Giovanni Battista Piranesi finishes *Roman Antiquities*

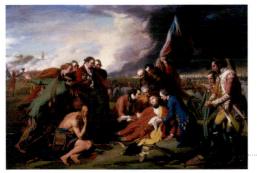

1770 Benjamin West's The Death of General Wolfe

1781 John Henry Fuseli's The Nightmare

1787 Antonio Canova's *Cupid and Psyche*

1765 Joshua Reynolds's Lady Sarah Bunbury Sacrificing to the Graces

1775 Claude-Nicolas Ledoux designs main entrance to the saltworks, Arc-et-Senans

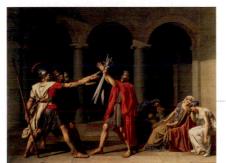

1784 Jacques-Louis David's Oath of the Horatii

Art in the Age of the Enlightenment, 1750–1789

1720

1730

1740

1750

1760

1770

1780

- 1734 Voltaire publishes Philosophical Letters
- 1738 Excavation of Herculaneum begins

- 1750 Jean-Jacques Rousseau publishes Discourse on the Arts and Sciences
- 1751 Denis Diderot and Jacques d'Alembert begin publishing the *Encyclopédie*
- 1755 Johann Winckelmann publishes Reflections on the Imitation of Greek Art in Painting and Sculpture
- 1756 Edmund Burke publishes A Philosophical Inquiry ... the Sublime and the Beautiful
- 1759 The British pottery firm of Josiah Wedgwood and Sons is founded
- 1756-63 French and Indian War
- 1765-82 James Watts perfects the steam engine
- 1768 Royal Academy of Arts, London, founded
 - 1770 George Stubbs's Lion Attacking a Horse
- 1774 Johann Wolfgang von Goethe writes The Sorrows of Young Werther
- 1775-84 American Revolution
- 1779 First iron bridge constructed, Coalbrookdale, England

1790

1789 French Revolution begins

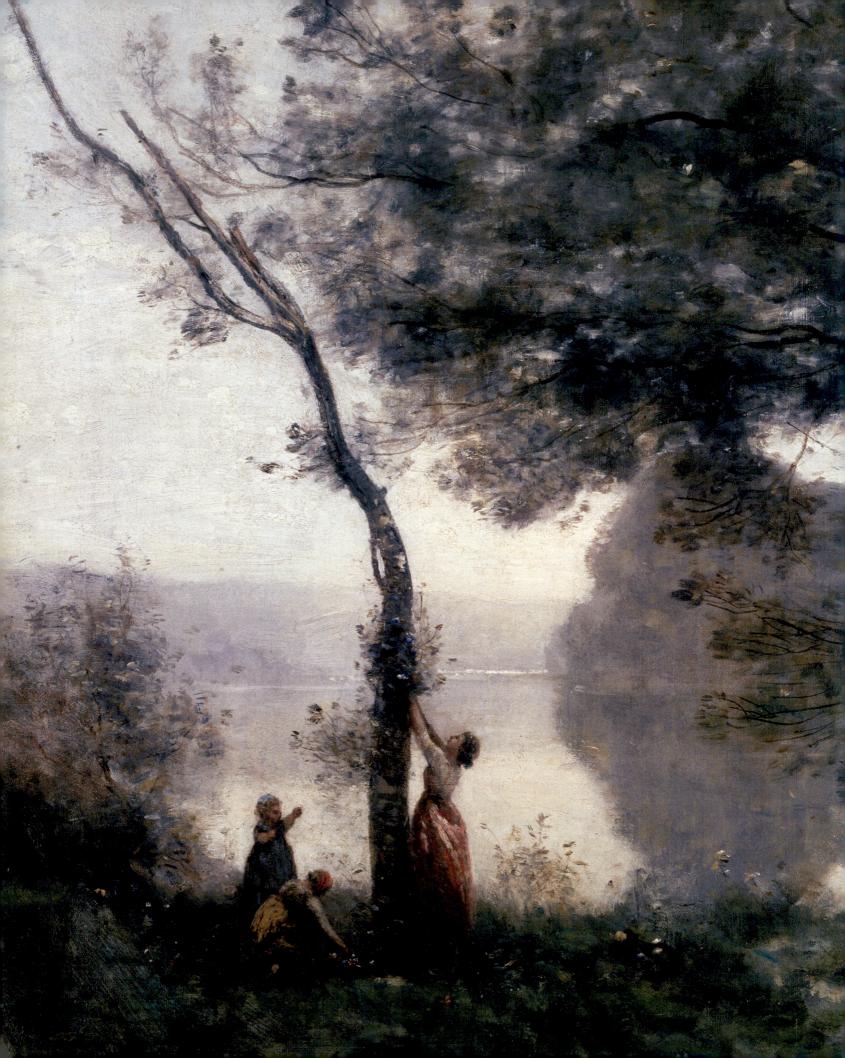

Art in the Age of Romanticism, 1789–1848

HERE IS NO PRECISE MOMENT WHEN NEOCLASSICISM WAS ABSORBED into Romanticism, and Romanticism itself emerged as a full-blown movement that dominated Western art. But generally this change is ascribed to the turn of the century. The word "Romanticism" did not appear until 1798, when the German writer and poet Friedrich von Schlegel

(1772–1829) applied it to poetry. The term itself derived from the Gothic novels of such writers as Horace Walpole in England (see page 800), which were based on medieval heroic literature called *romanz* in Old French, and projected an aura of gloom that became popular in the second half of the eighteenth century. By 1800, the Western world had begun to sense a fundamental transformation in consciousness occurring, a transformation that reached its peak in the first half of the nineteenth century.

This change in consciousness was an indirect result of the upheavals that accompanied the French Revolution, the Napoleonic Wars, and the rise of industrialization and urbanization. The Enlightenment seemed to have failed. Instead of social reform and progress, there was turmoil and dislocation, often accompanied by pessimism and a concomitant search for truth within the inner self rather than in society. The French Revolution may have given rise to republican government, political enfranchisement, nationalism, and public institutions, including museums, but it had also thrown most of Europe into war by 1792 and resulted in the execution of some 17,000 people under Robespierre's Reign of Terror in 1793–94. Fearful that Enlightenment reform spawned only revolution, European governments cracked down on liberals, instituting a harsh reactionary

Detail of figure 24.24, Jean-Baptiste-Camille Corot, *Souvenir de Mortefontaine (Oise)*

conservatism. The rise of Napoleon Bonaparte from commander of the Army of Italy under the Directory to self-proclaimed hereditary emperor in 1804 quashed the French Republic and initiated the Napoleonic Wars, which at their peak saw France occupy most of Europe and lasted until 1815. Napoleon's reign further increased the fervor of nationalism initiated by the French Revolution, and his military campaigns, covered in detail by the press, which proliferated in the opening decades of the century, provided the public with wondrous tales of valor and excitement that fed the Romantic imagination.

The military needs of war hastened the pace of the Industrial Revolution begun in Britain the previous century, and the return to peace with the defeat of Napoleon in 1815 hardly served as a brake. Waves of people fled the poverty of the countryside for the city to work in manufacturing. This new proletariat class, separated from the comforting predictability of the timeless rural world and needing to sell its labor, now experienced oppressive working conditions and subsistence wages, as well as poor housing in cities not designed to accommodate such a dramatic increase in population. The period saw the birth of modern labor and worker-management conflict, which culminated in 1848 with the publication of Karl Marx and Friedrich Engels's Communist Manifesto and a Europe-wide workers' revolution. The Industrial Revolution also gave rise to a powerful bourgeoisie, a wealthy middle class that controlled the means of production and demanded a greater voice in government.

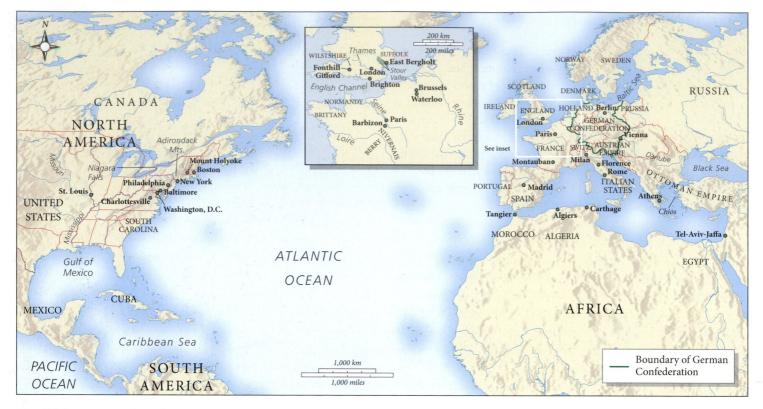

Map 24.1 Europe and North America in 1815

With this seemingly endless succession of crises, the West found a need to believe in something other than the Enlightenment values of logic and scientific empiricism. There arose a turning inward to the self, and a belief in the subjective emotion of the individual, promoted by Jean-Jacques Rousseau in France and the Sturm und Drang movement in Germany (see Chapter 23). What had been a strong undercurrent in the eighteenth century surfaced as the defining psychology of the West by the end of the century. Artists, writers, composers, and intellectuals now placed a premium on powerful emotion, intuition, and unrestrained creative genius. The era itself is often described as being dedicated to the "Cult of the Individual." For the intellectual and cultural elite, total liberation of the imagination and creative freedom replaced rules, standards, and logic. As expressed by the French Romantic writer Victor Hugo, "All systems are false; only genius is true." From this perspective, the mind was the conduit of nature, the only means of accessing elemental universal forces, God, and the goal of the artist was to tap into this reservoir of higher reality and express it. Sincerity and truthfulness were therefore now critical. Enlightenment morality was not applicable. Powerful emotions in response to violence, suffering, chaos, and ugliness replaced virtuous and noble actions and the perfection associated with ideal beauty. Romanticism produced a cult not only for exotic experiences but also for frightening, horrific, and extreme situations. Uniqueness became a strong value in art; copying someone else's genius, originality, or individualism was the manufacture of something false.

Consequently, Romanticism was not a style, but an attitude. It was a license to abandon logic and to follow one's genius wherever it led. It could lead to the distant past, the exotic present, the most grotesque and horrific aspects of human behavior, and the awesome forces of nature. It also resulted in a welling up of nationalistic spirit, as citizens were swept together not out of allegiance to a king but to a collective experience and language, eventually resulting in the rise of Italy and Germany as united countries in 1871. It also meant artists would no longer paint idealized Classical arcadias; instead they painted with pride and loving detail the countryside in which they themselves grew up, a countryside once considered too banal to render but that was now an emblem of God's presence, or filled with the powerful emotions of personal experience. And Romanticism meant artists were swept away by the emotions of liberty and freedom, the surge toward democracy, which, for example, was the driving force behind Ludwig van Beethoven's Symphony Number 3 in C Major, The Eroica, of 1804, originally dedicated to Napoleon and the civil liberties he instituted before he became emperor. While Romanticism may seem stylistically diverse, its attitude was cohesive, both passionate and powerful, as reflected in the work of some of the great names of the Romantic era: Beethoven, Hector Berlioz, Franz Liszt, Frédéric Chopin, Lord Byron, Mary and Percy Shelley, Samuel Taylor Coleridge, William Wordsworth, François-Renée de Châteaubriand, Victor Hugo, Henri-Marie Stendal, Herman Melville, and Edgar Allan Poe.

PAINTING

Of all the visual arts, painting is most closely associated in our minds with Romanticism because, unlike sculpture and architecture, it allowed for a spontaneous outpouring of emotion. In fact, many art historians think of the study or sketch, whether painted or drawn, as the quintessential Romantic medium. While some of the most famous Romantic paintings are Baroque in their dramatic handling of paint and energetic compositions, Romantic paintings can just as readily be tightly painted and composed in accordance with Neoclassical planes, resulting in frozen images that project chilling emotions.

Spain: Francisco Goya

In the opening decades of the nineteenth century, Spanish art was dominated by Francisco Goya y Lucientes (1746-1828), an artist whose work in many ways encapsulates the new psychology and issues pervading Europe. Born and raised in Aragon, he initially studied with Anton Raphael Mengs in Madrid. Goya did not much care for Mengs, and left to tour Italy in 1770 and 1771. Upon returning to Aragon, he studied with the painter Francisco Bayeu, developing a colorful, painterly Rococo style. Bayeu, a member of the Royal Academy of Fine Art in Madrid, arranged for Goya to design images for the Royal Tapestry Workshop, which brought him to Madrid again and gave him access to the royal court and Madrid aristocracy. Charles III (r. 1759-1788) appointed Goya royal painter in 1786, and his son Charles IV, in 1789, made him first painter to the king, putting him in the tradition of Velázquez, who had previously held the position (see page 691). For Goya, an Enlightened Spaniard who admired the French philosophes, there was not necessarily a conflict between supporting the monarchy and advocating liberal reform. The king recognized the need to bring a stagnant Spain into the eighteenth century and permitted a degree of economic and social development, which gave hope to the progressive forces. Goya was a member of this group that favored social reform, and his social circle, including many of his aristocratic clients, shared his outlook. But the French Revolution terrified heads of state throughout Europe and ushered in reactionary oppression, for now the Enlightenment became associated with revolution, not reform. Both Church and State suppressed the liberal reformers. Spain went to war with France, forging an alliance with its old enemy, Britain. On top of these reversals, Goya fell mysteriously ill in 1793, only just surviving and going deaf in the process. Now, Goya's art focused on exploring the human condition and the emerging modern psychology, on exposing wanton cruelty, misery, ignorance, and greed as universal constants, and on expressing the reality of death as a frightening, unknown void.

THE SLEEP OF REASON We can get some idea of Goya's reaction to the period's crises by looking at *The Sleep of Reason Produces Monsters* (fig. 24.1), one of 80 etching-and-aquatint prints from the series *Los Caprichos* (*The Capriccios*), conceived

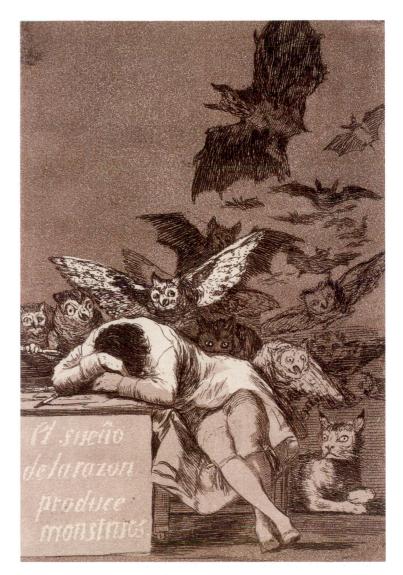

24.1 Francisco Goya, *The Sleep of Reason Produces Monsters*, from *Los Caprichos*. ca. 1799. Etching, aquatint, drypoint, and burrin, $8\% \times 6"$ (21.5 × 15.2 cm). Metropolitan Museum of Art, New York. Gift of M. Knoedler & Co., 1918. (18.64(43))

by the artist in 1797 and published at his own expense at a financial loss. Here, we see the artist asleep on the geometric block of reason, while behind him rises an ominous disarray of owls and bats, symbols of folly and ignorance, respectively. In the margin of a study for this image, Goya wrote, "The author's...intention is to banish harmful beliefs commonly held, and with this work of *caprichos* to perpetuate the solid testimony of truth." This print introduces the second half of the series, which satirizes a range of sins, superstitions, and forms of ignorance, and is populated with witches, monsters, and demons, in effect showing what the world is like when Enlightenment logic is suspended.

But it is just as easy to interpret *The Sleep of Reason* as exposing a second, non-Enlightenment side to Goya's personality—the emotional and illogical rather than the rational. We sense that the owls and bats, rather than being real, are released from the inner recess of Goya's mind, so that this nightmarish scene becomes an expression of the artist's own emotional state of despair or horror at the terrible turn of events transforming the Western world. In effect, in *The Capriccios* Goya is announcing his right to abandon reason and use his imagination to express his deepest feelings, his innermost psychology—to free his demons and employ whatever stylistic tools and symbols he needs in order to do so. We are now far from Neoclassicism and the Rococo as we enter a dramatic graphic world energized by Baroque contrasts of light and dark, asymmetrical composition, the febrile patterning of the wings of bats and owls, and the rasping lines of the Goya's rich intaglio process. (See *Materials and Techniques*, page 501.)

ROYAL COMMISSIONS Goya continued to work for Church and State, which, in addition to painting portraits, is how he earned a living. In 1800, the king commissioned him to paint The Family of Charles IV (fig. 24.2). This work is hardly a simple documentation of the royal family's likeness. And it is certainly not a grand machine designed to reaffirm the family's divine privilege and superiority, for the painting undermines this traditional premise by exposing their basic humanness, their ordinariness. The key to interpreting the picture is knowing that Goya meant it to be compared with Velázquez's The Maids of Honor (see fig. 19.38), a picture in the royal collection and known to everyone at court. In each painting, the artist is present and the royal family appears before a shadowy backdrop of two large oils. In addition, Goya's Queen Maria Luisa, standing in the center, strikes the same pose as Velázquez's infanta. Missing from Goya's portrait, however, is the all-important mirror, which in The Maids of Honor reveals the royal parents, the keystone that holds the picture together compositionally and thematically because it not only explains the scene but also establishes the hierarchical order of the figures. But where is the mirror in *Charles IV*? We must ask another question first, one that is always posed about Goya's picture: What is everyone gaping at so intently? The most likely answer is themselves. They are looking in a mirror—the unaccounted-for mirror—and Goya, standing *behind* his sitters, shows himself painting their reflection as they see themselves.

Théophile Gautier, a nineteenth-century French critic, cleverly noted their discomfort when he described the royal couple as looking like "the corner baker and his wife after they have won the lottery." Goya reduces his sitters to human animals, uncomfortable with themselves. Their clothes may be royal, but the family members are as awkward in them as in their false aristocratic poses, which lack the assuredness we saw in royal portraits by Van Dyck and Rigaud (see figs. 20.8 and 21.10). The figures appear lonely, isolated, even afraid. Goya presents each one as an individual, plagued by the same doubts about the meaning of existence and the same sense of alienation that haunt all humans. This Romantic sense of awe when confronting the infinite is Goya's creation, superimposed onto the royal family. Based on the principle of empiricism, many Enlightenment philosophes denied the existence of God, which the French Revolution did as well, suppressing the Catholic Church. Without God and religion, the meaning of existence is unknowable and beyond comprehension. This shockingly modern psychology casts a dark shadow over the

24.2 Francisco Goya, *The Family of Charles IV*. 1800. Oil on canvas,
9'2" × 11' (2.79 × 3.35 m).
Museo del Prado, Madrid

24.3 Francisco Goya, *The Third of May*, *1808*. 1814. Oil on canvas, $8'9" \times 13'4"$ (2.67 × 4.06 m). Museo del Prado, Madrid

room. Surprisingly, Charles IV did not reject the portrait, although he did not particularly like it either. Conceivably, the royal family overlooked the disturbing truths lying beneath the surface of the picture because they were blinded by Goya's brilliant flamboyant brushwork (difficult to see in reproduction), which surpassed even Velázquez's Baroque bravura. Goya's dynamic paint handling animates the surface—it is sparkling and dazzling, especially as seen in the clothes, jewelry, and medals.

An even more powerful mood of futility pervades The Third of May, 1808 (fig. 24.3), painted in 1814 and one of many paintings, drawings, and prints that Goya made from 1810 to 1815 in response to the French occupation of Spain in 1808. The corruption of the Spanish administration forced Charles IV to abdicate in 1807. He was replaced by his son Ferdinand VII, who was deposed in 1808 when Napoleon's troops marched into Madrid and put the emperor's brother, Joseph Bonaparte, on the throne. Enlightened Spain was initially optimistic that the Enlightened French would bring political reform. But in Madrid a people's uprising spurred by nationalism resulted in vicious fighting and wholesale slaughter on both sides, within days fanning out across the entire country and then dragging on for six years. Goya's enormous, dramatic picture, painted after Napoleon had been deposed and Ferdinand reinstated, shows the mass execution of Spanish rebels that took place on May 3, 1808, on a hill outside Madrid.

How different it is from Neoclassical history painting that presented great and famous exemplars of nobleness, morality, and fortitude! Goya presents anonymous nobodies caught up in the powerful forces of history. Here we see the mechanical process of the slaughter. One rebel with raised arms, dressed in the yellow and white colors of the papacy, has the pose of Christ on the Cross. His right hand has a wound suggesting the stigmata. But ironically Goya denies the rioters the status of martyrs. They are consumed by the fear of death, not the ecstasy of sacrifice. No divine light materializes to resurrect them, and the church in the background of this imaginary scene remains dark. When the stable lantern—which in its geometry and light could be construed as an emblem of Enlightenment logic and progress—is extinguished, there will be only eternal night, symbolized by the inert foreground body, whose face is reduced to a gory mass of paint. The faceless executioners, also small cogs in the wheel of history, are indifferent to their victims' fear of death and frantic pleas for mercy. Goya whips up the horror and emotional turmoil of his scene by rejecting tight Neoclassical paint handling, linearity, planarity, and even lighting, and by replacing this aesthetic with feverish loose brushwork, intense colors, compositional turmoil on the left, and a dramatically receding line of soldiers on the right.

Goya painted *The Third of May, 1808* at a time when he was desperate for work: He wanted to gain royal favor with this picture, hence his scripting of it so that it could be read as being about the sacrifice of the Spanish to the agents of political tyranny. But the real themes of the image are the anonymity of death and the senseless brutality of war. Its power lies in its ability to instill in a viewer an intense sense of terror that makes one confront the inescapable knowledge of one's own mortality.

Britain: Spiritual Intensity and the Bond with Nature

The road taken by Goya in *Los Caprichos* into a fantasy world that allowed his imagination and passions to go wild was most closely followed in Britain by William Blake, who viewed himself as a history painter. However, many British painters during the Romantic era took the same path as Romantic poets such as William Wordsworth (1770–1850) and Percy Bysshe Shelley (1792–1822) and steeped themselves in nature, being emotionally swept away by its beauties and moods or awed by its sublime power and intimations of the infinite.

WILLIAM BLAKE Across the English Channel in London, the artist William Blake (1757–1827) was also retreating into a personal visual world as he responded to issues very similar to those affecting Goya. Blake was an ardent admirer of Jean-Jacques Rousseau and his theories about the inherent goodness of humans, who are born innocent primitives before becoming corrupted by the restrictive artificialities of society. He detested European civilization for its rules and conventions, which he felt hindered personal freedom, including equality for women. He loathed European materialism and its lack of spirituality, and condemned institutional religion for being as autocratic as government and society in general. His passion to find spiritual truths in a physical world led him to flirt with fringe religions in the 1780s.

Blake began his career as an artisan engraver. He then enrolled in the Royal Academy in 1779 but left within a year, declaring its president, Joshua Reynolds, and the institution itself a microcosm of society, repressing imagination, creativity, and progress. As a result, he was largely self-taught. While never a recluse, Blake was quite insular, functioning on the edge of society. He did not show at the academy after the mid-1780s and received virtually no critical notice throughout his career.

Despite his intense dislike of the Royal Academy, Blake was a proponent of history painting, which he saw as a vehicle for reforming society. However, he shunned oil painting, which he associated with the artificial hierarchies of the academy, and instead turned to medieval manuscript illumination for inspiration, producing illustrated books of his own poetry that were designed to evoke the same kind of spirituality found in his model. Before becoming a visual artist, Blake was a poet, garnering an impressive reputation. In the late 1780s, he started selfpublishing his poetical works, which praised nature, freedom, youth, and imagination while denouncing the corruption of all

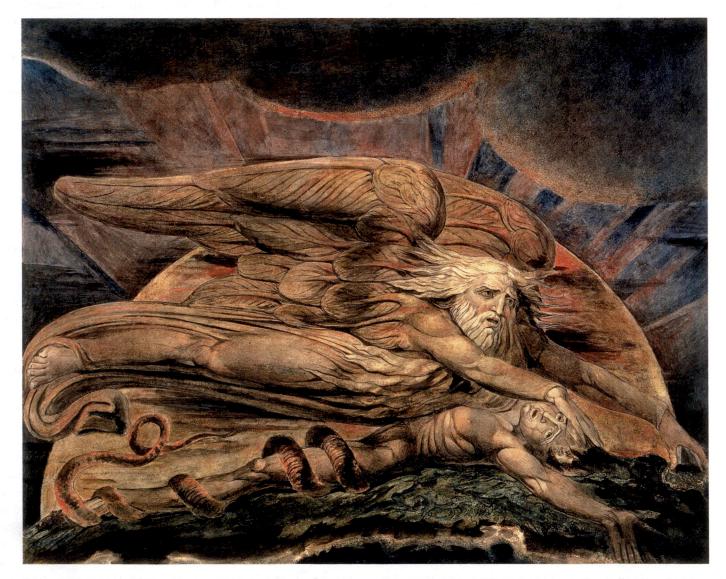

24.4 William Blake, *Elohim Creating Adam.* 1795. Monotype with pen and watercolor, 17 × 21¹/₈" (43.1 × 53.6 cm). Tate Gallery, London

Blake's Printing Process

For the series of 12 prints that included *Elohim Creating Adam* (see fig. 24.4), William Blake invented a process that is similar to **monotype**, a printing technique that would become popular by the end of the nineteenth century but was rarely used earlier. Monotype involves painting an image on one surface and then pressing paper against this wet surface to attain a counterimage, which unlike the original has a mottled, softer-looking surface. As the word monotype implies, generally only one impression is taken. However, a few impressions can be obtained before all of the original paint is consumed, with each successive image lighter than the previous.

Blake's process for the series was to first outline his image in black paint on a piece of millboard (a thick paperboard), often adding a small amount of modeling and detail as well. He would pull roughly three paper impressions from the millboard, using low pressure so as not to extract too much paint at one time. This would produce a simple black design without color. To finish his image, he would paint the millboard again but with colors, and press it on top of the pulled impressions with the black design. He then touched up the works with watercolor. Blake is said to have used oil paint for his printing, but considering his distaste for the medium he most likely used an egg-based tempera.

components of civilization, a corruption stemming from an overreliance on reason. Toward 1793–94, Blake spiraled into a deep depression, triggered by the violence and chaos of the French Revolution, Britain's declaration of war on France, and the repressive policies that British Prime Minister William Pitt instituted in response to the most radical phase of the French Revolution. Like Goya, Blake was witnessing the failure of the Enlightenment.

At this point the visual imagery began to dominate the poetry in Blake's books. Simultaneously, his art reached maturity in twelve unusually large color prints made mostly in 1795, such as Elohim Creating Adam (fig. 24.4). These works were never bound and presented in book form, so we do not know for sure the order in which they were meant to be seen or how Blake intended to use them. (See Materials and Techniques, above.) However, all of the prints relate to the artist's vision of the early history of the world, in which humans, when born, are still attached to the infinite from which they have just come, and are morally good, free, and filled with imagination. As they age, they begin to be ruled by reason, lose their freedom and morality, and become consumed by materialism, thus trapped in the finite. The subjects for this series are not all invented: Some come from Shakespeare, Milton, and the Bible, which, as we have discussed (see page 804), were favorite sources for sublime imagery in the period. Blake appropriated these themes because they could be integrated into his own philosophical system and thus support it.

Elohim Creating Adam comes from the Bible, Genesis 2:7: "And the Lord God formed man of the dust of the ground." Blake presents Adam's birth as an aspect of the Fall, for this is a representation of his material birth, not his spiritual one. His body is tense, his face even tortured and apprehensive, and his pose is that of Christ on the Cross. Around his legs is a giant worm, a symbol of the material world. Elohim, the Hebrew word for "Jehovah," projects an expression of foreboding, knowing full well the fate of humans. We need but compare this image to Michelangelo's *The Creation of Adam* (see fig. 16.21) on the *Last* *Judgment* wall of the Sistine Chapel to see how disturbing and negative Blake's presentation is.

Since the mid-1770s, Blake had been influenced by Michelangelo and the Mannerists as well as by medieval art, and the presence of all can be detected in this picture, though transformed by Blake's own style. We see Michelangelo's overstated musculature (see fig. 16.21), as well as the curvilinear line of manuscript illumination (see fig. 10.8). The absence of an environmental setting and the emphasis on figures alone, as well as the selection of a sublime, horrifying situation derives from Fuseli (see figs. 23.16 and 23.17), whom Blake greatly admired and periodically tried to befriend, without success.

The degree to which Blake mentally immersed himself in his fictitious worlds is remarkable. He claimed his visions were revealed to him by spirits: "I am under the direction of Messengers from heaven, Daily and Nightly." While we have to take this statement with a grain of salt, nonetheless, his art was not naturalistic (a faithful representation of reality), but a conceptual fantasy world in which he could play out his passionate moral beliefs, historical views, and vision of a utopian future. Objects are relatively flat, with space kept to a minimum, an artistic strategy that reinforces the ideal concepts behind his images.

JOHN CONSTABLE Landscape gradually became a major vehicle in the period's search for truth. This is not surprising considering the importance of nature in Romantic ideology—the need to bond with it and to express its essence as personally experienced. John Constable (1776–1837) is one of two British artists who stand out in the period for their landscapes. Constable was born and raised in the village of East Bergholt, in the Stour Valley in Suffolk, and spent most of his life painting this rich farmland, which until then had been considered too ordinary to be used as artistic subject matter. Instead of working at the family's prosperous farm and mill, Constable, in 1799, was permitted to study at the Royal Academy School in London. He eventually realized that he was just learning to replicate painting conventions, and returned to Bergholt to make "laborious studies from nature," drawings and oil sketches that he worked up into finished pictures in the studio but that retained the freshness and details of the original source. Constable even considered painting landscape scientific: "Painting is a science, and should be pursued as an inquiry into the laws of nature. Why, then, may not landscape painting be considered as a branch of natural philosophy, of which pictures are but experiments?" Constable was especially adept at capturing the ephemeral properties of nature—clouds, light, and atmosphere. He made countless studies of just the sky, "the key note, standard scale, and chief organ of sentiment."

Constable's pictures are packed with the emotion that welled within him when experiencing the beauty of the Stour Valley— "painting is with me but another word for feeling," he claimed. (See *Primary Source*, page 829.) His pictures were both scientific and subjective, as in *The Haywain (Landscape: Noon)* (fig. **24.5**) of 1821, shown at the Royal Academy, where he had been exhibiting since 1811. We do not just see but feel a blue sky pushing out darker clouds, and an invisible layer of moisture that makes everything glisten. Vibrant flecks of paint and color dissolve the material world and make the atmosphere sparkle. The sky is a symphony of subjectivity, presenting a range of emotions, as does the land. It can be dark and undulating, as in the dramatic, energized twisting of tree branches, or bright and placid, as in the light-filled horizontal spread of the distant hayfield. Constable fills his picture with detailed anecdote; besides the haywain, there is the dog, the boat, the harvesters in the distant field, and the puffs of smoke coming from the mill. This is no perfect world, representing ideal beauty or a Classical Arcadia. Rather, it is a particular site presented in all of its heartfelt specificity. One of the new emotions experienced in the Romantic era was national pride and artists now passionately painted their own countries—not just the Italian landscape—and they painted it with loving detail, not idealized to look like the Classical past.

The 6-foot canvas—an unusually large size for a genre painting and a controversial strategy for elevating landscape to a higher status as well as an attempt to gain attention—was based on numerous outdoor studies, mostly made from 1814 to 1816, and

24.5 John Constable, *The Haywain (Landscape: Noon).* 1821. Oil on canvas, $51\frac{1}{4} \times 73$ " (1.3 × 1.85 m). The National Gallery, London

John Constable (1776–1837)

From a letter to John Fisher

Fisher, the archdeacon of Salisbury Cathedral, was a lifelong friend of the artist. This letter of October 23, 1821, reflects Constable's sensitivity to the beauties of the English landscape.

How much I wish I had been with you on your fishing excursion in the New Forest! What river can it be? But the sound of water escaping from mill-dams, etc., willows, old rotten planks, slimy posts, and brickwork, I love such things. Shakespeare could make everything poetical; he tells us of poor Tom's haunts among "sheep cotes and mills." As long as I do paint, I shall never cease to paint such places. They have always been my delight, and I should indeed have been delighted in seeing what you describe, and in your company, "in the company of a man to whom nature does not spread her volume in vain." Still I should paint my own places best; painting is with me but another word for feeling, and I associate "my careless boyhood" with all that lies on the banks of the Stour; those scenes made me a painter, and I am grateful; that is, I had often thought of pictures of them before I ever touched a pencil.

Source: Charles Robert Lesslie, *Memoirs of the Life of John Constable*, ed. J. Mayne (London: Phaidon Press, 1951)

developed into this large presentation format in the artist's London studio, where he worked in the winter. Typically for his Stour pictures, life in *The Haywain* moves slowly, with rural laborers routinely doing what they have done for millennia in blissful harmony with nature. This was a period of social and economic unrest in the British agricultural community, putting tremendous financial pressure on the Constable property, then run by the artist's brother. This labor crisis is absent from Constable's poetic picture, which instead focuses on personal attachment to the land and the life the artist knew as a boy.

JOSEPH MALLORD WILLIAM TURNER The second major British landscape artist in this period is Joseph Mallord William Turner (1775–1851). In their basic operating premises, Constable and Turner could not be further apart. Whereas Constable painted with scientific accuracy the land he intimately knew, Turner aspired to rival great history painting and consequently invested his views with a rich overlay of historical motifs, references to the Old Masters, and metaphorical themes. His work was also often cataclysmic and horrific, portraying the powerful, uncontrollable forces of nature, and giving visual expression to the sublime as defined by Burke.

Turner began his career in the early 1790s as a for-hire topographical watercolorist. By 1799, at the unprecedentedly young age of 24, he became an associate of the Royal Academy. While he made numerous landscape studies of specific rural scenes as Constable did of Stour, his drive to artistic greatness led him to take on the great landscape and marine painters of the past— Claude Lorrain and Jacob Ruisdael—whose works his landscapes resemble in composition, subject, and atmosphere. The reason for this mimicry was to outdo the Old Masters at their own game: Turner's sun was brighter, his atmosphere moister, haze hazier, and perspectival space deeper. Like Constable, his handling of the intangible properties of nature—wind, light, reflections, atmosphere—was magical.

Turner's quest for the grandiose and his rich imagination led him to embed spectacular mythological and historical moments in his landscapes, creating historical landscape on an epic, sublime scale. *Snowstorm: Hannibal and His Army Crossing the Alps* (fig. **24.6**) of 1812 is one of his best-known historical landscapes, a genre he had developed by the late 1790s. In this work, the Carthaginian general Hannibal leads his troops across the French Alps in 218 BCE to launch a surprise attack on the Romans during the Punic Wars. A human sea of turmoil reigns in the valley below as Hannibal's troops plunder the alpine villages for desperately needed supplies. Above, the cataclysmic forces of nature—a wild snowstorm, turbulent wind, crashing storm clouds, and a blinding light from an ominous sun—threaten to engulf the insignificant figures below, too preoccupied with their immediate survival to notice. The great Hannibal is barely present, reduced to a speck on an elephant in the background. Dramatic light, diagonal recession, and bold brushwork reinforce the chaos and hysteria of the scene.

During the Napoleonic Wars, Turner made several pictures about Carthage, with which, as a great maritime empire, the British identified. In Snowstorm, however, the reference is probably to Napoleon's 1800 march across the Alps to invade Italy. Whether the precise allusion is to France or Britain probably does not matter, for the work's wider theme is the folly of empire, and imperial expansion was a hotly debated issue in both France and Britain at the time. The picture is also about the folly of existence. When Turner exhibited Snowstorm at the Royal Academy, he accompanied it with several lines from his unfinished poem "The Fallacies of Hope," which moralized about the plundering and ultimate defeat of Hannibal's army. This picture, like his later Carthage paintings, including the 1817 Decline of the Carthaginian Empire, is not meant to glorify or condemn human activity. Instead it is designed to put human activity and civilization into a grander cosmic scheme, in which they appear insignificant compared to the relentless, uncontrollable power of sublime universal forces. Turner's goal is the Romantic notion of making a viewer feel nature's unfathomable enormity, not to reproduce a landscape (although the painting is based on studies he made in the Alps). Consequently, an atmospheric haze shrouds the insignificant figures and a dramatically receding vortex ends in a blaze of eternal light. With Turner, Edmund Burke's idea of the sublime (see page 790) reaches a terrifying pitch. But more horrifying than the sheer power of nature are "the fallacies of hope," the Romantic notion of the infinity of the universe and the permanency of death, a modern psychology we have already seen in Goya.

24.6 Joseph Mallord William Turner, *Snowstorm: Hannibal and His Army Crossing the Alps.* 1812. Oil on canvas, $4'9" \times 7'9" (1.45 \times 2.36 \text{ m})$. Tate Gallery, London

The direct experience of nature becomes stronger in Turner's late work. Now, the image begins to disappear, replaced by an atmospheric blur of paint and color that seems to sit on the surface of the canvas, making a viewer feel immersed in it. Today, Turner is best known for this late abstract style, which he developed toward 1838 and is seen in The Slave Ship or Slavers Throwing Overboard the Dead and Dying-Typhoon Coming On (fig. 24.7) of 1840. These late works were condemned in Turner's own time. His contemporaries thought he had gone mad, for they found the works virtually unreadable, and certainly unintelligible. Furthermore, his epic stories were no longer drawn from mythology or history but from seemingly minor contemporary events. His earlier work may have been atmospheric, but there was always enough drawing to suggest precise objects, a distinct composition, and legible spatial recession and relationships, as we see in Snowstorm. Later, this readability evaporates in a haze of color and paint that represents the essence of mist, light, and atmosphere.

The Slave Ship shows the sick and dying human cargo being thrown into the sea during a typhoon. Turner was inspired by James Thomson's *The Seasons* (1730), where the poet describes how sharks follow a slave ship during a typhoon, "lured by the scent of steaming crowds, or rank disease, and death." Turner was also influenced by a recent newspaper account of a ship's captain who had jettisoned slaves in order to collect insurance, which paid for cargo lost at sea but not for death from illness. Here, Turner gives us a close-up of human suffering. Outstretched hands pleading for help, a leg about to disappear into the deep for a last time, the gruesome blackness of flailing chains and manacles, the frenzied predatory fish, and bloodstained water all dominate the immediate foreground. In the background is the slave ship, heading into the fury of the typhoon and its own struggle for survival, its distance and silence a metaphor for the callous indifference of the slavers. The searing brilliance of the sun bathes the sky in a blood-red aura, its seemingly infinite reach complementing the omnipotence of the raging sea.

This is a tragic, horrific scene, made a few years after Britain banned slavery entirely in the Abolition of Slavery Act (1833; the Atlantic slave trade had been outlawed in 1807). Turner certainly makes us feel the hardened inhumanity of the slavers, encouraging us to despise them. And yet, the picture has a haunting thematic and moral ambiguity: Birds eat fish and human carcasses, fish feed on other fish and discarded slaves, and slavers fight for their lives in the face of a storm. The picture is as much about the struggle of daily life and the role of fate as it is about the immorality of the slavers, the only constant being the frightening power of nature. 24.7 Joseph Mallord William Turner, *The Slave Ship* or *Slavers Throwing Overboard the Dead and Dying— Typhoon Coming On.* 1840. Oil on canvas, 35¼ × 48" (90.8 × 122.6 cm). Museum of Fine Arts, Boston. Henry Lillie Pierce Fund, Purchase. 99.22

Germany: Friedrich's Pantheistic Landscape

Human destiny is treated with a chilling bleakness and unsettling silence in the sublime landscapes of the German artist Caspar David Friedrich (1774–1840). While Turner focuses on the insignificance of human and animal life in the face of the allpowerful cosmos, Friedrich's concern is the passage from the physical way station of earth to the spiritual being of eternity. His landscapes are virtually pantheistic (seeing God's presence in nature), an especially German phenomenon, as he invests his detailed, realistic scenes with metaphysical properties that give them an aura of divine presence.

Friedrich was born into a prosperous bourgeois family of candle and soap manufacturers in the Baltic harbor town of Greifswald, then part of Sweden. Here, he found the austere landscape that served as the source material for his drawings and formed the foundation of many of his paintings. He studied drawing at the Academy of Copenhagen from 1794 to 1797 and then continued his training in Dresden, where he would maintain a studio throughout his life. Until 1807, he worked exclusively in drawing, shunning historical themes and instead making topographical landscapes, including many of the Baltic region. His paintings would retain the hard linear draftsmanship he developed in these years.

Gradually, his landscape drawings became metaphorical, often presented in groupings with cyclical themes, such as the times of the day or the four seasons. He continued this practice in his early paintings, which include Monk by the Sea, which was paired with Abbey in an Oak Forest (fig. 24.8), made in 1809-10. The former, which would be hung on the left and read first, pits the small vertical figure of a standing monk, back to viewer, against the vastness of the sea and an overwhelming explosive sky in a landscape so barren and abstract that the beach, sea, and sky are virtually reduced to vague horizontal bands. Traditionally, art historians interpret the funeral depicted in Abbey as that of this monk, in part because the coffin-bearing Capuchins wear the same habit as that of the Monk by the Sea. If the first picture depicts life contemplating death, the void represented by the sky and sea, this second is an image of death, as suggested by a frozen snowcovered cemetery, a lugubrious funeral procession, distraught barren oak trees, the skeletal remains of a Gothic abbey, and a somber winter sky at twilight. The abbey and oaks, obviously equated and imbuing nature with a spirituality and vice versa, form a gate that the burial cortege will pass under. Religious hope is stated in the crucifix scene mounted on the portal. The oval at the peak of the tracery window is echoed by the sliver of new moon in the sky, a symbol of resurrection. We sense a rite of passage, a direct connection, between abbey and sky. Just as the moon goes through a cycle as it is reborn, twilight yields to night followed by sunrise and day, and winter gives way to spring, summer, and fall; so also, it is suggested, death will be followed by an afterlife or rebirth. And yet, this is a very gloomy picture that

24.8 Caspar David Friedrich, *Abbey in an Oak Forest.* 1809–10. Oil on canvas, $44 \times 68\frac{1}{2}$ " (111.8 × 174 cm). Nationalgalerie, Staatliche Museen zu Berlin

leaves our fate after death in doubt, making us dread the unknown on the other side of the horizon. Friedrich's cold, marmoreal paint handling reinforces the lifelessness of the scene.

Friedrich's equating nature with religion was influenced by the pantheism of his friend the theologian Gotthard Ludwig Kosegarten, who delivered his dramatic sermons on the shores of the Isle of Rügen in the Baltic, using the awesome and desolate coastal landscape as a metaphor for God. Kosegarten's pantheism was far from unique in Germany, and was in large part a product of the Sturm und Drang movement (see pages 787 and 803). Two leading members of the movement, Goethe and Johann Gottfried Herder (1744-1803), also played a major role in stimulating late eighteenth-century German nationalism, the political manifestation of Romanticism, which is also reflected in Friedrich's painting. In Origin of Language (1772), Herder argued that language was not divinely endowed but stemmed from the collective experience of a people, triggering a search to define this experience. Herder, for example, collected an anthology of German folk songs, while the Grimm brothers did the same for folktales. This delving into the distant primitive past in search of one's roots was distinctly Romantic, for it created an emotional bond among people that in intensity was quite different from their former shared practical allegiance to an aristocracy. For his part, Goethe declared that Gothic architecture was native to Germany, and, unlike Classical buildings, was premised not on calculation but Romantic intuition, Gothic cathedrals rising up like the towering oak trees that make up the great northern forests.

Friedrich's most salient motifs in *Abbey* are the Gothic ruin and barren oak trees, motifs he knew his audience would immediately recognize as national emblems. The picture was made at a moment of national crisis. There was no Germany in 1810, only a loose confederation of some 300 German-speaking states and free cities called the Holy Roman Empire, nominally ruled by Austrian emperors of the Habsburg dynasty. The emotional surge toward unification was crushed when Napoleon's troops overwhelmed the country. Friedrich's crumbling abbey and striped oaks are symbols of the demise of nationalism, while the winter chill, deadening silence, and gloomy light of a disappearing sun are a reflection of the national mood, and especially Friedrich's.

America: Landscape as Metaphor

Art had not been a priority in the struggling British colonies in America during the seventeenth and eighteenth centuries, and the only art market that existed there was largely for portraiture. Sculpture was mostly limited to weather vanes and tombstones. This did not change dramatically in the Federalist period (1789–1801) and the opening decades of the nineteenth century, although the first academies and galleries were founded in the first quarter of the century—the Pennsylvania Academy of Fine Arts (1802), the Boston Atheneum (1807), and New York's National Academy of Design (1825). By 1825, New York had surpassed Philadelphia as the largest and wealthiest city in the nation—in large part due to the opening of the 383-mile (613-km) Erie Canal that ran from Buffalo to the Hudson River at Albany, funneling the raw materials and produce of the hinterlands into New York City. New York simultaneously became the nation's art capital, and consequently our discussion of American art will center on New York well into the twentieth century.

In the 1820s, landscape painting began to acquire status and, by the 1840s, it had eclipsed portraiture as the most esteemed form of American art. A young nation with little history, the United States became preoccupied with a search for its own identity, one that would distinguish it from its Old World roots. Literary figures such as William Cullen Bryant (1794-1878) and Ralph Waldo Emerson (1803-1882) identified the land itself as America's wealth and contrasted its unspoiled virginity to the densely populated, resource-impoverished lands of Europe. America was overflowing with natural resources, a veritable Garden of Eden. They also interpreted this pristine land as a manifestation of God, whose presence was to be seen in every blade of grass, ray of sun, and drop of water. To meditate on nature was to commune with God. This belief stemmed not only from the metaphysics of German philosophers-the same thought we saw expressed in Friedrich's paintings-but also from the American Transcendentalist movement, which surfaced in the 1830s and is perhaps best known today from such works as Emerson's Nature (1836) and Henry David Thoreau's Walden (1852). In this famous quote from Nature, Emerson expresses the spiritual unification with nature and the consequent role of the artist or writer to channel this unification into art: "Standing on the bare groundmy head bathed by the blithe air, and uplifted into infinite spaceall mean egotism vanishes. I become a transparent eyeball; I am nothing; I see all; the currents of the Universal Being circulate through me; I am part or parcel of God." Elsewhere, Emerson wrote: "The poet must be a rhapsodist—his inspiration a sort of bright casualty; his will in it only the surrender of will to the Universal Power." The American landscape became the emblem of the young nation.

THOMAS COLE AND THE HUDSON RIVER SCHOOL

America's first art movement, based on landscape and born in the 1820s, is called the Hudson River School, because the artists, most with studios in New York, were initially centered on the Hudson River Valley before fanning out through all of New England in the 1830s through the 1850s. Spring through fall, the artists traveled through New York and New England making studies, generally drawings, of this unique land, which they then developed into large paintings in their New York studios during the winter. The lead figure in this group was Thomas Cole (1801-1848), a founding member of the National Academy of Design who produced his first major landscapes after an 1825 summer sketching trip up the Hudson. Initially, his views were sublime, presenting a wild, primordial nature, often with storms pummeling the forests, dark clouds blackening the earth, and lightning-blasted trees. Despite depicting specific sites, his style relied on European landscape conventions and formulas, with little attention given to detail.

By the 1830s, however, Cole's paint handling became tighter and his pictures less formulaic and more specific, embracing a Romantic truth to nature that we saw in Constable. This is apparent in *The Oxbow* (fig. 24.9), made in 1836 for exhibition at the National Academy of Design. In this breathtaking view from atop

24.9 Thomas Cole, The Oxbow (View from Mount Holyoke, Northampton, Massachusetts, after a Thunderstorm). 1836.
Oil on canvas, 51½ × 76" (1.31 × 1.94 m).
Metropolitan Museum of Art, New York. Gift of Mrs. Russell Sage, 1908 (08.228)

Mount Holyoke in western Massachusetts, Cole presents the natural wonder of the American landscape. The foreground is sublime wilderness, with blasted and windswept trees and dark storm clouds dumping sheets of rain. Except for the representation of Cole next to his parasol looking up at us (and in effect declaring his preference for primordial nature), there is no sign of humans in the foreground. Far below in the sunlit valley, separated by distance, height, and the sharp contour of the mountain ridge, are the Connecticut River and its plain. Closer inspection reveals not just a natural plain but also cultivated fields and settlements. But they are in such harmony with nature that they seem to blend in. Here is the "Garden of Eden," as Americans described their land, blessed by the divine light breaking through the clouds. Cole underscores God's presence in the land by roughly etching, under the guise of cleared forest, the name "Noah" into the distant hill; upside down, these same letters become Hebrew letters for Shaddai, meaning "the Almighty."

Cole's settlers respect nature as well as its cycles, fitting right in. In the wilderness foreground, the dead trees and seedlings represent this cycle of life, death, and resurrection. First and foremost, the picture is a paean to the glory of the American land. Cole captures the immense scale of the American landscape and its many moods, from the wild sublimity of the foreground, to the pastoral tranquility of the valley, to the majestic vastness of the distant hills. In *The Oxbow*, we see the artist rhapsodizing in Romantic fashion as Emerson prescribed, bonding with nature and God.

The Oxbow was also a political painting, as viewers at the 1836 exhibition would have recognized. While most Hudson River School painters depicted the glory of God as manifested in the American land, a handful, following Cole's lead, also used landscape painting to comment on the economic and social issues consuming the nation. An 1829-32 trip to Europe gave Cole first-hand knowledge of Turner's paintings and reinforced Cole's interest in using landscape as a vehicle for themes of historical significance. In 1836, for example, Cole painted a five-picture series titled The Course of Empire, which traced the transformation of the same site from a primitive state, to an agrarian society, to a thriving empire, to a decadent empire, and lastly to a state of ruin. Just as Turner's landscapes were metaphors for social and political issues, so were Cole's. His audience would recognize in The Course of Empire a statement reflecting the heated debate about progress then consuming the country. On one side were those Americans arguing for a Jeffersonian agrarian America; on the other were the advocates of Jacksonian laissez-faire economics, which embraced unrestricted industrial, commercial, and financial development. Cole, who like the novelist James Fenimore Cooper (1789-1851) was an early environmentalist, found the rapid destruction of the wilderness and disrespect for the land disheartening. His vision of healthy development stopped at the Jeffersonian agrarian society, where Americans lived in harmony with the land. He equated Jacksonian politics with empire, which would result not only in the destruction of the land but also the eventual downfall of America. In The Oxbow, Cole proclaims his own personal preference for the wilderness, while championing the virtue of an agrarian civilization, one where Americans respect their covenant with God.

FREDERIC CHURCH AND NATIONAL LANDSCAPE Cole's only student, Frederic Edwin Church (1826-1900), fully understood how landscape could be used to make powerful political statements. Born into a wealthy family in Hartford, Connecticut, he joined Cole at his summer home in Catskill, New York, on the Hudson in 1844. In 1848, the year Cole died, he was made a member of the National Academy and was living in New York City. By 1850, Church had inherited Cole's mantle as America's foremost landscape painter, largely making pastoral or rural scenes showing man harmoniously living in nature. But throughout the 1850s, Church's work became increasingly sublime. He traveled to Niagara Falls to capture the awesome scale, power, and deafening roar of this famous landmark. His search for the sublime even took him to locales outside the United States, first going to the Andes in Ecuador and Columbia in 1853 to paint the exotic trappings of the tropics, and then sailing to the Arctic in 1859 to portray foreboding icebergs in Newfoundland and Labrador.

By January 1860, Church had begun working on *Twilight in* the Wilderness (fig. 24.10), which he finished that year, exhibiting it to wild acclaim, first in the Tenth Street Studio Building, where he had a studio, and then at the Goupil Gallery in New York. While working on this painting, he was also finishing up *The Heart of the Andes*, the result of a second trip to South America in 1857, and starting *Icebergs*, his first major iceberg painting. *Twilight* represents the wonders of the American wilderness, most viewers associating it with Maine and New Hampshire. The picture represents a temperate environment and nicely complements the tropical and Arctic themes of the other two works in Church's studio at the time, the trilogy in effect presenting a compendium of New World climates as described by the German explorer and naturalist Alexander von Humboldt in his five-volume book *Cosmos* (1845).

As its title suggests, the picture represents the American wilderness, a pure, unspoiled Garden of Eden, with no sign of human presence. Americans considered brilliantly colored sunsets unique to their country, thus an emblem of the nation, just as they did the spectacular autumnal foliage, which was especially popular with painters. But Church's use here of twilight probably has a second function, that of referring to the twilight of the wilderness as New England especially was being settled and crisscrossed with railroad tracks, and pioneers, driven by Manifest Destiny (the compulsion to settle the entire continent), were swarming west toward the Pacific. And twilight has a third function in the image. We must remember the painting was made in 1860, a year before the Civil War, which most everyone knew was looming on the horizon as the slavery issue violently divided the nation. Church makes the country the focus of his picture by putting an American eagle on top of the dead tree in the left foreground, the tree serving as a pole for the American flag of fiery

24.10 Frederic Edwin Church, *Twilight in the Wilderness*. 1860. Oil on canvas, 40×64 " (101.6 × 162.6 cm). The Cleveland Museum of Art, purchase, Mr. and Mrs. William H. Marlatt Fund (65.233)

red altocumulus clouds and blue sky. As the sun sets behind the horizon, Church casts doubts on the future of both the wilderness and the nation itself.

France: Neoclassical Romanticism

Neoclassicism dominated French art in the late eighteenth and early nineteenth centuries. This was because of Jacques-Louis David's powerful impact on painting (see pages 813-16). In his lifetime, David had some 400 students, and after 1800 his most gifted followers from the 1790s began to rival him for public attention. David convinced the new Republican government to abolish the French Royal Academy, although the biennial Louvre Salon exhibitions were still held during the Directory (1794–1799) and the Napoleonic era (1799-1814) and remained critical for an artist's success. David himself received major commissions from Napoleon, and was the emperor's official court painter. With Napoleon's defeat at Waterloo, David exiled himself to Brussels. But by then he had long been superseded by his students and followers. Despite the Neoclassical look of their paintings, these works were made in the Romantic era, and thematically we can describe them as belonging not to Neoclassicism but to Neoclassical Romanticism.

ANNE-LOUIS GIRODET AND THE PRIMITIVES Anne-Louis Girodet (1767–1824), one of David's most brilliant pupils, introduced a new type of Neoclassical painting in 1791 when he sent The Sleep of Endymion (fig. 24.11) back to Paris from Rome, where he was a pensioner at the French Academy, having won the Rome Prize. The painting was shown at the Salon of 1793 to universal praise. Rome Prize students were required to execute an oil painting of a nude. Girodet's figure conforms to the Neoclassical paradigm: It is a Classical nude with sharp contours and is carefully painted with tight brushwork. Rather than virile and virtuous, however, Girodet's nude is androgynous and sensuous. The choice of subject was also startling. Derived from Classical mythology, its theme was an indulgent hedonism at a time when everyone else was portraying noble sacrifice, as in David's The Oath of the Horatii (see fig. 23.27). Girodet presents the story of the moon-goddess Selene (Diana), who fell desperately in love with the mortal shepherd Endymion and put him into an eternal sleep so she could visit him every night. Here, we see one of these nocturnal visits, with Zephyr pulling back the branches of a tree so that Selene can seduce the sleeping shepherd. David's harsh, raking light gives way to a softer, more sensual illumination that gently caresses Endymion, creating a chiaroscuro that emphasizes the slow undulation of his soft, beautiful flesh.

24.11 Anne-Louis Girodet, The Sleep of Endymion. 1791... Oil on canvas, 6'6" \times 8'6" (1.97 \times 2.6 m). Musée du Louvre, Paris

Moonbeams dramatically backlight the figures, etching strong, elegant curvilinear contours.

Despite the erotic content, this is hardly a titillatingly playful Rococo picture, for the work has a powerful mood of primal sensuality, brought about in part by the mysterious moonlight. Combining Correggio's chiaroscuro and vaporous sfumato (see fig. 17.26) with the grace of Bronzino's contours (see fig. 17.11), two artists Girodet studied first hand in Rome, the painter created a picture that does not illustrate a story so much as it projects a state of mind characterized by powerful elemental urges, a quality that is distinctly Romantic.

In the late 1790s, a number of David's followers, who called themselves the Primitives, took their cue from Girodet's Endymion. Themes of sensuous love based on Classical myth, such as Cupid and Psyche and the death of Hyacinth in the arms of Apollo, became popular. Figures were backlit to highlight strong contours and create a sensuous undulating line. Reinforcing this taste for prominent outlines was the publication of John Flaxman's engraved illustrations of Homer's The Iliad and The Odyssey, made in Rome in 1792-93 and based on Greek vase painting. (See Materials and Techniques, page 792.) Flaxman's startlingly severe engravings, in which he reduced figures and objects to a simple line with no shading or modeling, were popular throughout Europe and exerted a tremendous influence over the style and motifs of art during the Romantic era. While the Primitives in David's studio were heavily influenced by Flaxman and Girodet, they also admired the stripped-down clarity of Greek vase painting and the simple forms of fifteenth-century

Italian painting, then considered "primitive" compared with the High Renaissance, hence the group's name.

JEAN-AUGUSTE-DOMINIQUE INGRES The painter Jean-Auguste-Dominique Ingres (1780–1867) was briefly in the Primitives group, and a strong emphasis on contour and line became one of the hallmarks of his Neoclassical style. He entered David's studio in 1797 and won the Rome Prize in 1801, although in part because of the Napoleonic Wars he could not take advantage of his award until 1806. Before leaving for Italy, he received a commission from the French Legislative Assembly for a *Portrait of Napoleon on His Imperial Throne* (fig. **24.12**), which he showed at the Salon of 1806, where it was heavily criticized, even by Napoleon. Ingres's Neoclassical roots are evident in the harsh Davidian planarity, compressed space, and emphasis on line or contour, although Ingres's edge is sharper, more lively, almost seeming to have a life of its own, as, for example, in the white border of Napoleon's robe.

But here the comparison with David and the Primitives stops and Ingres's Romanticism begins, although it does not overwhelm his Neoclassicism: He would be recognized as the great standard-bearer of the latter style in the first half of the nineteenth century. Ingres fills every square inch of his portrait of Napoleon with opulence—gold, gems, ermine, marble, tapestries, rare objects. In one hand Napoleon holds the golden scepter of Charlemagne, in the other the ivory hand of justice of the French medieval kings, both certifying his royal legacy. The elaborate gilt throne looks as if it is from imperial Rome. Its curved back

24.12 Jean-Auguste-Dominique Ingres, *Portrait of Napoleon on His Imperial Throne.* 1806. Oil on canvas, $8'9" \times 5'3"$ (2.66 × 1.6 m). Musée de l'Armée, Palais des Invalides, Paris

forms a halo around the emperor's head, which contemporaries recognized as a reference to God the Father in the central panel of Jan and Hubert van Eyck's *Ghent Altarpiece* (see fig. 14.10), then installed in the Napoleon Museum in the Louvre and part of the immense booty of Napoleon's conquests. Ingres even has Napoleon strike the same pose as the Van Eycks' God, which when combined with his iconic frontal position suggests that Napoleon is endowed with the same qualities, or at least that his actions are sanctioned by God. Ingres's deification of Napoleon is also strengthened by a resemblance to Zeus in a Flaxman line engraving.

Ingres's frozen larger-than-life image presents Napoleon as imperial, aloof, and divine, and its wondrously exotic and even fantastical Romantic content must have fascinated, even awed, the audience at the Salon of 1806. While preferring tight brushwork and a hard icy surface to painterly gesture, Ingres was clearly a magnificent colorist. In *Napoleon*, his hues match the objects in opulence and have the same gemlike quality he found in the sparkling oils of the Van Eycks' paintings. They have a similar level of realism in capturing various lush textures. Ingres was as concerned with harmonizing complex relationships of deeply saturated color as he was in balancing the intricate designs of his compositions.

In Italy, Ingres studied ancient art and fell in love with the Classicism of Raphael. But as a Romantic—which is what he considered himself to be—his interests were broad, even exotic, and led him to medieval, Byzantine, and Early Renaissance art. After his four-year stipend expired, Ingres stayed on in Italy at his own expense for an additional 14 years, often impoverished and, like a true Romantic artist, painting what he wanted, not what the academy dictated. Periodically, he sent pictures back to Paris for exhibition, where they were generally met with derision. An example is *Grande Odalisque* (fig. **24.13**), commissioned in 1814 by Caroline Murat, Napoleon's sister and the queen of Naples, and submitted to the Salon of 1819.

This painting is even more exotic than his portrait of Napoleon, for it represents a Turkish concubine and is one of the earliest examples of Orientalism, as the Western fascination with the culture of the Muslim world of North Africa and the Near East was then called. (Byron's Romantic poem The Corsair, also featuring a harem slave, was published the same year the painting was commissioned.) This fascination was, in part, sparked by Napoleon's campaign in Egypt in 1798-99 and by the detailed description of the region and its culture and customs in the 24-volume government-sponsored publication Description de l'Égypte, which appeared from 1809 to 1822. Orientalism reflects European imperialism and its accompanying sense of superiority that viewed non-Christian Arab culture as not only different and exotic but also inferior-backward, immoral, violent, and barbaric. Here, the exotic subject gave Ingres license to paint a female nude who was not a Greek goddess, although she recalls numerous Renaissance and Baroque paintings of a reclining Venus and sculptures of Ariadne from antiquity. To make his figure more appealing to a Paris audience, Ingres gave his odalisque European features, even a Raphaelesque face and coiffure. Although the figure is alluringly sensual, and the hashish pipe, incense burner, fan, and turban "authenticate" the exotic scene, the painting as a whole projects a soothing sense of cultivated beauty, refinement, and idealization that seems Classical. In other words, Ingres treats a Romantic subject in an essentially Neoclassical manner, including idealization.

Ingres's trademark is a beautiful Classical line, which we can see as he focuses on the odalisque's flesh. Bathed in a caressing chiaroscuro, the body gently swells and recedes with delectable elegance. Its contours languidly undulate with sensuality, the sharply defined edges and tan color contrasting with the objects around it. The opulent color of the objects and the lush fabrics and peacock feathers enhance the sensual aura of the picture.

24.13 Jean-Auguste-Dominique Ingres, Grande Odalisque. 1814. Oil on canvas, 35% × 63" (91 × 162 cm). Musée du Louvre, Paris. Inv. RF1158

Salon viewers noted the concubine's back had too many vertebrae, and certainly her elbowless right arm is too long; but as far as Ingres was concerned, the sweeping curves of both were essential components of the graceful composition, the line of the right arm even being continued into the folds of the drapery.

In 1821, Ingres received a commission to make an enormous painting of The Vow of Louis XIII for the cathedral in Montauban in his hometown. Penniless, otherwise forgotten, and living in Florence, with this painting Ingres turned his life around. He showed the picture at the Salon of 1824 to rave reviews and was hailed as the great savior of the Classical tradition. With the final fall of Napoleon in 1815, David, who had been named painter to the emperor in 1801, skulked off to Brussels, and the careers of all of his students had stalled at the same time, displaced by a new generation of painterly Romantic artists. Almost by default, Ingres, because of The Vow of Louis XIII, was now crowned the protector of Classicism, the champion of line over color, and the savior of the "wholesome traditions of great art" and ideal beauty from the unfettered emotionalism of the painterly Romantics. In 1825, he was elected to the French Academy, which as a Romantic he had disdained, and soon became its director. He was also awarded the Legion of Honor, the highest award in France for service to the state, established by Napoleon in 1802. His studio became the destination of choice for aspiring young history painters.

While Ingres defined himself as a history painter, since it held the greatest prestige within the academy, his strength was

portraiture, especially of women. His 1856 Portrait of Madame Inès Moitessier (fig. 24.14) is a good example. The work was commissioned in 1844, and over the next 12 years the guardian of ideal beauty transformed the wife of a wealthy banker into an image of Classical perfection, an earthly goddess. He gave her creamy smooth skin, beautiful curvilinear shoulders, arms, and hands, and a Raphaelesque face. He enriched her with a lavish rose-patterned gown lined with a fashionable fringe, opulent Renaissancerevival jewelry on the raised right arm and cabochon garnets surrounded with diamonds on the left, and a peacock-feather fan. Behind her is Chinese vase, a fanlike shield to protect her from fireplace heat in the winter, and an imposing gilt-frame mirror. Also contributing to her perfection are the immaculately smooth paint surface (free of painterly brushwork), the precise drawing, and the harmonious blending of a complicated composition with a richly colored palette.

Madame Moitessier's pose suggests various Classical prototypes, while her contemplative hand-to-head gesture derives from Roman murals at Herculaneum. The profile in the mirror, an obvious distortion, could not be more Greek. It also superimposes an eerie psychological veil on the work, reinforcing the introspection of her gesture and tinting the painting with a mysterious mood that converts the realistic materiality of Moitessier's physical surroundings into a spiritual embodiment of beauty. While the style is distinctly Neoclassical, this mysterious mood and the intensely lush setting give the picture Romantic overtones.

24.14 Jean-Auguste-Dominique Ingres, Portrait of Madame Inès Moitessier. 1856. Oil on canvas, $47\frac{1}{4} \times 36\frac{1}{4}$ " (120 × 92.1 cm). The National Gallery, London

France: Painterly Romanticism and Romantic Landscape

While Ingres was taking Neoclassicism deep into the nineteenth century, but now within the context of Romanticism, Antoine-Jean Gros, a second student of David's, opened up an alternative course, one that would abandon line, order, clear rational space, evenly diffused light, ideal beauty, and Classical repose for bold brushstrokes, dazzling color, impetuous drama, confused space, irrational lighting, and extreme emotions. In his wake came Théodore Géricault and Eugène Delacroix, who brought painterly Romanticism to the fore in the 1820s, resulting in contemporaries finally applying the word Romanticism, previously reserved for literature and music, to art. In the 1820s as well, landscape painting began to emerge from under the shadow cast by Neoclassicism. French Romantic landscape was never as apocalyptic as its British counterpart nor as pantheistic as in Germany and America. Instead it was more serene and poetic.

ANTOINE-JEAN GROS Gros (1771–1835) entered David's studio in 1785. During the turmoil of the French Revolution, David

was able to secure a pass for Gros to go to Rome, although by the time he arrived there the city was closed to the antipapist French. Through Napoleon's wife, Josephine, he met Napoleon in Milan, traveled with his army, and impressed the general with his art. Napoleon charged Gros with painting his battles and glorifying his campaigns. Bonaparte, who was as brilliant at propaganda as he was at military strategy, carefully controlled his public image and relied heavily on art to reinforce his political position. He made sure his commissions were shown at the Salons, where they would be seen by everyone and reported in the press, which was becoming more important in the opening decades of the century due to increased literacy and decreased paper and printing costs.

The Napoleonic era was a catalyst for French Romanticism. The drama, glory, valor, and adventures of the Napoleonic Wars provided endless material for the artistic imagination. The North African campaigns took Europeans into the forbidden Arab world and introduced them to a wondrous exotic subject matter that they brought back to Europeans anxious for new experiences. Gros's first commission, *Napoleon in the Pesthouse at Jaffa, March 11, 1799* (fig. **24.15**), came in 1804 and was exhibited in that year's Salon to huge success. This 23-foot-wide picture was

24.15 Antoine-Jean Gros, Napoleon in the Pesthouse at Jaffa, March 11, 1799. 1804. Oil on canvas, $17'5'_{2}" \times 23'7'_{2}"$ (5.32 × 7.20 m). Musée du Louvre, Paris

commissioned not only to promote the emperor's bravery and leadership but to reinforce his humanitarian image, which was propagandistically essential considering the enormous human loss tallied in many of his battles, especially in Jaffa (then in Palestine but today a section of Tel Aviv, Israel). During the campaign, the bubonic plague broke out among the French ranks. Legend has it that, to calm his troops, Napoleon fearlessly entered the pesthouse and walked among the patients. Here we see the general, like Christ healing the sick, courageously touching the open sore of a victim, his presence virtually willing the dying to rise. The painting ignores the fact that Napoleon poisoned these same sick troops when he retreated from Jaffa.

While Gros's drawing and brushwork are relatively tight and Davidian, the picture is one of overt, turbulent drama, created by the dark shadows, bursts of light, splashes of bright red, rapidly receding perspective of the arcades, and cloud-filled sky. Chaos prevails. Although Napoleon is placed in the center as a compositional anchor, he momentarily gets lost in the turmoil of the scene. Our eye goes to the circle of the dead, dying, and sick surrounding him, which includes the Michelangelesque figures in the foreground shadows and the "resurrected" nudes next to Bonaparte. The male nude is now neither heroic, as in David, nor lovely, as in Girodet, but helpless and horrifying. Napoleon's courageous act has to vie for a viewer's attention with the dark mood of psychological and physical suffering and the exoticism, to Western eyes, of the Arab attendants and Islamic architecture. (This picture helped launch the vogue for Oriental subjects that we saw in Ingres's Grande Odalisque.) The monumental arches compositionally may pay homage to David's The Oath of the Horatii (fig. 23.27), but instead of supporting a narrative of Neoclassical stoicism and clarity they contribute a Romantic exoticism and sense of foreboding of horrifying uncertainty.

THÉODORE GÉRICAULT Without the Napoleonic campaigns to feed his imagination, Gros's career soon waned. David's other outstanding students and followers, such as Girodet, were simultaneously eclipsed. The future was now represented by Théodore Géricault (1791-1824) and those who followed him. Géricault was independently wealthy and largely self-taught, frequenting the Napoleon Museum, where he copied the great colorists: Rubens, Van Dyck, and Titian. Gros, however, was his role model, and Gros and Rubens were clearly the artistic sources for Géricault's submission to the Salon of 1812, Charging Chasseur (fig. 24.16). The energetic brushwork, the sharp diagonal recession of the horse, the bold contrast of light and dark, the rippling contours on the horse's right legs, and the flashes of color could not be further from David or closer to Rubens. Completely gone is the Davidian planarity that structured the turmoil of Gros's pesthouse. Made during Napoleon's Russian campaign, the picture functions as an emblem of heroic valor. It is not meant to represent a specific event or person. Instead, the twisting chasseur (cavalryman) and rearing horse embody the psychological and physical forces that consume combatants in the heat of battle, and it is interesting how many compositional parallels there are

24.16 Théodore Géricault, *Charging Chasseur*. 1812. Oil on canvas, $11'5" \times 8'9"$ (3.49 × 2.66 m). Musée du Louvre, Paris

between rider and horse, suggesting the sheer animalistic forces driving the cavalryman's heroism. This is a picture of raw emotion and physical tension, devoid of Neoclassical reason and the rules of beauty and morality. As the great Romantic writer Stendhal (pseudonym of Marie-Henri Beyle, 1783–1842) said in his review of the 1824 Salon, "The school of David can only paint bodies; it is decidedly inept at painting souls."

Charging Chasseur revealed Géricault's lack of formal training; namely, his inability to draw as seen in the oddly twisted head of the cavalryman, for example. Continuing his independent study, he now worked from Classical models, copying High Renaissance painters at the Royal Museum, as the Louvre was called after the second fall of Napoleon in 1815 and with the establishment of Louis XVIII's Restoration monarchy. In 1816, he went to Italy, stopping in Florence to draw Michelangelo's Medici tombs (see fig. 17.5), before going to Rome to study the antiquities. Not long after his return to Paris in late 1817, he began thinking about the third and last painting he would exhibit at the Salons, *The Raft of the Medusa* (fig. 24.17), painted between 1818 and 1819 after many studies. In 1816, the *Medusa*, a government vessel, foundered off the West African coast with approximately 400 people aboard. The captain commandeered the

24.17 Théodore Géricault, The Raft of the Medusa. 1818-19. Oil on canvas, 16'1" × 23'6" (4.9 × 7.16 cm). Musée du Louvre, Paris

six lifeboats for government officials and officers, with the remaining 150 passengers being consigned to a makeshift raft that was set adrift by the crew at the mercy of the sea. When the passengers were finally rescued some two weeks later, only a handful were still alive. The callous captain was incompetent, an aristocrat who had been appointed for political reasons by the government of Louis XVIII. The headline-making event was condemned in the press as a reflection of the corruption of Louis's administration.

Géricault decided to paint the moment when the survivors first sighted a ship, not the more politically charged moment when the captain set the raft adrift. The painting is thus about the harrowing mental and physical experience of survival rather than an accusation of injustice. Géricault seems to have latched onto his subject after revisiting Gros's *Napoleon in the Pesthouse*, for the foreground is littered with Michelangelesque nudes. From the bodies of the dead and dying in the foreground, the composition recedes in a dramatic Baroque diagonal (see fig. 20.1), climaxing in the group supporting the frantically waving black man. As our eye follows this line of writhing, twisting bodies, we move from death to hope. But this is not a painting that is at root about hope, for there are no heroes, no exemplary moral fortitude. Rather the theme is the human species against nature, and Géricault's goal was to make a viewer feel the trials and tribulations of the castaways. The academic, Classically proportioned monumental figures are a catalogue of human misery, reflecting the death, cannibalism, fighting, insanity, sickness, exhaustion, hunger, and thirst that tormented the victims. The stark realism, obtained in part through tighter brushwork, heightens our visceral connection to the dramatically lit event; we too are on the crude raft, pitched about on the high seas, and aimlessly buffeted by the wind.

Géricault would never exhibit again in a Salon and within six years would be dead at the age of 32. His later work, unlike *The Raft*, was not monumental; nor does it show off the artist's ability to draw and incorporate Classical models into an otherwise Baroque composition with a Romantic mood. Rather, it was largely painterly, a commitment reinforced by a trip to London in 1820 where he saw the work of Constable and Turner. His technique is apparent in a remarkable series of ten portraits of insane men and women made during the winter of 1822–23, his last active months. Only five exist today, and they belonged to a physician named Georget, who specialized in psychiatry, leading scholars to think he may have commissioned the paintings for

documentary purposes. Géricault's contemporaries, following Caspar Lavater's theories (see page 803), believed there was a correlation between mental health and physiognomy, and that mental illness could be diagnosed by reading facial features. Having no need of money, Géricault obviously undertook the work for personal interest, and in addition to this series also painted guillotined heads and hospital inmates. The series allowed him to explore the mind and human suffering, as seen in Portrait of an Insane Man (Man Suffering from Delusions of Military Rank) (fig. 24.18). Using energetic brushwork that seems virtually to signify mental energy, he exposes the psychotic derangement plaguing his subject, including nervousness, fear, and a sternness that implies a delusion of importance. The presentation is sympathetic, reflecting the period's recognition of mental illness as a disease, but it does not undermine the powerful mood of alienation and irrationality that consumes the sitter. In contrast to the goddesslike perfection and poise of Ingres's Portrait of Madame Inès Moitessier, Géricault's insane man is an emblem of imperfection, embodying a range of human psychoses and foibles-a reflection of the Romantic interest in the psychological and physical suffering of the socially marginalized.

24.18 Théodore Géricault. Portrait of an Insane Man (Man Suffering from Delusions of Military Rank). 1822–23. Oil on canvas, $32\frac{1}{2} \times 26$ " (81 × 65 cm). Collection Oskar Reinhart "Am Römerholz," Winterthur, Switzerland. Inv. no. 1924.7

EUGÈNE DELACROIX In 1822, Eugène Delacroix (1798–1863) emerged as the standard-bearer of painterly Romanticism, the position Géricault so dearly coveted. Delacroix was seven years vounger than Géricault and came from a similar background-Parisian and wealthy. Like Géricault, he was essentially independent and self-taught, studying the great masterpieces at the Louvre, especially Rubens, Titian, and Veronese. His greatest excitement came when visiting the studios of Gros and Géricault. He befriended the latter in 1818 and posed for one of the figures in The Raft of the Medusa. His submission to the Salon of 1824, Scenes from the Massacre at Chios (fig. 24.19), presents a compendium of misery and suffering in the foreground and was obviously inspired by the groupings of the dead and dying in Gros's Pesthouse at Jaffa and Gericault's The Raft of the Medusa. The picture was inspired by the Greek war of independence. In 1820, the Greeks revolted against the ruling Ottoman Empire, and the following year the Turks raided the Greek island of Chios, destroying villages and either massacring or enslaving virtually the entire population of 20,000. Delacroix's painting was based upon this event and was in part made to show support for Greek independence as well as to express the Romantic passion for democracy and individual freedom.

In the middle- and background, Delacroix presents burning and slaving transpiring in a blur of smoke and confusion, while in the foreground, he presents a group of Greeks rounded up for execution or enslavement, a scene that is, by contrast, remarkably devoid of violence. Resignation, desperation at the impending loss of loved ones, and hopelessness reign, this pessimism being symbolized by the foreboding silhouette of the armed Ottoman guard. Delacroix reinforces the turmoil of the brutality in the background by the twisting and turning of the foreground figures and their undulating contours as well as by the chaotic piling up of bodies. The intense colors of the painting have darkened considerably over time, especially the blues and reds, which originally created an optical snap that was reinforced by the bravura of the brushwork and sharp value contrasts. Clearly, Rubens is behind these qualities as well as the two asymmetrical compositional pyramids organizing the foreground group and the diagonal recession into deep space. (Delacroix, however, subverts the traditional device of putting a hero at the apex of the pyramids by instead placing villains, the Turkish guards, there.) Delacroix was also influenced by the color and brushwork of Constable, who had three landscapes, including The Haywain (see fig. 24.5), in the same Salon. Upon seeing these, Delacroix repainted the sky at the last minute, giving it a brilliant luminosity, and he worked vivid colors into the garments.

This "terrifying hymn in honor of doom and irremediable suffering," as the poet and critic Charles Baudelaire (1821–1867) described the painting, established Delacroix as the great Romantic painter. It was the first time the term "Romantic" had been applied to a visual artist, making him the artistic equivalent of composer Hector Berlioz (1803–1869) and writer Victor Hugo (1802–1885). And certainly Delacroix shared their Romantic spirit. (See *Primary Source*, page 845.) The year 1824 was therefore

24.19 Eugène Delacroix, Scenes from the Massacre at Chios. 1824. Oil on canvas, 13'8" × 11'7" (4.17 × 3.54 m). Musée du Louvre, Paris

Eugène Delacroix (1798–1863)

From His Journal

Delacroix began his Journal in 1822 and maintained it irregularly until his death in 1863. He wrote it, he said, "for myself alone" in the hope that it would "do me a lot of good." This excerpt is from an entry for May 14, 1824. What torments my soul is its loneliness. The more it expands among friends and the daily habits or pleasure, the more, it seems to me, it flees me and retires into its fortress. The poet who lives in solitude, but who produces much, is the one who enjoys those treasures we bear in our bosom, but which forsake us when we give ourselves to others. When one yields completely to one's soul, it opens itself completely. ...

Novelty is in the mind that creates, and not in nature, the thing painted.

Source: Journals of Eugène Delacroix, tr. Walter Pach (New York: Crown Publishers, 1948)

a critical one. It was the year Géricault died, Constable was introduced in Paris, and Ingres returned from Italy, unaware that he would be anointed the guardian of the Classical tradition.

In 1825, Delacroix went to England, like Géricault before him, reinforcing his appreciation of British landscape and literature, especially the plays of Shakespeare, the poetry of Lord Byron (1788–1824), and the novels of Walter Scott (1771–1832). Delacroix would turn to their imagery, and to that of Dante and Goethe, to fire his imagination and cultivate his moods. One product of his reading was the 1827 painting *Death* of Sardanapalus (fig. 24.20), based on Byron's 1821 unrhymed poem Sardanapalus. Sardanapalus, the last Assyrian king, was overthrown by rebels because of his licentiousness and apathy. Too lethargic either to fight or to flee, he committed suicide.

24.20 Eugène Delacroix, Death of Sardanapalus. 1827. Oil on canvas, 12'11/2" × 16'27/8" (3.69 × 4.94 m). Musée du Louvre, Paris

24.21 Eugène Delacroix, Women of Algiers. 1834. Oil on canvas, 5'10⁷/₈" × 7'6¹/₈" (180 × 229 cm). Musée du Louvre, Paris

24.22 Eugène Delacroix. Detail of Women of Algiers. 1834

Immersing himself in the king's mind as developed by Byron, Delacroix invented the scene of his death: He commands his eunuchs to bring to his bed, which is on a pyre, all of his prized possessions, including wives, pages, horse, and dog. The Rubenesque traits we identified in the foreground of *Massacre at Chios* are intensified in this claustrophobic, chaotic composition. The only unifying element is the red bed, the perspective of which is so skewed it acts as a funnel, channeling all of the writhing

energy and jumble of precious and exotic opulence to the anchor of the composition, the inert, indifferent king. He is the epitome of *ennui* and impotence. As in *Massacre at Chios*, Delacroix ignores Classical space and volume, allowing undulating contours, riotous color, and compositional pandemonium to project simultaneously the disparate moods of destruction, fear, violence, power, despair, sensuality, and indifference. With this enormous canvas of wanton annihilation, Delacroix offended just about everybody at the Salon of 1827, for in it there was nothing left of David's Classical formula, and there was no redeeming moral, just fascinating horror.

Delacroix's style underwent a change in the 1830s after a trip to North Africa; his palette became brighter and his paint handling looser. In 1832-33, Delacroix was asked to visually document the duc de Mornay's diplomatic mission to Morocco, and he excitedly made hundreds of watercolors that provided him with wondrous Oriental themes for the rest of his life. In Morocco, Delacroix entered a world of exotic architecture, clothing, and landscape, of intense light, and of unimaginably bright colors in fabrics, tiles, and interior design that displayed a horror vacui rivaling his own. That his palette became more colorful can be seen in Women of Algiers (fig. 24.21), painted in Paris in 1834 from studies. To enter the secluded world of a harem, Delacroix had to obtain special permission, and the mood of the painting captures the sultry, cloistered feeling of this sensual den. We can almost smell the aroma of incense, the fragrance of flowers, and the smoke from the hookah. Delacroix's hues are as sensual as his subject. Color is dappled, and contours are often not continuous or drawn but just materialize through the buildup of adjacent marks (fig. 24.22). A sea of paint and color covering the entire surface dissolves Neoclassical planarity and space. This technique began to free paint from what it was supposed to represent and established a platform for a new artistic style just over the horizon, Impressionism.

Romantic Landscape Painting

David's Neoclassicism was so dominant it even cast its shadow over French landscape painting in the opening decades of the nineteenth century, which was planar and stylized, largely modeled on Poussin and Claude Lorrain. The exhibition of Constable's landscapes at the pivotal Salon of 1824 opened up new possibilities in the genre, and a younger generation impressed by the Englishman's powerful naturalism and Romantic moods made it the foundation of their work. By the following decades, they had established landscape as a viable genre in France, one that could rival history painting in popularity and paved the way for the rise of Impressionism in the 1860s.

JEAN-BAPTISTE-CAMILLE COROT The first major nineteenth-century French landscape painter was Jean-Baptiste-Camille Corot (1796-1875), who was already committed to a vision of landscape that had Romanticism's fidelity to nature when Constable's Haywain was exhibited at the Salon of 1824. Uninfluenced by Constable, Corot's landscapes had Classical underpinnings. In 1822, he studied with a Parisian Classical landscape painter, Victor Bertin, who taught him the rudiments of drawing and, more important, emphasized making small plein-air ("openair") studies called pochades, rapidly executed color studies in oil. In the studio, Bertin developed his sketches into large, formulaic Salon-oriented canvases. Corot rarely did, at least not initially; his small plein-air sketches often remained the final products until many years later, although he did not exhibit them either. When he later enlarged his pochades, he generally retained their accurate depictions of the land, refusing to idealize his scenes.

In 1825, Corot went to Italy and produced his first major body of work, about 150 small paintings, most of famous sites. *View of Rome* (fig. **24.23**), an oil on paper, is typical. Made on the spot in an hour or so, it is a literal, objective presentation of "the

24.23 Jean-Baptiste-Camille Corot, View of Rome: The Bridge and Castel Sant'Angelo with the Cupola of St. Peter's.
1826–27. Oil on paper mounted on canvas,
10½ × 17" (26.7 × 43.2 cm).
Fine Arts Museum of San Francisco. Museum Purchase,
Archer M. Huntington Fund.
1935.2 truth of the moment," as Constable would say. We are convinced we are looking at the Castel Sant'Angelo and St. Peter's Basilica and real, not stylized clouds. We can feel the sun's intense heat bouncing off the stone and see the clear late-afternoon light crisply delineating the buildings and bridge. Without idealizing his landscape, Corot displays an instinct for Classical clarity and stability that recalls Poussin and Claude. Strong verticals and horizontals anchor his composition to its surface of creamy brushwork, and his buildings, no matter how loosely painted and insignificant, have a monumental presence. Nature inspired Corot to create little poems of beautifully harmonized tones and colors, generally browns and greens, and a seamless integration of painterly brushwork and Classical grid.

After a second trip to Italy in 1834, Corot made a concerted effort to attract attention at the Salons and added to his output large historical landscapes, such as *Hagar in the Wilderness*, which gained him occasional sales and some interest. But it was not until the late 1840s, when he developed his third category of picture, the lyrical landscape, that he became popular, financially successful, and famous. Corot was no longer inspired directly by nature, but by his memories of landscape and the Romantic moods it provoked, as in his Souvenir de Mortefontaine (Oise) (fig. 24.24), painted in 1864. We sense that Corot's vision has been filtered through the haze of memory. The canvas is covered with thin, almost transparent brushstrokes, layered one over another, making everything somewhat indistinct, as if gently floating. A magical light pervades the scene, shimmering off the water, flickering through the trees, and prancing dotlike along the ground. Everything is light, ethereal, and insubstantial, like the reflections of the trees in the water, which seem to levitate. Corot gives us very little to look at in this idyllic scene, simply a rural woman who appears to be removing leaves from a tree while accompanying children pick flowers. Instead we look at the artist's beautiful tonal palette that gracefully shifts from brown, to green, to gray,

24.24 Jean-Baptiste-Camille Corot, *Souvenir de Mortefontaine (Oise)*. 1864. Oil on canvas, 25½ × 35" (65 × 89 cm). Musée du Louvre, Paris

to silver. We look at the powerful patterning of the trunks and branches of the foreground trees, and we delight in the magic of his gossamer brushwork. The picture is about creating a poetic mood, using abstract means to reinforce an idyllic vision that, while reminiscent of Claude Lorrain, reflects the Romantic yearnings of its author.

THÉODORE ROUSSEAU AND THE BARBIZON SCHOOL

Unlike Corot, a group of academically trained painters called the Barbizon School took their aesthetic lead directly from Constable, augmenting his direct impressions of nature with a study of the great seventeenth-century Dutch landscapists, such as Ruisdael (see fig. 20.28), who were exhibited in the Louvre. The group emerged in the 1830s and got its name from the village of Barbizon, which bordered the forest of Fontainebleau, where the artists painted and many settled. (Corot, who had a house in nearby Ville d'Avray, also often painted there.) The forest had been a royal hunting preserve, and as a result it offered nature in a relatively unspoiled state, undisturbed by the Industrial Revolution smoldering just 40 miles (64 km) away in Paris. The best-known Barbizon painter is Théodore Rousseau (1812– 1867). He learned the rudiments of painting from two academically trained artists and by copying landscapes in the Louvre. In the early to mid-1830s, his work was occasionally accepted at the Salons, from which he was then banished from 1837 to 1848, his view of nature being deemed too unseemly. He led a rather bohemian existence and permanently settled in Barbizon in 1848.

Under the Birches, Evening (fig. 24.25) of 1842-43 is a fine example of Rousseau's work, which is perhaps the most diverse of all of the Barbizon painters. Produced in the studio from studies made on a seven-month trip to the Berry region in central France, the painting, like those of Constable and Corot, avoids artificial compositional and stylized motifs and instead captures the essence of nature. We readily sense this is a specific site; each tree seems individualized, for example, and each wisp of cloud unique. We can feel the onset of twilight and the cool damp atmosphere of autumn. While the blue-green sky and brownish-orange foliage offer a touch of color, Rousseau's palette is somber and earthy, evoking soil, decaying plant and animal matter, and the interior gloom of a thicket. Like Constable's, Rousseau's brushwork is stippled, applied in small flecks that make the landscape pulse with energy, reinforced by the nervous outline of trees and bushes. We sense growth and the constant movement of nature. It is little wonder Rousseau was rejected at the Salons. His dark, honest pictures with their turgid brushwork must have been considered ugly and depressing by conservative taste.

24.25 Pierre-Étienne-Théodore Rousseau, *Under the Birches, Evening*. 1842–43. Oil on wood panel, 16⁵/₈ × 25³/₈" (42.2 × 64.4 cm). Toledo Museum of Art, Ohio. Gift of Arthur J. Secor. 1933.37

ROMANTIC SCULPTURE

Compared with painting, sculpture was a severely limiting medium for an artist at the opening of the nineteenth century. In its most monumental form, free-standing historical sculpture, it was mostly restricted to the human figure, and since the Renaissance the sculpted figure had been largely based on antique models. Nineteenth-century sculptors throughout Europe would overwhelmingly follow the Classical paradigm of one or two figures based on Greek and Roman prototypes and embodying some notion of virtue or beauty. In France, however, a dramatic change in the artistic climate toward 1830 allowed a small gap for experimentation. The rise of Delacroix and Romantic painting in the 1820s was followed by the new, more liberal constitutional monarchy of Louis-Philippe (the July Monarchy) that emerged after the 1830 revolution, which resulted from Charles X censoring newspapers and Parisians rising up en masse, forcing the king to abdicate. The bourgeoisie had more of a presence in the new government and in society in general, ushering in an era of middle-class taste. These two forces gave a handful of artists the courage to create Romantic sculpture, which rejected the Classical model of beauty, morality, and perfection, and instead explored new subjects, emotions, and compositions.

ANTOINE-LOUIS BARYE Antoine-Louis Barye (1796–1875) surprised his colleagues when he submitted a painted plaster of a tiger devouring a gavial (a species of crocodile) to the Salon of 1831 (fig. 24.26), winning a gold medal. There was no tradition of animal sculpture at the Salons, and previously, in 1828, Barye had shown portrait busts. Barye, however, loved animals, and drew them at the zoo. He was also a friend of Delacroix, whose Romantic themes included animal hunts and fights, thus providing Barye with a thematic vehicle for his interest in animal anatomy. Like Stubbs's *Lion Attacking a Horse* (see fig. 23.14), *Tiger Devouring a Gavial of the Ganges* is filled with Romantic terror, brute strength, and raw instinct unleashed without regard

to morality, law, or decorum. It is a fierce fight to the death in the wilds of nature. Appealing to the Romantic imagination, Barye selected exotic animals, and often animals that traditionally do not prey on one another (tigers do not eat crocodiles). He also set his struggles in exotic locales, such as on the banks of the Ganges in India. His composition is filled with movement and a variety of shapes and textures, reinforcing the chaotic struggle and animal energy. In the 1840s, Barye began mass-producing his animals in bronze in a variety of sizes, successfully marketing them to a worldwide middle-class audience, including in America, and becoming quite famous.

FRANÇOIS RUDE Fame eluded François Rude (1784–1855), a sculptor who brought nationalistic fervor to his figurative work and is best remembered for the bas-relief often known as *La Marseillaise* (fig. 24.27) on the Arc de Triomphe in Paris. Rude enrolled in the École des Beaux-Arts in 1809, studying sculpture; as a Napoleon sympathizer, he fled to Brussels when Bonaparte was defeated in 1815. He returned to Paris in 1827, and with a nationalistic zeal we associate with the Romantic era, he began studying French sculptural history—first the French Renaissance tradition of the School of Fontainebleau and Giovanni Bologna (see pages 601–03), and then delving deeper into the past to Claus Sluter (see pages 471–72).

It was a perfect match, then, when in 1833 Rude received one of the four sculptural commissions for the Arc de Triomphe, since the works were about patriotic fervor. The arch had been left unfinished when Napoleon was exiled in 1815, and Louis-Philippe and his minister of the interior saw the monument's completion as an opportunity to demonstrate that the new government supported national reconciliation. Hence the sculptural program consisted of four works by different artists, each surrounding the arch opening and offering something to every segment of the French political spectrum. Rude received the assignment thanks to the success of a rather Neoclassical-looking sculpture of a nude Neapolitan fisherboy playing with a turtle

24.26 Antoine-Louis Barye, *Tiger Devouring a Gavial* of the Ganges. 1831. Patinated plaster, height 17" (43 cm). Detroit Institute of Art. Founders Society Purchase, Mr. and Mrs. Horace E. Dodge Memorial Fund, and Eleanor Clay Ford Fund; 1983.11

24.27 François Rude, *The Departure of the Volunteers of 1792* (*La Marseillaise*). 1833–36. Stone, approx. $42 \times 26'$ (12.8×7.9 m). Arc de Triomphe, Paris

that he had submitted to the Salon of 1833. The Salon submission hardly anticipated the chaotic explosion we see in *The Departure* of the Volunteers of 1792, the formal title for *La Marseillaise*.

The scene honors the volunteers who rallied to defend the new French Republic from an Austro-Prussian threat in 1792. A winged allegorical figure representing both France and Liberty leads a collection of soldiers from different periods of the nation's past. Rather than a specific event, Rude evokes an eternal, allpowerful nationalistic spirit that emanates from the people and arises when called upon. While the figures have a Classical anatomy, strike Classical poses, and are aligned parallel to the wall in shallow relief, the composition is frenetic, a whirligig of arms, legs, and twisted bodies that energize the outpouring of patriotism that is swept along by Liberty above. This claustrophobic jumble of figures brings to mind Delacroix's turbulent pile of victims and objects in his *Death of Sardanapalus* (see fig. 24.20). When unveiled in 1836, *The Departure* was unanimously hailed the best of the four works on the Arc de Triomphe and was nicknamed *La Marseillaise* after the French national anthem, because it so successfully embodied the national spirit. Rude himself attained no lasting fame from the project, and without commissions, which sculptors, unlike painters, rely on, he had no opportunity to develop further the innovative aesthetic implications of *The Departure*.

ROMANTIC REVIVALS IN ARCHITECTURE

The social and political turmoil that rocked Europe from 1789 to 1848 resulted in a search for stability and comfort, which in architecture came in the form of revival styles. Instead of developing new forms, architects resurrected the past, its familiarity providing solace and continuity in a world that otherwise seemed fractured, uncertain, and in constant flux. Intellectually justifying this appropriation of the past was the theory of evolution, developed by the German philosopher Georg Wilhelm Friedrich Hegel (1770-1831), who saw history, and thus reality, as a continuous, step-by-step unfolding of events reacting to one another in a dialectic. The present thus builds on the past, which it absorbs. Hegel's theory of evolution was the foundation for much nineteenth-century thinking and was the critical force behind Charles Darwin's theory of the evolution of the species (1859) and Karl Marx's dialectical materialism, which viewed history as a class struggle (1867). In architecture, Hegel's theory resulted in the appropriation of more or less every known architectural style, selected for their associations, picturesque qualities, or exoticism. Egyptian, Greek, Roman, Romanesque, Gothic, Renaissance, Baroque, Chinese, Turkish, Queen Anne, rustic thatched cottage-everything and anything could be found revived in nineteenth-century European architecture. It was not unusual for an architect to submit several proposals for a single project, each in a different style. Nor was it unusual to find several periods represented in a single building.

Britain: The Sublime and the Picturesque

Although British architects experimented with every conceivable revival style in the first half of the nineteenth century, Gothic and Classical were the clear favorites, Gothic-revival buildings probably only being outnumbered by Classical-revival ones. However, it is an overarching eclecticism that characterizes British architecture in the Romantic era.

GOTHIC REVIVAL In Britain, sublime architecture peaked in the 1790s. In terms of the Gothic revival, this can be seen in James Wyatt's (1746–1813) Fonthill Abbey (fig. **24.28**), in Fonthill Gifford, Wiltshire, whose owner, William Beckford, wanted to upstage the playfulness of Strawberry Hill (see fig. 23.12) and build a medieval home that embodied the awe and gloom of Gothic romance novels. Rising to a breathtaking 120 feet, it not

24.28 James Wyatt. Fonthill Abbey, Fonthill Gifford, Wiltshire, England. 1796–1813. (Engraving from John Rutter's *Delineations of Fonthill and its Abbey*)

only looked like a Gothic cathedral, it was scaled like one. (The tower was originally 300 feet high, but it collapsed twice.) The entrance door was 35 feet high. The interior was filled with endless dark, narrow corridors, which along with its immense soaring tower provided a sensation of Burke's "infinite sublime." The exterior was not only awesome in its bold massing, it was also picturesque in its syncopated accretion of parts. Beckford, at one time one of the richest men in the world, sold Fonthill Abbey in 1822. In 1825, the tower collapsed once again, and the building was essentially destroyed. Most revival architects did not aspire to the sublime but satisfied their Romantic desires through historicism, exoticism, the picturesque, and associational qualities (see page 799). The most famous Gothic-revival building is the Houses of Parliament (fig. **24.29**) by Sir Charles Barry (1795–1860) and A. W. N. Pugin (1812–1852). It was commissioned in 1836 after the former building burned down, and the competition required the new Houses be designed in one of two "English" styles, Gothic or Elizabethan—91 of the 97 entries were Gothic. Barry, best known for his work in Classical- or Renaissance-revival styles, was the

24.29 Sir Charles Barry and A. W. N. Welby Pugin. Houses of Parliament, London. Begun 1836

head architect. Predictably, he laid out the building in a symmetrical, orderly fashion. He wisely hired Pugin, Britain's leading expert on the Gothic, to design the Gothic details on both exterior and interior, which he did with meticulous historical accuracy in the florid Perpendicular style (see pages 428–29). The picturesque towers are believed to be Pugin's contribution as well. Instead of being sublime, Gothic revival now is largely picturesque and associational, the style having been specifically selected to conjure up a sense of national pride.

CLASSICAL REVIVAL The vast majority of nineteenthcentury Classical-revival buildings are straightforward imitations of ancient sources. Virtually entire cities, like Glasgow and Edinburgh, were built in the Neoclassical style. In the Classicalrevival style, the sublime is perhaps best represented by John Soane (1753-1837), especially in his Bank of England. In 1788, Soane was made the surveyor (chief architect) of the bank, a position he held almost until his death. During this time the bank expanded into a complex aggregate of dozens of enormous buildings, all of which Soane designed (most were destroyed in a fire in 1927). As seen in the Consols Office (fig. 24.30), Soane's scale, inspired by Piranesi, was enormous, and his interior was austere, a reflection of the influence of Laugier (see page 806), whose treatises he owned in multiple copies. The interior of the Consols Office was meant to summon up the sublime grandeur of ancient Rome, for the enormous central space that expands into groinand barrel-vaulted bays evokes the Baths of Diocletian, an association reinforced by the segmented bathhouse-type windows, which for the sake of austerity and emphasis on geometric shape were left unframed.

ECLECTICISM John Nash (1752–1835) is one of the most eclectic architects of this period and in a sense epitomizes it. A contemporary of Soane (who was also quite eclectic), he moved from one style

24.30 Sir John Soane. Consols Office, Bank of England, London. 1797–99. Destroyed in 1927

to the next with agility and lightning speed, often creating designs of extraordinary daring. Regardless of style, his hallmark was picturesque variety, with most of his buildings having an asymmetrical massing that made them look like a buildup of additions. One day he might design a hamlet with a thatched roof, the next an Italianate villa, followed by a mansion with medieval battlements.

In 1815, Nash turned to the fashionable "Oriental" mode for the prince regent's Royal Pavilion at Brighton (fig. 24.31). The

24.31 John Nash. Royal Pavilion, Brighton, England. 1815–23

building had already been partially erected in a Palladian style when he took over, so he was handicapped from the start. He quickly solved the problem, however, by throwing an iron armature over the Palladian façade to support cast-iron onion domes and minarets. Quoting Gothic, Chinese, Islamic, and Indian architecture, both inside and out, he created a rich fantasy world that played to the Romantic desire to be transported to exotic places and into the distant past.

Germany: Creating a New Athens

Although Prussian architects were as eclectic as their British counterparts, they designed some of the finest Classical-revival buildings. The most renowned architect is perhaps Karl Friedrich Schinkel, named state architect in 1815 by Friedrich Wilhelm III.

KARL FRIEDRICH SCHINKEL Like many architects of the day, Karl Friedrich Schinkel (1781-1841) worked in every imaginable revival style-Classical, Romanesque, Gothic, Renaissance, and Rundbogen, the German term for Italian vernacular construction. He began as a Neoclassicist, however, as can be seen in the Altes Museum in Berlin (fig. 24.32), his second major commission. Designed in 1824, it was modeled on a Greek temple, in part with the intention of endowing the building with the aura of being a temple of aesthetic treasures, a place where one came not to worship the gods but to contemplate art. The entrance is on what looks like the side of a temple (the real sides-their edges seen at either end of the colonnaded façade—are plain stone walls with rectangular windows), a brilliant device to suggest a temple without actually copying one and avoiding the use of the pedimented façade so common in the Classical revival. The museum is raised on a high podium and accessed by a centralized staircase, which along with the colossal Grecian order gives the building a serene monumentality and strong sense of axis. The width of the staircase is echoed above by a second-floor attic, which encases a

domed room for the display of sculpture. Schinkel is a master of perfect proportions and scale, and the symmetrical and logical interior echoes the exterior harmony.

Prussia emerged as a major political force at the Congress of Vienna, held after the fall of Napoleon in 1815, and the ambitious building program instituted by Friedrich Wilhelm III was designed to reinforce his imperial ambitions. Part of the idea behind the Altes Museum was to link Berlin with the glory and grandeur of ancient Athens.

America: An Ancient Style for a New Republic

The Classical-revival style was ubiquitous in America, since the new republic modeled itself on the democracies of ancient Greece and Rome. The White House and nation's Capitol are Neoclassical, and most churches, banks, and government buildings were designed with a Graeco-Roman temple façade, although the Gothic was also very popular for churches.

THOMAS JEFFERSON Thomas Jefferson, an amateur architect, designed his home Monticello (1770-1782) as a Palladian villa, like Burlington's Chiswick House (see fig. 23.8), and he based his Virginia State Capitol (1785) on the Maison Carrée in Nîmes (see fig. 7.44). His best-known project in the Romantic era is the University of Virginia campus in Charlottesville (fig. 24.33). Like Monticello and the Virginia State Capitol, the campus is based on antiquity in order to evoke the democratic heritage from Greece and Rome as well as the grandeur of these two great civilizations, which form the bedrock of Western art and culture. Designed from 1804 to 1817, the campus consists of two rows of five Palladian villas connected by a roofed colonnade, off which are rooms for students. Each of the ten villas, which housed the professors and classrooms, was different, conceptually symbolizing individualism and aesthetically introducing picturesque variety. Each has a different Classical association: One with a Doric

24.32 Karl Friedrich Schinkel. Altes Museum, Berlin. 1824–30

24.33 Thomas Jefferson. University of Virginia, Charlottesville. Designed 1804–17, constructed 1817–28

order refers to the Baths of Diocletian in Rome, a second with an Ionic order to the Temple of Fortuna Virilis, also in Rome. At one end of the two rows and tying them together is a Pantheon-like rotunda, the library, suggested by fellow architect Benjamin Latrobe and built in 1823–26. Lastly, the tree-lined lawn separating the two rows of villas imparts the complex with the naturalism of a picturesque English garden. Jefferson's genius in Charlottesville was to use the Classical revival to create a metaphor for the new republic that expresses both the individualism and the unity that defined the new nation. His use of picturesque variety in the buildings and landscape as well as his use of a style that evokes a lost, distant past are qualities that are distinctly Romantic.

BENJAMIN LATROBE The most famous American architect during the Federal period was Benjamin Latrobe (1764-1820), who in 1795 emigrated from England, where he had been heavily influenced by John Soane and the Parisian Claude-Nicolas Ledoux (see page 808). A friend of Jefferson-which in part accounts for his winning the commission for the U.S. Capitolhe built the first Greek-revival building in the United States (1798, the severe Bank of Pennsylvania in Philadelphia) and later the first Gothic-revival house (Sedgeley Gatehouse, also in Philadlephia, where Latrobe lived). His most esteemed building is Baltimore Cathedral, designed in 1804-8. The exterior is a rather undistinguished Graeco-Roman temple façade with Ionic columns. (Latrobe also submitted a Gothic proposal for the building.) The interior, however, is an impressive sequence of vaulted spaces, the centerpiece of which is a Pantheon-like dome springing from an arcade of segmental arches (fig. 24.34). The arches and austere piers were inspired by Soane's 1792 Bank Stock Office at the Bank of England, while the elegant coffered vaulting recalls Robert Adam (see fig. 23.10). The vast interior was meant to evoke sublime Roman structures, an interest that can be traced back to Piranesi through Soane.

While Baltimore Cathedral may rank among Latrobe's most successful buildings, his most famous is the nation's Capitol, which along with the White House (another project Latrobe advised on when Jefferson became president) firmly established Neoclassicism as the nation's official architectural style. Latrobe's many students were equally committed to Neoclassicism, resulting in most major buildings in America being designed in a Neoclassical style.

24.34 Benjamin Latrobe. Interior of Baltimore Cathedral (Basilica of the Assumption), Baltimore, Maryland. Begun 1805

France: Empire Style

The course of the Classical revival in France was set by Napoleon, who commissioned several Roman structures in Paris to reinforce his imperial image. What is today the church of Mary Magdalene, in the Place de la Madeleine, was commissioned as a "Temple of Glory" to French soldiers and directly modeled on a Roman Corinthian temple, the Maison Carrée (see fig. 7.44). The Arc de Triomphe, of course, was meant to evoke Roman triumphal arches, while the 130-foot-high bronze Vendôme Column, initially called the Column of the Great Army, was modeled on the Column of Trajan (see fig. 7.39) and commemorated Napoleon's victory at Austerlitz in 1805. Little was actually built during Bonaparte's reign, however, and his greatest influence perhaps resulted from the interior-design style developed for his residences: Empire Style.

One of the finest examples is the state bedroom that the architects Charles Percier (1764–1838) and Pierre-François Fontaine (1762-1853) designed for Josephine Bonaparte at the Chateau de Malmaison outside of Paris (fig. 24.35). The style is opulent, using exotic materials and a saturated palette similar to those we saw in Ingres's 1806 portrait of Napoleon (see fig. 24.12). The bed, decorated with swans and cornucopias, is Roman-inspired, while the canopy resembles a military tent and is crowned by an imperial eagle. The tripod washstand is based on the discoveries at Herculaneum and Pompeii, although the sphinxes supporting the bowl are Egyptian, and the decoration of the bowl itself is Greek, an eclecticism characteristic of the Romantic taste for picturesque variety and associational references. Despite the rich materials, the room does not seem busy; rather, it appears serious and ponderous, the result of the deep hues, the weight of the objects (even the drapery seems monumental), and an underlying geometry. For Napoleon, Percier and Fontaine created an august imperial style that corresponded perfectly to the image of the new French emperor.

24.35 François-Honoré Jacob-Desmalter (after a design by Charles Percier and Pierre-François Fontaine). Bedroom of Empress Josephine Bonaparte. ca. 1810. Chateau de Malmaison, Rueil-Malmaison, France

1814 Jean-Auguste-Dominique Ingres's Grande Odalisque

1818-19 Théodore Géricault's The Raft of the Medusa

1824-30 Karl Friedrich Schinkel builds Altes Museum, Berlin

1814 Francisco Goya's The Third of May, 1808

Delacroix's Death of Sardanapalus

1827 Eugène

1836 Thomas Cole's The Oxbow

1836 Sir Charles Barry and A. W. N. Pugin begin the Houses of Parliament

1840 Joseph Turner's The Slave Ship

1789 French Revolution begins

1780

1790

1800

1810

1820

1830

1840

- 1798 First edition of Lyrical Ballads by Wordsworth and Coleridge
- 1804 Napoleon crowned emperor of France 1804 Ludwig van Beethoven finishes his Third Symphony, the Eroica
- 1808 France occupies Spain, completing occupation of much of Europe

1814 Lord Byron publishes The Corsair

- 1814 Louis XVIII restores monarchy in France
- 1815 Battle of Waterloo, final defeat of Napoleon

1830 The Liverpool and Manchester Railway opens, first steam passenger railway service

- 1830 Revolution of 1830, Paris, and July Monarchy, Louis-Philippe becomes king of France
- 1831 Victor Hugo publishes The Hunchback of Notre Dame
- 1832 Ralph Waldo Emerson publishes Nature
- 1833 Slavery Abolition Act, banning slavery in British Empire
- 1839 The daguerreotype and calotype, the first photography, are made commercially available

1848 Revolution of 1848, European-wide worker's revolt

1850

The Age of Positivism: Realism, Impressionism, and the Pre-Raphaelites, 1848–1885

OMANTICISM BEGAN TO DISSIPATE IN EUROPE AS AN INTELLECTUAL attitude and stylistic trend after 1848 and was gradually superseded by Realism. Increasingly, people came to rely on the physical, physiological, empirical, and scientific as a way to understand nature, society, and human behavior. Hard facts, not feelings, became the bricks and mortar of

knowledge. Positivism is the term often used to describe the new mentality of pragmatism and materialism that emerged in the 1840s. The word was coined by the French philosopher Auguste Comte (1798–1857), who in 1830 began to write a multivolume series called *Positive Philosophy*. Comte called for social progress to be based on observable fact and tested ideas—in other words, on science. This new scientific approach to studying society came to be called sociology.

Paralleling Comte's sociology was the appearance in the 1830s and 1840s of popular and widely distributed pamphlets called *physiologies*. These were short essays that analyzed in tremendous detail different niches of French society, not just professions and types, such as the Lawyer, the Nun, the Society Woman, but also such specific categories as the Suburban Gardener and the Woman of 30. In a world undergoing tremendous flux due to rapid industrialization and urbanization, the *physiologies* were a means of understanding the dramatic transformations that were occurring.

In politics, this new tough pragmatism was called *Realpolitik*, a German word meaning the "politics of reality," a concept that Otto von Bismarck (1815–1898), first chancellor of the German Empire, deftly used to create a united Germany toward 1870. In religion, Positivism brought about a renewal of eighteenth-century skepticism. Epitomizing Positivism is the rise of photo-

graphy in the 1840s, which most people perceived not as an art form but as a tool for faithfully recording nature and documenting the rapidly changing world.

In the arts, Positivism resulted in Realism. Now, artists and writers did not bury their heads in the Classical, historical past nor view the modern world through rose-tinted glasses or Romantic notions of the exciting and exotic. Instead they concentrated on contemporary life, and they presented it unembellished and unidealized. And because it was changing so rapidly, they presented it as fleeting too. As early as 1846, the poet and critic Charles Baudelaire called for an art based on modern life, writing that "The pageant of fashionable life and the thousands of floating existences-criminals and kept women-which drift about in the underworld of a great city...all prove to us that we have only to open our eyes to recognize our heroism." By the 1850s, réalisme was the rallying cry of the new art and literature. The evangelist of Realism was critic Jules-Antoine Castagnary (1831-1888), who in his 1857 Salon review wrote: "There is no need to return to history, to take refuge in legends, to summon powers of imagination. Beauty is before the eyes, not in the brain; in the present, not in the past; in truth, not in dreams."

Instead of valuing wild flights of imagination, the exotic, and the sublime, Realists planted both feet firmly on the ground and, generally without emotion, bluntly depicted modern life. This ranged from the grim existence of country peasants and the downtrodden urban poor to the leisure activities of the rapidly

Detail of figure 25.12, Edgar Degas, The Orchestra of the Paris Opéra

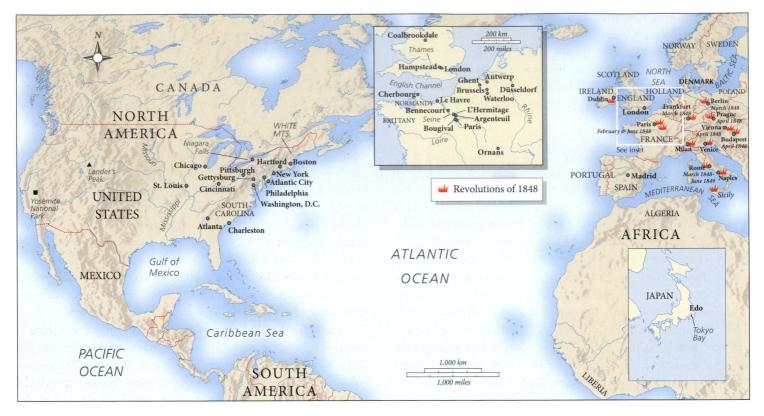

Map 25.1 Europe and North America in 1848

growing metropolitan middle class and *nouveau riche*. In landscape painting, this Realism evolved into Impressionism. Often working in the environs of Paris as well as in the city itself, the Impressionist painters documented the transformation of the landscape from rural to suburban, recording the incursion into the countryside of factories and railroads. They observed, too, the influx of moneyed Parisians, who built fancy weekend villas in farm villages, raced sailboats in regattas on such waterways as the Seine and Oise rivers, and dined, danced, and swam at fashionable riverside establishments. Painting rapidly outdoors with bold brushstrokes and strong colors, the Impressionists empirically captured the world before their very eyes, the shimmering sketchiness of their finished paintings reflecting the impermanence of a constantly changing contemporary world.

While the Impressionists were committed to creating an empirical representational art—a realistic art—a byproduct of their stylistic developments was the advent of Modernism. To the following generations, their bright colors and broad brushwork that is, the abstract qualities of their works—seemed to challenge the representational components as the subject matter of the painting. In the early twentieth century, critics and historians would label this shift in art toward abstraction as "Modernism." Impressionism also marked the appearance of the **avant-garde**, the notion that certain artists and ideas are strikingly new or radical for their time. This meant, in effect, that artists began making art that was only understood by a handful of people, namely other avant-garde artists and a few art experts, including collectors. The disconnect between the avant-garde and the general public, including the working class, who felt comfortable attending the highly publicized academy exhibitions, is reflected in the rise of commercial art galleries as the principal venue for the display of new art and the corresponding decline in power of academic Salons throughout the Western world. But while Realism served as a springboard for the abstraction of Modernism, we must remember that first and foremost it was a movement preoccupied with the dramatic changes occurring in society, and that its birth coincides with the great European-wide revolutions of 1848.

REALISM IN FRANCE

The year 1848 was one of uprising in France. Republicans, liberals, and socialists (those advocating a classless society in which either a popular collective or the government controls the means of production) united that year to demand an increased voice in government, and when King Louis-Philippe refused, armed conflict was imminent. The king abdicated. A provisional government was soon replaced by the Constituent Assembly. But the working class was still not represented; already organized into labor camps instituted by the new government, it revolted, storming Parliament. War raged in the streets of Paris, and 10,000 people were killed or wounded. This proletarian rebellion produced shock waves of class revolution that radiated throughout Europe, resulting in similar uprisings in major cities. Even Britain was threatened, as the Chartists, a socialist group, agitated for workers' rights, going so far as to gather arms and conduct military drills. As one contemporary French writer said, European society was "prey to a feeling of terror incomparable to anything since the invasion of Rome by the barbarians." It is no coincidence that Karl Marx and Friedrich Engels published their *Communist Manifesto* the same year.

The forces of conservatism ultimately prevailed everywhere. In France, Louis Napoleon Bonaparte (1808–1873), the emperor's nephew, was elected president of the Second Republic, largely on name recognition. In 1852, however, he dissolved Parliament and arranged to have himself "elected" emperor, becoming Napoleon III and establishing the Second Empire. France prospered under his reign, which ended in 1870 with the Franco-Prussian War.

The pace of the Industrial Revolution, which had not gained momentum in France until the 1840s, now increased dramatically, largely due to new financial systems instituted by Louis Napoleon, systems that also created unprecedented wealth. Dominated by financiers, industrialists, manufacturers, lawyers, and merchants, the bourgeoisie flourished, as did their hunger for material possessions. Reflecting the new consumerism was the 1855 Paris Universal Exposition, or World's Fair, in which countries from all over the world displayed their products. The Parisian exposition was a competitive response to the first international trade fair presented in London in 1851, the Great Exhibition of the Works of Industry of All Nations. In Paris, the new wealth and increased time for leisure activities gave rise to grand restaurants, cafés, department stores, theaters, clubs, parks, and racetracks, where people, often from different social classes, congregated and shopped.

Paris itself received a makeover, taking on its glorious modern-day form when, beginning in 1853, Georges-Eugène Haussmann (1809–1891), Louis Napoleon's minister of the interior, initiated huge municipal improvements. Among them was the creation of magnificent wide avenues that cut through the dark, dank, medieval rabbit warren of the Old City and that were flanked by chic modern apartment buildings. The result was spectacular perspectives (and arteries that permitted the rapid deployment of troops in the event of more insurrections), punctuated by beautifully landscaped parks, gardens, and squares, and anchored by grand civic buildings, including an opera house and stately railway stations. The boulevards opened up the city, permitting increased light and color, making the urban environment seem more salubrious, which it was. This new city is what the Impressionists would capture on their canvases.

Realism in the 1840s and 1850s: Painting Contemporary Social Conditions

French Realism arose simultaneously with the revolution of 1848. Especially in the hands of Gustave Courbet, the self-proclaimed banner-carrier of this art movement, and Jean-François Millet, the painter of peasants, Realism was a highly political style. It championed laborers and common country folk, groups that challenged the authority and privilege of the Parisian aristocracy and bourgeoisie and were in part responsible for the upheavals of 1848.

GUSTAVE COURBET Gustave Courbet (1819–1877) came from Ornans, a town at the foot of the Jura mountains near the Swiss border, where his father, a former peasant, was a prosperous landowner and vintner. He went to Paris in 1839 to study painting, and by the late 1840s had become a dominant figure at the new bohemian cafés on the Left Bank. There, Courbet met the literary avant-garde, befriending Baudelaire, the socialist journalist Pierre-Joseph Proudhon, and the critic and writer Champfleury. Largely under the influence of Proudhon, Courbet, already a republican, became a socialist. Meanwhile, Champfleury swayed him toward Realism. Champfleury, who collected folk art and was interested in such nonelitist art forms as popular prints, children's art, and caricatures, convinced Courbet to return to his rural roots and paint the simple world of Ornans.

In the fall of 1849, Courbet returned to Ornans, and there in his family's attic painted the 22-foot-wide Burial at Ornans (fig. 25.1), which was accepted at the Salon of 1850-51. The picture was an affront to many viewers. It presented common provincial folk, portrayed in a coarse, heavy form, without a shred of elegance or idealization. The people of Ornans, many of whom can be identified, posed for Courbet, and the artist not only documented their clothes and bearing but their distinguishing facial features, which included bulbous noses, grotesquely wrinkled faces, and unkempt hair. The bleak overcast landscape is equally authentic, based on studies made at Ornans cemetery. Courbet's Realism extends to the democratic presentation of the figures. Despite bold brushwork and a chiaroscuro vaguely reminiscent of his favorite artists, Rembrandt and Velázquez, the picture has no Baroque drama and no compositional structure to emphasize one figure over another-the dog is as important as the priest or mayor. Nor does it use Classical formulas, as Benjamin West did in his pyramidal groupings in The Death of General Wolfe (see fig. 23.6). Instead, the image embraces the bold, simple compositions found in such popular art forms, as broadsides, almanacs, and song sheets-the art of the people, not the academy.

The picture seems so matter-of-fact it is difficult to know what it is about. We see pallbearers and the coffin on the left, then a priest and assistants, followed by small-town patricians and, to the right, womenfolk. An open grave is in the foreground center. We do not even know whose funeral it is. Nor is it clear that this is a statement about the finality of death, although that is the strongest candidate for an overriding theme. Clearly, the picture is a document of social ritual that accurately observes the distinctions of gender, profession, and class in Ornans. More important, it brazenly elevates provincial bourgeois events to a lofty status equal to that of historical events. In effect, it is an assault on the highly esteemed genre of history painting. As such, Courbet's work repulsed many Parisians. Equally unsavory was the political threat represented by the Ornans bourgeoisie, who under the Second Republic had considerable voting power, capable of

25.1 Gustave Courbet, Burial at Ornans. 1849-50. Oil on canvas, 10'31/2" × 21'91/2" (3.13 × 6.64 m). Musée d'Orsay, Paris

swaying national elections. Furthermore, they were a sobering reminder to many members of the Parisian bourgeoisie of their own provincial and even peasant origins, which many tried to hide.

Courbet exhibited a second Ornans painting in the Salon of 1850–51, *The Stone Breakers* (fig. 25.2). Here, he presents on a confrontational, life-size scale two workers he met on the outskirts of town who were pounding stones to make gravel for a

road. Again, Courbet portrays the figures with complete veracity, their poverty and social class announced by their ragged clothes, by the coarseness of their labor, and by the dirt under their fingernails. He gives the workers the same detailed intensity as the stones, and the fact that their faces cannot be seen virtually transforms them into inanimate objects, like the rocks and tools. Once more, the composition lacks conventional structure, resulting in our eye jumping from one fact to another.

25.2 Gustave Courbet, The Stone Breakers. 1849. Oil on canvas, $5'3" \times 8'6"$ (1.6 × 2.59 m). Formerly Gemäldegalerie, Dresden (believed to have been destroyed in World War II)

While the public variously condemned and praised the picture for having a socialist message, both political sides admired the image's materiality. As in the Burial, Courbet used a broad application of paint, sometimes troweling it on with a palette knife, in effect transforming the artist into an artisan-laborer. This bold paint application reinforces the powerful physicality of the figures and by its physical presence virtually stands in for the material objects. In both Burial and Stone Breakers, figures are sandwiched into a shallow space. They are pushed up to the surface of the canvas, and the landscape behind is so flat it seems like a backdrop that forces our eye to stay in the foreground. Courbet would never admit to having a socialist agenda in Stone Breakers, but this "complete expression of human misery," as the artist himself described it, is obviously about social injustice and a product of the revolution of 1848. Rather than presenting rural life as pastoral or comic, as had been traditional in art, Courbet depicts its harsh reality.

In 1855, Courbet had 11 paintings accepted for the Paris Universal Exposition, a world trade fair designed to promote French commerce and industry. The fair's fine-art section replaced the Salon exhibition that year and featured such famous French masters as Ingres and Delacroix. To promote his career, Courbet created a sensation by doing what no living artist had ever done before: He commissioned a Classically inspired building near the fair where he mounted his own one-person show, which included Burial at Ornans. He titled his exhibition Du Réalisme (On Realism) and sold a pamphlet, a "Manifesto of Realism." In it, he made the following proclamation: "To be in a position to translate the customs, the ideas, the appearance of my epoch according to my own estimation: to be not only a painter, but a man as well, in short to create living art-this is my goal." At every turn, Courbet challenged academic values. He replaced the hallowed Greek and Roman tradition with bold images of the contemporary world, images that contained no references, either iconographic or compositional, to the Classical tradition or history painting. He daringly troweled paint onto the canvas, undermining the refinement of academic paint handling, whether the Neoclassical hard smooth surface of Ingres or the painterly Venetian and Rubensian tradition found in Delacroix; and while not rejecting the Salons, he refused to rely on them to promote his career and instead turned to commercial exhibition.

JEAN-FRANÇOIS MILLET We can see how matter-of-fact in presentation and unemotional Courbet's pictures are if we compare them with another Realist entry at the Salon of 1850–51, *The Sower* (fig. **25.3**), by Jean-François Millet (1814–1875). Like Courbet, Millet had a rural upbringing. Born into a family of well-to-do farmers near Cherbourg in Normandy, he grew up steeped in the land and the timeless seasonal cycle of farm life. He was well educated and well read, and after choosing a career in painting and studying in both Cherbourg and Paris, he began by making portraits, using a dark palette that reflected his love of seventeenth-century Spanish painting and Rembrandt. In the late 1840s, when back in Paris, he befriended several of the landscape painters of the Barbizon School (see page 849), and in 1848 he produced his first peasant picture, *Le Vanneur (The Grain Sifter)*. Pictures of peasant life would be his specialty for the remainder of his life. In 1848, after an outbreak of cholera in Paris, Millet settled permanently in Barbizon.

Coming on the heels of the revolution of 1848, Millet's pictures dignifying the peasantry were read politically. As seen in *The Sower*, his workers, like Courbet's, are poor and downtrodden: They wear tattered clothing and are consigned to a life of grueling work on the land. Shadowy and enormous, they were frightening to a Parisian audience still reeling from the revolution of 1848. More threatening yet, Millet ennobled them. The anonymous sower is monumental in size, a massive dynamic form consuming most of the picture frame. He is not so much an individual, as are Courbet's figures in *Burial at Ormans*, but a type the noble farmworker, who is poorly paid for his labor. Using a dark chiaroscuro reminiscent of Rembrandt, Millet casts the laborer in murky shadow, making him blend in with the soil from which he seems to emerge. He is the embodiment of the earth, a reading enhanced by the gritty coarseness of Millet's paint. The dramatic

25.3 Jean-François Millet, *The Sower*. ca. 1850. Oil on canvas, $40 \times 32\frac{1}{2}$ " (101.6 × 82.6 cm). Museum of Fine Arts, Boston. Gift of Quincy Adams Shaw through Quincy A. Shaw. Jr., and Mrs. Marion Shaw Haughton. 17.1485

sweep of the gesture and the undulating contours of the body align him with the eternal cyclical forces of nature itself. While a Realist in his peasant subject, Millet is clearly a Romantic in sensibility, his pictures aspiring to poetry and mood, not sheer fact.

HONORÉ DAUMIER Also appearing for the first time in the Salons at this time was Honoré Daumier (1808-1879). Daumier was famous as a caricaturist but virtually unknown as a painter. His lithographs began appearing regularly in Paris newspapers about 1830. (See Materials and Techniques, page 911.) The emergence of a sizeable and literate bourgeois public and the development of inexpensive paper and printing processes resulted in the modern-day newspaper, made all the more popular by being illustrated with lithographs and woodcuts. Daumier worked mostly for the socialist newspapers La Caricature and Le Charivari, both devoted to political and social satire. This was a perfect match, for Daumier was passionate about social causes, dedicating his life to exposing evil, from the corrupt and repressive activities of the government to the avarice and vanity of the nouveau riche. His brilliant lithographs quickly and subtly documented the different professions, classes, and types emerging in a rapidly growing and changing Paris, in some respects paralleling the lengthy factual descriptions of the physiology pamphlets. His characterizations anticipated the observations of types found in the urban Realists and Impressionists of the 1860s and 1870s. We can see Daumier's sharp eye, caustic humor, and succinct draftsmanship in It's Safe to Release This One! (fig. 25.4), made in 1834 after a workers' uprising in Paris that resulted in the deaths of numerous poor and innocent citizens at the hands of government forces. It presents a caricature of the overweight pear-shaped King Louis-Philippe,

25.4 Honoré Daumier, It's Safe to Release This One! 1834. Lithograph

who, feeling no pulse in a chained emaciated worker, announces he is now free to go.

Daumier undoubtedly wanted to be considered a fine artist, and with this in mind exhibited a handful of paintings at the Salons of 1849 and 1850–51. He was ignored, however. For the rest of his life he painted privately, exhibiting only once more, 1877, the year before he died, at Durand-Ruel, a major commercial gallery in Paris. His paintings were therefore essentially unknown. It appears Daumier taught himself to paint during the

25.5 Honoré Daumier, The Third-Class Carriage. ca. 1863–65. Oil on canvas, $25\frac{3}{4} \times 35\frac{1}{2}$ " (65.4 × 90.2 cm). Metropolitan Museum of Art, New York. Bequest of Mrs. H. O. Havemeyer, 1929. The H. O. Havemeyer Collection (29.100.129)

25.6 Rosa Bonheur, Plowing in the Nivernais: The Dressing of Vines. 1849. Oil on canvas, 5'9" × 8'8" (1.75 × 2.64 m). Musée d'Orsay, Paris

1840s. In contrast to his commercial work, his oils are pure compassion. He dispensed with humor and satire and, relying on his caricaturist's ability to concisely capture character and types, uncannily nailed the psychology of contemporary urban life, as seen in The Third-Class Carriage (fig. 25.5), made about 1863-65. Here, he renders a peculiarly modern condition, "the lonely crowd," in which throngs of workers are jammed into a thirdclass railway car, consigned to hard benches in contrast to the wide plush seats of first-class cars. A range of types, all anonymous, and part of the growing urban masses, endure their daily commute. The weary family in the foreground is the focus of the picture. They are simpler and poorer than the top-hatted petits bourgeois behind them and seem to represent the uprooted rural poor who have come to Paris in search of opportunity, only to become victims of modern urbanism. Silent and tired, they are imprisoned in a turgid gloom, shut off from the wholesome bright light seen through the windows. But Daumier presents them with fortitude and dignity, for the two women have the monumental forms we saw in Millet's Sower. What appears to be a simple peasant family is transformed into the Mother and Child with St. Elizabeth. Like Millet, whom he admired, Daumier is alternately labeled a Realist and a Romantic, his paintings similarly combining Realist subject matter with the powerful compassion of a Romantic.

ROSA BONHEUR A fourth Realist exhibiting at the Salon of 1850–51 was Rosa Bonheur, who garnered considerable attention. She studied with her father, a drawing instructor and socialist, who advocated full equality for women. From early on, Bonheur was determined to become a successful woman in a man's world.

Instead of making the small still lifes and watercolors traditionally associated with women, Bonheur became an animal painter and worked on a large scale, displaying the technical finesse of the finest academicians. Rather than the exotic animals of the Romantic world of Delacroix and Barye, Bonheur painted farm animals, including cows, horses, and sheep. Influenced by the scientific empiricism of natural history, she presented specific species, carefully studying each and accurately rendering them, often in minute detail. Bonheur began showing at the Salon of 1841, and during the course of the decade, her reputation grew. (See www.myartslab.com.)

In 1848, the new Second Republic, reflecting a Positivist compunction to document French regional agriculture, commissioned a large painting from Bonheur. At the Salon of 1850-51, she unveiled the 8-foot-wide result, Plowing in the Nivernais: The Dressing of Vines (fig. 25.6). The inspiration for this subject is believed to be The Devil's Pool (1846), a novel by George Sand (1804–1876), who, as a successful woman author, was a role model for Bonheur. In the book's preface, Sand announced that the novel "brings back civilized man to the charms of primitive life." As industrialization was beginning to transform France, creating complex urban centers filled with such ills as overcrowding, poor housing, class conflict, and dislocated migrants, Sand advocated a return to nature, to a simple "primitive" world, a theme also found in Millet's paintings and one that would become popular with the cultural community in the closing decades of the century. Bonheur's interest in animals in part reflected her own interest in nature, and after 1860, she left Paris and permanently settled in the rural forest of Fontainebleau, near Barbizon. There she lived with her companion, Nathalie Micas, and challenged societal conventions about women by wearing men's clothing, cropping her hair short, and smoking in public.

To create Plowing in the Nivernais, Bonheur spent weeks in the region, a rural area in central France, studying the unique qualities of the land, animals, farm tools, and regional dress, all of which Salon-goers recognized in her tightly painted detailed picture and responded to favorably. Unlike Millet's Sower, her image is factual and unemotional, and in contrast to Courbet's Ornans paintings, it plays down the unseemly qualities of rural life. We may see the ponderous weight of the enormous Nivernais oxen, but we experience no stench of animals, no sweat of labor, and no smell of earth, although it is all represented. Like the *physiologies*, Bonheur documents, catalogues, and presents. The large size of the oxen and the processional planar alignment lend a grandeur to the scene, which, combined with the tight paint handling, give the picture something of a Classical or academic aura that made it more palatable to a conservative public than Courbet's and Millet's more threatening images.

The Realist Assault on Academic Values and Bourgeois Taste

By presenting the provincial bourgeoisie and peasants on a scale usually reserved for history painting, Courbet launched an assault on the values of the French Academy and bourgeois taste. In effect, he declared contemporary life, and especially contemporary social conditions, just as valid (if not more so) a subject for painting as historical events, and his emergence signals the death knell for the traditional hierarchy of the genres that can be traced back to the establishment of the academies. (Ironically, vanguard artists would return to history and religious painting in the closing decades of the century.) Courbet's rejection of academic values in order to depict the social conditions of the modern world was taken up by Édouard Manet (1832–1883) in the 1860s. Focusing on urban rather than rural life, he painted musical gatherings in the Bois de Boulogne, the new park on the western outskirts of Paris where the upper classes came to be seen, and he painted the fashionable throngs who congregated at Longchamp, the new racetrack, also in the Bois. He painted chic masked balls held at the opera, courtesans with their clients, and the leisure activities at the new cafés, dance halls, and restaurants. His pictures are often complex, loaded with references, and densely layered with multiple readings. They are so rich as to be able to comment on academic values while capturing the energy, psychology, and changes occurring in modern society. This is especially true of The Luncheon on the Grass (see fig. 25.10), which he submitted to the Salon of 1863. To understand this picture, it is first necessary to look at the academic values that prevailed in the 1860s and that were used by the Salon jury.

OFFICIAL ART AND ITS EXEMPLARS While it is dangerous to characterize any one kind of art as being "academic" and promoted at the École des Beaux-Arts in Paris in the 1860s, many if not most of the academicians still believed in the supremacy of history painting, the Graeco-Roman paradigm, and the highly finished Neoclassical style of paint handling epitomized by Ingres. Among the more popular subjects was the female nude, and images of nudes plastered the walls of the Salons. However, these were not ordinary nudes, for they were all Venuses, Dianas, bacchantes, or nymphs: that is, they were noble beings with a Classical pedigree. Equally popular were nudes in genre scenes located in an exotic setting, such as a harem, as seen in Ingres's *Grande Odalesque* (see fig. 24.13), or in the distant past, such as ancient Rome. Nonetheless, the pictures were esteemed since they continued the Classical tradition of beauty and perfection.

The most prominent academic painter of the period was Adolphe-William Bouguereau (1824–1905), who became president of the Institute of France and the French Legion of Honor. In addition to gypsies, peasant girls, and religious themes, he painted mythological scenes, such as *Nymphs and a Satyr* (fig. **25.7**) of 1873. Here, nymphs playfully tug a satyr into the water in an image that is overtly erotic, as epitomized by the background nymph clutching the satyr's horn in unabashed ecstasy. Heightening the sensuality of flesh, gesture, and expression is

25.7 Adolphe-William Bouguereau, *Nymphs and a Satyr.* 1873. Oil on canvas, $9'_{3/8}" \times 5'107_{8}"$ (2.8 × 1.8 m). Sterling and Francine Clark Art Institute, Williamstown, MA

25.8 Jean-Baptiste Carpeaux, *The Dance*. 1867–69. Plaster, $13\frac{3}{4} \times 9\frac{3}{4}$ " (420 × 298 cm). Musée de l'Opéra, Paris

Bouguereau's detailed naturalism, which reflects a Positivist penchant to record. Even Bouguereau's idealized women seem real and not goddesslike, not just because of their naturalistic flesh but also because they are voluptuous—they look more contemporary than Greek or Roman.

Despite upholding the Classical tradition into the twentieth century, Bouguereau is far from being just a standard-bearer of a dying tradition. Besides his remarkable technical finesse, his pictures are distinguished by a powerful psychology—here of erotic abandonment—which will preoccupy artists later in the nineteenth century. His images are often set against a backdrop of nature, reinforcing the expression of elemental desires and reflecting the period's desire to escape from the complex world of urbanization and industrialization to simpler times of Arcadian and rural retreats.

Sculpture remained tied to the Classical tradition and similarly often focused on the female nude. One of the outstanding sculptors from the period was Jean-Baptiste Carpeaux (1827–1875), and among his best-known works is *The Dance* (fig. **25.8**), one of four marbles commissioned in 1867 for the public façade of the new Paris Opéra, each sculpture representing a component of opera as an art form. In the plaster model reproduced here which is livelier and more precise than the finished marble— Dance is represented by an erect, winged allegorical male, who serves as an erotic maypole around which gleeful, well-proportioned bacchantes worshipfully prance. The satyr lurking under Dance's cape underscores the licentious intentions of their ritualistic play, which is presented within a more serious, artistic concept of dance.

When *The Dance* was unveiled in 1869, critics panned it, declaring that the figures looked drunk, vulgar, and indecent. The naturalism certainly makes the dancers look undressed rather than nude; we see elbows, kneecaps, and rolls of flesh on bodies that Canova (see fig. 23.30) would have presented perfectly smooth. While the figures may evoke antiquity, they do not look quite Greek or Roman but rather Second Empire. Within a year, however, eyes had adjusted to Carpeaux's naturalism and the egregiously erotic work was hailed as a great monument in the Classical tradition.

Because of its dynamic Baroque composition and excessiveness (too much flesh, too much mirth), *The Dance* was a perfect complement for its setting, the Opéra (fig. **25.9**) designed by Charles Garnier (1825–1898), which was built from 1861 to 1874 and shared the same qualities. The Opéra has become an emblem of the opulence and extravagance of the Second Empire, reflecting the pretentious taste of the bourgeois audience that patronized the academic or Classical tradition. The building was a lynchpin in Haussmann's design for Paris, the dramatic focal point for the Avenue de l'Opéra, as well as the hub for several other major arteries.

The Opéra marks the extension of nineteenth-century revival styles to the Baroque, rivaling the Classical and Gothic revivals before 1860. With the double-columned colonnade Garnier suggests Perrault's Louvre (see fig. 21.11), thereby putting Louis

25.9 Charles Garnier. The Opéra, Paris. 1861-74

Napoleon in a line of descent from Louis XIV. The segmented arches springing from the columns at either end of the façade recall Lescot's Square Court of the Louvre (see fig. 18.2). The endless variety of colors and textures, the dazzling accretion of sculpture and decoration, and the extensive borrowing and recombining of architectural forms from the Renaissance and the Baroque—just the sheer density of *everything*—resulted in an opulent, ostentatious style that paralleled the materialistic conspicuous consumption of the period and appealed to *nouveau riche* tastes, although it was disdained by the old-moneyed aristocracy. The focal point of the interior was a dramatic grand staircase, which served as a stage on which high society paraded in order to be seen.

ÉDOUARD MANET Manet's *The Luncheon on the Grass* (fig. **25.10**) was a condemnation of bourgeois values and academic taste as well as a statement of what art should be about—the modern world. Manet himself came from a Parisian bourgeois background, and studied with a famous academician, Thomas Couture (1815–1879). His true masters were the painterly artists he copied at the Louvre—Hals, Titian, Velázquez, and Goya. He was a regular at the cafés, befriending Courbet, who was his role model, as well as Baudelaire and the Realist novelist and art critic Émile Zola (1840–1902). Like many Realist writers and artists, Manet was a *flâneur*, a social type that surfaced as early as the 1830s, when the physiology pamphlets began appearing. The *flâneur* was an impeccably dressed man with perfect manners who kept abreast of current events through newspapers and gossip. His day

was spent inconspicuously strolling the streets of Paris and observing the fleeting moments of modern life, which he then translated into a painted or written image. The *flâneur* was witty and gregarious and delighted in shocking the bourgeois. Manet's close friend Baudelaire ranks among the most famous *flâneurs* of the period.

Out of this background Manet produced the *Luncheon*, which shows two couples picnicking in the Bois de Boulogne. The painting was rejected by the 1863 Salon jurors. But that year the jurors rejected a record number of artists, causing such a popular outcry that Louis Napoleon declared there would be a *Salon des Refusés* (*Salon of the Refused*), to be held in a separate building but in conjunction with the official Salon of 1863. Many of the rejected artists preferred not to participate in what was perceived as an inferior exhibition. Manet, however, did take part.

The public showed up in record numbers to laugh at the rejects, and especially to view Manet's *Luncheon*, which was front-page news in the papers. *Luncheon* created a scandal by presenting a contemporary scene of a naked woman in a park with two nattily dressed men. The public was outraged, for obviously the nude had to be a prostitute. It did not matter that critics acknowledged that the painting was inspired by the well-known Renaissance *Fête Champêtre* (see fig. 16.30) in the Louvre, which similarly presented a nude seated with two dressed men. One writer even correctly recognized that the seated group exactly replicates the poses of river-gods in a print of about 1520 by Marcantonio Raimondi after Raphael's *The Judgment of Paris* (see fig. 16.28). No mention was made, however, that the woman in a

25.10 Édouard Manet, The Luncheon on the Grass (Le Déjeuner sur l'Herbe). 1863. Oil on canvas, 7' × 8'10" (2.13 × 2.69 m). Musée du Louvre, Paris

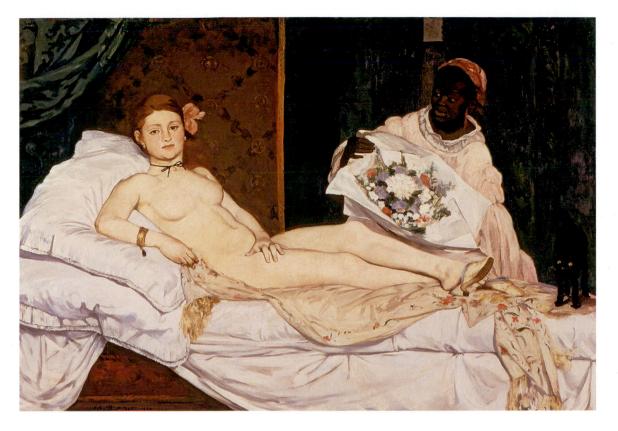

25.11 Édouard Manet, *Olympia.* 1863. Oil on canvas, 4'3" × 6'2¼" (1.31 × 1.91 m). Musée d'Orsay, Paris. Inv. RF2772

shift in the background is based on Watteau's *The Bather*, also in the Louvre. In fact, Manet originally used this title for his painting.

As far as the critics were concerned, referencing these august sources was not enough to justify Manet's flagrant lack of decorum, a crime he brazenly committed on a canvas roughly 7 by 9 feet, a scale generally reserved for history painting. So, why did Manet base his contemporary scene on historical sources? The answer may lie in the seemingly deliberate artificiality of his figures. As pointed out by one art historian, they look like École des Beaux-Arts students posing to re-create a famous painting. In effect, Manet is telling us the present cannot live in the past, which many academicians chose to do. As trumpeted by Baudelaire in 1846, Manet was declaring that artists must find their subject matter, their heroes, in the modern world. Furthermore, he was exposing the disguised eroticism that the tradition of the Classical nude had now stooped to. It is possible that Manet also used historical sources as a device to put himself into the long tradition of great art. In effect, he is announcing that his Realism is not only the most valid direction for art to take, but in addition that it is as important and vital as the great art of the past.

What convinced the jurors and public that Manet was an incompetent sensationalist who deserved to be relegated to the *Salon des Refusés* was his style. To their academically focused eyes, he could neither model nor create convincing space. The picture looked like a preliminary sketch, not a finished picture. The figures are two-dimensional cutouts, flattened by their crisp, silhouetting contours and a flourish of broad brushstrokes that dispense with the halftones between dark and light needed to mold volume—a shadow indicating a fold on a pant's leg, for example,

is rendered with one bold, black sweep of the brush. Cogent space is upended by making the woman wading in the background too large for her recessed location so that she seems to float over the seated group in front of her. All of the objects—figures, trees, the colorful still life of clothes and basket—hover in space, failing to connect and assemble into a coherent spatial structure.

Manet has undermined the order of the illusionistic Renaissance window and replaced it with a new unifying logica sensual sea of brushwork composed of lush, oily, and thickly applied paint that dramatically covers the entire surface of his canvas. Our eyes delight in the lusciousness of his brushwork, the wonderful variety of his Velázquez- and Goya-inspired blacks, the range of greens in the grass, and the deft play of darks next to lights that makes our eyes jump from one light area to another and from one dark patch to the next. These abstract qualitiespaint handling and value contrasts, for example-are the new structure of painting, not illusionistic space and modeling. With The Luncheon on the Grass, Manet began what twentieth-century critics would consider the Modernist tradition, a tradition that emphasized the abstract qualities of art and that would continue for the next 100 years. Manet undoubtedly delighted in how the unfinished, sketchy look of his paintings irreverently countered the slick drawing and modeling of the academic tradition and shocked bourgeois taste. Additionally, he used it to create a sense of dynamic energy and of the momentary that reflected the quickly changing modern world, the world captured by the flâneur's perspicacious eye.

Surprisingly, Manet was accepted into the Salon of 1865, for his *Olympia* (fig. 25.11), painted in 1863, is unequivocally a

courtesan, a prostitute with a wealthy, upper-class clientele. This nude, based on Titian's *Venus of Urbino* (see fig. 17.35), is the Second Empire gentleman's idea of a modern-day goddess, and everyone in Paris knew it, since Olympia was a common name adopted by powerful courtesans and kept women. With its Classical ring, the name was also a sly attack on the allegorical veiling of erotic nudes that appeared in the Salons.

Manet's Olympia portrays a reality of contemporary Paris: Many wealthy men—the same ones who bought academic nudes for their eroticism, not for their smokescreen Classicism—kept mistresses and visited prostitutes. Unlike Titian's Venus, Manet's Olympia is more real than idealized—she is angular, awkward, and harsh rather than voluptuously curvilinear. Furthermore, she is all business, returning our gaze with a daringly confident stare, a power stare that made men uncomfortable and fulfilled their worst fears of controlling, independent women. She engages the viewer in a way rarely seen in genre painting, reflecting Manet's interest in the new Parisian social mobility, the interaction of classes, and the importance of money and commodities in contemporary life.

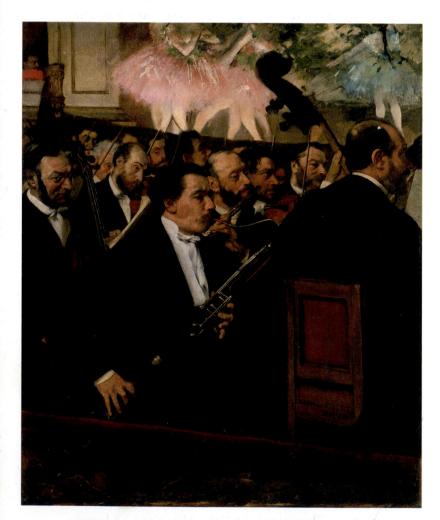

25.12 Edgar Degas, *The Orchestra of the Paris Opéra.* 1868–69. Oil on canvas, $22\frac{1}{4} \times 18\frac{3}{16}$ " (56.5 × 46.2 cm). Musée d'Orsay, Paris

EDGAR DEGAS AND JAPONISME Like Manet, Edgar Degas (1834–1917) came from a wealthy background, his father heading up the Paris branch of a family bank. And like Manet, he was something of a *flâneur*, although too much of a recluse to be considered a full-blown one. Initially he aspired to be a history painter. An admirer of Ingres, Degas emphasized drawing and modeling in his early work. By 1865, he had entered Manet and Baudelaire's orbit at the Café Guerbois, and now he turned to capturing modern Paris in his work. He developed a Manetinspired painterly approach to his subject matter, as well as innovative compositional devices that give his images a spontaneous, transitory quality. Furthermore, he put a viewer in the voyeuristic position of the unobserved *flaneur*. Now he started painting the new Haussmann boulevards, the millinery shops, Longchamp racetrack, café concerts, opera, bars, cafés, and ballet dancers at the Opéra. His sharp eye captured types from all levels of society, from the bourgeoisie and performers, to the socially marginalized and the working class.

A classic work from the 1860s is The Orchestra of the Paris Opéra (fig. 25.12). The painting began as a portrait of the bassoonist, in the center foreground, but was extended to include the other musicians and the dancers onstage. Essentially the picture is a genre scene of the orchestra pit, an unusual subject for a painting, although a precedent had been created by Daumier. Yet the subject here is not just the talented, toiling performers but the intensity, excitement, and fragmentation of contemporary life itself, which is presented in a matter-of-fact way. Degas has put us virtually in the pit, and we feel like unobserved voyeurs. Our view is not head-on but at an angle, which is unusual for a painting but certainly typical for a theatergoer. The bass violinist is arbitrarily cropped on the right, suggesting we are looking at the left side of the orchestra, seeing only a fragment of a complete view. The same is true of the ballet dancers, whose heads and legs are chopped off. X-rays have revealed that Degas cut the painting down at the top and sides after finishing it in order to further fragment the image.

Building on this energy are the planes of the wall, the stage, the front row of the orchestra, and the ballet dancers, all of which are slightly skewed, along with the angular thrust of the instruments and dancers' legs and arms. Space seems compressed, as far and near are dramatically juxtaposed, for example in the dark head of the bass and brightly colored tutus. The image seems to climb up the picture plane rather than recede in space. A precise line, retained from Degas's academic studies, still outlines figures and objects, but a sporadic spray of dashing brushwork, readily seen in the dancers' tutus, adds spontaneity and a fragmentary quality, giving us a feeling of the fleeting moment.

Scholars often attribute Degas's innovative compositions to the influence of Japanese prints, which flooded the Parisian market in the late 1850s. In 1853, American Commodore Matthew Perry steamed into Tokyo Bay with four warships and forced Japan to open its doors to the West after two centuries of isolation. By the early 1860s, the world was saturated with Japanese products. Fans, vases, kimonos, lacquer cabinets, folding screens,

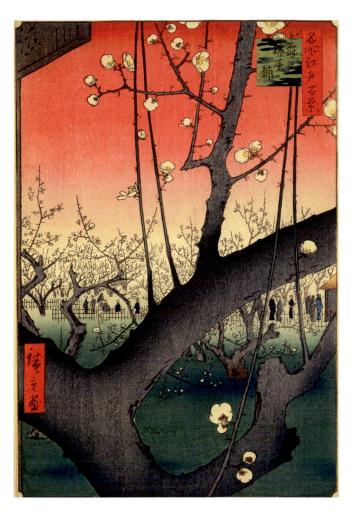

25.13 Andō Hiroshige, *Plum Estate, Kameido*, from the series *One Hundred Famous Views of Edo*. 1857. Woodblock print, 13³/₈ × 8⁵/₉" (34 × 22.6 cm). Brooklyn Museum of Art, New York. Gift of Anna Ferris. 30.1478.30

jewelry, and tea services were common items in most fashionable Western homes. The French were especially taken by Japanese culture, and their infatuation was called **Japonisme**, a term also used by the British and Americans. The most popular display at the 1867 Universal Exposition in Paris was the Japanese pavilion. Especially intriguing for artists were Japanese prints, works that first arrived in France as packing material for fragile objects but that were being collected by the late 1850s by the artists in Manet's circle, who found them visually fascinating.

As can be seen in *Plum Estate, Kameido* (fig. **25.13**) by Andō Hiroshige (1797–1858), Japanese image making was quite foreign to a Western way of seeing. Forms are flat with sharp contours, while space is compressed, the foreground pressed up against the viewer's nose, the background pulled right into the foreground space. There is no transition between near and far. Just the concept of situating a viewer in a tree from which to see the main activity miniaturized in the distance would have been radical to the eye of a Western artist. However, the flat contours, abrupt cropping, and spatial contraction of Japanese prints certainly influenced Degas and Manet, although in a far from obvious manner and never approaching direct copying.

Impressionism: A Different Form of Realism

The label "Impressionism" was coined by a hostile conservative critic in 1874 when reviewing the first exhibition of an artists' collaborative called the *Société Anonyme des Artistes* (best translated as "Artists, Inc."). We now refer to that show as the first Impressionist exhibition (there would be eight altogether between 1874 and 1886). Like the general public, the writer found the paintings so sketchy that he felt they were just impressions, not finished paintings. Actually, the word impression had already been applied to the Realism of Manet and Degas. It appears in the title of an oil by Claude Monet of the harbor at Le Havre, which he exhibited in the first Impressionist exhibition and called *Impression, Sunrise* (see fig. 25.15) and Monet used the term on occasion when explaining his ideas on art to friends. (See *Primary Source*, page 872.)

Impressionism shares with the Realism of Manet and Degas a sketchy unfinished look, a feeling of the moment, and a desire to appear modern. It also presents its subjects matter-of-factly. Many scholars even apply the term Impressionism to the work of Manet and Degas, in part to distinguish their Realism from the earthy, rural Realism of Courbet and Millet and to indicate how Impressionism often shares with them a sense of the urbane and the modern. Like Manet and Degas, the Impressionists were interested in recording the transformations occurring in French society, especially the leisure activities of the nouveau riche. While they, too, painted city scenes and genre, they focused more on the evolution of the sleepy rural villages surrounding Paris into bustling suburbs containing factories, commercial wharves, and railroad trestles, on the one hand, and restaurants, regattas, and boating for Parisian weekenders on the other. Rather than the figure, the Impressionists focused more on landscape and cityscape, and instead of constructing their compositions in the studio using models, they worked empirically, outdoors, where they recorded the landscape and weather conditions that they witnessed as an evanescent moment. They painted not so much objects as the colored light that reflected off them. In effect, they painted what they saw, not what they knew.

CLAUDE MONET The leader in developing Impressionism was Claude Monet (1840–1926), who was raised in Le Havre in Normandy. He studied with an accomplished local landscape painter, Eugène Boudin (1824–1898), who worked outdoors. But in order to get financial support from his grocer father, Monet was forced to study in Paris, and chose the academically minded but liberal painter Charles Gleyre. In the latter's studio he met Auguste Renoir, who along with the much older Camille Pissarro would form the core of the Impressionists. In the early 1860s, Monet was forced to serve in the army in Algeria, and like Delacroix before him (see page 847), he experienced intense light and color that were foreign to the cloud-covered temperate Normandy coast. Throughout the 1860s, Monet and his friends painted the landscape surrounding Paris, meeting Corot and the Barbizon artists, who further encouraged their working outdoors

Lila Cabot Perry (1848?-1933)

From "Reminiscences of Claude Monet from 1889 to 1909"

Perry was an American expatriate painter working in France in an Impressionist vein. Monet did not publicly theorize about art, and Perry's statement gives us one of the best insights into his ideas.

He never took any pupils, but he would have made a most inspiring master if he had been willing to teach. I remember his once saying to me:

"When you go out to paint, try to forget what objects you have

directly from nature. For Monet and his colleagues, however, these plein-air (outdoor) paintings were not small studies but large finished products. Painting rapidly with bold brushwork, they sought to capture light (and the color it carried) as it bounced off objects. Unlike Manet, who added oil to his store-bought paints to make them unctuous, Monet added none or very little, leaving them chalky and allowing color to supersede the plasticity of the paint. Nor did he varnish his finished oils, which would diminish their color. Monet's extensive use of primary and secondary colors, the principal hues on the traditional color wheel, was in part influenced by recent scientific research about color that demonstrated that the intensity of complementary colors (e.g., blue and orange, red and green, and yellow and violet) is before you—a tree, a house, a field, or whatever. Merely think, here is a little square of blue, here an oblong of pink, here a streak of yellow, and paint it just as it looks to you, the exact color and shape, until it gives your own naïve impression of the scene before you."...

He held that the first real look at the motif was likely to be the truest and most unprejudiced one, and said that the first painting should cover as much of the canvas a possible, no matter how roughly, so as to determine at the outset the tonality of the whole....

Monet's philosophy of painting was to paint what you really see, not what you think you ought to see; not the object isolated as in a test tube, but the object enveloped in sunlight and atmosphere, with the blue dome of Heaven reflected in the shadows.

Source: The American Magazine of Art, March 18, 1927

increased when they are placed next to one another. (See *Materials and Techniques*, page 874.)

We can see the effectiveness of Monet's palette in On the Bank of the Seine, Bennecourt (fig. 25.14), painted in 1868 in a village not unlike the many Seine and Oise river locations that Parisians took the train to on summer weekends and where the more affluent built impressive villas alongside rural cottages. The artist works with glaring sun-drenched whites and bright blues and greens accented with touches of red and yellow. Objects in shadow, such as leaves and grass, retain color and do not go black. Browns are not muddy but a light-filled tan. Monet maintains the strength of his colors by keeping the imagery close to the picture plane, not allowing it to suggest depth. As with Manet, there is no

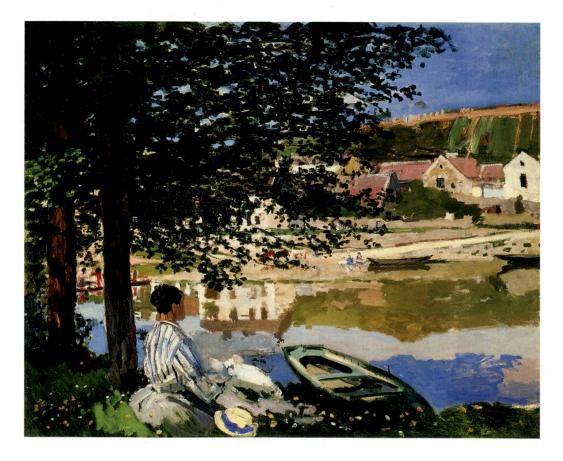

25.14 Claude Monet, On the Bank of the Seine, Bennecourt. 1868. Oil on canvas, $32\frac{1}{8} \times 39\frac{5}{8}$ " (81.6 × 100.7 cm). The Art Institute of Chicago. Mr. and Mrs. Potter Palmer Collection. 1922.427

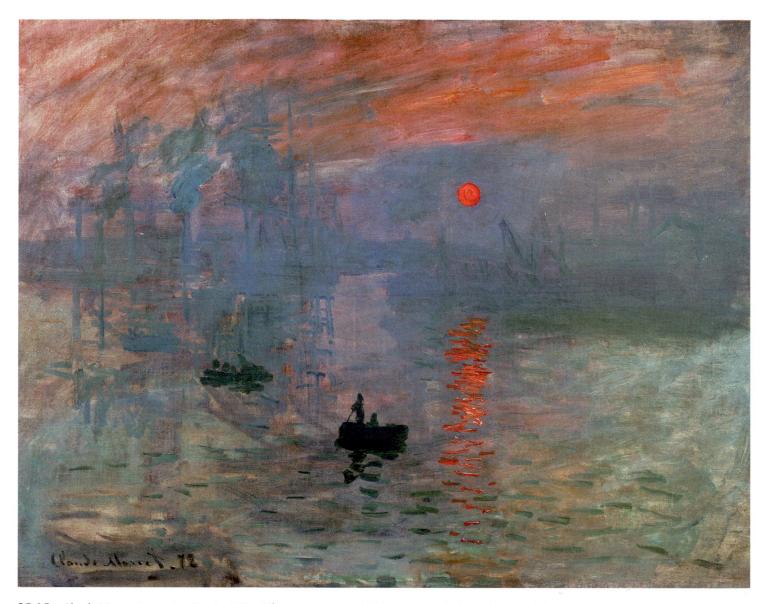

25.15 Claude Monet, Impression, Sunrise. 1872. Oil on canvas, 19 × 24 3/8" (48 × 63 cm). Formerly Musée Marmottan

chiaroscuro to model forms. The tree foliage is a two-dimensional silhouette, while the blue sky behind is equally flat. The reflection of the house on the water runs up and down the picture plane, reinforcing the two-dimensionality of the broad smears of light and dark blue in the river just below. The solid blue sky is virtually the same shade as the darker blue in the water, a correlation that momentarily pulls the sky to the foreground. The only motif that suggests depth is the rowboat running diagonally back in perspective. Also asserting the surface of the canvas is Monet's bold, variegated brushwork, which changes character from one object to the next and gives the picture a shimmering quality that suggests we are witnessing a split second in time.

Equally important, contemporaries realized the brushwork represented the unstable, rapidly changing qualities of modern life. These pictures looked nothing like previous landscapes; they lacked the Classical look of Claude Lorrain, the Baroque conventions of the Dutch landscape painters and their earthy palette, and the emotional constructions of the Romantics. Their very appearance was considered modern, as was their subject matter. We can safely assume that the fashionably dressed woman (Monet's wife) is meant to represent a vacationing Parisian who has been boating.

If in a work like On the Bank Monet painted with a range of colors, he was also capable of restricting his palette, as in Impression, Sunrise (fig. 25.15) of 1872, the work that spawned the name of the Impressionist movement. In this fog-shrouded view of the harbor at Le Havre in the early morning, we see Monet basically using only two colors, the complements blue and orange. Blue prevails, defining water and ships with their tall masts, while orange is restricted to the rising sun, the fiery sky, and reflections on the water. Instead of a symphony of color, we now get a single powerful note of orange playing off the blue ground. Monet titled the picture Impression instead of naming it after the port because, as he himself said, "it really couldn't pass for a view of Le Havre." Sunrises and sunsets were popular themes with artists and were prevalent at the Salons, but they were usually dramatic Romantic events set in a landscape or over

Impressionist Color Theory

mpressionism was more than just the result of a Realist premise based on spontaneously and empirically capturing color and light on canvas. Scientific discoveries, technical developments, and mundane practicalities also went into the evolution of the style. One of these was the development of the theory of color by chemist Michel-Eugène Chevreul (1786-1889) that appeared in his 1839 book The Principles of Harmony and Contrast of Colors. Chevreul worked in the dyeing department of the tapestry workshop of Les Gobelins in Paris, and he noticed the intensity of a color was determined not just by the color itself but also by its relationship to a neighboring color. Primary colors (red, yellow, and blue) and secondary colors (green, orange, and violet), which were made by combining two primaries, became stronger when placed next to one another, a relationship he called simultaneous contrast. (Tertiary colors combine two secondaries.) Value contrast, placing a light hue next to a dark one, also affected the power of a color. The greatest intensity came from the juxtaposition of complements-red and green, blue and orange, purple and yellowcolors opposite one another on the traditional color wheel. Place a pure green next to a pure red and the red becomes redder and the green greener, the energy of each color escalating to the point where they seem to vibrate and "pop."

Eugène Delacroix was probably the first artist influenced by Chevreul's theories, although he had intuitively developed similar ideas earlier and placed small marks of strong contrasting colors next to one another (see page 847). However, the Impressionists were the first to work principally with primary and secondary color, though their palette was hardly restricted to just these hues. To maintain color intensity, the Impressionists began working on a primed surface that was light, instead of the traditional somber brown or brownish-red

the sea. It is tempting to see Monet satirizing this Romantic nostalgic imagery in his picture, which eulogizes not so much the glory of nature but rather the dynamic rhythms of a large, commercial port.

Monet's quest in the 1860s and 1870s to capture the dramatic changes brought on by industrialization naturally took him to the great urban center of Paris. Here he pictured such modern icons as the Boulevard des Capucines, one of the new Haussmann avenues located near the Opéra and lined with fashionable apartment buildings and shops, and the Gare Saint-Lazare train shed. In 1876-77, Monet made ten paintings of the shed recording the hustle and bustle of travelers, workmen, and trains (fig. 25.16). It is as though one painting alone was not enough to take in the complexity of energy and activity beneath the glass-covered shed (for a discussion of these train sheds, see page 898), and each view represents a fragment of the constant flux of people, machines, and equipment. Again, we see Monet's variegated brushwork creating a blurry, pulsating world, in which we can make out a workman, passengers, and trains, and on the ground the shadow of the ironwork frame above. In the background, we see a railway trestle (the setting for one of Manet's most famous paintings), ground. Camille Corot pioneered a lighter primed canvas when he started using silver, which helped harmonize his tight palette of greens, silvers, and blues. It is unlikely that any of the Impressionists read Chevreul. But by the 1860s, his theories were common knowledge among many artists interested in color, and in 1867 they were repeated in Charles Blanc's *The Grammar of Painting and Engraving*, along with a discussion of Delacroix's use of simultaneous contrast.

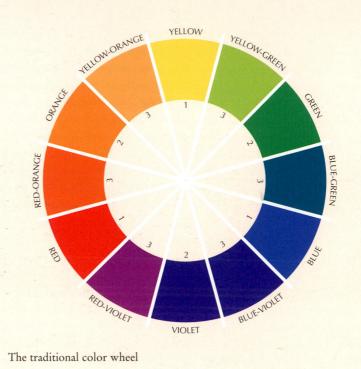

and beyond, the new grand apartment buildings lining a Haussmann boulevard. Monet's haze of color and brushwork softens everything, giving the steel of the tracks, locomotive, columns, and grid of glass roof almost the same ethereal, transitory quality as the charming, blue-shaded puffs of smoke floating upward. The harsh, impersonal, geometric qualities of modernity dissolve in a flood of light and color that virtually transforms this smoke-filled scene of stifling pollution, heat, and noise into a

visual paradise.

AUGUSTE RENOIR After meeting and befriending Monet in Gleyre's studio, Auguste Renoir (1841–1919) also developed an Impressionist style employing bright color, bold paint handling, and modern subjects. Often working beside Monet, Renoir painted landscapes. But he was attracted to the figurative tradition as well, and his career straddles the two genres.

Among his best-known genre paintings is *Luncheon of the Boating Party* (fig. **25.17**) of 1881. The picture is set in the Restaurant Fournaise on an island in the Seine at Chatou, a small village 9 miles (14 km) from Paris's Gare Saint-Lazare. Chatou was especially popular with boaters, and restaurants like this

25.16 Claude Monet, *The Gare Saint-Lazare: Arrival of a Train.* 1877. Oil on canvas, 315/8 × 385/8" (83.3 × 102.8 cm). Harvard Art Museum/Fogg Art Museum, Bequest from the Collection of Maurice Wertheim, Class of 1906, 1951.53

25.17 Auguste Renoir, Luncheon of the Boating Party. 1881. Oil on canvas, $51 \times 68"$ (130.2 × 175.6 cm). Acquired 1923. The Philips Collection, Washington, D.C.

25.18 Camille Pissarro, *Climbing Path, L'Hermitage, Pontoise.* 1875. Oil on canvas, $21\frac{1}{8} \times 25\frac{3}{4}$ " (54 × 65 cm). Brooklyn Museum of Art, New York. Purchased with Funds Given by Dikran K. Kelekian 22.60

catered to Parisians. In the background, on the river, we can just make out sailboats, a rowboat, and a commercial barge. We also get a glimpse of a train bridge.

The restaurant party consists of urban types, with the exception of Alphonese Fournaise, the restaurant owner's son, who leans against the railing, his muscular biceps the result of hauling rental boats into the water. Renoir carefully observes his figures' attire, allowing us to identify each type. The top-hatted man, for example, appears to be more conservative and moneyed (the model was a collector) than the younger men wearing straw boating caps-the models were Renoir's friends. Renoir even presents a range of boating caps, from a citified version worn by the seated figure on the lower right, to a country version on the man on the upper right, to an old-fashioned mariner's cap popular some 20 years earlier, worn by the man to the left of the top-hatted gentleman. The colorful sun-drenched scene of suburban leisure is pleasurable and relaxed, its sensuality enhanced by the lavish spread on the table and the gloriously lush brushwork of the tablecloth. The picture has the momentary quality we associate with Realism, achieved in part by the flickering, feathery brushwork and the asymmetrical composition that runs off the right side of the canvas, the picture being cropped and fragmented like Degas's The Orchestra of the Paris Opéra.

Luncheon of the Boating Party was made shortly before Renoir abandoned Impressionism. Renoir, like several of his colleagues, began to believe the critics' claim that the Realists could not draw

qualities found in the great art of the past. In *Luncheon of the Boating Party*, Renoir began to model his figures and even give distinctive contours to his objects and figures. As we shall see, avant-garde artists in the 1880s would return to many values we associate with Classical art.

and that their art lacked the timeless, monumental, and enduring

CAMILLE PISSARRO Pissarro (1830–1903) was the elder statesman of the Impressionists. A decade older than the others, he came to Paris in 1855 from his native St. Thomas in the Caribbean. During the 1860s, he sought out Corot (see page 847), who advised him, and he also studied the landscapes of Courbet and Charles Daubigny, a famous Barbizon-style artist, who worked outdoors and was especially known for painting landscape from a boat. As much as Pissarro was committed to landscape, he was also dedicated to developing a radical modern art, and by the late 1860s he had arrived at a style that like Monet's was empirical, spontaneous, and used bright color. Unlike Manet, Monet, Degas, and Renoir, he never considered himself a Parisian, and instead lived in the surrounding countryside, which was becoming suburban. While he occasionally painted factories and trains, he was a social anarchist who was dedicated to the people. Peasants and farms, not city dwellers and suburban pleasures, were his preferred subject matter. When in Paris, he socialized with his fellow artists at the Café Guerbois, and not only mentored the younger artists but also served as the arbitrator for Artists, Inc., of which he was a member, participating in all eight exhibitions.

Pissarro was a cautious, intellectual, and deliberate painter, who, like Monet in the 1860s, worked outdoors, where he developed a colorful palette and bold paint handling that captured weather conditions and a sense of fleeting imagery. His compositions were often extremely complex, as seen in Climbing Path, L'Hermitage, Pointoise (fig. 25.18) of 1875, set in Pontoise, a suburb of Paris. Here, in a light-speckled landscape, he places a dense flat screen of trees in front of a deep view back to a village. This peek into the distance is contrasted by the path to the right, which seems to rise up the picture plane rather than recede. While the tree trunks, leaves, and rocks are painted with broad brushwork and bold sweeps of a palette knife that render them as flat, almost abstract objects, the distant houses are constructed in perspective, as dense three-dimensional cubic forms whose solidity contrasts with the flatness of the foreground. While reflecting a Barbizonstyle love of nature and rural life, Pissarro simultaneously emphasized the abstract qualities of picture making, playing flat off solid, straight geometric line off unstructured organic forms, or a deep view through flat trees off a trail that rises up the picture plane. As we shall see, Pissarro's complex, highly structured compositions would have an enormous impact on fellow Impressionist Paul Cézanne, who in turn influenced Pablo Picasso and Cubism.

MANET AND IMPRESSIONISM The landscape styles of Monet, Renoir, and Pissarro resembled one another the most from the late 1860s to the mid-1870s. However, what is called the first Impressionist exhibition in 1874 was not designed to promote a particular style or artistic movement, although most of the 36 artists could be described as painterly and often used bright color, many of them working en plein air. Rather, the exhibition was meant to provide an alternative to the annual Salons. Degas, who participated in most of the exhibitions and was one of the most vociferous in promoting them, repeatedly disclaimed being an Impressionist. His lack of emphasis on color and light certainly separates him from the core group. Manet never exhibited with the Impressionists, holding out for Salon recognition and acceptance into the academy. By the early 1870s, however, he had adopted Impressionist color, and in 1873 was painting outdoors next to Monet in Argenteuil, just outside of Paris, although his paint application remained unctuous and his colors were never quite as intense.

We can see this more colorful palette in his last great Realist masterpiece, *A Bar at the Folies-Bergère* (fig. **25.19**), of 1881–82. Typical of Manet, the picture is rich in ideas and filled with references and hidden meanings, qualities generally not found in Realism or Impressionism. Manet has painted a second-floor bar, overlooking the main floor below, above which we can see the legs of a woman on a trapeze entering the picture in the upper left

25.19 Édouard Manet, A Bar at the Folies-Bergère. 1881–82. Oil on canvas, $37\frac{1}{2} \times 52^{"}$ (96 × 130 cm). The Samuel Courtauld Trust, Courtauld Institute of Art Gallery, London. P.1934.SC.234

corner. Most of the image, however, occurs in a mirror, a flat surface, like a painting, that presents an illusion. The illusion reflected behind the barmaid is that modern life is gay and festive. We see the densely packed sparkling interior of the dance hall that virtually symbolized Parisian nightlife at the time. But the barmaid, who is real, not a reflection, looks out at us with a sad blank expression, suggesting alienation, the reality of contemporary urban life. She, too, appears in the mirror, although her image is distorted, as she leans slightly forward and appears active and engaged. The mirror reveals that she has been approached by a dapper top-hatted gentleman, supposedly intent on buying the sensual drink and fruit at the bar. Some historians suggest he is propositioning the barmaid, citing evidence that some barmaids were also prostitutes and that they were as much an attraction of the Folies-Bergère as the entertainment and general conviviality. This theory would certainly account for the distortion of the barmaid in the mirror, suggesting she has two identities or roles. Regardless of the interpretation, this quiet interaction, removed from the festivity in the mirror, reflects the reality of modern lifeanonymous, arbitrary encounters and urban alienation. The picture also seems to comment on the materialism pervading contemporary values. The Folies-Bergère was very expensive, catering to the well-to-do, and the remarkable still life on the bar captures the lavish richness of the music hall. But despite the illusion of gaiety in the mirror, an emptiness and sadness fills the picture, evoking the inability of money to buy meaningful happiness. But Manet's pictures are often elaborate puzzles, which generally defy a secure reading, remaining open to wide and controversial interpretation.

BERTHE MORISOT Berthe Morisot (1841–1895) was a key figure in the Impressionist circle. Born into a comfortable Paris family, she and her sister Edna took up painting seriously in the late

1850s. Women were not permitted to attend the École des Beaux-Arts, but the sisters studied independently with minor but supportive and knowledgeable artists. When they gravitated toward landscape in the early 1860s, they sought out Corot, who, struck by the quality of their work, met with them often, even giving them one of his paintings to study. Both Morisots had Corot-like landscapes accepted at the Salon of 1864, and Berthe had a figure painting accepted the following year. Edna married in 1869 and stopped painting, but Berthe continued her artistic career.

As a woman, Morisot could not go to the Café Guerbois. She nonetheless became an intimate of and even a favorite within the avant-garde circle, socializing with Manet, Degas, and other Realists at dinners and salons-weekly evening receptions at someone's home, such as the one that Manet's mother hosted. She developed a close friendship with Manet, posing for him in seven paintings and eventually marrying his brother. Morisot's brushwork became looser and her palette brighter. She made landscape and figure paintings, depicting the modern leisure activities of the city, suburbs, and the seashore. Her figures are generally women and children, the models most readily available to her. While her women are fashionably dressed, they are not pretty, frivolous, and mindless; rather, they are meditative and thoughtful, sophisticated, and in control of their image. They are never presented as appendages to men (unlike in Renoir's Luncheon of the Boating Party). We sense Morisot defining a woman's world, one that is as valid and meaningful as a man's.

Morisot's pictures are virtually a catalogue of a well-to-do woman's activities: gathering flowers, taking tea, child-rearing, reading, sewing, and vacationing in the suburbs and by the sea. But undoubtedly what impressed Morisot's avant-garde colleagues was her brilliant technique and finesse: Her bold brushwork magically defined figures and objects while creating an

25.20 Berthe Morisot, Summer's Day (The Lake in the Bois de Boulogne). ca. 1879. Oil on canvas, $17^{13}/_{16} \times 29^{5}/_{16}$ " (45.7 × 75.2 cm). The National Gallery, London. Lane Bequest, 1917

abstract tapestry of paint across the surface of the canvas, a deft balancing act that even Manet had to admire. (The hanging committee for her memorial exhibition at the Durand-Ruel gallery in 1894 consisted of Monet, Degas, and Renoir.) We can see her painterly brilliance in Summer's Day (The Lake in the Bois de Boulogne) (fig. 25.20), which presents the classic Realist/ Impressionist theme of a leisure activity taking place at a trendy venue. Typical of Morisot, the fashionably dressed figures do not interact, but instead are deep in thought, or perhaps are even regarding the scene like a *flâneur*, which was then generally considered the prerogative of a man, not a woman. While the palette is closer to Manet's and Corot's than to Monet's, the scene is a summer's day with light flickering off objects. Morisot enhances the spontaneity created with her brushmarks by using the sort of asymmetrical, cropped composition first developed by Degas.

MARY CASSATT Like Morisot, Mary Cassatt (1844–1926) approached Impressionism from a woman's perspective, her Realism reflecting the social concerns developing within the women's movement of her time. Cassatt was an American. She trained at the Pennsylvania Academy of Art in Philadelphia, where her wealthy family moved from Pittsburg, in part to support her career as an artist, a most unusual attitude for the time. In 1866, she went to Paris and studied with the renowned academician Jean-Léon Gérôme. She also studied in Parma and Rome before returning to Paris in 1874, where she spent the remainder of her life. In Paris, she befriended Degas and abandoned her academic style for Realism. Invited by Degas, she participated in the fourth Impressionist exhibition in 1879. Now, she displayed a bright palette, strong brushwork that hugged the surface, and the compositional devices of asymmetry and cropping.

Like Degas and Manet, Cassatt was a figure painter, and her most famous themes from the late 1870s include women in *loges* at the opera, a subject also treated by Renoir and Degas. She also painted women at home: reading, visiting, taking tea, sewing, or bathing an infant. Like Morisot, she presents the modern sophisticated woman in dress, manners, and leisure activities. In the 1880s, she abandoned her *loge* theme and focused increasingly on domestic scenes, especially of women and children.

Scholars often attribute Cassatt's subject matter to the restrictions she faced as a female: As a respectable woman, she could not go unattended to the same places as her male counterparts. But more at issue was her belief in the importance of women in society, even if this importance was largely restricted to the home. Her views coincided with developments then occurring in the women's movement. In 1878, the International Congress of Women's Rights was held in Paris, and at the top of its agenda was the need for better education for women, which would mean free and compulsory education through secondary school; France enacted this as law in the 1880s. Education would not only allow women to become professionals but also to better manage their homes and families. The congress also focused on the important role that women played in nurturing children, advocating that

25.21 Mary Cassatt, *The Child's Bath.* 1891–92. Oil on canvas, $39\frac{1}{2} \times 26$ " (100.3 × 66 cm). The Art Institute of Chicago. Robert S. Waller Collection. 1910.2

mothers should nurse and care for their offspring rather than hiring wet nurses. This position reflects the increased importance sociologists placed on the care of children in general in the 1870s, which in part stemmed from a concern about the high infant mortality rate in Europe, especially in France. The path to a healthier society and nation, many argued, began in the home and was in the hands of the mother who nurtured her own children, both physically and emotionally, including attending to hygiene.

Cassatt's many domestic scenes of mothers tending their children, such as *The Child's Bath* (fig. **25.21**) of 1891–92, came out of this context. The pitcher and basin may seem quaint and old-fashioned to us today (only America had widespread indoor plumbing at this point), but regular bathing was a modern phenomenon for late nineteenth-century Paris, when people generally bathed only once a week. Not only is the picture about health, but also about intense emotional and physical involvement, as is reflected in the sensual yet tender manner with which the mother touches the child.

25.22 Claude Monet. Wheatstack, Sun in the Mist. 1891. Oil on canvas, $25\% \times 39\%$ " (65 cm × 100 cm). The Minneapolis Institute of Arts. Gift of Ruth and Bruce Dayton, The Putnam Dana McMillan Fund, The John R. Van Derlip Fund, The William Hood Dunwoody Fund, The Ethel Morrison Van Derlip Fund, Alfred and Ingrid Lenz Harrison and Mary Joann and James R Jundt

The picture contains all the ingredients we associate with Realism-the fashionable bourgeois décor and dress, the bright colors, and the sense of spontaneity in the brushwork and the skewed composition with its high viewpoint. The style of the picture reflects Cassatt's intense attraction to Japanese prints at this point in her career, an interest that is reflected in the overhead viewpoint as well as in the boldness of her forms and contours. Cassatt was also influenced by Renaissance art. Her palette has a chalky softness resembling tempera, and the strong line-defining contours have the same crispness as is found in fifteenth-century Italian painting. Many of Cassatt's presentations of a mother and child resemble Renaissance depictions of the Madonna and Child, an allusion that sanctifies the important role of women in creating a better society. But it also reflects the direction that Realism took after 1880, as many artists, as we saw in Renoir's Luncheon of the Boating Party, began to make a more monumental art that recalled the Classical art of the past.

MONET IN THE 1890S By the time the last Impressionist exhibition took place in 1886, any cohesiveness the core group had possessed was long gone, replaced by new concerns and styles. Manet's death in 1883 symbolically marks the death of the Realist movement that began with Courbet in the 1840s. Monet,

however, would live well into the twentieth century, and, while never abandoning the Realistic premise for his art and his commitment to Impressionism, he succeeded in making paintings that were among the most abstract of their day. At the same time, they became increasingly dreamlike, visionary, and poetic.

In the early 1890s, Monet began working more regularly in a series format, painting the same subject over and over, as he first did in the Gare Saint-Lazare series. His motifs included wheatstacks, Rouen Cathedral, and a line of poplar trees. The stack paintings came first, and he painted 30 of them, beginning in 1890. His goal was to show the same subject at different times of day and year, and under different weather conditions, believing life is not fixed but in continual flux. Working in a series format meant that the composition remained largely the same from one picture to the next. Again and again Monet painted a two-dimensional triangular wheatstack (occasionally he painted two) superimposed on top of a field in the foreground, with a line of trees, farmhouses, and distant hills at the horizon, and with the sky above. With compositional matters out of the way, Monet concentrated on color, his first love, which he changed from one painting to the next, theoretically to capture changing atmospheric and light conditions but also simply to give himself freer rein to improvise.

In Wheatstack, Sun in the Mist (fig. 25.22) of 1891, Monet used basically two complementary colors, orange and blue, in the haystack, pitting them against each other to make the stack vibrate. The remainder of the image is constructed with primary and secondary colors, similarly placed alongside one another, causing the entire scene to pulsate. Monet's flickering brushwork, now uniform streaks of varying length and direction, increases the shimmering effect and gives his wheatstacks a dreamy, haunting quality. Like the English landscapists Constable and Turner, Monet theoretically focused on capturing atmospheric effects, although it can be argued that because of his interest in color he was not as dedicated to transforming paint into atmosphere. He heavily reworked the Wheatstack canvases in his studio, suggesting that he was not solely dedicated to painting empirically. Critic Gustave Geffroy, in the introduction to the catalogue that accompanied the presentation of the Wheatstack at the Durand-Ruel gallery in Paris in 1891, strongly implied that the series is about experience and not seeing-that the paintings are about Monet's emotional reaction to the stacks and to nature. Geffroy gave the images a poetic reading, describing the stacks in one painting as "glow[ing] like heaps of gems," and in another as "hearth fires." By the 1880s, images of wheatstacks by French painters populated the Salons, the stacks an emblem of the nation's agricultural abundance, and Monet may have thought of the stacks similarly. Scholars have noted that his stacks sometimes echo the silhouetted shape of farmers' cottages lining the distant field, Monet thereby drawing a parallel between the two and paying homage to the farmers whose labor provides for the nation's food. Regardless of any such underlying messages, however, Monet's Wheatstack paintings seem more imaginary than realistic. Despite his claims to the contrary, Monet had moved well beyond the empiricism of 1870s Impressionism to create poetic, visionary images that paralleled the dreamlike fantasy worlds then being created by the Symbolist avant-garde, whom we will meet in the next chapter.

BRITISH REALISM

Realism took a very different form across the Channel, although the word itself was never applied to the art there. In Britain, Positivism produced a detailed naturalism, an intense truth to nature, and an interest in social types. There the Industrial Revolution had an almost 100-year head start over France. Industrialization and urbanization accounted for the poverty and other social ills so familiar to us today from the serialized novels of Charles Dickens (1812-1870), which were typically set in a cruel, corrupt metropolis suffocated by grime and soot. Materialism and greed were rampant. Cheap, ugly mass-produced objects replaced the highly refined handmade products that the aristocracy and upper class had once demanded. No longer were workers highly trained artisans with pride in their work but human machines suffering the drudgery of dawn-to-dusk mindless labor to turn out inferior consumer items with which they had no personal identity. It was precisely these conditions that

gave rise to the most radical of socialist organizations, the Chartists, and gave new energy to Christian socialism, the biblically based belief in community service and in the renunciation or sharing of personal wealth. It was also these conditions that the German political philosopher Karl Marx (1818–1883) and socialist Friedrich Engels (1820–1895) addressed in their *Communist Manifesto*, published in 1848 in England, where they were then living and working. It was artist, educator, writer, art critic, and environmentalist John Ruskin (1819–1900), however, who took the lead in attempting to arrest this decline into industrial hell. After Queen Victoria, he ranks as one of the greatest forces in the Victorian era, his influence extending well beyond Great Britain to mold American taste as well, beginning with the publication of the first of his four volumes of *Modern Painters* in 1843, and continuing with his *Seven Lamps of Architecture* after 1851.

Among Ruskin's most prominent beliefs was the need for contemporary society to aspire to a new spirituality and moral pride, which required adherence to truth and identification with what he considered the divinity of nature. He advocated art education for all social classes, for the working-class producer as well as the bourgeois consumer. He believed art was a necessity, not a luxury, for it molded people's lives and moral values—great art made great people. And by art Ruskin meant not only painting, sculpture, and architecture but also the decorative arts, all of which had to be as handcrafted, beautiful, and sincere as they had been in the Middle Ages.

Ruskin's emphasis on nature and religion marks the beginning of the nineteenth-century search for a simpler life, one that rejected the advances of urbanization and industrialization. As we've seen, Rosa Bonheur and George Sand were at virtually the same moment advocating a return to a "primitive" world—the countryside. For Ruskin, this purer primitive world could be found either in the spirituality of nature or medieval Christianity. By the end of the century, escape from the modern world and the search for the primitive would become dominant themes.

The Pre-Raphaelite Brotherhood

Ruskin championed the Pre-Raphaelite Brotherhood, a secret society started in September 1848 by three students at the Royal Academy School: William Holman Hunt, John Everett Millais, and Dante Gabriel Rossetti, who was the leader and spokesperson. The PRB, as they initially signed their paintings, denounced the art of the Royal Academy and most painting since early Raphael. They found the work decadent in that it clouded truth and fact with a muddy chiaroscuro and placed a premium on such artificial formal qualities as elegant contours or pleasing compositional patterning. Like Ruskin, the PRB abhorred bourgeois materialism and taste. Their heroes were the fifteenth-century Italian and Netherlandish primitives, such as Fra Angelico (see page 531) and Jan van Eyck (see pages 479-85), whose work they perceived as simpler, more direct, and hence sincere in its attempt to represent nature. They also considered this work more spiritual and moral because it was identified with the intensely religious Late Gothic period.

25.23 William Holman Hunt, *The Awakening Conscience*. 1853–54. Oil on canvas, $29\frac{1}{2} \times 22$ " (76.2 × 55.9 cm). Tate Gallery, London

WILLIAM HOLMAN HUNT The most religious of the Pre-Raphaelite Brotherhood was William Holman Hunt (1827–1910), who came from a poor working-class family. His work is characterized by a combination of Victorian moral didacticism and intense naturalism. The Awakening Conscience (fig. 25.23) of 1853–54 was inspired by a passage in Dickens's David Copperfield where David's friend, the simple fisherman Peggoty, goes searching for his beloved Emily, who has run off with an amoral dandy. Hunt tells the tale of one of the thousands of poor women appearing in the Realist literature of the period who perceived prostitution as their only hope of improvement even though it would inevitably lead to ruin. While sitting on her lover's lap and singing a song, a kept woman becomes aware of the lyrics, thinks of her family, and suddenly abhors her sinful situation, from which she must immediately escape. Hunt renders the room, cluttered with the shiny, vulgar products of crass consumerism, with a microscopic attention to detail worthy of Jan van Eyck, whose "Arnolfini Portrait" (see fig. 14.14) entered the collection of the National Gallery in London in 1842. In his review of the 1854 annual academy exhibition, Ruskin described the objects in Hunt's painting as having a "terrible lustre" and a "fatal newness" that reflected "the moral evil of the age." As in the "Arnolfini Portrait," every object seems to function symbolically. The cat chasing the bird under the table reflects the kept woman's position, and the clock approaching high noon denotes that the time left for decisive action is quickly expiring. The background mirror reflects an open window-redemption-since beyond we see the purity, beauty, and spirituality of nature, gloriously bathed in a bright divine light. Biblical warnings appear throughout the image, and on the bottom of the frame is a moralistic passage from Proverbs. The density of objects and figures in the painting

25.24 John Everett Millais, Christ in the Carpenter's Shop (Christ in the House of His Parents). 1849–50. Oil on canvas, 34×55 " (86.4 \times 140 cm). Tate Gallery, London

eliminates the compositional patterning and pleasing aesthetic contours that the Pre-Raphaelites disdained.

JOHN EVERETT MILLAIS The PRB was initially best known for biblical and literary pictures. While the subjects were drawn from a spiritual past, the themes were selected for their parallels with contemporary London and served as moral lessons. This is clear in Christ in the Carpenter's Shop (fig. 25.24), by John Everett Millais (1829-1896) and shown at the Royal Academy in 1850, where it was poorly received. The painting shows Jesus as a young boy in his stepfather's shop being comforted by his parents over a wound to his hand. Virtually every object in the room is a disguised symbol prefiguring the future role of Jesus as Savior. His cut palm anticipates the stigmata, his cousin John the Baptist carries a bowl that prefigures his calling, the flock beyond the door represents the congregation, and the tools on the wall, including the ladder, announce the Crucifixion. Millais's attention to realistic detail was perhaps the most intense of any member of the Pre-Raphaelites. To paint this picture, he went to a carpenter's shop to make studies of wood shavings and the musculature of a woodworker. He painted the sheep from severed heads.

The picture is more than an uncanny re-creation of a genre scene set during Jesus' boyhood. Rather, it is a Ruskinian political and social statement supporting quality workmanship and labor, spirituality being an attribute of hard-working artisans. Further identifying Christ with the working class, Millais depicts dirt beneath Jesus' fingernails, just as Courbet did with his stonebreakers, a detail that especially offended viewers. WILLIAM MORRIS About 1856, two young painters befriended the Pre-Raphaelites: William Morris (1834–1896) and Edward Burne-Jones (1833–1898). Morris would dabble in architecture and become a renowned poet, but his true calling was implementing Ruskin's theories about replacing shoddy mass-produced products with beautifully designed handcrafted ones that, as in the Middle Ages, workers would take pride in producing. After collaborating in 1859 with architects, painters, and designers in the PRB and Ruskin's circle to design and furnish his own house, Morris in partnership with some of these same artists opened a company in 1865, which came to be called Morris & Co. It manufactured beautifully crafted fabrics, wallpaper, tapestries, carpets, tiles, furniture, and stained glass, with Morris himself designing most of the wallpaper and fabrics, a talent that translated easily into the many book designs he also undertook.

The palette and motifs of the Morris company products were organic and Gothic, creating an aura of nature and spirituality. This aesthetic is apparent in the dining room (fig. **25.25**) that Morris designed in 1867 for a new applied-arts museum called the South Kensington Museum, known today as the Victoria & Albert Museum. The gold-ground panels at the top of the wainscoting were painted principally by Morris's good friend Burne-Jones and represent the 12 months of the year, and thus the cycle of life. Because of the gold ground, they evoke the Early Renaissance (see fig. 13.22) and its intense spirituality. Morris's wallpaper, laboriously handprinted from wood blocks, is a flat abstract pattern based on an olive branch. The simple chest, decorated by Burne-Jones and also recalling the early Renaissance

25.25 William Morris (Morris & Co.). Green Dining Room (William Morris Room). 1867. Victoria & Albert Museum, London

with its gold ground, is by the architect Philip Webb, who also designed the ceiling and the frieze above the wallpaper, abstract patterns largely based on botanical sources. As important as the handcrafting was the principle of truth to materials that Ruskin had advocated—that a material cannot be disguised as something it is not. Prefabricated plaster moldings, brackets, and decoration, then especially popular, were not allowed. In-vogue wallpaper mimicking the lush fabric that before the 1840s covered the walls of upper-class homes was condemned. Inferior wood could no longer be painted to resemble the grain of expensive wood. Morris and his collaborators' impact on the applied arts was farreaching, launching what is known as the Arts and Crafts Movement, which soon spread to the United States.

The Aesthetic Movement: Personal Psychology and Repressed Eroticism

While William Morris kept the moral and spiritual program of Ruskin alive with his Arts and Crafts Movement, the Pre-Raphaelite group had dissolved by 1860. Millais, for example, turned to anecdotal genre painting, and not only became a member of the Royal Academy but in 1896, the year of his death, its president. Rossetti, who had not been very productive in the 1850s, meanwhile gravitated toward a visionary, medieval-style art that expressed his own personal psychology, not social morality. Burne-Jones followed Rossetti down this path toward a visionary art that eventually developed into what is known as the Aesthetic Movement. Running through the paintings of both Rossetti and Burne-Jones is an undercurrent of repressed sexuality, a reflection of the strict moral code of Victorian Britain that outlawed even the discussion of sex.

DANTE GABRIEL ROSSETTI Today, Dante Gabriel Rossetti (1828–1882) is best known and most appreciated for his post-Pre-Raphaelite work. As the initial leader and spokesperson for the PRB, his shift away from its principles was significant for it anticipated the direction art was going to take in the closing decades of the century as Realism waned, to be replaced by a personal devotion to portraying strong emotions and imagination. The direct catalyst for this attitude was the poet Algernon Charles Swinburne (1837–1909), who in turn was influenced in the 1850s by the French critic Théophile Gautier. Gautier was a leading advocate of "art for art's sake," a theory maintaining that art's function was first and foremost to be beautiful, to appeal to the senses, and not to project moral values or tell stories. Rossetti came under Swinburne's spell, and the two men even shared a house in Chelsea after Rossetti's wife died in 1862.

This new aesthetic can be seen in Rossetti's *Proserpine* (fig. **25.26**) of 1874. The model was Jane Burden, William Morris's wife, with whom Rossetti was passionately in love, a sentiment she reciprocated. The artist presents her as Proserpine, the goddess abducted by Pluto, god of the underworld. Pluto forced her to eat six pomegranate seeds, which condemned her to spend six months of the year in Hades, the other half being spent above

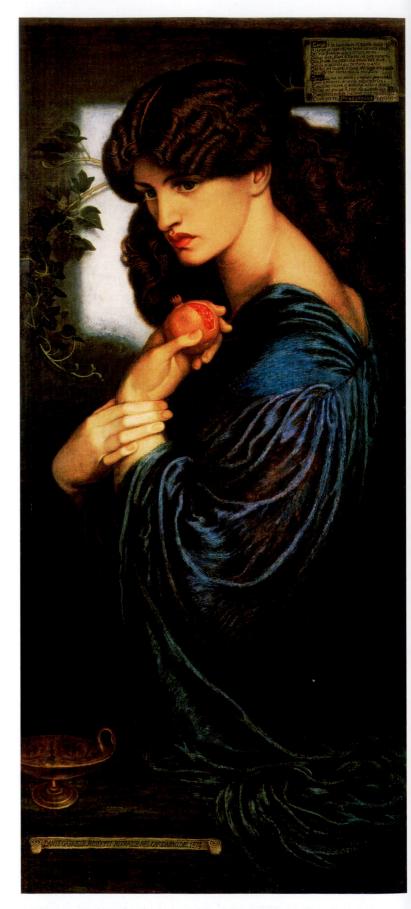

25.26 Dante Gabriel Rossetti, *Proserpine*. 1874. Oil on canvas, $49\frac{1}{4} \times 24$ " (125.1 × 61.0 cm). Tate Gallery, London. Presented by W. Graham Robertson, 1940

James Abbott McNeill Whistler (1834–1903)

From The Gentle Art of Making Enemies

The Gentle Art of Making Enemies (1893) is Whistler's autobiography.

As music is the poetry of sound, so is painting the poetry of sight, and the subject matter has nothing to do with harmony of sound or of color.

The great musicians knew this. Beethoven and the rest wrote

ground with her mother Ceres, goddess of the earth. Rossetti himself provides us with a succinct description of the painting:

Proserpine is represented in a gloomy corridor of her palace, with the fatal fruit in her hand. As she passes, a gleam strikes on the wall behind her from some inlet suddenly opened, and admitting for a moment the sight of the upper world; and she glances furtively toward it, immersed in thought. The incense-burner stands beside her as the attribute of a goddess. The ivy branch in the background may be taken as a symbol of clinging memory.

Rossetti was in part attracted to Burden because of her classic Pre-Raphaelite looks, including her long, elegant neck and hands, and rich, flowing raven hair. Here, she wears a sumptuous Renāissance robe, the folds picking up the curvilinear rhythm of the ivy and her hair, face, neck, back, and hands. She stands behind a table that recalls the ubiquitous ledge found in Italian Renaissance portraiture.

By presenting Burden as Proserpine, Rossetti was expressing how he perceived her as trapped in a cold, loveless marriage with Morris. The picture is ultimately about the artist's own feelings of longing, as expressed in the line from his poem in the upper right, "And still some heart until some soul doth pine." Rossetti, also a serious poet and a translator of the works of his hero Dante, has in effect created a pictorial poem, dominated by the slow sensuous curvilinear surface patterning, the lush deeply saturated robe, and rich, lustrous, flowing hair. While Burden is presented as chaste (their relationship was apparently never consummated) and spiritual, dripping with Renaissance piety, she is also sensual and alluring. Instead of Realism, reality, and social issues, Rossetti has presented us with a torpid dream world filled with his own sexual yearning.

JAMES ABBOTT MCNEILL WHISTLER By the late 1870s, Rossetti was depressive, paranoid, and reclusive, and rarely exhibited. His friend Burne-Jones thus became the standard-bearer for the Aesthetic Movement and showed at the Grosvenor Gallery, a new space dedicated to this new art. But the most famous and notorious proponent of Aestheticism is the American painter music—simply music; symphony in this key, concerto or sonata in that. ...

This is pure music as distinguished from airs—commonplace and vulgar in themselves, but interesting from their associations, as for instance, "Yankee Doodle. ..."

Art should be independent of all clap-trap—should stand alone, and appeal to the artistic sense of eye or ear, without confounding this with emotions entirely foreign to it, as devotion, pity, love, patriotism, and the like. All these have no kind of concern with it, and that is why I insist on calling my works "arrangement" and "harmonies."

Source: James Abbot McNeill Whistler, The Gentle Art of Making Enemies (NY: Putnam, 1925)

James Abbott McNeill Whistler (1834–1903). Raised in New England and Russia, Whistler studied with Charles Gleyre in Paris, where he lived from 1855 to 1859. He met Monet, befriended Courbet, and made his mark as a Realist, painting scenes of contemporary life that captured the underbelly of the city. After moving to London in 1859 (he never returned to America), he continued to spend long periods in Paris, maintaining his Parisian connections and friendships as well as submitting work to the Salons. He knew Gautier through Courbet and Manet, and in London befriended Swinburne.

By 1863, Whistler had abandoned French Realism to pursue Aestheticism, an example of which is his Symphony in White No. I: The White Girl, a title only applied later and probably inspired by Gautier's poem "Symphony in White Major." Whistler submitted the picture to the 1863 Salon des Refusés, where it hung not far from Manet's The Luncheon on the Grass. Like Gautier's poem, which is a complex interfacing of different white visions, the painting orchestrates a range of whites, soft yellows, and reds in a full-length portrait of the artist's mistress Jo, who is dressed in white against a largely white ground. While Gautier and Swinburne influenced Whistler conceptually, visually the artist came under the spell of Japonisme, an influence more clearly stated in Symphony in White No. II: The Little White Girl (fig. 25.27) of 1864. Here, Jo leans on the mantel of Whistler's London home, surrounded by a Japanese blue-and-white vase, fan, and a spray of cherry blossom, often identified with Japan. At one level, the painting is a sensual display of abstract color and shapes. Using thin, delicate brushstrokes and almost transparent layers of paint, Whistler orchestrates a graceful symphony of whites, yellows, reds, pinks, and blues across the picture plane. He plays the softness of his paint and such forms as Jo's dress against the rectangular linearity of the mantel, mirror, and reflected picture frames. The flowers entering the composition on the right are another delicate touch, a Japanese compositional device used earlier by Degas to create fragmentation and spontaneity but here to make the petals seem to float magically.

The painting was conceived as a tribute to Ingres, compositionally echoing his *Portrait of Madame Inès Moitessier* (see fig. 24.14) and acknowledging the great Neoclassicist's ability to create perfect beauty. But in psychology it is closer to Rossetti's

25.27 James Abbott McNeill Whistler, Symphony in White No. II: The Little White Girl. 1864. Oil on canvas, $30\frac{1}{8} \times 20\frac{1}{8}$ " (76.7 × 51.3 cm). Tate Gallery, London

25.28 James Abbot McNeill Whistler, *Nocturne in Black and Gold: The Falling Rocket.* ca. 1875. Oil on panel, $23\frac{3}{4} \times 18\frac{3}{8}$ " (60.2 × 46.8 cm). The Detroit Institute of Arts. Gift of Dexter M. Ferry, Jr.

Proserpine, for Whistler depicts a similarly dreamy, meditative, yet sensual mistress with long flowing hair. Jo's reflection levitates ghostlike in the mirror, an image that inspired Swinburne to write a poem, which Whistler affixed to the back of the canvas.

In the following decade, Whistler's work became increasingly abstract, as in Nocturne in Black and Gold: The Falling Rocket (fig. 25.28) of about 1875. He exhibited the painting in 1877 at the Grosvenor Gallery with seven other ethereal, thinly painted blue-gray nocturnes (a musical term meaning "night scenes") of the Thames River, all meant to support his art-for-art's-sake position. The Falling Rocket is by far the most abstract, to the point that the aging Ruskin accused Whistler of "throwing a pot of paint in the public's face," for which Whistler sued him for slander. The painting is a picture of fireworks at Cremorne Gardens, a popular nightspot in the Chelsea section of London. Although based on real events, the work was nonetheless concocted in the studio according to more subjective dictates. As Whistler explained at the Ruskin trial, "It is an artistic arrangement. That is why I call it a nocturne." As suggested by his titles, which include words such as symphony and sonata as well as

nocturne, Whistler considered painting visual music, declaring it, in essence, abstract. (See *Primary Source*, page 885.) Without the words "The Falling Rocket" in the title, we would be hardpressed to describe an actual subject; we would be left savoring Whistler's abstract display of orange and yellow sprinkles lazily drifting down over a gray-blue-brown ground of gossamer-thin brushstrokes. As in *Symphony in White No. II*, Whistler's surface has a delicate Japanese sensitivity, so refined that shapes and marks barely exist as one color bleeds through the haze of another. With his Grosvenor Gallery exhibition, Whistler moved art into a subjective, nonempirical realm. Unwittingly, he was presenting a preview of the art of the next two decades, as we shall see in the next chapter.

REALISM IN AMERICA

The ripple effect of the European revolutions of 1848 did not reach America, although it did produce waves of new immigrants. A more significant defining benchmark for the United States is the Civil War, which had a devastating physical, psychological, and economic impact on the nation. The Garden of Eden was ravaged. After the war, this metaphor for the country disappeared, displaced by the "Gilded Age," a term coined by Mark Twain and his coauthor for an 1871 book of the same name describing a new page in American history largely dominated by the robber barons, one that brought about tremendous wealth and ostentation. Twain's robber barons were the American speculators, manufacturers, industrialists, real-estate investors, and railway, coal, and iron magnates who made vast fortunes, often exploiting workers. Their new wealth transformed them into an American aristocracy with aspirations to all things European. The robber barons and their families traveled to Europe, brought back European furniture and art, and built European-style villas and chateaux. The result was a nostalgia by many for a more innocent, lost past, one perceived as pre-industrial.

The period is also defined by continued westward expansion, fulfilling what the nation saw as its God-given Manifest Destiny to overrun the North American continent. Survey teams mapped the new territories, and the Transcontinental Railroad, connecting East and West, was completed in 1869. By 1890, the government had subdued the Native American nations, either by containment in restricted territories or by violent annihilation. It honored Native Americans in 1913 by putting an Indian warrior, in headdress and Greek profile, on the American nickel. The reverse side portrayed the buffalo, also made "extinct" by westward expansion.

Scientific Realism: Thomas Eakins

Thomas Eakins (1844–1916), a Philadelphian, was among the earliest and most powerful Realist painters in America. His scenes of the modern world included not only middle-class leisure activities and the popular sports and pastimes of post-Civil War America but also surgery clinics portraying surgeons as modern heroes

25.29 Thomas Eakins, *Max Schmitt in a Single Scull (The Champion Single Sculls)*. 1871. Oil on canvas, $32\frac{1}{4} \times 46\frac{1}{4}$ " (82 × 117.5 cm). Metropolitan Museum of Art, New York. Alfred N. Punnett Endowment Fund and George D. Pratt Gift, 1934. (34.92)

and highlighting new scientific techniques such as anesthesia and antiseptic surgery. Eakins even brought a scientific approach to his Realism, which made it quite different from the Realism of Manet and Degas that he had witnessed while studying with a renowned academician in Paris in the late 1860s.

Among Eakins's first works upon returning to Philadelphia was a series of sculling pictures, such as Max Schmitt in a Single Scull (also called The Champion Single Sculls) (fig. 25.29), an 1871 painting that reflects the rising popularity of the sport and presents Max Schmitt, the winner of a championship race on the Schuylkill River in Philadelphia, as a hero of modern life. While the picture looks like a plein-air painting, what we see is not a quickly recorded Impressionist moment but a painstakingly reconstructed event. Eakins's paintings are grounded in intense scientific inquiry designed to ensure the accuracy of his Realism. He made numerous perspective studies of the skulls and oars, which result in the river receding with breathtaking mathematical precision, firmly locking the boats in space. He studied light effects and anatomy, and, as a teacher at the Pennsylvania Academy of Art, outraged his colleagues and suffered public scorn by having his students, including women, work from the nude model, rather than imitate plaster casts of Classical figures. His quest for Realism drove him to record minute details, including a steamboat and landscape behind the distant bridges, details

beyond the reach of normal vision. (Shortly afterward he would begin using photographs in addition to drawings as preliminary studies.) The second bridge is an emblem of modernity, for it is a railroad bridge, on which we can just make out a train and its puffs of smoke. Eakins's Realism even extends to modern psychology, for Schmitt's isolation in the broad expanse of the river seems a form of alienation, as does his expression of unfamiliarity as he twists to squint at *us*, not Eakins, who is in the scull behind Schmitt.

Iconic Imagery: Winslow Homer

Winslow Homer (1836–1910) was in Paris about the same time as Eakins. He was already disposed toward painting the modern world, for he began his career in 1857 as a magazine illustrator, recording the latest fashions and social activities and later covering the Civil War. He was in Paris in 1866–67, where he saw the work of Courbet, Millet, and Manet, but he was too early to experience the full impact of Impressionism. Upon returning to New York, he painted outdoor scenes of the middle class engaged in contemporary leisure activities, such as playing croquet, swimming at the newest New Jersey shore resorts, and taking horseback tours in the White Mountains of New Hampshire, diversions now accessible by train.

An Artist's Reputation and Changes in Art-Historical Methodology

A change in the methodology of art history can sometimes affect scholars' attitudes toward artists, sometimes resurrecting figures who had once been renowned but had gradually disappeared from the history books. A case in point is the American painter John Singer Sargent (1856–1925). In his day, he was one of the most famous and financially successful artists. He can even be considered the quintessential American artist at that time, for he lived and worked in Europe and his art appeared to embrace the European values that so many *nouveau riche* Americans aspired to emulate.

Sargent was born and raised in Florence, studied at the École des Beaux-Arts in Paris, and by 1879 was winning medals at the Salons. In part due to the encouragement of novelist Henry James, he moved permanently to London in 1886. He made his first professional trip to America in 1887, and immediately became the portraitist to high society, painting William Henry Vanderbilt of New York and Isabella Stewart Gardner of Boston, among others. By 1892, he was the most fashionable portraitist in London and perhaps on the Continent as well. Sargent's success was in part based on the luxuriousness of his imagery—expensive fabrics and furnishings—reinforced by his dramatic sensual brushwork.

Sargent was a proponent of the avant-garde. He befriended Claude Monet and acquired his paintings as well as Manet's. His own work reflects the painterly bravura of Manet, and like Manet he admired Velázquez. He also made numerous Impressionist landscapes and urban views, often in watercolor. Ironically, Sargent fell into oblivion because of the Modernism that evolved in the twentieth century. His consummate handling of paint may have had the abstract qualities that the Modernists admired, but his work was perceived as conservative. It failed to offer anything new. Worse yet, his avant-garde brushwork was carefully packaged in the old-fashioned formulas of society portraiture.

Sargent's reevaluation began in the 1950s, with a renewed appreciation of the paint handling in his Impressionist watercolors. In succeeding decades his reputation gradually inched its way up as Modernism was replaced by Postmodernism and its broader values. (See Chapter 30.) Representational art became fashionable again, and art historians began to appreciate art for the way in which it reflected the spirit of its age. Sargent's portraiture was now perceived as the embodiment of Victorian and Edwardian society and of the Gilded Age.

For example, gender studies, which began appearing in the 1970s, looked at his daring presentation of women, as can be seen in his 1897 portrayal of New York socialite Edith Stokes in *Mr. and Mrs. I. N. Phelps Stokes.* Instead of giving us a demure and feminine woman, Sargent presents a boldly aggressive Mrs. Stokes, who represents the "New Woman" who emerged in the 1890s (see page 904). In a period when the women's movement was fiercely advocating equal rights, many women were asserting their independence and challenging conventional gender roles. This New Woman was independent and rebelled against the conventional respectability of the Victorian era that sheltered women in domesticity. She went out in public; she was

John Singer Sargent, *Mr. and Mrs. I.N. Phelps Stokes.* 1897. Oil on canvas, 84¼ × 39¾" (214 × 101 cm). Metropolitan Museum of Art, New York. Bequest of Edith Mintum Phelps Stokes (MRS. I. N.), 1938. (38.104)

educated; and she was athletic, spirited, and flaunted her sexual appeal. Not only did she wear comfortable clothes, she even wore men's attire, or a woman's shirtwaist based on a man's shirt. Instead of self-sacrifice, she sought self-fulfillment. Sargent presents Edith Stokes as just such a woman, even having her upstage her husband. The placement of her hat over her husband's crotch was especially controversial. For its time, this was a radical presentation of a woman and a reflection not only of the sitter's personality and identification with women's issues, but also of Sargent's willingness to buck portrait conventions and societal expectations.

25.30 Winslow Homer, Snap the Whip. 1872. Oil on canvas, 22¼ × 36½" (56.5 × 92.7 cm). The Butler Institute of American Art, Youngstown, Ohio

Rather than portraying a world in flux, however, Homer created iconic symbolic images of American life and issues, as had Millet of the French peasant. We can see this emblematic approach in his Snap the Whip (fig. 25.30) of 1872. At first glance, this visual record of a children's game appears to be an Americanization of Impressionism, for the image is a sun-filled scene rendered with fairly strong color and flashy passages of brushwork. But Homer's color is not as intense as the Impressionists', nor his brushwork as loose. The picture is not about color and light and empirically capturing a specific moment: This image is frozen. The figures are carefully outlined, modeled, and monumental, their solidity reinforced by the geometry of the one-room schoolhouse and the bold backdrop of the mountain, which parallels the direction of the boys' movement. The barefoot children in their plain country clothes, like the one-room schoolhouse behind them, are emblems of simplicity and wholesomeness, their youth projecting innocence and hope for a recently reunified country. The game itself is symbolic of union, since the chain of boys is only as strong as its weakest link. At a time when the nation was staggering under the weight of the disillusionment brought on by the Civil War and the turmoil of rampant industrialization, Snap the Whip embodied the country's lost innocence and was a nostalgic celebration of values that were quickly fading into memory.

PHOTOGRAPHY: A MECHANICAL MEDIUM FOR MASS-PRODUCED ART

In 1839, photography was commercially introduced almost simultaneously in both France and Britain. As a mechanical process that would eventually lend itself to mass production and popular culture, it was a perfect fit with the Industrial Revolution and seems a natural consequence of it. It was also a perfect tool for the Positivist era, for initially it was largely perceived as a recording device for cataloguing, documenting, and supporting scientific inquiry. It had the appearance of being objective, paralleling the matter-of-fact presentation of much Realism and Impressionism.

The potential for photography had existed since antiquity in the form of the *camera obscura*, a box with a small hole in one end that allowed the entrance of light, projecting an upside-down image of an object outside to be cast on the inside wall at the opposite end of the box. An artist could then trace the projected image. We know that Vermeer and Canaletto, for example, occasionally used a *camera obscura* for their paintings. However, the problem that remained was how to *fix* the image mechanically, that is, how to give it permanence without the intervention of drawing.

First Innovations

In the early eighteenth century, silver salts were discovered to be light-sensitive, but it was not until 1826 that the French inventor Joseph-Nicéphore Niépce (1765–1833) made the first photographic image, a blurry view out of his window that required an eight-hour exposure time. He teamed up with artist Louis-Jacques-Mandé Daguerre (1787-1851), who, after discovering the light-sensitive properties of silver iodide and the use of mercury fumes to fix a silver iodide-coated copper plate, unveiled the daguerreotype in 1838. The French government acquired the process and offered it free to the rest of the world, excepting Britain, with whom the French were in fierce economic competition. The invention represented both a nationalistic and imperialistic triumph, for it enabled the French to document not only the monuments of France but of its colonies as well, especially Egypt. And it was also viewed as a "Republican" medium since, unlike painting and sculpture, it was affordable, making portraits available to all social classes.

Meanwhile, in Britain, William Henry Fox Talbot (1800–1877) announced in 1839 that he could fix an image on paper, rather than on metal or glass, and in 1841 he took out a patent for the new negative-positive photograph he called a **calotype**, a salted paper print. Unlike the daguerreotype, which resulted in a single image, the calotype generated endless positive paper prints from one paper negative.

Both the daguerreotype and calotype were displaced in the early 1850s by the simultaneous invention in France and Britain of the **wet-collodion process**. This technique used a very sensitive emulsion, collodion (gun-cotton dissolved in alcohol ether), that cut exposure time to under a second and produced a sharp, easily reproducible negative. However, the process was cumbersome, for it required the photographic glass plate to be both prepared and processed as soon as it had been used. This meant keeping the plate chemically wet at all times and transporting a portable darkroom. At about the same time, Louis-Désiré Blanquart-Évrard (1802–1872) developed the **albumen print**, which used salted egg white on paper, creating a smooth, more refined surface that revealed greater detail with less graininess. For the next 30 to 40 years, photographers used wet-collodion plates for recording images and then printed them on albumen paper.

In 1846, Talbot published a photographically illustrated book, *The Pencil of Nature*, the title being a reference to light, "Nature's pencil," which "draws" on an emulsion-coated surface. (The word *photograph* is from the Greek words for "light" and "drawing.") Here, Talbot framed many of the basic issues that would surround photography well into the future. He not only saw the medium as a *recording* process capable of scientifically documenting the world, but also as an *interpretative vehicle* that would allow for new ways of perceiving and understanding reality, thus permitting artistic vision. Well into the twentieth century, this latter insight did not prevent the general public from viewing photography primarily as a tool for recording truths as well as a symbol of the mechanization of the Industrial Revolution and its accompanying social ills.

Recording the World

By the 1850s, the most prevalent use of photography was for recording the world: people, sights, and objects. These pictures were generally viewed as fact, which is ironic since, as we shall see, photographers could manipulate images in various ways, including the selection of motifs and objects to be included in, or excluded from, a photograph.

PORTRAITURE Americans especially took to photography, which the artist and inventor Samuel Morse (1791–1872) brought back to New York from France just weeks after the French government made it available in 1839. Soon every American city had photography studios offering daguerreotype portraits, and this form of photograph remained popular in the United States long after it had been superseded in Europe by the albumen print. Americans especially loved its wealth of details and simple factuality, which was reinforced by the blunt presentation of the sitter, posed against a plain background that did not detract from his or her physical presence. The daguerreotype could record the most minute details clearly, a clarity that holds up even under a magnifying glass. (Do the same with an albumen print and you get a blur.)

In the daguerreotype portrait of the abolitionist John Brown (fig. **25.31**) taken by Augustus Washington (1820–1875), we can

25.31 Augustus Washington, *John Brown*. ca. 1846–47. Quarter-plate daguerreotype, $3\%_0 \times 3\frac{1}{4}$ " (10 × 8.2 cm). National Portrait Gallery, Smithsonian Institution, Washington, D.C.

25.32 Nadar, *Édouard Manet*. 1870s. Albumen salted paper print, mounted on Bristol board. Musée d'Orsay, Paris

count the hairs on Brown's head, trace the wrinkles on his face and hands, and even inspect the thread holding his buttons on. Unlike most of their European counterparts, American portraitists encouraged their clients to project a personality for their photographs. The photographer here captured Brown, in a stern, determined, and almost confrontational pose, taking a vow and holding what historians believe to be a flag for the Subterranean Pass Way, the name he gave to an "underground railroad" he was planning for transporting runaway slaves north. Washington had the most successful studio in Hartford, Connecticut, but Brown undoubtedly went to him as a fellow abolitionist, which the portraitist, a free African American and political activist, most likely was. But convinced that blacks would never achieve equality during his lifetime, Washington sold his business shortly before the Civil War and emigrated to the Republic of Liberia, meaning "liberty," founded in West Africa as a sanctuary for former slaves, who started arriving there in 1822.

In Europe, the largest portrait studio in the 1850s and 1860s belonged to Adolphe-Eugène Disdéri, whose business was headquartered in Paris but had branches in Madrid and London. His enormous staff churned out formulaic portraits using the same props and settings, often a Classical column and a pompous swag of drapery. These same props are found in royal portraiture (see fig. 21.10), and were now used to fulfill the upwardly mobile social aspirations of Disdéri's bourgeois patrons. In 1854, he increased the popularity of photographs when he invented the **carte-devisite**, a $2\frac{1}{2} \times 4^{"}$ visiting card with the visitor's portrait, which by 1859 were widely collected, a phenomenon called "cardomania."

Among the most celebrated early portraitists of the era was the Parisian Gaspard-Félix Tournachon (1820–1910), known simply as Nadar. He began his career as a journalist and caricaturist and may have taken up photography as an aid in making the lithographic caricatures for his planned compendium of the 1,000 most prominent personalities of the day, which he called *Le Panthéon Nadar*. He began cashing in on the public infatuation with celebrities by mass-producing albumen prints of the famous, in particular writers, actors, performers, and artists of bohemian Paris. His skill as a caricaturist proved invaluable in setting up his shots, enabling him to create incisive portraits that captured the essence of his sitter's mystique.

We can see this skill in Nadar's 1870s portrait of the painter Édouard Manet (fig. **25.32**). Although of bourgeois origin, Manet is not presented as moneyed. The sitter may wear expensive clothes and be seated in a lavish chair, but there is no pretentious Classical column or billowing drapery. Instead the emphasis is on Manet's forceful personality. He has turned his chair around in a businesslike, if not argumentative manner, grasping the top with his right hand, and with a gesture of confidence placing the other hand on his hip. His meticulously trimmed beard and mustache and dapper clothes confirm his renown as a dandy. Nadar, especially noted for his lighting, has backlit Manet's head, making the entire figure seem to thrust forward and reinforcing the intensity of the painter's stare.

VIEWS Along with portraits, views dominated photography, for they allowed people to travel the world without leaving their living room. Fulfilling the French government's vision of documenting its African conquests, Maxime Du Camp (1822-1894), a Parisian journalist, photographed the French territories in Africa and the Middle East, and in 1852 published 125 images in his book Egypt, Nubia, Palestine and Syria. More popular than such albums, which could be quite expensive, were stereocards, which by the 1860s were as prevalent as musical compact disks are today. Stereocards are side-by-side photographs of the same image taken by a camera with two lenses, replicating human binocular vision. When put into a special viewer, the twin flat pictures appear as a single three-dimensional image. To accommodate the tremendous demand for these images, distributing companies stocked as many as 300,000 different stereocards at one time. The quality of the rapidly reproduced prints was generally low, a problem compounded by their 2-by-5-inch size, although larger versions also existed. An awestruck world now slid the cards into their viewers and saw in three dimensions not only the dramatic changes occurring in Europe, such as new buildings, parks, and monuments, but such exotic climes as China, India, and Africa.

Of course, these same stereocards were available in the United States, which was an enormous market. American photographers were mostly preoccupied with documenting their own nation. A

25.33 Carleton Watkins, Yosemite Valley from the Best General View. 1865–66. Albumen print, 16¹/₈ × 20¹/₂"-(85 × 113 cm). The J. Paul Getty Museum, Los Angeles

large contingent of them, like their fellow painters, specialized in landscape, traveling west, often with survey teams, to record the sublime wilderness that symbolized the nation. One of the first and most famous of this group is Carleton Watkins (1829-1916), who beginning in 1861 made hundreds of glass stereographic views of Yosemite along with some 1,000 18-by-22-inch albumen prints. Despite his strong commercial sense, Watkins thought of his work as art, not documentation. Originally from Oneonta, New York, he went west to San Francisco with the Gold Rush in 1851, eventually making daguerreotype portraits and photographically documenting land for surveys. Hearing about the visual wonders of Yosemite, he took off in 1861 to photograph this awesome, primeval landscape. In order to capture the vast scale of the land, he felt it was necessary to make large prints, and consequently he developed a mammoth camera that used large glass plates. He then set off in a covered wagon with a ton of equipment, which included wet-glass plates and a darkroom to process them immediately after they were exposed.

The results, as seen in *Yosemite Valley from the Best General View* (fig. **25.33**), made on a second trip to Yosemite in 1865–66, were so breathtaking that when shown to President Lincoln they helped convince him to preserve Yosemite as a park. Watkins captures the sublime scale of the American wilderness, the mountain peaks dramatically dwarfing Yosemite Falls, one of the highest waterfalls in America. Watkins produced a lush image by working up extremely rich textures in the developing process and a sense of drama by

creating powerful value contrasts and a composition of forceful diagonals descending from both right and left. To keep the sky from going a monotonous white, which would have happened had he used the proper exposure for the land, Watkins employed a second negative to add clouds. If we take into consideration the degree of manipulation of the camera, including depth of focus, aperture time, the decisions that went into selecting and framing the composition, and the numerous tools used in the darkroom, we can understand why Watkins declared his photographs art, even exhibiting them in 1862 at the prestigious Goupil Gallery in New York.

DOCUMENTATION Photography was also put in the service of categorizing the social types so central to the Positivist mentality. Perhaps the best example of this use of photography is Adolphe Smith's *Street Life in London* (1878), initially issued monthly as illustrated brochures, much like the *physiologies* in France. Smith was the nom-de-plume for Adolphe Smith Headingley (1846–1924), a social activist, who teamed up with photographer John Thomson (1837–1921), who also wrote some of the lengthy text for each social type. As stated in their introduction, they viewed the photograph as an objective tool for validating their descriptions: "[We wish to bring] to bear the precision of photography in illustration of our subject. The unquestionable accuracy of this testimony will enable us to present true types of the London Poor and shield us from the accusation of either underrating or exaggerating individual peculiarities of appearance."

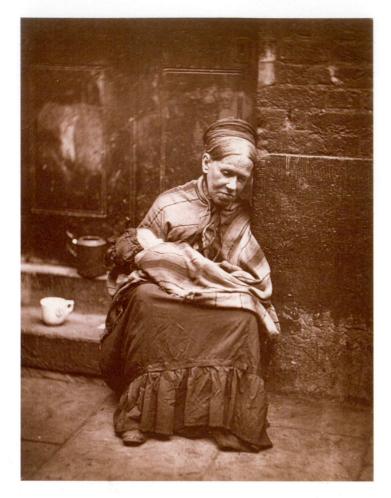

25.34 John Thomson. *The Crawlers*, 1877–78. Woodburytype. Victoria & Albert Museum, London

While most of Thomson's images seem quite objective and unbiased, some, like *The Crawlers* (fig. **25.34**), are powerful and compassionate, making the viewer sympathize with the plight of the poor. Here, a homeless widow minds the child of a working mother. The photo appeared in a brochure called *The Crawlers*, a reference to the indigent street dwellers who occasionally got enough money to buy tea and then, being too weak to walk, crawled to a pub for hot water.

Reporting the News: Photojournalism

Early photography also recorded famous events—a forerunner of photojournalism. Among the most outstanding examples are images of the Civil War, such as *A Harvest of Death, Gettysburg, Pennsylvania, July 1863* (fig. **25.35**) by Timothy O'Sullivan (ca. 1840–1882), who like Watkins became one of the great photographers of the American West. Before setting off to document the Civil War, O'Sullivan began his career as an apprentice to Mathew Brady (1823–1896), owner of the most famous photographic portrait gallery in America, located in New York. (Abraham Lincoln sat for Brady over 30 times and credited Brady's flattering

25.35 Timothy O'Sullivan, A Harvest of Death, Gettysburg, Pennsylvania, July 1863, from Alexander Gardner's Gardner's Photographic Sketchbook of the War. 1866. Albumen print (also available as stereocard), $7 \times 81^{1}/_{6}$ " (17.8 \times 22 cm). Brady Civil War Collection. Library of Congress, Washington, D.C. 1860 albumen print portrait with helping him win that November's presidential election.) In 1862–63, O'Sullivan signed up with the photographic team of Alexander Gardner and contributed 44 images to the album *Gardner's Photographic Sketchbook of the War* (1866). Unlike the banal European photographic images of the 1854–56 Crimean War, the Civil War photographs of O'Sullivan and his colleagues captured the horrific devastation wrought by the American conflict, despite the fact that the exposure time required by their cameras did not permit action pictures.

In A Harvest of Death, we feel the power of the documentary reality of photography, which a painted image can never have. We see real people and real death-images of an actual event on a definite date, the Battle of Gettysburg on July 3, 1863-not a fictitious image. Although we know that the war photographers often moved objects and bodies for the sake of their pictures, there is no evidence to suggest that O'Sullivan did so here. In any case he conveys the grim reality of war. The anonymous corpses are as lifeless as bales of hay waiting to be collected, hence the title. Their dark forms are hauntingly contrasted with the void of the overcast sky. The cropped bodies at right and left add to the brutality of the scene, so convincingly registered with the gaping mouth on the face of the dead soldier in the foreground. The living are pushed deep into the background, shrouded in the morning mist, as though life during this seemingly endless national conflict is itself dissolving into just the barest memory.

Photography as Art: Pictorialism and Combination Printing

Not all nineteenth-century photographers saw the new medium as primarily a tool to document reality. Some viewed it as high art and deliberately explored photography's aesthetic potential, confident it was as valid an art form as painting and sculpture. This attitude, which some critics found threatening (see Primary Source, page 896), was more prevalent in Europe than in America in the first 50 years of photography. Many artists experimented with the camera. Degas, for example, made photographs, although they had no obvious impact on or relationship to his painting, and Eakins used the photograph as he would a preliminary drawing, employing it to establish his compositions, which ultimately do not look photographic. Many painters and sculptors had collections of photographs, especially of models, which were used as source material. Courbet in particular is known to have used photographs from the 1860s for both his figurative paintings and landscapes. Arguments have been made that the look of photographs influenced artists, particularly Realists and Impressionists, but these claims remain controversial.

BRITISH PICTORIALISM In London, a group headed by Oscar Gustave Rejlander (1813–1875), a former painter who has been called "the father of art photography," and Henry Peach Robinson (1830–1901), another former painter who at one time was perhaps the most famous photographer in the world, began

making **composite images** designed to look like Old Master and contemporary paintings. Both artists posed and costumed figures, whom they put in staged settings. To make their final photograph, they would take numerous photographs, producing multiple negatives (Rejlander as many as 30), which they then laboriously arranged in what was basically a cut-and-paste assemblage. The resulting images were often heavy-handed, far from seamless and not at all lifelike. Contemporaries derogatorily referred to them as "patchwork quilts." Their style is called Pictorialism, because the staged images were meant to look like paintings. Despite the fame of its principal practitioners, Pictorialist combination printing did not remain popular.

More successful were those Pictorialists who had a personal aesthetic vision and instead of using multiple negatives used just one, manipulating the camera and printing process to meet their needs. Although far less well known during her lifetime, Julia Margaret Cameron (1815–1879) is perhaps the most celebrated today of the British Pictorialists. Unlike Rejlander and Robinson, she did not use combination printing. Her trademark was an out-of-focus blurring to make her images seem painterly, as seen in *Sister Spirits* (fig. **25.36**) of about 1865. Born in Calcutta and settling on the Isle of Wight in 1860 after the death of her

25.36 Julia Margaret Cameron, *Sister Spirits*. ca. 1865. Albumen print, $127_{16} \times 102''$ (31.6 × 26.6 cm). George Eastman House, Rochester, New York. Gift of Eastman Kodak Company

Charles Baudelaire (1821–1867)

"The Modern Public and Photography," from Part 2 of *The Salon of 1859*

Baudelaire, now known primarily for his poetry, was an important art critic at midcentury and a powerful advocate for artists painting contemporary life.

I am convinced that the badly applied advances of photography, like all purely material progress for that matter, have greatly contributed to the impoverishment of French artistic genius. ... Poetry and progress are two ambitious men that hate each other, with an instinctive hatred, and when they meet along a pathway one or other must give way. If photography is allowed to deputize for art in some of art's activities, it will not be long before it has supplanted or corrupted art altogether, thanks to the stupidity of the masses, its natural ally. Photography must, therefore, return to its true duty, which is that of handmaid of the arts and sciences. ... Let photography quickly enrich the traveller's album, and restore to his eyes the precision his memory may lack; let it adorn the library of the naturalist, magnify microscopic insects, even strengthen, with a few facts, the hypotheses of the astronomer; let it, in short, be the secretary and record-keeper of whomsoever needs absolute material accuracy for professional reasons. ... But if once it be allowed to impinge on the sphere of the intangible and the imaginary, on anything that has value solely because man adds something to it from his soul, then woe betide us!

Source: Art in Paris, 1845-1862, tr. Jonathan Maynes (London: Phaidon Press, 1965)

husband, Cameron soon became an intimate of leading poets and scientists, and a thorn in the side of the photography world when she challenged the supremacy of crisp, focused imagery. Like Rejlander and Robinson, she staged scenes using actors, costumes, and sets, and illustrated such literary sources as the Bible, Shakespeare, and the poet laureate Alfred, Lord Tennyson (1809–1892). Stylistically, her images recall artists as diverse as Rembrandt and Pietro Perugino (see page 553).

Sister Spirits reflects the impact of the Pre-Raphaelites and Aesthetic Movement, in particular their preference for spiritual images set in the Late Gothic or Early Renaissance periods. Her women look as though they have stepped out of a Perugino painting and suggest such saints as Mary and Anne. The two children look like angels, and the sleeping baby like the Christ Child. One can also view the picture as the Three Ages of Woman, since the title suggests that the baby is most likely female. Cameron's blurred foreground is more than just a gimmick to give the image a painterly touch. It also carries psychological and symbolic meaning, for by visually dissolving the flowers and baby, Cameron makes the focused women consciously aware of the undetermined fate of the sleeping infant. Concern, pensiveness, and questioning are registered on the faces, and we sense a spiritual female bonding in this tight grouping of figures, who are closed off in the background as the image again goes fuzzy. While the photograph has soft sensual elements, it does not present women as objects meant for a male viewer, nor as appendages to a male world. Instead it reflects a powerful female vision as it embraces a female spirituality.

Cameron was generally criticized not only for her blurry images, which were attributed to incompetence, but also for the very act of making photographs. As a female photographer in a sexist society, she found it difficult getting men to participate in her Pictorialist photographs, although they would pose for their own portraits. She was criticized for exhibiting her art, which was a rare event for respectable Englishwomen in the Victorian era, and she was admonished for selling her photographs through a major London print dealer—it was deemed inappropriate for women to earn money. By redefining camera focus, Cameron challenged not only what was becoming the normative approach to photographic vision but also a vocation that was specifically male. Ironically, by the end of the century, male photographers would adopt her vision.

COMBINATION PRINTING IN FRANCE In France, one of the most passionate champions of art photography was Gustave Le Gray (1820-1884). Initially a painter, he turned to photography and became one of the medium's technical innovators, being the first to use double printing (using two negatives), which he used to compensate for the bleaching out of the sky in his marine photographs. While he pioneered paper negatives and the wet-collodion process, both of which, as discussed, allowed for finer images and greater detail, his approach to the medium was often quite painterly, focusing on a dramatic contrast of dark and light. To accomplish this, he invented processes that produced extremely fine gradations of tone and one technique that allowed him to develop a print for up to two weeks after it was exposed, during which he could manipulate the image. He also touched up negatives with a brush to alter their tonality and remove objects, and he toned his prints with a solution of gold chloride in hydrochloric acid, resulting in a lush violetpurple quality.

These techniques can be seen in *Brig on the Water* (fig. **25.37**) of 1856, an especially rich albumen print made from two wetcollodion glass negatives, one for the sky, the other for the sea, since at the time sky and sea required very different exposure times. What makes this image so exceptional is the rich range of tones that Le Gray was able to achieve, largely due to his dark-room technique. This technique allowed him to darken the sides of the image to dramatically frame the sea. It also allowed for the rich patterning of the dark clouds, which are contrasted with

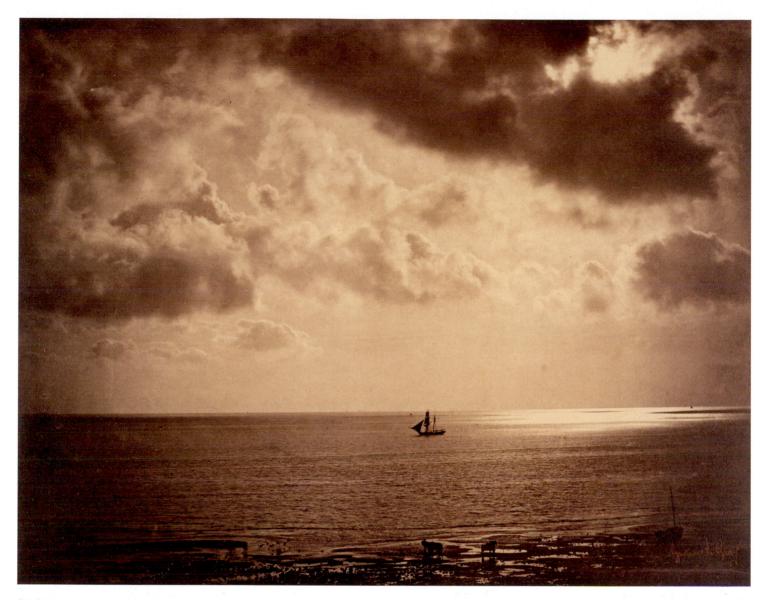

25.37 Gustave Le Gray, *Brig on the Water*. 1856. Albumen silver print from glass negative, $12\frac{5}{8} \times 16\frac{1}{16}$ " (32.1 × 40.8 cm). The J. Paul Getty Museum, Los Angeles. (84.XM.637.2)

lighter clouds in the center. And, finally, it allowed Le Gray to heighten the reflection of the setting sun on the water at the horizon, and to make light flicker among the waves in the foreground. The play of light and dark throughout the image is dramatic and the product of Le Gray's technical finesse. The result is a transcendental seascape where the drama of clouds, light, and sea dwarfing a lone silhouetted boat seems to embody the elemental forces of nature. Not surprisingly, *Brig on the Water* ranked among the most popular photographs of its day, one London dealer even claiming it had "800 copies subscribed for in two months."

Le Gray is believed to have been the first photographer to appear in the graphic-arts section of the Salons. He passionately felt photography was art, writing "the future of photography does not lie in the cheapness but in the quality of a picture....it is my wish that photography, rather than falling into the domain of an industry or of commerce, might remain in that of an art."

ARCHITECTURE AND THE INDUSTRIAL REVOLUTION

Iron was another product of the Industrial Revolution, and its relationship to architecture was as nebulous as that of photography to fine art. Initially, in the late eighteenth and early nineteenth centuries, iron was used for civil engineering, to build bridges and factories. Britain, home of the Industrial Revolution, began massproducing cast iron in 1767 and remained its greatest producer through the first half of the nineteenth century. It led the way in the architectural adaptation of iron, erecting in 1779 the first iron bridge, an arched structure spanning the narrow Severn River at Coalbrookdale. Soon, the metal was used for the columns in textile factories and, by 1796–97, for an entire internal structure.

Revival styles continued to dominate architecture up to the closing decades of the nineteenth century, but the use of iron, while quite limited, freed buildings and civic structures from historicism because form (design) was now determined by the material and by engineering principles, thus setting the stage for the advent of modern architecture—not in Britain but in Chicago—in the 1880s. The pragmatism of iron construction and the blunt presentation of the medium's structural properties parallel the pragmatism and realism of the Age of Positivism.

Ferrovitreous Structures: Train Sheds and Exhibition Palaces

In the early nineteenth century, builders often used cast iron for the columns of Gothic-revival churches, and in the 1830s, with the rise of railroads, they employed it for train sheds as well. The sheds had to span parallel tracks and platforms and be high enough to allow steam and smoke to dissipate. The first of these sheds, London's Euston Station (1835-39), spanned 40 feet. The grandest was London's St. Pancras Station (1863-76), the girded metal arches of which spanned 263 feet (fig. 25.38) and when extended in depth formed the largest undivided enclosed space up to that time. The cast-iron skeleton supported a roof of glass. This combination of iron and glass is often called ferrovitreous (for another example of a ferrovitreous train shed, see the Gare Saint-Lazare as represented in Monet's 1877 painting of the same title, fig. 25.16). Each arch of St. Pancras Station is actually a double arch, one on top of the other, tied together with a truss, a reinforcing structure composed of two or more triangles sharing sides. Known since Roman times when it was used for wood construction and hence by all roof and bridge builders, by 1860 the truss was ubiquitous in metal structures spanning large spaces.

25.38 St. Pancras Station, London. 1863–76. Lithograph. Science Museum, London

As spectacular an engineering feat as a train shed like St. Pancras was, it paled in comparison to the new railway bridges, which had to cross deep canyons and broad rivers. Train sheds were nothing more than small-scale pieces of bridge architecture, the arches girded together to whatever depth was needed. The regularized repetition of arches is itself symbolic of mass production, reflecting the ability of industry to churn out an endless supply of the exact same product at a constant rhythm.

Perhaps the most famous ferrovitreous building of the nineteenth century is the Crystal Palace (fig. 25.39), built in London in 1851 to house the first great international trade fair, the Great

25.39 The Crystal Palace at Sydenham, showing the main dome and entrance from the ornamental gardens and paths; probably by Phillip Henry Delamotte (1820–89). The Victoria & Albert Museum, London. Museum no. 39284

25.40 John and Washington Roebling. Brooklyn Bridge, New York. 1867–83

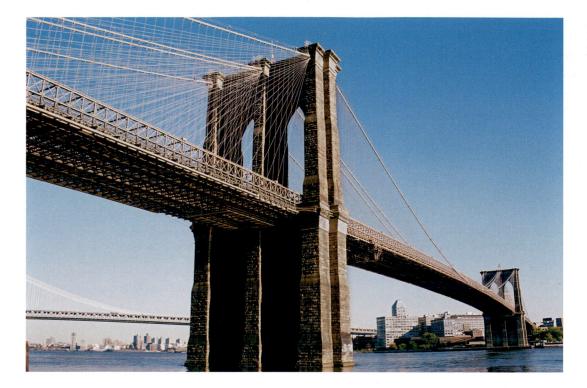

Exhibition of the Works of Industry of All Nations. The fair was designed to showcase the product development, technological advances, agricultural improvements, and fine and applied arts of the new industrial nations, with Britain expecting to shine as the most advanced. The exposition was not just a trade fair but a celebration of Western industrialization. Britain's preeminent greenhouse architect, Sir Joseph Paxton (1801–1865), designed the building and with engineers erected what is essentially a giant greenhouse. While the ferrovitreous materials are the same as in Paxton's earlier greenhouses, the form is not, for it resembles an English cathedral, with a long, barrel-vaulted center nave, a lower barrel-vaulted transept, and stepped-down side aisles. (After the exposition closed, the building was dismantled and moved to nearby Sydenham, where another transept was added. It was destroyed in a fire in 1936.) The building was a cathedral of industry, which had become the new religion. The familiar form and human scale of the building's small component parts, such as panes of sheet glass, must have helped put people at ease within this looming, visionary, 1,851-foot-long structure-its length determined by the year of the exhibition, 1851.

Historic Eclecticism and Technology

The Crystal Palace had a strong technological look, perhaps because it was conceived as a temporary, nontraditional building designed to host an exposition dedicated to technology and industry. Generally, monumental, stately buildings, such as courthouses, theaters, and parliaments, were not built of iron. Instead they were executed in stone and were associational or "representational," designed in a revival style that established a lineage to the Classical, Gothic, or Renaissance past. We saw, for example, how Garnier incorporated elements of the Louvre into the Paris Opéra in order to link Louis Napoleon to Louis XIV. Iron was reserved for industrial buildings, such as train sheds and bridges and enormous food markets (Les Halles, Paris, 1850s) and urban shopping malls (Galleria Vittorio Emmanuele, Milan, 1865–77).

BROOKLYN BRIDGE The need to cloak technology in historic eclecticism is apparent in what is perhaps the greatest spanning structure of the nineteenth century, the Brooklyn Bridge (fig. 25.40), designed by John Roebling (1806-1869) in 1867 and finished by his son Washington Roebling (1837–1926) in 1883. When announced, the bridge was considered a folly; when finished, a wonder of the world. Suspension bridges already existed, but on a much smaller scale, and no one imagined it possible to dig piers in such a deep waterway as New York's East River, to have them rise 300 feet above the water, and then to span the vast distance from Brooklyn to Manhattan while supporting fives lanes of traffic for railroads, carriages, and pedestrians. To accomplish this feat, John Roebling not only used vertical cables attached to the main drooping suspension cables, but also wire cables running from the top of the piers to regular intervals on the bridge, creating triangular units that he considered trusses.

Typical of the taste of the times, the two enormous piers are an eclectic combination of revival styles, with Gothic revival prevailing. In the original plan, however, the piers were Egyptian pylons, a motif retained in the final version only in the gorge moldings where the cables thread the top of the granite structure. As everyone at the time noted, the piers functioned like enormous Roman triumphal arches. The bridge was declared "America's Arch of Triumph," a reference not only to its awesome scale and achievements but also to America's technological superiority.

25.41 Henri Labrouste. Main reading room, Bibliothèque Sainte-Geneviève, Paris. Designed 1842, built 1842–51

BIBLIOTHÈQUE SAINTE-GENEVIÈVE By the 1850s, New York excelled at the production of cast-iron façades, where fiveand six-story buildings, generally used for light manufacturing, were entirely sheathed in skins of iron arches and columns resembling stone. The more monumental and nonindustrial the building, the less likely the overt use of iron. The most innovative use of iron in an important civic structure is in Paris, where the Bibliothèque Sainte-Geneviève was designed in 1842 by Henri Labrouste (1801–1875). The exterior of the library is designed in a Renaissance revival style that evokes Jacopo Sansovino's famous Library of San Marco (1536) in Venice and the Medici Bank in Milan (ca. 1460). The exterior gives no hint of the radical technology displayed within. The main reading room (fig 25.41), located on the second floor, consists of two airy barrel vaults, their columns and arches made of cast iron (the ceiling is mesh-reinforced plaster). Instead of the Italian Renaissance of the exterior, the interior suggests the Gothic, specifically a Romanesque refectory. But to a Parisian, the metal arches would immediately bring to mind the new train sheds, suggesting not only modern life but also a sense of voyage, which indeed is the function of books.

Labrouste did not *need* to use iron in his library: He chose to do so for metaphorical and symbolic purposes. In effect, he was announcing the importance of technology in fashioning a new and better world. This symbolic use of iron even appears in the first-floor entrance, where a dense arrangement of fluted square Classical columns suggesting an Egyptian hypostyle hall supports metal arches resembling modern iron bridges, a reminder to the visitor that books and technology are a bridge to the future.

Announcing the Future: The Eiffel Tower

The most famous iron structure from the period is the Eiffel Tower (fig. 25.42), erected by the French engineer Gustave

Eiffel (1832–1923) in 1887–89 as an entrance to the 1889 Paris International Exposition. To create his tower, Eiffel basically appropriated a trussed **pylon** from the many bridges he had already constructed. At 984 feet high, twice the height of any other structure then in the world, it dominated the city, and because its design was largely determined by its structural integrity rather than adherence to a particular architectural style, it initially affronted Parisians, who declared it an eyesore. The lacework tower was so thin it looked fragile and unstable; Eiffel added arches at the base and organic decoration on the two platforms (removed in the 1930s) to make visitors more comfortable with his radical, visionary structure.

As with the Brooklyn Bridge, however, the public, grasping at the familiarity of the arches at the base, soon came to view the tower as a triumphal arch, one heralding the triumph of French technology and industry. It also saw the tower as a declaration of the triumph of the people: For a pittance, anyone could take the elevator to the upper platforms. Here, common citizens could look down on the churches and palaces, the bastions of tradition and privilege, which the century's continuous march toward democracy had undermined. The Eiffel Tower became a tower of the people and a symbol of Paris, if not France as well. More important, it pointed to the architecture of the next century, one of Modernism that would shed historical references and instead allow style to reflect the nature of the new building materials.

25.42 Gustave Eiffel. Eiffel Tower, Paris. 1887-89

1849–50 Courbet's Burial at Ornans

1863 Manet's The Luncheon on the Grass

1867 William Morris designs Green Dining Room at the South Kensington Museum, today the Victoria & Albert Museum, London

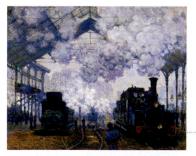

1877 Claude Monet's Gare Saint-Lazare

1892 Mary

Cassatt's The

Child's Bath

1851 Crystal Palace built to house the Great Exhibition of the Works of Industry of All Nations, London

1865 Julia Margaret Cameron's *Sister Spirits*

1872 Winslow Homer's Snap the Whip

1887 Construction begins of Eiffel Tower, Paris, opens 1889

The Age of Positivism: Realism, Impressionism, and the Pre-Raphaelites, 1848–1885

 1830 Auguste Comte begins publishing the multivolume *Positive Philosophy*, establishing sociology

1840

1850

1860

1870

- 1846 Ruskin publishes volume one of *Modern Painters* 1848 Karl Marx and Friedrich Engels publish *The Communist Manifesto*
- 1848 European-wide workers' revolutions 1848 Seneca Falls Convention, Seneca, New York, first women's rights convention in the United States 1850 Frederic Church's Twilight in the Wilderness
 - 1852 Hausmann begins redesign of Paris, ends 1870
- 1852 Louis Napoleon, nephew of Napoleon I, proclaims himself Napoleon III, emperor of Second Empire
- 1853 Commodore Perry of the United States opens up Japan to trade with the West

· 1856 Jean-Auguste-Dominque Ingres's Portrait of Madame Inès Moitessier

- 1861-65 American Civil War
- 1864 President Lincoln establishes Yosemite as a park
- 1869 First Transcontinental Railroad completed in Promontory Summit, Utah
- 1871 Foundation of Germany and Italy
- 1873 Mark Twain and Charles Dudley Warner publish The Gilded Age
- 1874 First Impressionist exhibition
- 1878 First International Congress of Women's Rights, Paris

1890

1880

Progress and Its Discontents: Post-Impressionism, Symbolism, and Art Nouveau, 1880–1905

HE CLOSING DECADES OF THE NINETEENTH CENTURY presented a cultural dichotomy. On one side were those who optimistically reveled in the wealth, luxury, and technological progress of the industrialized world. On the other were those who perceived these same qualities as signs of decadence, excess, moral turpitude, and a spiritual

decline. Ther former experienced exuberance and pride, the latter despair and anxiety. Depending on one's viewpoint, the period was either the *Belle Époque*, "the beautiful era," or the *fin de siècle*, "the end of the century," immersed in anxiety about impending change. Often associated with the *fin de siècle* is the Decadent movement, a literary fashion that started in France in the 1880s and focused on exotic, bizarre, self-indulgent characters obsessed with leading anti-bourgeois lifestyles of visionary splendor that rejected the rational and the mechanization of modernity. The movement spread throughout Europe in the following decade. In Britain, it was best represented by the writer Oscar Wilde, whose homosexuality, dandified dress, and appreciation for the precious and unusual virtually epitomized the movement.

The end of the century, as well as the 14 years leading up to World War I, indeed constituted a period of unprecedented economic growth and prosperity, nurtured by some 40 years of peace following the 1870 Franco-Prussian War. National consolidation was largely complete, with many countries functioning as republics. Germany and France joined Britain and Belgium as truly industrialized countries, with Germany even leapfrogging over Britain, producing twice as much steel by 1914. The United States was included as well in this exclusive group. Spurred by

Detail of figure 26.29, Victor Horta. Interior stairwell of the Tassel House, Brussels

both capitalism and a heated nationalism was a dramatic increase in imperialism, which resulted in the carving up of Africa as well as parts of Asia and the Pacific islands into fiefdoms to be economically exploited.

The modern era, which began in the eighteenth century, now evolved into a new phase called modernity, often labeled the "New Industrial Revolution." The steam engine was refined and improved. Electricity, the telephone, the internal combustion engine, gasoline, automobiles, submarines, airplanes, moving pictures, and machines increasingly defined modern life, whose pace quickened even as it became, at least for many, more comfortable and efficient. In 1901, Guglielmo Marconi sent a wireless signal across the Atlantic, further shrinking the globe.

The late nineteenth century saw a dramatic increase in a sense of European superiority. Despite the sharp political divisions arising from nationalism, Europeans and such European-linked countries as the United States, Canada, Australia, and New Zealand shared a similar way of life and attitudes. They felt their world constituted the "civilized" world, and everything—and everyone—else was "backward." Enlightenment philosophy and science, Europeans believed, had reached a climax, creating the most sophisticated and elevated branch of humankind. As never before, Europeans became race-conscious, with whites considering themselves superior. Charles Darwin's theory of evolution, set forth in the *Origin of Species* (1859) and *Descent of Man* (1871), was twisted to reinforce this view of white supremacy. If

Map 26.1 Europe and North America at the end of the nineteenth century

life was a struggle that resulted in the "survival of the fittest" through "natural selection" of the "most favored races," then clearly, it seemed, advanced Western civilization was the "most favored race."

Many cultural anthropologists, however, refused to label any society as better than any other, and found tribal societies to be just as complex as Western civilization. The mores and values of any culture, they argued, were appropriate to its environment and circumstances. And then there were Europeans who found tribal cultures to be superior; lamenting industrialization and suspicious of unchecked progress in the West, they perceived the newly colonized, exploited territories in Africa and the Pacific as unspoiled utopias, havens from the materialistic evils of modern civilization. Continuing the tradition launched by Jean-Jacques Rousseau in the eighteenth century, they viewed these so-called primitive societies as still steeped in nature and thus virtuous and pure, as well as connected to universal spiritual forces.

Modernity also resulted in a renewed search for the spiritual in the closing decades of the century. Anthropologists demonstrated that the rituals, practices, and beliefs of Christianity were not unique at all, but had parallels in tribal cultures and Eastern religions. The strongest expression of this attitude appeared in Sir James Frazer's (1854–1941) multivolume *The Golden Bough*, which even declared that magic and religion were separated by a very fine line. As growing numbers of people fled progress by embracing an intense spirituality, they were drawn to orthodox Western religions as well as to Eastern-inspired practices such as Theosophy and Rosicrucianism. Many were also drawn to animism and the occult, the period witnessing a dramatic increase in the appearance of psychic and spiritual mediums.

The late nineteenth century also marks the rise of psychology. The German physiologist Wilhelm Wundt (1832–1920) transformed psychology from a philosophy to a natural science by basing it on scientific method, which he detailed in his 1874 *Principles of Physiological Psychology*. Meanwhile, the research of the Russian Ivan Pavlov (1849–1936) sparked an intense interest in how human behavior is conditioned by experience and environment. And in Vienna, the neurologist Sigmund Freud began to formulate his theories of the unconscious, publishing his *Interpretation of Dreams* in 1900. This interest in the mind and the elemental forces driving human responses went well beyond the scientific community to permeate popular and high culture, and artists as diverse as Auguste Rodin and Edvard Munch increasingly focused on the unseen forces residing deep within the mind that produced such outward manifestations as sexual urges and anxiety.

Another major influence molding this period was the emergence of the "New Woman": women bent on changing the restrictive laws and conventions of Victorian society. The women's movement, launched in the second quarter of the nineteenth century in both Europe and America, became a powerful force in the last quarter, as women organized and forcefully demanded political, economic, educational, and social equality. By the 1890s, the term "New Woman" had been coined, and the mass media, especially in America, developed a visual image to describe her: She was tall, athletic, and independent, and she rejected the onerous probity of the Victorian era, wearing comfortable, masculine-inspired clothing while also flaunting her sexuality. This New Woman threatened most Victorian men, who viewed her independence as a challenge to their power, preferring women to stay at home, uneducated and without financial independence. Male artists were no exception, and the castrating, dominating *femme fatale* became a popular theme, a visual expression of male fears. At the same time, an increasing number of women artists presented women from a female viewpoint, one that gave them social importance and dignity, as Mary Cassatt and Julia Margaret Cameron had done before (see Chapter 25). These artists broke with the male tradition of depicting women as sex objects or as being defined only by their dependence on men.

In many respects, progress was the watchword of the late nineteenth century, and the force to which artists responded. The vast majority rejected it, seeking a spiritual, utopian, or primitive alternative. The result was a range of styles or movements, chief among them Post-Impressionism, Symbolism, and Art Nouveau. Most of the artists built on the brilliant formal innovations of Manet and the Impressionists and created work that was more abstract than representational. Their art was also highly personal, not reflecting a group vision. Consequently many artists, such as Vincent Van Gogh and Paul Cézanne, cultivated their own distinctive form of mark making. Often their work was visionary, depicting fantasies and dreamworlds, and often it was spiritual, as it sought relief from the crass, empty materialism of modernity and a more meaningful explanation for existence. Many artists found their subject matter in the sanctuary of the Classical, medieval, and biblical past, which the Realists had so fiercely rejected. Even modern architecture indulged in fantasy and spirituality. Art Nouveau, for example, succeeded in freeing architecture from the dominance of the eclecticism of revival styles by creating buildings that eerily resembled strange but marvelous organic forms. At the same time, the great Chicago architects of the 1880s and 1890s developed the first glass and steel skyscrapers and, in the case of Frank Lloyd Wright, complex houses made up of a relentless modern geometry of horizontals and verticals. Still, they often invested their modern buildings and houses with a powerful spirituality that tied them as much to cosmic forces as they did to the constant march of progress. While Realism and Impressionism had sought to capture the essence of the modern world, Post-Impressionism, Symbolism, and Art Nouveau largely struggled to escape it and to provide an antidote.

POST-IMPRESSIONISM

The early twentieth-century British art critic Roger Fry coined the term Post-Impressionism to describe the avant-garde art that followed Impressionism, work that became a springboard that took art in new directions. Each of the Post-Impressionist artists—Paul Cézanne, Georges Seurat, Vincent van Gogh, and Paul Gauguin—developed a unique style. Still, there are artistic conditions that unify the period from 1880 to 1904. The Post-Impressionists rejected the empiricist premises of Realism and Impressionism in order to create art that was more monumental, universal, and even visionary. Post-Impressionists, with the exception of Seurat, also rejected a collective way of seeing, which we found in Impressionism. Instead, each artist developed a personal aesthetic. Like the Impressionists, however, many Post-Impressionists continued to mine Japanese art for ideas. They also maintained the anti-bourgeois, anti-academic attitude of the Impressionists, similarly turning to artists' cooperatives and private galleries to promote their art.

Paul Cézanne: Toward Abstraction

Actually, Cézanne (1839-1906) is of the same generation as the Impressionists, developing his Post-Impressionism in tandem with the rise of that style. Born into a wealthy but socially isolated family in Aix-en-Provence in southern France, he rejected studying law and went to Paris to study art in 1861. He enrolled at a drawing academy, but was essentially self-taught, copying paintings in the Louvre by Delacroix and Courbet, among others. From 1864 to 1869, Cézanne submitted intentionally crude, dark, intensely worked paintings depicting mysterious, morbid, and anonymous orgies, rapes, and murders to the Salon. These works were rejected, as the anti-bourgeois, anti-academic Cézanne knew they would be. In part, they were meant to shock and disgust the jurors. He painted with a palette knife and the dark pigments of Courbet, and he was also inspired by the Romantic imagery of Delacroix as well as the thematic brazenness of Manet. He even painted several Modern Olympias, inspired by Manet's Olympia (see fig. 25.11), one of which he showed at the first Impressionist exhibition in 1874. (He would participate in the first three shows.)

In 1872, Cézanne left Paris for Pontoise and then nearby Auvers at the suggestion of Camille Pissarro (see page 876), who was already living there. The older artist became his mentor, and they bonded in their desire to make an art that stylistically looked modern. He began painting landscapes, occasionally at Pissarro's side. With this steadying influence, Cézanne's emotionalism dissipated, his palette lightened, even becoming colorful, and his compositions took on a powerful structural integrity, which had been suggested in his earlier work but now blossomed. As he would state later in life, he wanted "to make of Impressionism something solid, like the art in the museums."

We can see how he achieved this goal in a work from the next decade, *Mont Sainte-Victoire* (fig. 26.1), painted around 1885 to 1887 in Provence, where the reclusive artist settled in the early 1880s. Typical of Impressionism, this canvas presents a light-filled landscape painted with broad brushstrokes and fairly bright color. The picture seems to shimmer at first, then it freezes. Cézanne has locked his image into a subtle network of shapes that echo one another. The curves and bends of the foreground tree branches can be found in the distant mountain and foothills. The diagonal lines on the edges of the green pastures reverberate in the houses, mountain slopes, and the directionality of the clusters of parallel

26.1 Paul Cézanne, *Mont Sainte-Victoire*. ca. 1885–87. Oil on canvas, $25\frac{1}{2} \times 32$ " (64.8 × 92.3 cm). The Samuel Courtauld Trust, Courtauld Institute of Art Gallery, London. P. 1934. SC. 55

dashlike brushstrokes, perhaps best seen in the green pine needles. Just as the building to the right of the tree has a solid cubic presence, combinations of contiguous flat green pastures and ocher fields cause blocklike forms to emerge from the earth, before they dissolve once again in thin planes of color. A fair number of vertical stresses, often quite minute, are tucked into the landscape and play off strong horizontals to suggest an underlying grid.

Many aspects of the picture can be read in two diametrically opposed ways. There is an Impressionistic flicker, but it is a structurally frozen image. The picture is a deep panoramic view, and yet it is also flat and compressed, for the distant sky sits on the same plane as the foreground tree branches. This conflation is in part due to the tapestry of aligned, off-white brushstrokes that seem simultaneously to encase the pine needles and be woven into the sky. Every brushstroke sits on the surface of the canvas as a flat mark asserting the surface; and yet the strokes overlap one another, causing a sense of space or depth to exist between them. Even line has a dual function, for it can be read as shadow, as on the top of the mountain, making depth happen, or it can be seen as a flat contour. There is a conflict here between figuration and abstraction, for while the picture obviously depicts a real world, we are never allowed to forget that we are looking at flat paint, lines, and patches of color applied to a flat canvas. We can sense the enormous amount of time that went into resolving all of these conflicts and achieving a balance between two- and three-dimensional space. Most pictures took Cézanne years to paint as he meticulously pondered every mark. (See *Primary Source*, page 907.)

In addition to landscape, Cézanne made portraits of acquaintances (never commissions, since his father provided him with a modest income), still lifes, and figure paintings, especially bathers in a landscape, and in every genre we can see the same conflicts and suppression of tension. In his 1879–83 *Still Life with Apples in a Bowl* (fig. **26.2**), we can immediately sense a Chardinesque monumentality (see fig. 22.9). There is a balancing of apples in the compote (stemmed bowl) with those on the dish, and a balancing of the folds of the white cloth with the wallpaper's leaf motif.

Paul Cézanne (1839–1906)

From a letter to Émile Bernard

Bernard had worked with Gauguin to formulate the style of the Pont-Aven School. He began a correspondence with Cézanne after meeting him at Aix-en-Provence in the spring of 1904, when this letter was written.

May I repeat what I told you here: treat nature by the cylinder, the sphere, the cone, everything in proper perspective so that

each side of an object or a plane is directed towards a central point. Lines parallel to the horizon give breadth, that is a section of nature or, if you prefer, of the spectacle that the Pater Omnipotens Aeterne Deus spreads out before our eyes. Lines perpendicular to this horizon give depth. But nature for us men is more depth than surface, whence the need of introducing into our light vibrations, represented by reds and yellows, a sufficient amount of blue to give the impression of air.

Source: Paul Cézanne: Letters, Ed. John Rewald, Tr. Marguerite Kay (London: Bruno Cassirer, 1946)

Everything is framed by the forceful horizontal edges of the table. Each apple has a powerful physical presence as it is built up out of slablike brushstrokes, its form also carefully delineated with a distinct line. The folds of the cloth are equally plastic, their illusionistic tactility reinforced by the concrete presence of parallel bricks of paint. But the picture also has a nervous energy and ethereal flatness: The compote refuses to recede in space because its back lip tips forward. The same is true of the dish. Its edges disappear behind the apples and we have difficulty imagining their connection to each other in space. The tabletop is also spatially disorienting, for it tilts forward and up the canvas rather than moving back into space. The chunks of brushstrokes are obviously flat marks, and they cover the surface with a nervous energy. This energy is epitomized by the strange interior life that the folds of the cloth seem to have. Meanwhile, the wallpaper's leaf pattern momentarily does a reversal as it escapes its twodimensional assignment to take on a three-dimensional life, one as concrete as that of the apples or folds of cloth. Cézanne has abandoned faithfully observed reality to create his own pictorial world, one that adheres to a private aesthetic order and

26.2 Paul Cézanne, Still Life with Apples in a Bowl. 1879–83. Oil on canvas, 17⅓ × 21¼" (43.5 × 54 cm). Ny Carlsberg Glyptotek, Copenhagen, Denmark

26.3 Paul Cézanne, Mont Sainte-Victoire Seen from Bibemus Quarry. ca. 1897–1900. Oil on canvas, $25\frac{1}{2} \times 31\frac{1}{2}$ " (65.1 × 80 cm). The Baltimore Museum of Art. The Cone Collection, Formed by Dr. Claribel Cone and Miss Ette Cone of Baltimore, Maryland. (BMA 1950.196)

acknowledges with every move that art is inherently abstract painting is first and foremost about putting paint on canvas to create an arrangement of line and color.

Cézanne's art became increasingly abstract in the last ten years of his life, as can be seen in Mont Sainte-Victoire Seen from Bibemus Quarry (fig. 26.3), painted from 1897 to 1900. Mont Sainte-Victoire was a favorite motif, almost an obsession, as it appeared in over 60 late paintings and watercolors. The deep vista we saw in the earlier view of the mountain has now been replaced with a more compressed version. The overlapping of representational objects is one of the few devices suggesting depth. Otherwise, the image is an intense network of carefully constructed brushstrokes, lines, and colors that begs to be read as an intricate spaceless tapestry. The foreground trees bleed into the quarry rock, or on the upper right into the sky. The sky in turn melds into the mountain, from which it is distinguished only by the defining line of the summit. No matter how flat and airless, the image, as with any Impressionist picture, paradoxically is also filled with light, space, and movement. Looking at this hermetic picture, we cannot help but feel how the tension and energy of his early romantic pictures were suppressed and channeled into a struggle to create images that balanced his direct observation of nature with his desire to abstract nature's forms. Here is the work of the painter most responsible for freeing the medium from a representational role and giving artists license to invent images that instead adhered to painting's own inherent laws. The Paris gallery Durand-Ruel began exhibiting the withdrawn, unknown Cézanne in the late 1890s, and in 1907, at his death, he had a retrospective at the avant-garde Salon d'Automne exhibition, which had a powerful

influence on contemporary artists, especially Pablo Picasso and Henri Matisse, as we shall see in the next chapter.

Georges Seurat: Seeking Social and Pictorial Harmony

Like Cézanne, Georges Seurat (1859-1891) wanted to make Impressionism more like the great art of the past. He studied briefly in 1878 at the École des Beaux-Arts with a follower of Ingres, and after a year of compulsory military service in Brittany returned to Paris, where he spent the rest of his short life. He set up a studio, where he worked intensively in isolation, and in 1884 he unveiled his new style with a large picture called A Bathing Place, Asnières, which depicts a group of laborers swimming in the Seine in a working-class suburb of Paris, not far from where Seurat grew up. The picture, refused at the Salon, was shown in 1884 at the first exhibition of the Independent Artists, a new artists' cooperative whose shows were unjuried like those of the Impressionists' Artists', Inc. Seurat next participated in what would be the last Impressionist exhibition, in 1886, submitting A Sunday Afternoon on the Island of La Grande Jatte (fig. 26.4). The dates of the two shows are significant, for they mark the end of the Impressionist era and the rise of Post-Impressionism.

La Grande Jatte's roots in the Realism of Manet and in Monet's Impressionist canvases are obvious, since this is a scene of the middle class taking its Sunday leisure on a sunny, colorfilled afternoon. The painting presents a compendium of types that contemporaries would have easily recognized, such as the courtesan, shown walking a monkey, and the boatman, who is the 26.4 Georges Seurat, A Sunday Afternoon on the Island of La Grande Jatte. 1884–86. Oil on canvas, $6'10" \times 101'/4"$ (2.08 × 3.08 m). The Art Institute of Chicago. Helen Birch Bartlett Memorial Collection. 1926.224

sleeveless man smoking a pipe in the left corner. (Seurat's cataloging of types extends to the dogs in the foreground and boats on the Seine.) Seurat renders his figures as icons, for each is silhouetted in profile, frontally, or in a three-quarter view, following the prescription of the famous Roman architect Vitruvius for the arrangement of sculptural figures on temples. Seurat declared that he wanted "to make the moderns file past like figures on Pheidias' Panathenaic frieze on the Parthenon, in their essential form." And this was no idle claim. The 6-by-10-foot canvas was meant to function on the scale of great history painting and be seen in the tradition of Poussin and David. Like a history painter, Seurat made detailed studies for every component of his work, even producing a painting of the landscape alone, before the insertion of the figures, and looking like a stage set.

INFLUENCE OF PUVIS DE CHAVANNES Critics noted that Seurat's *La Grand Jatte* recalls the Classical murals of Pierre Puvis de Chavannes (1824–1898), whose work was so ubiquitous that his fame was widespread by the 1880s. His paintings, such as *The Sacred Grove, Beloved of the Arts and Muses* (fig. 26.5), are set in an idyllic mythical or biblical past where life is serene, bountiful, and carefree. In Puvis's world there is little movement, and

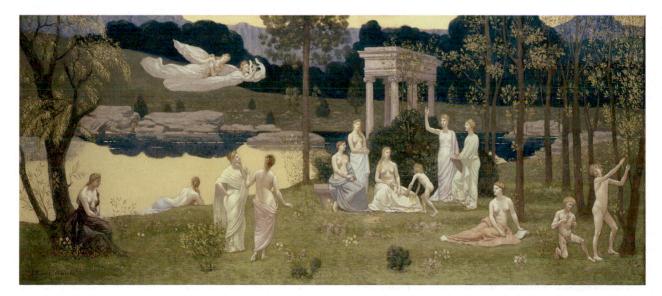

26.5 Pierre Puvis de Chavannes, *The Sacred Grove, Beloved of the Arts and Muses.* 1884. Oil on canvas, $3\frac{1}{2} \times 7\frac{1}{2}$ " (93 × 231 cm). The Art Institute of Chicago. Potter Palmer Collection. 1922.445

certainly no exertion. Without appearing geometric, everything is orderly, either vertical or horizontal, with a soothing planarity bringing everything into harmonious alignment. The decorative flatness evokes ancient murals as well as fourteenth- and fifteenthcentury Italian frescoes. There is a minimum of detail, endowing the picture with a tranquil and unencumbered look. His figures tend to be silhouetted in profile or frontal, and often have an archaic angularity and simplicity that adds to the aura of primitive purity and innocence. Puvis, who emerged from the academic ranks in the early 1860s, provided a startling Classical alternative to Bouguereau (see page 866), although his classicizing, dreamy images often appealed to the same conservative audience. By the 1880s, they would attract the avant-garde as well, which saw in their visionary world and abstract simplicity the same sanctuary from modern life that they too were trying to attain.

SEURAT AND NEO-IMPRESSIONISM As much as Seurat was influenced by Puvis, his agenda could not have been more different, for instead of escaping into a distant past his goal was to create a utopian present, a poetic vision of middle- and workingclass tranquility and leisure. His religion was not just Classicism, but also science. Familiar with the color theory of the American physicist Ogden Rood, he believed that colors were more intense when mixed optically by the viewer's eye rather than on the palette. Consequently, he would build up his paint surface, first laying down a thin layer of a partially mixed local color, over which came a layer of short strokes of related hues, and finally a top layer of equally sized dots of primary and binary color (fig. 26.6). As explained in an 1886 article by Seurat's friend, the art critic Félix Fénéon, this top layer of "colors, isolated on the canvas, recombine on the retina: we have, therefore, not a mixture of material colors (pigments), but a mixture of differently colored rays of light." It does not matter that Seurat misinterpreted Rood and that the claim is not true. Seurat believed his colors were more luminous than the Impressionists', and certainly his technique, which he called "Chromoluminarism" and scholars later labeled

26.6 Detail of fig. 26.4

26.7 Georges Seurat, *Le Chahut*. 1889–90. Oil on canvas, $66\frac{1}{2} \times 54\frac{3}{4}$ " (169 × 139 cm). Rijksmuseum Kröller-Müller, Otterlo, the Netherlands

"Pointillism" or "Divisionism," created a uniform, if vibrant, surface that was a kind of systematized Impressionism. Like the figures, the regularized surface of Seurat's pictures seem mechanical, as though the subjective hand-eye reaction of the Impressionist has been replaced by a machine capable of recording color and light with uniform dots of paint.

In his review of the 1886 Impressionist show, Fénéon labeled Seurat's style Neo-Impressionism—the "New Impressionism" and before the decade was out, it had an army of practitioners who were attracted to its scientific approach, monumentality, and modern look. Many worked well into the twentieth century. As distinctive as the technique is, it would be a mistake to emphasize it at the expense of the meaning of the art. Seurat was a socialist sympathizer and was dedicated to creating a utopia of middleand working-class tranquility and leisure. His socialist vision of a harmonious, perfect world and belief in science as the force to make this happen characterize his method.

Seurat's experimental approach led him to the theories of French psychophysiologist Charles Henry as outlined in his treatise *A Scientific Aesthetic* (1885). Henry claimed that colors, as well as lines, carried specific emotional meaning (e.g., yellow or a

Lithography

rease rejects water. Starting with that principle, Aloys Senefelder, an inspector of maps at the royal printing office in Munich, invented the process of lithography shortly before 1800. Essentially, an artist draws on stone with greasy crayon or ink, called tusche. The stone is then dampened with water, which is absorbed into the porous stone, except where there is tusche drawing. The printmaker next applies printer's ink, which adheres only where there are tusche marks. The stone is then put through a press, and the image is printed in reverse on paper. The process requires such technical proficiency that artists usually work with skilled lithographers who do the technical work and "pull" the prints, that is, they run the paper through the press. A later variation of the process allowed artists to draw with tusche on paper, which was then transferred onto the stone. Artists immediately embraced lithography, and it became one of the most popular print mediums of the nineteenth and twentieth centuries.

Unlike engraving plates (see *Materials and Techniques*, page 501), which wear down with repeated printing and require frequent strengthening of the lines, lithography needs no maintenance, and a seemingly unlimited number of prints could be produced from a single stone. Toward 1830, paper was becoming less expensive and literacy was growing, a combination that increased the medium's appeal to newspaper and magazine publishers, whose print runs were rising. Of the many newspaper illustrators who worked in lithography, Honoré Daumier became the most celebrated (see fig. 25.4).

line rising from a horizontal connotes happiness, while blue or a descending line evokes sadness). Seurat put this theory into practice in the major paintings of his last five years, genre paintings of popular urban entertainment, such as circuses and cabarets. In the joyous and festive Le Chahut (fig. 26.7) of 1889-90, we cannot miss the dominant yellow hue and upward thrusting lines. The scene represents the finale of a cancanlike dance at a nightclub near Seurat's studio, a scene so closely based on reality that the actual performers can be identified, although they, like the audience to either side of the runway, function as a catalogue of types as well. Seurat uses a Degas-like skewered, cropped, and conflated composition, which he then freezes, transforming figures and even furniture, such as the gas lamps, into powerful icons. We can never mistake Seurat's images for Realism; instead he presents an idealized world. His passionate belief in science, technology, and machines as the tools to attain progress and equality will be shared by later generations of artists, especially following World War I.

Henri de Toulouse-Lautrec: An Art for the Demimonde

Paradoxically, Seurat, along with the other Post-Impressionist artists, constituted a new avant-garde that would lead art down a path that made it esoteric and thus incomprehensible for mass audiences. The artist who succeeded in capturing urban exuberance With the development of larger printing presses and the ability to print in several colors, lithography became the preferred medium for posters, which in the closing decades of the nineteenth century began to feature images in addition to words. Advertisers now wanted pictures of their products and strong colors so that their poster would stand out from other advertisements. Artists responded. Large colored lithographic posters began to plaster the sides of buildings, commercial wagons, and omnibuses, reflecting the consumerism overtaking Europe. The art world quickly recognized the aesthetic merits of many such posters, and in 1889 a poster exhibition was mounted for the International Exposition at the Palace of Liberal Arts in Paris. Collectors began buying posters, galleries began selling them, and artists made them with collectors in mind. Today, Henri de Toulouse-Lautrec is among the most acclaimed of the artists who made colored lithographic posters (see fig. 26.8).

and decadence at the close of the nineteenth century for the wider public was Henri de Toulouse-Lautrec (1864–1901). His pictures of the Cirque Fernando were exhibited at the circus, while those of dancehalls, cabarets, and nightclubs (that is, the shadowy nightlife of the demimonde, or fringe society) were shown at those same venues, although he also exhibited with the new artists' cooperatives. His widest impact, however, was made through his large colorful lithographic posters advertising these popular spectacles, which were plastered in public places all over Paris. His images of urban nightlife became the public's perception as well, and his work continues to form our image of *fin-desiècle* Paris. (See *Materials and Techniques*, above.)

Toulouse-Lautrec was a master of caricature, as can be seen in *La Goulue* (fig. **26.8**), which features the popular Moulin Rouge dancer Louise Weber, nicknamed La Goulue (The Glutton), who is credited with creating the French dance the cancan. The Moulin Rouge was a cabaret located in Montmartre, a bohemian neighborhood notorious for its raucous, low-class nightclubs. Lautrec himself settled there after coming to Paris in 1882 from his hometown in the Midi-Pyrénées region of France, where he was born into an aristocratic but not particularly wealthy family. He was crippled by a genetic disease and childhood leg injuries, which resulted in his having a man's torso on a child's legs, and being only 5'1" tall. This handicap did not prevent him from thriving in the thick of the bohemian nightlife of Montmartre, where he was

26.8 Henri de Toulouse-Lautrec, *La Goulue*. 1891. Colored lithographic poster, $6'3" \times 3'10"$ (1.90 × 1.16 m). Private collection

a regular at the clubs and brothels, the subject of his art, before dying of alcoholism at the age of 36.

Toulouse-Lautrec initially studied privately with an academic painter, but embraced the avant-garde upon discovering the art of Degas. In addition, he was heavily influenced by Japanese art. Both sources can be seen in the flat silhouettes, cropping, and conflated space of *La Goulue*, and Degas in the subject matter. But Toulouse-Lautrec is more abstract than Degas, abandoning naturalism for **cartoonish** fantasy and working with a minimum of marks and flat planes of color and line. Unlike Seurat, who creates a three-dimensional monumental world, Toulouse-Lautrec's vision is paper-thin. And it is satirical. With this stripped-down vocabulary, he captures La Goulue's physical exertion as well as her psychological isolation and detachment. He poignantly contrasts the animated La Goulue with the bizarre, zombielike profile of Valentin le désossé ("Valentin the Boneless"), famous for his idiosyncratic dancing. Toulouse-Lautrec is able to succinctly elicit the collective spirit and rhythm of the dancing through the repetition of silhouetted feet, a rhythm picked up by the repetition of the words "Moulin Rouge" above and the three yellow gas lamps. Even the lettering, with its staggered placement and shifts in scale, adds to the beat of the picture, as does the syncopation of the limited color. The floorboards streaking back add to the pace of the image. With minimal effort, Toulouse-Lautrec even tells us much about the shadowy audience, for he has catalogued a range of types by presenting the shapes of their hats. But despite the illusion of gaiety, there is something empty and soulless in this picture, suggested by La Goulue's weary expression, the distorted, if not ominous Valentin le désossé, and the dark anonymous onlookers. Toulouse-Lautrec presents a dissolute world, one he knew all too well, and one that represented the fruit of advanced civilization. This is the decadent fin-de-siècle Paris from which artists like Van Gogh and Gauguin will try to escape.

Vincent van Gogh: Expression Through Color and Symbol

Before becoming a painter, the Dutch artist Vincent van Gogh (1853-1890) had tried his hand at, among other things, preaching and teaching. Drawn to these vocations by his desire for a life both spiritually fulfilling and socially useful, Van Gogh eventually determined that art alone could provide access to the ideal world he sought. After receiving a rudimentary art training, he spent the years 1883 through 1885 painting at the family's vicarage (his father was a pastor) in the village of Nuenen in Holland, where he was deeply affected by the dignity, spirituality, and stolid sturdiness of the impoverished peasants. His major work from this period, The Potato Eaters (fig. 26.9), reflects his compassion and respect for the underclasses, as described in one of the 650 pages of letters he wrote to Theo, his brother: "I have tried to emphasize that these people eating their potatoes in the lamplight, have dug the earth with those very hands they put in the dish, and so it speaks of manual labor, and how they have honestly earned their food. I have wanted to give an impression of a way of life quite different from us civilized human beings." Here, we see Van Gogh's admiration and respect for a simple life based on direct contact with nature as well as his suspicion of bourgeois values and urban modernity. His artistic role models include Millet, whose powerful and sympathetic depictions of peasants are echoed in Van Gogh's, and his countryman Rembrandt, whose tenebrism shrouds this humble, almost ritualistic supper in a reverential cloak. What especially distinguishes this image is Van Gogh's excited expressionism, which gives the picture a raw, crude energy that simultaneously endows the peasants with a surging elemental vitality and reflects the artist's own uncontainable enthusiasm and passion for his subject matter. Gnarled fingers and hands, prominent twisted physiognomies, rippling

26.9 Vincent van Gogh, *The Potato Eaters*. 1885. Oil on canvas, $32\frac{1}{4} \times 45$ " (82×114.3 cm). Vincent van Gogh Foundation/Van Gogh Museum, Amsterdam

folds of clothing, ceiling beams that recede with eruptive force, a clock and a picture of the Crucifixion that seem to jump off rather than hang on the wall—everything explodes within the picture, despite the tranquility of this event of work-weary laborers taking their frugal evening meal. Van Gogh's thick excited marks, which convey his overbearing enthusiasm and compassion, reinforce the powerful physical presence of his peasants.

In 1885, Van Gogh briefly enrolled at the Academy of Fine Arts in Antwerp, where he studied Rubens's paintings and collected Japanese prints, which he admired for their abstract qualities and because of their bright colors and nonindustrial imagery mistakenly believed presented a rural, utopian world. Unhappy in Belgium, Van Gogh then went to Paris to be with his brother, who handled the contemporary painting department at an art gallery. Here, from 1886 to 1888, he experienced Impressionism and Neo-Impressionism first hand, consuming their lessons with the same fervor he applied to everything else. His bold energetic brushwork now carried primary and binary hues and his pictures were filled with color and light. Restless as always, he started hounding fellow painters to join him in starting an artists' commune in the sun-drenched south of France, a "Studio of the South," which he envisioned as an Occidental Japan.

Only Paul Gauguin bought into this dream, and even he only lasted two months, finding Van Gogh's intense troubled personality insufferable. Alone in Arles, Van Gogh thrived in the Provençal landscape, fiercely generating from 1888 to 1889 his strongest body of work, including *Night Café* and *Starry Night*. His intense uncontrollable emotions took over and his painting became increasingly expressionistic, using color and brushwork abstractly to convey emotion rather than to document reality and employing a personal symbolic vocabulary. In *Night Café* (fig. **26.10**), he registered his revulsion at an Arles den of iniquity, claiming he wanted "to express the terrible passions of humanity by means of red and green." This symbolic use of complementary color visually creates a harsh acidic atmosphere, made all the more sour by the jarring range of off-greens that appear on the billiard table, tabletops, bar, ceiling, and even in the waiter's hair. The morbid blood-red of the walls bleeds into the strident floorboards, whose fiery yellow seems to connote hell, not happiness, an aura reinforced by the rays emanating from the gas ceiling lamps.

The personality that prevailed in the majority of Van Gogh's pictures, however, is the one that painted *The Potato Eaters*, the one that belonged to the secular evangelist who celebrated all life and longed for universal harmony. This can be seen in *Starry Night* (fig. **26.11**), painted after the artist committed himself to a mental institution near Saint-Rémy in Provence. Here, we see the inviting hearth-lit homes of plain rural folk, snugly ensconced in a valley, which is pervaded by a spiritual, celestial blue, the same color as the sky, uniting both. The yellow glow from the rectangular windows visually ties the homes with the yellow round stars in the universe above, their contrasting shapes a kind of yin and yang of elemental harmony. An upwardly spiraling cypress tree, filled with life, which it symbolizes, dominates the foreground. Its verticality echoes that of the church steeple, suggesting its spirituality, and both penetrate the fiery, star-filled sky, linking earth

26.10 Vincent van Gogh, Night Café. 1888. Oil on canvas, $8\frac{1}{2} \times 36\frac{1}{4}$ " (72.4 × 92.1 cm). Yale University Art Gallery, New Haven. Bequest of Stephen Carlton Clark, B.A. 1903.1961.18.34

26.11 Vincent van Gogh, *Starry Night*, 1889. Oil on canvas, 28³/₄ × 36¹/₄" (73 × 93 cm). Museum of Modern Art, New York. Acquired through the Lillie P. Bliss Bequest (472.1941)

with the transcendental. The sky is alight with spectacular cosmic fireworks—haloes of stars and joyous tumbling clouds reflect the undulation of the mountains and trees below. There is no mistaking this visionary painting, filled with expressionistic, abstract color and brushwork and personal symbolism, for a Realist or Impressionist picture. Here, Van Gogh created the primitive world and utopia he always dreamed of inhabiting: the peaceful tranquility of simple, unpretentious people, nurtured by nature and in harmony with universal forces. Despite his frenetic output and humanitarian commitment, Van Gogh, deeply troubled, depressed, and suffering from seizures, committed suicide within a year of painting *Starry Night*.

Paul Gauguin: The Flight from Modernity

Paul Gauguin (1848–1903), the fourth of the major Post-Impressionists, shared Van Gogh's distaste for advanced civilization and likewise yearned for a utopian alternative. His abandonment of society, however, was perhaps the most radical of any artist of his time. A Parisian stockbroker, he was attracted to art, collected the Impressionists, and, by the early 1870s, had taken up painting himself. He lost his job in 1882 and began to paint full time. He studied with his friend Pissarro, who introduced him to the work of Cézanne, and participated in the last four Impressionist exhibitions between 1881 and 1886. In 1886, he abandoned Paris to begin a nomadic search for a more meaningful existence, which he believed existed in a simpler society in tune with nature. He first went to the village of Pont-Aven, a remote, rural community in Brittany. Here, locals wore a distinctive regional costume and displayed an intense, charismatic piety.

After briefly leaving Brittany for the Caribbean island of Martinique in 1887, Gauguin returned to Pont-Aven in 1888, where he painted with a colleague, Émile Bernard. They were joined by other artists, who came to be called the "Pont-Aven School." Together they developed a style they called Synthetism, a reference to their synthetic production of images based on imagination and emotion as opposed to a mimetic, empirical replication of reality. In their search to produce an authentic, direct art, as free of civilized influences as possible, they turned to a variety of vernacular and primitive sources, including crude popular illustrations (especially religious) and folk, children's, and medieval art. They were also attracted by what they viewed as archaic styles, such as the fourteenth-century Italian primitives and both Egyptian and Mesopotamian art, art that was not naturalistic. Especially appealing to them were medieval stained-glass windows, because of their spiritual function and saturated colors, and cloisonné enamels, which similarly use curvilinear lead dividers to separate areas of flat color.

The impact of medieval glass and cloisonné is apparent in Gauguin's *The Vision after the Sermon* (fig. **26.12**), where an undulating blue line encases flat planes of color. Gauguin presents a group of Breton women just after they have heard a sermon about

26.12 Paul Gauguin, The Vision after the Sermon (Jacob Wrestling with the Angel). 1888. Oil on canvas, $28\frac{3}{4} \times 36\frac{1}{2}$ " (73 × 92.7 cm). The National Galleries of Scotland, Edinburgh

Jacob wrestling with the angel. The artist attributes to the women a blind, naïve piety that allows them to see spirituality in such mundane objects as a cow, whose shape resembles the two struggling biblical figures the priest has just described. In a bold composition that conceptually comes from Japanese prints (see fig. 25.13), Gauguin places the cow and the wrestlers to either side of a tree, sharply contrasted on an intense mystical field of red. The objects of the women's vision clearly exist in an otherworldly sphere, where they appear to float magically. Everything seems possessed in Gauguin's picture, invested with an unseen religiosity. The string ties on two of the women's caps are animated and snakelike, while the silhouettes of the hats on the two women seen from the back on the right seem to take on a life all their own. Flat, curvilinear forms, and even forms within forms, can be found throughout the image, levitating, just as the cow and the wrestling figures do.

Despite its provincial charm and remove from Paris, Brittany for Gauguin was geographically far too close to modern civilization and its decadent materialism. (Seasonally, it was also overrun with tourists.) In 1891, therefore, he left for the French colony of Tahiti in the South Pacific, convinced that on this remote island he would find Jean-Jacques Rousseau's "noble savage," an elemental, innocent human, "a primitive" steeped in nature and in harmony with the universe. In Tahiti, he also felt he would be able "to go back...as far back as the dada from my childhood, the good old wooden horse." (Dada is French for "rocking horse.") He expected to live in a tropical Garden of Eden, uncovering the most basic truths about human existence. And a Garden of Eden is what he depicts in Where Do We Come From? What Are We? Where Are We Going? (fig. 26.13) from 1897. Fruit hangs from the trees for the picking, while a statue of a god oversees the welfare of the islanders, bestowing blessings and an intense spirituality on every aspect of daily life, while pointing to heaven and the afterlife. The tropical landscape is dense, lush, and sensuous, an abstract tapestry of deeply saturated, flat curvilinear forms in which everything seems to gently float. Life is languorous and untroubled, and time has stopped. When the picture was shown in Paris, critics, not surprisingly, compared it with Puvis's Classical worlds of milk and honey (see page 909).

As the title suggests, the painting represents the three stages of life—birth is pictured on the right, youth in the center, and old age at the far left. The entire painting is a remarkable synthesis of cultures, religions, and periods, testifying to Gauguin's desire to portray the elemental mythic forces underlying all humanity. The center figure is a Tahitian Eve. The statue of the deity on the left is a compilation of the Tahitian goddess Hina, a Javanese Buddha, and an Easter Island megalith. The old woman on the left is derived from a Peruvian mummy Gauguin saw at a Paris ethnological museum. Torsos are twisted so that they resemble Egyptian figures, and the bright gold upper corners with title and signature recall Byzantine and Early Renaissance icons. Pervading the image is the spirituality and look of medieval stained glass, as well as the bold forms and colors of Japanese prints.

Where Do We Come From? is a reflection of Gauguin's belief that the renewal of Western art and civilization as a whole must come from outside its own traditions, which he perceived as being corrupt. He advised other artists to shun Graeco-Roman forms and to turn instead to Persia, the Far East, and ancient Egypt for inspiration. This idea itself was not new. It stems from the Romantic myth of the noble savage and the ideas of the Enlightenment more than a century earlier, and its ultimate source is the age-old belief in an earthly paradise where people once lived, and might one day live again, in a state of nature and innocence. No artist before Gauguin had gone as far in putting this

26.13 Paul Gauguin, Where Do We Come From? What Are We? Where Are We Going? 1897. Oil on canvas, 4'5¾" × 12'3½" (1.39 × 3.74 m). Photograph © Museum of Fine Arts, Boston. Arthur Gordon Tompkins Residuary Collection. 36.270

Paul Gauguin (1848–1903)

From a letter to J. F. Willumsen

The Danish painter J. F. Willumsen was a member of Gauguin's circle in Brittany. Gauguin wrote this letter to him in the autumn of 1890, before his departure for the South Seas.

As for me, my mind is made up. I am going soon to Tahiti, a small island in Oceania, where the material necessities of life can be had without money. I want to forget all the misfortunes of the past, I want to be free to paint without any glory whatsoever in the eyes of the others and I want to die there and to be forgotten there. ... A terrible epoch is brewing in Europe for the coming generation: the kingdom of gold. Everything is putrefied, even men, even the arts. There, at least, under an eternally summer sky, on a marvellously fertile soil, the Tahitian has only to lift his hands to gather his food; and in addition he never works. When in Europe men and women survive only after unceasing labor during which they struggle in convulsions of cold and hunger, a prey to misery, the Tahitians, on the contrary, happy inhabitants of the unknown paradise of Oceania, know only sweetness of life. To live, for them, is to sing and to love. ... Once my material life is well organized, I can there devote myself to great works of art, freed from all artistic jealousies and with no need whatsoever of lowly trade.

Source: The Genesis of Modernism, Ed. Sven Loevgren (New York: Hacker Art Books, 1983)

doctrine of "**primitivism**"—as it was called—into practice. His pilgrimage to the South Pacific had more than a purely private meaning: It symbolized the end of the 400 years of expansion that had brought most of the globe under Western domination. Colonialism, once so cheerfully—and ruthlessly—pursued by the empire builders, was, for many, becoming a symbol of Western civilization's corruption. Gauguin was disappointed to discover that large portions of Tahiti had already been spoiled by colonization, the French absorbing it as a protectorate in 1842 and making it a fully fledged colony in 1880.

SYMBOLISM

CHAPTER 26

Although Gauguin devised the label Synthetism to describe his art, he was soon heralded as a Symbolist. Symbolism was a literary movement announced in a manifesto issued by poet Jean Moréas (1856-1910) in the newspaper Figaro Littéraire in 1886. The poet Charles Baudelaire, author of a book of poems titled Flowers of Evil (1857), was considered a forebear of the movement, and the poets Stephen Mallarmé and Paul Verlaine ranked among its salient representatives. Another poet, Gustave Kahn, succinctly encapsulated the movement's essence when he wrote shortly after the appearance of Moréas's manifesto that the writer's goal was to "objectify the subjective...instead of subjectifying the objective," meaning the everyday, contemporary world was to be rejected, and replaced by one of dreams that abstractly expressed sensations, moods, and deepseated fears and desires. The label was soon extended to the visual arts, and Gauguin's name always topped anyone's list of important Symbolists. Van Gogh, with his expressionist fantasies, was considered a Symbolist as well. In 1891, art critic Georges-Albert Aurier defined Symbolism with five adjectives: "ideal, symbolist, synthetist, subjective, and decorative." Gauguin himself felt compelled to use Symbolist terminology to describe his painting Where Do We Come From? when it was exhibited at Ambroise Vollard's gallery in Paris in 1898. Writing from Tahiti, he stressed the picture was "musical," declaring that it communicated via the abstract qualities of line, color, and form, and not through anecdote. At this time, the rich, chromatic operas of Richard Wagner (1813–1883), filled with intense passion and psychological urges, were the rage in Paris, as they were throughout Europe and America, and they inspired Symbolist writers and painters alike to use abstract means to project powerful emotional yearnings and tap into the most elemental states of mind.

The Nabis

Gauguin's impact was tremendous, and by the 1890s, flat curvilinear organic patterning was ubiquitous. For example, it is the basis for Toulouse-Lautrec's posters, and it is apparent in many of his oils as well. Gauguin was also the formative influence on the Nabis, a secret organization founded in 1888 by young Parisian artists, including Édouard Vuillard and Pierre Bonnard, who were stunned by the novelty and spirituality of Gauguin's Pont-Aven paintings. *Nabi* is Hebrew for "prophet," and as the name suggests, the members immersed themselves in religion of all kinds as well as in the occult and the supernatural.

Although the Nabis broke up by the mid-1890s, Édouard Vuillard (1868-1940), along with Bonnard, developed into a major artist. Abandoning the group's religious thrust, he retained its emphasis on emotion expressed through abstraction, which fellow Nabis member Maurice Denis summed up in a famous quote when he wrote, "A picture-before being a warhorse, a female nude, or some anecdote-is essentially a flat surface covered with colors in a particular order." Reality dissolving into an abstraction of emotion can be seen in Vuillard's small intimate oil of 1893, The Suitor (fig. 26.14). Here, we see the artist's favorite theme, interiors, which are magical, not mundane. He presents his dressmaker mother, his sister, and her husband, a respected painter and member of the Nabis. The real world disappears in a poetry of paint. Lush, dappled brushwork and a subdued but colorful, rich palette create a tranquil, sensuous mood. Tables, chairs, figures, and bolts of fabric are two-dimensional ghosts floating in an enchanting sea of paint, color, and form that embodies the sweet intimacy and languid pace of bourgeois domesticity.

26.14 Édouard Vuillard, *The Suitor (Interior with Work Table)*. 1893. Oil on millboard panel, $12\frac{1}{2} \times 14$ " (31.8 × 35.6 cm). Smith College Museum of Art, Northampton, Massachusetts. Purchased, Drayton Hillyer Fund, 1938. SC. 1938:15.

Other Symbolist Visions in France

Two artists predating Symbolism were embraced by the movement: Gustave Moreau and Odilon Redon. Moreau emerged in the 1860s, and Redon the following decade. Both gained in notoriety when they were featured in Joris-Karl Huysmans's notorious 1884 Symbolist novel À *Rebours (Against Nature)*. Huysmans's protagonist, Des Esseintes, an aristocrat, is a jaded decadent eccentric who leaves Paris and retreats to a remote village. Here, the self-obsessed recluse transforms his house into a strange dreamworld, filled with wondrous objects reflecting his personal dissolute aesthetic. In one famous chapter, Des Esseintes, in order to display his gems, has them affixed to a tortoise, which, heavily laden with the stones, collapses and dies after a few steps. His walls are decorated with prints of artworks by Moreau and Redon.

GUSTAVE MOREAU The imagery of Gustave Moreau (1826–1898) combined exotic Romantic motifs with an unsettling, mysterious psychology set in a supernatural world. In his large watercolor *The Apparition* (fig. 26.15) of about 1876, we see the New Testament tale of Salome being presented with the head of St. John the Baptist. Herod, touched by his stepdaughter's dance at his birthday feast, granted Salome one wish, and at her mother's request, she asked for the Baptist's head. But instead of appearing on a charger, as is traditional, the head, encased in a radiant halo and gushing blood that pools on the floor, magically levitates. We see a bold stare-down between good and evil and between wanton sexuality and stern morality, as suggested by Salome's scant costume and erotic pose and John's stoic, condemning visage. The

decoration and costumes are Near Eastern, and the vast Classical hall dazzles with imperial opulence. Flowers, clothing, columns, and walls are created with minute, gemlike brushstrokes that are reminiscent of Delacroix (see page 843) and make everything sparkle. (Even the palette is Delacroix's.) In Moreau's hands, the story of Salome is not simply illustrated, but becomes a macabre hallucination of sex and death, presented through a dazzling haze of jewel-like marks and a smoldering, golden light.

ODILON REDON Even more visionary and dreamlike are the intense images of another artist claimed by the Symbolists, Odilon Redon (1840–1916). His drawings and prints deliver crepuscular fantasies enveloped in a velvety blurring of black charcoal or lithographic crayon. Among many sources, he especially drew inspiration from the grim, horrifying prints of Goya (see fig. 24.1). Redon's style can be seen in the lithograph reproduced here from an 1878 series dedicated to Edgar Allan Poe (fig. **26.16**). Translated into French by Baudelaire and Mallarmé, Poe's terrifying

26.15 Gustave Moreau, *The Apparition (Dance of Salomé)*. ca. 1876. Watercolor, $41\frac{3}{4} \times 28\frac{3}{8}$ " (106 × 72 cm). Musée du Louvre, Paris. RF 2130

26.16 Odilon Redon, *The Eye Like a Strange Balloon Mounts Toward Infinity*, from the series *Edgar A. Poe.* 1878. Charcoal on paper, $16^{5}/_{8} \times 13^{1}/_{8}$ " (42.2 × 33.2 cm). Museum of Modern Art, New York. Gift of Larry Aldrich 4.1964

psychological tales were popular in France. Redon was inspired by Poe's Romantic mood, but his lithographs do not illustrate Poe directly: They are "visual poems" in their own right, evoking the macabre, hallucinatory world of Poe's imagination. If Goya created very pointed horrific nightmares, Redon envisions nebulous poetic dreams. Things float, glide, and hover, and edges are soft, grainy, and indistinct. Everything in Redon's world is in doubt and in some kind of strange evolutionary flux. Here, a balloon quietly morphs into a hairy eye and parts the sky as it rises up to heaven carrying a head severed at the nose. Below, a primordial plant with pyrotechnic fronds glows against a forbidding dark sea. Connotations of resurrection, transcendence, a rite of passage, life, death, eternity, and the unknown are embedded in The Eye, but the image's narrative meaning remains shrouded in mystery. Instead, what prevails is a troubling psychology and a feeling of frightening uncertainty.

HENRI ROUSSEAU A Symbolist preoccupation with portraying fundamental human urges and the psychology of sexual desire can also be seen in the work of Henri Rousseau (1844–1910), who was essentially self-taught and because of his naïve style is labeled a "primitive painter." A retired customs officer who started painting in the mid-1880s, Rousseau took as his ideal the hard-edged academic style of the followers of Ingres (see fig. 24.13), which in his autodidactic hands took on a charming, simplistic look. He sought inspiration in illustrated books and the botanical gardens in Paris. "When I go into the glass houses [of the botanical gardens] and I see the strange plants of exotic lands, it seems to me that I enter a dream." We see such a dream in this 1910 painting (fig. 26.17), in which he presents a nude woman mysteriously

26.17 Henri Rousseau, *The Dream.* 1910. Oil on canvas, $6'8'_2'' \times 9'9'_2'''$ (2.05 × 2.96 cm). Museum of Modern Art, New York. Gift of Nelson A. Rockefeller

lying on a sofa in a cardboard stage-set fantasy of a playfully colored, luxuriant jungle. Wide-eyed animals stare voyeuristically at her. We assume they are male, as suggested by the phallic orange snake and the musician playing a flute, an overt symbol of masculine sexual desire. Rousseau gives us an image of sexual longing, reinforced by the primordial pull of the jungle with its voluptuous iridescent flowers and fruit and the cosmic glow of a full moon presiding in the sky. Beginning in 1886, Rousseau showed at the Salon des Indépendants (an annual exhibition of independent artists), receiving little recognition during his lifetime. But in 1905, he was discovered by Pablo Picasso and his circle, who admired his naïve paintings for their flatness and abstraction as well as for their creative honesty and directness.

Symbolism Beyond France

Strange dreamlike imagery was not unique to Paris. By the late 1880s, a Symbolist otherworldly aesthetic of fantasy, escapism, and psychology could be found throughout the Western world, including America.

JAMES ENSOR AND LES VINGT In Belgium, Symbolism surfaced in the extraordinarily crude and visually aggressive paintings of James Ensor (1860–1949), who like Gauguin was repulsed by modernity and led a reclusive life above his parents' souvenir shop at the seaside resort of Ostend. In 1877, he enrolled in the Brussels Academy of Fine Arts, lasting three years, even though he described it as "that establishment for the near-blind" and declared, "All the rules, all the canons of art vomit death like their bronze brethren." He identified with socialists and anarchists and, in 1883, helped found in Brussels the counterpart of the Parisian Independent Artists. Called Les Vingt (The Twenty), it offered unjuried exhibitions for a wide range of avant-garde Belgium artists, from Impressionists to Neo-Impressionists to Symbolists. But when the group started showing Whistler, Seurat, and Redon and became international, Ensor, a Belgian nationalist, permanently retreated to Ostend, where he immersed himself in his own world, one of disgust at the pretenses, artificiality, corruption, and lack of values of modern civilization. Turning his back on the cold refinement of academic art, he embraced popular culture, declaring, "Long live naïve and ignorant painting!" His nationalism and loathing of insincere refinement led him to admire the grotesque depictions often found in the work of Breugel and Bosch (see pages 655–58 and 492–93). The carnivals they painted still lived on in Ostend in annual festivals, for which the Ensor souvenir shop sold masks.

Ensor's mature style can be seen in his enormous 14-foot-wide Christ's Entry into Brussels in 1889 (fig. 26.18), painted in 1888 and representing a Second Coming of Christ. Beneath a banner declaring "Long Live Socialism" and swallowed up in the crowd and pushed into the background is a diminutive Christ on a donkey. The crowd wear masks, which reveal as opposed to hide the greed, corruption, and immorality that resides behind the false face of contemporary society. Not only does Ensor appropriate the masks from his parents' shop to give his image a primitive grotesqueness, but he paints everything with a crudeness and distortion we associate with popular art forms-caricature, graffiti, and naïve and children's art. A garish red intensified by its complement, green, hypes the stridency of this repulsive, claustrophobic image. Here, we see the philosophical antithesis of Seurat's genteel La Grande Jatte, which was shown at a Les Vingt exhibition the year before and seen by Ensor. The similar scale of Christ's Entry suggests Ensor's chaotic vision of ubiquitous evil is a sarcastic response to Seurat's Pollyanna rendition of modernity.

26.18 James Ensor, Christ's Entry into Brussels in 1889. 1888. Oil on canvas, 8'6½" × 14'1½" (2.6 × 4.3 m). Collection of the J. Paul Getty Museum, Los Angeles. 87. PA. 96.

26.19 Edvard Munch, *The Scream*. 1893. Tempera and casein on cardboard, 36×29 " (91.4 × 73.7 cm). Munch Museet, Oslo, Norway. (Stolen in May 2003.)

EDVARD MUNCH Much Symbolist painting was influenced by Gauguin's mysterious sinuous patterning and abstraction, as well as by a desire to explore visually the most elemental psychological forces underlying modern civilization. Perhaps no one did this better than the Norwegian painter Edvard Munch (1863–1944), whose style matured in the early 1890s after he spent time in Paris, where he experienced first hand the curvilinear planes of Gauguin's Pont-Aven paintings and the intense brushwork and color of Van Gogh's Arles pictures. His themes, however, could not be more different, for his painting investigated the psycho-logy of sex and the meaning of existence, thus delving into the deepest recesses of the mind, as did the plays of his two Scandinavian friends, the playwrights Henrik Ibsen and August Strindberg.

Munch crafts an image of horrifying anxiety in *The Scream* (fig. **26.19**), painted in 1893 after he had moved to Berlin. Clasping hands to a skull-like head, a grotesquely compressed, writhing figure gives voice to a base fear that appears funneled into it from the oozing, unstable landscape behind. The violent perspective of the uptilted walkway and rapidly receding railing combined with

the thin streaking brushwork elevates the hysteria to a frightening feverish pitch.

The Scream was perhaps in part prompted by the 1883 eruption of the Indonesian volcano Krakatoa, which was so violent it generated the loudest sound heard by any human (the soundwaves traveled 1,500 miles [2,400 km]) and spewed forth ashes that circled the globe, immersing Europe in frightening blood-red or blue sunsets for some six months. After witnessing such an apocalyptic display of color in Christiania (now Oslo), Munch, already in a melancholic mood, wrote in his diary, "I sensed a great, infinite scream pass through Nature."

AUBREY BEARDSLEY While a morbid, fear-of-the-infinite psychology appears in much of Munch's work, perhaps his most prevalent subject is the uncontrollable yearnings of the libido, along with the sexual conflict it produces, especially as expressed by the femme fatale theme. This is a topic that preoccupied contemporary artists and writers. One of the most famous examples is Oscar Wilde's French play Salomé, which launched a vogue for Salome imagery. Wilde, an Irish fin-de-siècle writer and notorious aesthete, rewrote the biblical story. In the New Testament version, Salome asks for John's head at her mother behest. In Wilde's rewrite, she asks for it herself, because the saint spurns her sexual advances. The theme is distinctly sexual passion, with overtones of perversion, and its outrageous, bizarre behavior is characteristic of the sort of material relished by the British decadents. The play was published in French in 1893, with pictures by the British illustrator Aubrey Beardsley (1872–1898), who was in Wilde's circle of decadent writers and artists. In the image reproduced here (fig. 26.20), Salome possessively holds John's severed head, which although dead still projects disdain. His snakelike hair and her octopus coif transform them into a pair of irrational Medusas driven by base hatred. John's blood drips into a dark pool, nourishing phallic plants that, like an insidious vine, slither around Salome. Their nightmarish confrontation takes place in a flat abstract world of curvilinear elegance, one so precious that the line virtually disappears at times as it twists in a sultry rhythm. As we shall shortly see, this plantlike, tendril quality is stylistically characteristic of Art Nouveau (see page 927), an architectural and decorative arts style that emerged in the 1890s. But thematically, the motif is used by Beardsley to reinforce the oppressive decadence of his image.

GUSTAV KLIMT A fascination with organic patterns and the psychological meanings they might convey also pervades the work of Gustav Klimt (1862–1918), whose career unfolded primarily in Vienna. Beginning in 1902, Klimt made a series of paintings centering on the theme of "The Kiss," the best-known version dating from 1907 to 1908 (fig. **26.21**). Although reflecting Klimt's own personal life (the model was his lover), the theme is Symbolist-inspired and relates directly to an 1897 painting by Munch of the same title. (In turn, both pictures were inspired by Rodin's sculpture *The Kiss.*) Munch's image presents a couple in a similarly unified form, but they are a simple dark mass, with the

lovers' faces frighteningly merging as if consuming one another. Klimt's version of the theme with its rich surface patterning shows a faceless lustful male losing his identity as he is lured by passion and consumed by an enticing but indifferent *femme fatale*, who draws him perilously close to the abyss below. (For a discussion of the *femme fatale* theme, see *The Art Historian's Lens*, page 923.)

Formally inspired by the divine shimmer of Byzantine mosaics, which he studied first-hand in Ravenna (see page 256), Klimt cloaks his figures in richly patterned gold-leafed robes and encases them in a halo of bright light. Set on a mountain carpet of wild flowers and floating high above a celestial neverland, the painting simultaneously suggests the beauty and the spiritual pull of passion as well as its fleeting nature and painful consequences. In his intricate designs and shifting surfaces, Klimt hints at the instability inherent in individual subjectivity and social relations.

The Kiss has a strong decorative component, most evident in the lovers' exotic robes. In 1897, Klimt was one of 22 founders and the first president of the Vienna Secession, an avant-garde artists' organization. It was part of a loosely allied international

26.20 Aubrey Beardsley, *Salomé*. 1892. Pen drawing, 11×6 " (27.8 \times 15.2 cm). Aubrey Beardsley Collection. Manuscripts Division, Department of Rare Books and Special Collections, Princeton University Library, New Jersey. Special Collections, Princeton University Library, New Jersey

26.21 Gustav Klimt, *The Kiss.* 1907–08. Oil on canvas, 5'10%" × 5'10%" (1.80 × 1.80 m). Österreichische Nationalbibliothek, Vienna

secession movement that started in Munich in 1892 and spread to Berlin that same year as progressive artists broke ranks with academic institutions. Not only did the Vienna Secession provide an alternative to the conservative academy, but its objectives included showcasing the applied arts and breaking down the hierarchy that placed painting and sculpture at the pinnacle and the decorative arts in the artisanal lower ranks. The secession movements equally embraced photography.

Symbolist Currents in American Art

In the 1880s, a small number of American artists also began to make more ethereal, otherworldly pictures. Today often labeled Tonalists, their imagery was more poetic and music-inspired, in many respects reflecting Whistler's Aestheticism (see page 885). Generally, no American is grouped with European Symbolism. Putting labels aside, however, two artists have strong parallels with the movement: Albert Pinkham Ryder and Henry Ossawa Tanner.

ALBERT PINKHAM RYDER Albert Pinkham Ryder (1847–1917), a somewhat reclusive New York artist, especially later in life, abandoned empirical observation to abstractly express his emotions. Born in New Bedford, Massachusetts, and moving to New York in 1867, he studied at the National Academy of Arts. Rather than the modern world, it was literature that inspired him, in particular works by the medieval English poet Geoffrey

Feminist Art History

t is tempting to view Gustav Klimt's *The Kiss* as just another example of *fin-de-siècle* decadence and indulgence, and a preoccupation with the psychology of sexual urges. But we can begin to read the image in other ways if we ask how this picture and others of its kind from this period present women, recognizing that it was made by a male and reflects male attitudes toward women. Now we can place the picture within the context of the late nineteenth-century feminist movement and the emergence of the New Woman, both of which threatened male dominance. Interestingly, this new approach to interpreting images like *The Kiss* is itself a product of another feminist movement that began late in the twentieth century.

Feminism emerged from the social radicalism of the 1960s, and its effects on the practice of art history were felt almost immediately. Feminist art historians began to reconstruct the careers and examine the work of women artists including Berthe Morisot, Mary Cassatt, Paula Modersohn-Becker, and Käthe Kollwitz. These studies demonstrated that women artists, far from being peripheral oddities, contributed importantly to the nineteenth-century avant-garde. In her groundbreaking essay of 1971, "Why Have There Been No Great Women Artists?", Linda Nochlin examined Western notions of genius and artistic success and concluded that social and economic factors prevented women from achieving the same status as their male counterparts. These factors, rather than inherent ability, were responsible for the relative paucity of "great women artists." Nochlin's essay spurred the historical study of artists' training, exhibition practices, and the effects of the art market on artists' careers. Other scholars, including Griselda Pollock and Rozsika Parker, went even further, examining art-historical language with its gender-based terms such as "Old Master" and "masterpiece."

Nochlin's essay also sparked an interest in studying artistic genres, such as the female nude and scenes of everyday life. Feminist scholars revealed the unspoken commercial and ideological interests vested in

Chaucer and Edgar Allan Poe. He was also influenced by the Bible, and, as with so many artists on both sides of the Atlantic, by Wagner's operas. In 1881, Ryder painted *Siegfried and the Rhine Maidens* (fig. **26.22**), beginning at midnight after attending a performance of Wagner's *Götterdämmerung* in New York, and obsessively painting nonstop for 48 hours. He continued to rework the painting until 1891, when it was exhibited at the Society of American Artists, an organization established, like the Impressionists' "Artists, Inc." (see page 871), to provide an alternative exhibition opportunity to that of the academy, in this case the restrictive staid National Academy of Fine Arts. Here, we see again a variant of the *femme fatale* theme, as a sexual struggle is embedded in the legend of the alluring Rhine maidens who

26.22 Albert Pinkham Ryder, *Siegfried and the Rhine Maidens*. 1888–91. Oil on canvas, $19\% \times 20\frac{1}{2}$ " (50.5 × 52.1 cm). National Gallery of Art, Washington, D.C. Andrew W. Mellon Collection

these scenes. In particular, feminist art historians brought to light previously ignored connections between depictions of women and late nineteenth-century attitudes toward gender roles and female sexuality. Quite often in the art of this period, images of women conform to simplistic (yet socially powerful) stereotypes of good or bad women. Mothers, virginal heroines, and martyrs represent the good women; prostitutes, adulteresses, and the myriad *femmes fatales*, such as vampires and incubuses, represent the bad.

The second wave of feminist art history, which would continue throughout the 1980s, was launched as early as 1973 when British film critic Laura Mulvey used psychoanalytic methods to introduce the concept of the controlling power of the male viewer's gaze. Studying Impressionist and Post-Impressionist imagery in terms of who gets to look and who is watched, feminist art historians exposed the operations of power, visual pleasure, and social control. "Men look at women, women watch themselves being looked at," the critic John Berger wrote in Ways of Seeing (1972). For Berger, Western art reflects the unequal status of men and women in society. Griselda Pollock analyzed the "Spaces of Femininity" in Impressionist paintings, and examined the ways in which some respectable bourgeois women artists like Cassatt and Morisot depicted a very different experience of modern life from their male peers. And the working-class Montmartre model-turned-artist Suzanne Valadon, who grew up in the studios of Impressionists such as Degas, painted revolutionary nudes from the position of someone who knew what it meant to pose for the artist's gaze.

Beginning in the 1990s, a third generation of feminist art historians broadened the scope of feminist art history to include gender studies, queer theory, the politics of globalization, and post-colonial studies. Nineteenth-century art remains fertile ground, however, for such interdisciplinary study, and new feminist investigations of this period continue to shape the discipline of art history.

foretell Siegfried's doom for refusing to return to them an allpowerful ring. Echoing the power of Wagner's music, often designed to project mythic Nordic forces, the broadly painted, fantastical landscape erupts with seething trees and a wild curvilinear sky, all seeming to emanate from the writhing forms of the maidens. who even seem to have at their command the supernatural pull of the moon. We sense uncontrollable power, reflecting uncontainable emotions, channeled through every brushstroke and distorted form.

HENRY OSSAWA TANNER The African-American artist Henry Ossawa Tanner (1859–1937) fell under the spell of Symbolism in Paris. Tanner studied in the 1880s under the liberal and supportive Thomas Eakins in Philadelphia, becoming a Realist. With little hope of achieving artistic parity in racist America, he went to Paris in 1892, where he settled permanently. There, his work began to show the influence of Symbolism as he experimented with abstraction and pursued new themes, even producing several Salome paintings. Tanner was the son of a preacher, and his work is dominated by religious imagery, such as Angels Appearing before the Shepherds (fig. 26.23). The composition of this visionary painting is ingenious, for Tanner positions us in the sky with the angels. From this vantage point, we see the Holy Land: a breathtaking abstraction of lines and marks that nonetheless unmistakably contains hills, terraces, walls, and a city. We can even make out the shepherds' fire, the only note of strong color in what is otherwise a tonal symphony dominated by blue. Using rich, lush brushwork, Tanner dissolves the material world, making it ethereal and ephemeral, and as weightless as the transparent angels. Humanity is reduced to a speck in the vast scheme of the universe.

26.23 Henry Ossawa Tanner. Angels Appearing before the Shepherds. ca. 1910. Oil on canvas, $25\frac{3}{4} \times 31\frac{7}{8}$ " (65.3 × 81.1 cm). Smithsonian American Art Museum. Gift of Mr. and Mrs. Norman Robins

The Sculpture of Rodin

The Symbolist desire to penetrate and portray the innermost essence of being had a parallel in sculpture in the work of Auguste Rodin (1840–1917). The most influential sculptor of the late nineteenth century, who singlehandedly laid the foundation for twentieth-century sculpture, Rodin's career started slowly. He was rejected by the École des Beaux-Arts, forcing him to attend the Petite École, which specialized in the decorative arts. His big break came in 1880, when he won a prestigious commission to design the bronze doors for a new decorative arts museum. Although the project eventually fell through, Rodin continued to work on it right up to his death. Called The Gates of Hell (fig. 26.24), the 17-foot-high doors were inspired by Baudelaire's Flowers of Evil and Dante's Inferno from the Divine Comedyindeed, at one point the thinker sitting in the tympanum contemplating the chaotic ghoulish scene below was to be Dante. Ultimately, the doors became a metaphor for the futility of life, the inability to satisfactorily fulfill our deepest uncontrollable passions, which is the fate of the sinners in Dante's second circle of hell, the circle that preoccupied Rodin the most. It is the world after the Fall, of eternal suffering, and Adam and Eve are included among the tortured souls below. Despite Rodin's devotion to the project, The Gates of Hell was never cast during his lifetime.

Rodin made independent sculptures from details of The Gates, including The Thinker (fig. 26.25) and The Three Shades, the group mounted at the very peak of The Gates, which shows the same figure turned in three different positions. While his figures are based on familiar models-The Thinker, for example, recalls the work of Michelangelo, his favorite artist-they have an unfamiliar, organic quality. Rodin preferred to mold, not carve, working mostly in plaster or terra cotta, which artisans would then cast in bronze for him. We see where Rodin's hand has worked the malleable plaster with his fingers, for his surfaces ripple and undulate. His medium, instead of being smoothed out, remains intentionally rough and uneven, unlike Canova, for example, whose marble aspires to an uninterrupted graceful perfection (see figs. 23.30 and 23.31). With Rodin, we are made to feel privy to the creation of the figure, as if watching God making Adam out of clay. This primal quality is reinforced by his figures' nudity, which is less a Classical reference than a device to present an elemental form, stripped down to the very core of its humanity to expose primordial fears and passions.

For the sake of expression, Rodin does not hesitate to distort his figures, shattering Classical notions of the idealized figure and beauty. Look, for example, at *The Shades* atop the doors of *The Gates of Hell*. Their Michelangelesque musculature has been yanked and twisted, endowing these specters with a form that is at once familiar and unfamiliar. These uncanny messengers have arisen from tombs and now cast their message of eternal gloom on the teeming humanity below. We can even see this distortion to a lesser degree in *The Thinker*. Here, massive hands and feet project a ponderous weight that underscores the thinker's psychological

26.24 Auguste Rodin, *The Gates of Hell* (entire structure). 1880–1900. Plaster, height $18'1" \times 13'1" \times 3'1"$ (5.52 × 4.00 × 0.94 m). Musée d'Orsay, Paris

26.25 Auguste Rodin, *The Thinker*. 1879–87. Bronze, height 27¹/₂" (69.8 cm). Musée Rodin, Paris

load, while his elongated arm is draped limply over his knee, suggesting inertia and indecision.

Equally expressive is Rodin's use of fragments; works that are just a hand or a torso, for example. The part not only represents the whole, embodying its essence, but it serves to strip away the inessential and focus on specifics. In The Walking Man (fig. 26.26), which he began in 1877-78 as a preliminary study for a sculpture of St. John, we see another example of this distortion. The anatomy was again inspired by Michelangelo, while the partial body evokes damaged Classical statues. By not including a head, Rodin removed the distraction of the face and any associations it might carry such as identity and psychology, allowing him instead to stress movement, specifically forward motion. Initially just a study, Rodin eventually identified it as a self-sustaining work, recognizing that the headless, armless figure projected a powerful sense of humanity in its organic quality as well as providing an endless wealth of visual delight in the handling of the plaster. He had a first version cast in bronze before 1888, when it was exhibited at the Georges Petit gallery in Paris.

Rodin's emphasis on psychology can be seen in the *Burghers* of *Calais* (fig. 26.27), a monument commissioned by the Calais city fathers to commemorate six citizens who agreed to sacrifice themselves during the 1347 English siege of Calais, a major event in the Hundred Years' War. In exchange for the execution of the six burghers, the English agreed to lift the siege and spare the

town and the rest of its citizens. Rodin depicts the volunteers in crude burlap sacks and snakelike ropes trudging to their imprisonment and death. (Ultimately, they were freed.) Instead of courageous, noble heroes, he presents six men confronting death and displaying, among their emotions, fear, resignation, and anguish. They are not a united group but a chaotic mass, each alone with his thoughts. Massive distorted hands and feet, slumped bodies, and awkward gestures make the figures human. Rodin wanted the monument to sit on the ground in a plaza outside the town hall, so it would appear that the figures were walking from the building, thus allowing viewers to share the space of the burghers and experience their trauma. The ignoble, blunt monument embarrassed the town council, however, which hid it on a desolate site, mounted on a high pedestal.

Clearly, Rodin's preoccupation with expressing elemental fears and passions relates him to the Symbolist quest to plumb the depths of the mind. His thematic interests were stated as early as 1864, and in some ways it is possible to view him as a late Romantic. What ultimately marks him as a Symbolist, though, is

26.26 Auguste Rodin, *The Walking Man*. Model 1878–1900, cast ca. 1903. Bronze, height 33¼" (84.45 cm). National Gallery of Art, Washington, D.C. Gift of Mrs. John W. Simpson

26.27 Auguste Rodin, Burghers of Calais. 1884–89. Bronze, $6'10^{1}/_{2}" \times 7'11" \times 6'6" (2.1 \times 2.4 \times 2 m)$. Hirshhorn Museum and Sculpture Garden, Smithsonian Institution, Washington, D.C. Gift of Joseph H. Hirshhorn, 1966. 66.4340

his interest in the psychic toll exacted on the individual by civilization. Whether he is exploring the crushing effects of war or the emotional costs of creative effort, Rodin emphasizes the psychological consequences of modern life. His ability to convey intense psychological states through forms at once familiar and abstract confirms his kinship with Symbolism. It was the hidden, inner struggle that Rodin, the Symbolists, and the nascent science of psychology sought to understand and render visible.

ART NOUVEAU AND THE SEARCH FOR MODERN DESIGN

In 1895, a German entrepreneur, Siegfried Bing, opened a decorative-arts shop called La Maison de l'Art Nouveau (The House of New Art) in Paris. Bing had made a fortune importing Japanese art and furnishings, and now sought to promote the Japanese principle of total design; Every detail of an interior space should be integrated into a single style. Aiming to eliminate any distinction between the fine and decorative arts, he hired famous architects, artists, and designers to develop every detail of entire rooms for his shop, as well as to design individual products, including furniture, vases, tiles, and stained-glass windows. This new style was called Art Nouveau, after Bing's shop. Elsewhere in Europe it took on different names, such as the Jugendstil (Youth Style) in Germany and the Secession Style in Vienna. Though varying somewhat from one country to the next, the style, which is particular to architecture and the decorative arts, is usually characterized by abstract organic forms and arabesques.

Art Nouveau can be seen in part as a response to William Morris's Arts and Crafts Movement, and certainly the emphasis

on handcrafted, finely designed products reflects this. The design products of Louis Comfort Tiffany (1848–1933) were another important influence on Art Nouveau, especially his stained-glass windows (fig. **26.28**) and glass lampshades with their organic motifs. Having a gemlike luster and the spiritual glow of medieval stained glass, Tiffany products are generally based on nature, depicting wooded landscapes, flowers, and trees. Coming on the heals of the Arts and Crafts Movement and anticipating Art Nouveau, Tiffany technically falls into neither category, and is a category unto itself. Tiffany's New York store, however, was the inspiration for Bing's La Maison de l'Art Nouveau.

Important differences exist between the Arts and Crafts Movement and Art Nouveau. Unlike the Arts and Crafts designers, many Art Nouveau artists embraced mass production and new industrial materials. And while Art Nouveau designs are clearly organic, they are often purely abstract rather than based on identifiable botanical specimens, as is the case in Morris's and Tiffany's designs.

The Public and Private Spaces of Art Nouveau

Compared with dark, ponderous Victorian interiors, the buoyant naturalism of Art Nouveau was a breath of fresh air, exuding youth, liberation, and modernity. It shared with Symbolism the element of fantasy, in this case biomorphic fantasy, which can especially be seen in architecture. Art Nouveau architects concerned themselves equally with exterior finish and interior space. Their typically complex, animated façades endow Art Nouveau buildings with a sculptural quality that engages viewers as they approach. This energy continues in the interior, for Art Nouveau spaces pulsate with a sense of movement—interior

26.28 Louis Comfort Tiffany. Manufactured by Tiffany Studios. *A Wooded Landscape in Three Panels.* ca. 1905. Glass, copper-foil, and lead, $86^{1}/_2 \times 131^{9}/_{16} \times 1^{3}/_{4}$ " (219.7 × 334.2 × 4.4 cm). Museum of Fine Arts, Houston, Museum Purchase with funds provided by the Brown Foundation Accessions Endowment Fund. 96.765. A, B, C

decoration and furnishings give the impression of having germinated and grown *in situ*. This effect is often enhanced by the admission of sunlight through glass ceilings or skylights, lending the space the fecundity of a greenhouse where everything seems to have grown spontaneously.

VICTOR HORTA The style began in Brussels with Belgian architect Victor Horta (1861-1947). Born in Ghent, Horta studied drawing, textiles, and architecture at the city's Académie des Beaux-Arts, and worked in Paris before returning to Belgium to start his own practice. In 1892, Horta designed the Tassel House in Brussels. The centerpiece of this is the ironwork of the stairwell (fig. 26.29), the malleable wrought-iron columns and railings that were shaped into vines that evolve into whiplash tendrils on the walls, ceiling, and mosaic floor. The supporting role of the columns has been downplayed by making them as slender as possible. In a play on the Corinthian capital, they sprout ribbonlike tendrils that dissolve into arches. The linear patterns extend to the floor and wall, a device that further integrates the space visually. Sunlight filters through the glass ceiling, heightening the organic quality of the space. The curvilinear patterning derives from a variety of sources, including Japanese prints and Gauguin's cloisonnism (see fig. 26.12), although Horta's undulating linearity would in turn influence contemporary art, as seen in Beardsley's Salomé (see fig. 26.20). Everything has an organic fluidity, a springlike sense of growth and life, which has the effect of destroying the conventional boxlike quality of interior space.

26.29 Victor Horta. Interior stairwell of the Tassel House, Brussels. 1892–93.

26.30 Hector Guimard. Métro station, Paris. 1900

HECTOR GUIMARD Art Nouveau next migrated to Paris, where its most famous practitioner was the architect Hector Guimard (1867–1942), who is especially renowned for designing the entrances to the Paris Métro, or subway, which opened in 1900 (fig. 26.30). Like Horta, he worked with wrought and cast iron, patinated a soft, earthy green, but his sensitivity, while still

organic, is quite different. If Horta suggests dynamic whiplash tendrils, Guimard evokes a lethargic prehistoric world, part plantlike, suggesting stalks and tendrils, and part zoomorphic, evoking praying mantises and dinosaurs. Even the lettering of the word "Métropolitain" morphs into strange organic characters, irregular, primitive, and foreboding. How appropriate for an architecture marking entrances to a new underworld. And how revealing that the style for a high-tech, machine world should be an escapist fantasy that is emphatically organic. Aside from his very public designs for the Métro, Guimard's practice was largely limited to private houses and apartment buildings for the haute bourgeoisie. He remained faithful to Art Nouveau even after it passed from fashion, around 1910.

ANTONI GAUDÍ Among the most bizarre Art Nouveau creations sprung from the wild imagination of Antoni Gaudí (1853–1926). Gaudí worked in Barcelona, the next and last major stop for the short-lived Art Nouveau, and his style reflects the fervent Catalan nationalism of the period, drawing heavily upon Mediterranean architectural traditions. His remarkable Casa Milà (fig. **26.31**), a large apartment house, expresses his fanatical devotion to the ideal of "natural" form, one quite different from Horta's plantlike designs. On the one hand, the building conjures up the Spanish Baroque, the Plateresque (indigenous Renaissance architecture suggesting elaborate silver plate), and the Moorish mosques of southern Spain. On the other, it is pure nature. Believing there are no straight lines in nature, Gaudí created an undulating façade and irregularly shaped interior spaces (fig. **26.32**), in effect destroying the architectural box. With its huge

26.31 Antoni Gaudí. Casa Milà, Barcelona. 1905–10

26.32 Antoni Gaudí. Plan of typical floor, Casa Milà

26.33 Charles Rennie Mackintosh. North façade of the Glasgow School of Art, Glasgow, Scotland. 1897–1909

stone blocks, the exterior evokes austere seaside cliffs while the wrought-iron balconies resemble seaweed and the scalloped cornice mimics ocean waves. To twenty-first-century eyes, the chimneys may recall soft ice-cream cones, but in 1905, they would have evoked, among other things, sand castles. These references to the seashore suggest Barcelona's distinctive geographic, cultural, and economic relationship to the Mediterranean. Gaudí was a fervent supporter of Catalan nationalism, so Barcelona, the capital of Catalonia, was especially symbolic for him. Perhaps more important, Gaudí was extremely religious, an ardent Catholic, and he viewed nature as a spiritual sanctuary and escape hatch from modernity. He spent the last decades of his life building an enormous Art Nouveau cathedral, La Sagrada Família, so vast in scale that it remains unfinished today.

CHARLES RENNIE MACKINTOSH Just as Gaudí's buildings evoke the landscape and culture of Catalonia, the work of the Glasgow architect Charles Rennie Mackintosh (1868–1928) speaks to a decidedly northern, Scottish sensibility. Mackintosh's designs are often labeled Art Nouveau, and he certainly began in this camp, especially adhering to Arts and Crafts values, and retaining organic qualities in his work throughout his career. As can be seen in his most famous building, the Glasgow School of Art (fig. 26.33), built from 1897 to 1909, his work is infinitely more mainstream than Gaudí's, Guimard's, or Horta's. The façade is largely rectangular. Its austere windows, which hint at the Queen Anne revival style, dominate the building, making it look very geometric. The grid of the windows is reinforced by the horizontal overhang above the entrance. The entrance section evokes a Scottish baronial tower, within which is set an arched Baroque aedicula, or altar, with a Queen Anne oriel, or picture window, in a niche above. In other words, the building is an abstract presentation of

26.34 Charles Rennie Mackintosh. Salon de Luxe, Willow Tea Rooms, Sauchiehall Street, Glasgow. 1904

revival styles, but those styles are so reduced to a geometric essence that they almost disappear. Modern architects, especially in Vienna, would be especially inspired by this abstracting process. The only suggestion of the curvilinear Art Nouveau is in the eccentric, organic ironwork, including the railings and fences, the entrance arch with lantern, and the strange plantlike brackets used by windowcleaners.

Mackintosh's interiors, for which he is most noted, retain more of a balance between the geometric and organic, as seen in his 1904 Salon de Luxe at the Willow Tea Rooms in Glasgow (fig. 26.34). The door and walls have a frail linear patterning suggesting willow branches, and the backs of the chairs gracefully buckle and taper, while their leg brackets curve. A severe grid of verticals and horizontals, however, epitomized by the nine squares on the backs of the chairs, sharply organizes the room, which nonetheless is quite elegant and refined. Regardless of labeling, Macintosh's design is certainly "new" and also total, encompassing every detail in the room, down to the door handle, all of which are beautifully handcrafted. While not the botanical and zoological fantasies of Horta and Guimard, Macintosh's vision equally dispatches the historical past and certainly charts strange territory, making tearoom guests feel as though they have passed through a magic door into a marvelous unidentifiable wonderland.

AMERICAN ARCHITECTURE: THE CHICAGO SCHOOL

Little did anyone know in 1871 that Chicago's devastating Great Fire would launch modern architecture and make American architects for the first time the most advanced in the world. Once the flames of the fire were extinguished, the issue at hand was not just one of rebuilding. Chicago had been growing rapidly, putting a premium on real estate, and now there was a need to maximize land use by building vertically. This was made possible by the invention of the safety elevator, perfected in New York in the 1850s and 1860s by Elisha Otis. Ambitious construction was delayed for ten years, however, due to the national financial collapse of 1873, which lasted through the decade. When rebuilding finally proceeded in the 1880s, it was dominated by young designers who had largely been trained as engineers with virtually no architectural background. This meant they were not hampered by strong preconceived notions of what buildings should look like and were open to allowing their structures to reflect the new technologies and materials they employed. They abandoned the historicism of revival architecture and designed abstract structures as they allowed form to follow function. The buildings they erected were technically so complicated and the workload was so great that the major architects paired off into complementary teams: Burnham and Root, Holabird and Roche, and Adler and Sullivan. Of this group, only Louis Sullivan had attended architectural school, one year at MIT and a half-year at the École des Beaux-Arts in Paris.

Henry Hobson Richardson: Laying the Foundation for Modernist Architecture

Designed by Boston architect Henry Hobson Richardson (1838-1886), the Marshall Field Wholesale Store (fig. 26.35) provided an intellectual challenge to the new generation of Chicago architects. Born in New Orleans and educated at Harvard, Richardson rose to international fame for his Romanesque-revival work, which became so renowned that the style was eventually named after him. Made of stone, his buildings were massive, bold, and highly textured. They were also quite simplified, emphasizing volumetric forms. With the Marshall Field Wholesale Store, a seven-story building that took up an entire Chicago block, Richardson's style evolved to its most refined form, one that moved beyond the Victorian Romanesque revival. The building was composed of weighty stone walls made of red granite and red sandstone, and because it took up the entire city block, it felt massive, giving it a powerful physical presence. The scale and rough texture of the blocks as well as the dark hollows of the recessed windows added to the building's sculptural quality.

The building was highly associational, or referential. The arches, especially when used by Richardson, recalled the Romanesque, although they evoked a fifteenth-century Florentine palazzo as well (see fig. 15.32). The three-tier layering of the building also calls to mind Beaux-Arts architecture (see fig. 25.9), a reference to the rigorous architectural program of the Paris École des Beaux-Arts that established strict design

26.35 Henry Hobson Richardson. Marshall Field Wholesale Store, Chicago. 1885–87. Demolished 1931

principles. These rules included a stylobate-column-entablature configuration, that is, a base, rise, and crown format. In the Marshall Field building, the stylobate, or platform, was represented by the basement level, with the next two tiers representing the columnated level and the entablature. Despite parallels to past architecture, the building was remarkably abstract: There were no columns, piers, capitals, or entablatures per se. Instead the uniform stone, despite its rustication, was like a continuous skin covering the building. This innovative design that abstracted historical style would pose a major challenge for Chicago architects.

Louis Sullivan and Early Skyscrapers

Richardson did not consider himself a Modernist, and he was not one. But the abstraction of the Marshall Field building helped spawn Modernist architecture. As important as Richardson's influence were technical developments. As the Chicago fire clearly demonstrated, iron is not fire-resistant; intense heat makes it soften, bend, and, if hot enough, melt. To avoid towering infernos,

26.36 Louis Sullivan. Wainwright Building, St. Louis, Missouri. 1890–91. Destroyed

it was necessary to fireproof the metal, enveloping iron, and shortly thereafter steel (which was only developed as we know it today in the early twentieth century) with terra-cotta tiles and later in a coating of concrete (modern concrete, called Portland cement, was invented in England in 1825). The insulation also prevented corrosion.

An equally important technological development was the invention of the **curtain wall**. Unlike a self-supporting wall, the type Richardson used for the Marshall Field Wholesale Store, a curtain wall hangs from the lip of a horizontal beam at floor level on each story. Without this innovation, the base of the wall for a tall building would have to be extremely thick in order to support the weight of the wall above, severely limiting the number of floors. Furthermore, curtain walls allowed for entire walls to be made of glass, and with the development toward midcentury of plate glass, that is, large sheets of glass, it was now possible to design glass towers. The first extensive use of the curtain wall was in Chicago for the 1884–85 Home Insurance Building, which had a steel skeleton, and was designed by William Jenney, the elder statesman of the Chicago architects.

The architect generally credited with playing the main role in developing the aesthetic implications of the steel skeleton into powerful architecture is Louis Sullivan (1856–1924). In 1880, Sullivan joined the Chicago firm of Dankmar Adler, which in 1883 became Adler and Sullivan (Adler left the firm in 1891). Adler was the engineer, planner, and project manager who kept building construction moving forward, while Sullivan was the idealistic visionary who provided the design concepts.

Sullivan's early masterpiece is the Wainwright Building (fig. 26.36), erected in St. Louis in 1890-91. (Most of his major buildings, however, are in Chicago.) Using the curtain wall, Sullivan designed a building that reflects the grid structure of the steel skeleton, although for aesthetic purposes he doubled the number of external piers, with only every other one having a structural beam behind it. The major problem for the early architects of skyscrapers was how to design a building that rose so many floors, while maintaining a visually interesting exterior that did not rely on outmoded revival styles. Sullivan's solution was ingenious. Like Richardson's Marshall Field Wholesale Store, his building is largely abstract. The end piers are widened, as in Marshall Field, dramatically framing the building, and the spandrels (the decorated horizontal panels between piers) are recessed, both elements giving the building a monumental sculptural quality and the sense of a building evolving from a solid block. The seven-story colossal piers and the enormous one-story cornice add to this grandeur. Again, we see the Beaux-Arts stylobate-column-entablature configuration of the Marshall Field building, which feels even more Classical in the Wainwright Building because of the grid and absence of Romanesque arches.

While the building's exterior presents a compilation of abstract, geometric forms, largely reflecting the substructure, Sullivan did not hesitate to design terra-cotta panels for the cornice and spandrels that feature a pattern based on an antique rinceau motif (an ornamental vine, leaf, or floral design). Sullivan

intended these biomorphic decorations to symbolize his belief that architecture should utilize new technologies to promote social harmony and progress and to be part of a natural organic evolution of the world. Sullivan fervently believed in the spiritual theories of Emmanuel Swedenborg (1688-1772), a Swedish philosopher, theologian, and Christian mystic who preached that universal forces run through and unite all things, each of which is otherwise unique and an individual. His building reflects Swedenborgianism, which became popular at this time along with so many other nontraditional religions and cults. The decoration, for example, allowed Sullivan to distinguish the various parts of the building, giving each a separate identity (e.g., the upper story, the spandrels), and yet at the same time, all of these distinctive parts are tightly woven together into a unified whole, as suggested by the powerful grid of piers and spandrels. The flowering plant life energizes the building, reflects the vitality of the human element within, and relates both to the universal current flowing through all things. Although he was down-to-earth, practical, and

26.37 Louis H. Sullivan. Schlesinger and Meyer Store, then Carson-Pirie-Scott store (now the Sullivan Center). Chicago. 1899–1904

26.38 Louis Sullivan. Cast-iron ornament, Schlesinger and Meyer Store

functional—it was Sullivan who issued the famous dictum that "form ever follows function"—he was also a visionary Symbolist. (See <u>www.myartslab.com</u>.)

Sullivan's style became considerably lighter, airier, and abstract by 1900, anticipating the floating, geometric, glass boxes of twentieth-century Modernist architecture. This style can be seen in the Schlesinger and Meyer Store in Chicago (fig. 26.37), which was originally a commission for the three-bay, nine-story section on the left but evolved into the twelve-story structure we see today. Now, the thin vertical piers actually reflect the skeleton behind, and the mechanomorphic façade echoes the structural steel grid behind it. The wall has virtually disappeared, giving way to glass. Instead of the enormous monumental one-story cornice we saw on the Wainwright Building, Sullivan's top-floor "entablature" is actually a hollow recessed balcony, capped by a sliver of a cornice, which instead of being a weighty lid seems to be a floating piece of cardboard, in keeping with the airy lightness of the building. There is still a Beaux-Arts "base," but it seems recessed (although it is not) because of the horizontal molding above, making the nine floors of horizontal windows seem to float. The first floor dissolves in a wild flurry of Art Nouveau plant forms that cover cast-iron panels (fig. 26.38), in effect unifying the building with cosmic forces. With the Schlesinger and Meyer Store, the aesthetic for the Modernist skyscraper had perhaps reached its finest expression to date.

Frank Lloyd Wright and the Prairie House

After studying engineering at the University of Wisconsin, Frank Lloyd Wright (1867–1959) worked for Sullivan from 1888 until 1893. His sensitivity and strengths, however, could not have been more different. While Sullivan specialized in commercial buildings, Wright's forte was domestic architecture, although his public buildings are brilliant. Sullivan's innovations were largely in façades, whereas Wright's were in space, including interior space and its relationship to the exterior. Wright's architecture, like Sullivan's, is based on nature, and his reputation was established with what are known as his Prairie Houses, so-called because their strong horizontal sweep echoes the planarity of the Midwest landscape where the homes were built.

The crowning achievement of Wright's Prairie Houses, which he began designing in the early 1890s, is the Robie House (fig. **26.39**), designed in Chicago in 1908. The building was so shockingly modern it would take architects a good ten to 20 years to understand it and develop its implications. As can readily be seen from the exterior, the house is an abstract play of not only horizontals and verticals, but also of open spaces and enclosed volumes. The dramatic cantilevered roofs (which are not flat as suggested by our reproduction, but slightly sloping) define one space, while the floor of the terrace, or the balcony below, charts another. The interior spaces not only flow into the exterior, but into one another, for rooms, especially public rooms, generally do not have doors and four walls (fig. **26.40**).

Wright always claimed that his extraordinary ability to envision complex space and design came from playing with the Froebel blocks that his mother bought for him at the 1876 World's Fair in Philadelphia. Developed by Friedrich Froebel as part of his campaign to institute kindergarten throughout Germany, the blocks were designed to serve as a child's first building blocks, and were part of a program that progressed to working with sticks and clay, folding paper, and weaving various materials. The Froebel "gifts," as each stage was called, not only taught Wright to think in terms of abstract form, but also organic growth. Froebel was influenced by crystallography and consequently emphasized pattern making, not construction, with the pattern spreading out uniformly from a center row (the child was required to use all of the blocks). When it was complete, the child was encouraged to attach symbolic content to the shapes, relating

26.39 Frank Lloyd Wright. Robie House, Chicago. 1908-10.

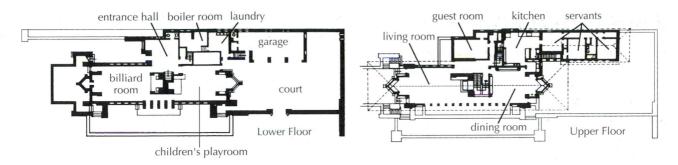

26.40 Plan of Robie House

the patterns to the living world of plants and the cosmos (suns and stars, for example). Equally important for Wright's development was a visit to the Japanese temple at the 1893 Chicago World's Fair. Here, he saw the dramatic projection of eaves, and severely geometrically shaped rooms that had sliding doors, which allowed one room to flow into another. Everything in a Japanese building was as tightly interlocked as in a Froebel project.

As abstract and geometric as the Robie House is, the home resonates with nature and the organic. Even in our reproduction, the house, made of a horizontal brick manufactured to Wright's specifications (the face is 1½ by 5 inches), appears perfectly integrated into the land, its lateral spread paralleling the surrounding plains. Wright thought of his architecture as organic, evolving much as a crystal develops or a tree grows. The Robie House, like many of his domestic designs, radiates from a large masonry fireplace, which Wright saw as a domestic altar to the "gods of shelter." The rest of the house develops organically from this fulcrum, with one room naturally flowing into another and into the exterior, which in turn is integrated into the surrounding land. This sense of growth can readily be seen from the exterior, where the lateral spread of roofs, terraces, and balconies seems to be in constant movement. The picturesque variety of overhangs and recesses creates a play of light and shadow that we do not normally associate with architecture, but rather with nature.

Wright's interior design also embraces this organic note. Reproduced here is the living room from the Francis W. Little House (fig. 26.41), perhaps his finest extant early interior. Influenced by William Morris's Arts and Crafts Movement as well as the principles, if not the look, of Art Nouveau, Wright, when possible, designed every detail of his interiors, with everything hand-made and of the highest quality. Like his architecture, his furniture and designs are geometric, continuing the spatial interplay of his buildings. But the geometric designs that appear on the leaded stained-glass windows and ceiling grillwork are actually abstractions of plant and landscape motifs, and the palette of the room features somber, yet warm, earth colors. As much as

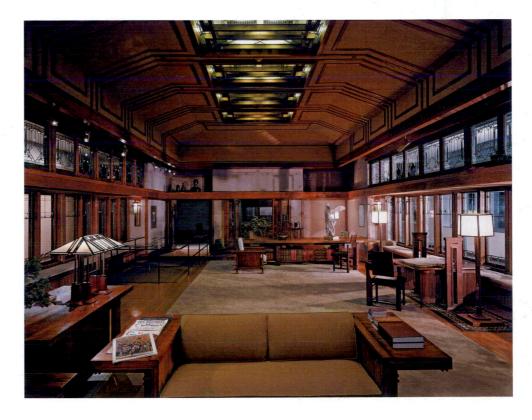

26.41 Frank Lloyd Wright. Living room of the Francis W. Little House, Wayzata, Minnesota, designed 1912–14, as installed at the Metropolitan Museum of Art, New York. Purchase Bequest of Emily Crane Chadbourne, 1972. 1972.60.1

we may want to see early Wright as an abstract, machine-age thinker conceptually playing with spaces and completely breaking with tradition, his theories and sensitivity are very much of the 1890s—he still has one foot planted in the Symbolist nineteenth century that advocated a retreat from modernity into the arms of nature and its rejuvenating spiritual forces.

PHOTOGRAPHY AND THE ADVENT OF FILM

The primary preoccupation of photographers at the end of the century was the ongoing debate about whether photography was art. Complicating the matter was the dramatic increase in nonart photography. The invention of the half-tone printing process was one reason for this upsurge, for it resulted in photographs being printed directly in newspapers, magazines, and books using either lithographic or relief printing. It also brought about the rise of the picture postcard, which during the height of its popularity in 1907-8 resulted in some 667 million postcards, most with pictures, being sent through the U.S. Mail. Another reason for the proliferation of photographs was the invention of dry plates, which replaced the awkward and impractical wet-plate process. Now, photographers could work faster and go anywhere. The process reduced exposure time to one-fiftieth of a second, and hand-held cameras with shutters were invented, making tripods unnecessary. Cameras could now record movement. And now cameras and prints were readily available at low cost to everybody. In 1888, the Eastman Dry Plate Company of Rochester, New York, introduced the Kodak camera. It came loaded with a paper roll containing 100 frames, which, once exposed, were sent back to the company in the camera for developing and printing. The company's advertisement declared, "You press the button—We do the rest." Also appearing about this time was the single-lens reflex camera, which had a mirror that allowed the photographer to see the image in a viewer. Suddenly, everyone was taking pictures, and the word "snapshot" came into common parlance. Toward 1890, there were 161 photographic societies worldwide and 60 photographic journals. The medium became so popular that many newspapers carried an amateur photography column.

Pictorialist Photography and the Photo Secession

To counter the image of photography as a ubiquitous, mindless popular tool best suited for documenting the visual world, organizations sprang up dedicated to promoting the medium as high art. The first was the Wien Kamera Klub (Vienna Camera Club), founded in 1891, soon followed by the Linked Ring in London and the Photo-Club de Paris (1894). The Berlin, Munich, and Vienna Secessions, dedicated to breaking down any hierarchical ranking of the arts, showed art photography. In 1902, Alfred Stieglitz quit the conservative Camera Club of New York to form the Photo Secession, taking its name from the European secession groups. All of these photography organizations had international memberships, often with some of the same members, mounted

26.42 Peter Henry Emerson, *Poling the Marsh Hay.* 1886. Platinum print. Gernsheim Collection. Harry Ransom Humanities Research Center, University of Texas, Austin

exhibitions, and published magazines. And they all promoted a Pictorialist aesthetic, placing a premium on a painterly, artistic look, countering the sharp focus that characterized postcard, stereoscope, newspaper, and magazine images and the single fixed focus of the Kodak camera. Photographs by art photographers were taken out of focus, like those of Julia Margaret Cameron, whose work experienced a resurgence of interest. Pictorialist photographs were often highly textured, as a result of gum being brushed onto the printing paper before exposure or due to the use of a rough, pebbly paper.

PETER HENRY EMERSON The British photographer Peter Henry Emerson (1856–1936) became a role model for Pictorialist photography, although ironically his own aim was to combine art and science by applying a scientific approach to the creation of the image: His pictures were meant to look scientific, not artistic. Emerson was a medical doctor, who abandoned the profession for photography in 1885. He was influenced by the German scientist Hermann von Helmholtz's theory of vision, which maintains that the eye at any one time can only focus on one area, with everything else becoming hazy. Wanting to make a realistic photography based on scientific principle, Emerson set out to produce images that replicated Helmholtz's optical premise. In Poling the Marsh Hay (fig. 26.42), the foreground woman is most in focus while the rest of the image is mildly blurred or indistinct. The picture appeared in Emerson's book Life and Landscape on the Norfolk Broads (1888), a folio of 40 mounted platinum prints, a photographic process that yielded an extraordinarily fine range of soft gray tones since the platinum lies directly on the surface of the paper, and is not embedded in albumen or a gelatin emulsion. Emerson was fascinated by the rural world of southeast England, where time seemed to stand still and hay was harvested by hand, not with the new steam-driven tractors. In this nostalgic image, we are presented with a Romantic view of an idyllic life of humans immersed in nature. Ironically, Emerson's scientific goal to realistically replicate the world as the eye sees it resulted in a poetic timeless vision, a soft-focused dreamworld of indistinct lush grays and of mysteriously floating darks and lights, such as a ghostly silhouetted tree and the light mystically shimmering on the canal and marshes.

GERTRUDE KÄSEBIER The international Pictorialists took their lead from Emerson and Cameron, among others, and similarly created painterly, dreamlike images. New Yorker Gertrude Käsebier (1852–1934) was one of the more prominent figures in the group, becoming a member of the Linked Ring in 1900, less than five years after taking up photography, and one of the founding members of Stieglitz's Photo Secession in 1902. Fleeing a wretched marriage, she enrolled in art classes at the Pratt Institute in 1889, and soon took up the camera with the intention of making art, although she supported herself through studio portraiture. In *Blessed Art Thou Among Women* (fig. **26.43**), an 1899 platinum print on Japanese tissue, a thin paper, we see Käsebier displaying the hallmarks of Pictorialism: a soft, grainy image,

26.43 Gertrude Käsebier, *Blessed Art Thou Among Women*. 1899. Platinum print, $9\frac{1}{6} \times 5\frac{3}{16}$ " (23 × 13.2 cm). Metropolitan Museum of Art, New York. Alfred Stieglitz Collection, 1933. (33.43.132)

slightly out of focus, and with a spectacular range of lush grays that only a platinum print can provide, made all the more delicate by being printed on a gossamerlike Japanese tissue. The mother wears a white Pre-Raphaelite-looking house robe and conspicuously stands before a religious image of the Annunciation on the back wall. The daughter, who is about to cross the threshold to go out into the world, is encased in a mandorlalike divine light created by the brilliant white that surrounds her, especially defined by the small gap between her and her mother. The scene has a spiritual quality, set within a sanctum dedicated to maternal protection and nurturing. In a modern urban society becoming increasingly fast, fragmented, and materialistic, Käsebier creates a tranquil domestic sanctuary based on, as the title suggests, the nurturing care of a mother. Käsebier's image shares with Mary Cassatt's *The Child's Bath* (see fig. 25.21) the same late nineteenth-century feminist belief in the important role that women play in the development of children, and with Cameron's *Sister Spirits* (see fig. 25.36) a female bonding or spiritual sisterhood designed to protect the rights and future of their gender.

EDWARD STEICHEN Along with Käsebier and Stieglitz, Edward Steichen (1879-1973) also helped to found the Photo Secession. Steichen's early contributions to this movement were painterly and moody, his landscapes having the same poetic and mystical quality found in the Tonalist painting that was inspired by Whistler's Aestheticism. His early style can be seen in his 1902 portrait Rodin with His Sculptures "Victor Hugo" and "The Thinker" (fig. 26.44), a gum print. Using the painterly effect of the gum combined with the fuzziness of the focus, he created an image that looks more handcrafted than mechanically reproduced, demonstrating that the photographer made aesthetic decisions that profoundly affected the meaning of the image. Picturing together the brooding silhouettes of Rodin and The Thinker, Steichen uses them to frame a brightly lit, phantomlike Victor Hugo. Clearly, Steichen identifies Rodin with The Thinker. One of the readings of the famous sculpture is that it is meant to represent Rodin and the daunting creative process and mental struggle behind the development of a work of art. This interpretation certainly accounts for this image, as suggested by the light striking Rodin's "brain" and the emergence of Victor Hugo as an apparition, a figment of Rodin's imagination. While in some respects Rodin is portrayed here as a Romantic genius, we also sense a Symbolist psychology at work-ideas do not gush from

26.44 Edward Steichen, *Rodin with His Sculptures "Victor Hugo" and "The Thinker."* 1902. Gum print, $14\frac{1}{4} \times 12\frac{3}{4}$ " (36.3 × 32.4 cm). Courtesy George Eastman House

26.45 Alfred Stieglitz, *The City of Ambition*. 1910. Photogravure on Japanese tissue mounted on paperboard, $13\frac{3}{8} \times 10\frac{1}{4}$ " (34 × 26 cm). Metropolitan Museum of Art, Alfred Stieglitz Collection. 1949. (49.55.15)

his imagination and emotions, but instead they are the result of a long creative struggle, a prolonged search into the dark recesses of the mind.

ALFRED STIEGLITZ Several of the Pictorialists in the Stieglitz circle photographed New York City, although paradoxically their images have a Romantic atmospheric quality more appropriate to landscape than the hard geometric look we associate with urban concrete and steel. By 1900, New York, not Chicago, was the city of skyscrapers, and as America attained global technological and financial superiority, New York and its "cathedrals of capitalism" became an emblem of this superiority. Even though Stieglitz (1864-1946) abhorred modernity and lamented the city's "mad, useless Materiality," he repeatedly photographed Gotham from the early 1890s up to 1910, as seen in The City of Ambition (fig. 26.45) of 1910. Typical of Pictorialist images of New York, his pictures allow meteorological effects, such as snow, mist, steam, and fog, to upstage the buildings. In The City of Ambition, Stieglitz uses the Pictorialists' characteristic soft focus. The metropolis looms large, but buildings are indistinct and in

shadow, softened by puffs of smoke and the clouds behind. Light shimmering on the water gets as much attention as the skyline, and we are very much aware of the glow of the sun setting behind the buildings. Stieglitz capitalizes on this light to orchestrate a beautiful symphony of gray rectangular forms harmonizing with rich darks and bright whites. He captures the awesome scale of the city, this "monster" as he described it, and he suggests, by immersing it in an atmospheric veil, that it seems to comfortably coexist with the awesome forces of nature.

Documentary Photography

Among the most powerful documentary photographs made in the closing decades of the nineteenth century were those chronicling the horrific working and living conditions of the modern city. Some of the best-known work was made in New York, a crowded, fast-growing metropolis teeming with indigent immigrants and migrants readily victimized by unscrupulous landlords and employers. These masses were unsupported by social services and unprotected by the government. Conditions were especially appalling in the immigrant slums on the Lower East Side and the violent, lawless bars and brothels of Five Points, a district largely centering on the Bowery. Unlike the Pictorialists, whose techniques and subjects often softened the realism of their images, documentary photographers embraced the medium's capacity to produce direct, seemingly truthful records. Some documentary photographers felt that their work attained the status of art due to its apparent ability to convey "truth." Others pursued documentary photography for commercial or even political ends. Jacob Riis numbered among the latter.

JACOB RIIS Emigrating from Denmark in 1870, Jacob Riis (1849-1914) became a police reporter in the roughest neighborhoods of New York City, and was so appalled by the degradation and squalor he found there that he began photographing it in order to generate support for social reform. He made lantern slides of his images to illustrate his lectures, and published others in newspapers and magazines. Although Riis did not consider himself an artist, his works are undeniably striking. In order to create authentic, unposed, spontaneous images, he used a "flash," a magnesium flash powder (the predecessor of the flashbulb), which allowed him to enter tenements, flop houses, and bars at night and instantaneously take a picture, temporarily blinding his shocked subjects but capturing a candid image, as seen in Five Cents a Spot (fig. 26.46). Here, he has burst into an overcrowded sleeping den on Bayard Street, creating an image that documents the greedy abuse of the homeless and leaves no doubt as to the unsanitary conditions that made such squalid, illegal quarters a breeding ground for disease. Riis published his photographs in a groundbreaking book, How the Other Half Lives (1890), which in part resulted in the bulldozing of the shanties in the Bayard Street neighborhood and the transformation of the site into a park. An army of social photographers emerged around and after the turn of the century, among the best known Lewis Hine and Jessie Tarbox Beals.

26.46 Jacob Riis, *Five Cents a Spot, Unauthorized Lodgings in a Bayard Street Tenement.* ca. 1889. Gelatin silver print, $8 \times 10^{"}$ (20.3 \times 25.4 cm). Museum of the City of New York, Jacobs Riis Collection #155

Riis's work has something of the look of a snapshot, an uncomposed, quickly taken photograph, and with the advent of small hand-held cameras, this look was common to amateur photography. The snapshot, like the documentary photograph, returns us to the issue of photography as art. Since 1890, virtually everyone in developed countries has accumulated albums, drawers, and boxes filled with snapshots, visual memories of the past. Are they art? In a sense, they are all art, as will be discussed in the next chapter when we study Marcel Duchamp. What is really at issue is whether it is good art, and the answer here is obvious. The vast majority of the billions of images are generic, banal, and predictable, and their value is largely personal, which is no small matter. And yet, there is that rare person with an extraordinary aesthetic sensitivity who, with little technical instruction, produces remarkable images.

HENRI LARTIGUE Such a person was Henri Lartigue (1894– 1986), born into a wealthy French family who gave him his first camera when he was six years old. With this expensive toy, Lartigue proceeded to document his privileged family, filling some 120 albums with images that also captured the advent of modernity—automobiles and airplanes, for example. His images, such as *My Hydroglider with Propeller*, are often humorous, if not outright uproarious. Made in 1904 at the age of ten, the picture shows Lartigue in his bathtub, his head surrealistically cut off at the neck by the water line and "floating" alongside his toy hydroplane, a toy based on a modern invention. Reproduced here is a later work, *Avenue du Bois du Bologne* (fig. 26.47), made at the age of 17 and part of a series of photographs the teenage artist made in one day of fashionably dressed women parading their wealth on the main thoroughfare in the famous Paris park

26.47 Henri Lartigue, Avenue du Bois du Bologne (Woman with Furs, or Arlette Prevost, called "Anna la Pradvina," with her dogs "Chichi" et "Gogo") 15 Janvier 1911, Avenue du Bois de Boulogne, Paris. 1911. Gelatin silver print, $2\frac{1}{3} \times 4\frac{1}{3}$ " (6.6 × 11.1 cm). Donation Jacques Henri Lartigue, Paris

of the same name. Here, Lartigue has captured an amply furdraped "animal lover" walking her dogs, their scrawny build humorously contrasted with her materialistic bulk, and their nervousness with the inanimate drooping skins of her handwarmer. This wonderful composition, which has the voyeuristic quality of a Degas painting, also includes an automobile and a horse-drawn carriage—the new and the old. Its representation of affluence and the inclusion of a car have made it one of the icons of the *Belle Époque*.

Lartigue eventually attended art school and became known as a painter as well as a professional photographer, producing numerous portraits and society photographs. However, his boyhood photographs went unknown until he was 69, and when discovered they were shown at the Museum of Modern Art in New York and in a large spread in *Life* magazine, touted not only for their quality but also because they captured the essence of the time. Their legacy also includes the introduction of humor into the medium, which would become a regular feature of twentiethcentury fine-art photography. Meanwhile, it was not until the 1990s that the aesthetic value of the anonymous snapshot was appreciated, driving collectors and curators to scour flea markets and estate sales for that rare remarkable work, that one-in-amillion shot with riveting subject matter or compelling aesthetic qualities. Called folk, vernacular, and sometimes "found" photography, it is today collected and exhibited by several of the world's best-known museums.

Motion Photography and Moving Pictures

In 1878, Eadweard Muybridge (1830–1904), who had made some of the most remarkable photographs of Yosemite the decade before, was hired by Leland Stanford, a business tycoon, politician, and founder of Stanford University, to use photography to resolve one of the great questions plaguing horse trainers and artists for centuries: Do all four legs of a horse leave the ground when it is running? Setting up 12 cameras on a raceway and creating a calibrated backdrop, he made a series of sequential photographs (fig. 26.48) that once and for all answered the question: Yes. Artists ever since have used these images to draw a horse in motion, including Degas in 1879. Muybridge became a celebrity, and was invited to the University of Pennsylvania in Philadelphia to make studies in locomotion, producing in the 1880s some 100,000 images of nudes and animals. He published 781 plates in Animal Locomotion (1887). These motion studies convey a peculiarly modern sense of dynamics, reflecting, especially in their regularly repeated serial imagery, the new tempo of life in the machine age.

The French physiologist Étienne-Jules Marey (1830–1904) saw Muybridge's horse-in-motion photographs reproduced in the magazine *La Nature*, and became obsessed with studying motion as well. He used a single camera, the lens open, placed behind a rotating disk with regularly placed slots. When a slot appeared, an image was recorded, so that a moving object would appear in a different position each time. Since he was interested in the

26.48 Eadweard Muybridge, *Untitled* (sequence photographs of the trot and gallop), from *La Nature*, December 1878. Gravures. George Eastman House, Rochester, New York

mechanics of locomotion and not the figure itself, he clothed his models in black body suits with a white stripe running along the length of the side. The models were then photographed in action against a black wall. Thus, only the white line of movement is visible in his photographs (fig. **26.49**). Though Marey saw no artistic merit in these studies, the results offer fascinating abstractions. And, as we shall see, they would influence artists who were interested in rendering the movement of an object through space. As important, Marey's and Muybridge's studies reflected a rapidly increasing interest in creating moving pictures. They were building on the popular parlor-game amusements that created images in motion. One device, called a zoetrope, consisted of slotted cylinders with a sequence of images of, for example, a moving horse on the inside. When spun and viewed through the rapidly moving slots, the horse would appear to be trotting. Muybridge invented an apparatus he called the zoöpraxiscope,

26.49 (a and b) Étienne-Jules Marey, *Man in Black Suit with White Stripes Down Arms* and *Legs*, *Walking in Front of a Black Wall*. ca. 1884. Chronophotograph. Institut Marey, Beaune, France

which similarly used a cylinder, but the image was projected, like a magic lantern slide, onto a wall. Enticed by the implications of Muybridge's zoöraxiscope, Thomas Edison in 1894 patented the kinetoscope, which consisted of moving images recorded on a 50foot roll of flexible film that were viewed in a peepshowlike box. The show lasted 13 seconds. The following year, the French Lumière brothers, Louis and Auguste, introduced the handcranked camera and electric film projector and produced the first moving picture, which lasted 25 seconds. It showed workers leaving their father's factory at the end of the day.

In America, movie production was dominated by two companies, Thomas Edison and American Mutascope, which sent crews around the world to record various monuments, sites, and events. The pictures lasted only a few minutes at best and were presented in vaudeville houses in between acts. Filmmakers were now confronted by the same crisis that photographers had faced in 1839: What to film and how to film it. Generally, they focused on movement and action, as can be seen in Edison's 1899 moving picture of a train crossing the Brooklyn Bridge (fig. **26.50**; to view the film *New Brooklyn to New York via Brooklyn* Bridge, No. 2, see hdl.loc.gov/loc.mbrsmi/edmp.1734), filmed by a fixed camera positioned at the front of the first car. The Brooklyn Bridge film is revealing on many levels. First, it is a reminder that the early films, like those of today, had to appeal to a mass audience and present subjects of popular interest. Technological inventions and moving images of modernity, such as subways, skyscraper construction, the one million electric lights at the new Coney Island Amusement Park, and sleek oceanliners and battleships coming into New York harbor, seem to make up a large portion of the existing Edison inventory from the late 1890s. Second, the film is remarkable for its modern attitude toward speed and space. As the train travels through the trussed structure, we become mesmerized by the rhythm of the wooden supports passing by and feel the speed of the electrified cars. Soon, the square structure becomes just an abstraction of squares within squares (fig. 26.50). As we shall see in the next chapter, objects, space, and time were understood much differently in a modern mechanized era dominated by electricity, vertiginous 55-story office towers, high-speed trains, cars, and, soon, airplanes and moving pictures.

26.50 Thomas Edison. Still from the film New Brooklyn to New York via Brooklyn Bridge, No. 2. September 22, 1899. Black-and-white film, 2'13"

1880 Rodin begins The Gates of Hell

1878 Eadweard Muybridge makes sequence photographs of a horse galloping

1885-87 Cézanne's Mont Sainte-Victoire

1886 Seurat shows *La Grande Jatte* at the last Impressionist exhibition, marking the end of Impressionism and the beginning of Postimpressionism

1889 Van Gogh's Starry Night

1892 Victor Horta designs Tassel House, Brussels

1890–91 Louis Sullivan's Wainwright Building is erected, St. Louis, Missouri

Progress and its Discontents: Post-Impressionism, Symbolism, and Art Nouveau, 1880–1905

- 1878 First International Congress of Women's Rights, Paris
- 1880s European nations colonize Africa
- 1882 The Edison Illuminating Electric Company provides electricity to lower Manhattan
- 1884 Seurat shows A Bathing Place at first exhibition of Independent Artists, Paris
- 1886 Jean Moréas publishes a Symbolist manifesto in Figaro Littéraire
- 1888 Van Gogh and Gauguin go to Arles
 1888 The Nabis are founded in France
 1888 Karl Benz begins manufacturing a combustion-engine automobile in Germany
- 1890 The National American Woman Suffrage Association formed
 1891 Gauguin goes to Tahiti

1891 Claude Monet's Wheatstack, Sun in the Mist

- 1895 Siegfried Bing opens La Maison de l'Art Nouveau in Paris
- 1897 Vienna Secession founded, with Gustav Klimt as its first president
- 1900 The Paris Métro opens
 1900 Sigmund Freud publishes The Interpretation of Dreams
 1901 First transatlantic radio signal
 - 1903 Wright brothers' first flight

1910

1870

1880

1890

1900

1893 Edvard Munch's The Scream

Toward Abstraction: The Modernist Revolution, 1904–1914

HE OPENING DECADES OF THE TWENTIETH CENTURY SAW THE continued upward march of modernity. But, as in the preceding decades, artists both embraced and fled from progress. In some instances, they even clung to tradition while they purveyed the new, which we shall see, for example, in the work of Pablo Picasso and Henri Matisse, two artists who

successfully knitted together the new and revolutionary in style with the familiar and enduring in subject matter. The period is marked by landmark scientific developments that artists, like the public at large, could not ignore. In 1890, the German physicist Max Planck (1858–1947) proved that energy was not distinguishable from matter, in effect beginning a line of thought that led to quantum physics. He showed that energy was emitted and absorbed in bundles called quanta, disproving the idea that energy existed in a stable, uniform state. Energy and, therefore, matter were in constant flux. This concept was especially pertinent to the discovery of radioactivity in 1902 by British physicist Ernest Rutherford (1871–1937). In 1913, the atom itself was further redefined when the Dane Niels Bohr (1885-1962) declared that it consisted of electrons traveling in specific orbits around an atom's nucleus, and that matter was not solid but instead in constant movement. But the greatest amendment to classical physics was proposed by Albert Einstein (1879-1955). Einstein's revolutionary concepts appeared in a series of papers published in 1905 and 1916, and they included his theory of relativity, which claimed that time, space, and motion were not fixed but all relative, especially in relation to the observer's own position. The Newtonian world order, based on notions of energy and matter that remained

stable, was now supplanted by a more complex and contingent notion of the universe.

Similar ideas emerged in accounts of human behavior by philosophers and psychologists. Henri Bergson (1859-1941), a French philosopher, was so influential in the first years of the twentieth century that he was well known even to the general public. Bergson postulated that we experience life not as a series of continuous rational moments, but as intuited random memories and perceptions that we then piece together to form ideas. The world, therefore, is complex and fractured, or as expressed by the Harvard philosopher and psychologist William James (1842-1910), whose theories independently paralleled Bergson's, a "booming buzzing confusion." Only intuition transcended this chaos. The mind, according to Bergson, was pure energy, an *élan* vital ("vital force") that penetrated the essence of all things. While Bergson was philosophically redefining consciousness, the Viennese neurologist and founder of psychoanalysis Sigmund Freud (1856-1939) continued to refine his ideas of the unconscious through observations made during clinical practice, an approach that he felt gave his conclusions a scientific basis. Despite taking a different approach from Bergson, Freud likewise developed a model of human consciousness as fragmented and conflicted.

Artists now pictured this new, constantly shifting, even fractured world discovered by scientists, philosophers, and psychologists. Some artists, such as Picasso and Georges Braque, in a sense emulated scientists, treating their studios like laboratories

Detail of figure 27.14, Vasily Kandinsky, Sketch I for "Composition VII."

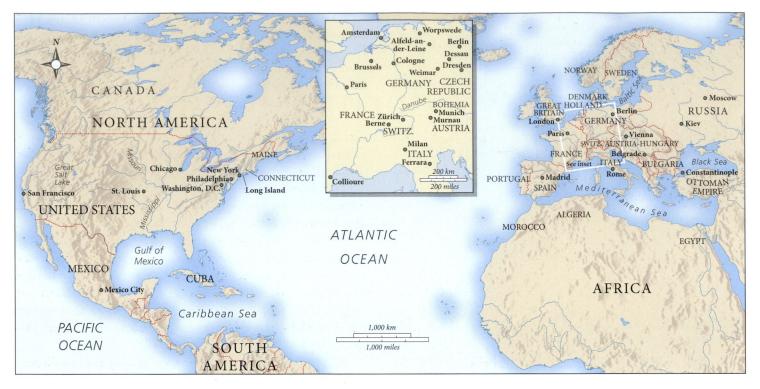

Map 27.1 Europe and North America in August 1914

in which to analyze the very language of painting and where each creative breakthrough served as a steppingstone to the next as they sought to develop a new model of visual perception. Others, such as the Italian Futurists, embraced modernity and used new scientific discoveries, along with the radical stylistic developments of Picasso and Braque, to express the psychology of modern life and the impact of the technological wonders transforming the world.

Other artists, however, especially many of the German Expressionists, sought an antidote to the cold, impersonal tenor and crass materialism of modernity and tried to invest contemporary life with spirituality. Continuing Gauguin's quest to find a spiritual peace in a so-called primitive world that was in tune with nature, many artists turned to the direct, more abstract vocabulary of tribal art as well as to children's, folk, and medieval art. Many of these artists were heavily influenced by Theosophy, a brand of mysticism that dates back to Plato, but that in the nineteenth century took new form in the Theosophical Society, founded in New York in 1875 by the Russian émigrée, occultist, medium, and mystic Madame Helena Blavatsky. Basically, Theosophists claimed all religions are the same, with each containing an essential component of one larger grand religion. Therefore, all had to be studied. More important, Theosophists claimed that all creation is part of one eternal life, a "Radical Unity," and that everything is therefore mystically interconnected. For artists attempting to visualize the spiritual, the essence of which cannot be seen and is therefore abstract, the new stripped-down vocabulary of art was the perfect vehicle.

FAUVISM

The rise of Fauvism, the first major style to emerge in the twentieth century, is part of a colorist tradition that can be traced back through Van Gogh, Gauguin, Monet, and Delacroix to Titian and the Venetians. The Fauves, however, took the free, expressive use of color to new heights. Van Gogh and Gauguin had the greatest impact on the group, as is readily apparent in the work of Henri Matisse (1869-1954) and André Derain (1880-1954). Matisse was well aware of the aesthetic traditions with which he was wrestling. Trained in the studio of Gustave Moreau (see page 918), Matisse had received an exacting academic education at the École des Beaux-Arts. He therefore understood the extent to which he was both continuing and breaking tradition when, in 1905, he presented his latest pictures at the Salon d'Automne, or Autumn Salon, an important annual venue for vanguard artists established in 1903 by Matisse and Derain, among other artists. As exhibitions of avant-garde art proliferated in Paris at the turn of the century, the Salon d'Automne enjoyed a special status as a juried show where critics anticipated seeing the best of the new work. Few critics or other viewers for that matter were prepared for what they saw there in 1905.

By that year, Matisse had not only moved beyond his academic training with Moreau, but had passed through an Impressionist phase in the 1890s, then a Cézannesque period, and finally a Neo-Impressionist stage. Strongly influenced by the Post-Impressionists' use of color for formal and expressive ends, Matisse pushed the independence of color even further. His experiments proved

27.1 Henri Matisse, *Femme au chapeau* (Woman with a Hat). 1905. Oil on canvas, $31\frac{3}{4} \times 23\frac{1}{2}$ " (80.6 × 59.7 cm). San Francisco Museum of Modern Art. Bequest of Elise S. Haas. 91.161.

too radical for some. Art critic Louis Vauxcelles was so shocked by the "orgy of pure colors" that he encountered in the work of Matisse, Derain, and their colleagues at the *Salon d'Automne*, that he declared the pictures *fauves*, or "wild beasts."

A classic example of the Fauve work exhibited in 1905 is *Femme au chapeau* (fig. 27.1). While the subject evokes a tradition of coloristic, virtuoso portraiture that stretches back to Vigée-Lebrun, Rubens, and Titian (see figs. 23.29, 20.3, and 16.33, respectively), Matisse's use of color is totally new. As with Impressionism, the color is intense, the image constructed of primary and secondary colors that look as if they have been squeezed directly from the tube. But now color does not have a representational function, adhering to a specific object. Instead it seems to have a life all its own, with patches of color sitting next to one another in what seems like random fashion. Along with the brushwork, color seems to reside uniformly on the surface of the image, reflecting Matisse's careful study of Cézanne's paintings. On the one hand, the background splashes of greens, yellows, reds, and blues appear to exist on the same plane as the head and body in the foreground, locking all together as in one continuous flat mosaic. On the other, there is just enough overlapping of representational objects, such as arm and torso, to create space, and of course there is the abstract pictorial space suggested by contiguous planes of color and brushstroke, as we saw in Cézanne. Matisse, however, has dispensed with Cézanne's structure and monumentality, and instead achieves compositional coherence by balancing intense, complementary hues applied with brash, seemingly spontaneous brushwork.

Traditionally, art historians have placed the work of the Fauves in the category of Expressionism, but this is problematic, since the term generally applies to work displaying an outpouring of emotion—a tortured, anguished, or a pained state of mind. Despite the riot of color and chaos of brushstrokes, *The Woman with the Hat* is not about the sitter's or the artist's psychology. The figure is nothing more than an armature for an exercise in design and the release of color from a naturalistic or documentary function. The same is true of Matisse's landscapes and still lifes from this period as well.

André Derain, likewise, understood painting as an intellectual rather than an emotional medium. His *Mountains at Collioure* (fig. **27.2**), a subject located in the south of France, where he was painting with Matisse in 1905, may seethe with Van Gogh's energetic brushwork and Gauguin's arabesques, but Derain did not intend it to embody those artists' spirituality or primitivism. Like the figure for Matisse, the landscape is just a vehicle for Derain's complex play of joyous color and surface design. Derain's overriding interest is in the *formal*—meaning abstract qualities of image making, with special emphasis on bright color functioning in a nonrepresentational role.

The Fauves were never an organized group. The term was applied by critics to artists, many of whom had been friends since 1900, who used bright color and happened to show together at the *Salon d'Automne* of 1905, where the similarity of their work was recognized. By 1908, Fauvism had disintegrated. For Matisse, it was just one more stage toward making art that was, as he put it, "something like a good armchair in which to rest from physical fatigue." In other words, Matisse sought to use color in an abstract way that was beautiful, peaceful, serene, and sensuous.

We can see Matisse beginning to move out of Fauvism in his 1905–06 painting *Le Bonheur de Vivre (The Joy of Life)* (fig. 27.3). This work shows the influence not only of Derain's curvilinear patterning but also of first-hand experience with Gauguin's paintings; Gauguin's estate was being stored in Collioure, and Matisse visited the collection twice. The color in *Le Bonheur* remains intense and nonrealistic, but now it is contained in graceful arabesques. Matisse's most innovative move here is to dispense with logical space and scale while increasing the abstraction. No matter how abstract and flat Derain's and Matisse's Fauvist pictures of just a year earlier are, they still project a rational progression of space. Now, in Matisse's work, that space is gone, as two enormous reclining nudes in the middle ground are as large as, if 27.2 André Derain, *Mountains at Collioure*. 1905. Oil on canvas, $32 \times 39\frac{1}{2}$ " (81.5 × 100 cm). National Gallery of Art, Washington, D.C. John Hay Whitney Collection

27.3 Henri Matisse, *Le Bonheur de Vivre (The Joy of Life)*. 1905–06. Oil on canvas, $5'8" \times 7'9^{3}/4"$ (1.74 × 2.38 m). The Barnes Foundation, Merion, Pennsylvania

27.4 Henri Matisse, *The Red Studio*. 1911. Oil on canvas, $5'11'_4$ " × $7'2'_4$ " (1.81 × 2.19 m). Museum of Modern Art, New York. Mrs. Simon Guggenheim Fund

not larger than, the pipe player and kissing couple in the foreground. Figures dissolve into one another and trees into sky and hills, so that it is nearly impossible to tell which sits in front of which. Reality gives way to a joyous abstract orchestration of colored lines and planes, which takes its hedonistic cue from the Classical idylls of ritual, dance, and music making of Puvis de Chavannes (see fig. 26.5). The pipes, garlands, shepherd, and sense of Graeco-Roman nudity evoke an archaic Classical world, the same world conjured by such French painters as Poussin and Claude (see figs. 21.7 and 21.8).

Because of the intensity of its color, *Le Bonheur* is generally labeled a Fauvist picture. By 1907, however, Matisse's palette, while still colorful, was subdued, becoming sensuous and serene rather than joyfully riotous. We can see this new sensitivity in his 1911 *The Red Studio* (fig. 27.4). While the subject is again a conventional one—in this case, the artist's studio—in Matisse's hands, the theme takes on new import. On the one hand, reassuringly familiar objects appear, such as pencils, a collection of studio props arranged as a still life, and several of Matisse's own canvases and along the right wall his sculpture. On the other hand, *The Red Studio* offers a viewer a completely novel visual experience through the manipulation of color and line to radically redefine pictorial space.

As the title indicates, the painting's keynote is the color red, which is like a flat window shade pulled through the entire canvas. Basically unvarying in tone, it momentarily becomes floor, wall, and tablecloth because of the white-line drawing, before popping back to the surface as a perfectly flat red shade. Even the white lines that delineate the table, high-backed chair, and wall, for example, and suggest recession and thus space, ironically reinforce the two-dimensionality of the image, for they are not painted lines. Rather, they are slivers of canvas that Matisse has allowed to show through.

Matisse's slightly rust-colored red is highly evocative. It is enticing, lush, sensuous, soothing, and comforting, telling us with extraordinary efficiency and immediacy that this studio is warm, cheerful, and relaxing. The paintings on the wall seem to float on this red field, popping up to the surface of the image and asserting themselves as objects of pride and accomplishment. Matisse similarly highlights his box of pencils, plate, flowers, and chair, personal objects that must have been special to him. Only by dispensing with conventional space and volume, meaning realism, could Matisse push these objects to the fore and make them so prominent. The flat red field also serves as a foil that allows Matisse to create a wonderful syncopated rhythm with the paintings and other objects, producing a vitality that suggests artistic creativity, which complements the peacefulness of the room. Without entirely dispensing with the representational world, Matisse has used an abstract vocabulary to convey his soothing message.

CUBISM

The second major style to emerge in the new century was Cubism, largely under the leadership of Pablo Picasso and Georges Braque. Cubism was not just an innovative style that sparked new ways of thinking about the look of art. It was also important because it introduced new ways of thinking about the purpose of art, which happened when its subject matter became not so much the still lifes and portraits that were embedded within Cubist abstraction but rather an analysis of the very language of painting. Picasso was the first to push the limits of the abstraction observed in the work of Cézanne, Derain, and Matisse.

Reflecting and Shattering Tradition: Les Demoiselles d'Avignon

Pablo Picasso (1881–1973) was born in the Spanish town of Malaga, on the Mediterranean coast, where he began his artwork

under the direction of his father, who was a painter. At age 15, he moved to Barcelona and continued his training at the Escuela de Bellas Artes. He was soon a major figure in Barcelona's art community, working primarily in a Symbolist style. After roughly four years of shuttling back and forth between Barcelona and Paris and leading a desperate, abject existence, he settled permanently in Paris, moving into a run-down building nicknamed the bateau-lavoir ("laundry boat") in bohemian Montmartre, the rural hill overlooking the city. The neighborhood was a center for the impoverished cultural avant-garde, and Picasso quickly became part of the group's inner circle, which also included writers Max Jacob (1876-1944) and Guillaume Apollinaire (1880-1918). In 1907, Picasso shocked even his closest companions when he unveiled in his studio Les Demoiselles d'Avignon (The Young Ladies of Avignon) (fig. 27.5). The painting's style departed sharply from Picasso's previous work. To his contemporaries, this large, frightening picture seemed to come out of nowhere.

Of course, the painting did not emerge from an aesthetic vacuum. Among Picasso's sources were the great French history

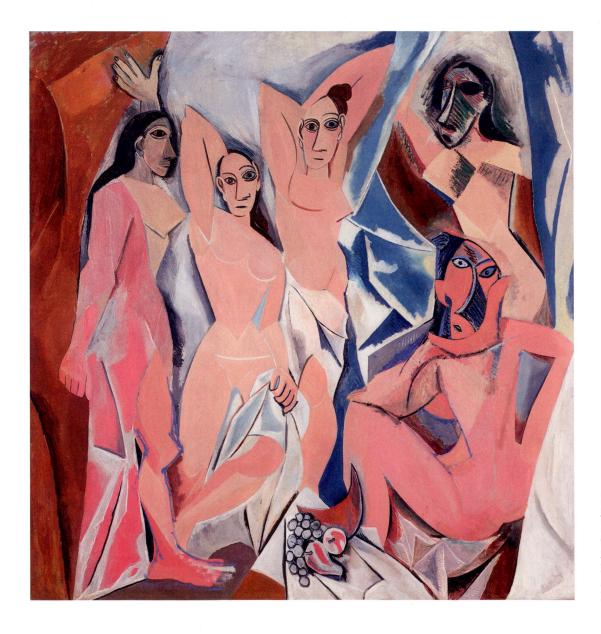

27.5 Pablo Picasso, Les Demoiselles d'Avignon (The Young Ladies of Avignon). 1907.
Oil on canvas, 8' × 7'8"
2.44 × 2.34 m). Museum of Modern Art, New York.
Acquired through the Lillie P. Bliss Bequest

The Myth of Primitivism

European countries began trading with Africa shortly before 1600 and the South Pacific (Oceania) in the late eighteenth century. But it was not until the nineteenth century that serious attempts were made to collect the art of these regions. Missionaries, traders, and government administrators sent home native objects, their activities increasing dramatically with the colonization of Africa and the Pacific in the closing decades of the century. The result of this collecting was the founding of ethnographic museums or ethnographic departments in fine art museums in major cities in Europe and the United States.

Despite the fact that tribal art was housed and presented in museums, including some that even specialized in antiquities, the works were perceived as artifacts, not art. It was ethnographic material. Paul Gauguin was the first artist to take a serious interest in tribal objects as art, incorporating Polynesian motifs and stylistic components into his paintings, prints, and sculpture, work that sought to escape the corrupting influence of decadent Western civilization by turning to socalled "primitive" cultures, which he perceived as more pure, natural, and unspoiled (see page 915). But it was not until about 1905 that tribal art began to have a broad impact on contemporary artists. The Fauves, including Henri Matisse and André Derain, were among the first artworld figures to begin collecting the sculpture of Africa and Oceania, soon followed by Pablo Picasso and Constantin Brancusi, as well as the German Expressionists, especially Ludwig Kirchner, who are discussed in this chapter.

The attraction of tribal art was twofold. First, much of it was abstract (although much was also naturalistic), reinforcing the abstraction of modern art. Its simplification of form, color, line, and composition and rejection of naturalism paralleled developments occurring in avant-garde art. For some artists, such as Picasso and Kirchner, the work was probably attractive for its expressionistic qualities, qualities that they perceived as frightening, even barbaric, and that could be incorporated into their work to express powerful emotions and a strained psychological state.

paintings of the seventeenth and eighteenth centuries; the canvas he chose for the work is uncharacteristically large, consistent with the dimensions of a painting destined for the traditional Salon. And the nude was a classic academic subject. An antithetical and more immediate influence was the avant-garde work of Matisse, with whom Picasso maintained a friendly rivalry until the older artist's death in 1954. In the case of *Les Demoiselles*, he was responding to the spatial ambiguity of Matisse's *Le Bonheur de Vivre*, which Picasso felt compelled to upstage. These sources were not immediately apparent to visitors to Picasso's studio, and *Les Demoiselles* initially outraged Matisse and everyone else. But once understood, it provided inspiration for untold artists for decades to come.

The title of the painting refers to the "red-light" district in Barcelona. Early studies show a sailor in a brothel, seated before a table with a plate of fruit and surrounded by prostitutes. In the final painting, the sailor is gone, but the theme remains, for we, the viewers, become the sailor seated at the table in front of the Second, tribal art was alluring to the avant-garde because, as for Gauguin, it represented humanity in an unspoiled, more natural state, a perception that can be traced to Jean-Jacques Rousseau's Enlightenment concept of the "noble savage" (see page 787). Before the discovery of tribal art, this return to nature and a simpler, more primordial time when humans were directly connected to universal forces was reflected by an interest in rural, even peasant, life, the Middle Ages, or Classical arcadias, as seen in the art or theory of George Sand, Rosa Bonheur, John Ruskin, the Pre-Raphaelites, William Morris, and Puvis de Chavannes (see Chapters 25 and 26).

The process of deriving inspiration from tribal cultures is called primitivism, and the term is often expanded to include appropriations of other art forms perceived as simple, naïve, and direct, such as Pre-Columbian, Native American, Archaic Greek, medieval, children's, and self-taught art. The first major publication on the subject, Robert Goldwater's Primitivism in Modern Art, came out in 1938. The book said little or nothing about the nature of tribal art, which Goldwater loved, and presented it as primitive, even inferior, in comparison to Western art, ignoring the aesthetic and social issues embedded in the work that would demonstrate that it was as sophisticated, complex, and rich as European fine art. With the advent in the 1960s of Postmodern philosophy (see page 1075), which argued that all viewpoints are biased and contain hidden agendas, scholars themselves began to realize their own prejudices and stopped perceiving tribal art as primordial, as had the modernist artists. Postcolonial scholarship, the scholarship coming out of the African independence movement that began in the 1950s, similarly attacked Western scholarship. Particularly influential was Edward Said's Orientalism (1978), which argued that the Western mind, because it had always considered Islamic culture as the inferior "other," could never responsibly report on North Africa and the Near East.

fruit, an age-old symbol of lust. Coming through the brothel curtains and staring directly at us are perhaps five of the most savage, confrontational nudes ever painted. Thematically, then, the picture began as a typical Symbolist painting about male lust and castrating women, a continuation of the *femme fatale* theme prevalent in late nineteenth-century art and literature, as well as a reflection of Picasso's personal sexual conflict with women and his intense fear of venereal disease.

Instead of relying on conventional forms of pictorial narrative to tell his tale, Picasso allowed the abstract qualities of the medium to speak for him. For example, the formal qualities are threatening and violent, while the space is incoherent and jarring, virtually unreadable. The entire image is composed of what looks like enormous shards of glass that overlap in no comprehensible way. Instead of receding, they hover on the surface of the picture plane, jostling each other. Sometimes the facets are shaded, as in the diamond-shaped breast of the harlot parting the curtain on the right, but Picasso has reversed the shading, in effect detaching the

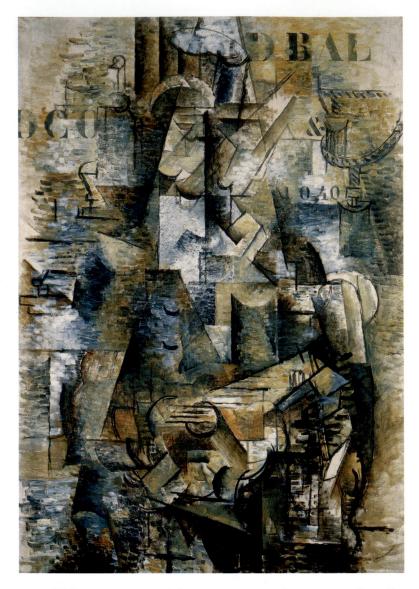

27.6 Georges Braque, *The Portuguese*. 1911. Oil on canvas, $45\% \times 32\%$ " (116 × 81.6 cm). Kunstmuseum, Basel. Gift of Raoul LaRoche, 1952

breast from the body. Even more incomprehensible is the seated figure below her, who has her back to us yet simultaneously faces us. The table with fruit is tilted at such a raking angle that it would shock even Cézanne, who provided the most immediate model for this spatial distortion (see fig. 26.3) and was the subject of a major retrospective in Paris in 1907. The menacingly pointed melon sets the shrill tone for the picture and through its unsubtle phallic erection announces the sexual theme.

The use of conflicting styles within a single picture is another disturbing quality. The three nudes to the left with their almondshaped eyes and severe facial features were inspired by ancient Roman Iberian sculptures, which Picasso collected. But the frightening faces on the right are entirely different. At this point in the creation of the painting, or so the story goes, Picasso's Fauve friends took him to the Trocadéro Museum of ethnographic art, where he saw African masks, providing the source for the ski-jump noses, facial scarifications, and lopsided eyes. The story seems logical enough. We know Matisse and Derain were already collecting African art, attracted to its abstract qualities and admiring how Africans had relinquished naturalism for the sake of expression. And Picasso and Matisse had known one another since 1905. Direct sources for Picasso's borrowings can be found in African sculpture, and the abstraction and "barbarism" of the masks must have appealed to the artist's sensibility. (See *The Art Historian's Lens*, page 951.)

Picasso adamantly denied the influence at this time of *art nègre*, as African art was then called, although he would soon collect it himself. And, sure enough, in the early 1990s, art historians discovered that his source was possibly his own imagination, a claim based on doodlings in his sketchbooks that predate his exposure to African art. The striations, for example, were notational marks for shadow, while the head of the crouching *demoiselle* was actually the result of a witty transformation of a female torso into a face (visual double-entendres occur frequently in Picasso's art). But given Picasso's friendship with the Fauves, it is hard to imagine that he had not heard about and visited the Trocadéro Museum before he finished the painting.

Regardless of his sources, what cannot be denied is Picasso's willingness to look anywhere for inspiration, from the lowly source of his own caricaturing to African masks (then considered artifacts and not art), to Classical Greek sculpture, reflected here by the tradition of the monumental nude, which Matisse had presented so differently in *Le Bonheur de Vivre*. But most important about *Les Demoiselles* is the new freedom it announced for painting, for now line, plane, color, mass, and void were freed from their representational role to take on a life all their own. The picture laid the foundation for Analytic Cubism.

Analytic Cubism: Picasso and Braque

It may seem incredible that Les Demoiselles owes anything to the methodical, highly structured paintings of Cézanne, but Picasso had carefully studied Cézanne's late work and found in his abstract treatment of volume and space the basic units from which to derive the faceted shapes of what became Analytic Cubism. Picasso did not arrive at this style on his own, however, and even seemed creatively stalled after Les Demoiselles. To help him move beyond this point, the emotional Spaniard needed an interlocutor, a rational steadying force, someone with whom he could discuss his ideas and experiment. This intellectual partner was the French artist Georges Braque (1882-1963), who conveniently lived around the corner from him in Montmartre. From 1908 to 1910, the two fed off each other, their styles developing from representational pictures of fractured forms and space, as seen in Les Demoiselles, to shimmering evanescent mirages of abstract lines and brushwork, as found in Braque's 1911 painting The Portuguese (fig. 27.6). Picasso and Braque were so intertwined during this period that their styles began to merge by 1910.

The Portuguese is a classic example of the Analytic Cubism that had emerged in 1910. Gone is the emotional terror and chaos of *Les Demoiselles*. Braque arranged a grid of lines following the shape of the canvas and an orderly geometric pattern of diagonal lines and curves, all recalling Cézanne's vision of a tightly structured world. Despite being abstract, however, these shapes also function as signs or hieroglyphs. The circle at the lower center is the sound-hole of a guitar, and the horizontal lines are the strings, although Braque used the same sign to indicate fingers, a confounding or visual punning of objects that is characteristic of Cubism and a declaration that art is a signing system, like language. The stenciled letters and numbers come from a poster that probably read "Grand Bal" and listed the price of admission (10 francs 40 centimes). The lines and shadows suggest arms, shoulders, and the frontal or three-quarter pose of a figure that tapers toward the head. In the upper right, we see lines that suggest rope and a pier. By providing these subtle visual clues, Braque prompts the viewer to recognize that the painting shows a guitar player, in a Marseille bar, with a view of the docks through a window. As with Les Demsoiselles, we find a conventional subject-a genre scene-presented in a radical new artistic language. The light that floods the picture and falls on individual facets seems real or naturalistic but fails to create coherent space and volume. Ultimately everything is in a state of flux without absolutes, including a single interpretation of reality. The only reality is the pictorial world of line and paint, which Braque is telling us is as much a language as the hieroglyphic signs that he has embedded in his image.

In a 1909 review of Braque's earlier work, Louis Vauxcelles, who had named Fauvism, labeled the paintings "Cubism," influenced by Matisse's description of earlier Cubist works as appearing to be made of little cubes. The word was then applied to the analytic experiments of Braque and Picasso.

Synthetic Cubism: The Power of Collage

To focus on structure, line, and space, Picasso and Braque painted monochrome images, thus removing the problem of color from their Analytic Cubism. This situation changed in 1912, however, when they began working in collage, pasting flat objects, generally paper, onto canvas. Picasso made the earliest known example in May 1912, when he glued onto the surface of a Cubist painting a sheet of imitation chair caning, a product not unlike contact paper. (These oilcloth sheets with a chair-caning pattern printed on them were normally pasted on wood as an inexpensive way to repair a broken seat.) This device allowed him to complicate notions of the real and the illusionistic, for the chair caning was simultaneously real—a piece of real imitation chair caning—and illusionistic, a picture of chair caning. Clearly, collage allowed Picasso to continue parsing the language of painting,

Picasso and Braque realized immediately the broader implication of collage—the pasted image now literally sat on top of the canvas, a statement Matisse had made a year earlier about painted imagery in *The Red Studio* when he revealed the canvas to emphasize how paint sat atop its surface. Once and for all, the Renaissance conception of the picture plane as a window into an illusionistic world was shattered. Instead of a window, the picture surface became a tray on which art was served. Art occurred in front of, not behind, the canvas, a fact Édouard Manet had implied some 50 years earlier (see page 868).

Collage completely changed the way in which Braque and Picasso made their images. Instead of breaking down or abstracting an object into essential forms, the artists now synthetically constructed it by building it up or arranging it out of cut pieces of paper, hence the name Synthetic Cubism. Constructing the image out of large, flat shapes meant that they could introduce into Cubism a variety of textures and colors, as seen in Picasso's *Guitar, Sheet Music, and Wine Glass* (fig. **27.7**) of 1912. Because music is abstract, like their art, it became a favorite theme for the Cubists, who wished to establish parallels between the two art forms. Picasso built his composition on a background of real wallpaper that, like the imitation chair caning used earlier, serves as a visual pun on illusion and reality.

Picasso puns with solid forms and intangible space as well. The guitar sound-hole, an element that should be negative space

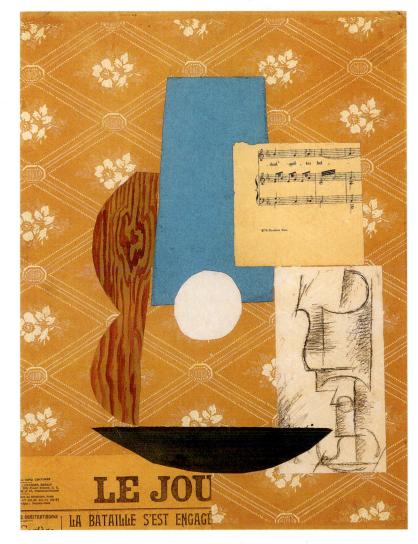

27.7 Pablo Picasso, *Guitar, Sheet Music, and Wine Glass.* 1912. Charcoal, gouache, and pasted paper, $24\frac{5}{8} \times 18\frac{1}{2}$ " (62.5 × 47 cm). The McNay Art Institute, San Antonio, Texas. Bequest of Marion Koogler McNay

but appears as a solid circle of paper, contrasts with the wine glass in the Analytic Cubist drawing, which should be threedimensional and solid but instead consists of lines on a flat piece of off-white paper that has more physical presence than the drawn glass. Picasso even tells us he is punning, for he has cropped the newspaper collage at the bottom to read "LE JOU," a shortening of Le Journal, or "newspaper," which in French sounds like the verb jouer, meaning "to play." The headline for the article is "La Bataille s'est engagé," which translates as "The Battle Has Started," and refers to the violent war then raging in the Balkans, with Greece, Serbia, Bulgaria, and Montenegro fighting for independence against the Ottoman Empire (see map 27.1). Picasso uses the announcement to signal the friendly rivalry between himself and Braque. Possibly, he is subtly contrasting the sensual pleasure of his still life and its implied comfortable bourgeois lifestyle with the horrendous suffering of the Balkan conflict, in effect commenting on French or middle-class indifference to the tragedy occurring to the east.

The logical peak of Cubism occurred when Picasso extended Synthetic Cubism to sculpture and created the first construction, a three-dimensional assemblage of materials. Although his earliest construction was made in 1912 (and evidence suggests Braque had made some even earlier), Picasso did not produce a large number of these sculptures until 1914–15. Most were musical instruments, such as Violin (fig. 27.8) of 1915. Instead of pasting paper onto canvas, he assembled flat or slightly bent sheets of painted metal into a low relief. Just as he had for painting, he now redefined sculpture. Instead of being carved, chiseled, or molded, his sculpture was assembled, and, unlike most sculpture since the Renaissance, it was painted. He used paint perhaps with a bit of irony, since the cross hatching used to represent shading in his paintings is unnecessary for a sculpture, the three-dimensional form not requiring illusionistic shadow. Again Picasso puns with his medium as he comments on the language of art, describing the properties of sculpture and how it functions. While the subject of the work is a violin, we would never know this for certain were it not for the title. Recognizing a violin is not the issue, however, for Picasso is more concerned with creating a visual equivalent to music-here a staccato rhythm of shape, color, and texture-that transforms the individual metal components into playful musical notes that we can almost hear.

The outbreak of war in 1914 disrupted daily life, bringing an end to the brilliant visual game between Picasso and Braque. By then, the two artists had completely transformed painting and sculpture, undermining some 700 years of tradition by destroying notions about what art forms could be. Conventional systems for representing perspectival space were demolished, and now line and color conveyed formal or expressive content instead of serving to duplicate observed reality.

Braque and Picasso sparked a revolution in our perception of reality as radical as those of Freud and Einstein. Music and literature were undergoing similar transformations. For example, Russian composer Igor Stravinsky (1882–1971) changed the face of music with his primitive, rhythmic ballet score *The Rite of*

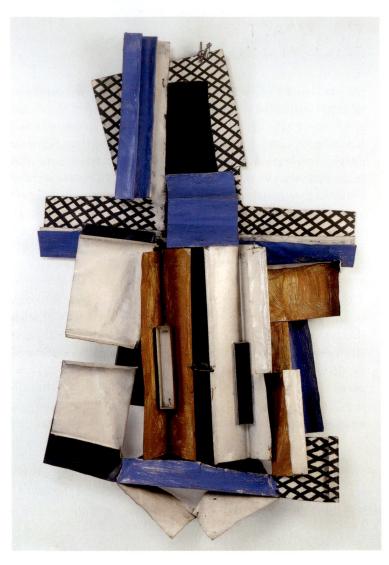

27.8 Pablo Picasso, *Violin.* 1915. Construction of painted metal, $37\frac{1}{2} \times 25\frac{5}{8} \times 7\frac{1}{2}$ " (94.5 × 65 × 19 cm). Musée Picasso, Paris

Spring, first performed in 1913 in Paris, where it caused a riot because people found it merely cacophonous noise that abandoned all musical rules. Irish author James Joyce (1882–1941) similarly dismantled and restructured the novel in *Ulysses*, begun in 1914, in which he disrupted the continuity of the narrative by giving a reader multiple views of the characters' personalities and psychologies.

Especially close to the Cubists, however, was the writer Gertrude Stein (1874–1946), who with her brother Leo amassed an astonishing collection of works by Picasso and Matisse, which they displayed in their Paris apartment. Stein is famous for such phrases as "Rose is a rose is a rose is a rose" or "Out of kindness comes redness and out of rudeness comes rapid same question, out of an eye comes research, out of selection comes painful cattle." Inspired by Cézanne, her novels and poems have a streamof-consciousness and fractured abstract quality meant to evoke "the excitingness of pure being." Like Cubism, Stein's rhythmic "word-paintings" deny any absolutes.

THE IMPACT OF FAUVISM AND CUBISM

Matisse's and Picasso's liberation of color and line from illusionistic roles marked important steps in the development of modern art. As innovative as their achievements were, their interests and sensibilities during these years were limited. Their works were rational, intellectual, and pleasurable, and they focused on such traditional subjects as still life, portraiture, and the figure. Yet they provided a new artistic vocabulary for artists with very different interests and concerns, artists who used this new language to project powerful emotions, spirituality, and the intensity of modernity.

German Expressionism

The long tradition of Expressionism in German art extends back to the grotesque physical and psychological tensions of such Renaissance artists as Matthias Grünewald (see fig. 18.10) and Albrecht Dürer (see fig. 18.14). German Expressionism surfaced as a cohesive movement toward 1905, and although it encompassed a range of issues and styles, it can be characterized as tortured, anguished, brutally primitive, or passionately spiritual, reflecting elemental cosmic forces.

27.9 Paula Modersohn-Becker, *Selbstbildnis, Halbakt mit Bernsteinkette* (Self-Portrait with an Amber Necklace). 1913. Oil on canvas, $24 \times 19^{3}/4^{"}$ (61 × 50.2 cm). Kunstmuseum, Basel

A precursor of the first German Expressionist movement is Paula Modersohn-Becker (1876–1907), whose career was cut short by her early death at the age of 31. Her artistic activity was limited to two mature years, during which she produced remarkable pictures that promised a brilliant future. In 1898, she settled in the commune of Worpswede, a haven for artists and intellectuals seeking escape from modern urban life, just outside Bremen in north Germany. There, she befriended two major Symbolist writers, the poet Rainer Maria Rilke (1875–1926) and the novelist Carl Hauptmann (1862–1946), both of whom urged her to seek the spiritual in her art and to reject the naturalistic. Modersohn-Becker visited Paris regularly, and in 1905–06 she was especially influenced by exhibitions of works by Gauguin and Cézanne.

The emergence of her individual style is represented by her 1913 Selbstbildnis, Halbakt mit Bernsteinkette (Self-Portrait with an Amber Necklace) (fig. 27.9). In this radical picture, the artist presents herself nude. With this gesture, Modersohn-Becker reclaims the nude female form for women, endowing it with a creative vitality and meaning that challenges the tradition of the passive nude Venuses and bathers popular since the Renaissance. The artist presents herself as an emblem of fertility, an earth-goddess, from which all life flows. Showing herself frontally, like an icon, she reduces her contours to a Gauguin-like curvilinear simplicity. Her awkward yet charming pose suggests the primitive, recalling especially Gauguin's Tahitian women (see fig. 26.13). Her amber necklace even resembles a lei, or garland of flowers. She poignantly displays two small flowers, symbols of fertility, which she has colored and shaped similarly to her nipples, drawing a parallel between the two. Also symbolic of fecundity is the garden that she stands in. A celestial blue halo deifies her and reinforces her elemental presence. What is revealing about the image is Modersohn-Becker's German primitivism, which differs so radically from that of Gauguin. There is a cultivated crudeness throughout the picture, reflected in the pasty application of paint, particularly in the masklike face and neck, and the awkward gestures, especially of her left hand. It appears as well in the ungainly flat ear and coarse fingers of the right hand. Despite the beautiful, colorful palette, we sense a raw, primal energy and an earthiness, characteristics of much German Expressionism.

DIE BRÜCKE (THE BRIDGE) Scholars generally assert that German Expressionism began with Die Brücke (The Bridge), a group conceived in 1903 when four Dresden architecture students, including Ernst Ludwig Kirchner (1880–1938) and Erich Heckel (1883–1970), decided to form an art alliance "to clear a path for the new German art." In 1905, the group officially formed and went public with no artistic program other than to oppose "older well-established powers" and to create a "bridge" to the future. Like so many progressive Germans, their vision was formed by the philosopher Friedrich Nietzsche (1844–1900). In his most famous book, *Thus Spoke Zarathustra* (1883–85), Nietzsche called for the rise of an *Übermensch*, or "superhuman," a youthful noble of superior intellect, courage, fortitude, creativity, and beauty who would dominate the inferior masses huddling safely in the conventional, restrictive past. This strong-willed *Übermensch* would be the "bridge" that would lead the world into a glorious future of new ideas.

The initial problem confronting these largely self-taught artists, who shared a communal studio in a former butcher's shop, was to find appropriate subject matter and a way to express it. Initially they focused on the unsettling psychology of modern Germany and turned to intense color to convey their message. Kirchner, the leader of Die Brücke, was perhaps the first to mature artistically, about 1907, as seen in his Street, Dresden (fig. 27.10) of 1908. The group's love of Van Gogh and their recent discovery of Matisse are reflected in the intense Fauvist color liberated from a representational role. As important is the impact of Edvard Munch (see fig. 26.19), who exhibited throughout Germany and often resided in Berlin after 1892. The disturbing psychological undertones and arabesque patterning are decidedly Munch-like, and Kirchner's crowded street evokes a claustrophobic anxiety worthy of the Norwegian symbolist. Like most Munch images, this one focuses on sexual confrontation. Wraithlike women stare out. One, dressed in yellow, lifts her dress to reveal her petticoat. Searing pinks, yellows, and oranges contrast with electrifying blues and greens, creating a disturbing dissonance and sexual excitement. This picture could never be mistaken for a Matisse. For the Bridge artists, prostitutes were emblems of the decadence of urban life, embodying the immorality and materiality of the city.

In 1906, the Berlin painter Emil Nolde (1867–1956) had a one-person show at the Galerie Arnold in Dresden. The Brücke artists were so captivated by Nolde's powerful use of color that they invited him to join the group. Older than the other members,

27.10 Ernst Ludwig Kirchner, Street, Dresden. 1908 (dated 1907 on painting). Oil on canvas, $4'11'_4$ " × $6'6'_8$ " (1.51 × 2 m). Museum of Modern Art, New York

he lasted only a year, for his brooding nature and highly personal style were not really compatible with the group's communal mission. Still, his preoccupation with intense emotion and color conformed to the direction in which the group was heading, in part due to his influence. In 1909, after recovering from a serious illness, he made a series of religious pictures, including *The Last Supper* (fig. **27.11**). Nolde claimed that in this picture he "followed an irresistible desire to represent profound spirituality, religion,

27.11 Emil Nolde, *The Last Supper.* 1909. Oil on canvas, $32\frac{1}{2} \times 41\frac{3}{4}$ " (86 × 107 cm). Kopenhagen Statens Museum for Kunst Wvz Urban 316

and tenderness." This painting, created in a passionate fervour over several days, is about emotion, his own as well as that of Jesus and the apostles. Nolde crowds the figures and presses them to the surface of the picture plane, making their passions ours. A somber yet ardent red dominates, contrasted by its complement green and laced with yellows and blues, making the surface appear to burn with emotion. He used bold slabs of paint to crudely construct faces and bodies, an effect difficult to see in reproductions. A brutal angularity occasionally appears in chins and noses, and color patterns have jagged edges, as in the hair of the foreground figures.

At first the faces look like masks and are almost grotesque. These are not Ensor masks (see fig. 26.18), however, nor are they masks at all. The distortions and strident gestures, both figural and painterly, underscore the expressive power of the scene. The rawness of the figures, a quality we saw in Modersohn-Becker, enhances the direct emotional force. It also makes the protagonists appear more human and earthy, paradoxically more real despite their sketchiness. By this point in his career, Nolde regularly visited the Völkerkundemuseum in Berlin, drawn to the spirituality and expressionism of the tribal artifacts displayed there. Here, we can sense his adoption of the abstracting, simplification, and directness found in much African art and see him using it to create similar powerful psychological effects.

The ranks of Die Brücke gradually expanded to eight or nine artists, but by 1909, the members began moving one by one to Berlin. There, they found a more sophisticated art scene, dominated by Herwarth Walden's avant-garde art publication *Der Sturm*, begun in 1910, a concept he had expanded into a gallery of the same name by 1911. By that year, all the Brücke artists had relocated, although the group did not disband until 1913. Heavily influenced by Cubism, their style began to change as well. Most abandoned the undulating contours of Munch and the Jungendstil (German Art Nouveau) and embraced a fractured planarity and geometric linearity.

This new style that emerged toward 1910 can be seen in Erich Heckel's A Crystal Day (fig. 27.12) of 1913. Although Die Brücke artists retained the linear look of Cubism, they generally used it to create psychological tension rather than a complicated pictorial space. In this work, Heckel uses Cubist line and fracturing of space to portray abstract, universal ideals. While Kirchner portrayed the psychologically debilitating and moralistically bankrupt side of modernity, Heckel presented the antidote, a Rousseauian elemental, almost primitive, unification with nature and its universal forces. In A Crystal Day, Heckel captures cosmic energy through the power of his long streaking lines that, especially in sky and lake, look like a painterly abstract Cubist composition. Similar asymmetrical jagged shapes are echoed throughout, locked in a tight mosaic. Even the angular figure, reduced to a simplified form and vaguely reminiscent of the African sculpture the group so admired for what it considered its primal directness, is closely woven into the linearity of the land. Heckel gives us the feeling of a common life force surging through all of nature, binding everything together. This reading is

27.12 Erich Heckel. A Crystal Day. 1913. Oil on canvas, $47\frac{1}{4} \times 37\frac{3}{4}$ " (120 × 96 cm). Pinakothek der Moderne, Munich. Loan from Collection of Max Kruss, Berlin

confirmed by the clouds and their reflections in the water, which have been transformed into the crystals of the title and reflect the belief that crystals held spiritual properties, a perception popularized by the poet Paul Scheerbart in 1914 (see page 979).

In their quest to create a nationalistic art, Die Brücke artists revived the printmaking technique of woodcut, favored by German artists during the early Renaissance. (See Materials and Techniques, page 958.) Adding to the medium's attraction was its expressive rawness-one can sense the grain of the wood, which gives not only a stridency but also an earthly, organic feeling to the images. These qualities can readily be seen in Kirchner's Peter Schlemihl: Tribulations of Love (fig. 27.13) of 1915, one of a series Kirchner created to illustrate the prose tale Peter Schlemihl's Wondrous History (1814) by Adelbert von Chamisso (1781-1838), which tells the tale of a man who sells his shadow, thus his soul, for a pot of gold. This colored woodcut shows the use of the ambiguous space of Cubism to project the invisible inner workings of the mind and to juxtapose that with the representational world. Here, we see a man next to a manifestation of his psychosexual conflict. Spatial dislocation, a splintering sharpness to the edges, a chaotic composition, and the touches of emotion-evoking color (a passionate violent red and a chilling melancholy blue)all abstract qualities-create an unsettling and distressing image.

The Woodcut in German Expressionism

Some of the best-known European artists in the fifteenth and sixteenth centuries practiced the printmaking medium of the woodcut, but by the early nineteenth century this method had been eclipsed by new commercial printing technologies, such as wood engraving and lithography. These technologies produced images of great detail that could be executed rapidly and mass-produced. In the late nineteenth century, however, European painters and sculptors returned to the woodcut as an artistic medium precisely because it produced a crude, unsophisticated look in contrast to the slick techniques of modern image reproduction.

Japanese woodblock prints were the elaborate product of a series of designers, block cutters, and printers, and Europeans in the mid-nine-teenth century avidly collected them. In the 1890s, Edvard Munch and Paul Gauguin reinvented a very different form of the woodblock print, or woodcut, as did such German Expressionists as Ernst Ludwig Kirchner (see fig. 27.13) and, somewhat later, Käthe Kollwitz in the early 1900s. Their simplified, hand-made process contributed to the planar effect of flat, simplified shapes, which can evoke strong

emotional tensions. Unlike the division of labor characteristic in the production of Japanese prints and in those of northern Renaissance artists such as Albrecht Dürer, these modern artists designed, cut, and printed the woodcuts themselves. They could thus exploit unforeseeable expressive qualities in the wood grain that became evident only during the carving process. Munch developed an influential technique in which he cut the block into jigsaw pieces that were inked individually, reassembled, and printed, resulting in a multicolor print produced in one pull through the press. The Kirchner woodcut seen in figure 27.13 was printed from two blocks.

Although many prints by these artists appear spontaneous or perhaps haphazard, they are in fact the result of deliberate forethought: The block had to be cut in such a way that the wood remaining in relief, when rolled with ink, produced the sought-after image. There was no room for error, for the artist had not only to plan the positive and negative spaces but also to reverse his intended picture because, when printed, the impression created is a mirror image of the original woodblock design.

Kirchner, like Heckel, displays a Brücke reliance on the expressive distortions of African sculpture, seen especially in the sharp angularity and faceting of the man's face.

DER BLAUE REITER (THE BLUE RIDER) The second major German Expressionist group, Der Blaue Reiter (The Blue Rider), developed in Munich, in southern Germany. It officially lasted but four months, from December 1910 to March 1911. Like their Brücke counterparts, the artists associated with Der Blaue Reiter drew on art forms from Western art history as well as non-Western and folk-art traditions to create images that reveal their skepticism toward modern, industrial life. The group focused on expressing a spirituality they believed resided beneath the surface of the visual world.

The key figure in Der Blaue Reiter was the Russian artist Vasily Kandinsky (1866–1944). He left Moscow in 1896 to study art in Munich and brought with him Russian influences, namely the spirituality of native religious icons and the robust, emotional colors of folk art. His interest in folk culture was rekindled when, in 1908, he moved with painter and partner Gabriele Münter (1877–1962) to Murnau, just south of Munich in the Bavarian Alps. There he immersed himself in folk culture and was deeply affected by the powerful colors and the directness of the folk decorations and paintings on glass, a medium that he and Münter adopted.

27.13 Ernst Ludwig Kirchner, *Peter Schlemihl: Tribulations of Love.* 1915. Color woodcut from two blocks on wove paper, $13\frac{1}{4} \times 8\frac{1}{4}$ " (33.6 × 21.7 cm). National Gallery of Art and Brücke Museum. Collection of Karl and Emy Schmidt-Rottluff

When in Munich, the couple lived in the Schwabing neighborhood of Munich, a bohemian enclave of cafés and liberalism. The area was a breeding ground for explorations of spirituality and the occult, especially Theosophy, which was a daily topic of conversation for many. Kandinsky owned the book Theosophie by German philosopher Rudolf Steiner (1861-1925) and attended his Theosophy lectures in Berlin in 1908. Inspired in part by Steiner's ideas, Kandinsky in 1910 wrote Concerning the Spiritual in Art, published the next year and read worldwide. In it, he proclaimed the need to paint one's connectedness with the universe and to use an abstract vocabulary, one that functioned much like music, to portray the abstract qualities of spirituality. He wrote that "color directly influences the soul. Color is the keyboard, the eyes are the hammers, the soul is the piano with many strings. The artist is the hand that plays, touching one key or another purposively, to cause vibrations in the soul." (See Primary Source, page 960.) Because of this parallel with music, Kandinsky titled his works "composition," "improvisation," and "concert." Kandinsky, a well-read intellectual, was also influenced by the recent scientific discoveries of Einstein and Rutherford, which demonstrated that matter was not solid and stable but instead existed in a state of flux, convincing Kandinsky that a spiritual force coursed through all matter.

While Kandinsky advocated abstract art by 1910, it was not until 1911 that his own work became entirely nonobjective. In 1910, he began a series of ten paintings called "Compositions." The first works were abstract but still readable, with objects reduced to simple childlike forms vaguely recognizable as figures, trees, horses, mountains, or churches, for example. (A rider on a horse, often blue, occasionally appears, the horse and rider motif being common in Kandinsky's oeuvre and often interpreted as a reference to the artist himself and his idol St. George, the Christian dragonslayer, and their parallel quest to bring a new spirituality into the world. As is apparent, the motif became the group's name.) In these 1910 paintings, forms are often reduced to flat color and encased in a dark line, the deeply saturated color and line resembling the spiritual stained glass of churches. The total abstraction that appeared in 1911 can be seen in his 1913 painting Sketch I for "Composition VII" (fig. 27.14). This was one of numerous preliminary studies for a large final version that

27.14 Vasily Kandinsky, *Sketch I for "Composition VII.*" 1913. Oil on canvas, $30\frac{3}{4} \times 39\frac{3}{8}$ " (78 × 100 cm). Felix Klee Collection

PRIMARY SOURCE

Vasily Kandinsky (1866–1944)

From Concerning the Spiritual in Art

Kandinsky hoped to inaugurate a new spiritual era for modern human beings through his art. These remarks first appeared in 1911.

If you let your eye stray over a palette of colors, you experience two things. In the first place you receive *a purely physical effect*, namely the eye itself is enchanted by the beauty and other qualities of color. You experience satisfaction and delight, like a gourmet savoring a delicacy. Or the eye is stimulated as the tongue is titillated by a spicy dish. But then it grows calm and cool like a finger after touching ice. These are physical sensations, limited in duration. They are superficial, too, and leave no lasting impression behind if the soul remains closed.

And so we come to the second result of looking at colors: their psychological effect. They produce a correspondent spiritual vibration, and it is only as a step towards this spiritual vibration that the physical impression is of importance. ...

Generally speaking, color directly influences the soul. Color is the keyboard, the eyes are the hammers, the soul is the piano with many strings. The artist is the hand that plays, touching one key or another purposively, to cause vibrations in the soul.

It is evident therefore that color harmony must rest ultimately on purposive playing upon the human soul.

Source: Vasily Kandinsky, *Concerning the Spiritual in Art*, tr. Francis Golffing, Michael Harrison and Ferdinand Ostertag (NY: Wittenborn, Schultz, 1947)

retains some of the same compositional elements but has a different palette. While Kandinsky's hues still have the deep resonance of stained glass, the recognizable motifs of the earlier works are gone, yielding to an abstract play of color and painted line and form. The image may appear apocalyptic and chaotic, but these dynamic qualities are meant to capture the universal spiritual forces as the artist himself felt them. Despite the total abstraction, the image still feels like landscape—it has a horizontal spread we associate with the genre, and there is still a feeling of recession due to overlapping forms. But this "landscape" can be read as cosmic as much as earthly, and it is so abstract it can even be interpreted as microcosmic as well (portraying a microscopic view of nature).

Which is precisely Kandinsky's point since it is a picture of ubiquitous abstract mystical powers as the artist himself felt or experienced them.

Franz Marc (1880–1916), who met Kandinsky in 1910 or 1911, shared many of the same objectives, especially the quest to portray spirituality. Both artists discussed how animals instinctively bonded with nature and thus with the cosmos. (This belief as well accounts for Kandinsky's repeated use of the horse and rider motif, which dates to 1903.) Marc claimed that "animals with their virginal sense of life awakened all that was good in me." This statement conveys a feeling shared by all the artists of Der Blaue Reiter: the belief that Western, industrialized society was

27.15 Franz Marc, Animal Destinies (The Trees Showed Their Rings, The Animals Their Arteries).
1913. Oil on canvas, 6'4½" × 8'7" (1.94 × 2.62 m). Öffentliche Kunstsammlung Basel, Kunstmuseum, Basel, Switzerland. 1739 spiritually bankrupt and therefore the need to return to nature. By 1911, Marc was interweaving animals, often horses, into tightly composed landscapes, and by early 1912, he was using Cubism to effect this instinctual interlocking of animal, nature, and primordial forces, as seen in *Animal Destinies* (fig. **27.15**) of 1913.

In this work Marc has transformed Cubist facets into dynamic rays of light that seem to have passed through an unseen mystical crystal. The horses, foxes, and deer dissolve into these spiritual bolts of light, becoming one with them and a universal life force. A sense of a cataclysmic finale pervades the image, suggesting death, or the end of the life cycle, at which point living matter fulfills its destiny by being absorbed back into the cosmos. On the reverse of the canvas, Marc wrote, "And all being is flaming suffering," suggesting the inevitability of a spiritual redemption and the innate ability of animals to accept this course. Marc's colors are the deep saturated hues of stained-glass windows, this reference to mystical illumination being reinforced by the illusionistic light streaming through the image.

By 1911, Der Blaue Reiter had dissolved. The group had two shows. The first was in the Galerie Thannhauser in Munich in December 1911. It then toured Germany, often to harsh reviews, closing at Der Sturm Galerie in Berlin. Clearly, the German viewing public was not ready to embrace the group's striking and abstracted images of nature, despite the works' evocation of traditional art forms such as stained-glass windows and religious icons. The second exhibition featured works on paper and was mounted at a Munich bookstore. Perhaps more important than their exhibitions was the Der Blaue Reiter Almanac (The Blue Rider Yearbook), which included members' work along with reproductions of examples of Egyptian, Gothic, Asian, tribal, and folk art. Even works by children found a place in the Yearbook. Further enhancing the publication's eclecticism was an article on the spirituality of music by the great tonalist composer and Theosophist Arnold Schönberg (1874-1951), who was also a painter and member of Der Blaue Rieter. The Yearbook was in effect a catalogue of art that was simple, direct, and spiritual-art that Kandinsky and Marc believed tapped into the cosmos and shared their own goals.

PAUL KLEE One artist whose long career touched on many of the elements expressed in the *The Blue Rider Yearbook* is the Swiss painter Paul Klee (1879–1940). Officially, Klee was only minimally involved with Der Blaue Reiter. He had come to Munich in 1898 to study painting and had settled there in 1906. On friendly terms with Kandinsky and other members of Der Blaue Reiter, Klee's understanding of Expressionism and other modern art movements came from his travels throughout Europe, although no voyage had a more decisive effect on him than a two-week trip to Tunisia. As had been the case with Delacroix and Monet the century before, the bright light and color of North Africa overwhelmed Klee. Soon after arriving, he wrote in his diary, "Color has taken hold of me....That is the meaning of this happy hour: Color and I are one. I'm a painter." But equally important for his development was his connection to

27.16 Paul Klee, *The Niesen*. 1915. Watercolor and pencil on paper, $7\frac{1}{8} \times 9\frac{1}{2}$ " (17.7 × 26 cm). Hermann and Marguerite Rupf-Stiftung

Der Blaue Reiter, for his art was the most comprehensive amalgam of all the sources listed in the *Yearbook*, especially children's art, tribal art, and music. (Klee himself was an accomplished flutist.)

Klee's new Tunisia-inspired palette appears in The Niesen (fig. 27.16) of 1915. Combined within the grid of Cubism is an abstract use of color reminiscent of Matisse and Kandinsky. The image echoes the directness and naïveté of children's and folk art, as well as the luminescent, saturated colors of stained-glass windows, the white of the paper flickering through the transparent watercolor to create a glowing illumination. We instantly sense the spirituality that is the foundation of this picture and almost feel as though we can retrace Klee's steps in its creation. The triangular mountain, the Niesen, dominates the image, its rock-hard geometry providing a sense of permanence and eternity while reflecting the Theosophical belief in the spirituality of the triangle, which represents, among other things, the mystical correspondence of the universe. The night sky is filled with religious symbols, such as the Jewish Star of David and the Islamic crescent moon, which mingle with primitive hieroglyphic suns. The branches of the sole tree, suggesting life and all living things, rhythmically correspond to the rays emanating from the stars and suns above and are further linked to them by the Niesen, the shape of which powerfully connects earthly elements with cosmic ones. Through their color, the rectangular planes in front of the mountain evoke trees and plants, light, sun, fire, sky, and earth.

Using an abstract vocabulary of color and shape, into which are inserted a handful of representational signs, Klee has stripped away everything inessential. He reveals in a poetic, understated way his innermost feelings about the nature of life and the universe. Or as he himself said, "Art does not render the visible; rather it makes visible." Adding to the charm and intimacy of Klee's art is its small scale and childlike "draftsmanship."

Austrian Expressionism

Another major center for Expressionism was Vienna. Home of Sigmund Freud, it was an especially repressive city, socially and culturally dominated by a conservative bourgeoisie and an aloof aristocracy resistant to change. In reaction, many avantgarde artists led bohemian lifestyles, shunning middle-class morals and standards. Not surprisingly, Viennese artists generated some of the era's most neurotic and disturbing visual imagery, their art reflecting their psychic distance from conventional society.

OSKAR KOKOSCHKA Perhaps the most prominent Viennese Expressionist is Oskar Kokoschka (1886–1980), who entered the Vienna School of Arts and Crafts in 1905 and specialized in portraiture. In 1908, he exhibited with Gustav Klimt (see page 921) and other avant-garde artists at the *Vienna Kunstschau*, an exhibition for modern art, where his violent portraits, inspired by Van Gogh, generated so much controversy he was expelled from

art school. Kokoschka called his expressionistic portraits "black portraits," and the sitters appeared to be so troubled that he became known as "the Freud of painting" who "paints the dirt of one's soul." Kokoschka described his process similarly: "From their face, from the combination of expressions and movement, I tried to guess the true nature of a person, recreating with my own pictorial language, what would survive in the memory." The following year, Kokoschka produced an exceptionally violent and sexual stage play, in the process capturing some of the deepest passions of the mind. The reaction to the play was so negative Kokoschka was forced to flee Vienna, going to Berlin for two years before returning.

We can get a sense of how expressionistic his portraits looked from the figures in *The Bride of the Wind* (fig. 27.17), Kokoschka's 1914 self-portrait with his lover Alma Mahler, the notoriously beautiful and sophisticated widow of the famous Austrian composer Gustav Mahler (1860–1911). By 1914, their passionate relationship was threatened, and it ended the following year. *The Bride of the Wind* reflects the artist's distress. Originally,

27.17 Oskar Kokoschka, *The Bride of the Wind*. 1914. Oil on canvas, $5'11'_4$ " × $7'25_8$ " (1.81 × 2.20 m). Öffentliche Kunstsammlung Basel, Kunstmuseum, Basel, Switzerland

Kokoschka intended to disguise this personal dilemma by calling the work Tristan and Isolde, after Wagner's opera about two tragic lovers. The final title comes from Georg Trakl (1887-1914), a bohemian Viennese poet who produced morbid and nightmarish work. Kokoschka expresses his anxiety through coarse, violent brushstrokes and a seething, swirling composition. Oblivious to this turmoil, Mahler is shown peacefully sleeping, while Kokoschka restlessly worries, his body transformed into a flayed corpse, his hands grotesquely gnarled. The couple are contained in a monstrous shell-like cradle adrift in a landscape that is bleak, uncontrollable, and subject to cosmic forces, as suggested by the gravitational pull of a distant moon. This lunar force seems to represent a Freudian sexual drive, for the moon is recessed in a vaginalike tube and framed by phallic peaks. The bizarre environment seems liquid and insubstantial, the entire image transformed into a threatening quagmire of paint and representing psychological urges and instability.

EGON SCHIELE Egon Schiele (1890–1918), another major Viennese painter, likewise defied bourgeois mores. He watched his father's painful death from syphilis, which probably accounts in part for his preoccupation with sickness and mortality. He then feuded bitterly with his conservative middle-class uncle in order to become an artist. He attended the Vienna Academy of Fine Art, and Gustav Klimt soon took him under his wing. At Klimt's invitation, Schiele exhibited at the same 1908 and 1909 *Vienna Kunstschau* exhibitions as Kokoschka. He soon dropped out of art school and with friends established yet another secessionist organization, the Neukunstgruppe (New Art Group). Inspired by Klimt's defiance toward bourgeois conservatism, he led a bohemian life, and in 1911 fled Vienna with his mistress to live in nearby small villages.

Schiele's art is dominated by images of nudes-of himself, prostitutes, and lovers-and although he worked in oil, many of his finest works are on paper, such as Self-Portrait (Man Twisting Arm Around Head) (fig. 27.18) of 1910. The nude had dominated Western art since antiquity, but Schiele's presentation of the unclothed body departs from the tradition of the heroic male nude introduced in Classical antiquity and revived in the Renaissance. Here instead is an outright affront in its frank presentation of the body and its sickly and grotesque distortions. Schiele made the drawing most likely just after his uncle had cut him off financially, and it seems to represent the conflict between conformist bourgeois guardian and independent bohemian painter. Schiele is defiant, not only in his demonic glare and bold, contorted gestures but also in his willingness to present himself as disfigured and ghoulish. However, we also sense an element of self-scrutiny. The 20-year-old artist reveals ribs, underarm hair, and nipple. We sense the body's skeleton, its physicality, and, despite the confrontational stare, its vulnerability. Schiele's evocative handling of the medium, the velvety quality of the charcoal and splashes of watercolor, reinforce the sensuality of the flesh exposed to deterioration, one of the work's dominant themes. Just as his career was taking off in 1918, Schiele fell victim to the

27.18 Egon Schiele, *Self-Portrait (Man Twisting Arm Around Head).* 1910. Watercolor, gouache and charcoal on paper, $17\frac{3}{4} \times 12\frac{1}{2}$ " (45 × 31.75 cm). Private collection, New York

pandemic influenza that killed 20 million people worldwide, including his pregnant wife who died three days before him.

Cubism after Picasso and Braque: Paris

In France, Cubism was thoroughly entrenched by 1911–12, expanding well beyond Picasso and Braque. A handful of individual painters had closely followed Picasso's and Braque's developments in 1909–10, and in late 1910 they began exhibiting together at the large Paris Salons and at a private gallery, calling themselves the Section d'Or (Golden Section). Original members Robert Delaunay, Albert Gleizes, Jean Metzinger, and Henri Le Fauconnier were soon joined by Fernand Léger, Roger de La Fresnaye, Marcel Duchamp, and his brother Raymond Duchamp-Villon. In 1912, Gleizes and Metzinger published *Du Cubisme* (*Cubism*), the first book on the subject. **ROBERT DELAUNAY** Of this group, Robert Delaunay (1885– 1941) was among the most influential. Unlike concurrent Analytic Cubist works by Braque and Picasso, Delaunay's 1910 Cubist paintings of the Eiffel Tower, an icon of modern technology, incorporated color, reflecting the artist's background as a Neo-Impressionist toward 1905. They also differed in their subject: the movement and energy of modernity and the constant flux of the contemporary world.

Delaunay's preoccupation with the dynamism of the modern world is evident in his 1914 *Homage to Blériot* (fig. 27.19), honoring the French aviator Louis Blériot (1872–1936), inventor of the single-wing airplane and the first person to fly across the English Channel. Delaunay integrates emblems of the modern world airplanes, propellers, and the Eiffel Tower—into a Cubist composition that is a kaleidoscope of floating balls and rotating disks suggesting whirling propellers and blazing suns. He creates movement not only through the shifting forms of Cubist space but also through the use of what Delaunay called "simultaneous contrasts," the placement of flat planes of primary and secondary colors next to one another, not only creating movement but also light and space, none of which is illusionistic.

Two years before, Delaunay had exhibited total abstractions called *Simultaneous Disks* or *Simultaneous Contrasts*, paintings consisting entirely of the multihued concentric circles seen in *Homage to Blériot*. While Delaunay's color theory was derived

27.19 Robert Delaunay, *Homage to Blériot*. 1914. Tempera on canvas, $8'2'_{2}'' \times 8'3'' (2.5 \times 2.51 \text{ m})$. Öffentliche Kunstsammlung Basel, Kunstmuseum, Basel, Switzerland. Emanuel Hoffman Foundation. (1962.6)

from that of the nineteenth-century color theorist Michel-Eugène Chevreul (see page 874), his move into total abstraction was prompted by his contact with Marc and Kandinsky, who included him in the first Blaue Reiter exhibition. Some of these abstract paintings contain overlapping circles, suggesting a relationship among spheres in space, a reading reinforced by the subtitle Sun and Moon. The critic Guillaume Apollinaire, in his review of the 1913 Salon des Indépendants, even drew a parallel between Delaunay's paintings of simultaneous disks and music when he labeled his abstract work "Orphism," a reference to the mythological lyre player Orpheus. But despite numerous parallels with Kandinsky, Delaunay's interests lay in depicting modernity and using an abstract vocabulary of simultaneous contrasts of color to create space, light, and movement, especially the fast tempo of a modern world of trains, planes, automobiles, electricity, telephones, and movies.

Italian Futurism: The Visualization of Movement and Energy

In January 1909, Filippo Tommaso Marinetti (1876–1944), a freeverse poet based in Milan, launched the Futurist movement when he published his *Manifesto of Futurism*, a pamphlet sent to thousands of artists and poets. On February 20, it appeared on the front page of the Parisian newspaper *Le Figaro*. Marinetti called for a rebirth of Italy, a country he saw as mired in the dusty, anachronistic Classical past. He advocated an uncompromising acceptance of modernity in all its manifestations, including electricity, automobiles, and machines, writing that "all subjects previously used must be swept aside in order to express our whirling life of steel, of pride, of fever and of speed." (See www.myartslab.com.)

For Marinetti, Futurism was a continual process, a permanent revolution. As soon as one change is effected, a new one must begin. Artists were no longer the manufacturers of a high-end product for a wealthy clientele, but rather they were vital forces operating within the community and influencing such daily concerns as fashion, games, toys, graphics, interior design, sports, food, and behavior. Marinetti toured Italy, enrolling artists, musicians, playwrights, architects, and designers into his movement. He arranged Futurist *soirées*, where from a stage he expounded upon his theories, often provoking, if not insulting, the audience in his attempt to incite them to action or even violence, which Marinetti perceived as socially cleansing and productive. Marinetti was intent on generating constant activism, which he saw as the conduit for the cultural *risorgimento*, or rebirth, of Italy.

After a 1909 lecture in Milan presented to the avant-garde art group Famiglia Artistica (Artistic Family), Marinetti enlisted a handful of its members, including Umberto Boccioni (1882– 1916), to become Futurists. In 1909, these artists were mostly Neo-Impressionists who transformed the color and energy of Divisionism to portray the dynamism of modernity. Their manifesto claimed that "Motion and light destroy the materiality of bodies" and that their concern would be the visualization of

27.20 Umberto Boccioni, *States of Mind I: Farewells.* 1911 (second version). Oil on canvas, $28 \times 37\%$ " (70.7 × 96 cm). Museum of Modern Art, New York. Gift of Nelson A. Rockefeller

movement and energy. For their visual vocabulary, they rejected anything redolent of Classical Italian culture and instead turned to science: the motion studies of Marey and Muybridge (see page 940), Ernst Mach's graphic representations of shock waves, and Wilhelm Konrad Röentgen's x-rays, which, like Rutherford's discovery of the structure of the atom, proved the physical world was not stable but in constant flux. Much like Seurat, they wanted to create a new artistic language based on science, but without prescribing any one style. Their goal was to capture the intensity of movement—physical, psychological, and universal. In effect, they wanted to visualize Bergson's *élan vital*.

Initially following Marinetti's lead, the Futurists were activists. By the end of 1911, however, they had become disenchanted with Marinetti's politics and instead chose to concentrate on art. More important, they turned from Neo-Impressionism to Cubism in their search for aesthetic direction. Their interest in Cubism, however, departed from the concerns of Braque and Picasso because the Futurists wanted to convey motion, dynamic energy, and social progress. After visiting Paris and seeing Cubist works in 1911, Boccioni painted *States of Mind I: Farewells* (fig. **27.20**). Embedded in a fractured world of Cubist facets is an eruption of steam, sound, moving objects, and psychic energy. The white curving lines over the locomotive reflect Mach's lines of thrust, whereas the repetition of the vaguely rendered greentinted embracing couple is inspired by Muybridge's motion sequences. Boccioni is championing not just modern technology, as represented by the train, electric railroad signals, and trussed steel towers, but the perpetual movement of all objects and energy. In a May 1911 lecture in Rome, he proclaimed that painting had to capture the energy in all matter, energy in perpetual motion that dissolves the object while fusing it with surrounding space, an effect he called "plastic dynamism."

In *States of Mind I: Farewells*, we sense not only the dematerialization of the train and figures through time and movement, in part created by Boccioni's application of Divisionism, but also the simultaneous presence of space as something plastic and as vital as form. Swirling throughout the chaotic image is also an emotional energy—a sense of painful separation and disappearance—which

27.21 Umberto Boccioni, Unique Forms of Continuity in Space. 1913 (cast 1931). Bronze, $437_{8}' \times 347_{8}' \times 153_{4}'''$ (111.4 × 88.6 × 40 cm). Museum of Modern Art, New York. Acquired through the Lillie P. Bliss Bequest. (231.1948)

the title reveals as a theme of the work. This "plastic dynamism," or the fusing of object and space, is evident in Boccioni's sculpture *Unique Forms of Continuity in Space* (fig. **27.21**) of 1913. The pointed forms trailing off legs and torso capture the direction of the energy, as if the displaced space were itself worn like a mantle.

Cubo-Futurism and Suprematism in Russia

Of all the major European countries in the 1910s, Russia was the least industrialized. Nevertheless, it became an important center for avant-garde art. Most of the population were serfs ruled by an indifferent czar and dominated by the Orthodox Church. Despite a recent rush to modernize and become a world power, Russia in some respects remained trapped in the Middle Ages. In a culture dominated by folk-art and icon-painting traditions, how did radical art emerge? Part of the explanation may lie in the country's desperate need for reform. When, in 1917, the October (or Bolshevik) Revolution was led by Vladimir Ilyich Lenin (1870– 1924), marking the first officially Communist-led revolution of the twentieth century, the change it brought about was far more radical than it had been in eighteenth-century America or France. The transformation in Russia was so revolutionary that it even embraced equality for women, who had proved integral to developing the radical art of the preceding years.

THE RUSSIAN AVANT-GARDE In Moscow, Sergey Shchukin and Ivan Morozov, two of the greatest collectors of contemporary art, made available to Russian artists their extraordinary holdings of works by Matisse and Picasso, among other vanguard artists. In response to these works and to growing ties with the western European avant-garde, Russian artists began to explore Cubism and other approaches to abstraction. In 1910, a group of Russian artists formed an avant-garde art association called the Jack of Diamonds to support exhibitions of experimental work. Two years later, a splinter group, The Donkey's Tail, emerged. The latter especially was modeled on the Futurists. These groups embraced the modern, emphasizing the machine and industry, both critical to bringing Russia into the twentieth century.

One of the outstanding painters in this avant-garde circle was Lyubov Popova (1889–1924), who studied in Paris in 1912 and in Italy in 1914, experiencing first hand the latest developments in Cubism and Futurism. These influences are reflected in *The Traveler* (fig. **27.22**) of 1915. In this depiction of a woman wearing a yellow necklace and holding a green umbrella, Popova combines the fracturing of Cubism with the energy and movement of Futurism.

KAZIMIR MALEVICH By 1913, many of the Russian artists were calling themselves Cubo-Futurists, a term coined by Kazimir Malevich (1878–1935) that reflects the dual origins of the style. Malevich had exhibited with both the Jack of Diamonds and The Donkey's Tail. In 1913, he designed Cubo-Futurist costumes and sets for what was hyped as the "First Futurist Opera" and titled Victory over the Sun. Presented in St. Petersburg, this radical "opera" embraced the principle of zaum, a term invented by progressive Russian poets. Essentially, zaum was a language based on invented words and syntax, the meaning of which was supposedly implicit in the basic sounds and patterns of speech. The poets' intention was to return to the nonrational and primitive base of language that, unencumbered by conventional meaning, expressed the essence of human experience. In Victory over the Sun, performers read from nonnarrative texts often consisting of invented words while being accompanied by the clatter of an out-of-tune piano. Malevich's geometric costumes and sets were equally abstract. A stack of triangles ran up and down the legs of one costume, while one backdrop was a square divided in half to form two triangles, one white, the other black.

27.22 Lyubov Popova, *The Traveler*. 1915. Oil on canvas, $56 \times 41\frac{1}{2}$ " (142.2 × 105.4 cm). Norton Simon Art Foundation, Pasadena, California

Kazimir Malevich (1878–1935)

From The Non-Objective World

Kazimir Malevich first published The Non-Objective World in 1919 in the catalogue for the 10th State Exhibition in Moscow. Here, he emphasizes how nonobjective art represents feeling, not objects, as it strips away all of the accumulations of civilization to get at the essence of existence, much as so-called primitive artists do.

Under Suprematism I understand the supremacy of pure feeling in creating art. ...

Hence, to the Suprematist, the appropriate means of representation is always the one which gives fullest possible expression to feeling as such and which ignores the familiar appearance of objects. ...

Even I was gripped by a kind of timidity bordering on fear when it came to leaving "the world of will and idea," in which I had lived and worked and in the reality of which I had believed. But a blissful sense of liberating non-objectivity drew me forth into the "desert," where nothing is real except feeling ... and so feeling became the substance of my life.

This was no "empty square" [referring to the *Black Square*] which I had exhibited but rather the feeling of non-objectivity. ...

The black square on the white field was the first form in which non-objective feeling came to be expressed. The square = feeling, the white field = the void beyond this feeling. ...

The Suprematist square and the forms proceeding out of it can be likened to the primitive marks (symbols) of aboriginal man which represented, in their combinations, *not ornament but a feeling of rhythm*.

Suprematism did not bring into being a new world of feeling, but, rather, an altogether new and direct form of representation of the world of feeling.

Source: Kazimir Malevich, *The Non-Objective World*, tr. Howard Dearstyne (Chicago: Theobald, 1959)

27.23 Kazimir Malevich. Installation photograph of the artist's paintings in 0, 10 (Zero-Ten): The Last Futurist Exhibition. St. Petersburg, December 1915

It took Malevich two years to realize the implications of *zaum* for his art. In 1915, after working in a Cubo-Futurist style similar to Popova's, Malevich presented 39 nonobjective geometric paintings in a St. Petersburg exhibition entitled 0, 10 (Zero-Ten): The Last Futurist Exhibition (fig. 27.23). The best-known work in the show is Black Square, seen in the installation photograph hanging in the manner of a Russian icon across the corner of a room. Malevich labeled his new work "Suprematism." In his 1919 Suprematist treatise The Non-Objective World, Malevich explained that Suprematism refers to the supremacy of feeling. (See Primary Source, above.) This feeling is not just personal or emotional but revelatory, for the abstract essence of the world is

27.24 Kazimir Malevich, *Suprematist Composition: Airplane Flying.* 1915 (dated 1914). Oil on canvas, 22⁷/₈ × 19" (58 × 48.3 cm). Museum of Modern Art, New York. Purchase. Acquisition confirmed in 1999 by agreement with the Estate of Kazimir Malevich and made possible with the funds from the Mrs. John Hay Whitney Bequest (by exchange). (248.1935)

translated into painting using an entirely new abstract language, stripped of any vestiges of realism. Like his fellow Russian Kandinsky, Malevich was a mystic, searching for cosmic unity, even a utopian world, as did supporters of the Bolshevik Revolution of 1917. *Black Square* embodies both the legacy of simple, otherworldly Russian icons and the mysticism of folk art. Its simple black form is as iconic as a frontal Madonna or saint, with the white ground extending off the four sides and projecting a sense of infinity.

Malevich's abstract language included different geometric shapes and colors. In *Suprematist Composition: Airplane Flying* (fig. **27.24**), also painted in 1915, he used red, yellow, and blue shapes in addition to black to create a sensation of movement and floating. Color, size, and shape produce a unique rhythm against the white ground. From one composition to the next, Malevich altered the rhythm by changing these formal characteristics. Although the title includes the word "airplane" and suggests an infatuation with technology, the image itself relates to the experience of air travel and the new relationship to the universe brought about by this mode of transportation.

Unfortunately, reproductions of Malevich's paintings almost never show their organic quality. The shapes in *Airplane Flying* may appear to be hard-edged, geometric, and machine-made, but in person one can see that their boundaries waver ever so slightly and there is a sense of a human hand applying paint to canvas. Malevich's paintings contain the same human presence, even if not as overtly stated, that is evident in the work of Kandinsky. And like Kandinsky, Malevich, through his white ground which evokes infinity, suggests a connection with the universe.

Cubism and Fantasy: Marc Chagall and Giorgio de Chirico

Malevich reduced Cubist geometry to the point that Cubist structure itself disappeared. Fellow Russian Marc Chagall (1887-1985), however, embraced Cubist composition in many of his works and remained a representational artist. With its ability to juxtapose and integrate the most disparate objects, Cubism was a perfect tool for creating dreamlike fantasy worlds. Chagall grew up in the Jewish quarter of Vitebsk, and his paintings evoke his memories of the simpler times, values, and rituals that he had experienced in the shtetl. In 1910, Chagall moved to Paris, where he immediately converted to Cubism, as seen in I and the Village (fig. 27.25) of the following year. But this dream image is hardly a Cubist intellectual dissection of form. Using the saturated colors of a stained-glass window and the simple shapes of Russian folk art, Chagall conjures up the most elemental issues of life itself. Man and animal are equated in almost mirrorlike symmetry, and the translucent, ephemeral quality of their heads makes the scene appear ethereal and mystical. The circular composition suggests the cycle of life, with birth as the blooming bush and death as the farmer carrying a scythe. Or it could be interpreted as the four seasons. Chagall did not explain his works and adamantly denied they had any links to storytelling or fairy tale.

27.25 Marc Chagall, *I and the Village*. 1911. Oil on canvas, 6'3⁵/₈" × 4'11¹/₂" (1.92 × 1.51 m). Museum of Modern Art, New York. Mrs. Simon Guggenheim Fund

Instead his dreamscapes are a Cubist kaleidoscope of objects and incidents evoking the most elemental issues of life and often embedded in a wondrous fairy-tale scene that has powerful psychological repercussions.

Arriving in Paris at virtually the same moment as Chagall was the Italian artist Giorgio de Chirico (1888–1978). While studying in Munich from 1905 to 1909, de Chirico was heavily influenced by German Symbolist artists, the Theosophy of Schopenhauer, and the philosophy of Friedrich Nietzsche, who described life as a "foreboding that underneath this reality in which we live and have our being, another and altogether different reality lies concealed." He moved to Italy in 1909, settling in Florence in 1910, where, influenced by the strong southern light of Italy and the arcades of the Piazza Santa Croce, he made the first of his "Metaphysical Town Squares," images of an empty piazza formed by austere buildings rendered as bold simple forms and carefully delineated by strong line. His compositions and use of space became increasingly complex after his arrival in Paris in 1911, as seen in his 1914 *Mystery and Melancholy of a Street* (fig. 27.26), made after his permanent return to Italy in 1914. His reliance on strong diagonal lines, such as the receding buildings and shadows, and his use of unstable disjointed space make his works vaguely echo Cubism.

And yet de Chirico's pictures are stylistically conventional, even suggesting stage sets. Unlike his Futurist compatriots, de Chirico idolized rather than rejected the Classical past, although he subverted its austere authority by evoking a Romantic melancholy, using ominous shadows, intense light, and skewed perspective to create an unsettling eeriness. In *Mystery and Melancholy of a Street*, railroad tracks, darkened windows and arches, the empty van, and the girl with the hoop seem to be symbols, but de Chirico provides no clues about their meaning, insisting none existed. Instead, the painting offers a dreamscape, one with a poetic mood and wide open to interpretation. De Chirico called his work "Metaphysical Painting," revealing the reality underlying the appearance of things. As we shall see in the next chapter, his psychologically provocative poetic reveries would serve as a springboard for representational Surrealism in the coming decade.

MARCEL DUCHAMP AND THE ADVENT OF AN ART OF IDEAS

Along with Picasso and Matisse, Marcel Duchamp (1887–1968) played a major role in defining the art of the first half of the century, his influence then surging in the second half to the point that he almost singlehandedly molded post-1950 art. His great contribution was declaring that art was as much about ideas, thus residing in the mind, as it was about the beauty of what can be seen, thus of the retina. Realizing that Picasso and Braque, among others, were calling into question the meaning of art as they made the very nature of art visible, Duchamp took their development one step further by looking at the cerebral rather than formalist components of art and calling into question its very status as art by asking: What is art, and how does art function?

Working in Paris in the 1910s, Duchamp quickly digested Impressionism and Post-Impressionism. Toward 1911, he took on Cubism, as seen in *Nude Descending a Staircase*, *No. 2* (fig. **27.27**), which he attempted to exhibit at the 1912 Salon des Indépendants.

27.26 Giorgio de Chirico, *Mystery and Melancholy of a Street.* 1914. Oil on canvas, $34\frac{1}{4} \times 28\frac{1}{2}$ " (87×72.4 cm). Private collection

27.27 Marcel Duchamp, *Nude Descending a Staircase*, *No.* 2. 1912. Oil on canvas, 58×35 " (147×90 cm). Philadelphia Museum of Art. Louise and Walter Arensberg Collection. 1950–134-59

The hanging jury, which included some of his friends and even his two brothers, Raymond Duchamp-Villon and Jacques Villon, found the painting neither serious nor Cubist enough, so Duchamp withdrew it. The work began as an illustration for a poem that described a figure ascending a stairway to the stars. Ever the iconoclast, Duchamp portrayed a nude figure, mechanical-looking and grandly descending a staircase, as he described it, "More majestic you know, the way it's done in music halls." Duchamp was fascinated by Marey's chronophotographs, which inspired the sequential movement of his "nude." Because one needs to know the title to understand that the figure is unclothed, Duchamp underscores the way in which words become an integral part of an artwork, going so far as to paint the title on the front of the work. With this gesture, Duchamp makes an important move in his exploration of the essence of art. A title, which defines a work, circumscribes its meaning, and also serves as a tool for remembering the work, fulfilling a role as important as the artwork itself. Here, then, Duchamp makes plain the inseparability not only of artwork and title, but of visual and linguistic experience.

Duchamp's machinelike figure was not unique for 1912. By then, the theme was becoming commonplace in Cubist art, reflecting the era's worship of technology as a symbol of modernity and science's ability to improve the world. For example, Duchamp's older brother, Raymond Duchamp-Villon (1876-1918), was a Cubist sculptor who on occasion rendered living forms as machines, as in Horse (fig. 27.28). Initial drawings show a realistic horse, but the final sculpture is an abstract monument to horsepower: The body has become a tapering cylinder with the tension of a coiled spring, and the legs look like thrusting pistons. Cubist facets and geometry have been ordered into an animal of twisting dynamism. Duchamp-Villon's horse, like most other mechanomorphic figures from the period, underscores the import role of industry in fashioning the modern age. In contrast, Marcel Duchamp's mechanical nude is humorous, sarcastic, and sacrilegious.

27.28 Raymond Duchamp-Villon, *Horse*. 1914 original, 1955–57 version from an edition of seven. Bronze, $39 \times 24 \times 36$ " ($99 \times 61 \times 91.4$ cm). The Art Institute of Chicago. Gift of Margaret Fisher in memory of her parents, Mr. and Mrs. Walter L. Fisher. (1957.165)

27.29 Marcel Duchamp, *Bicycle Wheel.* 1913/1951 (third version, after lost original of 1913). Assemblage: metal wheel mounted on painted wood stool, $50\frac{1}{2} \times 25\frac{1}{2} \times 16\frac{5}{8}$ " (128.3 × 64.8 × 42.2 cm). Museum of Modern Art, New York. The Sidney and Harriet Janis Collection. 595.1967 a-b

The following year Marcel Duchamp's humorous inquiry into the nature of art culminated in a revolution as monumental as Picasso's *Les Demoiselles d'Avignon*. Duchamp placed a bicycle wheel upside down on a stool (fig. **27.29**) and declared it art. He later labeled his sculpture an "Assisted **Readymade**," because he had combined two found objects—a witty challenge to the notion that art involved only technical skill and craft. As important, he demonstrated that context determines the meaning of art, since by uniting these disparate objects, taking each out of its normal context and putting it in a new one, he gave each component of his sculpture a new meaning. Actually, *Bicycle Wheel* is so enigmatic it provokes wild interpretations, demonstrating that the meaning of a work of art also comes from viewers who bring their experiences to bear on the work. To an art historian, for example, the stool may suggest a pedestal and the wheel a head, an interpretation that can be seen as a clever engagement with artistic tradition, evoking the countless sculpted portrait busts that line museum galleries. A cyclist or a barfly most likely would come up with an entirely different scenario for the piece.

Duchamp was adamant that his Assisted Readymades had no aesthetic value. The act of combining stool and wheel, placing each in a new context, was more important to him than the resulting object. Duchamp made two other Assisted Readymades prior to World War I; none was exhibited. Only during the war years was his revolution fully unleashed on the art world, as we shall see in the next chapter (see page 986). But it is important to introduce Duchamp as prewar artist, for although he became a major figure in the Dada movement, which arose in large part as a reaction to World War I, it must be understood that his revolutionary art was not initially made as a political and social statement but rather as an artistic one that came on the heals of the investigations of Picasso and Braque.

CONSTANTIN BRANCUSI AND THE BIRTH OF MODERNIST SCULPTURE

Like Picasso's constructions and Duchamp's "Assisted Readymades," the sculptures of Constantin Brancusi (1876–1957) were among the most innovative artworks being produced before the war. Indeed, Brancusi's work is so minimal-looking and abstract it has come to symbolize modern sculpture itself. Ironically, Brancusi's background could not have been more removed from the modern world. The son of Romanian peasants, he grew up herding sheep in the remote village of Tîrju-Jiu in the Carpathian mountains. The region had a long tradition of ornate folk carving, in which Brancusi excelled. After studying art in Bucharest and passing through Munich in 1903, he settled in Paris and became an assistant to Auguste Rodin. Declaring that "Nothing can grow under big trees," he struck out on his own.

Escaping the far-reaching shadow of Rodin, an artist with strong ties to nineteenth-century art, Brancusi steered a radical course that, aesthetically if not thematically broke, with sculptural tradition and laid a foundation for much twentieth-century sculpture. Brancusi's mature style began to evolve as early as 1907, and by 1910 it had reached a minimal essence, as seen in *The Newborn* (fig. **27.30**) of 1915. Here, he reduces his subject to an ovoid resembling an egg, which suggests fertility and birth. The

27.30 Constantin Brancusi, *The Newborn*. 1915. Marble, $5\frac{3}{4} \times 8\frac{1}{4} \times 5\frac{7}{8}$ " (14.6 × 20.9 × 14.9 cm). Philadelphia Museum of Art. Louise and Walter Arensberg Collection. 1950–134-10

form also resembles a head, with the concave depression as the mouth releasing its first cry and the slender triangular piercing as the nose. Yet the whole is so abstract that we are left with a sense of the simple form of the marble, which seems to harbor the hidden mysteries of life. The work has the elemental power of the Cycladic sculpture (see pages 82-84) and simplified, geometric African masks that Brancusi, like Picasso and Matisse, knew so well. Brancusi understood that by using a minimalist vocabulary, he was able to shed in works like The Newborn the clutter of visual reality to pursue invisible essential truths that revealed the very core of existence. As Brancusi explained, "Simplicity is not an end in art, but one arrives at simplicity in spite of oneself in approaching the real sense of things." His works evoke an essence of perfection, as though the scale, the smooth unblemished surfaced, and the composition are so precise that they cannot be altered one iota without destroying their purity and the sense that they capture a primordial reality underlying all life.

Brancusi's sculpture focuses on only a handful of themes, which he repeated numerous times, often in different mediums, including bronze, wood, stainless steel, and stone of different kinds. The shift in medium allowed Brancusi to explore both the visual and psychological associations of his material. His meticulous control over his work included designing the bases and pedestals, as can be seen in *Bird in Space* (fig. **27.31**), where the

^{27.31} Constantin Brancusi, *Bird in Space*. 1928 (unique cast). Bronze, $54 \times 8\frac{1}{2} \times 6\frac{1}{2}$ " (137.2 × 21.6 × 16.5 cm). Museum of Modern Art, New York. Given anonymously

sculpture includes the cylindrical stone base and the hourglassshaped wood pedestal. This stacked system of presentation has the effect of distancing the sculpture from the space of the room and placing it within its own perfect world. Brancusi also realized the height of the presentation of his sculpture affected a viewer's physical and psychological relationship to it, and thus reading of it. Brancusi insisted, for example, that *The Newborn* be exhibited on a low pedestal, forcing a viewer to lean over the piece, placing his viewers in the position of an adult looking down at an infant in a cradle. In contrast, *Bird in Space* would be presented very high, like a soaring bird.

Brancusi introduced the bird motif as early as 1910. *Maiastra* was based on Romanian legends about a magical golden bird whose song held miraculous powers. By the 1920s, Brancusi showed the same bird soaring, as in *Bird in Space*, instead of perched. The elegantly streamlined form balances on a short, tapering column, the pinched section suggesting the juncture of legs and body. But of course we do not really see a bird. Instead Brancusi has presented us with the spirit of flight, as suggested by the smooth streamlined form that seems to gracefully and effort-lessly cut through the air. Using an entirely different vocabulary, Brancusi, like Malevich, sought to reveal "the real sense of things."

AMERICAN ART

Modernism did not come to America until the second decade of the twentieth century. It first appeared in New York at "291," the nickname for the Little Galleries of the Photo Secession, the progressive art gallery owned by Alfred Stieglitz (see page 936). Beginning in 1909, Stieglitz started featuring such seminal Modernists as Picasso, Matisse, Henri Rousseau, Rodin, and Brancusi as well as African art and children's art. The key breakthrough Modernist event in New York was the 1913 *International Exhibition of Modern Art*, known as the Armory Show after the 26th Street armory where it was held. Exhibited were over 400 European works, mostly French, from Delacroix, through Courbet, Monet, Gauguin, Van Gogh, and Cézanne, to Picasso, Brancusi, and Matisse. Three times as many American artists were represented, but by comparison their work often looked provincial and was largely ignored.

Ruthless newspaper reviews lambasted the radical contemporary French art, and the public came out in droves—75,000 people attended the four-week show. They came especially to ridicule Duchamp's *Nude Descending a Staircase No.* 2, which one reviewer claimed looked like an "explosion in a shingle factory."

27.32 Arthur Dove, *Plant Forms*. ca. 1912. Pastel on canvas, $17\frac{1}{4} \times 23\frac{7}{8}$ " (43.8 × 60.6 cm). Whitney Museum of American Art, New York. Collection of the Whitney Museum of American Art. Purchase with Funds from Mr. and Mrs. Roy R. Neuberger 51.20

The exhibition's slogan was "The New Spirit," and its symbol was the pine-tree flag of Revolutionary Massachusetts. The American organizers intentionally set out to create their own revolution, to jolt conventional bourgeois taste and bring about an awareness and appreciation of contemporary art. Despite the public's derision, the show spawned several modern art galleries and collectors adventurous enough to dedicate themselves to supporting radical art.

America's First Modernists: Arthur Dove and Marsden Hartley

American artists digested European Modernism almost as quickly as it was made, but those resident in Europe, especially in Paris, absorbed most rapidly the new movements of Fauvism and Cubism. In 1908, a young Arthur Dove (1880–1946) was in Paris, where he saw work by Matisse and the Fauves. When he returned to New York, he met Stieglitz and began showing at "291."

While remaining involved in the New York City art world throughout his life, Dove lived in rural areas in New York State and Connecticut, even spending several years on a houseboat anchored off Long Island. His art focused on nature, not modernity, and capturing universal forces. By 1910, he was painting complete abstractions, two years before Kandinsky and Delaunay, and this abstraction can be seen in a work from 1912, *Plant Forms* (fig. **27.32**), from a series of pastels titled *The Ten Commandments*, a title invoking spirituality.

In this work, Dove has supplied aspects of nature without painting them illusionistically. As with Cubism, the composition is made up of abstract components, although they overlap in a logical, consistent fashion to suggest continuous recession in space. The work has light and atmosphere as well as an organic quality, largely due to the elliptical, oval, and round forms and the biomorphic shapes suggesting plants and trees. We associate the colors green, ocher, and brown with earth and vegetation, and white and yellow with light. The curved white and yellow forms evoke suns, moons, and hills, and although the frondlike shapes recall plants and trees, they also seem like symbols of an unidentifiable burst of energy. We feel the powerful surge of nature and an elemental life force, and because each form suggests many different objects, Dove is able to convey the universal interconnectedness of all things. The picture is cosmic in its scope, yet provides an intimate view of nature. Dove's preoccupation with portraying potent natural forces will become a major theme in American art and, as we shall see, one of the major issues for artists in Stieglitz's circle.

Stieglitz's stable of artists also included Marsden Hartley (1877–1943), a Maine native who was making Pointillist paintings of the New England woods when the two met in 1909. In 1912, Hartley set off for Paris, where he became infatuated with the tribal art on view at the Trocadéro Museum, declaring, with an air of Western supremacy, that one "can no longer remain the same in the presence of these mighty children who get so close to the universal idea in their mud-baking." He stated that art had to be

27.33 Marsden Hartley, *Portrait of a German Officer*. 1914. Oil on canvas, $68\frac{1}{4} \times 41\frac{1}{8}$ " (173.4 × 105.1 cm). Metropolitan Museum of Art, New York. The Alfred Stieglitz Collection, 1949. (49.70.42)

"created out of spiritual necessity" and, finding French art superficial and lacking soul, he went to Berlin in 1913. There he read the writings of the great German mystics, such as Jakob Boehme (1575–1624). He then developed a unique form of Synthetic Cubism, which he combined with Fauvist and German Expressionist color to produce paintings filled with spiritual content, as can be seen in *Portrait of a German Officer* (fig. **27.33**), completed in 1914 and later bought by Stieglitz.

This large painting is one in a series dedicated to the memory of Karl von Freyburg, Hartley's lover, who was among the first soldiers killed in World War I. Shown in the painting are such German military paraphernalia as iron crosses, insignia, helmets, boots, service stripes, badges, flags, spurs, and tassels. In a sense, this abstraction is a still life that in spirit recalls Victorian keepsake boxes made for the deceased and containing photographs, clothing, hair, and memorabilia-all pressed under glass. The painting is dominated by a triangle and is filled with circles that reflect Kandinsky's Theosophical belief in the symbolism of geometry. In its jumble of color, form, and composition, Portrait of a German Officer expresses a cosmic force similar to Kandinsky's "Compositions" (see fig. 27.14) from the same period, and at times its abstraction seems to suggest landscape almost as readily as it does still life. With the outbreak of World War I, Hartley returned to the United States and to making landscapes, using an Expressionist style that revealed the elemental, spiritual power of nature.

EARLY MODERN ARCHITECTURE

In Chapter 26, we saw the emergence of two distinct approaches to modern architecture, one in the United States and another in Europe. American artists such as Louis Sullivan and Frank Lloyd Wright challenged historicism and conventional revivalism when they eliminated the distinction between the form of a building and its proposed function. In Europe, we also saw a rejection of revival styles when Art Nouveau defined modern architecture as an organic style of growth and movement. Throughout the twentieth century, modern architecture followed these opposite poles set by the Chicago School and Art Nouveau—the rational, geometric and functional versus the personal, referential, and expressive.

Austrian and German Modernist Architecture

Austria and Germany shaped modern architecture in the opening decades of the century. Charles Rennie Mackintosh, discussed in the previous chapter (see page 930), became the rage in Europe in the 1890s and was particularly idolized in Vienna at the turn of the century by young architects searching for an alternative to Art Nouveau.

ADOLF LOOS An especially influential Viennese architect was Adolf Loos (1870–1933). After graduating from the Dresden College of Technology, Loos traveled to Chicago to attend the 1893 Columbian Exposition and stayed three years, digesting the functionalism of the Midwest architects and especially coming under the spell of Louis Sullivan. Upon returning to Vienna, he designed interiors and wrote for a liberal magazine, in which he railed against the extravagant ornamentation of Art Nouveau. In 1908, he published his functionalist theories in a book titled *Ornament and Crime*. He declared that except for tombs and monuments, buildings should be functional. "Modern man, the

27.34 Adolf Loos. Garden façade of Steiner House, Vienna. 1910

27.35 Peter Behrens. A.E.G. Turbinenfabrik (Turbine Factory), Berlin. 1909–10

man with modern nerves, does not need ornamentation; it disgusts him," he wrote. He even drew a parallel between ornament and scatological graffiti. Furthermore, as a socialist, he found decoration and historicism particularly offensive because of their associations with the wealthy as well as with the oppression of the artisan.

Loos put his theories into practice in the Steiner House (fig. **27.34**) of 1910. In the U-shaped garden façade seen here, Loos used a severe design that emphasizes geometric blocklike components of the structure. Loos's unadorned building even results in the cornice almost disappearing, being reduced to a thin, almost undetectable strip. The windows, especially the horizontal ones, seem more functional than aesthetic. In 1923, Loos migrated to Paris, where, as we shall see, High Modernist architects embraced his antiornamentalism, and viewed his Steiner House as an important model.

HERMANN MUTHESIUS AND PETER BEHRENS In Germany, government and industry nurtured Modernist architecture. In 1896, government officials sent architect Hermann Muthesius to London, then the world leader in quality mass production, to study British industry and design. Upon returning home in 1904, Muthesius was appointed to the Prussian Trade Commission and given the task of restructuring education in the applied arts. To dominate world markets, he advocated mass production of functional objects executed in a well-designed machine style. In 1907, he was instrumental in establishing the Deutsche Werkbund, an association of architects, designers, writers, and industrialists whose goal was "selecting the best representatives of art, industry, crafts, and trades, and combining all efforts toward high quality in industrial work." In architecture he called for a new monumental style based on Schinkel's Classicism (see page 854), but reflecting modern industrial values, meaning mass production and modular components.

One of Muthesius's appointments to the Werkbund was architect Peter Behrens (1868–1940), who had been head of an appliedarts school in Düsseldorf. Also in 1907, Behrens was named design consultant to A.E.G., the German General Electric Company; he was responsible for the design of their buildings, products, and marketing materials. Between the Werkbund and A.E.G., Behrens had a mandate to implement the German belief in industrialization as its Manifest Destiny, and he was charged with finding a visual expression for the brute reality of industrial power. He accomplished this goal in his finest A.E.G. building, the 1909 Berlin Turbinenfabrik (Turbine Factory) (fig. **27.35**).

27.36 Walter Gropius and Adolf Meyer. Fagus Factory, Alfeld-an-der-Leine, Germany

This temple to industry is a veritable symbol of industrial might. The enormous main space is constructed of a row of hinged steel arches (their shape echoed in the roofline on the façade) like those used for nineteenth-century ferrovitreous train stations and exhibition halls (see figs. 25.38 and 25.39). Instead of a greenhouse encased in a historical facade, however, Behrens produces an abstract monumental structure that evokes a noble Classical temple and Egyptian entrance gateway. The corners are massive rusticated Egyptian pylons that support an enormous gable, whereas the windows on the side walls are recessed so that the lower portion of the steel arches is exposed, making the row of arches resemble a colonnade. Yet Behrens declares the building's modernity not only in its austere abstract vocabulary but also in the enormous window on the end-an unmistakably Modernist transparent curtain wall that seems to hang from the "pediment."

Although Behrens aggrandized industry in the monumental Turbinenfabrik, he did not produce the machine style that Muthesius was advocating—the *Typisierung*, a type or a basic unit, the equivalent of a mass-produced modular building that could be used by all architects. This machine style would be developed by the three architects in Behrens's office: Walter Gropius, Ludwig Mies van der Rohe, and Le Corbusier.

WALTER GROPIUS Of the architects in Behrens's office in 1910, Walter Gropius (1883-1969) was the most advanced. With associate Adolf Meyer, he was commissioned in 1911 to design the Fagus Factory (fig. 27.36), a shoe plant in Alfeld-an-der-Leine. Well versed in the achievements of Loos and Behrens, Gropius nonetheless reached back to the Chicago School and utilized their steel-grid skeleton, sheathed in a ferrovitreous curtain wall. The factory's glass façade appears to be magically suspended from the brick-faced entablature above. It even turns corners unobstructed. The building feels light and transparent, the window mullions thin and elegant. Horizontal opaque panels, the exact size and shape of the glass, indicate each of the three floors and continue the modular composition of the windows. The only nod to the past is the prominent Beaux-Arts entrance and the thin pseudo-piers faced in brick that support the entablature. Otherwise, with the Fagus Factory, Gropius created the machine style Muthesius was seeking: an unadorned building that adheres to a grid skeleton. This building type was so efficient and reproducible it would serve as the prototype for the glass-box structures that would dominate world architecture for the rest of the century.

German Expressionist Architecture

Not all German architects embraced technology, the Machine Age, and Muthesius's concept of the *Typisierung*. Some instead designed expressive spiritual structures meant to counter the cold impersonal impact of modernity.

HENRI VAN DE VELDE Another Werkbund architect was Henri van de Velde (1863–1957), a native of Belgium, where he was initially a successful Neo-Impressionist painter and then an Art Nouveau architect and designer. In 1901, he became consultant to the craft industries in the Grand Duchy of Saxe-Weimer. Van de Velde was a strong advocate of Nietzsche's theory of the *Übermensch* and believed in the importance of designing powerful, expressive architecture. He was also heavily influenced by the Munich psychologist Theodor Lipps and his theory of *Einfühlung*, meaning "empathy," the mystical projection of the ego onto the art object. This background led him to examine Wilhelm Worringer's 1908 book *Abstaktion und Einfühlung* (*Abstraction and Empathy*), which advocated attaining transcendence through abstraction as well as championing an aesthetic of emphatic expression of vital psychic states.

On a 1903 trip to Greece and the Middle East, Van de Velde became entranced by the powerful simplicity and purity of Assyrian and Mycenaean buildings (see pages 34-37 and 93-99), which he translated into modern terms in the theater he built for the 1914 Werkbund Exhibition in Cologne (fig. 27.37). This structure was deliberately designed to counter Mathesius's Typisierung, as best represented by Gropius's model factory at the 1914 fair. Despite its massive abstraction, Van de Velde's structure seems like a living organic body rather than a cold, rigid box. Each space within the building is readable from the exterior and has its own identity. Because of the curves, the building seems to swell and breathe. However, this is no longer the springtime effervescence of Art Nouveau; rather, it is a reflection of a need to invest architecture with a spirituality and life force and to enhance these qualities by echoing the powerful monumentality and purity of the forms of ancient Near Eastern civilizations.

BRUNO TAUT A more overt spiritual contribution at the 1914 Werkbund Exhibition was Bruno Taut's (1880–1928) Glass Pavilion (fig. 27.38), built for the glass industry and reflecting his belief in the mystical properties of crystal. The guru of glass was poet Paul Scheerbart, whose 1914 essay "Glasarchitektur," published in *Der Sturm*, had a tremendous impact on artists and architects. (See www.myartslab.com.) The entablature of Taut's Glass Pavilion is even etched with Scheerbart's aphorisms about the power of glass.

Scheerbart claimed that only a glass architecture that opened all rooms to light could raise German culture to a new spiritual

27.37 Henri van de Velde. Werkbund Theater, Cologne. 1913–14. Demolished 1920

27.38 Bruno Taut. Glass Pavilion, Werkbund Exhibition, Cologne. 1914

level. Consequently, Taut used glass brick for the walls and floors. The bulbous dome, which resembles a giant crystal, is made of two layers of glass; the outer one reflective, the inner one a myriad of colored-glass pieces resembling medieval stained glass. Taut also considered his cupola to be Gothic, its facets evoking the *élan vital* of the ribbing of the Flamboyant style. The ceiling of the

main space had a central oculus that emitted a shower of colored spiritual light.

MAX BERG The year before, the mystically inspired architect Max Berg (1870-1947) used a similar ocular motif for his Jahrhunderthalle (Centennial Hall) (fig. 27.39) in Breslau, erected to celebrate the 100th anniversary of Germany's liberation from Napoleon's rule. Berg's Expressionism is quite Romantic, for the enormous building, made possible by ferroconcrete (steel-reinforced concrete), conjures the sublime grandeur of Piranesi's fantasies of Rome (see fig. 23.3) and Boullée's visionary monuments (see fig. 23.24). (See Materials and Techniques, page 1013.) Massive elliptical arches resemble an ancient Roman aqueduct or bridge bent into a circle and springing from the floor. The ribbing of the ceiling recalls the Pantheon, but solid and void have been reversed since the coffered section is now windows, creating an aura of celestial light that makes the dome seem to float. The Pantheon's ocular opening is now closed. At the time, critics likened this dark disk to the iris of an eye, and the entire levitating dome to a giant eyeball connected to the universe. As expressed by one contemporary writer, "the cosmos opened to reveal the courses of the stars and the empyrean."

In 1925, Berg abandoned architecture to dedicate his life to Christian mysticism. But in 1912, when Die Brücke and Der Blaue Reiter were committed to leading Germany into a world of higher spirituality through painting, prints, and drawings, Berg sought to achieve the same in ferroconcrete and glass.

27.39 Max Berg. Interior of the Jahrhunderthalle (Centennial Hall), Breslau, Germany. 1912–13

1905-06 Matisse's Le Bonheur de Vivre

1907 Picasso's Les Demoiselles d'Avignon

1911-13 The Fagus Factory, designed by Walter Gropius and Adolf Meyer, is erected

1914 Marsden Hartley's Portrait of a German Officer

1910 Egon Schiele's Self-Portrait with Twisted Arm

1915 Malevich's Black Square

Toward Abstraction: The Modernist Revolution, 1904–1914

1870

 1875 Madame Blavatsky and Henry Steel Olcott found the Theosophical Society in New York

1890

1910

1915

1880

1900 1900 Igmund Freud publishes The Interpretation of Dreams

1905
 1905-15 Albert Einstein introduces the theory of relativity
 1905 Critic Louis Vauxcelles names Fauvism
 1905 Die Brücke (The Bridge) formed
 1905 Alfred Stieglitz opens his gallery "291"

1907 Henri Bergson publishes Creative Evolution 1907-8 Gustav Klimt, The Kiss

1908 Henry Ford introduces the Model T Ford

- 1909 Critic Louis Vauxcelles names Cubism
 1909 Filippo Tommaso Marinetti issues a Manifesto of Futurism
 1909 Louis Blériot flies across the English Channel
- 1910 Der Blaue Reiter (The Blue Rider) formed
- 1911 Vasily Kandinsky publishes Concerning the Spiritual in Art
 - 1912 Picasso creates first collage and the first-known construction

1913 First performance of Igor Stravinsky's *The Rite of Spring*

- 1913 Niels Bohr introduces atomic theory 1913 Armory Show in New York City
- 1914 James Joyce begins Ulysses
 1914 World War I begins

Art Between the Wars

HYSICALLY AND PSYCHOLOGICALLY, WORLD WAR I DEVASTATED Western civilization. The destruction and loss of life were staggering, with hundreds of thousands of soldiers dying in single battles. The logic, science, and technology that many thought would bring a better world had gone horribly awry. Instead of a better world, the advancements of the nineteenth century

had produced such hi-tech weapons as machine guns, long-range artillery, tanks, submarines, fighter planes, and mustard gas.

To many, the very concept of nationalism now seemed destructive, and the rise of the first Communist government in Russia in 1917 offered some the hope of salvation. Around the world, branches of the Communist Party sprang up, with the goal of creating a nationless world united by the proletariat, the working class that provides the labor force for the capitalist system. Others maintained that a new world order could not be attained without first destroying the old; they advocated anarchy, which remained a constant threat in the postwar decades. Despite this drive to create a nationless and classless world, by the 1930s, it was fascism that had taken hold of European politics. Fascism, a totalitarian political system that exalts the nation over the individual and demands allegiance to a single leader, held a special appeal in nations defeated in World War I. Germany, in particular, had been humiliated by the terms of the Treaty of Versailles, and had suffered extreme inflation and then economic collapse. Germans gradually came under the spell of Adolf Hitler (1889-1945) and the Nazis, who skillfully used economic crises and anti-Semitism to consolidate their power. In Italy, Spain, and Japan, as well, fascists, under the command of charismatic leaders, took control. Armed with new technological tools of

Detail of figure 28.38, Joseph Stella, The Voice of the City

destruction, these nations would plunge the world into another great war by 1939.

While fascism, communism, anarchy, and democracy jockeyed for dominance in Europe, America enjoyed unprecedented prosperity in the 1920s. Historians have called the economic and cultural exuberance of the postwar years the Roaring Twenties; it was a time of jazz, speakeasies, radio, and film. The 1920s also saw the rise of the city as the emblem of the nation. Technology and machines were king in America, where the world's largest skyscrapers could be erected in a year. This economic exhilaration came to a screeching halt with the stock market crash of October 1929, which sent the entire world into a downward economic spiral known as the Great Depression, which lasted throughout the 1930s. A reactionary backlash then occurred in both Europe and America: fascism in the former, and a conservative regionalism and isolationism in the latter. Nonetheless, the 1930s marked the advent in America of liberal social and economic programs, instituted by Franklin Delano Roosevelt's administration (1932-44). Believing that economic markets were inherently unstable, Roosevelt advocated the New Deal, which created millions of government-sponsored jobs, including many for artists.

Perhaps the strongest defining influence for artists between the wars was the Great War itself and the technology, science, and Enlightenment rationalism that allowed it to be so devastating. The war directly produced Dada, a movement that created a nonsensical nihilistic art that attacked bourgeois values and

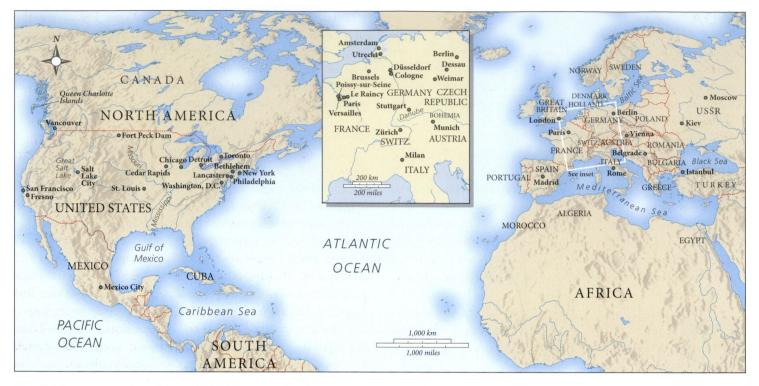

Map 28.1 Europe and North America in the 1920s and 1930s

conventions, including a faith in technology. The Dadaists aimed to wipe the philosophical slate clean, leading the way to a new world order. Other artists embraced the modernity of the Machine Age (as this interwar period is sometimes called), seeing it as a means to create classless utopias; still others rejected it, seeking higher truths or a meaningful spirituality in an increasingly materialistic, soulless world. Both groups often turned to abstraction to implement their vision. Those supporting technology embraced the geometry and mechanical look of the Machine Age, while those who rejected it sought higher truths often using an organic or biomorphic vocabulary.

A second major force for the period was Sigmund Freud, whose theories about the unconscious and dreams were a formative influence on Surrealism, a prevailing movement in the 1920s and 1930s. Like many abstract artists, the Surrealists sought to reveal invisible realities—not spiritual ones, but elemental universal forces that drove all humans. These unseen realities were deeply embedded in the mind and symbolically revealed in dreams. Freud maintained that the conventions of civilization had repressed the elemental needs and desires that all people shared, and that this suppressed, invisible world of desires and sexual energy was fundamental to human behavior, the driving force within all humans. Freud acknowledged that civilized societies required the repression and channeling of those desires, but asserted that individuals paid a price in the form of neuroses and discontent. For Surrealist artists, as well as writers and intellectuals, Freud's theory of the unconscious confirmed the existence of realities unseen by the eye or unperceived by the conscious mind, and they served as the springboard for the development of Surrealist imagery and style.

Politics also strongly shaped the art of the period. Many, if not most, avant-garde artists were socialists and Communists, or at least sympathizers, and their utopian dreams and aesthetic visions stem in part from these political ideologies. The narrative, representational murals of the great Mexican artists directly champion Communism, especially when paired with science, as the vehicle for creating a classless utopian society. With the rise to power of Hitler and his National Socialist Party, many avant-garde artists turned their attention to making antifascist imagery and exposing the insane thinking and sadistic brutality of the new German government.

This period also saw a growing interest in racial and ethnic identity, which was expressed in Mexican art and African-American art. The Mexican muralists were preoccupied with national identity, which they associated with the indigenous population, not Euro-Mexicans, while African Americans sought to uncover their heritage and culture. Just as Mary Cassatt, Berthe Morisot, and Margaret Julia Cameron sought to present women from a female viewpoint, obtaining very different results from male artists, the Mexicans and African Americans did the same for native and African cultures. These artists presented a very different image of and attitude toward non-European civilizations.

DADA

The Great War halted much art making, as many artists were enlisted in their countries' military service. Some of the finest were killed, such as the German Expressionist Marc and the Italian Futurist Boccioni. But the conflict also produced one art movement: Dada. Its name was chosen at random, the story goes, when two German poets, Richard Huelsenbeck and Hugo Ball, plunged a knife into a French-German dictionary and its point landed on dada, the French word for "hobbyhorse." The word's association with childishness as well as the random violence of the poets' act of word choice fit the postwar spirit of the movement perfectly. As the birth story of Dada suggests, the foundations of the movement lay in chance occurrences and the absurd. Logic and reason, the Dada artists concluded, had led only to war. For them, the nonsensical and the ridiculous became tools to jolt their audience out of their bourgeois complacence and conventional thinking. The movement was profoundly committed to challenging the status quo in politics as well as in culture. Dada began in 1916 in neutral Zurich, where a large number of writers and artists had sought refuge from the war and dedicated themselves, as Ball declared, "to remind the world that there are independent men, beyond war and nationalism, who live for other ideals." The Dada spirit spread across the West and to parts of Eastern Europe and would become a reference point for artists throughout the twentieth century.

Zurich Dada: Jean Arp

In Zurich, the poet Hugh Ball founded the Cabaret Voltaire in 1916 as a performance center where writers and artists could protest the absurdity and wastefulness of the Great War. (The name Voltaire referred to the great Enlightenment *philosophe* whose ideas epitomized the logic that the Dadaists were attacking; see page 786.) Ball was soon joined by the Romanian poet Tristan Tzara, who became Dada's most vociferous proponent. The artists and writers at the Cabaret Voltaire attacked the rational thinking that, in their view, produced the depraved civilization responsible for the war. Their target was all established values—political, moral, and aesthetic—and their goal was to level the old bourgeois order through "nonsense" and anarchy. In the end, they hoped to produce a *tabula rasa*, a clean slate, that would provide a new foundation for a fresh understanding of the world.

The Cabaret Voltaire group, which included the Alsatian painter and poet Jean Arp, mounted boisterous performances. Wearing fanciful costumes, including primitive cardboard masks, they recited abstract phonetic poems of nonwords. ("Zimzum urallal zumzum urallal zumzum zanzibar zumazall zam" went one line in Hugo Ball's *O Gadji Beri Bimba*. To listen to Ball's sound poems, go to www.myartslab.com.) The readings were virtually drowned out by an accompanying "music," a cacophony of sounds, often the arrhythmic beating of a drum. The performers' chaos whipped the audiences into frenzies of catcalls, whistles, and shouts. Some evenings, Tzara harangued the audience with rambling, virtually incomprehensible Dada manifestos. And, just as chance had named the Dada movement, it was used to create works themselves. Dada poems were "written" by pulling words out of a hat. Sometimes one poem was read simultaneously in different languages, or different verses of the same poem were read simultaneously in one language. The resulting chance weaving of words together in a new way created a fresh unpredictable poetic fabric, both in sound and meaning. Some performances included danses nègres and chants nègres, as African dance and music were called, reflecting the group's interest in so-called primitive cultures, cultures supposedly free of the evils of advanced civilization. Furthermore, the Dada artists believed that the directness and simplicity of African cultures put those cultures in touch with the primal essence of nature itself. Perhaps the most far-reaching influence of Dada performances was that they tore down the boundaries that had separated the various arts as visual artists, musicians, poets, actors, and writers worked together. Furthermore, the Dadaists destroyed any hierarchy of medium and genre. The Zurich Dadaists exhibited a broad range of avant-garde art, such as paintings by Klee and de Chirico (see pages 961 and 969, respectively)-as long as the art undermined bourgeois taste and standards. Most of the art presented at the Cabaret Voltaire and its successor, the Galerie Dada, was abstract. Among the strongest visual artists in the group was Jean (or Hans-his name changed with the shifting national status of his hometown Strasbourg) Arp (1886-1966), whose abstract collages hung on the walls of the Cabaret Voltaire on opening night. Arp made his collages by dropping pieces of torn rectangular paper on the floor; where they fell determined the composition. Although he claimed that chance alone arranged the papers, Arp probably manipulated them.

Arp believed that chance itself replicated nature. For him, life, despite the best-laid plans, was pure happenstance. Arp had been in Munich with Kandinsky (see pages 958-60), and there he adopted a mystical view of the world that envisioned a life force running through all things, binding them together in no particular order. Like Kandinsky, Arp sought to capture abstract universal forces. This spiritual outlook can be seen in the low-relief sculptures he began making at about this time, such as The Entombment of the Birds and Butterflies (Head of Tzara) (fig. 28.1). The different shapes were determined by doodling on paper. He then had a carpenter cut the shapes out of wood, which Arp painted and assembled into abstract compositions evoking plant and animal forms as well as clouds, cosmic gases, and celestial bodies. The title came last, and, as it suggests, the image can be also seen as a head, suggesting an elemental connection between humans and nature.

The Cabaret Voltaire closed by the summer of 1916 and was replaced by a succession of other venues. Meanwhile, Tzara's magazine, *Dada*, spread the word about the movement worldwide. By the end of the war in late 1918, Zurich had been abandoned by many of the major artists, and by early 1919, Zurich

28.1 Jean (Hans) Arp, *The Entombment of the Birds and Butterflies* (*Head of Tzara*). 1916–17. Painted wooden relief, $15\frac{3}{4} \times 12\frac{3}{4}$ " (40 × 32.5 cm). Kunsthaus, Zurich

Dada had drawn to a close. Only after the war was over did Tzara hear that there was a New York Dada movement happening simultaneously, if not in name, at least in spirit.

New York Dada: Marcel Duchamp

New York Dada was centered on Marcel Duchamp and Francis Picabia, both of whom fled Paris and the war in 1915. Picabia was notorious for his satirical portraits in which the subject is represented by a machine. In one, the photographer Alfred Stieglitz (see pages 936, 938, and 974) was portrayed as a camera, which takes on human qualities embodying Stieglitz's personality. The New York artists had no Cabaret Voltaire, no manifestos, and no performances, although they did hold a weekly salon at the home of the wealthy writer Walter Arensberg and his wife, Louise. From 1915 to 1916, they published their avant-garde art and ideas in a magazine entitled *291*, which was sponsored by Alfred Stieglitz, who as well as being a photographer was one of the first dealers of avant-garde art in America. The word Dada was never used at the time to describe their art; it was only applied in retrospect because their spirit was similar to that found in Zurich.

Perhaps the highlight of New York Dada is Duchamp's Fountain (fig. 28.2). Duchamp submitted this sculpture to the 1917 exhibition of the Society of Independent Artists, an organization begun several decades earlier to provide exhibition opportunities for artists who did not conform to the conservative standards of New York's National Academy of Design, which had been the primary exhibition venue. Duchamp labeled his Fountain an "Assisted Readymade." He took the term Readymade from American readymade clothing, and applied it to his sculptures that simply re-presented a found object, such as a snow shovel, which Duchamp hung from the ceiling and entitled In Advance of a Broken Arm. Objects that he "assisted," by joining them with other objects, as in Bicycle Wheel (see fig. 27.29), or by signing, as in Fountain, he called an "Assisted Readymade." As we saw in Chapter 27, Duchamp began working with found objects when he made his Bicycle Wheel in 1913, although he did not exhibit his Readymades and coin the term until he was in New York. Fountain was, in fact, a urinal manufactured by J. L. Mott Iron Works in New York. Duchamp selected it, purchased it, turned it 90 degrees, set it on a pedestal, and crudely signed it with the fictitious name of "R. Mutt"-a reference not only to the manufacturer but also to the character Mutt in the popular Mutt and Jeff comic strip. The sculpture was

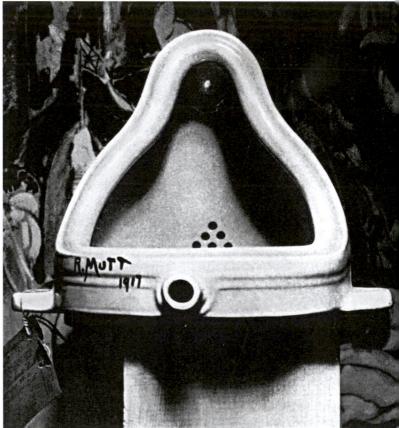

28.2 Marcel Duchamp, *Fountain*. 1917. Photograph by Alfred Stieglitz, from *The Blind Man*. May 1917. Philadelphia Museum of Art, Louise and Walter Arensberg Collection

submitted to the society's exhibition under Mutt's name, not Duchamp's. According to the society's rules, anyone paying the \$6 admission fee would have his or her work accepted. But Duchamp knew the hanging committee would not consider *Fountain* art and so not allow it to go on view, and when it was removed at the opening, his friends formed a rowdy procession that drew attention to its rejection.

Duchamp continued the hoax of R. Mutt's authorship of the work when he wrote an article about the piece in a small newspaper he published with artist Beatrice Wood, *The Blind Man*, which only survived two issues but was well circulated in the avant-garde art world. The article was illustrated by a Stieglitz photograph of *Fountain* placed before a painting by Marsden Hartley (see fig. 27.33), an arrangement that underscored that the proper context for the appropriated urinal was the art world. The article defended Mutt's right to create a Readymade: "Whether Mr. Mutt with his own hands made the fountain or not has no importance. He chose. He took an ordinary article of life, placed it so that its useful significance disappeared under a new title and point of view...[creating] a new thought for that object."

Like all of Duchamp's works, Fountain is rich in ideas, and it stands as one of the seminal works of twentieth-century art, although the original has disappeared. The sculpture is all about ideas. A viewer of Fountain must ask: What is the work of art? Is it the urinal, the provocation of submitting it to the exhibition, the flamboyant parade when it was removed from the show, or the article about it in The Blind Man? Obviously, it is all of these things. Even the title is essential to the work, since it is an essential part of the sculpture, and it allows Duchamp to make it clear that he is attacking one of the more revered art forms, the fountain, which is the centerpiece for most European towns and city squares and is, in some respects, a symbol for the tradition of fine art. The satirical title also reinforces the humor of the piece, an ingredient found in much of Duchamp's work. Duchamp is telling us art can be humorous; it can defy conventional notions of beauty, and while intellectually engaging us in a most serious manner, it can also make us smile or laugh. Duchamp challenges the notion of what art is and the importance of technique or craft, as well as of the artist's signature. He also asks how a work of art takes on meaning. Here, Duchamp emphasizes the relationship between context and meaning: By taking a urinal out of its normal context he has changed its meaning. (For a more extensive discussion of Duchamp, focusing on his Mona Lisa with a moustache, see the Introduction, pages xxvi-xxvii.) He even allows a viewer to assign meaning to the work, underscoring how this is a reality for all art, not just his. Ironically, unlike all art that preceded his, his Readymades have no aesthetic value and theoretically no intended meaning. They are merely a device to launch ideas.

Because *Fountain* is industrially manufactured and can be easily replaced if broken or lost (the original is lost, and in 1964 the work was editioned, that is to say, several identical examples were produced), Duchamp also questions the significance attached to the uniqueness of a work of art. As we shall see, in the second half of the twentieth century, Duchamp will become the dominant figure in art as artists worldwide make what will be called Conceptual Art. For those artists, an idea or conceptual premise is the most important component of their work, in effect replacing the visual component.

In contrast to Zurich Dada, New York Dada was very quiet. In Manhattan, the group was far removed from the war, and it did not have a political agenda. Its focus was largely on defining art, following Duchamp's lead. More important, New York Dada was light-hearted and witty, as in Picabia's humanoid machines and Duchamp's *Fountain*. Dada art with a more acute sense of social mission was produced in wartorn Germany.

Berlin Dada

With the end of the war, the Dada poet Richard Huelsenbeck (1892-1974) left Zurich for Berlin. There, he found a moribund city, which like the rest of Germany was without food, money, medicine, or a future. Germans, especially the working class, loathed the military-industrial machine, which they felt had betrayed their interests by leading them into war. With the surrender, conditions worsened as Germany was punished by harsh and, some thought, unrealistic reparation demands. Inflation was rampant, and the value of the German currency plunged. Open class conflict in 1919 resulted in Communist-led worker uprisings in Berlin and Munich that were brutally repressed by right-wing armed units. The Weimar Republic government, which had replaced the Kaiser (emperor) and represented Germany's first experience with democracy, failed to revive the economy. Its refusal in 1923 to make war reparations only resulted in further humiliation when the French military occupied the Ruhr Valley and seized the German assets in that coalmining region.

For many, hope lay in the East, in Russia, where the Bolshevik Revolution established the prospect for a nationless world governed by the proletariat. The artists and writers of Berlin Dada looked to international worker solidarity as Germany's salvation. Here was a situation where Dada anarchy and nihilism could be put to practical use. Almost without exception, the Berlin Dada contingent made political art and were political activists, with some members, such as George Grosz and John Heartfield, joining the Communist Party.

In Berlin, the poet Huelsenbeck employed the usual Dada devices. He created an organization, Club Dada, and published manifestos calling for the overthrow of the bourgeois establishment and the creation of an egalitarian society. The principal members of the group included Raoul Hausmann, Hannah Höch, George Grosz, and John Heartfield. In 1920 they organized the first Dada International Fair, which featured worldwide Dada art. In the center of the fair, hanging from the ceiling, was an army-uniformed dummy with the head of a pig and wearing a sign saying "Hanged by the Revolution." The work, a collaboration by Hausmann and Grosz, epitomized Dada's abhorrence of the establishment. RAOUL HAUSMANN Hausmann (1886–1971) quickly became the leader of Berlin Dada, and was perhaps the most visually inventive, as can be seen in his 1920 assemblage Mechanical Head (Spirit of the Age) (fig. 28.3). He used found objects, which at the time were so foreign to the art world they were considered junk: a hairdresser's dummy, a collapsible cup, a crocodile wallet, labels, nails, a bronze segment of an old camera, a typewriter cylinder, a length of measuring tape, and a ruler. But now we see a new approach to making sculpture: The found objects are assembled together, an approach generally labeled "assemblage." Through this accumulation of objects, Hausmann presents a mindless, lifeless dummy, the contemporary German, whose actions and thoughts are molded by external forces, rendering it mechanical, even robotic, and with no personal identity. Hausmann claimed the typical German "has no more capabilities than those which chance has glued onto the outside of his skull; his brain remains empty."

Hausmann, however, is best known for his use of language and collage. Like Hugo Ball in Zurich, he wrote and performed phonetic poems made according to the laws of chance. (To listen to his Dada poems, go to <u>www.myartslab.com</u>.) His interest in words, letters, and sound led him in 1919 to innovative experiments with typography, in which he used different typefaces and

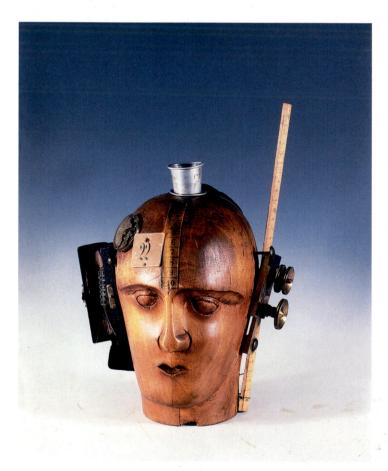

28.3 Raoul Hausmann, *Mechanical Head (Spirit of the Age)*. ca. 1920. Assemblage, height 12³/₄" (32.5 cm). Musée National d'Art Moderne, Centre Georges Pompidou, Paris

sizes for individual letters cut from magazines and newspapers, the shifts in scale indicating how the letter should be emphasized when sounded. These words were incorporated into ingenious collages made from material cut from different printed sources and rearranged in new contexts.

HANNAH HÖCH Some of the most elaborate and powerful Dada collages from the period were created by Hannah Höch (1889-1978), who was Hausmann's companion from roughly 1915 to 1922. Her Dada collages mimic manipulated portraits made for German soldiers. Individuals or entire battalions hired photographers to create fictitious portraits by photographing them, then cutting out their heads and pasting them onto preexisting pictures of, for example, mounted militia. (See Primary Source, page 991.) Cut with the Kitchen Knife Dada Through the Last Weimar Beer Belly Cultural Epoch of Germany (fig. 28.4) speaks volumes about the agenda of Berlin Dada. Using a chaotic, cramped composition of crowds, words, machinery, and lettering of different sizes and styles, Höch captures the hectic social, political, and economic intensity of the Weimar Republic. Her collage of photographs represents images of contemporary life made by photographers for the popular press. To Höch and her Dada colleagues, the camera was another machine that could be associated with the technological advances that had led to the war. With her "kitchen knife," she "killed" the machine, and rearranged the imagery to create a hand-made photograph, thus humanizing the mechanical. The resulting image is a spinning, gearlike composition with a portrait of the radical antiwar artist Käthe Kollwitz at the center. German masses and the new leaders of their government, the Weimar Republic, are pushed to the sides and villainously labeled as the "anti-Dada," meaning against Dada and leftist politics.

Collage, of course, was not new. But previously it had been used in a more refined manner, particularly by the Cubists, who had generally transformed the found materials taken from popular culture into beautiful art (see fig. 28.12). With Hausmann and Höch, however, collage retained the look and feeling of popular culture, especially the advertising look seen in the mass media. The Berlin Dadaists did not call their works collages, which suggests fine art. Instead, they labeled them **photomontages**, which evoked machine-made, mass-produced images. Their photomontages looked like antiart, and their powerfully abrupt compositions embodied the group's political stridency.

KÄTHE KOLLWITZ Though not a Dada artist, Käthe Kollwitz (1867–1945), spotlighted by Höch in *Cut with the Kitchen Knife*, provided an important precedent for the political and expressive nature of Berlin Dada and is often simply labeled an Expressionist. A generation older than Höch, she was denied admission to the Berlin Academy because she was a woman. She studied at a women's art school, and after marrying a doctor, settled in a working-class neighborhood in Berlin. There, her husband treated the poor, who became the subject of her art. She shunned painting as an elitist medium of the academy and

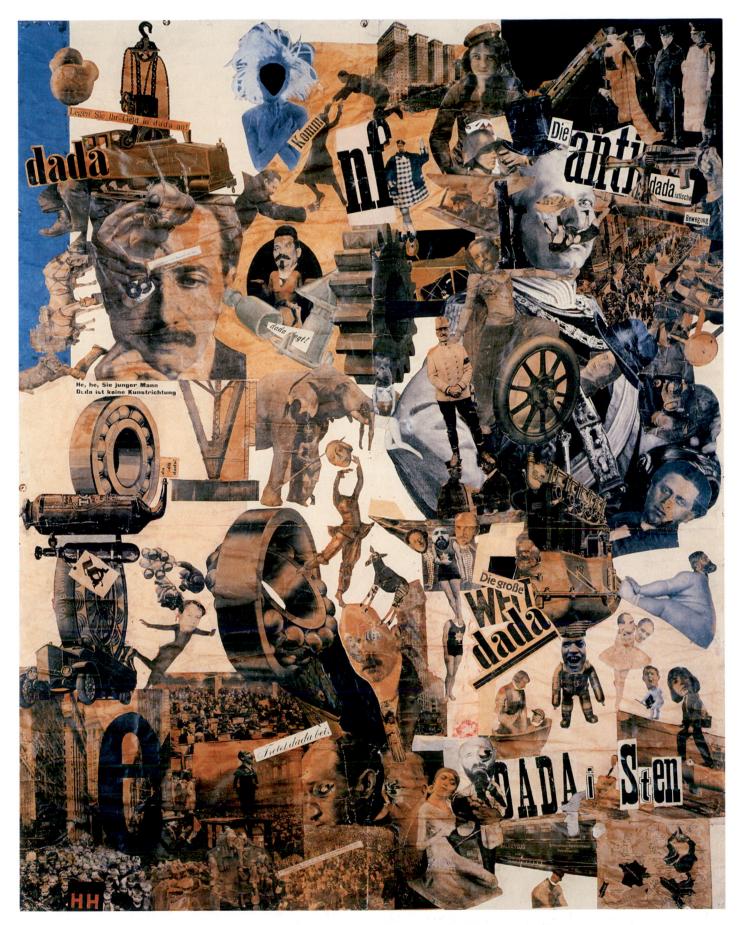

28.4 Hannah Höch, *Cut with the Kitchen Knife Dada Through the Last Weimar Beer Belly Cultural Epoch of Germany.* ca. 1919. Collage, 44% × 35%" (114 × 90.2 cm). Staatliche Museen, Berlin

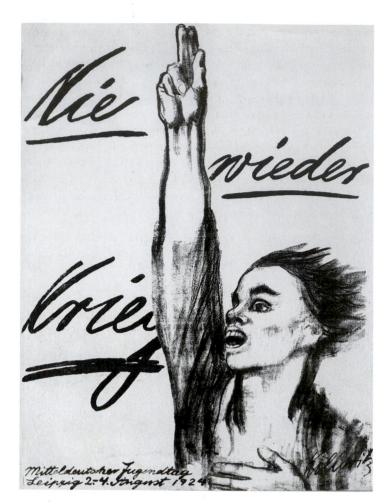

28.5 Käthe Kollwitz, *Never Again War!* 1924. Lithograph, 37 × 27½" (94 × 70 cm). Courtesy Galerie St. Étienne, New York

the bourgeoisie, and instead made drawings and prints, which could be mass-produced and circulated to wider audiences. For the Berlin Dada artists, who were committed to clear political messages, Kollwitz was an inspiration. Although for the 1920s, her representational style was somewhat conservative, her message was influential, for she had created a large body of powerful Expressionist work that conveyed her sympathies with the working class, and victims of war. In addition, her imagery contains far more women than does that of her male counterparts and reflects her socialist vision of women playing an equal role in the ideal Germany of the future. Typical of her Expressionist style of strident marks, strong value contrasts, and powerful emotions is her antiwar poster Never Again War! (fig. 28.5), a lithograph published in 1924 and embodying personal content, since Höch lost a son in World War I. In 1920, Höch became the first woman ever admitted to the Prussian Academy of Fine Arts.

GEORGE GROSZ An early maker of Dada photomontages, George Grosz (1893–1959), provides a clear example of the Expressionist element in Berlin Dada and its direct connection with Kollwitz. (Like Höch, Grosz is often labeled a postwar Expressionist.) Grosz, who had been seriously wounded twice in

the war and had suffered a mental breakdown, was especially bitter about the disastrous course charted by Germany's leaders. Upon convalescing and returning to Berlin, he was stylistically inspired by the expressive Cubism of the Futurists and worked in this style at the same time as he produced his more radical photomontages. A fine example of his Cubist style is Germany, A Winter's Tale (fig. 28.6) of 1918. Here, the city of Berlin forms the kaleidoscopic, chaotic background for several large figures, which are superimposed on it as in a collage. They include the marionettelike "good citizen" at his table and the sinister forces that have molded him: a hypocritical clergyman, a brutal general, and an evil schoolmaster. For Grosz, this triumverate reflects the decadent world of the bourgeoisie that he, like many German intellectuals, hoped would be overthrown by Communism. In 1920, he, along with Kollwitz and other artists, joined the International Workers Aid, a Communist organization.

28.6 George Grosz, *Germany, A Winter's Tale*. 1918. Oil on canvas. Formerly Collection Garvens, Hannover, Germany

Hannah Höch (1889–1978)

From an interview with Édouard Roditi

In an interview with art historian Édouard Roditi, the German Dada artist Hannah Höch talks about the inspiration for her Dada photomontages.

A ctually, we borrowed the idea from a trick of the official photographers of the Prussian army regiments. They used to have elaborate oleolithographed mounts, representing a group of uniformed men with a barracks or a landscape in the background, but with the faces cut out; in these mounts, the photographers then inserted photographic portraits of the faces of their customers, generally coloring

Cologne Dada

In the city of Cologne, Dada initially took its lead from Berlin, but it was never as political. Dada artists here were intrigued by Freud's theory of the unconscious and favored figures that combined mechanical and human forms (sometimes called mechanomorphic art), reminiscent of the work of Duchamp and Picabia. The key Cologne Dada artists were Max Ernst (1891-1976) and Johannes Baargeld (a pseudonym based on the German word Bargeld, meaning "cash"), both of whom appropriated the Berlin artists' collage techniques. Ernst and Baargeld were iconoclasts, not social evangelists, who delighted in submitting their witty low-end irreverent collages to the staid Cologne Kunstverein Exhibition in 1919, creating a scandal. When prohibited from showing there the following year, Ernst mounted a solo exhibition at a nearby brewery, forcing visitors to walk past the lavatory to get to the "gallery," where the central work was a sculpture that visitors were instructed to destroy with an axe he provided.

Typical of Ernst's work from this very productive period is 1 Copper Plate 1 Zinc Plate 1 Rubber Cloth 2 Calipers 1 Drainpipe Telescope 1 Piping Man (fig. 28.7), a gouache, ink, and pencil drawing on an illustration from a 1914 book about chemistry equipment. With a line here and a dab of paint there, Ernst transformed the picture of laboratory utensils into bizarre robotic figures set in a stark symbol-filled landscape. Perhaps we should say dreamscape, for the glazed-over stares and skewed de Chirico-like perspective, which culminates in a mystifying square, give this little collage an elemental power that suggests some otherworldly sphere-one of the imagination. Ernst was influenced by others who had made dream imagery, but he was also familiar with de Chirico's metaphysical paintings, to which he was introduced by his friend Jean Arp. The dreamlike quality of Ernst's image endows his figures with heavy psychological overtones. Not surprisingly, Ernst was fascinated by Sigmund Freud's theories about the unconscious and the importance of dreams.

Through Arp, Ernst was put in contact with two leaders of the Paris Dada movement, poets André Breton and Paul Éluard, both them later by hand. But the aesthetic purpose, if any, of this very primitive kind of photomontage was to idealize reality, whereas the Dada photomonteur set out to give to something entirely unreal all the appearances of something real that had actually been photographed. ...

Our whole purpose was to integrate objects from the world of machines and industry in the world of art. Our typographical collages or montages also set out to achieve similar effects by imposing, on something which could only be produced by hand, the appearances of something that had been entirely composed by a machine; in an imaginative composition, we used to bring together elements borrowed from books, newspapers, posters, or leaflets, in an arrangement that no machine could yet compose.

Source: Édouard Roditi, Dialogues: Conversations with European Artists (Bedford Arts Publishers, 1990)

28.7 Max Ernst, 1 Copper Plate 1 Zinc Plate 1 Rubber Cloth 2 Calipers 1 Drainpipe Telescope 1 Piping Man. 1920. Gouache, ink, and pencil on printer paper, 12×9 " (30.5 × 22.9 cm). Estate of Hans Arp

of whom had also come under Freud's spell, entranced by the idea that the unconscious contained realities that had been suppressed by civilization. In 1921, they arranged for Ernst to show his Dada collages at a small avant-garde exhibition in Paris, where they made such a sensation he was hailed as the "Einstein of painting." The following year, Ernst emigrated to Paris. In 1924, Breton issued his *Surrealist Manifesto*, anointing Ernst's 1921 show, because of its dreamlike images, as the first Surrealist exhibition.

Paris Dada: Man Ray

The transition from Dada to Surrealism was well under way by 1922, and it occurred in Paris. Dada had established a foothold in the French capital with the return of Duchamp at the end of 1918 and with the arrival of Picabia from Barcelona in 1919. As in Zurich, the thrust behind Paris Dada came from the literary contingent. Inspired by Tzara's *Dada* magazine, three young poets— Louis Aragon, André Breton, and Philippe Soupault—founded a journal called *Littérature*. It was so avant-garde that there was hardly anything in it that the literary establishment would consider literature. In addition to phonetic poems by Tzara, it included Breton and Soupault's collaborative poem "Les Champs magnétique" ("Magnetic Fields") of 1920, which was written in a stream-of-consciousness style that was derived from working sessions lasting up to ten hours.

One artist who moved in and out of the Paris Dada circle was the independent American Man Ray (1890–1976). He had befriended Duchamp in New York, participated in New York Dada, and followed Duchamp to Paris in 1921. Best known as a photographer, Man Ray was extraordinarily inventive and worked in many mediums, some, such as airbrush painting, being quite innovative. Most important, Man Ray was the first artist to consistently use photography within a Dada context, often using the same conceptual premises, favoring idea over technique, as are found in Duchamp's work, thus freeing the medium from the merely representational restrictions placed on it by fine-art photographers. Man Ray helped establish photography, at least within Dada and Surrealist circles, as a medium that was viewed on a par with painting and sculpture.

In 1922, Man Ray had a major impact on the development of photography, as well as on Dada and abstract art, when he popularized the **photogram**—a one-of-a-kind cameraless photograph made by putting objects directly on photographic paper and then exposing both the object and paper to light (fig. **28.8**). Solid objects block light from striking the white paper, so they appear white in the image, while the spaces between and around the objects become black, since there is nothing to prevent the light from exposing the paper. Tzara dubbed Man Ray's print a "rayograph," and that year, using cover prints (photographic copies of the original print) made by Man Ray, Tzara published a limitededition book, entitled *Champs délicieux* ("Delicious Fields," a pun on "Magnetic Fields"), containing 12 rayographs.

Our reproduction is one of these untitled works, which reveals the silhouettes of a brush and comb, a sewing pin, a coil of

paper, and a strip of fabric, among the identifiable items. The image, like much of Man Ray's work, helps demonstrate the close relationship between the random and defiant art of Dada and the evocative, often sensual, art of Surrealism. The objects appear ghostlike and mysterious and float in a strange environment where darks and lights have been reversed and a haunting overall darkness prevails. Shapes and lines move in and out of dark shadows, sometimes vibrating, as with the brush-and-comb silhouette, other times crisply stated, as in the center oval. Because Man Ray exposed the paper with a light bulb that he moved several times during the process, he created multiple light sources, which caused the edges of some objects to shimmer and allowed other forms to recede back in space instead of just existing as flat silhouettes. His pictures, as with the Surrealist art that would follow, are a magical blend of the real and nonreal. We feel the presence of a real comb and sewing pin, and yet they seem to exist in a poetic otherworldly realm, even evoking the inner world of the mind and black-and-white world of dreams. Just as strange and inexplicable is the relationship of these objects and shapes to one another.

28.8 Man Ray. Untitled, from *Champs délicieux*. 1922. Gelatin silver print

Man Ray also used the same process to make films, which have the same dreamlike quality as his rayographs. At Tzara's invitation, he participated in what turned out to be the final major Dada event in Paris, La Soirée de la Coeur de la Barbe (The Bearded Heart Soirée) in 1923. To make his film, Man Ray sprinkled sand on a segment of unexposed film, and, nails, and tacks on another, creating a three-minute abstract movie titled The Return to Reason (to view the film, visit www.myartslab.com), an ironic title because the hallucinatory flickering of white objects floating in pitch-blackness creates a sense of chaos that is far from rational. To flesh out the film, Man Ray added segments of a carousel photographed at night, a tic-tac-toe-gridlike mobile dancing with its own shadow, and a nude model dissolved in harsh striped lighting, which are equally abstract and dreamlike. Like the rayographs, the film represented a new way to view the world, one that was essentially Surrealist, although the term had yet to be coined or the movement recognized. This short movie, Man Ray's first, not only introduced film to the Parisian fine-art world, but it also helped spawn a flurry of experimental films by other artists. Shortly after Man Ray's movie was screened that evening, a riot broke out when Breton, Éluard, and Soupault, all uninvited, stormed the stage screaming that Dada was dead. Though Dada continued to provide the intellectual foundation for challenging art throughout the century, the spirit of the moment was clearly shifting away from chance and nonsense to the psychological investigations of Surrealism.

SURREALISM

Surrealism existed in spirit, if not in name, well before 1924, but the movement was formally launched by Breton that year with his Surrealist Manifesto. Surrealism, Breton wrote, is "pure psychic automatism, by which it is intended to express, either verbally, or in writing, or in any other way, the true functioning of thought. Thought expressed in the absence of any control exerted by reason, and outside all moral and aesthetic considerations." Banished was the Neoclassical god of reason, the sureness of logic, and the need to portray an observable reality. Also gone was Dada nihilism, replaced by an intensive exploration of the unconscious. Surrealists argued that we see only a surface reality. More important was uncovering the reality that, as Freud maintained, resided in the deep-seated secrets and desires of the unconscious mind. For Freud, the basic human desires, particularly the sexual ones, that define our individual identities are repressed by the conventions of civilization but are revealed in dreams. Random dream images are, for Freud, charged with meaning and provide the "royal road to the unconscious." They contain symbols of our desires and anxieties. Using his own and his patients' dreams as "raw material," Freud decoded dream images into what he believed to be their true meaning, claiming sexual desires or concerns were often disguised as ordinary objects. A vase, for example, is a symbol of female sexuality, the vagina, while a tall building or a mountain suggests phallic maleness.

Breton's manifesto proposed several ways to tap into the unconscious. He encouraged the use of dreamlike images, the juxtaposition of unrelated objects that would jar the imagination, and stream-of-consciousness writing. He called for "the future resolution of these two states, dream and reality, which are seemingly so contradictory, into a kind of absolute reality, a surreality." He emphasized the concept of creating "the marvelous," images, either verbal or visual, that are mysterious, chance, and poetic, and that jolt the audience into a new, unknown plane of reality—surreality.

Surrealism was first a literary style. Breton traced its roots to several sources, including the comte de Lautréamont's 1869 novel Chants de Maldoror, which included wondrous passages of surreal images, the most famous perhaps being "as beautiful as a chance encounter of a sewing machine and an umbrella on an operating table." Breton's literary circle delighted in such "chance encounters" of words, even devising a game in which each participant provided words for a sentence, not knowing what had already been written. One such game produced "The exquisite corpse will drink the new wine," and "Exquisite Corpse" became the game's name. Surrealist visual artists played Exquisite Corpse as well. Folding a piece of paper, each artist drew on his or her segment without seeing what the others had done, only where they had left off. The result was a provocative image of unrelated objects or a strange form. But visual art had little place in Breton's manifesto, and visual artists were only mentioned as a footnote, appearing in a single sentence. Among those listed were Ernst, Man Ray, de Chirico, and Picasso.

Picasso and Surrealism

Perhaps the most surprising name on Breton's list is Picasso's. The Dada artists found little of interest in the analytic logical thinking of the Cubists. But Breton saw Picasso's Cubism as the first step toward loosening the grip of reality on the artistic imagination, and he declared Picasso's 1907 *Les Demoiselles d'Avignon* (see fig. 27.5) one of the first Surrealist images. Beginning in the mid-1920s, Picasso's work paralleled that of the Surrealists. They shared many symbols and myths, mostly sexual, including the female praying mantis, which eats it male partner upon mating, and the suffering, tortured male minotaur, which has the head of a bull on the body of man. But Picasso was very independent, and though he provided artwork for Surrealist publications and participated in some Surrealist shows, he did not consider himself a Surrealist.

With Breton's 1924 Surrealist Manifesto, the primal sexual forces seen in Les Demoiselles and smoldering beneath the surface of many of his Synthetic Cubist paintings of the mid- to late 1910s burst into the foreground of Picasso's works, as seen in Three Dancers (fig. 28.9), made in 1925, less than a year after Breton published his manifesto. These are not the Three Graces, but rather disquieting nudes engaged in a strange performance. The figure in the center—the most conventionally rendered—appears at one moment to be completing a pirouette, at the next moment

28.9 Pablo Picasso, *Three Dancers*. 1925. Oil on canvas, $7'\frac{1}{2}" \times 4'8\frac{1}{4}"$ (2.15 × 1.4 m). Tate Gallery, London

to be crucified. The contorted figure to the left has been reduced to an assemblage of abstruse hieroglyphic forms, which never quite coalesce into a single meaning. Her head is shaped like a quarter-moon, and it has been placed against a backdrop of a night sky filled with stars as represented by the abstracted fleursde-lis of the wallpaper. Some scholars claim the head resembles a Torres Strait, New Guinea mask that Picasso had in his personal collection of tribal art, and is thus a reflection of the artist's interest in the expressive primordial power of so-called primitive art, which Surrealists felt penetrated into the deepest recesses of the mind. The figure on the right is the most sedate or controlled of the three, causing some art historians to view the dancers as emblems of love, sex, and death. At every turn, Cubist fracturing dissolves the forms into disorienting shapes and colors, permitting multiple interpretations of the scene. What seems to be a dance rehearsal in a light-filled studio at one moment turns into

a midnight Dionysian bacchanal at the next. What remains consistent, however, is the pivotal role of the female body, whether as a symbol of erotic athleticism, threatening sexual frenzy, or spiritual suffering. Just as Freud attributed to the female body the power to incite desire as well as dread in men, Picasso, like the Surrealists, places the female form at the service of a male viewer's contradictory libidinal impulses.

WELDED SCULPTURE Picasso also turned to sculpture to express his urge to portray the unseen deep-seated psychological passions that drive physical urges, and it led him to revolutionize sculpture for a second time (see page 954). By late 1928, he was welding metal, which he experimented with for the next five years, starting a trend that by the 1940s established welded steel as a major sculptural process rivaling cast bronze and chiseled stone. Picasso began working in the medium when he decided to make sculpture based on the linear drawing of the figures in his

28.10 Pablo Picasso, *Head of a Woman*. 1929–30. Painted iron, sheet metal, springs, and colanders, $39\frac{3}{8} \times 14\frac{1}{2} \times 23\frac{1}{4}$ " (100 × 37 × 59 cm). Musée Picasso, Paris

28.11 Julio González, *Head.* ca. 1935. Wrought iron, 17³/₄ × 15¹/₄" (45.1 × 38.7 cm). Museum of Modern Art, New York. Purchase (266.1937)

current paintings, figures that were in effect skeletal stick figures. The resulting three-dimensional sculptures were made up of metal rods that represented the painted lines, and they looked like a line drawing in space.

Gradually, Picasso turned from metal rods to working with metal in a variety of shapes and sizes, including the use of found objects, as seen in *Head of a Woman* (fig. **28.10**) from 1929–30, which was made from colanders, springs, iron, and sheet metal. Picasso is still drawing in space, as seen in the hair, face, skull, and body—if this is indeed what these abstract shapes are. He has pared his figure down to a barebones essence, peeling away the superficial layers of physicality to reveal the psychological core of the woman that lies beneath, a rather strident, threatening psychology that reflects a male perception and fear of the opposite sex. The sculpture's overall resemblance to African masks, and the use of tribal hieroglyphic notations for different parts of the body, such as the stick legs, reinforce its elemental quality.

To do his welding, Picasso hired fellow Spaniard Julio González (1876–1942), who had learned the skill in a Renault automobile factory. By the 1930s, González was making his own work, such as *Head* (fig. **28.11**) of around 1935, which would garner him a reputation as the world's foremost practitioner of welded sculpture. González specialized in figures and heads,

which, like Picasso's *Head of a Woman*, project primitive, psychological, and hallucinatory qualities. Here, the sculptor reduces the figure to a pernicious clamplike mouth, stalklike eyes, spiky hair, and frazzled face (or is it the mind?), all attached to a moonlike crescent not only suggesting a skull but also the cosmos, a parallel we saw Jean Arp make as well in *The Entombment of the Birds and Butterflies* (see fig. 28.1)

Surrealism in Paris: Spurring the Imagination

In 1925, Breton, like everyone, was having doubts about the possibility of Surrealist painting or sculpture. Many argued that the visual arts, unlike writing, did not allow for a stream of consciousness since artists always had the work in front of them and, while creating, could see where they had been and think about where they were at that moment. The resulting imagery might seem surreal, but the method was not. Initially, many of the visual artists Breton championed relied on automatic drawing and chance to produce their images. In late 1925, Breton organized the first Surrealist exhibition, which featured Ernst, Picasso, André Masson, and Joan Miró, but also included de Chirico, Klee, Man Ray, and Arp.

MAX ERNST The use of automatic drawing had been initiated by the French painter André Masson (1896–1987) the year before, in 1924. In this process, Masson first made a series of lines while in a trancelike state, lines that he then used to spur the imagination to further develop the image. In 1926, he began prompting his unconscious by also randomly putting glue on his canvases and then sprinkling sand over the surface, the sand adhering where there was glue. The result of these chance techniques was the creation of mysterious environments inhabited by primitive organic forms, suggesting both the origin of life and the powerful universal urges that drive it.

Not to be outdone by Masson, Ernst in 1925 developed frottage, one of several devices he developed throughout his career to spur his imagination. Frottage consists of rubbing graphite, crayon, or charcoal over paper placed on an object, such as floorboards, chair caning, or pressed flowers, and then discerning an image in the irregular pattern of the wood grain or in the botanical geometry. When wiping paint over canvas, the technique is called grattage. In either case, the process often spurred Ernst's imagination to create a primeval forest filled with birds, animals, and bizarre, frightening creatures. While the pictures often have a mythic force similar to Masson's imagery, they are also filled with a frenetic sexual energy. Grattage is the basis for Die Ganze Stadt (The Entire City) (fig. 28.12) of 1935-36, one of several paintings made on this theme at about this time for which Ernst placed canvas over boards and then rubbed dried paint over the surface. The result in each case is an austere and massive Mayan-like structure evoking an extinct monumental civilization, swallowed by the forces of nature and time, as suggested in this picture by the dominance of the enormous acidic-colored celestial body in the sky and the crawling animallike plantlife with lush buds in the

28.12 Max Ernst, Die Ganze Stadt (The Entire City). 1935-36. Oil on canvas, 231/2 × 313/4" (60 × 81 cm). Kunsthaus, Zurich

foreground. A dark mood of twilight prevails, underscoring a sense of futility about humans trying to permanently achieve the goals of their primary, elemental desires.

JOAN MIRÓ A Catalan from Barcelona, Joan Miró (1893–1983) came to Paris in 1920 and took a studio next to Masson's. Soon after, through a hole in their adjoining wall, Masson whispered to Miró to go see Breton, not Picasso—because "he was the future." Within a short time Miró had abandoned Cubism and begun painting from his imagination. (Actually, he claimed he was working from hallucinations brought on by starvation—"I was living on a few dry figs a day.") He adopted Masson's wiry line and the childlike drawing and atmospheric quality of Klee (see fig. 27.16). Miró's pictures became abstractions of biomorphic and geometric forms set against a minimal color field that suggested a landscape or watery environment. Miró's paintings became increasingly abstract, as seen in *Composition* (fig. **28.13**), a 1933 oil. The work was one in a series based on collages on cardboard made from images cut out of catalogues with the idea that the shape and even details of the objects would fire his imagination. The setting of *Composition* is a hazy atmospheric environment of washes, suggesting the same kind of primeval landscape as in Masson's abstractions. This eerie world is populated by strange curvilinear floating forms that suggest prehistoric and microscopic creatures, as well as spirits, ghosts, or souls. We can even find a story in places, such as two figures playing with or fighting over a ball in the upper left corner. Or are they? Other features in the painting express ideas about sex, struggle, and fear. Miró uses a minimal vocabulary, which includes color as well as form, to create a mythic image evoking humans' most primal urges and needs.

Representational Surrealism: Magritte and Dalí

Initially, Breton's strongest support was for an abstract Surrealism that was based on chance, spontaneity, and trance. Over the next decade, however, artists with all kinds of styles would move in and out of the movement, most abandoning it, in part because of **28.13** Joan Miró, *Composition.* 1933. Oil on canvas, $51\frac{1}{4} \times 63\frac{1}{2}$ " (130.2 × 161.3 cm). Wadsworth Atheneum, Hartford, Connecticut. Ella Gallup Sumner and Mary Catlin Sumner Collection Fund

the group's strong socialist and Communist stance, but also because of Breton himself, who was rather controlling and functioned as though he were the Pope of Surrealism, capriciously anointing or not anointing and even excommunicating artists as Surrealists for the flimsiest of reasons.

RENÉ MAGRITTE By the late 1920s, more and more artists were working in a representational or quasi-representational style. One such was René Magritte (1898–1967), who was from Brussels. There, he was a member of the Surrealist circle, a group of artists and intellectuals who were also very involved

with Communism. Magritte spent 1927 to 1930 in Paris, but Breton never officially recognized him as a Surrealist. He then returned to Belgium, where he spent the remainder of his life, not achieving fame until late in his career. His *The False Mirror* (fig. **28.14**), painted in 1928, reads like a manifesto of Surrealism, proclaiming the superior reality of the unconscious mind. We see an uncanny close-up of an eye, which reflects a distant sky. The iris, however, is transformed into an eerie eclipsed sun, behind which, Magritte suggests, lies the unconscious, which perceives the reality of things. The eye absorbs only the visual, not the real, world.

28.14 René Magritte, *The False Mirror*. 1928.Oil on canvas, $21\frac{1}{4} \times 31\frac{1}{8}$ " (54 × 81 cm).Museum of Modern Art, New York

28.15 Salvador Dalí and Luis Buñuel. A still from the film *An Andalusian Dog (Un Chien Andalou).* 1929. France

SALVADOR DALÍ Arriving in Paris a few years after Magritte was another major representational Surrealist. Salvador Dalí (1904–1989) came from Madrid, where he had already developed a meticulously detailed Realist style heavily based on the psycho-

logical complexes that Freud described in his writings. He made a grand entrance into the world of Parisian Surrealism with his 17minute film An Andalusian Dog (see www.myartslab.com), which he made with fellow Spaniard, the filmmaker Luis Buñuel (1900-1983). The movie opens with Buñuel on a balcony with a woman and, as a cloud mysteriously passes behind them, the camera goes to a close-up of an eye, we assume the woman's, which is then dramatically sliced by a straight razor. This opening scene has been interpreted as a reference to the Oedipus complex and fear of castration, which is symbolized by a fear of blindness, two major themes in Freud's writings about male psychological development. The entire film, which consists of one unexplainable, bizarre sequence after another, lends itself to similar Freudian analysis. To produce their Surrealist effects, Dalí and Buñuel rely on montage, juxtaposing unrelated objects to create dream sequences that constantly put objects into new contexts designed to generate the "marvelous" and to jolt the unconscious. In one famous sequence, a needley sea urchin morphs into a woman's hairy armpit; in another, a man's mouth first disappears, then becomes a woman's crotch; and in yet other, ants swam over a hand appearing in a crack in a door. In yet another famous sequence, the film's protagonist drags across a room two priests and two grand pianos, each containing a putrefying dead donkey

28.16 Salvador Dalí, *The Persistence of Memory*. 1931. Oil on canvas, $9\frac{1}{2} \times 13$ " (24.1 × 33 cm). Museum of Modern Art, New York. Given anonymously (162.1934)

(fig. 28.15), a sequence suggesting among other things the admonishments of the church about sex and how they suppress basic human urges.

Similar themes and Freudian psychology appear in Dalí's visual art. Dalí made his paintings using a process he called "paranoiac-critical"-"[a] spontaneous method of irrational knowledge based upon the interpretative-critical association of delirious phenomena." He created paintings in a frenzy, a selfinduced paranoid state where he would begin with a single object in mind. Then, he would respond to that object and so on, developing a mysterious image reflecting an irrational process that released the unconscious. The Persistence of Memory (fig. 28.16) began with the strange amorphous head with an elongated trailing neck lying on the ground. A plate of soft Camembert cheese then inspired him to paint the soft pocket watches. While allowing no certain "final" reading, the picture evokes a host of associations, the most obvious being the crippling passage of time that leads to inevitable deterioration and death, although the title suggests we are looking backward to the past, not forward to the future. Many scholars interpret the flaccid watches as symbols of impotence. In any case, Dalí has created a provocative dreamscape of mysterious objects that can be read as metaphors for the deepest desires, fears, and anxieties, especially sexual, of the mind, and that can unleash multiple interpretations from a viewer's own unconscious.

Surrealism and Photography

Photographers, following Man Ray's lead, were discovering that their medium, which could both manipulate reality and create dreamlike sequences, were perfect vehicles for Surrealism. Many major photographers, not in Breton's circle, were deeply affected by Surrealism. One of the most famous outsiders was the Frenchman Henri Cartier-Bresson, who neither manipulated nor staged his images.

HENRI CARTIER-BRESSON Cartier-Bresson (1908-2004) made some of the most extraordinary images of the twentieth century. Trained as a painter, he turned to photography in the early 1930s when, influenced by the Surrealists, he sought to find the extraordinary in the ordinary and decided that the best means for accomplishing this was through photography. Armed with the new small, portable 35mm Leica camera, he took to the street to photograph what he called "the decisive moment," which he defined as "the creative fraction of a second when you are taking a picture," and "using intuition you ask your artistic question and decide almost simultaneously." We can see this decisive moment in his Behind the Gare Saint-Lazare (fig. 28.17) of 1932. All over the world, Cartier-Bresson made photograph after photograph that miraculously captured the same supernatural magic we see in this fleeting, ghostlike image of a silhouetted man inexplicably suspended in midair. A master of strong value contrasts, Cartier-Bresson was able to transform stones, ladder, and arcs into strange hieroglyphic shapes that materialize out of the water. Like Dalí and Ernst, he establishes a powerful eerie dialogue among objects,

28.17 Henri Cartier-Bresson, *Behind the Gare Saint-Lazare*. 1932. Gelatin silver print

such as the man, clock, ladder, and reflections, sending the mind on an endless journey of associations and interpretations.

The Surrealist Object

When Joan Miró began work on his *Composition*, he started with an image that, like a dream, took him on a journey of psychological exploration and formal invention. Surrealists created objects that would initiate such journeys for viewers as well as for themselves. In fact, some of the most succinct Surrealist artworks were fetishistic objects, mysterious poetic things, that were found and created, and had no narrative, but jolted the unconscious and spawned infinite associations, mostly sexual and often violent. As early as 1921, Man Ray had already made one of the first Surrealist objects, *The Gift* (fig. **28.18**), a gift for the composer Erik Satie. The work is nothing more than tacks glued onto the flat side of a clothing iron. It is a shocking dislocation of both a household item and hardware that creates something unidentifiable, without logic or narrative, but filled with innuendoes of violence, pain, and sex.

28.18 Man Ray, *The Gift.* 1921 (1958 replica). Painted flatiron with row of 13 tacks with heads glued to the bottom, $6\frac{1}{8} \times 3\frac{5}{8} \times 4\frac{1}{2}$ " (15.5 × 9.2 × 11.43 cm). Museum of Modern Art, New York. James Thrall Soby Fund (249.1966)

Probably the most famous Surrealist object was made by Meret Oppenheim (1913–1985). Oppenheim, the daughter of a Jungian psychologist, went to Paris as an 18-year-old in 1932. For a period she was Man Ray's model and assistant. Inspired by an off-hand comment she made when lunching with Picasso in 1936, she covered a teacup, saucer, and spoon with gazelle fur and called it *Object* (fig. **28.19**), although Breton, when he included it in a Surrealist exhibition, retitled it *Luncheon in Fur*, punning on Manet's sexually fraught *Luncheon on the Grass* (see fig. 25.10). Oppenheim presents us with eroticism offered and eroticism denied, for, individually, fur and beverage are sensual, but juxtaposed as they are, they are disconcerting, if not outright repulsive. The fur anthropomorphizes the porcelain and spoon, and suggests, among other things, pubic hair. The work is designed to trigger the unconscious, to evoke infinite associations that deal with the repressed realities of eroticism, sensuality, desire, and anxiety. Using minimal means, Oppenheim created the "marvelous" that takes a viewer into the realm of the surreal.

ORGANIC SCULPTURE OF THE 1930S

The abstraction of such Surrealists as Masson and Miró inspired many artists to search for universal truths residing beneath the surface of things. As had the Romantic landscape painters of the previous century, they focused on nature, trying to pry loose the unseen pulse of the cosmos that coursed through the natural world. To reveal these higher truths and realities, a number of artists, including Alexander Calder in Paris and Henry Moore and Barbara Hepworth in England, turned to working with abstract organic forms. Often, they showed in Surrealist exhibitions and were occasionally labeled Surrealists, especially since their work dealt with hidden realities. But despite many parallels, their interests were quite different from Breton's as they evolved in the 1930s. Breton was more concerned with the psychology of anxiety, desire, and sex, while the artists working with abstract organic forms were more interested in the powerful forces of the universe. With the exception of Calder, they did not use chance or

28.19 Meret Oppenheim, *Object (Luncheon in Fur)*. 1936. Fur-covered teacup, saucer, and spoon; diameter of cup $4\frac{3}{4}$ " (12.1 cm); diameter of saucer $9\frac{3}{8}$ " (23.8 cm); length of spoon 8" (20.3 cm). Museum of Modern Art, New York

other devices to spur their imaginations. In some respects, their work relates more to Malevich, Kandinsky, and Mondrian than to the card-carrying Breton Surrealists. Some artists, like Jean Arp, whom we met in a Dada context but who became one of the first Surrealists, abandoned Breton's circle in the early 1930s and joined an international Paris-based group called Abstraction-Création, which was dedicated to abstract art. Similarly, Miró as well, without changing style, quit the Surrealist movement, claiming he was not a Surrealist.

Alexander Calder in Paris

Arp convinced his friend Alexander Calder (1898–1976) to become a member of Abstraction-Création as well. Calder, an American from Philadelphia, had settled in Paris in 1926, where he also befriended Miró and the abstract Dutch painter Piet Mondrian, whom we shall meet shortly. In the early 1930s, he started making mobiles, a name that Duchamp gave his kinetic sculptures. Calder's first mobiles were propelled by motors, but later mobiles were constructed of painted sheet metal attached to metal wires that were hinged together and perfectly balanced. With the slightest gust of air, the mobile seems to glide, tilting and turning in space. Some of his mobiles make a chiming sound as 'hammers' periodically swing around to strike gonglike elements. The mobiles vary in size from tabletop models to others with a 30-foot span that are suspended from a ceiling.

Like Miró and Arp, Calder generally used organic shapes, as seen in *Lobster Trap and Fish Tail* (fig. **28.20**) from 1939. The forms suggest marine life, but generally they are abstract and, like Miró's paintings, simultaneously suggest the microscopic and macroscopic. The black forms in *Lobster Trap* can be seen as a school of fish, but viewed together suggest something skeletal, even primeval. Calder was inspired to develop kinetic sculpture to suggest growth and cosmic energy. He kept his colors basic, generally using primary and secondary colors, as well as black and white. All colors stem from these, so Calder's palette symbolized the basic building blocks of life, a notion he shared with Mondrian (see page 1005), whose Paris studio he visited in 1930.

28.20 Alexander Calder, *Lobster Trap and Fish Tail.* 1939. Painted steel wire and sheet aluminum, approx. $8'6" \times 9'6"$ (2.59 × 2.89 m). Museum of Modern Art, New York, Commissioned by the Advisory Committee for the Stairwell of the Museum

Henry Moore and Barbara Hepworth in England

The organic abstract style favored by Miró, Arp, and Calder jumped the English Channel in the 1930s, surfacing in the work of Henry Moore (1898–1986) and Barbara Hepworth. Moore studied at the Royal College of Art in London from 1921 to 1925, and in the following five years, from extensive museum visits in England and on the Continent, and through art publications, he digested the contemporary art of Brancusi, Arp, Miró, and Picasso. He was also influenced by the period's intense interest in non-Western art, including the Pre-Columbian art of Mexico.

By the early 1930s, Moore's mature style had emerged, represented here by *Recumbent Figure* (fig. **28.21**), made in 1938. The work is reminiscent of a Classical reclining river-goddess, although it is based more directly on Pre-Columbian figures. The sculptor is more interested in projecting the elemental and universal than in Classical antiquity as he explores the associations between the forms of nature and the shape of the figure. We see a woman, but the stone retains its identity as stone, looking like a rock that has been eroded by the elements for millions of years. Moore ingeniously suggests that figure and rock are one and the same, even making the female form harmonize with the striations of the stone. The universal forces present in the rock are transferred to the figure, which becomes an earth-goddess or fertility figure. The undulation of her abstract body virtually transforms her into a landscape. Adding to the mystical aura is Moore's brilliant interplay between solid and void, each having the same weight in the composition and evoking the womblike mystery of caves or tidal pools embedded in seashore rocks.

Moore felt comfortable showing works similar to *Recumbent Figure* at the International Surrealist Exhibition held in London in 1936; he may have seen an affinity with the Surrealists in his attempts to express a higher reality lying beneath the surface of things. But Moore felt equally comfortable exhibiting in shows of abstract art, and his sculpture poses a classic case of the problematic nature of labeling art.

Barbara Hepworth (1903-1975) identified entirely with abstraction, and was a member of Abstraction-Création. She traveled to Paris in 1933 and visited the studios of Arp and Brancusi; she also met Picasso. She was in Paris again in 1935 and met Mondrian. Like Moore, who was with her for a time at the Leeds School of Art and was a lifelong friend, she was interested in investing her abstract forms with a sense of the unseen forces of nature. She began working in abstraction in the early 1930s, and within a few years her sculpture became geometric. Instead of seeming hard-edged and mechanical, however, they are organic and mysterious, a quality that became even stronger after she moved to a cottage overlooking St. Ives Bay in Cornwall on the southwest tip of England when war broke out in 1939. Her sculpture was a personal response to nature. (See Primary Source, page 1003.) In Sculpture with Color (Deep Blue and Red) [6] (fig. 28.22), the egglike form, vaguely reminiscent of Brancusi's heads and

28.21 Henry Moore, *Recumbent Figure*. 1938. Green Horton stone, length approx. 54" (137.2 cm). Tate Gallery, London

Barbara Hepworth (1903–1975)

"On Sculpture" (1937)

In a 1937 book of artists' statements, British abstract sculptor Barbara Hepworth made the following statement about how her work reflects universal truths and an individual's relationship to nature.

The whole life force is in the vision which includes all phantasy, all intuitive imagination, and all conscious selection from experience. Ideas are born through a perfect balance of our conscious and unconscious life and they are realized through this same fusion and equilibrium. The choice of one idea from several, and the capacity to relate the whole of our past experience to the present idea is our conscious mind: our sensitivity to the unfolding of the idea in substance, in relation to the very act of breathing, is our unconscious intuition. ...

Contemporary constructive work does not lose by not having particular human interest, drama, fear or religious emotion. It moves us profoundly because it represents the whole of the artist's experience and vision, his whole sensibility to enduring ideas, his whole desire for a realization of these ideas in life and a complete rejection of the transitory and local forces of destruction. It is an absolute belief in man, in landscape and in the universal relationship of constructive ideas. The abstract forms of his work are now unconscious and intuitive-his individual manner of expression. His conscious life is bent on discovering a solution to human difficulties by solving his own thought permanently, and in relation to his medium. ... [Abstraction] is no escapism, no ivory tower, no isolated pleasure in proportion and space-it is an unconscious manner of expressing our belief in a possible life. The language of colour and form is universal and not one for a special class (though this may have been in the past)-it is a thought which gives the same life, the same expansion, the same universal freedom to everyone.

Source: Circle—International Survey of Constructive Art, ed. J. L. Martin, B. Nicholson, and N. Gabo (London: Faber and Faber, 1937)

28.22 Barbara Hepworth, *Sculpture with Color (Deep Blue and Red) [6].* 1943. Wood, painted white and blue, with red strings, on a white painted wooden base, $11 \times 10^{"}$ (27.9 × 26 cm). Private collection

newborns, is an elemental shape, suggesting fertility and birth. The carved wood is finely polished and covered with an immaculate sheen of white paint, producing a surface that, like the shape of the work, evokes purity. In addition, the white of the shell heightens the mystery of the dark cavity, which harbors a sky or water of deep blue. The stretched red strings have the intensity of the sun's rays and perpetual energy of life forces. Hepworth herself said, "the strings were the tension I felt between myself and the sea, the wind or the hills."

CREATING UTOPIAS

While Dada and Surrealism constituted a major force for the period between the wars, they were not the only movements. Many twentieth-century artists remained committed to exploring abstract art. Surrealists and abstract artists often shared similar social goals: Both groups championed individual freedom, and both wished to undermine bourgeois values, to eradicate nationalism, to destroy capitalism, and to create a classless society. (See www.myartslab.com.) Many Dadaists and Surrealists were socialists who also participated in Communist Party activities. Similarly, many abstract art itself as a vehicle for creating a utopian society.

Two major centers of geometric abstraction emerged simultaneously: Constructivism appeared with the Russian Revolution in 1917, and De Stijl (The Style) appeared in Amsterdam. A third center was the Bauhaus in Germany, an art school founded in 1919 that succeeded as a significant force in the following decade and was often influenced by Constructivist refugees from Russia and De Stijl artists. Constructivism and the Bauhaus were especially influenced by the period's belief that industry and machines would create a better world, and the inter-war era, which indeed was dominated by tremendous technological advances, is often referred to as "The Machine Age."

Russian Constructivism: Productivism and Utilitarianism

The most direct connection between abstract art and radical politics came in the revolutionary society that developed in Russia. There, before and after the October Revolution of 1917, artists committed themselves to developing new art forms that they hoped would bring about a new utopian society. Building on the innovations of Malevich's Suprematism (see page 966), several movements followed, each attempting to put art at the service of the new revolutionary society.

VLADIMIR TATLIN As Malevich was developing his Suprematist painting in Moscow, a fellow Russian, Vladimir Tatlin (1885–1953), was working in Berlin and Paris. In 1914, Tatlin visited Picasso's Paris studio and saw his constructions (see page 954). Upon returning to Russia, he then made his own constructed reliefs (fig. 28.23), which he called "counterreliefs," for which he used cardboard, wood, and metal covered with a variety of materials, including glazes, glass, and plaster. Similar to Russian icons and Malevich's Black Square (see fig. 27.23), some of the counterreliefs spanned corners, in effect using the space of the room to create a small environment. Unlike Picasso's constructions, which were generally musical instruments, Tatlin's were nonobjective, that is, they were totally abstract like Malevich's paintings, and not meant to evoke real objects. Following Tatlin's lead, other Russian sculptors began making abstract sculpture from geometric forms, a movement that in 1922 was formally called Constructivism.

With the Bolshevik Revolution in 1917, Tatlin's attitude toward his art changed. He embraced Communism and focused his efforts on supporting the party's goal of creating a utopian society. He worked for the Soviet Education Commissariat and turned his attention to architecture and engineering. A major component of his teachings was his passionate belief in the utility of modern machinery, the democratic quality of mass-produced objects, and the efficiency of industrial materials. Technological modernity was the future and the new religion, and industrial efficiency and materials had to be incorporated into art, design, and architecture, where they would produce a new, better, classless world. In other words, the social revolution had to be complemented with an aesthetic revolution. According to Tatlin's theory

28.23 Vladimir Tatlin, *Corner Counterrelief.* 1915. Mixed media, $31\frac{1}{2} \times 59 \times 29\frac{1}{2}$ " (80 × 150 × 75 cm). Presumed destroyed

28.24 Vladimir Tatlin, *Project for "Monument to the Third International.*" 1919–20. Wood, iron, and glass, height 20' (6.10 m). Destroyed; contemporary photograph

of Constructivist Productivism, everything—from appliances to clothing, from living spaces to theaters—now had to be machinelike and streamlined. Form must follow function and objects were to be stripped of all ornamentation, which was associated with bourgeois values and aristocratic ostentation.

Tatlin's most famous work is his *Project for "Monument to the Third International*" (fig. **28.24**), begun in 1919 and exhibited in Petrograd (St. Petersburg) and Moscow in December 1920. The project was actually a model for a building—which was never built—that was supposed to be 1,300 feet high, which would have made it the tallest structure in the world at that time. It was to have a metal spiral frame tilted at an angle and encompassing a glass cube, cylinder, and cone. These steel and glass units, housing conference and meeting rooms, were to revolve, making a complete revolution once a year, month, and day, respectively. The industrial materials of steel and glass and the dynamic, kinetic nature of the work symbolized the new Machine Age and the dynamism of the Bolshevik Revolution. The tower was to function as a propaganda center for the Communist Third

28.25 Alexander Rodchenko, *Advertisement: "Books!"* 1925. Rodchenko Archive, Moscow, Russia

International, an organization devoted to world revolution, and its rotating, ascending spiral symbolized the aspirations of Communism.

Following Tatlin's dictum of "Art into Life," many artists, at least temporarily if not completely, gave up making conventional art in order to design functional objects that would help create the great classless utopia. Both Aleksandr Rodchenko (1891-1956) and his wife Varvara Fedorovna Stepanova (1894-1958) fall into this category. In the early 1920s, Rodchenko stopped making Suprematist paintings and Constructivist assemblages to focus on graphic design, as seen here in a poster promoting literacy (fig. 28.25). We are far removed from the organic and human Art Nouveau posters of Toulouse-Lautrec (see fig. 26.8), for example. Instead, a bold mechanical geometry prevails, with a nearly spaceless image pressed to the surface. Even the letters are austere and geometric. Bold color creates an energy that is reinforced by the design, where the word "Books," for example, is shaped like a megaphone that emits the phrase "In All Spheres of Knowledge." At the time, Stepanova was the designer for a Moscow textile factory. In the sportswear reproduced here (fig. 28.26), we again see bright colors and a simple yet energetic machinelike geometry. There is no ornamentation or reference to the past, nothing that could be associated with any class, time period, ethnic type, or region. Confronted with the problem of creating a new society, the Constructivist designers invented a new graphic language, one that was distinctly modern, utilitarian, and classless.

De Stijl and Universal Order

In 1917 in Amsterdam, Piet Mondrian (1872–1944), with painter Theo van Doesburg (1883–1931) and several other artists and architects, founded a movement called De Stijl (The Style). Architect Gerrit Rietveld (1888–1964) joined the group in 1919. Though not backed by a revolutionary government, as were the

28.26 Varvara Fedorovna Stepanova, *Design for Sportswear*. 1923. Gouache and ink on paper, $11\frac{7}{8} \times 8\frac{1}{2}$ " (30.2 × 21.7 cm). Collection Alexander Lavrentiev

Russian artists, their goal was every bit as radical and utopian, for De Stijl artists sought to create, through geometric abstraction, total environments that were so perfect they embodied a universal harmony. Unlike their Russian counterparts, their mission was literally spiritual. Driven by Mondrian and Van Doesburg's intense commitment to Theosophy, De Stijl artists, as did the Communists, sought a universal order that would make nationalism obsolete. They called their style the International Style, applying it most often to a new architecture of glass and steel that was modern, pure, and universal, with no national identification.

PIET MONDRIAN In the magazine *De Stijl*, the group's publication, the artist Piet Mondrian (1872–1944) presented his theory of art in a series of articles. (See *Primary Source*, page 1007.) His philosophy was based on Theosophy (see page 946), which he was

28.27 Piet Mondrian, *Composition No.II/Composition I//* Composition en Rouge, Bleu et Jaune (Composition with Red, Blue, and Yellow). 1930. Oil on canvas, 20¹/₈ × 20¹/₈" (51 × 51 cm). The Fukuoka City Bank Ltd., Japan. © 2009 Mondrian/Holtzman Trust, c/o HCR International, Warrenton, Virginia, USA

interested in before his move to Paris in 1911. After returning to neutral Amsterdam during the Great War, he was further influenced by the ideas of mystical lay philosopher and close acquaintance M. H. J. Schoenmaekers and especially Schoenmaekers's book New Image of the World, the only book other than his own publications in his library. Schoenmaekers argued that there was an underlying mathematical structure to the universe that constituted true reality. He believed that an artist could access and present this structure through rational manipulations of geometric forms. Mondrian developed an art based on such geometry and, using Schoenmaekers's term, he called it Neo-Plasticism, meaning "New Plasticism." By "plastic" in painting, he meant that the world of the painting had a plastic, or three-dimensional, reality of its own that corresponded to the harmonious plastic reality of the universe. In other words, he sought to replicate in his art the unseen underlying structure of the cosmos.

Beginning in 1917, Mondrian struggled to achieve this using total geometric abstraction, and only succeeded in his efforts upon returning to Paris in late 1919. After establishing his style, he pretty much retained it for the rest of his life, as seen in *Composition en Rouge, Bleu et Jaune* (fig. **28.27**) of 1930. His paintings, which are always asymmetrical, are remarkable for their perfect harmony. Mondrian very precisely gives every element in his painting equal weight. Each line and rectangle in this square canvas is assigned its own identity. Every line exists in its own right, not as a means of defining the color rectangles. (The thickness of the lines often varies in his paintings, a function of individual identity.) Each component in the painting sits on the same plane on the surface—there is no foreground or background, no one object sitting on top of another. Despite this perfectly interlocking surface, the painting has a feeling of tremendous space, even of infinity, largely due to the rectangles expanding off the edges of the canvas. Space and mass have merged into a harmonious whole in what Mondrian called "dynamic equilibrium," where everything is energized yet balanced. Mondrian has attempted to capture the complexity of the universe—the individuality of its infinite components and the harmony and spiritual sameness that holds everything together.

Mondrian did endless variations of these motifs. Even the color did not change, since these elementary hues, from which all colors are derived, are symbolic of the building blocks of the cosmos. But in principle, painting was not the end product of Mondrian's aesthetic program. He considered it just a stop-gap measure until perfect abstract environments of architecture, furniture, and objects embodying all of these same principles could be achieved. Until then, the world needed his painting.

GERRIT RIETVELD Mondrian's De Stijl colleagues sought to implement his theories in architecture and interior design. In 1917, Gerrit Rietveld (1888–1964), a furniture maker who became a self-taught architect, designed the "Red-Blue" chair (fig. **28.28**), representing the first attempt to apply Neo-Plasticism to the

28.28 Gerrit Rietveld. Interior of Schröder House, with "Red-Blue" chair, Utrecht, Holland. 1924

Piet Mondrian (1872–1944)

From "Natural Reality and Abstract Reality" (1919)

This is an excerpt from an essay originally published in the magazine De Stijl in 1919. Here Mondrian explains how Neo-Plastic painting, using an abstract vocabulary, captures universal harmony.

The cultivated man of today is gradually turning away from natural things, and his life is becoming more and more abstract. Natural (external) things become more and more automatic, and we observe that our vital attention fastens more and more on internal things. The life of the truly modern man is neither purely materialistic nor purely emotional. It manifests itself rather as a more autonomous life of the human mind becoming conscious of itself.

Natural man—although a unity of body, mind and soul—exhibits a changed consciousness: every expression of his life has today a different aspect, that is, an aspect more positively abstract.

It is the same with art. Art will become the product of another duality in man: the product of a cultivated externality and of an inwardness deepened and more conscious. As a pure representation of the human mind, art will express itself in an aesthetically purified, that is to say, abstract form. The truly modern artist is aware of abstraction in an emotion of beauty; he is conscious of the fact that the emotion of beauty is cosmic, universal. This conscious recognition has for its corollary an abstract plasticism, for man adheres only to what is universal.

The new plastic idea cannot, therefore, take the form of a natural or concrete representation, although the latter does always indicate the universal to a degree, or at least conceals it within. This new plastic idea will ignore the particulars of appearance, that is to say, natural form and color. On the contrary, it should find its expression in the abstraction of form and color, that is to say, in the straight line and the clearly defined primary color. ...

We find that in nature all relations are dominated by a single primoridal relation, which is defined by the opposition of two extremes. Abstract plasticism represents this primordial relation in a precise manner by means of the two positions which form the right angle. This positional relation is the most balanced of all, since it expresses in a perfect harmony the relation between two extremes, and contains all other relations.

If we conceive these two extremes as manifestations of interiority and exteriority, we will find that in the new plasticism the tie uniting mind and life is not broken; thus, far from considering it a negation of truly living life we shall see a reconciliation of the matter-mind dualism.

Source: De Stijl, Vol. I, 1919

28.29 Gerrit Rietveld. Schröder House, Utrecht, Holland. 1924

decorative arts. One of the more uncomfortable chairs ever made, its emphasis was on spiritual aesthetics, employing flat planes and primary colors to implement Mondrian's dynamic equilibrium. Once the De Stijl members discovered and understood Frank Lloyd Wright (see page 934), whose works were published and available in Europe in 1911, they were able to apply architectural solutions to the theoretical ideas of Neo-Plasticism. They recognized that Wright had destroyed "the box," and declared "the new architecture will be anticubic." Combining the color and floating planes of Mondrian and the fluid spaces of Wright, Rietveld produced the definitive De Stijl building in 1924, the Schröder House in Utrecht (fig. 28.29), which was built onto the end of existing row houses. On the façade, we can find Mondrian's "floating" rectangles and lines. Even the Wright-like cantilevered roof appears to float. The interior (see fig. 28.28) is designed according to the same principles, with wall-to-ceiling sliding panels allowing for a restructuring of the space. Both inside and out, the Schröder House is a three-dimensional Mondrian painting-ethereal, buoyant, and harmonious, embodying dynamic equilibrium.

The Bauhaus: Creating the "New Man"

As we have seen, most Dadaists, Surrealists, and abstract artists were socialists or Communists who believed the Bolshevik Revolution in Russia would save the world from bourgeois materialism and decadence and would establish a worldwide utopian society. Left-wing artists flocked to Berlin in 1922 to see the first Russian Art Exhibition, which presented the Constructivists for the first time in the West. Twice more that year, the avant-garde held conferences in Germany, attempting to commit to a social program that would put art at the service of restructuring society. All of these attempts came to naught. Instead, it was the Bauhaus, an art and design school, that gradually emerged as the strongest center for advocating social progress through art.

The Bauhaus was founded in Weimar, Germany, in 1919 by the great Modernist architect Walter Gropius (see page 978). In many respects, the Bauhaus School was the embodiment of Muthesius's German Werkbund (see page 977), since the goal of the workshops was to design modern high-quality productionline products. Its guiding principle, however, was more utopian and less commercial, for the Bauhaus (meaning House of Building) was dedicated to the creation of utilitarian design for "the new man" through the marriage of art and technology. The school was formed by the merger of two Weimar arts and crafts schools, and designed to combine the fine and applied arts, giving each equal weight, as had the earlier Secessionist movements (see page 922). The artists were called artisan/craftspeople, and their mission was to create an abstract environment of the most progressive modernity. Their design ethic was based on "the living environment of machines and vehicles." Only "primary forms and colors" could be used, all in the service of creating "standard types for all practical commodities of everyday use as a social necessity." Like De Stijl, this was a philosophy oriented toward environments, not just painting and sculpture, and the Bauhaus is

often more associated with the work that came out of the textile, metal, and ceramic workshops, such as Marcel Breuer's 1927 aluminum tubular chairs and Anni Albers's abstract textiles, than with the paintings of Klee, Kandinsky, and Josef Albers, who also taught at the school.

MARCEL BREUER We can see the Bauhaus machine aesthetic at work in the living room of a Gropius house built in 1927 for a Werkbund housing development in Stuttgart (fig. 28.30). The furniture and lighting were designed by Marcel Breuer (1902–1981), a former Bauhaus student who became a faculty member in 1925, heading the furniture workshop. All of Breuer's objects are geometric, made of modern materials, and easily mass-produced. On the far right is perhaps his most famous product, the "Wassily" armchair, made of polished, nickel-plated tubular steel and cotton fabric. In its planarity, Breuer was clearly influenced by the Rietveld "Red-Blue" chair (which Van Doesburg had introduced to the Bauhaus in 1921 when he taught there and Breuer was a student). But now heavy wood has been replaced by a strong but light metal tube that is geometrically structured in an airy, open pattern. The feeling that results echoes the transparency and weightlessness of Suprematist painting and Constructivist sculpture, qualities that can even be seen in Tatlin's Project for "Monument to the Third International" (see fig. 28.24). Breuer described a practical side to his design when in the product catalogue he wrote that the chair "provides a light, fully self-sprung sitting opportunity, which has the comfort of the upholstered

28.30 Walter Gropius. Two houses for the Werkbund housing development Weissenhof Settlement, Stuttgart, with furniture by Marcel Breuer. 1927

28.31 László Moholy-Nagy, *Light-Space Modulator*. 1922–30. Exhibition replica, 2006, constructed courtesy of Hattula Maholy-Nagy. Steel, plastic, wood, and other materials with electric motor, $59\frac{1}{2} \times 27\frac{1}{2} \times 27\frac{1}{2} \times 27\frac{1}{2} \times 11.1 \times 69.9 \times 69.9$ cm). Harvard Art Museum, Busch-Reisinger Museum, Hildegard von Gontard Bequest Fund, 2007.105

armchair, but with the difference that it is much lighter, handier, more hygienic."

LÁSZLÓ MOHOLY-NAGY One of the strongest advocates of Constructivism at the Bauhaus, and perhaps the most influential figure there, was the Hungarian László Moholy-Nagy (1895–1946). Gropius hired Moholy-Nagy in 1923 as head of the metal workshop, but gradually he became the school's primary theoretician, concerned particularly with light and movement. As early as 1922, he began designing Constructivist sculptures that generated light, as seen in *Light-Space Modulator* (fig. **28.31**). This machinelike construction of planes of plastic, steel, and wood was propelled in a circle by a motor and projected an ever-changing light spectacle onto its surroundings. It was used as a prop in a 1930 ballet at the Bauhaus, but Moholy-Nagy also viewed it as a tool to study light and space, hoping to uncover new applications for environmental or stage lighting.

WALTER GROPIUS Many art historians consider the crowning aesthetic achievement of the Bauhaus to be the building itself, designed by Gropius in 1925–26 when the school moved from Weimar to Dessau. The building consists of three L-shaped wings coming off a central hub: The Shop Block, a workshop wing, is shown in figure 28.32; a second wing had classrooms; and a third wing held an auditorium/theater, dining hall, and dormitory with studios. From the air, the complex looked like a Constructivist sculpture of rectangular blocks. The Bauhaus is dominated by a clearly articulated geometry. The workshop wing looks like an empty glass box, the glass curtain wall on two sides continuing around corners and flush with the stuccoed parapet above and

28.32 Walter Gropius. Shop Block, Bauhaus, Dessau, Germany. 1925–26

socle, or projecting molding underlying the wall, below. Instead of mass, we feel a weightless volume as defined by the metal and glass wall. And because the building projects over a setback half-basement, it seems to float.

Perhaps more than anything designed by De Stijl, Gropius's Bauhaus came to epitomize High Modernist architecture-the architecture that evolved out of Early Modernism (see pages 976-80) in the period between the two wars. With High Modernism, buildings became more severely geometric and so light they seemed to float. Their unadorned geometric shapes represented volume, not mass. Their walls, regardless of material, were thin membranes of a taut veneer that encased the building, and, as with the Bauhaus workshop, often this veneer was a curtain of glass, although horizontal strips of windows were generally favored by High Modernist architects. But High Modernism was more than just a style; it was a social movement predicated on a utopian socialist philosophy and a rationalist belief in progress. Life could be improved, the theory went, by creating a Machine Age environment. Ultimately, the movement was reduced to a style in 1932 when Philip Johnson and historian Henry-Russell Hitchcock organized an exhibition entitled The International Style at the newly opened Museum of Modern Art in New York. Their concern was with the look of the architecture, not its social premises. The exhibition brought the style to the attention of Americans, and resulted in the label "International Style," coined by De Stijl, being used to describe High Modernist architecture.

LUDWIG MIES VAN DER ROHE In 1930, architect Ludwig Mies van der Rohe (1886–1969) became the last director of the Bauhaus, which closed in 1933. In the 1920s, Mies had been at the center of the Berlin avant-garde. A student of Peter Behrens, he became a leading Modernist, and in 1927 organized the experimental Weissenhof Estate exhibition in Stuttgart, where leading architects were invited to build inexpensive but quality housing for workers. At this point he was converted to High Modernism, or the International Style, and was heavily influenced by the floating planes of De Stijl and the complex spaces of Wright. His motto, however, was "Less is more," and his architecture is characterized by a severe geometry and simplicity. Nonetheless, his buildings never seem austere; they invariably have elegant proportions and a sense of refinement that makes them seem rich and lush. When budget allowed, he augmented this refinement by using luxurious materials, such as expensive marble and travertine, bronze, chrome, and tinted glass.

We can see these qualities in his German Pavilion (fig. 28.33), designed for the 1929 Barcelona Exposition and dismantled after the fair closed. (A reconstruction exists in the same site today.) The pavilion itself was the German exhibit, and the building simply consists of spaces with no specific uses attached to them. There is nothing overtly innovative here; the overlapping horizontal and vertical planes, the interlocking open-form space, and canterlevering had been used previously in the work of Wright and the De Stijl architects. Mies's innovation is subtle, and it resides in its simplicity of style. Geometry is everywhere. The pavilion sits on an enormous rectangular platform of beautiful travertine, and is partially enclosed by rectangular walls of travertine or Tinian marble. At either end, the platform is not covered and there is an asymmetrically placed but perfectly balanced rectangular pool lined with lush-looking black glass. The cantilevered flat roof is supported by a grid of eight slender piers, each a chrome x, between which are five partition walls, two in onyx, and the three others made of different kinds of glass-clear, frosted, and green-and encased in chrome mullions (fig. 28.34). Using a minimal vocabulary, Mies created a sumptuous, elegant feast for the eye. Even the cantilevered chair he designed for the pavilion, known as the "Barcelona" chair and seen in figure 28.34, is simultaneously simple and posh, and, in contrast to the Rietveld "Red-Blue" chair, exceptionally comfortable.

28.33 Ludwig Mies van der Rohe. German Pavilion, 1929. Guggenheim International Exposition, Barcelona

28.34 Ludwig Mies van der Rohe. Interior of the German Pavilion, with Barcelona Chairs, 1929. Guggenheim International Exposition, Barcelona

The Machine Aesthetic in Paris

The machine aesthetic and the utopian dream that accompanied it also made their way to Paris, where they found a rather different voice in the architecture of Charles-Édouard Jeanneret, called Le Corbusier (1886–1965). While developing his radical architectural theories, Le Corbusier also practiced as a painter, working under his given name Jeanneret. He created a style of painting that he called Purism, which reflected his belief in the supremacy of a machine aesthetic that embodied a Classical spirit. Purism influenced the French Cubist Fernand Léger, who was already well disposed toward glorifying the efficiency and purity of modern technology. Unlike Moscow, Amsterdam, and Dessau, Paris had no art schools or major artistic movements pushing for a utopian vision. Instead, the cause there was undertaken by individuals.

LE CORBUSIER'S IDEAL HOME Le Corbusier was Swiss, and led a rather peripatetic life prior to settling in Paris in the 1910s. In 1907, in Lyon, France, he met architect Tony Garnier, who had developed an ideal industrial city, the Cité Industrielle, which influenced Le Corbusier to think in terms of socialist utopian architecture and the creation of an easily reproducible architectural type that would provide superior housing for every-one. The following year in Paris, he worked part time for Auguste

Perret, the architect responsible for popularizing ferroconcrete steel-reinforced concrete—as an architectural material. Most important, however, he demonstrated, as Max Berg had in his Breslau Jahrhunderthalle in 1912–13 (see fig. 27.39), the practicality of ferroconcrete: It is inexpensive, adaptable, easy to use, and very strong, combining the tensile strength of steel with the compressive resistance of concrete. (See *Materials and Techniques*, page 1013.) It is the medium Le Corbusier would adopt for most of his buildings. The last major influence on Le Corbusier was his experience in 1910 working in Peter Behrens's office in Berlin, where his colleagues included Walter Gropius and Mies van der Rohe. Here, he worked first hand with the German avant-garde architects who would be responsible for developing the International Style, and even then he was talking about creating a machine-based, easily reproduced architecture.

In 1922, Le Corbusier opened an architectural firm with his cousin Pierre Jeanneret, and over the course of the next two decades, he designed a series of houses that allowed him to develop and implement his theories of the ideal house, one that could serve as a prototype for all homes. (See *Primary Source*, page 1012.) He called his first type, developed in 1914, the Dom-Ino, because the house consisted of concrete floors with ceilings that sat on concrete columns arranged in a grid pattern that resembled the dots on a domino. By 1923, he had developed the

PRIMARY SOURCE

Le Corbusier (1886–1965)

From Towards a New Architecture (1923)

First published in 1923, Towards a New Architecture codified ideas that were being widely discussed among architects, and it became the first manifesto of the International Style. The following excerpts are from the opening argument.

The Architect, by his arrangement of forms, realizes an order which is a pure creation of his spirit; by forms and shapes he affects our senses to an acute degree and provokes plastic emotions; by the relationships which he creates he wakes profound echoes in us, he gives us the measure of an order which we feel to be in accordance with that of our world, he determines the various movements of our heart and of our understanding; it is then that we experience the sense of beauty. Primary forms are beautiful forms because they can be clearly appreciated.

The great problems of modern construction must have a geometrical solution. ...

The house is a machine for living in.

Standards are a matter of logic, analysis, and minute study. ...

Man looks at the creation of architecture with his eyes, which are 5 feet 6 inches from the ground.

Industry, overwhelming us like a flood which rolls on towards its destined ends, has furnished us with new tools adapted to this new epoch, animated by the new spirit.

The problem of the house is a problem of the epoch.

If we eliminate from our hearts and minds all dead concepts in regard to the house, and look at the question from a critical and objective point of view, we shall arrive at the "House-Machine," the massproduction house, healthy (and morally so, too) and beautiful. ...

Source: Le Corbusier, Towards a New Architecture (New York: Dover, 1986)

principles for his ideal home, which he published in an article entitled "Five Points of a New Architecture." His five points were the following: (1) no ground floor, with the house raised on columns called **pilotis**; (2) a flat roof, which would be used as a garden terrace; (3) an open floor plan, with partitions slotted between supports; (4) free composition of the exterior curtain walls; and (5) preferably ribbon (horizontal) windows. The raised house allowed for privacy and light and made the outdoors accessible by putting a garden on the roof. Much later, Le Corbusier remarked that "a house is a machine for living in," which suggested—wrongly—to many critics that he advocated a brutal functionalism that was not concerned with beauty and comfort. In fact, Le Corbusier wanted to create a Classical purity based on geometry and a machine-age look. "Architecture is the masterly, correct, and magnificent play of masses brought together in light," he wrote. "Cubes, cones, cylinders, and pyramids are the primary forms which light reveals to advantage." Within this aesthetic, however, his emphasis was on the human being and "living." Machine Age values and technology were meant to serve humans, and consequently his houses, using the latest technology, would have a Machine Age look and efficiency. And they would be filled with light.

The 1928–29 Villa Savoye (fig. **28.35**) in Poissy-sur-Seine, outside Paris, is Le Corbusier's best-known house, and here we can see most of the elements called for in his "Five Points": the pilotis, the raised living space, the ribbon windows, and the flat-roof

28.35 Le Corbusier. Villa Savoye, Poissy-sur-Seine, France. 1928–29

Reinforced Concrete

Reinforced concrete became one of the most popular building mater-Rials in the twentieth century. Concrete is a cement mixture of sand, limestone, and water that contains small stones or other (generally solid) small objects. While its history dates to 5600 BCE in the Balkans, the Romans were the first to use it extensively, starting in the second century BCE (see pages 186-87). Romans builders used concrete for bridges, docks, pavements, and aqueducts, but it was also used for homes and major civic buildings, such as the Pantheon (see fig. 7.23).

Concrete virtually disappeared from architecture after the Fall of Rome. Its revival began in 1824, when an English mason, Joseph Aspdin, patented an improved cement. Because it resembled a natural stone found on the Isle of Portland, the new material was called Portland cement. To make it, Aspdin heated clay and limestone to especially high temperatures, a process still used today. While concrete is fire-resistant and can stand extremely high compression, or

François Hennebique. System for reinforced concrete. 1892 (After Curtis)

engineer François Hennebique designed a ferroconcrete post-and-slab construction where each floor/ceiling was an integral part of the structure, not a separate element lying on top of a supporting frame (see

Auguste Perret. Notre Dame, Le Raincy, France. 1923-24

evenly applied weight, it does not have much tensile strength. That is, it does not hold up under unevenly applied stresses. To solve the problem, engineers reinforced the concrete by embedding iron rods within it. Steel rods replaced iron rods in the late nineteenth century. (A form of steel first appeared in the second half of the nineteenth century, although modern steel was not invented until toward the end of the century.) Iron and concrete were a perfect match, since the materials complemented each other. Concrete protected the iron, which otherwise melted and corroded easily, while iron provided the tensile strength that concrete lacked.

Almost simultaneously in England and France, inventors began to patent ferroconcrete, as steel-reinforced concrete is called. A British plasterer patented concrete floors and roofs made with iron bars and wire rope, while a French gardener took out a patent on steelreinforced concrete planters, eventually designing guardrails, posts, and beams as well. But it was not until the 1890s that the French fig.). Hennebrique's engineering was applied largely to industrial buildings and simply imitated traditional post-andlintel styles.

Credit for introducing ferroconcrete to "high" architecture generally goes to the French architect Auguste Perret, who designed apartment buildings and parking garages using steel-reinforced concrete in the opening decades of the twentieth century. One of his most famous buildings is the Raincy Church, outside Paris, built in 1922 (see fig.), which conceptually uses the Rationalism we saw in Soufflot's Saint-Geneviève (see fig. 23.19) while aspiring to implement the lightness and airiness of a Gothic cathedral. Max Berg's Jahrhunderthalle (see fig. 27.39) in Breslau, built in 1912-13, also played a major role in popularizing ferroconcrete. Ultimately, it

became the principal medium for Le Corbusier and a favorite for Frank Lloyd Wright (see page 934).

In addition to its strength, ferroconcrete is attractive because it is inexpensive. The concrete component is readily available. The steel, the most expensive and rare component, makes up only 1 to 6 percent of the structure. By 1904, ferroconcrete was being used in skyscrapers; the first use was in the Ingalls Building in Cincinnati, which was 16 stories and rose to 210 feet. By 1962, it was being used in modern high-rises, including the 60-story twin towers of Marina City in Chicago. From 1998 to 2003, the largest building in the world was the ferroconcrete Petronas Towers in Kuala Lampur, Malaysia, designed by Cesar Pelli, who is based in Hartford, Connecticut. Rising 88 stories and 1,483 feet, the building would have been prohibitively expensive without ferroconcrete, since Malaysia does not manufacture steel. Like much of the world, however, Malaysia readily produces high-quality concrete.

28.36 Le Corbusier. Interior of the Villa Savoye, Poissy-sur-Seine, France. 1928–29

terrace, which is protected behind the enormous cylindrical windscreens that look like oceanliner smokestacks. The main floor, the second, has an open-space plan using partition walls, and it faces into a court (fig. **28.36**), from which a ramp leads up to the roof. Everywhere we look we see a beautiful classicizing geometry, the building blocks of Le Corbusier's design aesthetic. The building is a perfect square box precisely defined by its taut skin of concrete. The pilotis are cylinders, and the windbreakers are enormous arcs. Obscured by the shadow in figure 28.35 is another geometric curve on the ground floor, which encloses the garage and servants' quarters. Like the Bauhaus and the Schröder House, the villa appears light, virtually floating on its pilotis.

But as abstract and futuristic as the house may seem, it resonates with the past. We can project onto it the classic, white stuccoed Mediterranean house, oriented around a central court, that sits on a hill overlooking the sea. Le Corbusier also described his villa as a *jardin suspendu*, a hanging garden reflecting the mythical gardens of Babylon. The building also recalls Palladio in the perfection of the square, while the colonnade of pilotis echoes a Doric temple. The ramps (there is a circular staircase as well) linking the floors have reminded scholars of the great entrance ramps of Mycenae. In one of the great statements of High Modernism, Le Corbusier presents the Modernist, Machine Age update of the great Greek temple perched on a hill, overlooking nature, and permeated with light and air.

PURISM AND FERNAND LÉGER In 1917, Le Corbusier met the painter Amédée Ozenfant (1886–1966), and together they developed a theory called Purism, which in essence was a

Neo-Platonic concept that reduced all artistic expression to an abstract Classical purity reflecting a machine aesthetic. Clean line, pure forms, and mathematical clarity were highly valued. In 1918, they published an essay entitled "After Cubism" that railed against the distortions of the Cubist style, and in 1920 they published another essay, "Purism," which gave a label to their theory. As stated before, Le Corbusier was a painter as well. Working and writing under his given name Charles-Édouard Jeanneret, and like his colleague, Ozenfant, he made mostly still lifes, which used the multiple perspectives of Cubism but reduced objects to geometric mechanomorphic forms that run parallel to the picture plane.

The Cubist Fernand Léger (1881–1955) became an adherent of Purism, although he never defined himself as such. He was certainly predisposed to its ideas, for in the early 1910s, he had made abstract, mechanical-looking Cubist figures, and was an outspoken socialist and champion of modernity and technological advancement. In the early 1920s, however, his style reflected the machinelike geometry and Classicism advocated by Jeanneret and Ozenfant, as can be seen in Three Women (Le Grand Déjeuner) (fig. 28.37) of 1921. His almost identical-looking nudes are constructed of circles and cylinders. Their body parts, such as hair and faces, are so similar they could be interchangeable. Virtually all of the objects look machine-made, and, as with the figures, they are reduced to cubes, cones, cylinders, and pyramids. Organic and man-made elements are virtually indistinguishable, and both types are ordered in a tight grid of horizontal and verticals and run parallel to the picture plane. Color is also kept to essentials-the primary and binaries-the building blocks of the

28.37 Fernand Léger, *Three Women* (*Le Grand Déjeuner*). 1921. Oil on canvas,
6'¼" × 8'3" (1.8 × 2.5 m). Museum of Modern Art, New York. Mrs Simon Guggenheim Fund.
189.1942

color spectrum. Léger has taken the Classical theme of the monumental nude (although here we seem to be in a brothel) and updated it by placing it in a contemporary world of technological harmony and perfection, in effect telling us, as Seurat had 30 years earlier (see page 908), that the new Classicism and world order are based on the machine and science.

ART IN AMERICA: MODERNITY, SPIRITUALITY, AND REGIONALISM

Perhaps more than Europe, the United States could embrace the machine as the emblem of progress, for after World War I, America was the undisputed technological world leader. In contrast to the European avant-garde that sought a classless, nationless world, Americans were preoccupied with national identity. And generally they did not have a utopian vision. Instead they viewed skyscrapers, factories, and machines as symbols of the nation's technological superiority. But not everyone embraced modernity. As the economy boomed in the postwar years, culminating in the dizzying exuberance of the Roaring Twenties, many artists rejected materialism and looked to the spiritual. While some artists turned to nature in search of universal truths, others sought strength in old-fashioned American values that could be found in the American heartland, especially in the mythic conservative lifestyle of its hearty, hard-working, Godfearing farmers.

Still others responded to the poverty and social discontent that coexisted with the boom years. The period was marked by the oppression of labor, violent labor strikes, and anarchist threats. Racism escalated in the South, led by the dramatic growth of the Ku Klux Klan and increased lynchings of black men. The Twentieth Amendment granted women the right to vote in 1920, but it had no impact on granting social and economic parity, as women continued to be restricted to "women's jobs" and less pay. The Great Depression exacerbated these injustices, resulting in the rise in the 1930s of a representational art called Social Realism.

The City and Industry

Arriving in New York harbor for the first time in 1915, Marcel Duchamp marveled at the towering skyscrapers and pronounced them the epitome of modernity. He saw in America the future of art. The skyscraper and modern industry did indeed become the emblems of America, replacing landscape, which had dominated painting in the previous century. Skyscrapers were symbols of modernity, industry, and commerce, and thus of the country's technological and financial superiority, for the United States entered the century as the wealthiest and most modern country in the world. World War I fueled the economy, ushering in an era of unprecedented consumerism and materialism. Known as the Roaring Twenties and the Jazz Age, the 1920s were dominated by the culture of the city, for by 1920 more people lived in cities than in the countryside.

The symbol of the nation was New York, dominated by skyscrapers. Beginning in the late 1910s, these "cathedrals of capitalism" or of "commerce" became the favorite subject for painters and photographers—and for sculptors and designers—who presented the icon in all its technological splendor. Skyscrapers were shown soaring toward the heavens without a hint of the streets or humanity below. Bridges, factories, dams, refineries—anything that demonstrated America's advanced modernity—were also transformed into monuments as grand as the pyramids of Egypt and as sacred as the Gothic cathedrals of France. JOSEPH STELLA Perhaps the greatest single visual icon of the city was made by the Italian immigrant Joseph Stella (1877–1946). Entitled The Voice of the City (New York Interpreted) (fig. 28.38) and completed in 1922, it is an 8-foot-high, five-panel work that features on its center panel an abstraction of the city's towers, with the famous Flatiron building in the foreground, surrounded by both actual and fictitious buildings. The panels flanking the center panel represent the "Great White Way," Broadway, which has been reduced to an abstraction of color and light. The far-left panel presents the harbor on the Hudson River on the west side of lower Manhattan, while the right panel shows the Brooklyn Bridge on the east side. Every image features the technological wonders of Manhattan. We see communication towers, air-venting systems, and elevated trains in the harbor picture. The Great White Way panels present the dazzling illumination of Times Square at night, which at the time had no equivalent anywhere else in the world. In effect, these two panels are a homage to electricity and the energy of the city. And even 35 years after opening, the Brooklyn Bridge still remained one of the world's great feats of engineering.

Stella came to America in 1896, thus witnessing the rise of modern New York City at the turn of the century. He temporarily returned to Italy to study in 1910, where he met the Futurists (see pages 964–66). Through the Stieglitz gallery and his friendship with Duchamp and Man Ray, among others, he kept in touch with European trends, with Cubism becoming his primary artistic language in the 1910s. The Great White Way panels especially reflect the tenets of Futurism, for here we see the sound waves and Mach-like indications of motion that we saw in Boccioni's States of Mind I (see fig. 27.20). Their dizzying kaleidoscope of color powerfully captures the intense visual experience of Times Square at night. But in the skyscraper and Brooklyn Bridge panels, Stella is not only representational, he is iconic, centering his motifs and transforming them into emblems of modernity. His palette is deeply saturated, and color is often encased in heavy black-line drawing, in effect transforming his image into a medieval stained-glass window. He reinforces the religious motif by adding a predella at the bottom (see page 525), which itemizes the different tunnels and utility tubes running beneath the city. In effect, Stella is declaring technology and modernity the religion of the twentieth century.

PAUL STRAND Photography, it turns out, was especially well suited for capturing the triumphs of the Machine Age. However, the first photographs of modern New York, such as Alfred Stieglitz's *The City of Ambition* (see fig. 26.45), romanticized the metropolis by immersing it in a soft pictorial haze. A breakthrough occurred when a young New Yorker, Paul Strand (1890–1976), from 1915 to 1917 made a large body of work of

28.38 Joseph Stella, *The Voice of the City (New York Interpreted)*. 1920–22. Oil and tempera on canvas, five panels, $8'3\frac{3}{4}" \times 22'6"$ (2.53 × 6.86 m). The Newark Museum, Newark. 37.288 a–e **28.39** Paul Strand, *Wire Wheel.* 1917. Platinum print from enlarged negative, $13 \times 10^{1}/4^{"}$ (33.1 × 26.1 cm). George Eastman House

sharply focused, high-contrast photographs. Stieglitz immediately recognized their importance and showed a selection of them at "291." *Wire Wheel* (fig. **28.39**) is from this period. Its abstracted subject is a Model T Ford, an icon of the Machine Age since it marked the advent of the assembly line. The picture rejects the "painterliness" of turn-of-the-century pictorial photography. In its place is a new compositional style based on the Cubism that Strand saw displayed at Stieglitz's "291." By taking a close-up of the car, Strand created a skewed perspective and tight cropping, resulting in a difficult-to-read image with a flattened and complicated space.

In 1920, Strand collaborated with painter/photographer Charles Sheeler (1883–1965) to make a film intended to capture the energy and grandeur of New York. Entitled *Manhatta (New York the Magnificent)* (see <u>www.myartslab.com</u>), it opens with commuters arriving by ferry in lower Manhattan, spilling off the boat in teeming masses, and swarming through the financial district on their way to work. At the end of the film, the crowds get back on the boat at sunset. Rapid editing, vertiginous shots

28.40 Paul Strand and Charles Sheeler. Still from the film *Manhatta* (*New York the Magnificent*). 1920. Black-and-white film, no sound, 10 minutes. Frame enlargement from 2008 2k digital restoration by Lowry Digital

28.41 Margaret Bourke-White *Fort Peck Dam, Montana*. 1936. Time-Life, Inc.

taken from the top of skyscrapers (fig. **28.40**), raking angles, and sharp value contrasts—all simulating a Cubist fracturing—are among the formalist devices that give this movie a sense of surging energy and constant movement designed to capture the rapid pace of modernity and the powerful current of the urban experience. Interspersed throughout the film are fragments of Walt Whitman's 1860/1881 poem *Mannahatta* which proclaims the greatness, energy, and might of New York.

MARGARET BOURKE-WHITE Strand's hard-edged aesthetic transformed photography, not only in America, but eventually throughout the world. His style was especially appropriate for technological and industrial images, reinforcing the machinemade precision of the subject. Photojournalist Margaret Bourke-White especially embraced this new aesthetic and was drawn to technological imagery, especially machines, airplanes, and dirigibles. In Fort Peck Dam, Montana (fig. 28.41), she presents a symbol of American technology. The picture was the cover image for the very first issue of Life, published on November 23, 1936. The photograph's power lies in its severe austerity, which reinforces the mammoth scale of the dam, dwarfing the antlike workers below. Each of the dam's pylons is identical, looking as though they were pressed out of an enormous machine mold, and because the photograph of the dam is cropped on either side, these gigantic assembly-line towers seem endless as well. Owing to their severe monumentality, they take on the grandeur of ancient Assyrian or Egyptian monuments. Again we find an artist declaring modern technology to be the new Classicism.

CHARLES DEMUTH In his 1927 painting My Egypt (fig. 28.42), depicting contemporary grain elevators near his native Lancaster, Pennsylvania, Charles Demuth (1883–1935) similarly transformed American modernity into a Classical icon. Demuth had studied in Paris from 1912 to 1914, absorbing European Modernism, and by the 1920s he was traveling in the most sophisticated artistic circles and showing with Alfred Stieglitz. His work is quite varied in style, even in a given period, and here we see him working in the American counterpart of Purism, a style called Precisionism. In the 1920s, a group of American artists, including Demuth, developed a look that had the hard-edged geometric quality of Cubism but was far more representational. It came to be called Precisionism not only because of its precise geometry and drawing, but also because it seemed to capture the precision of mechanization and industry, which was often its subject matter. Brushwork was meticulous, and at one point these artists, who rarely showed together and did not think of themselves as a group, were called Immaculates.

At first glance, *My Egypt* seems quite Cubist. But the physical integrity of the grain elevators is barely compromised, and what seems like Cubist fracturing are mysterious, almost mystical, beams of light that only slightly distort the objects but quite successfully invest the building with a brute power, if not a mystical transcendence. The title suggests that such agricultural architecture as grain elevators were America's pyramids. The smokestack

28.42 Charles Demuth, My*Egypt.* 1927. Oil and graphite on composition board, 2'11³/₄" × 2'6" (91 × 76 cm). Whitney Museum of American Art, New York. Purchase, with Funds from Gertrude Vanderbilt Whitney. 31.172

endows the grain elevators with an industrial might, and the geometry of the ventilation ducts and massive cylinders of the storage tanks virtually transform the building itself into an efficient machine.

STUART DAVIS Among the American artists who captured the essence of the modern experience using abstraction was Stuart Davis (1892–1964). The 1913 Armory Show in New York (see page 974) converted Davis into a dedicated Modernist, and by the 1920s his work was becoming increasingly abstract. Just as Mondrian tried to find an abstract equivalent for invisible life forces, Davis wanted to create the plastic equivalent for experiencing modern life—flying in an airplane, looking down from a towering skyscraper, listening to jazz music, or riding in a speeding car, motorcycle, or train. He wanted to capture the experience

of the "new lights, speeds, and spaces which are uniquely real in our time." To do this, he used a Synthetic Cubist vocabulary, and by the 1930s his palette had become bright, limited to primary, secondary, and tertiary colors, and his forms quite jaunty and their juxtaposition raucous, as seen in *Hot Still-Scape for Six Colors—Seventh Avenue Style* (fig. **28.43**) of 1940. After describing how his colors were used like musical instruments to create a composition (Davis loved jazz and swing), he went on to describe his picture, painted in his Seventh Avenue studio: "The subject matter...is well within the experience of any modern city dweller. Fruit and flowers; kitchen utensils; fall skies; horizons; taxi cabs; radio; art exhibitions and reproductions; fast travel; Americana; movies; electric signs; dynamics of city sights and sounds; these and a thousand more are common experience and they are the basic subject matter which my picture celebrates." Embedded

28.43 Stuart Davis, Hot Still-Scape for Six Colors—Seventh Avenue Style. 1940. Oil on canvas, 36×45 " (91.4 × 113.9 cm). Photograph © Museum of Fine Arts, Boston. Gift of the William H. Lane Foundation and the M. and M. Karolik Collection, by Exchange, 1983.120

within this playful jumble of color and shapes and overlapping planes are smokestacks, seascapes, and brick walls, all reduced to funky hieroglyphic notations, which in their cartoony character seem to tap into American popular culture. In an almost indefinable way, Davis's sensitivity captures the pulse of America—its gaudy advertising, its love of the new, its jazz, its mobility, its intensity and speed, even its rootlessness.

Art Deco and the International Style

While the skyscraper became the national emblem of America's modernity, the buildings themselves were aesthetically conservative compared with European architectural developments, especially the International Style. Their distinguishing characteristic was their height. By 1900, New York had become the home of the skyscraper, taking the lead from Chicago. Buildings became progressively taller, with Cass Gilbert's 792-foot Woolworth Building dominating the cityscape in 1913. Aesthetically the new towers were very nineteenth-century, reflecting a variety of historical styles, often the Gothic. The wealth of the Roaring Twenties produced furious building campaigns, as architects competed to design the world's tallest building. Almost simultaneously, the 77story Chrysler Building and 102-story Empire State Building went up in 1930.

The Chrysler Building (fig. 28.44) designed by little-known architect William van Alen (1883–1954), is often considered the finest Art Deco skyscraper. Art Deco is a decorative-arts style

that emerged in 1925 at the Exhibition of Decorative and Industrial Art held in Paris. Like the Bauhaus school, Art Deco concepts aimed to close the gap between quality design and mass production. It was an outgrowth of Art Nouveau, but it replaced the organic forms with a Machine Age geometric and streamlined look. Unlike the Bauhaus, Art Deco had no utopian goal; it was largely bourgeois, indulging in fantasy and lavishness. It was about decorative veneer, not idealistic substance. Within the geometry and streamlining of the machine aesthetic, it absorbed a wide range of historical references, from Cubist fracturing to the zigzag patterning of Native American and Pre-Columbian design. Deco designers loved lush colors, opulent materials, and shiny surfaces. Inspired by the geometry of machines, it generally drew together a variety of angular forms, often in jagged, staccato rhythms, and set them off against organic motifs that recall Art Nouveau or Jugendstil. We can see these qualities in the Chrysler Building. The geometry is streamlined in the tapering tower with its steadily receding arches. The flamelike triangular windows create a staccato rhythm, and the entire crown is sheathed in glistening stainless steel. Gargoyles duplicating the hood ornament for the 1929 Chrysler decorate the corners.

The International Style came to America about this same time, appearing in Raymond M. Hood's 1931 McGraw-Hill Building in New York and in the 1929–32 Philadelphia Savings Fund Society Building (fig. **28.45**) by George Howe (1886–1955) and William E. Lescaze (1896–1969). That Howe and Lescaze got to design a modern building is itself quite remarkable, since there was nothing else like it in America when it was planned. The building already presented an enormous financial risk, as potential renters were becoming scarce as the Great Depression deepened. Their building has many of the characteristics of High Modernism, but its floating, cantilevered blocks with glass curtain walls were compromised when the client insisted the piers get pushed to the outer perimeter of the building, creating strong vertical accents and interfering with the horizontal windows and the thin tautness of the wall. As a result, the building seems more massive than its light, floating European counterparts (see fig. 28.32). But the Philadelphia

28.44 William van Alen. Chrysler Building, New York. 1928–30

28.45 George Howe and William E. Lescaze. Philadelphia Savings Fund Society Building, Philadelphia. 1929–32

Savings Fund Society Building reflects its functionalism well, as each of the Constructivist-like blocks that we can see on the exterior was designed to accommodate a different purpose.

Seeking the Spiritual

In the 1910s, much of the American creative community turned its attention to producing a specifically American art. Writers, musicians, artists, and poets all felt that American culture was derived from Europe; now, they would seek to discover what was unique about the American experience and try to express it in an indigenous way. For some artists, like Stella in *The Voice of the City (New York Interpreted)* and Demuth in *My Egypt*, the answer lay in American modernity. Others looked to nature, going back to the pantheistic Romanticism of the Hudson River School and its successors. Stieglitz especially became preoccupied with this issue of an American art, deciding in the 1920s to represent only American artists and naming his last gallery, which he opened in 1928, An American Place. Stieglitz himself became increasingly intolerant of modernity, initially resisting buying a radio or a car, and like so many others at the time shunning materialism to seek a spirituality in modern America. Stieglitz, who had published sections of Kandinsky's *Concerning the Spiritual in Art* (see page 959) in *Camera Work*, himself became preoccupied with visually capturing an equivalent of his emotions when confronting sublime nature.

The artists that Stieglitz showed from the early 1920s until his death in 1946 were generally, but not always, preoccupied with finding a higher meaning in life within a materialistic modern world, often focusing on nature. One was Georgia O'Keeffe, with whom Stieglitz became romantically involved in 1918 and later married.

GEORGIA O'KEEFFE When Stieglitz first showed her work in 1916, Georgia O'Keeffe (1887–1986) was making small abstract minimalist watercolors that evoked sublime landscapes. Toward 1920, her presentation of nature evolved into close-ups of flowers, as seen in *Black Iris III* (fig. **28.46**) of 1926, where the image is so magnified it virtually becomes abstract. We do not have to look far to find the pictorial source for O'Keeffe: Paul Strand. O'Keeffe briefly fell in love with the young, handsome Strand in

28.46 Georgia O'Keeffe, *Black Iris III*. 1926. Oil on canvas, $36 \times 29\%$ " (91.4 × 75.9 cm). Metropolitan Museum of Art, New York. The Alfred Stieglitz Collection, 1949

28.47 Edward Weston, *Pepper*. 1930. Gelatin silver print. Center for Creative Photography, Tucson, Arizona

1917 and was smitten as well by the power of his photography, especially the use of the close-up image. This compositional device, she wrote, forced a viewer to see flowers with the same intensity that she did. But by abstracting the close-up, O'Keeffe accomplished much more: The forms of the flowers morph into the parts of a woman's body, and the iris is redolent of female sexuality. The petals ethereally dissolve into their surroundings, seeming to become one with the rest of nature.

Partly because of Stieglitz's marketing, critics described O'Keeffe's flowers as overtly erotic and sexual, which the new loose morality of the Roaring Twenties could accommodate. This interpretation outraged O'Keeffe, who denied that her pictures were about sexuality per se. And they are not. As with the banned sexually explicit novels of her friend the English author D. H. Lawrence, her paintings were not about lust but the uncontainable surging force of nature, which includes the urge to procreate. Sexuality was portrayed as being natural, beautiful, and as essential as a flower blossoming, disseminating pollen, and reproducing. And if her wonderful organic flower, which seems to be growing before our very eyes, begins to take on the look of other objects, such as clouds, smoke, buttocks, and flesh, it only increases the sense of universal equivalence that she believed ran through all things. In this microcosm of an iris, O'Keeffe presents a macrocosm so large it encompasses the entire universe.

EDWARD WESTON Due to both Strand and O'Keeffe, the close-up became a popular device with both painters and photographers in the 1920s, and in the hands of some artists it had the same spiritual dimensions found in O'Keeffe's paintings. Pepper (fig. 28.47) by the Californian Edward Weston (1886-1958) falls into this category, as the rippling gnarled vegetable is transformed through lighting and cropping to resemble, in some places, a curled up figure (the back facing the upper right corner, buttocks to the lower right) and, in other places, breasts, arms, and so on. Weston was inspired to work with sharp-focus photography after a visit to New York in 1922, where he met Stieglitz and Strand. He then abandoned Pictorialist photography. Using a largeformat camera that allowed him to print from 4-by-5 inch or 8by-10-inch negatives, he was able to achieve rich detail and highly refined, beautiful textures. In 1932, he founded, with Ansel Adams, Imogen Cunningham, and others, a San Francisco photography group called f/64, a reference to the very small camera aperture that allowed for tremendous depth of field, and thus sharp, crisp images.

Regionalism and National Identity

While the New York avant-garde sought a national identity and spirituality using either images of modernity or compact abstract styles, a group of Midwest artists, headed by Grant Wood, Thomas Hart Benton, and John Stewart Curry, turned to "oldfashioned" representational art and regional imagery. Although trained in modern-art centers (Benton and Wood studied in Europe as well as in New York and Chicago), they generally preferred to work in the Midwest, where they came from and with which they identified.

The most famous image produced by this group is *American Gothic* (fig. **28.48**) by Grant Wood (1891–1942) of Cedar Rapids, Iowa. The picture was shown at the Art Institute of Chicago in 1930, where it caused a stir and brought Wood to national attention. It was intended as a window into the Midwest world in which the artist grew up and lived. A fictitious father and spinster daughter are presented as the God-fearing descendants of stalwart pioneers who first worked the soil. They are dressed in old-fashioned clothes

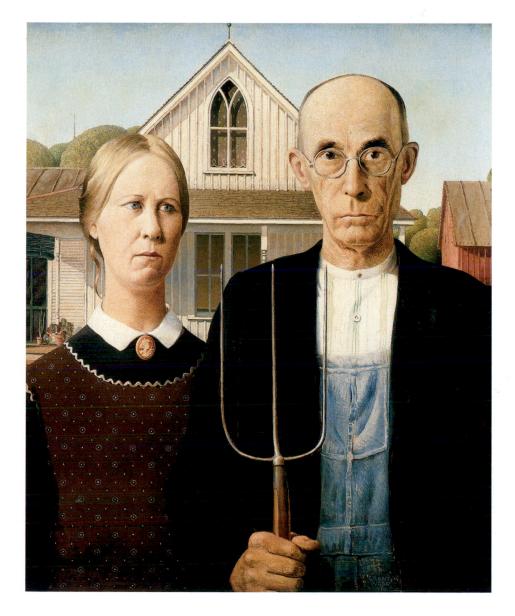

28.48 Grant Wood, *American Gothic.* 1930. Oil on beaverboard, $30^{11}/_{16} \times 25^{11}/_{16}$ " (78 × 65.3 cm). Unframed. The Art Institute of Chicago, Friends of American Art Collection. 1930.934

and stand firmly against the march of progress. The style of their house, from which the title of the painting is taken, is Carpenter Gothic, a nineteenth-century style evoking both the humble modesty and old-fashioned ways of the residents as well as their religious intensity, which parallels the fervor of the medieval period when Gothic cathedrals were built. Wood further emphasizes his characters' faith by developing numerous crosses within the façade, and by putting a church steeple in the distant background.

In addition to being hard-working and reverent, we also know these farmers are orderly and clean, as suggested by the crisp drawing and severe horizontal and vertical composition. This propriety also stems from the primness of the woman's conservative dress and hair and the suggestion that she carefully tends to the house, as she does to the plants on the front porch. The figures' harsh frontality, the man's firm grasp on his pitchfork, and his overalls suggest that they are industrious and strong. There is no hint of modernity, and the simplicity and austerity of the setting suggests they are frugal. Nonetheless, many critics viewed Wood as ridiculing his sitters and their lifestyle, and indeed the painting does contain humor, such as the woman warily looking off to the side as if to make sure nothing untoward is occurring. But regardless of interpretation, no one seemed to deny that the picture captured something fundamentally American, and especially Midwestern.

The Harlem Renaissance

From 1910 to 1940, approximately 1.6 million African Americans fled the racism and poverty of the rural South for the cities of the industrial north, where they hoped to find jobs as well as justice and equality. In the North, the new migrants often discovered they had exchanged rural poverty for urban slums, and the racism encoded in Southern Jim Crow laws for prejudice, segregated neighborhoods, and second-class citizenship. Nonetheless, the confluence of blacks in New York's Harlem and Chicago's South Side resulted in a cultural flourishing devoted to self-discovery and to establishing a black identity, something white America had methodically denied African Americans. The movement was then called the New Negro Movement, although today it is generally known as the Harlem Renaissance, after its primary center, often described as its "capital."

Leading this movement in literature, music, theater, and art was the Howard University philosopher Alain Locke (1886–1954), who called for a distinctive style that evoked a black sensibility and perspective. He advocated recapturing the African past and its art, which white avant-garde artists had already done, although presenting it from their own narrow perspective and using it to reflect their own needs and interests. Locke encouraged representations of African Americans and their lives as well as a

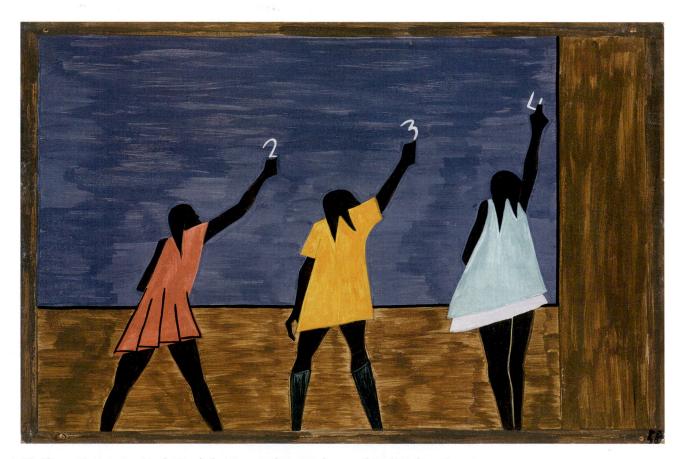

28.49 Jacob Lawrence, *In the North the Negro Had Better Educational Facilities*, from the series *The Migration of the Negro*, number 58. 1940–41. Casein tempera on hardboard, 12×18 " (30.5 × 45.7 cm). Museum of Modern Art, New York. Gift of Mrs. David M. Levy

portrayal of the distinctive physical qualities of the race, just as African masks often stressed black physiognomy. In effect, he was advocating artists and writers to declare that Black is beautiful. In his promotion of a black aesthetic, he encouraged artists to depict a distinct African-American culture, one that departed from the Euro-American tradition and reflected the enormous contributions Americans of African descent had made to American life and identity.

Prior to the Harlem Renaissance, African-American fine artists made art that was inspired by the art that their Euro-American counterparts were producing, with the intention of "fitting in," conforming, and appealing to market values, which were determined by white artists. They made the same landscapes, still lifes, and genre scenes, all devoid of black content. (However, in the crafts and folk art, such as quilts, metalwork, and furniture, and in music as well, African Americans were often influenced by African traditions.) With the Harlem Renaissance, artists began making African Americans the subject of their art. Although most major African-American artists worked within the Modernist tradition, they also offered an alternative to this tradition by making racial identity a prominent theme in their work. In effect, they made the subject of race and the power of its presentation as important as formal innovation.

JACOB LAWRENCE The most famous painter to emerge from the Harlem Renaissance was Jacob Lawrence (1917–2000), who received his training as a teenager in the 1930s at the federally sponsored Harlem Art Workshop and Harlem Community Art Center. Lawrence regularly went to midtown to take in all the art the city had to offer, from a 1935 exhibition of African Art at the Museum of Modern Art, to Mexican textiles, to all of the latest European styles. In the late 1930s, he began making large narrative series dedicated to black leaders, including Harriet Tubman, Toussaint L'Ouverture, and Frederick Douglass. The images were small and modest, made of poster paint on cardboard or posterboard.

Lawrence is best known for his Migration Series, begun in 1940. In 60 images, Lawrence presented the reasons for blacks migrating north and their experiences in both the North and the South. While the series is anecdotal, the images did much of the talking through their abstraction, as seen in number 58, In the North the Negro Had Better Educational Facilities (fig. 28.49). Three girls write numbers on a blackboard, but we do not see their faces, which would make them individuals. Instead, we see numbers and arms rising higher, suggesting elevation through education, and we see a clean slate for a clean start. The girls' brightly colored dresses affirm life and happiness, while the jagged and pointed edges in their hair and skirts impart an energy and a quality of striving. Lawrence generally shows a collective black spirit, not an individual or individual expression. He is interested in a human spirit that relentlessly and energetically moves forward, building a better future. His sparse and beautifully colored pictures embody a remarkable psychology, which is often reinforced by the Modernist space of his pictures. Here, a flat field pushes the figures to the surface, prominently displaying them, and the composition's geometry seems to reinforce the discipline of the students' dedication to education.

MEXICAN ART: SEEKING A NATIONAL IDENTITY

The Mexican Revolution, which began in 1910 with the overthrow of the dictatorship of General Porfirio Díaz and ended in 1921 with the formation of the reformist government of Alvaro Obregón, triggered a wave of nationalism within the cultural community, one that focused on indigenous traditions while rejecting European influences. A government building campaign resulted in a large number of impressive mural commissions, which in turn gave rise to a school of artists headed by Diego Rivera, David Siquieros, and José Clemente Orozco. Either socialists or Communists, the muralists proclaimed murals as the true art of the people. The Mexican muralists gained international renown and were especially popular in the United States, where they received important commissions, ironically from major capitalists such as the Rockefeller family.

Diego Rivera

Diego Rivera (1886-1957) is perhaps the best known of the three major muralists. He lived in Europe, primarily in Paris, from 1907 to 1921, and was an accomplished Cubist. By the late 1910s, Rivera was consumed by the idea of creating a nationalistic revolutionary art through mural painting, and he traveled to Italy to study Renaissance murals. Upon returning to Mexico, he jettisoned his elite esoteric Cubism for the straightforward representational art of fifteenth-century Italy, giving it a monumentality that also echoed the strong simple forms of Aztec and Mayan art. Furthermore, he shunned easel painting, declaring it a bourgeois capitalistic art form, a commodity for the rich. He viewed his fresco murals as a public art, an art for the masses. He also felt his art should be about the indigenous people, not the Euro-Mexicans and their European customs. Consequently, many of his mural commissions are about national identity and the uniqueness of Mexican customs and tradition.

Rivera was a Communist, and his politics, especially his championing of the common folk and labor, appear in his murals. From 1930 to 1934, he received numerous commissions in the United States, and his representational art had a tremendous impact on American mural painting, which was proliferating due to support from Franklin D. Roosevelts's New Deal administration which provided artists with work. One major project was the lobby of the RCA building in Rockefeller Center. Entitled *Man at the Crossroads Looking with Hope and High Vision to a New and Better Future*, it included a portrait of the Communist leader Lenin, which outraged the Rockefellers, who had commissioned the mural. The Rockefellers paid Rivera but then destroyed the mural. Rivera remade it as *Man*, *Controller of the*

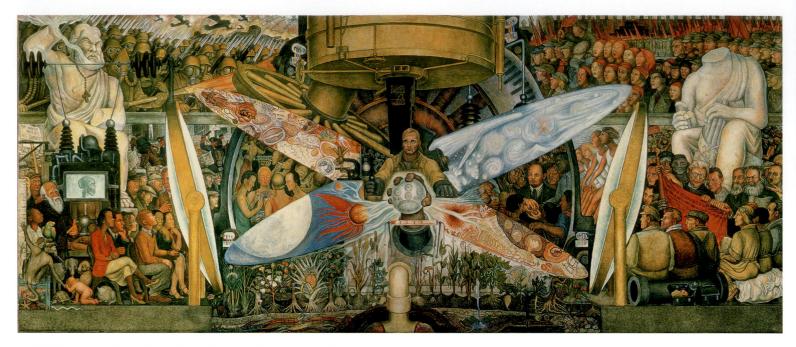

28.50 Diego Rivera, *Man, Controller of the Universe.* 1934. Fresco, $15'11" \times 37'6"$ (4.85 × 11.45 m). Museo del Palacio de Bellas Artes, Mexico City

Universe (fig. 28.50) at the Museo del Palacio de Bellas Artes in Mexico City in 1934. The painting champions science and Communism, which, for Rivera, were the twin tools of progress. In the center of the composition we see Man, positioned under a telescope and with a microscope to his right (our left), indicating that humankind will control the future through science. Two crisscrossing ellipses of light seem to emanate from Man, one depicting a microscopic world, the other the cosmos. Below him is the earth, and the superior agricultural products generated by scientific discovery. To Man's left (our right), we see, sandwiched between the healthy microorganisms and a harmonious cosmos, Lenin holding hands with workers of different races. Beyond is a scene of healthy unified labor. To Man's right (our left) are the evils of capitalism. Between the ellipses showing diseased organisms and a clashing cosmos is a decadent bar scene depicting the well-heeled bourgeoisie, including John D. Rockefeller, Jr. Beyond are frightening soldiers and discontented, protesting laborers.

FRIDA KAHLO A more remarkable, if less influential, artist from this period was Rivera's wife, Frida Kahlo (1907–1954). She was almost killed in a traffic accident when she was 18, and, when recuperating, she started painting, cultivating a folk style that reflected her strong interest in the power of naïve Colonial pictures (art often made by self-taught or little-trained artists) and such folk imagery as ex-votos (a Catholic folk image of religious devotion often created in gratitude for a special event in some-one's life). Kahlo's imagery was personal, focusing on her state of mind, generally her tumultuous relationship with her philandering husband or her lifelong excruciating suffering from her injuries. She made easel pictures, often quite small, which, while focusing on herself, nonetheless deliberately placed her in a

Mexican context. She often presented herself in traditional Mexican clothing and jewelry, and with attributes associated with folk beliefs and superstition.

We can see this focus on her own identity and psychology in her 1939 painting The Two Fridas (fig. 28.51), made when she and Rivera were divorcing. On the left is the European Frida, lightskinned, even sickly pale, and in Victorian dress, reflecting her father's Hungarian Jewish ancestry. To the right sits the Mexican Frida, dark-skinned and in peasant costume, reflecting her mother's Indian and Creole background. More important, this is the Frida that Rivera wanted her to be. She holds a miniature portrait of Rivera as a boy, the source of the blood coursing through her and into the European Frida, who has cut the connection back to her Mexican self, in effect draining the blood, and life, out of the indigenous self. The exposed heart, dripping blood, and the miniature have the surreal drama found in the Mexican ex-votos that Kahlo so admired, while the crisp contours and minimal modeling of the figures and the bench, for example, echo their plain direct folk-art style. Contrasted with these simple unarticulated passages are meticulously detailed motifs, such as the hearts and lace, which change the texture of the image, making it all the more bizarre. André Breton was in Mexico in 1938 and declared Kahlo a Surrealist, a label she objected to, declaring she was not painting dreams but rather the reality of her life. Her pictures were not meant to churn the unconscious, but rather to reflect her own pain and suffering, both physical and psychological.

MANUEL ÁLVAREZ BRAVO Breton also added photographer Manuel Álvarez Bravo (1902–2002) to his roster of Surrealists. Bravo, who was self-taught, was in the muralist circle in Mexico City and was equally preoccupied with creating a Mexican art.

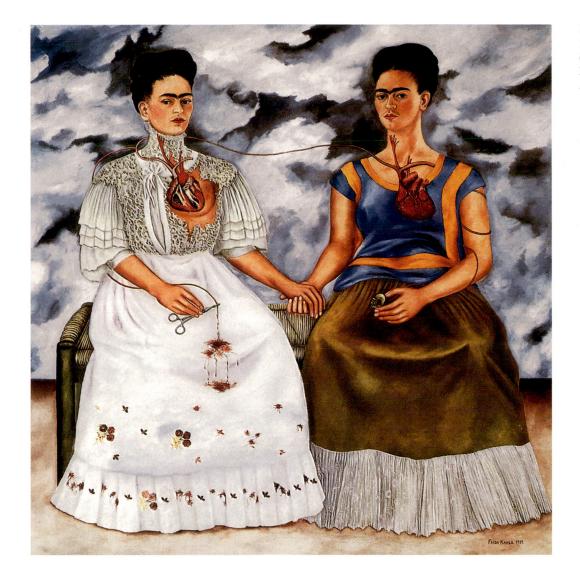

28.51 Frida Kahlo, *The Two Fridas.* 1939. Oil on canvas, $5'8\frac{1}{2} \times 5'8\frac{1}{2}''$ (1.74 × 1.74 m). Museo de Arte Moderno, Instituto Nacional de Bellas Artes, Mexico City

28.52 Manuel Álvarez Bravo, *La Buena Fama Durmiendo* (*Good Reputation Sleeping*). 1938–39. Gelatin silver print. Museum of Photographic Arts, San Diego, California

Like Cartier-Bresson's images, Bravo's have an uncanny quality, sometimes due to an unusual juxtaposition of objects, sometimes simply because of a strange silence and mysterious shadows. In some respects, his Surrealism was the result of his quest to capture the magical essence of folk myths and superstitions, as seen in La Buena Fama Durmiendo (Good Reputation Sleeping) (fig. 28.52). Here, Bravo posed his model on the roof of the national arts school where he was teaching, having her lie on a Mexican blanket and binding her wrists, ankles, and feet as well as her pelvis and upper legs in bandages. He allows her pubic hair to show, and surrounds her with thorny cactus pears. Breton wanted to use this image for the cover of a 1940 international Surrealist exhibition he was organizing for Mexico City. Owing to the jarring relationship of prickly pears to the model, the exposed crotch, the strange tightly wound bandages, and the violent stains on the wall, it is not difficult to understand why. But Bravo's motivation was not just about evoking the pain, suffering, violence, and desire associated with sex; he also wanted to encompass the intensity of local legends that went back centuries. In Mexican folklore, for example, the thorny pears are supposed to ward off danger during sleep. The bandages were inspired by watching dancers bind their feet, which reminded Bravo of Pre-Columbian sculptural reliefs of dancers, which were related to the earth-goddess Coatlicue, who was conceived without sexual intercourse. The image is a wonderful exercise in doctrinaire Surrealism, but at the same time it is steeped in the myth and magic of Mexican tradition, especially drawing upon indigenous and folk culture.

THE EVE OF WORLD WAR II

In October 1929, the New York stock market crashed, unleashing the Great Depression that fanned out around the globe. The deprivation it inflicted lasted an excruciating 16 years. In Europe and Asia, fascists rose to power—Mussolini in Italy, Hitler in Germany, Franco in Spain, and Hirohito in Japan. Communist Russia became totalitarian with the emergence of Stalin in the late 1920s. In 1931, Japan invaded continental Asia.

For European artists, the rise of Hitler was the defining influence. To those bent on establishing a democratic classless world, his policies were insane. He was aggressively militaristic, believing great nations are based on a powerful, ruthless military. He declared Aryans, Germans of Scandinavian and Teutonic descent, to be a master race, superior to all others, and claimed Germany's economic and political decline resulted from its ethnic and linguistic diversity. He especially faulted Jews and Communists for undermining German superiority, and by the late 1930s, Jews, Slavs, Gypsies, gays, the mentally and physically impaired, as well as Communists and political dissenters, were imprisoned, sent to work camps, or executed. The utopian dream of Dada, Surrealism, De Stijl, Constructivism, and the Bauhaus proved to be just that, a dream. Hitler forced the closing of the Bauhaus in 1933, and in 1937, the Nazis staged a "Degenerate Art" exhibition in Munich, denigrating German avant-garde artists in full public view. In America, social realism and representational regional art gained at the expense of avant-garde art. While regionalists painted stoic or dynamic scenes of American fortitude and drive, others focused on the plight of the urban poor.

America: The Failure of Modernity

The avant-garde continued to work in abstraction through the 1930s, but in an era dominated by the terrible social ills of the Great Depression, it became increasingly difficult for artists not to be socially concerned. Many in the avant-garde got involved by becoming socialists or Communists and by supporting the labor movement, even forming their own unionlike organizations. But for many artists, political activity was not enough. Now, more and more artists worked in a style called Social Realism, a representational format that focused on such pervasive problems as poverty, labor oppression, suffering migrant workers, alienation resulting from increased urbanization and industrialization, and racism, especially as seen in the Ku Klux Klan lynchings.

28.53 Edward Hopper, *Early Sunday Morning*. 1930. Oil on canvas, $35 \times 60^{\circ}$ (88.9 × 152.4 cm). Whitney Museum of American Art. Purchase with funds from Gertrude Vanderbilt Whitney (31.426)

EDWARD HOPPER One of the most powerful representational painters of the period was Edward Hopper (1882-1967), who was based in New York. His pictures are saturated with the alienation associated with life in the big city, and more generally with modern America. A classic Hopper is Early Sunday Morning (fig. 28.53) of 1930. The image is frightening in its uncanny quiet and emptiness, qualities reinforced by the severe frozen geometry of the composition. The second-floor windows suggest a different story for each apartment, but none is forthcoming as their inhabitants remain secreted behind curtains and shades. A strange relationship exists between the fire hydrant, the barber-shop pole, and the void of the square awning-framed window between them, an uneasiness that we project onto the unseen inhabitants of the building. The harsh morning light has a theatrical intensity. Hopper's only loves outside of art were film and theater, and his paintings have a cinematic and staged quality that intimates that something is about to happen. His pictures are shrouded in mystery, and because their settings are distinctly American, the dreary psychology he portrays becomes distinctly American as well.

WALKER EVANS The largest art patron during the Great Depression was the United States government, which put tens of thousands of unemployed artists to work through the Works Project Administration and Federal Art Project, important components of Franklin D. Roosevelt's New Deal. What was so remarkable about these programs was their lack of racial, ethnic, or gender discrimination, which resulted in financial support for women and minorities. One especially influential project was the Farm Security Administration (FSA). Designed to document the suffering and poverty of both rural and urban Americans, the FSA hired about 20 photographers at a time to record the desperate

28.54 Walker Evans, *Graveyard*, *Houses, and Steel Mill, Bethlehem*, *Pennsylvania.* 1935. Film negative, $8 \times 10^{\circ}$ (20.3 \times 25.4 cm). Museum of Modern Art, New York. Gift of the Farm Security Administration (569.1953)

28.55 Dorothea Lange, *Migrant Mother, California.* 1936. Gelatin silver print, Library of Congress, Washington, D.C.

conditions of the poor. Their images were then distributed to the media, where they often had a powerful impact on public opinion.

One of the first photographers hired in 1935 was Walker Evans (1903–1975), who was fired two years later because he was stubbornly difficult and did not make the sort of images that the FSA was looking for: images that dramatically portrayed how wretched the conditions were in America. Instead, his subtle photographs focus on the nation's psychology, showing its gloom and alienation, much as Hopper's paintings did. This can be readily seen in the work reproduced here (fig. **28.54**). We see a town without people, where the cemetery, workers' row houses, and treeless industrial landscape of smokestacks and telephone poles summarize the denizens' lives, succinctly conveying the meaningless, rote, empty life cycle of the American worker. In addition to creating a tragic mood, Evans's genius lies in the brilliant formal play of his detailed compositions that subtly pit light against dark and vertical against horizontal.

DOROTHEA LANGE One of the most famous images from the FSA project is Dorothea Lange's (1895–1965) *Migrant Mother*, *California* (fig. **28.55**). Using the sharp-focus photography that had become commonplace by the 1930s, Lange created a powerful image that in its details captures the sitter's destitution, and in

its complex composition of hands, arms, and turned heads, the family's emotional distress. Because of this photograph and an accompanying news story, the government rushed food to California, and eventually opened relief camps for migrant workers. The immediate impact of this poignant photograph testifies to the overpowering credibility that the medium of photography can have, and we have to wonder if the article about the migrant workers had not included Lange's photograph if the government would have sent aid.

Europe: The Rise of Fascism

If America had to contend with economic deprivation in the 1930s, the situation was even worse in Europe, where the dark cloud of fascism added to the gloom of the worldwide financial collapse. In rapid succession, Italy, Germany, and Spain became fascist dictatorships, depriving citizens of their civil liberties and threatening the peace and security of the surrounding nations. The Enlightenment logic that had ushered in some 200 years of progress seemed to be crumbling, replaced by a world that had lost its sense as a large portion of the European population gave up their freedom and followed Mussolini, Hitler, and Franco down an authoritarian path that ended in World War II. Many artists responded to this threat to civilization. Among the first was Max Ernst, who, by the late 1920s in Paris presciently saw the threat that was coming to Western civilization. *Die Ganze Stadt* (see fig. 28.12), which Ernst made in 1935–36 after the rise of Hitler and which was discussed earlier in the chapter in the context of Surrealism, is more than just a dreamscape prompted by grattage and aimed at provoking our own subconscious—it is an announcement that such basic human urges as greed and pride will condemn humans to failure and is a premonition of World War II.

MAX BECKMANN AND GERMAN EXPRESSIONISM No

one movement or style had a monopoly on making art protesting the rise of fascism. Certainly, postwar German Expressionists, such as Köllwitz, and Berlin Dadaist were predisposed to political protest. German Expressionism continued throughout the 1920s and 1930s, taking on forms quite different from Die Brücke and Der Blaue Reiter but nonetheless retaining a sense of violence, suffering, and the grotesque that can be traced back to the Renaissance. Although we looked at George Grosz within the context of Berlin Dada, he is generally viewed as a postwar German Expressionist, which considering the clear political nature and narrative character of a work like *Germany, A Winter's Tale* (see fig. 28.6) is perhaps a more accurate label. Another postwar Expressionist active since the 1910s was Max Beckmann

28.56 Max Beckmann, *Departure*. 1932–33. Oil on canvas, side panels $7'\frac{3}{4}" \times 39'\frac{4}{4}"$ (215.3 × 99.7 cm), center panel $7'\frac{3}{4}" \times 45 \frac{3}{6}"$ (215.3 × 115.2 cm). Museum of Modern Art, New York. Given Anonymously by Exchange

(1884–1950), whose art tended to be more universal than Grosz's, focusing on the folly and despair of existence. Beckmann's pessimistic view of human nature stems from his experience in World War I, which caused him to become an Expressionist in order to "reproach God for his errors." In the early 1930s, he began working in his final style, seen in Departure (fig. 28.56), which is one of nine enormous triptyches (inspired by the triptyches of Hieronymus Bosch) that the artist made in the last 20 years of his life. The complex symbolism in the flanking panels represents life itself, seen as endless misery filled with all kinds of physical and spiritual pain. The bright-colored center panel represents "the King and Queen hav[ing] freed themselves of the torture of life." Beckmann assigned specific meaning to each action and figure: The woman trying to make her way in the dark with the aid of a lamp is carrying the corpse of her memories, evil deeds, and failure, from which no one can ever be free so long as life beats its drum. But Beckmann believed that viewers did not need a key to his iconography; any interpretation would inevitably be similar to his, at least in spirit, if not in the details. The grotesquely distorted figures, strident angular lines, jagged forms, compressed claustrophobic space, and heavy, morbid black line encasing everything reinforce the insane, hell-on-earth mood of this nightmarish image.

The triptych's rich allegory and symbolism reflects Beckmann's early study of the Old Masters and his deep appreciation for the grim and disturbing imagery of Bosch and Grünewald (see pages 492–93 and 635–37). But such narratives of mythic proportions, which only start appearing in Beckmann's art in the 1930s, seem to reflect the artist's familiarity with Parisian Surrealism. The Frankfurt-based Beckmann was a regular visitor to Paris, and it appears he returned with more than just a semblance of Picasso's palette, for he seems to have also brought home the Surrealist emphasis on myth. His hell-on-earth nightmare of bizarre and sadistic events relies on disjointed puzzling motifs that parallel the devices he saw in the dream imagery of the Surrealists.

Shortly after Beckmann began Departure, life itself became surreal in Germany, for Hitler became chancellor in 1933. Now the Nazis turned from bullying and threats to overt violence toward their perceived enemies and inferiors, anyone they viewed as being at odds with the "Aryan" ideals of the Third Reich. German avant-garde art was deemed depraved and therefore ridiculed. The artists were forbidden from buying art supplies. Eventually, their work was confiscated from museums and either destroyed or sold in Switzerland to raise money. In 1937, the Nazis removed some 650 pieces of German modern art from museums and presented them in an exhibition entitled Degenerate Art, which opened in Munich and then toured Germany for three years. Beckmann was represented in this humiliating exhibition, an event that contributed to Ernst Ludwig Kirchner's suicide. But by 1937, Beckmann was in the United States, a path taken by numerous other artists, including Moholy-Nagy, who established a new Bauhaus in Chicago, today the Institute of Design at the Illinois Institute of Technology.

28.57 John Heartfield, *As in the Middle Ages, So in the Third Reich.* 1934. Poster, photomontage. Akademie der Künste, John Heartfield Archiv, Berlin

JOHN HEARTFIELD John Heartfield, the Berlin Dadist who, along with Grosz, Hausmann, and Höch, played a seminal role in the development of photomontage in the early 1920s, now took aim at the Nazis, creating some of his most powerful work. *As in the Middle Ages, So in the Third Reich* (fig. **28.57**) is a wonderful example of his montage technique, which consisted of collaging disparate images together and then photographing them. In this poster, he juxtaposes a Nazi victim crucified on a swastika with a Gothic image of the figure of humanity punished for its sins on the wheel of divine judgment. Heartfield was not interested in the original meaning of the Gothic motif; he used it to imply that the Nazis had ruthlessly transported the nation back to what he viewed as the dark barbaric past of the Middle Ages.

PABLO PICASSO In 1936, civil war broke out in Spain when conservatives loyal to the king and under the leadership of Franco (the Nationalists) tried to overthrow the popularly elected leftist, republican government (the Republicans or Loyalists). In some ways, it was a rehearsal for World War II. Hitler and Mussolini

28.58 Pablo Picasso, *Guernica*. 1937. Oil on canvas, 11'6" × 25'8" (3.51 × 7.82 m).
 Museo Nacional Centro de Arte Reina Sofia, Madrid. On Permanent Loan from the Museo del Prado, Madrid

provided military and political support for the Nationalists, who included monarchists, fascists, and Catholics. The Loyalists consisted of Communists, socialists, and Catalan and Basque separatists, as well as the International Brigade, made up of volunteers from all over the world. On April 26, 1937, Hitler's Nazi pilots used saturation bombing to attack the undefended Basque town of Guernica, killing thousands of civilians. Picasso, like most of the free world, was outraged, and responded by painting *Guernica* (fig. **28.58**), an enormous black, white, and gray mural that he exhibited as a protest at the Spanish Republican Pavilion of the 1937 Paris International Exposition. He pulled every artistic device out of his Cubist and Surrealist arsenal to create a nightmarish scene of pain, suffering, grief, and death. We see no airplanes and no bombs, and the electric lightbulb is the only sign of the modernity that made the bombing possible.

The symbolism of the scene resists exact interpretation, despite several traditional elements: The mother and her dead child are descendants of the Pietà, the woman with the lamp who vaguely recalls the Statue of Liberty suggests enlightenment, and the dead fighter clutching a broken sword is a familiar emblem of heroic resistance. We also sense the contrast between the menacing human-faced bull, which we know Picasso intended to represent the forces of brutality and darkness, and the dying horse, which stands for the people.

Picasso insisted, however, that the mural was not a political statement about fascism, and it is interesting that many of the figures were used quite differently in Picasso's earlier work. The horse and bull are motifs from the bullfight, which Picasso had been using since the early 1930s as a metaphor for sexual conflict. The presence of the huge vulva-shaped tear on the side of the horse is certainly not a coincidence. Nor is that of the same sexual orifice on the inside of the sword-holding arm broken off of a Classical statue of a soldier. Nor is it coincidence that the flames on the back of the supplicating woman on the right remind us of the sawtooth groin of the sexually aggressive dancer in Three Dancers (see fig. 28.9), or that the quarter-moon silhouetted against a rooster's head just beyond her flailing breast reminds us of the same dancer's moon-shaped head. And is it coincidence that this figure, who resembles a Mary Magdalene at the Cross, also brings to mind Goya's supplicating rebel in The Third of May, 1808 (see fig. 24.3)? If it were not for the title, there is not much to indicate this is not another of Picasso's images about the tormenting psychology of sexual conflict that we saw as far back as Les Demoiselles d'Avignon (see fig. 27.5) of 1907.

But the title cannot be ignored—nor the smashed statue of a soldier, the suffering women and children, the political use of the painting at the International Exposition, and the fact that it was made in response to the destruction of Guernica. When Picasso denied that this was an antifascist picture, he may very well have meant in part that this monumental mural was more than just mundane propaganda against Franco and his ilk. Like Beckmann's *Departure*, we cannot help but feel that this horrifying image is meant to portray the psychology of a world in perpetual conflict and misery—albeit using sexual imagery to convey this message, but this is what Picasso knew best. In *Guernica*, however, Picasso, unlike Beckmann, does not provide a boat to take us away to safety.

1917 Duchamp's Fountain

1919–20 Vladimir Tatlin's Project for "Monument to the Third International"

1920-22 Joseph Stella's The Voice of the City

1926 Georgia O'Keefe's Black Iris III

1929 Ludwig Mies van der Rohe designs German Pavilion for International Exposition, Barcelona

1934 Diego Rivera's *Man, Controller of the Universe*, Museo del Palacio de Bellas Artes, Mexico City

1936 Meret Oppenheim's *Object* (Luncheon in Fur)

1936 Dorothea Lange's Migrant Mother, California

1937 Picasso's Guernica

Art Between the Wars

1900

 1900 Sigmund Freud publishes The Interpretation of Dreams

1910

1920

1910-20 Mexican Revolution
 ca. 1910-40 The Great Migration, as 1.6 million
 African Americans move from the South to the
 North, Midwest, and West

1917 Piet Mondrian with others forms De Stijl

 1919 Walter Gropius founds the Bauhaus which is relocated to Dessau in 1925

1920 First Dada International Fair, Berlin
 1920 19th Amendment to the U.S. Constitution
 passed giving women the right to vote

 1924 André Breton publishes his first Surrealist Manifesto

 1925 Exhibition of Decorative and Industrial Art, Paris, launching Art Deco style

1929 Great Depression begins

1930

- 1933 Hitler comes to power in Germany
 1933 Franklin D. Roosevelt launches the New Deal
- 1936 Spanish Civil War begins, with rise of Francisco Franco as dictator

1939 John Steinbeck publishes *The Grapes* of *Wrath*

1939 World War II begins

1940

Postwar to Postmodern, 1945–1980

CHOLARS TRADITIONALLY VIEW WORLD WAR II (1939-45) AS A turning point for the art world, the time when its focus shifted from Paris to New York and when America's first major art movement, Abstract Expressionism, captured the world's attention, even dominating world art. In fact, the 1950s, not the 1940s, were the watershed for the second half of the

century. It was then that Duchamp's preoccupation with how art functions became a driving force as the decade progressed. Likewise, many artists became obsessed with the concept, also rooted in the early Cubism of Picasso and Braque, that art and image making were a form of language, and they dedicated their work to revealing the structure of this visual language and the complex ways it could be used to present ideas and opinions, even to deceive and manipulate.

2

It was also in the 1950s that artists, again following Duchamp's lead, realized that art need not be limited to the traditional mediums, such as oil on canvas or cast bronze or chiseled marble. It did not have to hang on a wall or sit on a pedestal. Artists could use anything to make art, and by the late 1950s and 1960s, they did. They made art with televisions, film, junk, earth, fluorescent lights, steel tiles, acrylics, entire environments, postcards, and words. **Performance Art, Earthworks**, Conceptual Art, Mail Art, **Happenings**, and Video Art are just a handful of the movements and mediums that sprang up from the mid-1950s through the 1970s.

In part, this burst of new mediums reflects the expansive spirit of the period, especially in America. World War II ended 16 years of financial depression and deprivation, and by the 1950s, the United States had become a nation of consumers. Returning soldiers, eager to resume their lives, married and had children in record numbers, creating the baby-boom generation. Americans in large numbers moved from cities to new cookie-cutter tract houses in the suburbs. And as never before, they shopped—these new homes often had several cars, power boats, barbeque grills and lawn furniture, washing machines, self-cleaning ovens, televisions sets, transistor radios, stereo record players, and homemovie cameras and projectors. As suggested by these last items, Americans as never before chased the latest technology, which was developing quickly in part due to World War II and now the Cold War waged between the Communist U.S.S.R and the democratic West and which was characterized by fighter jets, helicopters, the hydrogen bomb, missiles, rocket ships, satellites, and space travel.

The new postwar American lifestyle, however, was not equally available to all. Magazines, newspapers, film, and the new medium of television reflected the reality of a distinct hierarchy within American democracy, with white males heading up a patriarchal society that viewed women, people of color, and gays as second-class citizens. It was a decade of conformity, symbolized at one extreme by the white businessman in a gray flannel suit climbing the corporate ladder while the prim housewife tended the family and house, played golf and tennis at the country club, and participated in the PTA and church activities. Beatniks, Zen Buddhists, avant-garde jazz musicians, bikers, and urban gangs of

Detail of figure 29.2, Jackson Pollock, Autumn Rhythm: Number 30

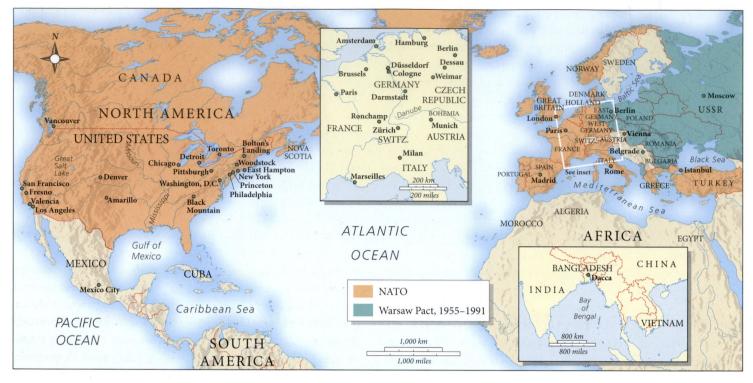

Map 29.1 Cold War alliances

juvenile delinquents established alternative lifestyles in the late 1940s and 1950s.

But it was the Civil Rights Movement that first seriously challenged the status quo in the second half of the 1950s, gaining tremendous momentum in the following decade. Spurred also by the Vietnam War (1959–75), which generated persistent antiwar protests, the mid-1960s began a period of social upheaval that reached a feverish pitch in the 1970s, producing the feminist movement, Gay Pride, Black Power, Gray Power, and environmental groups such as Greenpeace. It was an age of liberation aimed at shattering the status quo and questioning the validity of any claim to superiority or fixed truth. And in the forefront was art, which by the 1950s was challenging the existence of absolutes. But before this artistic revolution could occur, the center of the art world had to move from Paris to New York. This "coup," often referred to as the "Triumph of New York Painting," coincided with the rise of Abstract Expressionism in the late 1940s.

EXISTENTIALISM IN NEW YORK: ABSTRACT EXPRESSIONISM

Abstract Expressionism evolved out of Surrealism, which traced its roots to the Dada movement of the 1910s (see page 985). Like the Surrealists, the Abstract Expressionists were preoccupied with a quest to uncover universal truths. In this sense, their heritage goes back to Kandinsky and Malevich as well (see pages 958 and 966). In many respects, Abstract Expressionism is the culmination of the concerns of the artists of the first half of the twentieth century. But the Abstract Expressionists were also driven by a deep-seated belief in Existentialism, a philosophy that came to the fore with the devastation caused by World War II. The war shattered not only faith in science and logic, but even the very concept of progress, the idea that it was possible to create a better world. A belief in absolute truths had been abandoned.

Existentialism maintains that there are no absolute truths—no ultimate knowledge, explanations, or answers—and that life is a continuous series of subjective experiences from which each individual learns and then correspondingly responds in a personal way. Essential to this learning process is facing the direst aspects of human existence—fear of death, the absurdity of life, and alienation from individuals, society, and nature—and taking responsibility for acts of free will without any certain knowledge of what is right or wrong, good, or bad. The Abstract Expressionists, like so many intellectuals after the war, embraced this subjective view of the world. Their art was a personal confrontation with the moment, reflecting upon their physical, psychological, and social being.

The Bridge from Surrealism to Abstract Expressionism: Arshile Gorky

Surrealism dominated New York art in the early 1940s. In late 1936, the seven-year-old Museum of Modern Art mounted the blockbuster exhibition *Fantastic Art, Dada, and Surrealism,* an eye-opener for many New York artists. Some artists not converted by the exhibition were nevertheless swayed by the dramatic influx of European artists who fled the Continent shortly before and during World War II. André Breton, Marcel Duchamp, André Masson, and Max Ernst were just a few of the many artists and intellectuals who sought the safety of Manhattan and were a powerful presence in the art world. Peggy Guggenheim, a flamboyant American mining heiress who had been living in Europe, returned to New York and opened a gallery, Art of This Century, which featured Surrealism. Surrealism was *everywhere*, and many New York artists took to it enthusiastically.

Just as Dada developed into Surrealism, New York Surrealism seamlessly evolved into Abstract Expressionism. The transformation occurred when all of the symbols and suggestions of myths and primordial conditions disappeared, and images dissolved into a complete abstraction containing no obvious references to the visible world. We can see the beginning of this process in the paintings of Arshile Gorky (1904–1948), an Armenian immigrant, whose family fled Armenia to escape the genocide of the ruling Turks of the Ottoman Empire. Gorky's mother died of starvation in his arms in a Russian refugee camp. By the 1930s, Gorky was in New York, where, over the next decade, his Cubist style began to evolve toward complete abstraction. At his wife's farm in Connecticut, he would dash off minimal abstract line drawings inspired by nature. In the studio, he would then develop, often using preparatory drawings, these linear patterns into paintings, similar to his 1944 surrealistically titled *The Liver Is the Cock's Comb* (fig. 29.1).

Here, we see wiry black-line drawing and washes of predominantly red, blue, yellow, and black playing off of one another, giving a sense of how the composition developed as a series of psychological reactions with one mark or color triggering the next, and so on until completion. While the painting has echoes of Miró's biomorphic shapes (see fig. 28.13), Masson's automatic drawing (see page 995), and Kandinsky's color and cosmic chaos (see fig. 27.14), it is more abstract and flatter than the work of his predecessors, with the image kept close to the surface. We cannot safely read much into the picture other than a feeling of a landscape filled with some kind of organic animation, perhaps genitalia and figures, which seem eruptive, violent, and in conflict. In fact, many scholars have suggested that Gorky's abstractions refer to the Turkish slaughter of Armenians, but again, the picture is too abstract to interpret. What stands out as a prominent theme is the art process itself, our sense of how the image was made and how it seems to have been determined by Gorky's own powerful emotions. Gorky was one of the last two artists that Breton anointed a Surrealist, a label Gorky rejected, since he undoubtedly saw himself as expressing his innermost feelings and memories, not exploring his repressed self.

29.1 Arshile Gorky, *The Liver Is the Cock's Comb.* 1944. Oil on canvas, 6'¼" × 8'2" (1.86 × 2.49 m). Albright-Knox Art Gallery, Buffalo, New York. Gift of Seymour H. Knox, 1956

Jackson Pollock (1912–1956)

From "My Painting"

In 1947, when these remarks were recorded, Pollock rejected the usual easel format by placing his unstretched canvases directly on the floor. Using ordinary paint, he claimed he was not just throwing paint but delineating some real thing in the air above the canvas.

My painting does not come from the easel. I hardly ever stretch my canvas before painting. I prefer to tack the unstretched canvas to the hard wall or the floor. I need the resistance of a hard surface. On the floor I am more at ease. I feel nearer, more a part of the painting, since this way I can walk around it, work from the four sides and literally be in the painting. This is akin to the method of the Indian sand painters of the West. I continue to get further away from the usual painter's tools such as easel, palette, brushes, etc. I prefer sticks, trowels, knives and dripping fluid paint or a heavy impasto with sand, broken glass and other foreign matter added.

When I am *in* my painting, I'm not aware of what I'm doing. It is only after a sort of "get acquainted" period that I see what I have been about. I have no fears about making changes, destroying the image, etc., because the painting has a life of its own. I try to let it come through. It is only when I lose contact with the painting that the result is a mess. Otherwise there is pure harmony, an easy give and take, and the painting comes out well.

The source of my painting is the unconscious. I approach painting the same way I approach drawing. That is direct—with no preliminary studies. The drawings I do are relative to my painting but not for it.

Source: Possibilities, I (winter 1947-48), p. 79. Reprinted in by Francis V. O'Conor, Jackson Pollock (NY: Museum of Modern Art, 1967)

Abstract Expressionism: Action Painting

Three years later, in 1947, Jackson Pollock made the physical act of energetically applied paint—the gesture—the undisputed focus of painting. This is not to say that his abstract **gesture paintings** are just about the art process, because that process is now a metaphor for the human condition, which previously had been represented through hieroglyphs and biomorphic forms. Almost simultaneously, a second artist emerged, Willem de Kooning, who similarly employed bold gestural abstraction to express his innermost feelings.

JACKSON POLLOCK Through the 1930s, Jackson Pollock (1912–1956) was a marginal figure in the art world who worked odd jobs, including being a custodian at what is today called the Solomon R. Guggenheim Museum. In the early 1940s, just when he started Jungian psychoanalysis, he became a hardcore Surrealist, making crude but powerful paintings filled with

29.2 Jackson Pollock, *Autumn Rhythm: Number 30.* 1950. Enamel on canvas, 105 × 207" (266.7 × 525.8 cm). Metropolitan Museum of Art, New York, George A. Hearn Fund, 1957 (57.92)

slapdash hieroglyphs, totems, and references to primitive myth, whipped about in a swirling sea of paint. His big break came in 1943 when Peggy Guggenheim exhibited his work at her gallery, Art of This Century, and gave him a stipend to paint.

At the Betty Parsons Gallery in 1948, Pollock unveiled his first gesture or action paintings, the latter term being coined in the 1950s by art critic Harold Rosenberg (1906-1978). A famous example of this style is Autumn Rhythm: Number 30 (fig. 29.2) of 1950, an 8-by-17-foot wall of house paint that was applied by dripping, hurling, pouring, and splattering when the unstretched canvas was on the floor. Pollock had worked on it from all four sides, and he claimed that its source was his unconscious. (See Primary Source, page 1038.) Despite the apparent looseness of his style, Pollock exerted great control over his medium by changing the viscosity of the paint, the size of the brush or stick he used to apply the paint, and the speed, reach, and direction of his own movements, and he rejected many paintings when the paint did not fall as anticipated. The energy of the painting is overwhelming, and from its position on a wall the work looms above us like a frozen wave. Our eye jumps from one stress to another-from a white blob, to a black splash, to a Masson-like automatic line, and so on. There is no focus upon which the eye can rest. Because of these even stresses throughout the image, Pollock's compositions are also often described as allover paintings.

Pollock constructed his picture as he went along, with each new move playing off the previous one, and emotional intuition dictating the next gesture. The resulting image is not just a record of the physical self, but also of the psychological being. Because the artist must face the challenge of the bare canvas and the risktaking responsibility of making each mark, painting becomes a metaphor for the challenges of the human condition and the risks inherent in taking responsibility for one's actions, particularly in an Existentialist world. World War II dashed the blind belief in the superiority of science, progress, and utopian societies. The one thing that could be trusted and believed in was the self, and *that* became the sole subject of Abstract Expressionist painting.

WILLEM DE KOONING Pollock's style was too personal to spawn significant followers. The gesture painter who launched an entire generation of painters was Willem de Kooning (1904–1997), a Dutch immigrant, who quietly struggled at his art for decades in New York's Greenwich Village. Encouraged by his friend and mentor Arshile Gorky, de Kooning made Picassoinspired Cubist-Surrealist paintings in the 1940s, mostly of women. He finally got his first one-person show in 1948, at the Egan Gallery, when he was 44. The radical works he presented appeared to be total abstractions of dramatically painted curving lines and shapes that entirely covered the canvas with the same evenness as in Pollock's allover paintings.

Despite the spontaneity implied by the bravura paint handling, the pictures were laboriously crafted, often using methods similar to those of the Surrealists. For example, de Kooning fired his imagination by pinning line drawings on his canvas, not only at the beginning but throughout the process. Charcoal lines

29.3 Willem de Kooning, *Woman I*. 1950–52. Oil on canvas, $75\% \times 58$ " (1.93 × 1.47 m). Museum of Modern Art, New York. Purchase

drawn on dried paint to both provoke and experiment with composition sometimes remained in the final picture. He jump-started other paintings by inscribing large letters across the canvas. Like Pollock, he constructed the paintings through a continuous process of gestural reactions based on intuition and emotion, with the resulting marks reflecting his presence, feeling, and uncontrollable urges. Unlike Pollock, however, de Kooning's Expressionist paint handling retained the push-pull of Cubist space and composition, with one painterly form residing above or below another.

De Kooning shocked the art world with his second exhibition, held at the Sidney Janis Gallery in 1953. He did the unthinkable for an Abstract Expressionist: He made representational paintings, depicting women, as seen in *Woman I* (fig. **29.3**), a work he struggled with from 1950 to 1952. It now became clear that the curvilinear patterning of the earlier abstractions was as sexual as everyone had suspected, or as the critic Tom Hess put it, the works were "covert celebrations of orgiastic sexuality." De Kooning reportedly painted and completely repainted *Woman I* hundreds of times on the same canvas, and he also made numerous other paintings of women in the summer of 1952 when he was in East Hampton on Long Island, New York. The process of making the picture was almost as important as the final product, as though it were a ritualistic catharsis of sorts.

Woman I is by far the most violent and threatening of numerous paintings in the Women series, the other women having a neutral appearance and embodying a broad range of attributes. Nonetheless, de Kooning intended Woman I to be equally unfixed in meaning, or as open to interpretation. He was surprised that viewers did not see the humor in his threatening, wide-eyed, snarling figure, which was based as much on contemporary advertisements of models smoking Camel cigarettes as on primitive fertility goddesses, such as the Paleolithic Woman of Willendorf (see fig. 1.14), both of which the artist cited as sources. In the Women series, as in all of his paintings, de Kooning played out his own ambivalent emotions, which, because they constantly changed, allowed him to keep repainting his figure.

Abstract Expressionism: Color-Field Painting

Abstract Expressionism had a flip side. If one side was gestural painting, then the other was **color-field painting**. Instead of bombastic brushstrokes and the overt drama of paint, these painters used large meditative planes of color to express the innermost primal qualities that linked them to universal forces. The objective of the color-field painters, like that of their gestural counterparts, was to project the sublime human condition as they themselves felt it. The principal color-field painters—Mark Rothko, Barnett Newman, and Clifford Still—all started out by making mythinspired abstract Surrealist paintings in the 1940s and were close friends until 1952.

MARK ROTHKO Mark Rothko (1903–1970) ranks among the best-known color-field painters. His paintings from the 1940s draw heavily from Greek tragedy, such as Aeschylus' Oresteia, and from Christ's Passion cycle and death—scenes with a harrowing psychology where the lone individual faces ultimate truths about existence, death, and spirituality. But all suggestion of figuration disappeared in 1947. In 1949, Rothko arrived at his mature style, from which he did not deviate for the remainder of his life.

Now, Rothko's paintings consisted of flat planes of color stacked directly on top of one another, as in the 10-foot-high 1953 work *No. 61 (Rust and Blue)* (fig. **29.4**). There is no longer any storytelling, nor any hieroglyphics or symbols, even in the title. But the painting is still mythic, for the artist has painted what he himself has confronted, the inevitable void of our common future and our sense of mystical oneness with unseen cosmic forces, a theme reminiscent of Caspar David Friedrich's *Abbey in an Oak Forest* (see fig. 24.8). Rothko's subject, he explained, was "tragedy, ecstasy, doom, and so on." His ethereal planes are so thin, color glimmers through from behind and below, creating a shimmering spiritual light. Their edges are ragged, and like clouds dissipating in the sky, they seem precariously fragile. Although the painting

29.4 Mark Rothko. *No. 61 (Rust and Blue)* (also known as *Brown, Blue, Brown on Blue).* 1953. Oil on canvas, $115\frac{3}{4} \times 91\frac{1}{4}$ " (2.94 × 2.32 m). Museum of Contemporary Art, Los Angeles. The Panza Collection

is not about process, we feel Rothko's hand building up the planes with individual marks, giving the work a poignant organic quality. Space is paradoxically claustrophobic and infinite. On the one hand, the planes literally crowd the picture to the edges and hover at the very front of the picture plane, while on the other hand, the pervasive blue ground seems to continue forever, uncontained by the edge of the canvas and suggesting infinity. Enormous shifts in scale give a sense of the sublime. Note, for instance, the tiny, thin wisp of soft white on the bottom of the middle plane, which seems so insignificant in comparison to the enormous planes and the vast size of the canvas.

Regardless of the palette, whether bright yellows and oranges or the more moody blues and browns in *No. 61*, the colors in a Rothko painting have a smoldering resonance that makes the image seem to glow from within and evoke a spiritual aura. Rothko wanted viewers to stand close to his enormous iconic images, which would tower over them, and where they would be immersed in this mystical void of the unknown future, as if standing on the precipice of infinity and death. After making a series of predominantly dark paintings, Rothko committed suicide in 1970.

New York Sculpture: David Smith and Louise Nevelson

Like the Abstract Expressionist painters, the avant-garde sculptors of the postwar period were originally Surrealists, and most were similarly steeped in Existentialist philosophy. Some, like David Smith, developed their compositions as they worked on their sculptures, which were largely abstract. Others, like Louise Nevelson, retained the hieroglyphic signs of Surrealism but now began working on an enormous scale, in part spurred by the scale of Abstract Expressionist painting.

Along with Alexander Calder (see page 1001), who returned to America with World War II, David Smith (1906–1965) was perhaps the most visible American sculptor at midcentury. He began as a painter, but upon seeing illustrations of welded steel sculpture by Picasso and González (see pages 994–95), he adopted the blowtorch as his tool and metal as his medium, which he used throughout his career. He was friendly with the Abstract Expressionist painters, and even after moving to a farm in Bolton's Landing in upstate New York in 1940, he periodically came to the city for long periods and socialized with them in Greenwich Village.

Smith was steeped in the Existentialist philosophy of his circle, and, like his colleagues, he dedicated his work to expressing his physical and psychological being. His career follows a path similar to Rothko's, moving from Surrealist sculptures that were basically drawings of organic forms in space, suggestive of Miró, to totally abstract iconic forms. Beginning in the mid-1940s, Smith constructed his sculptures from large reserves of metal that he always had on hand, working not so much from preliminary sketches and preconceived notions of a finished product but, like de Kooning and Pollock, by a continuous chain of reactions to each gesture, which in his case would be made in a welded material. Despite his working method, which allowed him to work and think in the round, he generally conceived his sculptures like paintings, to be seen almost two-dimensionally from a single viewpoint.

An example of Smith's late, iconic style is the Cubi series (fig. 29.5), begun in 1961 and consisting of 18 works. Because of its severe geometry, the Cubi series is unusual for Smith. He did not have equipment to cut stainless steel, and consequently was forced to order it from the manufacturer in precut rectangular shapes, which he assembled into boxes of different sizes that he welded together based on intuition and personal emotion. Despite their relentless geometry, these enormous sculptures are hardly mechanical and unemotional. They are both anthropomorphic and totemic, evoking giant figures and ritualistic structures. They have the sublime presence of a prehistoric monument and embrace a powerful spirituality. It is as though the elemental forms, placed on a tabletop altar, are the very building blocks of the universe itself, their sense of movement and solidity reflecting the essence of life, their precarious arrangement the inevitable impermanence of all things. Smith ended by burnishing the steel, giving it a textured finish. And because we can feel his touch here, the work takes on a surprising organic quality.

29.5 David Smith, *Cubi* series as installed at Bolton's Landing, New York. Stainless steel. Left: *Cubi XVIII*. 1964. Height 9'8" (2.95 m). Museum of Fine Arts, Boston. Center: *Cubi XVII*. 1963. Height 9' (2.74 m). Dallas Museum of Art. Right: *Cubi XIX*. 1964. Height 9'5" (2.87 m). Tate Gallery, London

29.6 Louise Nevelson, *Sky Cathedral—Moon Garden Plus One.* 1957–60. Painted wood, black, $9'1" \times 10'2" \times 1'7"$ (2.78 × 3.1 × 0.5 m). Collection of Milly and Arne Glimcher, New York. Courtesy PaceWilderstein, New York

Smith's work became dramatically larger in the 1950s, influenced, in part, by the scale of Abstract Expressionist painting. Another Surrealist sculptor followed suit: Louise Nevelson (1900–1988), who emerged in the 1940s. By the 1950s, she was working with fragments of black-painted wood assembled in mysterious black boxes, and by the end of the decade, she began making enormous walls of these boxes.

One of these is *Sky Cathedral—Moon Garden Plus One* (fig. **29.6**), produced from 1957 to 1960. In it, fragments of furniture and architecture become provocative Surrealist objects in a poetic dreamlike setting. We sense we are looking at the flotsam and jet-sam of civilization, the fragments of people's lives, of people long gone. But as the title suggests, Nevelson's forms also evoke land-scape and the cosmos, the round shapes suggesting the planets and moons, the splintered wood the mountains, and the accumulation of boards the rock formations. Nevelson wanted her black works (others are all gold or white) illuminated by a blue light, which would suggest twilight, the moment of transformation, when things begin to look different and to change into something else, swallowed up by unseen mystical forces.

EXISTENTIALISM IN EUROPE: FIGURAL EXPRESSIONISM

Abstract Expressionism was identified with the United States, which in the late 1950s began exporting the work to Europe in exhibitions sponsored by the federal government. These shows, ostensibly for the sake of good international public relations, strutted the country's artistic superiority and virility, and complemented its military, financial, and technological dominance. They were cultural pawns in the Cold War. While Europeans developed a counterpart to Abstract Expressionism, perhaps the best-known Existentialist painting was figurative. Two especially powerful artists were Jean Dubuffet and Francis Bacon. Both were loners, with no group or movement affiliations, and artistically kept to themselves, independently developing their own responses to the existential loneliness of human existence.

Jean Dubuffet

As a young man, the Frenchman Jean Dubuffet (1901–1985) was an unlikely candidate for artistic fame. Until the early 1940s, his commitment to, and even his belief in, art was intermittent, and he often worked for a family wine business. Many of his attitudes paralleled Dada: He was antiart and antibourgeois. What interested him most was finding a way to see beyond the blinders of civilization, with its limited concepts of beauty and reality. As had Kandinsky, Malevich, and Mondrian before him, Dubuffet sought to reveal higher truths, namely the interconnectedness of all things in the universe.

Critical to Dubuffet's development was his discovery in the early 1940s of the art of the untrained and insane, which he called **Art Brut** (literally, "Raw Art") and collected. He felt artists untouched by conventional training were uninhibited by the superego and expressed primal urges and desires that were directly connected to mystical forces. Graffiti, children's art anything equally unrestrained and spontaneously produced—fell

29.7 Jean Dubuffet, *Le Métafisyx*, from the *Corps de Dames* series. 1950. Oil on canvas, $45\frac{3}{4} \times 35\frac{1}{4}$ " (116.2 × 89.5 cm). Musée d'Art Moderne, Centre Georges Pompidou, Paris

into this same category. Dubuffet adopted these direct untutored styles in his own art because he believed they represented a universal language that anyone could understand and appreciate.

The second major ingredient in Dubuffet's worldview is the concept that all things are equally consecrated because everything is composed of the same matter and energy. We can see this virtually illustrated in Le Métafisyx (fig. 29.7), painted in 1950 in his Art Brut style. Here, he literally etches his woman into a deep bed of paint, which is crude and rough, suggesting earth, ancient plaster walls, and stone. Not only is this comic-repulsive, soilencrusted woman identified with mineral matter, she is also timeless, for she resembles an archaeological find excavated from a remote prehistoric site. The frenetic graffitilike style is so abstract, we can read the figure in endless ways and even see the scratchy wiry lines as representing an unseen energy that courses through all things. There is even the suggestion of the body dissolving back into elemental matter. Le Métafisyx is part of a series called Corps de Dames (Women's Bodies), which in its crude drawing and grating texture was meant to shock, challenging the art world's conventional notions of beauty and art.

Francis Bacon

Across the English Channel in London, Francis Bacon (1909–1992), a second loner, was stirring up the art world by expressing his own existential angst. One look at his *Head Surrounded by Sides of Beef* (fig. **29.8**) of 1954 and we realize we are in the presence of one of the more frightening images of the twentieth century. Bacon emerged as a force on the London art scene right after World War II, and it is tempting to view his horrific pictures as a statement about the senseless savagery he had just witnessed. But Bacon's themes were already in place well before the war, and presumably they stem largely from his own horrible circumstances, which included abuse as a child and an adult life dominated by the classic vices of alcohol, gambling, and promiscuous sex.

We cannot be sure that these experiences account for Bacon's work, for unlike Dubuffet and the Abstract Expressionists, for example, Bacon did not pontificate about art, issue manifestos, or declare that painting had to fill social voids. Like his Existentialist contemporaries, he painted from the gut, claiming that when he started a picture he had no idea where he would end up. His first painting based on Velázquez's *Pope Innocent X* (there are 45 versions), which is the source for the central figure in *Head*

29.8 Francis Bacon, *Head Surrounded by Sides of Beef.* 1954. Oil on canvas, $51\frac{1}{6} \times 48$ " (129.9 × 121.9 cm). Unframed. The Art Institute of Chicago. Harriott A. Fox Fund. 1956.1201

Surrounded by Sides of Beef, supposedly began as a garden scene. Our painting not only refers to the Velázquez portrait, but also to a contemporary photograph of Pope Pius XII (whose bespectacled head we see), a Rembrandt painting of a flayed ox, and a still of a nurse screaming in the 1925 classic silent film Battleship Potemkin by Sergei Eisenstein (1898-1948). In most of Bacon's paintings based on Velázquez's Pope Innocent X, the focal point is the primal scream of the sitter, the wide dark pit of the opened mouth. In our figure, however, this motif is not nearly as prominent, as it is balanced by the crucified slab of beef that frames the sitter. Add the black void, the claustrophobic compression of the glass cage, and the gritty quality of sections of the paint surface, and we have a house of horror, obviously the chamber of the artist's grim psyche. A viewer cannot get back from the scene, which seems thrown in one's face by the bold brushwork that prominently sits on the surface of the canvas, pulling the image along with it and toward us. Bacon said of his paintings, "You can't be more horrific than life itself."

REJECTING ABSTRACT EXPRESSIONISM: AMERICAN ART OF THE 1950s AND 1960s

By the mid-1950s other styles were already beginning to overshadow Abstract Expressionism. The 1950s planted the seeds of a cultural revolution, producing a thirst for freedom of expression that required the invention of radically new art forms. Combines, **environments**, Happenings, Minimal Art, and Conceptual Art took art into uncharted territory, breaking down the barriers that had previously narrowly restricted art to certain standard mediums.

Re-Presenting Life and Dissecting Painting

No one person or event triggered the dramatic change that occurred in art in the 1950s, but artist Robert Rauschenberg and musical composer John Cage certainly played major roles. Rauschenberg probably spoke for many when he explained why he rejected Abstract Expressionism: "It was all about suffering and self-expression and the State of Things. I just wasn't interested in that, and I certainly did not have any interest in trying to improve the world through painting." Jasper Johns, Rauschenberg's close friend at the time, similarly rejected Abstract Expressionism. While both artists made paintings that had the gestural mark making of the Abstract Expressionists, these works were an intellectual, impersonal analysis of art rather than an explosion of feelings and primal urges.

ROBERT RAUSCHENBERG AND JOHN CAGE Robert Rauschenberg (1925–2008) was a Texan from a working-class family who ended up in New York studying painting by 1947. A critical component of his development was attending the avant-garde

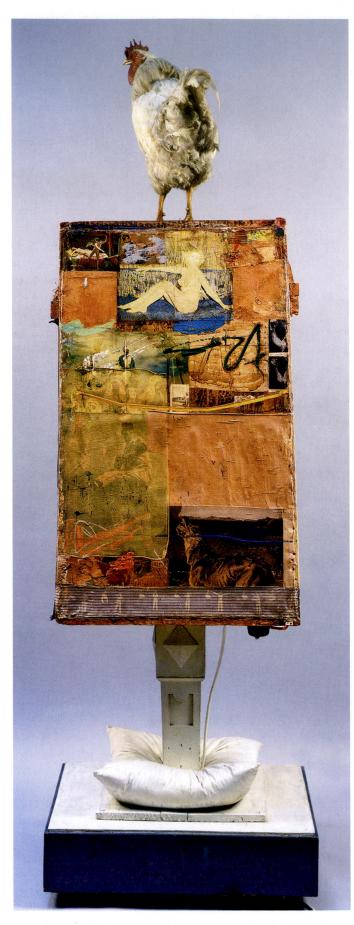

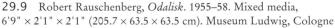

Black Mountain College in North Carolina in the fall of 1948, and again in 1951 and 1952. The painting department at the small liberal arts school was headed by Josef Albers (1888-1976), who, with his wife, Anni (1899-1994), had taught at the Bauhaus, in Germany (see pages 1007-10). Rauschenberg did not care for Albers as a teacher, but the institution encouraged experimentation, which turned Rauschenberg away from pure painting, toward an analysis of the very concept of art. At Black Mountain in 1951, he made a series of White Paintings, which he exhibited at the Stable Gallery in New York in 1953. These were large canvases painted a solid white, with no evidence of brushwork. Viewers wondered what they were supposed to see. Themselves, for one thing. Their shadows were cast on the canvases, which also caught reflected colored light and accumulated dust and dirt. These canvases captured real life, which was presented without comment or meaning. Viewers could read anything into them that they wanted. Like Duchamp, Rauschenberg was making Conceptual Art, determined by chance, and aimed at capturing the world without attaching any firm meaning in that process. In their objective neutrality, these extraordinary paintings were the antithesis of the intensely personal Abstract Expressionism, which ruled the day.

One of the people who thoroughly understood the White Paintings was John Cage (1912–1992), an avant-garde composer who was garnering a reputation for his works for altered piano, a piano with objects placed under the strings to change their sound. In response to the White Paintings, Cage wrote 4'33", a piano piece first performed in Woodstock, New York, in 1952. The work was "played" by a pianist who sat down and opened the keyboard and did nothing else for 4 minutes and 33 seconds. During this time the audience listened to the sounds of the real world: the shuffling, coughing, and whispering in the recital hall and the sounds of falling rain and chirping birds coming in through an open window. The last sound was the keyboard case being shut, signaling the end of the piece.

These and many other conceptual works from this period were designed to remove the artist from the work of art as well as to ask such questions as: What is art? How does it function? Rauschenberg picked up where Duchamp had left off. His art, however, is never meant to shock or destroy, and his attitude and approach are always positive. He is a presenter, not a nihilist. He is a collector of life, which he gathers up and energetically presents for us to think about and interpret for ourselves. Furthermore, he was not interested in painting life, but in *representing* it. "I don't want a picture to look like something it isn't. I want it to look like something it is. And I think a picture is more like the real world when it's made out of the real world."

In 1955, Rauschenberg incorporated the real world into his art when he began making **combines**, innovative works that combined painting, sculpture, collage, and found objects, as in his *Odalisk* (fig. **29.9**) of 1955–58. This four-sided "lamp"—there is an electric light inside—is crowded with collaged material culled from contemporary magazines and newspapers as well as detritus from the street and from thrift shops. Even the title is part of this

busy collage, for it has to be considered when we try to construct a narrative for the work. But is there a narrative in this poetic collage of disparate materials? Obviously, Odalisk has a subject, for it is filled with sexual innuendo: the phallic pole jammed into the pillow on the bottom, the stuffed cock mounted above the nude pinup with a dog howling at her from below, the comic strip of a woman in bed being surprised by a man (on a side of the sculpture not pictured here). Even the title, which is a pun on the female odalisque (see fig. 24.13) and phallic obelisk (a tall, tapering stone monument), can be interpreted sexually. But the artist places no value on materials, suggests no interpretation, makes no grand statement. The work just is. It is our materials, our time, our life. Rauschenberg re-presents it with extraordinary formal powers and with a poetry of paint and collage. In its energy and fragmentation, the work powerfully captures the spirit of the constantly changing world and the fractured way we experience it.

JASPER JOHNS In 1954, Rauschenberg met Jasper Johns (b. 1930) and moved into a loft in the same run-down building in lower Manhattan. Although Johns incorporated objects into his paintings before Rauschenberg made his combines, he is primarily a painter, and his works are literally about painting. This can be seen in Three Flags, a work of 1958 (fig. 29.10). Because of the Americana theme, many writers talk about this painting as Pop Art, a style that in New York emerges in the early 1960s and derives its imagery from popular culture. American pride surged in the postwar period as the United States emerged as the most powerful and wealthiest nation in the world. More than ever before, images of the flag were everywhere and an integral part of vernacular culture. Three Flags, however, is not about popular culture, for it is part of series in which the artist repeatedly painted flat objects, such as numbers, targets, and maps, with the intention of eliminating the need to paint illusionistic depth. Here, he has painted a flat object (a flag) on a flat surface (the canvas), so we are not tempted to read, for example, a white star as sitting on top of a blue field because we know it does not. Furthermore, Johns does not place the flag in any context that allows us to read specific meaning or emotion into it. The flag is a sign to which Johns has attached no specific meaning or emotion. In other words, Johns has created a nonillusionistic, impersonal image. What we are left to look at is how the picture was made. Johns's very beautiful and methodical application of wax-based encaustic paint reminds us that a painting consists of paint on canvas. And, of course, painting can be about color, here red, white, and blue. Lest we forget that a painting is a three-dimensional object, Johns has stacked three flag paintings one atop another. We see their sides and hence their depth. Lastly, Johns reminds us that painting can produce an image. However, he does not give us an illusionistic image; we would never mistake Johns's flag for a real flag. As such, Johns tells us an image is a sign, that painting is an abstract language, just like verbal language. Just as a word is a sign, standing for something else, so too is painting; it signifies something else, just as numbers and maps are signs for something else.

29.10 Jasper Johns, *Three Flags.* 1958. Encaustic on canvas, $30\% \times 45\% \times 5$ " (78.4 × 115.6 × 12.7 cm). Whitney Museum of American Art, New York

While the intellectual gymnastics in Johns's paintings are complex and rigorous, the works themselves are objective, devoid of any emotion. Like Rauschenberg, Johns paved a way for artists to break away from the subjectivity and vocabulary of Abstract Expressionism. His powerful assertion of the properties of painting and its inherent flatness would inspire numerous artists in the following decades.

Environments and Performance Art

Rauschenberg's combines played a major role in setting off a chain reaction that caused an explosion of art making that entirely redefined art. Art was no longer just painting, sculpture, and work on paper; now, it took on the form of limitless mediums and moved out of galleries and museums into the real world, sometimes interacting with daily life, other times taking place in such faraway locations that few people ever got to see it. Art was often no longer an object; rather it could be temporary and ephemeral, something that could not be bought and sold.

ALLAN KAPROW In 1956, months after Pollock's death in a car crash, Allan Kaprow (1927–2006), a painter teaching at Rutgers University in New Brunswick, New Jersey, published an article in *Art News* entitled "The Legacy of Jackson Pollock." He described how Pollock's action paintings, often because of their scale and the fact that some contained real objects, had started to become environmental. The next step, he claimed, was to make environmental art: "Pollock, as I see him, left us at the point where we must become preoccupied with and even dazzled by the space and objects of our everyday life, either our bodies, clothes, rooms, or, if need be, the vastness of Forty-second Street." Kaprow knew Rauschenberg's work (he was awed by the *White Paintings*), and this pronouncement about incorporating everyday life into art sounds like a description of the Texan's combines.

In 1958, Kaprow began to make what he called environments, constructed installations that a viewer can enter. His most famous environment, *Yard* (fig. **29.11**), came in 1961. Filled mostly with used tires, the work had the allover look and energy of a Pollock painting, but visitors to the town-house garden where it was installed were expected to walk through it, experiencing it physically, including its smell. Like Rauschenberg in his combines, Kaprow attached no firm meaning to his works, although the discarded synthetic materials suggest a modern industrial urban environment, as well as a sense of waste, even death.

To learn how to add sound to his environments, Kaprow sat in on John Cage's music composition course at the New School for Social Research, a class filled with artists—not musicians almost all of whom went on to become famous. Music was made by chance and generally without traditional instruments. A typical exercise would be to compose a piece with radios and use a method governed by chance, such as the I-Ching, an ancient Chinese system of divination based on random number-generation procedures, to determine when and by whom each radio would be turned on and off and the length of the piece.

The class inspired Kaprow to add the live human figure to his environments, which, unlike *Yard*, initially were made of a variety of collaged nonart materials that ran from floor to ceiling, vaguely resembling a Rauschenberg combine. He unveiled the result to the New York art world in 1959 at the Reuben Gallery as *18 Happenings in 6 Parts*. Using polyfilm walls, Kaprow divided his

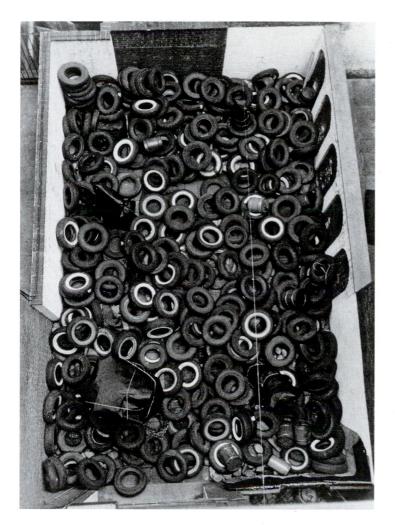

29.11 Allan Kaprow, *Yard.* 1961. Environment of used tires, tar paper, and barrels, as installed at the Martha Jackson Gallery, New York, life-size. Destroyed. Research Library, The Getty Research Institute, Los Angeles, California (980063)

collaged environment into three rooms, in which seated spectators watched, listened, and smelled as performers carried out such tasks as painting (Rauschenberg and Johns participated), playing records, squeezing orange juice, and speaking fragments of sentences, all determined by chance. In a sense, the work was like a Rauschenberg combine that took place in time and space and with human activity. Because of the title of Kaprow's innovative work, a Happening became the term for this new visual art form, in which many of the major artists of the day, including Rauschenberg, started working. While many artists accepted this term, others used different labels, all of which can be grouped under the umbrella term Performance Art, which is distinguished from theater in that it takes place in an art context.

ROBERT WHITMAN 18 Happenings unleashed a flurry of Happenings, or Performance Art, which lasted through the mid-1960s. Soon-to-be-famous artists like Claes Oldenburg, Jim Dine, Robert Morris, and Red Grooms along with Rauschenberg created works. The artist who has dedicated his life to the

genre, which he prefers to call Theater Pieces, is Robert Whitman (b. 1935), a student of Kaprow's at Rutgers and also another vagabond in Cage's famous New School composition class. In 1960, he presented American Moon at the Reuben Gallery. The set was made up largely of paper, cardboard and polyfilm, yet these banal materials were leant a poetic beauty by the strange, nonnarrative actions of the performers, which occurred at a lyrical pace. All of these elements-common materials, poetic imagery, and lyrical pacing-would characterize his work, defying interpretation while evoking a broad range of responses. (To view the performance and a documentary film on this and other Theater Pieces, see <u>www.myartslab.com</u>.) If Kaprow's performance pieces were prosaic, mundane, and very down-to-earth, Whitman's were abstract and dreamlike, garnering him a reputation with art historians as the master of the medium and one of its most innovative practitioners. Whitman thought of his Theater Pieces as one continuous image that unfolds in space and time. Abandoning words, he took the most mundane objects, such as a candle, piece of fruit, or lightbulb, and over time, using light, color, movement, and pacing, transformed it into something magical and mysterious. An especially radical feature of American Moon was film projection, which he used in many of his performances, as seen in Prune Flat (fig. 29.12) of 1965, where film, shadow, and the real-life performers are hauntingly juxtaposed, creating multiple layers of imagery and an oneiric sense of mystery. Whitman's use of film, which he also used in 1964 installations he called Cinema Pieces, were made before the advent of video, and anticipated the Video Art and installations of later decades.

GEORGE BRECHT Also in John Cage's class with Kaprow in 1958 was another unregistered student, George Brecht (1926–2009), who for a class assignment wrote a composition for automobiles entitled *Motor Vehicle Sunset Event*. For this work, participants drew cards with instructions and at sundown in a city parking lot they revved engines, honked horns, rolled down windows, slammed doors shut, and opened and closed hoods and trunks. Brecht began typing up this and other **Events**, as he called

29.12 Robert Whitman, *Prune Flat.* 1965. As performed in 1976. Courtesy of Dia Art Foundation

these compositions, on white cards and mailing them to acquaintances, an act that initiated an art form that came to be called Mail Art. (Brecht's good friend, Rutgers University art teacher Robert Watts, began designing art stamps to mail their Event cards, thus inventing Stamp Art.)

By 1960, Brecht's Events had become quite minimal. Three Aqueous Events, printed on a roughly 2-by-3-inch card, consisted of the title and under it three bulleted words: "water," "ice," and "steam" People receiving the card in the mail could respond in any way they wanted-they could even frame the card. Allan Kaprow, for example, thought of making iced tea. What is the work of art in Three Aqueous Events? The idea? The card itself? The execution of the piece? And who is actually the artist in this work that allows the recipient to be the creator? Brecht was posing the classic Duchampian questions while simultaneously integrating art into daily life and taking it off the aesthetic and intellectual pedestal reserved for high art. By 1962, Brecht's example had helped spawn a New York-based international art movement called Fluxus, similarly dedicated to making a conceptual art that violated the conventional distinctions between art and life, artist and nonartist, museum and street, and which included Performance Art as a major component. One of the group's most famous works is Brecht's Drip Music (1959), which was executed by having the performer mount a stepladder and pour water at varying rates and intervals into a bowl on the floor.

GEORGE SEGAL Living down the road from Kaprow in rural New Jersey was George Segal (1924–2000), who responded to his friend's environments and Happenings by creating representational, not abstract, environments out of real objects and populated by plaster figures, as in *The Gas Station* (fig. **29.13**) of 1963. Now, the performers are frozen, reduced to ghost-white mannequins. To create them, Segal used real people, making castings of them by using plaster medical bandages. Like Rauschenberg and Kaprow, he was breaking down the barrier between art and life. But his art is far from neutral; it is emotional and makes a statement. Segal's work highlights the alienation he perceived in contemporary life. This alienation can be seen in his figures, which are left white, as though drained of life. Generally they are lethargic, exhausted, and alone, and seem trapped by a harsh geometry of the horizontals and verticals of their setting.

The works even contain symbols used in more traditional art. Gas Station, for example, is dominated by a Bulova clock, a memento mori ("reminder of death") motif, which floats in a 10foot expanse of darkness. Its shape mysteriously resonates with the tire on the floor. The vending machine, tires, cans of highperformance oil, and the gas station itself suggest modernity, technology, and fast, efficient living. Missing from this materiality, however, is something meaningful-human interaction and spirituality. Segal retains the existential angst of his Abstract Expressionist background by questioning the meaning of modern existence. Although he often used contemporary branded objects, such as Coke bottles, to give his environments the look of reality and modernity, Segal never celebrated the products of consumer culture, nor questioned how mass-media imagery, including advertising, manipulates its audience. His sculpture is closer in spirit and style to the paintings of Edward Hopper (see fig. 28.53) than to Pop Art, with which he has been mistakenly associated.

29.13 George Segal, *The Gas Station.* 1963. Plaster figures, Coca-Cola machine, Coca-Cola bottles, wooden Coca-Cola crates, metal stand, rubber tires, tire rack, oil cans, electric clock, concrete blocks, windows of wood and plate glass, 8'6" \times 24' \times 4' (2.59 \times 7.32 \times 1.22 m). National Gallery of Canada, Ottawa

Pop Art: Consumer Culture as Subject

Pop Art is a style that emerged in New York in the early 1960s, although it had appeared in a very different guise and with less fanfare in Britain a decade earlier-this incarnation had no impact on the development of American Pop. The style got its name because it derives its imagery from popular or vernacular culture. Like Rauschenberg and Kaprow, Pop artists re-presented the artifacts of the world they lived in, namely the imagery of the mass media, although they did it using conventional painting rather than new mediums. Unlike Johns and Segal, both of whom occasionally used popular imagery, Pop artists focused on the products of popular culture by taking what art historians often describe as a low art form, that is commercial art, and incorporating it into one that is considered high, meaning fine art. By doing so, however, they subversively revealed the manipulative impact of the mass media. Among the best-known Pop artists are the Americans Roy Lichtenstein, and Andy Warhol, as well as the British collagist and painter Richard Hamilton. Although not labeled a Pop artist, the German Sigmar Polke similarly appropriated imagery from mass culture as he not only critiqued that culture but also explored the meaning and language of art.

ROY LICHTENSTEIN Another close friend of Kaprow's was Roy Lichtenstein (1923–1997), who was hired in 1960 to teach painting at Rutgers University. When he arrived he was an Abstract Expressionist painter. Within a year, however, he was making what would be considered Pop paintings, in part influenced by Kaprow's dictum to make art that did not look like art. (See *Primary Source*, page 1050.)

The contemporary life that Lichtenstein scavenged and represented was not the urban streets, as was the case with Kaprow, Rauschenberg, and Segal, but the crude black-and-white advertisements in telephone books and newspapers and the prosaic drawings in comic books. These he cropped and adjusted into visually riveting images, such as Drowning Girl (fig. 29.14). Traditionally, Lichtenstein is appreciated for seeing the beauty of "low art" and elevating it to "high art," in effect celebrating popular culture, and in particular American culture. When first shown, however, his paintings were so radical they were thought hideous and were not even considered art by many. After all, they looked like images from comic books. Furthermore, art, and particularly Modernist art, was supposed to move art forward, investigating new aspects of abstraction. High art was not supposed to look like low art, and it was not supposed to be representational.

Lichtenstein's work does more than just blur the distinctions between fine art and mass culture. Like Johns, whose *Flag* paintings had a profound impact on him, Lichtenstein was interested in the language of art, particularly in regard to issues of perception. He does not just imitate the comic strip, he also plays with that genre's technique of making an image out of benday dots, the small dots that when massed together create color and shading in

29.14 Roy Lichtenstein, *Drowning Girl.* 1963. Oil on canvas, $5'7_{\%}^* \times 5'6_{34}^*$ " (1.72 × 1.69 m). Museum of Modern Art, New York. Philip Johnson Fund and Gift of Mr. and Mrs. Bagley Wright

printed material. He was intrigued by how an illusion of threedimensional volume could be made using flat dots and flat black lines. When viewed from close up, Lichtenstein's large images dissolve into flat abstract patterns, virtually becoming Abstract Expressionist compositions.

Lichtenstein did not randomly select his sources or select them just for aesthetic purposes, for the images that he used for his paintings from 1961 to 1964 tend to fall into a distinct pattern: Men are portrayed as strong, virile soldiers and fighter pilots, whereas women are shown as emotionally distraught, dependent on men, and happily slaving around the house doing domestic chores. With deadpan brilliance, Lichtenstein made his paintings a mirror of contemporary society, revealing the stereotyping deeply embedded in the media. But the paintings themselves appear objective and unemotional, giving little suggestion of a polemical agenda or a sense of the artist's presence, whether his hand (brushwork) or emotions.

ANDY WARHOL Andy Warhol (1928–1987) was making art based on comic books at exactly the same time as Lichtenstein. When the dealer Leo Castelli decided to represent Lichtenstein and not him, Warhol turned to other kinds of popular imagery, namely product design and newspaper photographs. Warhol was from Pittsburgh, and in the 1950s in New York he established himself as a successful illustrator of women's shoes, learning first

Roy Lichtenstein (1923–1997)

From an interview with Joan Marter

In this 1996 interview with the art historian Joan Marter, Roy Lichtenstein talks about the enormous impact Allan Kaprow's environments and New York happenings had on the development of his Pop Art.

- JOAN MARTER: In one of your interviews, you say that "although I feel that what I am doing almost has nothing to do with Environments, there is a kernel of thought in Happenings that is interesting to me." Can you comment?
- ROY LICHTENSTEIN: Well, there's more than a kernel of thought in Happenings that is interesting to me. ... Many of them tended to have American objects rather than School of Paris objects. I'm thinking of the tires, and the kind of advertising sort of things in [Claes] Oldenburg's and [Jim] Dine's Happenings. They were like an American street, maybe from Pollock in a certain way. The Environments are like expanded Pollocks; they are allover in the same kind of sense. If I look at Pollock now, I think they're really beautiful; I don't get all of the gutsy stuff—the cigarette butts and house paint, and everything they're made out of. They had a big

hand the deceiving and manipulative role of advertising and product packaging. He was also fascinated by the impact of the mass media on public opinion. Among his most famous works and among the first he made after abandoning cartoon imagery is the first that he mass-produced, *Campbell's Soup Cans* (fig. **29.15**). He influence on Happenings. Because the Environment would envelop you the way that we thought that Pollock's paintings enveloped you—they were big and seemed to have no end. They were allover, all of that. Some of that, I think, went into Environments, which were kind of a background for Happenings. ... But the thing that probably had the most influence on me was the American rather than the French objects.

- JM: Do you remember anything specifically [about Allan Kaprow's work] that interested you?
- RL: The tires he did [*Yard* at the Martha Jackson Gallery, 1961; see fig. 29.11]. Also other things with strips of paper and things written on them [*Words*, at the Smolin Gallery, 1962]. I think the thing I most got from him was this kind of statement about it doesn't have to look like art, or how much of what you do is there only because it looks like art. You always thought artists should be original, whatever it was. I was doing Abstract Expressionism very late, 1961, and much of that was because it looked like art to me. ... I was amazed at how much he [Kaprow] actually liked [my *Look Mickey* and the other first Pop paintings]. Most people hated it at first.

Source: Off Limits: Rutgers University and the Avant-Garde, 1957-1963, ed. Joan Marter (NJ: Rutgers University Press, 1999)

painted 32 Campbell's soup can images for his first exhibition, in 1962, at the Ferus Gallery in Los Angeles, which at the time had a burgeoning contemporary art scene. The Campbell company then offered 32 varieties of canned soup, hence 32 paintings, which Warhol hand-painted. Warhol installed the works as

29.15 Andy Warhol, *Campbell's Soup Cans.* 1961–64. Acrylic on canvas, 32 works, each $20 \times 16"$ (50.8 \times 40.6 cm). Museum of Modern Art, New York. Gift of Irving Blum; Nelson A. Rockefeller Bequest, gift of Mr. and Mrs. William A. M. Buirden, Abby Aldrich Rockefeller Foundation monotonously as possible, evenly spacing them and placing them on a shelf, as soup cans would be presented in a supermarket. (In our illustration, the works, some later and silkscreened, are arranged in a grid.) Just as the soup came off a mass-production assembly line, Warhol, soon after his Ferus Gallery exhibition, began mass-producing his paintings in his studio, which he called "the Factory." Assistants made the works to his specifications, using a silkscreen process to print a photographic image of a soup can onto canvas, or onto paper, as he did to make prints. (For a more extensive discussion of this process as well as of his portrait of Marilyn Monroe, see the Introduction, pages xxi and xxvi.) Although a workaholic and highly involved with the production of his art, Warhol gave the public the illusion that he barely touched his own paintings and prints, just signing them on the back. With this Duchampian gesture, Warhol tells us that paintings are commodities, that people are buying a name productthat is, a Warhol-and that art is about ideas, not necessarily about technique or craftsmanship.

But Warhol is also commenting on the camouflaging function of product design, how it tells us nothing about the mass-produced product it promotes and how the packaging lures us into buying it. Warhol's art underscores how Campbell's soup is everywhere, having penetrated the farthest reaches of the country, and that mass production, uniformity, and consumerism dominate American society. In effect, his *Soup Cans* are a portrait of America. Like Lichtenstein, Warhol neither praises nor condemns.

BRITISH POP While Pop Art emerged in America in the early 1960s, it had already appeared in London in the mid-1950s. Protesting the conservatism of the Institute of Contemporary Arts, which largely promoted prewar painters and sculptors, a handful of artists formed the Independent Group, dedicated to bringing contemporary life into contemporary art. The war had left Britain commercially weak and with few creature comforts. Thus, the British were more than ready to appreciate the celebrity promotion and advertisements for appliances, cars, and homes that they found in the American magazines that flooded London. Well before their American counterparts, the British were fascinated by the technology and consumerism they saw taking over American society. The Independent Group, led by artists Richard Hamilton (b. 1922) and Eduardo Paolozzi (1924-2005) and critic Lawrence Alloway (1926-1990), embraced American mass culture and celebrated it in their art.

Using the photomontage technique developed by the Berlin Dadaists (see page 988), Richard Hamilton cut images from comic books and body-building and pinup magazines, as seen in his *Just What Is It That Makes Today's Homes So Different, So Appealing?* (fig. **29.16**) of 1956. Sprinkled around the room depicted in this small collage are the latest hi-tech commodities: a tape recorder, television, and Space Age vacuum cleaner. A Ford logo decorates a lampshade, while a can of ham sits on a coffee table as though it were a sculpture. The weightlifter carries a lollipop inscribed with the word "pop," a term coined by Alloway, announcing that this is Pop Art. Sex permeates the image as Hamilton exposes, and perhaps even celebrates, the powerful role sexual innuendo plays in advertising.

THE IMPACT OF POP ART IN GERMANY During the 1960s and 1970s, the art world was focused so heavily on New York that other art centers, especially those in Europe, were all but ignored. Artists in Düsseldorf were producing some of the most important work of the period, yet only Joseph Beuys, whom we shall meet later in this chapter, was well known internationally. It was not until the mid-1980s that the New York art world discovered Sigmar Polke (b. 1941) and Gerhard Richter (b. 1932), two East German transplants, who toward 1963 cultivated a kind of German Pop Art.

Polke and Richter were heavily influenced by the combines of Robert Rauschenberg and by Pop Art, especially the works of Roy Lichtenstein and Andy Warhol, which they knew from magazines. They were also well versed in the Dada antiart movement, since the first postwar Dada exhibition took place in Düsseldorf in 1958, and they were mesmerized by Fluxus, the group that like Dada rejected high art and was dedicated to transforming life into art. Fluxus literally came to Düsseldorf in 1963 when the group presented a festival of performances, Festum Fluxorum. Combined with these artistic forces was the impact of the "economic miracle" of the Marshall Plan (European Recovery Program) in Germany,

29.16 Richard Hamilton, *Just What Is It That Makes Today's Homes* So Different, So Appealing? 1956. Collage on paper, 10¹/₄ × 9³/₄" (26 × 24.8 cm). Kunsthalle Tübingen. Sammlung Zundel, Germany

29.17 Sigmar Polke, *Alice in Wonderland.* 1971. Mixed media on fabric strips, $10'6" \times 8'6'_4"$ (3.2 × 1.6 m). Private collection, Cologne

which by 1963 brought about a stable economy and a degree of consumerism. As a result, Polke and Richter, to varying degrees, were preoccupied with mass-media imagery, commodity culture, and analyzing art, revealing how it functions and takes on meaning. For a brief period they called their art "Capitalist Realism," a pun on Socialist Realism, the official representational propaganda art of East Germany and the rest of the Soviet Union. Richter, in his paintings, largely focused on appropriating photographs, both mass-media and family, using a blurry presentation to undermine the reality of the image and turn it into a fictitious haze, thus revealing the artifice of painting and suggesting the ambiguity of the meaning of the original photograph.

Polke's work was more varied at this time; throughout his career, the look of his work and the issues he has dealt with have changed constantly. In the 1960s, he made countless drawings, often based on images in magazines and advertising, showing common products. He used a range of styles, such as a slick deadened illustrational look and a crude cartoony style. He also often used nonart materials, such as blue ballpoint pen on notebook paper. These works were a rejection of the refinement of the highart tradition, and at the same time they were quite cynical, not only toward artistic values but also the mass media and how it transformed commercial products into appealing objects: The objects in Polke's drawings weren't appealing. Polke also made drawings and paintings using Raster dots, the small dots used in commercial printing. He blew up the original magazine photograph so large the image became a fascinating grid of dots. In a 1966 painting entitled Bunnies a re-presentation of a magazine photograph of bunnygirls at a Playboy club (here the commodity is sex), the original image became a pixilated blur, the bunnies reduced to vibrating dots of different shades of black and gray and just barely visible. In Bunnies, Polke exposes the artificiality of image making, revealing how the original magazine photo was not reality but just an image consisting of dots.

Before the decade was out, Polke was creating art on a wide range of surfaces and with a wide range of materials, as suggested by Alice in Wonderland (fig. 29.17) of 1971, which is paint printed on store-bought printed fabric, not canvas. One fabric is covered with soccer players and the other with polka dots, the latter a visual pun on the artist's name but also a reference to his use of Raster dots, and thus the media. Like Warhol, Polke printed appropriated images on his fabric-a ghost-white image of a basketball player, pirated from a magazine, and the caterpillar with a hookah and Alice biting into a mushroom, taken from the illustrations by Sir John Tenniel for Lewis Carol's 1865 Alice in Wonderland. Difficult to see in reproductions are the appropriated 1950s-style outlines of the heads of a man and woman, handstamped several times in red and yellow. Polke bombards us with a variety of pilfered images, images executed in a range of styles and from many different periods. In effect, he is telling us that we both see and know the world through images, and that this pictorial world becomes the real world, our reality. Supposedly, the painting was inspired by watching sports on television while under the influence of drugs, the theme of hallucination being suggested by the caterpillar's hookah and Alice's mushroom. If this is the case, we can add portraying the experience of sensory perception to the long list of issues we find in this painting. Another issue is how context structures meaning. Polke demonstrates this by layering his motifs, for the narrative of his scavenged images would change if they were juxtaposed differently. Ultimately, it is virtually impossible to attach a fixed meaning to Alice in Wonderland, allowing us to assume that Polke sees art, and images in general, as not having fixed meanings-only interpretations depending on context and who is doing the interpreting.

Ultimately, Polke and Richter did not consider their art Pop Art, and despite Polke re-presenting media images, as did Warhol and Lichtenstein, there is no mistaking his art for theirs. In his work, there is no sense of fun or light humor and no sense of celebrating low art, even if the Americans were actually being subversively ironic in their celebration. To the contrary, his paintings and drawings often have a sense of parody, or as seen in *Alice in Wonderland*, and a sense of loss or sadness, as evoked by the ghostlike figures, the chaos of the imagery, and the emptiness of the "television snow" of polka dots. Instead of seeming objective and unemotional, his art appears subjective and emotional. As we shall see in the next chapter, Polka's art, heavily influenced by Pop, anticipated many of the fundamental issues of Postmodernism, and his layering of imagery and interest in how images and art function and take on meaning would prove quite influential.

FORMALIST ABSTRACTION OF THE 1950s AND 1960s

The most influential art critic in the United States in the 1940s and well into the 1960s was Clement Greenberg, who wrote art reviews for *The Nation* and *The Partisan Review*. He began by championing Pollock's formalism, but as the 1940s progressed he increasingly promoted an art that was totally abstract and nonreferential and dealt with just those qualities inherent to the medium, that is color, texture, shape of field, and composition. Such work, which emphasized the formalist or abstract qualities of the medium, could make no reference beyond itself. Greenberg's theories had an enormous impact on the way painters, sculptors, and other critics thought about art. His criticism helped lay a foundation for the Post-Painterly painting and Minimalist Art of the 1950s and 1960s.

Formalist Painting

Formalist painting emerged in the heyday of Abstract Expressionism, the early 1950s, and in large part as a reaction to it. Just as Rauschenberg, Johns, Kaprow, and the Pop artists rejected the subjective components of Pollock and de Kooning, the formalist painters sought to make unemotional art. They replaced bold, gestural brushwork with smooth surfaces that gave no hint of the artist's hand or feelings. Instead of the push-pull of Cubist space of de Kooning's style of Abstract Expressionism, they powerfully asserted the flatness of the canvas, virtually eliminating any sense of space. Led by Greenberg, they were attracted to the formalist implications of Abstract Expressionism, not its emotional content. They also embraced the style's enormous scale. Among the formalist styles of the period are Post-Painterly Abstraction, Hard-Edge Abstraction, and Minimalism.

HELEN FRANKENTHALER Greenberg championed Helen Frankenthaler (b. 1928) as one of the new formalists. Frankenthaler was inspired by Jackson Pollock, who, toward 1950, in an attempt to expand his art beyond drip paintings, began working on unprimed canvases, using just black enamel paint and allowing

it to seep into the fabric, creating a smooth surface. Frankenthaler built on the implications of this technique. In a breakthrough work of 1952, *Mountains and Sea* (fig. **29.18**), she developed **stain painting**. Frankenthaler had just returned from Nova Scotia, and using charcoal on unprimed canvas, she quickly laid in a composition suggesting landscape. Working like Pollock, she put her canvas on the floor. She then poured thin oil paint on it, tilting it to allow the paint to run, drawing and painting by changing the angled tilt of the canvas rather than using a brush. The thin oil bled into the canvas, becoming one with it and having the translucency of watercolor. Greenberg admired the picture's flatness and the fact that the paint was not tactile, a three-dimensional quality

29.19 Ellsworth Kelly, *Red Blue Green*. 1963. Oil on canvas, $7'8" \times 11'4"$ (2.34 × 3.45 m). Museum of Contemporary Art, San Diego, La Jolla, CA. Gift of Jack and Carolyn Farris that he felt would result in the illusion of space. He declared you could not sense the artist's hand, and thus her presence, and praised the picture's nonreferential "decorativeness" as opposed to its "expressionistic" qualities. While Pollock first used unprimed canvas, it was Frankenthaler's example of thin translucent oils that spawned in the 1950s and 1960s legions of stain painters, of whom the best known are the Washington Color School painters. Unlike Frankenthaler, however, her followers' work was entirely abstract.

Greenberg's personal infatuation with Frankenthaler apparently blinded him to the Abstract Expressionist side of her work. Like her many followers, she is now often labeled a Post-Painterly Abstractionist, a term that refers to the smooth nongestural nature of this kind of abstraction, but in the 1950s and 1960s she was generally considered a second-generation Abstract Expressionist. As the title implies, *Mountains and Sea* reflects her experience of the Nova Scotia landscape. The energy of the curving, explosive composition seems to embody the sublime force of nature, while the soft translucent colors and white unprimed canvas evoke the brilliant glare of sunlight. Although essentially abstract, the picture is filled with references, which is generally true of her work up to the present day.

ELLSWORTH KELLY In contrast, there are no references whatsoever to be found in the abstraction of Ellsworth Kelly (b. 1923). Kelly developed a distinctly American brand of formalist painting in Paris from 1948 to 1954. During these years, he began to reduce painting to a barebones simplicity, which some critics called Hard-Edge Abstraction. To free his mind from earlier art, he based his abstractions on shapes he saw in the world around him, especially negative spaces, such as the opening under a bridge, a shadow, or a window. His paintings use just a handful of geometric shapes in solid primary and secondary colors to explore how forms move through space, how colors interact, and how "figure" relates to "ground," that is, how image relates to background. Kelly generally locks his figure and ground so tightly into a single unit they seem to coexist on the same spatial plane.

In *Red Blue Green* (fig. **29.19**), a 1963 work, Kelly plays a red rectangle and a blue curved shape off a green ground. The left side of the painting appears fixed, whereas the right has movement. When standing in front of this enormous work, which is more than 11 feet wide, a viewer can feel at one moment the green ground consuming the blue and at the next moment the blue plunging down into the green. In other words, the figure–ground relationship is reversed. But never to be forgotten is the sheer intensity of the color, especially as presented on such a large scale. Kelly's genius is the simplicity of his gesture: He stripped everything else away, including any sense of himself, to make a painting that is about color—in this case red, blue, and green—and movement.

FRANK STELLA Just as Kelly was returning from Europe, a young Frank Stella (b. 1936) began his studies at Princeton University, opting for an art education at a university rather than an art school, which became commonplace after the war. Within a year of graduating, he was in New York and the talk of the town because of his "Black Paintings," included in a 1959 Museum of Modern Art exhibition called *Sixteen Americans*. These were total abstractions consisting of black parallel bands created by allowing white pinstripe lines of canvas to show through. He soon began working in color, as in *Empress of India* (fig. **29.20**) of 1965, and on an enormous scale, here over 18 feet across. Inspired by the inherent flatness of Johns's *Flag* paintings (fig. 29.10), Stella made entirely flat works as well.

29.20 Frank Stella, *Empress of India*. 1965. Metallic powder in polymer emulsion on canvas, 6'5" × 18'8" (1.96 × 5.69 cm). Museum of Modern Art, New York. Gift of S. I. Newhouse, Jr.

Frank Stella (b. 1936)

Pratt Institute Lecture

In 1959, Stella gave a lecture to students at New York's Pratt Institute in which he discussed his paintings then being shown in the Museum of Modern Art's Sixteen Americans exhibition. He specifically addressed what he saw as one of the most pressing formalist issues facing painters at the time: how to make a composition that was not about the relationship of its parts.

There were two problems which had to be faced. One was spatial and the other methodological. In the first case, I had to do something about relational painting, i.e., the balancing of the various parts with and against each other. The obvious answer was symmetry—make it the same all over. The question still remained, though, of how to do this in depth. A symmetrical image or configuration placed on an open ground is not balanced out in the illusionistic space. The solution I arrived at—and there are probably quite a few, although I know of only one other, color density—forces illusionistic space out of the painting at a constant rate by using a regulated pattern. The remaining problem was simply to find a method of paint application which followed and complemented the design solution. This was done by using the house painter's technique and tools.

Source: Pratt Institute Lecture, 1959

There is no figure-ground relationship in *Empress of India*, and no push-pull of Cubist and Abstract Expressionist space. In fact, there is no hierarchy to the composition, which is determined by the V-shape of each of the four canvases that have been butted together. Stella said of his work, "What you see is what you see." In other words, the painting has nothing that you do not see—no hidden meanings, symbols, or references. Despite giving his work suggestive titles such as *Empress of India*, Stella wanted his canvases viewed simply as objects with an independent life of their own, free from associations. (See *Primary Source*, above.)

Fellow artists and critics evaluated this kind of abstract art on its ability to invent new formalist devices (for example, Stella's ability to create perfectly flat, spaceless painting or the innovative shapes of his canvases). However, the power of such work lies in the sheer force of its scale and dramatic sense of movement as the Vs change direction to create new lines of movement. Because Stella used a stripped-down artistic vocabulary and often determined his compositions using a geometric premise, critics often describe his paintings from this period as Minimal Art.

Formalist Sculpture: Minimal Art

A group of sculptors emerged in the early 1960s who generally composed their work using a mathematical or conceptual premise, paralleling in sculpture what Stella was doing in painting. Their reliance upon geometry in this new work emphasized conceptual rather than emotional content, and it favored the means and materials of mass production. Their sculpture came to be known as Minimal art. Artists often avoided making the objects themselves, preferring to send specifications to an artisan, or more likely a factory, for production. Like Pop paintings, Minimal

^{29.21} Donald Judd, *Untitled*. 1969. Copper, ten units, $9 \times 40 \times 31$ " (22.8 × 101.6 × 78.7 cm) each, with 9" (22.8 cm) intervals; $170 \times 40 \times 31$ " (432 × 101.6 × 106.7 cm) overall. Solomon R. Guggenheim Museum, New York. Panza Collection. 91.37.13

sculpture lacks the evidence of the artist's touch that traditionally served as the sign of personal emotion and expression as well as proof of the artist's technical accomplishment. There is no sign of the artist at all. Furthermore, the artists used unconventional nonart materials to make art—Plexiglas, fluorescent tubes, galvanized steel, magnesium tiles—continuing the exploration of new materials that characterized so much of the art making of the late 1950s and 1960s. Similarly, one of their concerns was to make art that did not look like art. Like Stella, they wanted their artworks to be perceived as independent objects, having no reference to things beyond themselves.

DONALD JUDD The characteristics of Minimalism are apparent in *Untitled*, a 1969 sculpture of copper boxes (fig. 29.21) by Donald Judd (1928–1994). The sculptor determined the shape and spacing of the boxes by mathematical premise (each box is 9-by-40-by-31 inches, with 9 inches between boxes), not by intuition or artistic sensitivity, as David Smith, for example, operated (see fig. 29.5). Like Stella's paintings, Judd's work was constructed by serial repetition of elements so there is no hierarchy of composition and no evocation of emotion. A viewer can take in and readily understand his composition at a glance.

Judd described his sculpture as a "specific object," meaning it was a real object that had no references beyond itself. Viewers were to admire it for its scale, color, texture, and proportions, for example. In addition to possessing the properties of a well-made "real thing," Judd's boxes occupy space like ordinary things as well. They are not presented on a base, and there is no glass case to protect them. By relinquishing the props that announce an object to be a work of art, Minimalism heightens our awareness of the spaces in which we view art. In other words, the space around the object becomes an integral part of the work and of the art experience.

DAN FLAVIN The Minimalist whose work was perhaps most severely limited to mathematical formulas is the light sculptor Dan Flavin (1933–1996), renowned for working with common fluorescent tubes, which he used to sculpt with colored and white light. Flavin's tubes were store-bought and came in 2-, 4-, 6-, and 8-foot lengths.

Although difficult to tell from reproductions, Flavin's deceivingly simple works are spectacularly beautiful, even when they use just white light, as in *the nominal three (to William of Ockham)* (fig. **29.22**). The magical quality of the light as it radiates through the surrounding space is mesmerizing, even calming, often projecting a Classical serenity. For some viewers, it even embodies spirituality. The work, however, is strictly formalist and is determined by geometric premises, here a progression from one to two to three lights. No references are intended, despite the suggestion of the title, which Flavin attached upon finishing the work.

Flavin's sculpture is often extremely simple, consisting of a single tube of white or colored light, sometimes placed vertically on the wall and sitting on the floor, other times coming off a corner along a wall at a 45-degree angle. With Minimalism, art reached "Ground Zero." Reduced to bare essentials, it *seemed* to have no place left to go.

29.22 Dan Flavin. *the nominal three (to William of Ockham).* 1963. Fluorescent light fixtures with daylight lamps, each 6' (1.83 m). Solomon R. Guggenheim Museum, New York. Panza Collection. 91.3698

THE PLURALIST 1970S: POST-MINIMALISM

The cold objectivity of Minimalism and formalist abstraction dominated contemporary art in the mid-1960s and into the 1970s, overshadowing styles that focused on subjectivity and the human figure. Even Pop Art seemed unemotional and machine-made. But as the 1960s developed, so did an interest in an art based on emotion, the human being, and referential and representational subject matter. In the midst of the Vietnam War and the civil rights-led social revolution that challenged the status quo, artists began to view formalist abstraction as an escapist indulgence. With Minimalism, many artists felt that the Modernist avantgarde had completely lost touch with society, retreating into a hermetic world of its own. By the mid-1960s, artists could no longer remain removed from their emotions and the hotly contested social and political issues of the day. By the late 1960s, American artists began to put the human component back into art, and many addressed the issues tearing the nation apart. The responses were diverse, with artists using what seems like an endless array of mediums to deal with an endless array of issues. Now, many artists made art that was temporary or conceptual and could not be collected, in effect dematerializing the art object and reflecting the antimaterialist stance of the 1960s social revolution. (See The Art Historian's Lens, page 1059).

Artists themselves became quite political as they attacked the bastions of white male art, museums and commercial galleries. Women, African Americans, Latinos, American Indians, and Asian Americans vociferously protested their exclusion from the art world by picketing museums and denouncing the prejudices of those organizations. More important, they began making art that dealt with issues that museum curators and directors did not consider mainstream or valid aesthetic concerns—issues such as gender, ethnic and racial identity, as well as sexual orientation. Disenfranchised artists, like the Impressionists 100 years earlier, began opening their own galleries to provide an alternative to museums. Because the pluralism of the 1970s came on the heels of Minimalism, and in many respects is a response to its hermetic aesthetics, the art from this decade is often called Post-Minimalism.

Post-Minimal Sculpture: Geometry and Emotion

Some of the first Post-Minimal sculptors retained the geometry of Minimalism, but they were hardly creating insular, discreet objects. To the contrary, their geometric forms were loaded with powerful emotional issues.

EVA HESSE One of the outstanding Post-Minimalists in the 1960s was Eva Hesse (1936–1970). Her accomplishment is astonishing when one considers that her career was cut short when she died of a brain tumor at age 34. Born in Hamburg, Germany,

she was raised in New York after her Jewish parents fled Nazi persecution. Hesse worked with a variety of unusual materials, such as acrylic paint on papier-mâché slathered over balloons. Her sculptures were abstract and had a basis in geometry. But because they reveal the dripping, pooling, flowing, stretching, and drying by which they took shape, they also suggest organic forms and processes, and growth and sexuality. In 1968, she began using fiberglass, which became her trademark material and was perhaps responsible for her brain cancer.

A classic work is Untitled (fig. 29.23), which has as its starting point the geometric form of Minimalism. The four rectangular units of which it is composed imply boxes or framed paintings because of their curled edges. Contradicting their geometry are the uneven rippling surfaces and sides, which transform the fiberglass into an organic substance, especially recalling skin. The strange ropelike latex appendages eccentrically flopping from either side of center suggest arms or legs, momentarily transforming the boxes or frames into a family of individuals. Ultimately, these appendages are nothing more than abstract elements, like the rectangular units. The work is full of contradictions: It is simultaneously funny and morbid, geometric and organic, erotic and repulsive, abstract and referential. (See www.myartslab.com.) Perhaps the most powerful quality in Hesse's sculptures is the sense of frailty, wear, decay, and aging-best expressed in Untitled by the wobbly "legs."

RICHARD SERRA Emerging at the same time was sculptor Richard Serra (b. 1939), who befriended Hesse. He explored the properties of sculpture in a series of works that included making **process art**, in which the creative act itself was the art, such as

29.23 Eva Hesse, *Untitled.* 1970. Fiberglass over wire mesh, latex over cloth and wire (four units), $7'67_{\%}" \times 12'35_{\%}" \times 3'61_{2}"$ (2.31 × 3.75 × 1.08 m), overall. Des Moines Art Center, Des Moines, IA. Purchased with Funds from the Coffin Fine Arts Trust, Nathan Emory Coffin, Collection of the Des Moines Art Center, 1988 (1988.b.a-d)

Studying the Absent Object

By the 1970s, art historians and critics were talking about the "dematerialization of the art object" in contemporary art. By this, they meant that art was no longer exclusively an object. Art was also something that could *not* be bought and sold, something so temporary that it could be seen only for a brief time, making it difficult for scholars and critics to study, analyze, and write about it. Artists were now making temporary sculpture out of crumpled paper, bread placed on the mouth of a volcano, or patterns made in the snow. Many of the artists making temporary art photographed their work. The photographs became works of art in themselves and allowed scholars to study the artists' output.

A handful of artists worked almost entirely in temporary mediums and left no record in photographs, films, or drawings. Not surprisingly, their careers along with their contributions and accomplishments are today underrecognized, if not virtually lost to art historians. Perhaps the most vulnerable artists were the performance artists who emerged

throwing molten lead at the spot where floor and wall meet, a kind of Jackson Pollock action sculpture that resulted in a violent, energetic splattering on wall and floor. It also resulted in **sitespecific art**, since it could not be removed from the site of its creation without substantially altering the work.

By the late 1960s, Serra was making objects—now extremely heavy geometric lead forms—and invoking such themes as gravity, fear, and life and death. In *Corner Prop* (fig. **29.24**), an enormous lead cube weighing thousands of pounds is precariously propped up against the wall with a lead rod, with *nothing* securing either element. The piece, like much of Serra's sculpture from this period, communicates an unmistakable threat of violent collapse and an aura of danger that can be terrifying. In an even more frightening piece, Serra placed an enormous rectangular lead plate on the floor and another directly above, at a right angle, attached to the ceiling. The viewer was expected to walk on the one plate, thereby passing under the other. Serra's sculptures may look like Minimal Art, but they are loaded with narrative and emotion.

Earthworks and Site-Specific Art

By the late 1960s, the Post-Minimal aesthetic operated on an enormous scale, not only far beyond the confines of the gallery but far away from the art world, and in many instances in uninhabited remote areas. Several artists began sculpting with earth, snow, volcanoes, lightning, and deep-sea sites, their work often temporary and existing today only in photographs and drawings. Often the work had a strong geometric component, reflecting the influence of Minimal Art and Hard-Edge Abstraction. But in contrast, this sculpture generally was filled with references, including environmental, ontological (concerned with the nature of being), and political issues, as we will see in the work of Robert Smithson and the team of Christo and Jeanne-Claude. toward 1960 (see page 1046). Yvonne Rainer and Robert Whitman, for example, had a wide following and strongly influenced art in the 1960s, but today they are largely forgotten. Their work was performed, sometimes once, sometimes for several weeks, and then it disappeared. During the 1960s, Whitman, especially, had tremendous visibility. His integration of film projection into his Performance Pieces (see fig. 29.12) was startlingly innovative, anticipating the video installations that would become popular in the 1980s (see page 1047). Like his performances, Whitman's installations disappeared when they were dismantled and put into storage, where they cannot be seen, unlike conventional paintings or sculptures. Today, his Theater Pieces are occasionally performed, and one work, *Prune Flat*, has been acquired by a museum, the Dia Center for the Arts in New York, which owns the "score," the detailed drawings for costumes, and instructions for performance.

29.24 Richard Serra, *Corner Prop.* 1969. Lead antimony, box $25 \times 25 \times 25"$ (63.5 × 63.5 × 63.5 cm), pole 6'8" (2.03 m)

ROBERT SMITHSON One of the most famous earthworks, works of art created by manipulating the natural environment, is Spiral Jetty (fig. 29.25), a site-specific sculpture made by Robert Smithson (1938-1973) in 1970. Smithson, who was a friend of Serra's, became a prominent figure in the New York art world in the mid- to late 1960s because of his articles on art, which often took an environmental approach to discussing land and nature. He also became known for his nonsite sculptures, which were "landscapes" consisting of rocks and stones from specific sites (often in neighboring New Jersey) that Smithson put into geometrically shaped metal bins or mirrored boxes on a gallery floor. A map or aerial photograph showed the actual site of the "landscape." Instead of painting a landscape, Smithson was re-presenting the real thing in the form of what looks like a Minimal sculpture. What a viewer was witnessing was the entropy, or steady degradation, of the land as it was removed from one site and taken to another.

Like Hesse's sculpture, Smithson's Minimalist-looking sculpture is full of references and issues, which is apparent in *Spiral Jetty*. The work is 1,500 feet long, 15 feet wide, and involved moving 6,650 tons of earth and black basalt. It is located at Rozel Point, a remote area of Utah's Great Salt Lake, whose surrounding landscape looks like an industrial wasteland because of the rusting, discarded mining equipment littering the vicinity. Just as time consumes civilization, and all things for that matter, so too will the jetty eventually disappear as it erodes into the lake. The spiral form, as it wraps around itself, going nowhere, and trapping microorganisms that turn the water red, seems like the relic of a prehistoric civilization. Rather than just a minimal geometric shape to be admired for its own sake, *Spiral Jetty* is a powerful sculpture that utilizes time as a major component to speak about the entropy of all things.

CHRISTO AND JEANNE-CLAUDE Christo (Christo Javacheff, b. 1935) is a Bulgarian-born American artist. He met his Frenchborn American wife and collaborator Jeanne-Claude (Jeanne-Claude de Guillebon, b. 1935) in Paris in 1958. There, the couple were interested in creating a social dialogue and provoking their audience to think about their immediate world. In one work, Christo and Jeanne-Claude dammed up a narrow Paris street with a neat Minimalist-looking stack of barrels, preventing passage. However, they are best known for wrapping unidentified objects in fabric, stimulating viewer curiosity about the object as well as the reason for the gesture. In 1964, they moved to New York.

29.25 Robert Smithson, *Spiral Jetty*. 1970. Total length 1,500' (457.2 m); width of jetty 15' (4.57 m). Great Salt Lake, Utah

29.26 Christo and Jeanne-Claude, *Running Fence*, Sonoma and Marin counties, California. 1972–76. Fabric, $18' \times 24'_{2}$ miles (5.5 m × 39.4 km)

Their goal was to operate on an environmental or architectural scale, which they first did on a small scale in 1961 in Cologne (*Dockside Packages*) and on a large scale in 1969 when they wrapped a 1-million-square-foot section of a rocky coast in Australia. Since then they have wrapped enormous buildings, and a bridge, and surrounded 11 islands with floating fabric, creating site-specific sculptures.

Reproduced here is *Running Fence* (fig. **29.26**), proposed in 1972 and executed in 1976. On the one hand, the work looks like Minimal Art, since it consists of predetermined mathematical units that extend to fill an allocated space, here the 24½-mile (39.5-km) hilly terrain in California's Sonoma and Marin counties, with one terminus literally ending in the ocean. Each segment is 18 feet high and consists of cloth attached to steel poles. But this work is not only about the object itself, which was removed by the artists after being displayed for two weeks. Rather, it includes the entire process of implementing the concept: from the endless negotiations with government officials and landowners (mostly ranchers), the acquiring and supervising of an enormous workforce, the manufacturing of the work, and removal of it. It took four years to produce, the largest stumbling block being the tremendous community resistance. But the dialogue resulted in a raised consciousness about the land. It forced people to look at the land, and to think about it, recognizing how it was financially, emotionally, and aesthetically valued. The use of the word "fence" in the title specifically raised issues about how the land was to be used, and for whom.

Once installed, *Running Fence* transformed the landscape. The fence itself was like a fleet of ships sailing across hill and dale. Probably hundreds of thousands of people came to experience it. In a documentary of the project, one rancher, who had fought the installation, described how he and his son slept next to the fence one night—listening to it ripple in the wind, watching the stars—in effect undergoing a transformative experience. And then it was gone. Nothing was left, except memories of experiences, pieces of the cloth, which were given to the landowners, and hundreds of drawings that Christo had made to finance the \$3.2 million project, which Christo and Jeanne-Claude paid for themselves.

Conceptual Art: Art as Idea

Although the Frenchman Marcel Duchamp had made ideas the focus of art beginning in the 1910s (see page 970) and American George Brecht had begun to create a kind of conceptual art in the 1950s (see page 1047), the term itself did not become commonplace until the late 1960s, when a large number of artists started producing art that emphasized ideas rather than the aesthetics of style. Of course, ideas appear in all art, but the ideas are closely tied to the formal qualities of the art and cannot exist without them. In Conceptual Art, the art generally exists solely as an idea, with no visual manifestation other than words. Or the idea or information can appear as a graph, chart, map, or documentary photograph. In addition to works that are entirely Conceptual, we can also talk about art that is basically visual and aesthetic but has a Conceptual component as well. For example, Smithson's Spiral Jetty has such an element for we know that the work is going to very slowly disappear, which is something that was not visible when it was made in 1970. But with the Conceptual artists, idea, concept, or information will be the consuming quality of the work.

JOSEPH KOSUTH By the late 1960s, more and more artists were making art based on ideas, and in 1970, the Museum of Modern Art in New York mounted an exhibition entitled *Information*, dedicated to Conceptual Art and taking as its thesis that art provides information and ideas, not visual aesthetics. The show's cocurator was artist Joseph Kosuth (b. 1945). Characteristic of Kosuth's own work is *One and Three Chairs* (fig. **29.27**) of 1965, in which he combined a large gelatin-silver print of a folding chair with the real chair and a photograph of

a dictionary definition of a chair. By using words instead of just an image, Kosuth tells us how cerebral and nonaesthetic his intentions are.

The work appears to be a textbook study in semiotics-the science of signs-a popular topic in universities and in a small segment of the art community at the time. In the language of semiotics, the real chair is the "signified," the photograph is the "signifier," signifying that particular chair, and the dictionary definition is the idealized nonspecific chair. By arranging three versions of a chair in this particular way, Kosuth has determined their context, which leads a viewer to consider issues of language and meaning, rather than such typical art issues as beauty and expression. Reading the definition, we tend to think of the real chair next to it. If it were not present, we would probably think of some other chair from our own experience. If we look only at the photograph of a chair, we may even think the subject of the photograph is not necessarily the chair but the absence of a person sitting in the chair. The title is an important part of the work, for it too provides context, suggesting we can view the chairs as the same chair (one chair) or as three different chairs with very different stories. In other words, this work is about ideas as much as it is about the aesthetics of the visual presentation, which is as unemotional and straightforward as Minimalism. Ultimately, the task of establishing meaning is the viewer's.

One and Three Chairs also reflects a new approach to photography that appeared in the mid-1960s: The medium was no longer the sacred preserve of professional photographers, who worked on a modest scale, carefully took their own photographs, and often slaved over their prints. Now, photographs were used by Installation, Earthwork, Performance, and Conceptual artists, who in their primary medium often worked on a large scale.

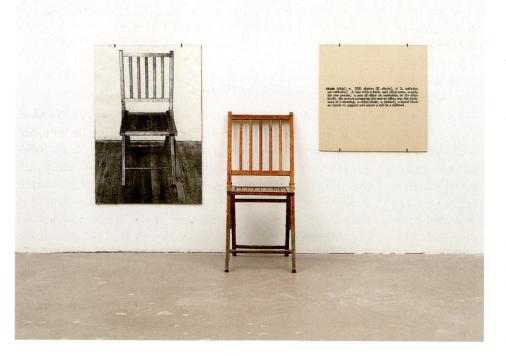

29.27 Joseph Kosuth, *One and Three Chairs.* 1965. Wooden folding chair, photographic copy of chair, and photographic enlargement of dictionary definition of chair; chair, $32\frac{3}{4} \times 14\frac{7}{8} \times 20\frac{7}{8}$ " (82.2 × 37.8 × 53 cm); photo panel, $36 \times 24\frac{1}{8}$ " (91.5 × 61 cm); text panel, $24 \times 24\frac{1}{8}$ " (61. × 62.2 cm). Museum of Modern Art, New York. Larry Aldrich Foundation Fund They now made photographs based on their work, and produced large photographs to suggest the scale of their primary work, the photographs even rivaling painting in size. Generally, they did not take their own pictures, and few if any did their own printing. Most shocking to traditional photographers, they often integrated photography into other mediums, as Kosuth did in *One and Three Chairs*, thus violating the time-honored integrity of the medium.

JOSEPH BEUYS Beuys (1921–1986) was a German Conceptual artist who produced work so complex and rich in ideas it is nearly impossible to pin down exactly what his art is. His objects, diagrams, photographs, and performances interrelate so tightly that no one piece can comfortably stand on its own. He was based in Düsseldorf, a city that by the 1970s was home to many of the world's leading artists, its art scene perhaps second only to New York's. Beuys played a major role in developing this artistic climate. His impact included spurring German artists to confront their nation's Nazi past, to rediscover the German Romantic tradition, and to invest their art with spirituality, much as the German Expressionists had done in the early twentieth century.

Two key factors in Beuys's development were his experiences in World War II as a fighter pilot in Hitler's Luftwaffe (airforce) and the 1963 arrival in Düsseldorf of the Fluxus artists. Beuys propagated a myth that his plane was shot down in 1943 in a snowstorm over Crimea, and that nomadic Tartars saved him from freezing to death by covering him in animal fat and layers of felt, materials that became a foundation for much of his sculptural work. Whatever Beuys's war experience actually was, it was clearly traumatic, for after attending the Düsseldorf Art Academy in the late 1940s, he disappeared into the German countryside to work as a farmhand and purge himself of his guilt and anxiety.

In 1961, Beuys was teaching at the Düsseldorf Art Academy, and two years later he was introduced to Fluxus, adopting Performance Art and joining them for a segment of their European tour. In 1965, he performed How to Explain Pictures to a Dead Hare (fig. 29.28). For three hours he moved his lips as if silently lecturing the dead hare cradled in his arm about the pictures surrounding him on the walls. Attached to his left sole was felt, and to his right, steel, the one representing "spiritual warmth," the other "hard reason." Honey and gold paint covered Beuys's head, transforming him into a shaman, a high priest who uses magic to cure ills. The honey represented a life force. This mysterious ritualistic performance was about the meaninglessness of conventional picture making-art that had to be explainedand about the need to replace it with a more spiritual and natural form of communication, an art the meaning of which could be felt or intuited by a viewer rather than understood intellectually. The performance was designed to create a magical art that would cause people to invest their own lives with spirituality. Everyone who watched the performance apparently found it riveting and unforgettable, even if they did not understand it. His objects, too, such as a worn wooden chair with a pile of fat on its seat, affected people similarly.

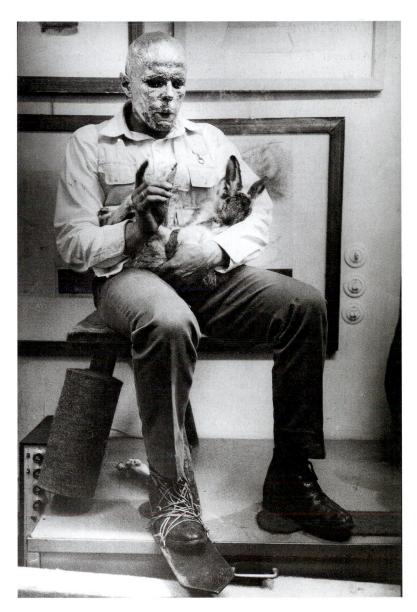

29.28 Joseph Beuys, *How to Explain Pictures to a Dead Hare*. 1965. Performed at Galerie Schmela, Düsseldorf, Germany

Television Art: Nam June Paik

Another artist who participated in Fluxus activities in Düsseldorf in the early 1960s was the Korean-born musician, Performance artist, and sculptor Nam June Paik (1932–2006). Paik's background was in music, but shortly after studying composition with John Cage in Darmstadt, Germany, in 1958, he became a radical Performance artist, exploring unconventional mediums. Living in Düsseldorf in 1963 and performing in the Fluxus program, he began making art using television monitors. He labeled television the "electronic superhighway" and declared it the medium of the future, dedicating his life to working with it. His earliest television art used single monitors with simple abstract patterns, such as a single horizontal or vertical line. Or using a magnet, he distorted a television signal to create arclike or wavy compositions. In 1964, he moved to New York, and with the launch of the

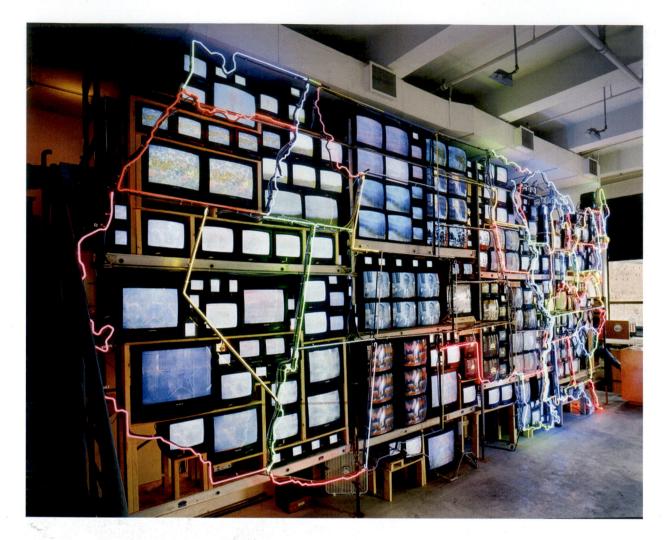

29.29 Nam June Paik, *Electronic Superhighway: Continental U.S.* 1995. Installation: Fortyseven-channel closedcircuit video installation with 313 monitors, laser disk images with sound, steel structure and neon, $15 \times 32 \times 4'$ $(4.57 \times 9.75 \times 1.2 \text{ m}).$ Courtesy Nam June Paik Studio, New York

first affordable video camera by Sony, he began to use video as well as live-broadcast television.

Paik's work in the 1970s became increasingly grand and complex. Typical of the more elaborate structure of the later work is a piece from 1995, *Electronic Superhighway: Continental U.S.* (fig. **29.29**). Fed by numerous computer-controlled video channels, this installation consists of dozens of monitors inserted in a neon map of the 48 continental states. The rapidly changing images generally relate to the respective states, except for New York, which was fed from a live camera in the New York Holly Solomon Gallery, where the work was shown and from where our reproduction originates.

In *Electronic Superhighway*, Paik reaffirms the prevalence of television in American society, presenting his work with the fast-paced continuous stream of information characteristic of broadcast television. The work celebrates American vernacular culture, both in its use of neon and television as mediums and in the Americana presented on the videos. Television is America, Paik tells us. It is, in effect, real life, because most Americans experience the world through their television screens. Paik is not condemning the medium, which would be antithetical to the objective position of a Fluxus artist, but simply revealing its power to define contemporary life.

ART WITH A SOCIAL AGENDA

Most of the postwar artists discussed thus far did not have a social agenda. Even some who did, such as Lichtenstein and Warhol, subversively buried their message so that it was not readily visible, especially to the groups they criticized. While an atmosphere of counterculture dominated the vanguard art world paralleling the social revolution occurring not only in America but also worldwide by the late 1960s, few artists made political art. By the 1970s, however, the trickle of artists making work that dealt with social issues began to swell into a torrent. So great was its influence that we now think of social issues as playing a major role in avant-garde art for the last 35 years. An art with a social agenda became a key component of 1970s Post-Minimalism.

Street Photography

Not everyone was caught up in the economic boom and technological euphoria of the 1950s. Some observers, including many outstanding photographers, perceived serious problems within American society. In part inspired by the powerful photographs of Walker Evans (see fig. 28.54), they trained their cameras on the injustices smoldering beneath the placid surface of society and made what is often called **street photography**, a reference to their taking to the streets to find their imagery. They were free to do so because photography was not handcuffed by the Modernist aesthetics of painting and sculpture that demanded an increasingly abstract nonreferential art.

Perhaps the best known of the postwar street photographers is Robert Frank (b. 1924), who emigrated from Switzerland in the 1940s. In 1955, Frank crisscrossed the nation, taking candid, unposed photographs in banal public settings, which he then published as a photoessay in a book called *The Americans* (1958). American publishers found his view of America so grim that Frank had to go to France to find someone to produce the book. An American edition finally came out in 1959 with an introduction by Jack Kerouac (1922–1969), author of the classic Beatnik novel *On the Road* (1957).

Like his friend George Segal, Frank used his work to reflect his concerns about the alienation and lack of spirituality in twentieth-century America. Drug Store, Detroit (fig. 29.30) is characteristic of his national portrait of emptiness, alienation, and despair. Under a barrage of bold advertising (reminding us of Andy Warhol's Campbell's Soup Cans), some 15 men order, among other items, artificial orange whips, each patron seemingly unaware of the others. On the other side of the counter dutifully serving the white males are African-American women, undoubtedly working for a minimum wage. Just as the cake is trapped in the airless foreground case, the waitresses seem trapped behind the counter in the drudgery of their menial jobs. The glare of bare fluorescent bulbs bouncing off linoleum, Formica, and plastic is a reminder of the period's deadening aesthetic of efficiency and modernity, while the monotonous lineup of jukeboxes on the counter opposite the patrons underlines the "sell, sell, sell" mentality of American business.

Unlike Bourke-White, Evans and Lange (see pages 1018 and 1029), Frank avoids refinement in his documentary photographs. His prints are blurry and gritty, and grimy blacks violently contrast with whites. Their harsh crudeness projects an undercurrent of unease and disquiet. We sense the speed with which Frank operated in the informal settings he encountered, wielding his 35mm single-lens reflex camera as spontaneously as his instinct dictated. It should come as no surprise that the downtown Detroit where this photograph was taken was largely destroyed during the race riots of the late 1960s. (For a discussion of a second documentary photographer, Lee Friedlander, from this period, see the Introduction.)

African-American Art: Ethnic Identity

Other American artists soon joined the street photographers and began doing what had been unthinkable in the art world of the 1960s: turning their backs on both Minimalism and abstraction in general and instead making art about the nation's problems and issues, particularly those concerning race, ethnic background, gender, and sexual orientation. Because of the Civil Rights Movement, African-American artists were challenged to make art about their

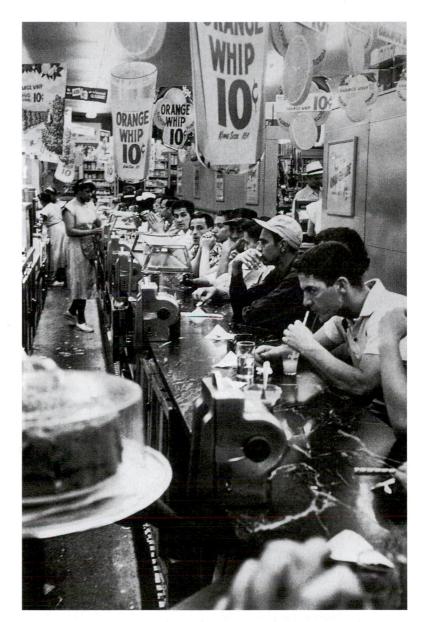

29.30 Robert Frank, *Drug Store, Detroit.* 1955. Gelatin silver print, 11×14 " (27.9 × 35.5 cm). Courtesy of the Pace MacGill Gallery, New York

heritage. At college and in art school, they were trained like everyone else to make abstract art. But their communities pressured them to do the exact opposite: Make narrative art and take up the black cause. To balance both claims was a challenge.

ROMARE BEARDEN In New York in 1963, a number of African-American artists formed a loose group called Spiral, dedicated to supporting the Civil Rights Movement. They met in the studio of Romare Bearden (1911–1988), a New York University-educated mathematician and philosopher who in the 1940s increasingly became a committed artist. Influenced by Martin Luther King, Jr.'s 1963 March on Washington, D.C., Bearden suggested a collaborative project for Spiral that involved the members all contributing to a large photocollage about black

PRIMARY SOURCE

Romare Bearden (1911–1988)

From a 1984 interview with Joseph Jacobs

Romare Bearden talks about why collage was so important for him and its relationship to jazz.

One of the attractions of collage for me is it allows me to work quickly, which is a very twentieth-century attitude. The development of the machine, and now of the computer, killed man's capacity for patience. It is too nervous a century for people to paint the way Jan van Eyck painted, for example. Many modern super-realist paintings, which may look as detailed as a Van Eyck, are made from photographs or slides which get projected onto the canvas and are then painted. Collage is the cutting out rather than the painting of things, and it allows a more direct way to get something down. Just cut it out and put it down.

No, the physicality of the medium did not attract me to collage. Also, I don't think of my use of collage as an extension of Abstract Expressionism. Rather I would like to think of it within the context of Cubism. My quarrel with Abstract Expressionism, if any, is that sometimes the space is naturalistic. If you place in one area of the canvas a large field of blue, and then in another area you put an orange, you have painted sunlight, which is naturalistic space and light. I prefer to bring things forward, not just for the sake of making Cubism, but to make flat painting and not fool the eye with depth and perspective. And that is achieved by having the collage sit on the surface. ...

Yes, you can draw parallels between my work and jazz. As you just said, there is a spirit that is there before a work is begun and develops with the work that is similar to the kind of improvisation that one gets in jazz. ... [Jazz] has a rhythmic component, and it also has interval. When you listen to the piano of Earl Hines, what really counts is the silences between the notes struck. ... The same importance of interval can be seen in confetti thrown at a wedding; the confetti dazzles the eye, but it is the spaces between the pieces that really causes things to happen.

Source: Joseph Jacobs, *Since the Harlem Renaissance: 50 Years of Afro-American Art* (The Center Gallery of Bucknell University, 1985). Lewisburg, Pennsylvania. 1985

29.31 Romare Bearden, *The Prevalence of Ritual: Baptism.* 1964. Collage of photochemical reproduction, synthetic polymer, and pencil on paperboard, 9¹/₈ × 12" (23.2 × 30.5 cm). Hirshhorn Museum and Sculpture Garden, Smithsonian Institution, Washington, D.C. Gift of Joseph H. Hirshhorn, 1966

identity. When no one turned up, Bearden undertook the project by himself, cutting up newspapers and magazines to make collages, for which he became famous.

The composition of Bearden's collages is based on Cubism, as seen in The Prevalence of Ritual: Baptism (fig. 29.31), created in 1964, but the subject matter is distinctly African-American. Bearden grew up in Charlotte, North Carolina, before moving to New York City's Harlem, and the fractured image shows a baptism, reflecting the importance of religion in black culture. The faces not only express the African physiognomy but in some instances also suggest African masks. This work has the effect of tracing American culture back to its African roots and reinforcing the continuous importance of ritual and community. The collage composition has a wild syncopation and even a sense of improvisation that seems to relate to the black jazz musicians of the period, such as Charlie Parker or John Coltrane. (See Primary Source, page 1066.) The power of Bearden's work lies in the artist's ability to pack so much information and energy into a single image that it overflows with the vitality and essence of the African-American experience, an energy we saw as well in the small temperas of Jacob Lawrence (see fig. 28.49).

MELVIN EDWARDS At virtually the same moment, Melvin Edwards (b. 1937) took an entirely different approach to reflecting his racial background. Raised in Houston, Texas, and studying welded-steel sculpture and formalist aesthetics at the University of Southern California in Los Angeles, Edwards was outraged at the lynchings of blacks in the South, which were increasing as the Ku Klux Klan responded to the Civil Rights Movement. In 1963, he began to make a series of relief sculptures entitled *Lynch Fragments* (fig. **29.32**), incorporating chains and spikes and brutal metal fragments, all of which took on a brown tonality when oiled to prevent rusting.

While there is no set reading of these works—which Edwards, a New York resident, continues to make today along with monumental sculpture—they evoke oppression, bondage, violence, and anger, as well as skin color. They also appear to refer to African masks (which the artist denies is intended) and ritual, and in their bold frontality they display a sense of confrontation and dignity. These basically abstract works, which fulfilled the demands of his university teaching to make nonrepresentational art, are so open to interpretation that we can view them as autobiographical as well. A horseshoe that appears in many of the *Lynch Fragments* is the artist's reminiscence of visits to his uncle's ranch outside of Houston. Edwards's political and expressive abstraction stands in stark contrast to the Minimalist Art being produced at the same time and anticipated Post-Minimal sculpture.

BETYE SAAR With Betye Saar (b. 1926), there is no attempt to accommodate the art establishment by catering to formalist abstraction. Her work is brazenly representational and, like Bearden, her themes are obviously dedicated to her African-American heritage. Saar, who is from Los Angeles, where she still lives, got her B.A. in design from the University of California,

29.32 Melvin Edwards, *Lynch Fragment: Some Bright Morning*. 1963. Welded steel, $14\frac{1}{4} \times 9\frac{1}{4} \times 5$ " (36.2 × 23.5 × 12.7 cm). Collection of the artist

Los Angeles, and graduate degrees in education and printmaking from nearby universities. But it was not until she experienced first hand the Surrealist assemblage boxes of the New Yorker Joseph Cornell in 1968 that she found her mature artistic voice. She began working in the same technique, as can be seen in Shield of Quality (fig. 29.33) of 1974. The work is part of a series of boxes inspired by the death of the artist's great-aunt. Each is like a Victorian keepsake box, containing relics of the ancestor-a glove, a feather from a hat, lace, buttons, and a baby spoon, for example. Vintage photographs are arranged in a triptych, transforming the box into a portable altar. The shrine pays homage to the values the great-aunt handed down, values reflected in the quality and propriety of the objects themselves. And the box counters America's racial stereotyping by presenting African Americans as middle-class, a reminder that Saar was born in 1926 and grew up in precivil-rights America.

Like so much of Saar's work, *Shield of Quality* focuses on women and is also about female pride and the important role of

29.33 Betye Saar, Shield of Quality. 1974. Mixed media, $18 \times 14^{3}_{4} \times 1^{"}$ (45.7 × 36.4 × 2.5 cm). Collection of the Newark Museum. Purchase 1998, The Members' Fund (98.37). Photograph courtesy of Michael Rosenfeld Gallery, LLC, New York

women in society. Clearly, by working on a small-scale and making delicate effeminate work, Saar was defying the art establishment, turning her back on the enormous canvases and sculptures being churned out by white males. With Saar, we have stepped into the feminist era.

Feminist Art: Judy Chicago and Gender Identity

Betty Friedan's 1963 book *The Feminine Mystique* signaled the start of the feminist movement. Almost simultaneously a number of women artists began making work that dealt with women's issues. Nancy Spero (b. 1926) made simple but powerful expressionistic drawings depicting violence toward women, while Mimi Smith (b. 1942) made what is now recognized as the first American clothing art, objects such as a Minimalist *Girdle* (1966), constructed of rubber bathmats that capture the discomfort of women's clothing. And, as just discussed, Betye Saar made boxes that paid homage to women.

The best-known work coming out of the women's movement is *The Dinner Party* (fig. **29.34**), orchestrated by Judy Chicago (b. 1939) and made by over 400 women between 1974 and 1979. By the late 1960s, Chicago was a dedicated feminist, who in the early 1970s established a Feminist Art Program, the first of its kind, at California State University at Fresno. Shortly thereafter, with artist Miriam Schapiro (b. 1923), she started a second similar program at the California Institute of the Arts in Valencia. The thrust of these courses was to encourage women to make art and deal with gender issues, which the art world, including university and art-school faculties, said she could not do because the work did not conform to the aesthetic norms of Modernist formalism that signified serious art. The Feminist Art Program was designed to provide support for women artists and to redefine aesthetic values in contemporary art.

The Dinner Party reflects Chicago's shift from a maker of abstract Minimalist objects and paintings to works on feminist themes in alternative mediums and installations. It pays homage to the many important women who Chicago felt were ignored, underrated, or omitted from the history books. Chicago laboriously researched these lost figures. She then designed a triangular table with 39 place settings, 13 to a side, each honoring a significant woman, ranging from ancient goddesses to such twentieth-century icons as Georgia O'Keeffe. In addition, 919 other women's names are inscribed on the white floor tiles lying in the triangular intersection of the tables. Each place setting included a hand-painted ceramic plate that pictured a vagina executed in a period style. American poet Emily Dickinson's sex, for example, is surrounded by lace, and French queen Eleanor of Aquitaine's is encased in a *fleur-de-lis*. Under each place setting is an embroidered runner, often elaborate and again in period style.

Instead of using bulldozers, chainsaws, hoists, and welding equipment as men did for their environments, Chicago intention-

29.34 Judy Chicago, *The Dinner Party*. 1979. Mixed media, $3 \times 48 \times 42'$ ($0.9 \times 17.6 \times 12.8$ m). Brooklyn Museum of Art, New York

ally turned to mediums associated with women—painted china, ceramics, and embroidery—and created an elegant, beautiful work that subtly operates on an epic scale, spanning millennia. Also present is a sense of community and ritual, for we feel as though Chicago has appropriated and transformed the Christian male theme of the Last Supper into a spiritual communion of women.

LATE MODERNIST ARCHITECTURE

Modernist architecture thrived after World War II, especially in America, which had previously preferred traditionalist architecture (skyscrapers, for example, in a Gothic style) as discussed in the previous chapter (see pages 1020–21). But now Modernist architecture was only a look or style. It no longer had the utopian vision and revolutionary zeal to improve the world that we saw in the High Modernism of De Stijl and the Bauhaus (see pages 1007–10), and in the art and design of Constructivist Productivism (see pages 1003–05). However, some of the most influential buildings of the period continued to be built by the major High Modernist architects: Wright, Mies van der Rohe, and Le Corbusier. While Mies continued the International Style aesthetic of light, floating geometric buildings with taut, thin glass walls, Frank Lloyd Wright and Le Corbusier, joined by the emerging Philadelphia architect Louis Kahn, developed a sculptural architecture that emphasized mass and the physical presence of a building, and they were not afraid to be referential.

Continuing the International Style: Ludwig Mies van der Rohe

Postwar Late Modernism resulted in glass boxes sprouting up in urban centers and dotting the beltways that circled American cities, especially beginning in the 1960s and 1970s. The glass box

29.35 Ludwig Mies van der Rohe and Philip Johnson. Seagram Building, New York. 1954–58

became the required image for corporate headquarters, such as I. M. Pei and Henry N. Cobb's John Hancock Center in Boston (1977) and Skidmore, Owens, and Merrill's Sears Tower in Chicago (1974). If one were to choose a single building to epitomize the Late Modernist skyscraper it would have to be Mies van der Rohe's Seagram Building (fig. **29.35**) in New York, built from 1954 to 1958, with interiors by Philip Johnson (1906–2005). This building was imitated worldwide, but rarely did the imitations begin to approach the perfection that Mies achieved with his aesthetic of "Less is more" (see page 1010).

We can see these minimal gestures in the Seagram Building. Mies began by removing the 38-story building from its urban environment and placing it on a pedestal, that is a plaza elevated above street level. The plaza is simple but sumptuous; it is made of pink granite, has two shallow pools placed symmetrically on either side of the building, and is surrounded by a low serpentine marble wall. The weightless tinted glass-and-bronze tower sits on a colonnade of pilotis that leaves the first floor open, and every detail, including the paving stones, is carefully proportioned to create a sense of perfection and elegance. With the rise of Hitler in Germany, Mies had joined Moholy-Nagy at the new Bauhaus in Chicago, and in the Seagram Building we can see the influence of the nineteenth-century Chicago School in the emphasis on the skeletal grid of the building. To acknowledge the functionalism of the grid, Mies used thin I-beams for the mullions between windows. They provide the vertical accent that the proportions of the horizontal spandrels so perfectly counterbalance with their thin ridges on top and bottom. Inside and out, lavish, beautifully harmonized materials embellish the building's exquisite proportions.

Sculptural Architecture: Referential Mass

Mies's architecture was essentially nonreferential, just like Minimalist sculpture. However, his contemporaries Le Corbusier and Frank Lloyd Wright took Late Modernist architecture in a different direction. Their buildings contain references and are organic, if not outright expressionistic. Made of poured concrete, they are massive monumental buildings that have a powerful sculptural presence.

LE CORBUSIER In his late style, Le Corbusier abandoned the taunt, light walls and floating architecture of his early villas for a massive, sculptural, and even referential style. This late work can be quite expressive, even to the point of being oppressively massive and harsh, and it is often referred to as Brutalist. Especially abrasive is his use of concrete, which instead of being smooth and highly finished is now left raw, having a rough texture and revealing the pattern of the wood forms.

A sculptural masterpiece from this period is Notre-Dame-du-Haut (fig. **29.36**), a chapel in Ronchamp, France, built from 1950 to 1955. While the main interior space is basically simple, an oblong nave, the exterior erupts with diagonals and curves. The concrete-covered masonry walls are thick and massive, and the poured concrete roof, which is hollow and the concrete left raw, is ponderous, even if it paradoxically seems to float. Visitors enter the front through an enormous fissure in the wall, giving them a sense of slipping through a cleft in a rock formation. The pointed façade reminds us of a ship's prow, while the roof recalls the bottom of a boat, allusions to such vessels of salvation as Noah's Ark and St. Peter's fishing boat. But these shapes also suggest a nun's cowl, praying hands, and a church spire. The vertical towerlike

29.36 Le Corbusier. Notre-Dame-du-Haut (from the southeast), Ronchamp, France. 1950–55

forms to the left, a bell tower, and right resemble the nearby prehistoric dolmens of Carnac (see fig. 1.24). A sense of the primordial continues in the cavelike interior, where the ceiling precipitously drops from 32 feet over the altar to 16 feet in the center of the room. Faint streams of colored light pierce the stained-glass windows set in the thick walls (fig. **29.37**), gently illuminating the space and giving it a mystical aura. Regardless of religion, anyone visiting Notre-Dame-du-Haut is likely to be transported to the realm of the mysterious and magical.

FRANK LLOYD WRIGHT Rising almost simultaneously in New York as Mies van der Rohe's Seagram Building was Frank Lloyd Wright's Solomon R. Guggenheim Museum, located some 50 blocks north in Manhattan. For a discussion of this building, see the Introduction and fig. I.16.

29.37 Le Corbusier. Interior of Notre-Dame-du-Haut.

29.38 Louis Kahn. National Assembly Building, Dacca, Bangladesh. 1962

LOUIS KAHN Louis Kahn (1901–1974) is a difficult artist to place and is alternatively labeled an Expressionist, a Brutalist, and a Proto-Postmodernist. He was in his fifties when he finally found his architectural voice, largely due to a year spent at the American Academy in Rome in 1950–51. Here, he awakened to the importance and power of the ancient monuments of the Mediterranean, from the pyramids of Egypt to the baths and aqueducts of Rome to the Athenian Akropolis. Their bold, sculptural forms and pure geometry evoked a timeless serenity and Classical grandeur and became the building blocks of his Modernist aesthetic. In the late 1950s, Kahn discovered the Expressionist, Brutalist style of late Le Corbusier, of whom Kahn said, "He was my teacher, although he didn't know it." He rejected High Modernism's emphasis on light volume defined by a taut membrane as he instead designed massive, weighty

structures that evoked ancient civilizations that seemed capable of defying the ravages of time.

We can see these qualities in his 1962 ferroconcrete National Assembly Building in Dacca, Bangladesh (fig. **29.38**). The assembly chamber is in the center, surrounded by concentric circles of meeting rooms, press offices, and a mosque, each building separated by unroofed walkways, creating a veritable light-filled city. Monumental triangles, rectangles, and circles puncture the massive walls of each ring of rooms, allowing light to filter in and virtually structure the space. The entire complex looks like a fortress, the outer wall projecting the sublime presence of antiquity, although functionally it is designed to keep out the harsh sun of the Indian subcontinent. As we shall see in the next chapter, Kahn's referential architecture would inspire the next generation of architects.

1950 Jackson Pollock's Autumn Rhythm: Number 30

1955-58 Robert Rauschenberg's Odalisk

1965 Joseph Beuys's How to Explain Pictures to a Dead Hare

5007	Loup	Nost	logr	Sour	Soor	Sour	tour
							8
2017	Sout	LouP.	Sout	5007	3057	Soup	BOUT
1007	Sos?	Sour	5007	TOUT	1007	Lour	Laur
Sour	1007	Bour	Sour	Sout	Louy	1007	SOUT

1962 Andy Warhol's Campbell's Soup Cans

1970 Robert Smithson, Spiral Jetty

1979 Judy Chicago's The Dinner Party

Postwar to Postmodern, 1945-1980

1945-49 Jean-Paul Sartre publishes his existential trilogy Les Chemins de la Liberté (The Roads to Freedom)

1950 1950-53 Korean War

1940

1960

- 1955-68 First phase of the civil rights movement 1956 Tunisia gains independence from France, launching the independence movement in Africa 1956 William H. Whyte publishes The Organization Man, a description of impact of mass organization, especially corporations, on the United States
- 1957 Jack Kerouac publishes On the Road 1957 Russia launches Sputnik I
- 1963 Betty Friedan publishes The Feminine Mystique
- ca. 1965 Commercial portable video cameras become available
- 1965 United States enters the Vietnam War 1966 Jewish Museum, New York, mounts Primary
- Structures, first exhibition of Minimal Art 1968 The leftist student protest and strikes in Paris in May that eventually brought about the fall
- of the De Gaulle government 1969 Stonewall riots in New York City as gays
- respond to police persecution
- 1969 Woodstock Festival, Bethel, New York
- 1969 Moon landing
- 1970 Museum of Modern Art, New York presents Information, first exhibition of Conceptual Art
- 1971 Greenpeace Foundation founded

1970

The Postmodern Era: Art Since 1980

HE ART THAT CAME TO THE ART WORLD'S ATTENTION TOWARD 1980 is generally known as Postmodern art. The term was coined in the mid-1960s by European literary critics, and was applied to the theories of such French philosophers as Jacques Derrida (1930–2004), Roland Barthes (1915–1980), and Michel Foucault (1926–1984), as well as to the sociologist

and cultural critic Jean Baudrillard (1979-2007) and psychoanalyst Jacques Lacan (1901–1981). At the heart of much European Postmodernism, which is also called Deconstructionism or Post-Structuralism, is the premise that all text, and by extension visual art, contains hidden hierarchies of meaning "by which," as Derrida expressed it, "an order is imposed on reality and by which a subtle repression is exercised, as their hierarchies exclude, subordinate, and hide the various potential meanings." In other words, any text or artwork has an agenda, or point of view, as does any interpretation or use of a text or art. Revealing this agenda means "deconstructing" it. The result is there are no fixed truths or realities, no absolutes-just "hierarchies," which are forever changing. We shall see an especially fine example of this theory later in the chapter when we look at the art of Fred Wilson, who in 1992 placed slave manacles in a case of fine silver at the Maryland Historical Society in Baltimore (see fig. 30.19). The society was presenting the silver as refined aesthetic objects, reflecting the evolution of style. By inserting the manacles, Wilson changed the context of the silver, and thus he changed its meaning as well-now the goblets, pitchers, and teapots became icons of wealth brought about by the enslavement of blacks. As reflected in Wilson's deconstruction of the historical society's display, artists and critics starting in the late 1970s began to digest

Frank Gehry. Guggenheim Museum, Bilbao, Spain. See also figure 30.9

European Postmodernism and were applying it to art. They were especially interested in how art functioned as a visual language, particularly as one of propaganda, manipulation, and power that determined taste and values and structured, for example, ethnic, sexual, racial, and gender identities.

In a sense, these ideas were not entirely new to the 1970s art world. We have already seen Marcel Duchamp dealing with similar issues in the 1910s, and Robert Rauschenberg, George Brecht, Joseph Kosuth, Roy Lichtenstein, Andy Warhol, and especially Sigmar Polke touching on them as well in the 1950s and 1960s. While the immediate seeds of Postmodernism in the visual arts date from this time, a self-consciousness about entering a new era only occurred in the art world in the late 1970s. In large part, this new awareness stemmed from the critical writing in a new art magazine, October, founded in 1976, which reflected European Postmodern philosophy. (See www.myartslab.com.) As a result, a large number of artists and critics asked more overtly and persistently: How do words and images acquire meaning? What is the message? Who originates it? What-and whose-purpose does it serve? Who is the audience and what does this tell us about the message? Who controls the media-and for whom? More and more artists, such as Fred Wilson, began using familiar images in new contexts, revealing-or deconstructing-their deeper social, political, economic, and aesthetic meanings. The preferred mediums for many of these artists were those of the mass media, namely photography, electronic signs, billboards, and video.

Map 30.1 Europe and North America in the 21st century

While this Postmodernist attitude emerged toward 1980, it has been only one of numerous issues that have preoccupied the art world in the last 30 years. The period is characterized by pluralism, in effect continuing the pluralism associated with 1970s Post-Minimalism (see pages 1058-69). Now, however, pluralism had a philosophical foundation in Postmodern theory. By denying any one system, reading, interpretation, or truth, Postmodern theory destroyed the credibility of the authoritarian hierarchies of styles, mediums, issues, and themes, and it opened the door for everything and everyone. It also had an enormous impact on art history, as art historians began to question the validity of the traditional story of art, generally told from a narrow viewpoint, generally male-centric and European-American, and emphasizing the evolution of style. Now, scholars approached art from countless angles, using issues of gender, sexual orientation, ethnicity, race, economics, and politics to demonstrate the many layers of meaning and ideas embedded in a work of art. In part, this trend had begun in the late 1960s, a result of the social revolution that accompanied the civil rights movement and the Vietnam War and challenged the validity of the status quo.

Postmodernism marked the end of the Modernist era, which peaked in the 1950s and 1960s with such styles as Abstract Expressionism and Minimal Art. Modernism viewed modern art as a linear progression of one style building upon the last, continuously advancing art toward the "new." Because of this emphasis on style, tremendous importance was placed on the individual and stylistic originality. But the pluralism of the 1970s accompanied by Postmodern theory ended the need for artists to invent the new. By the 1980s, artists had license *not* to be new. Not only did they appropriate art in every imaginable style and medium from the history of civilization and combine them as they saw fit, many of the leading artists, such as Felix Gonzalez-Torres, Jeff Koons, Kiki Smith, and Damien Hirst, did not even concern themselves with cultivating a distinguishable style as they jumped from one medium to the next, relying on a theme rather than a look to tie their work together. Message was more important than a readily identifiable, single style, a hallmark of Modernism. Artists also challenged the premium that Modernism placed on individuality and authorship, with many artists collaborating or working in groups, such as the Guerrilla Girls and Group Material.

The Postmodern era also redefined the nature of the art world itself. The art establishment widened to embrace artists of all ethnicities and races, accepting all kinds of mediums, styles, and issues without placing a value on one over another. In this new environment, often referred to as multiculturalism, artists who had been marginalized in the 1970s became mainstream. Furthermore, in the 1990s, artists from all over the world, not just America and Europe, played a major role in molding contemporary art. A benchmark exhibition for presenting this new world view was *Magiciens de la Terre*, organized in 1988 by the National Museum of Modern Art (Pompidou Center) in Paris and featuring artists from all the continents.

The acceptance of artists worldwide mirrors the global restructuring of the last 20 years. The Cold War ended as the Berlin Wall fell in 1988 and the U.S.S.R. was dissolved soon after. Political and economic realignments resulted as first Russia and then China abandoned a strict adherence to Communism, experimented with capitalism, and opened up to foreign trade and investment. In the 1990s, Europe formed the European Union, and the United States, Mexico, and Canada signed the North American Free Trade Agreement. Barriers were falling everywhere, with people crossing borders more readily than ever before. Another important force behind the creation of a world art is the long-term impact of the independence movements, especially in Africa and Asia, of the 1950s and 1960s. These new post-colonial nations asserted their cultural traditions as viable and valuable alternatives to mainstream culture, which in the last 25 years have increasingly been woven into the fabric of a world culture.

But perhaps the communications field more than anything else was responsible for the creation of the "Global Village." Television, cellular phones, satellites, computers, global positioning systems, and the Internet have linked the world, reminding us that the Post-Industrial era is also the Information Age. Today, the world's leading artists come from countries as varied as Lebanon, Iran, Israel, Cambodia, Thailand, Korea, India, Japan, China, South Africa, Mali, Russia, Colombia, Brazil, Cuba, and Iceland. They readily travel the globe, often have studios in numerous countries, and exhibit regularly worldwide, especially participating in the international explosion of contemporary art fairs and annual or biennial art shows that take place in such disparate venues as Istanbul, Dubai, Moscow, Johannesburg, Saigon, Havana, and Shanghai.

In this world of complex media and changing interpretations, scholars do not always agree on the meaning of Postmodernism. While the term initially was applied specifically to the European philosophy that emerged in the 1960s, today scholars and art historians use it quite loosely to encompass all of the art made since 1980. In effect, they use it to mean art made after Modernism, and we will use it in the same way here. But the sign that we have nonetheless entered a new era is the fact that we can no longer treat art as a succession of isms or styles. While some historians and critics have tried to identify movements or styles, such as Neo-Expressionism, Neo-Geo, and Neo-Conceptualism, these are forced labels that do not hold up to scrutiny. Unlike the other chapters in this book, the fine art will be presented not within the context of style but instead under headings of theme or issue.

ARCHITECTURE

Postmodernism appeared in architecture in the 1960s and was accompanied by a manifesto of sorts. In his book *Complexity and Contradiction* (1966), the architect Robert Venturi called for a new architecture, one that rejected the cold, abstract Modernist International Style. The new architecture would be referential, that is, buildings would recall earlier architectural styles, or contain motifs that referred to the past and present. By the 1980s, an architecture that the architectural community labeled "Postmodern" had emerged. The term, however, was used specifically to describe work that made references to earlier periods and styles.

Since fundamental to European Postmodern theory is the concept that no one authoritative style or set of principles can prevail, architecture since the 1980s reflects a broad range of issues and interests, going well beyond just designing referential buildings. Among them is a revised Modernism, one strain of which we can call Hi-Tech because of its highly technological appearance. Another strain is Deconstructivism, a concept relating to Derrida's theories of Deconstruction and embracing the notion that architecture should not have a fixed structure or logic, thus being wide open to interpretation.

Postmodern Architecture: A Referential Style

Modernist architecture, best characterized by High Modernism or the International Style (see page 1010), was rule-bound and abstract. Some architectural critics—as well as the general public—found it cold and impersonal. With Postmodernist architecture, buildings, as in the nineteenth century, once again contain references to earlier architectural styles. Sometimes they project a sense of place, imparting an aura of uniqueness that makes them special to those using them. While Postmodern architecture did not come to the fore until about 1980, a handful of architects had been advocating and practicing a new architecture by the 1960s, among them Robert Venturi.

ROBERT VENTURI Robert Venturi (b. 1925) upset the architectural establishment by attacking Modernist architecture in Complexity and Contradiction. He challenged Mies van der Rohe's dictum "Less is more" with "Less is a bore" and argued that architecture could be whatever the architect wanted it to be. He asserted that art and the architectural past, as well as life itself, are filled with complexity and contradiction, and buildings should be too. Instead of being pure, simple, and conventional, buildings should be complicated, rich, and filled with references to the past and to the present as well. Buildings should contain meanings, even if these are contradictory, as had been the case in Mannerist architecture (see page 592). And structures could be fun and humorous as well as serious. Venturi's idol was Louis Kahn, who was also based in Philadelphia and whose Modernist buildings, such as the National Assembly Building (see fig. 29.38) in Dacca, Bangladesh, are filled with overt historical references. Venturi admired Kahn's daring use of symbolism and historical layering. Venturi outraged the architectural world again in 1972, when he published Learning from Las Vegas with his wife, the architect Denise Scott Brown. The couple declared Los Angeles and Las Vegas to be the modern-day equivalents of ancient Rome and Renaissance Florence, and they proposed that the strip malls, neon signs, and highways of these American cities reflected contemporary needs and a new architectural language, one that should be embraced by architects.

Venturi practiced what he preached. In 1962, he designed a house for his mother in Chestnut Hill, Philadelphia (fig. 30.1). The structure resembles a Modernist abstraction of flat planes, strict geometry, clean lines, and a play of forms and spaces, notably in the enormous cleft in the center of the façade. But the house is also referential, for it is a parody of a conventional

30.1 Robert Venturi. Vanna Venturi House, Chestnut Hill, Philadelphia. 1962. Venturi, Scott Brown and Associates, Inc.

American home, complete with a slanted gable (the actual roof is much lower), a nineteenth-century pane-glass window, twentieth-century tract-house sliding-glass windows, a front porch, and behind that a large rectangular block that looks like a chimney but is not, since the real chimney, much smaller, pokes up out of it. Venturi then complicates the house with endless architectural references—the cleft, for example, derives from Kahn's medievalcity buildings with slotted parapets and lintels embedded in the wall. The use of the "lintel," which seems to support the two halves of the façade, combined with the opening of the porch, recalls an Egyptian pylon, while the broken segmental arch, functioning like a molding, brings to mind Pierre Lescot's Square Court at the Louvre (see fig. 18.2). Venturi has imbued the overscale house with humor, irony, and allusions, transforming the traditional American home into a rich architectural statement.

MICHAEL GRAVES The American architect whose name is perhaps most synonymous with Postmodern architecture is Michael Graves (b. 1934), who is based in Princeton, New Jersey. He rose to national attention in 1980 when he received a commission for the Public Services Building (fig. 30.2) in Portland, Oregon. The design is filled with paradox, as every element on the building's surface begs to be seen in several ways: flat and sculptural, representational and abstract, historical and modern.

The form of the building is a Palladian cube sitting atop a platform, with the square or near-square motif echoed in the outline of the façade and in additional squares within (for example, the

enormous mirror-glass window, which encases a square defined by the maroon vertical piers). The individual windows are each 4 feet square. The wall can be read as a flat mural, a thin Modernist membrane stretched over the metal skeleton; but suddenly it becomes three-dimensional and sculptural, an effect heightened by the maroon-colored vertical shafts in front of the large mirror window. These mullionlike shafts become the fluting of pilasters, topped with bracket capitals, which support an enormous keystone above. Yet, if you read the keystone with the beige-colored wall, it becomes part of a flat arch framing the mirror window. The façade can even be described as anthropomorphic, for the pilasters and keystone can be read as a huge face, the capitals as eyes, and the pilasters as legs. The building has a whimsical sense of play, but it is also serious, recalling such great historical models as Palladio, Mannerism, and one of Graves's favorite predecessors, John Soane, who is reflected here in the sublime pilasters (see fig. 24.30). The enormous curtain-wall window, massive corner piers, and prominent "pediment" bring to mind Behrens's Turbinenfabrik (see fig. 27.35), not coincidentally one of the great Early Modernist buildings made just before Modernism abandoned all overt reference to the historical past.

JAMES STIRLING As subtle, complex, and difficult as Graves is the London architect James Stirling (1926–1992), as can be seen in his Neue Staatsgalerie in Stuttgart (fig. 30.3). This museum and theater complex is located on the side of a steep hill, with a highway at its base and a city street above. Like Kahn's National

30.2 Michael Graves. Public Services Building, Portland, OR. 1980–82

30.3 James Stirling. Neue Staatsgalerie, Stuttgart. 1977–83

Assembly Building, Stirling's bold massing of simple forms and switchback ramps evoke ancient civilizations. Egypt especially comes to mind because of the large pylonlike forms and clefts that allow for narrow passageways. The pattern of alternating sandstone and travertine suggests medieval Italian structures, while the enormous wavelike window of the museum reverberates with memories of Paxton's Crystal Palace (see fig. 25.39) and the great curtain-wall window in Behrens's Turbinenfabrik. The curving window also suggests a grand piano, reminding us of the building's function as a performance hall. The pink and blue tubular railing and the blue I-beam support for the "pedimented" museum entrance are Hi-Tech and industrial. The same can be said for the skeletal taxi stand, whose ferrovitreous construction is also reminiscent of Paxton, while its form recalls a Greek temple. As in the work of Venturi and Graves, all these familiar sources are seamlessly melded into a unified vision that brings the past into the present. The result is a building that is distinctly modern yet imparts a Kahn-like monumentality and aura of importance.

New Modernisms: High-Tech Architecture

Late 1970s and 1980s Postmodernist architecture, with its historicism and symbolism, was important for launching new architectural freedoms. Released from the narrow constraints of pure Modernism, architects were free to explore a new range of possibilities that went well beyond the eclectic historical references of Postmodernism. Facilitating and even encouraging artistic license was the worldwide economic boom of the 1980s and 1990s, when unprecedented amounts of private and corporate money poured into building projects, dramatically energizing architecture and architectural vision. Just as New York real-estate developers in the 1920s had competed to create the tallest building, so clients worldwide now strove to erect the most spectacular, exciting structure, one with international cachet. At every level, the public was no longer settling for undistinguished generic Modernist buildings. Even the American strip malls of the 1980s were designed as Mediterranean minicities (Victorian, Queen Anne, Tudor, and Romanesque were popular styles as well), with many

30.4 Richard Rogers and Renzo Piano. Centre National d'Art et Culture Georges Pompidou, Paris. 1971–77

of those built in earlier decades in a Modernist style getting Postmodern facelifts.

Major Postmodern architecture in the vein of Venturi and Graves faded in the 1990s, superseded by an exhilarating diversity that expanded architecture to a true Postmodernism, if we use the term in its broadest sense to mean pluralism. Many architects now revisited Modernism, reinvigorating it with the new artistic license that had emerged during the late 1970s. An extreme version of this New Modernism is Hi-Tech, whose buildings resemble powerful industrial machines. Like Postmodern architecture, the most immediate roots of Hi-Tech design can be found in a few examples in the 1950s and 1960s, one of the earliest being James Stirling's 1959-63 Engineering School in Leicester, England. Perhaps the most famous prototype for Hi-Tech Modernism is the 1971–77 Pompidou Center (fig. 30.4) in Paris. There, architects Richard Rogers (b. 1933) and Renzo Piano (b. 1937) exposed the building's utilities-instead of being buried within the interior, they are displayed on scaffolding around the perimeter of what is otherwise a classical Modernist glass box. Elevators, escalators, and plumbing, electrical, and ventilation ducts are all prominently displayed as exterior "ornament." Besides challenging architectural aesthetics, this device has the advantage of completely opening up the interior space, allowing for any necessary configuration.

NORMAN FOSTER By the late 1970s, Hi-Tech Modernism had come to the fore, its arrival announced in part by the eye-popping Hong Kong and Shanghai Bank (HKSB) (fig. 30.5), designed in 1979 by Norman Foster (b. 1935) at a cost of \$1 billion. Here was a skyscraper that did not look like a skyscraper. Gone is the grid of the typical office tower, replaced by a complex structural apparatus that looks like a machine. The building is composed of four units, each consisting of four colossal piers that are pushed to either end of the rectangular building. Mammoth trusswork supports are cantilevered from these piers, and the floors then hang from these cantilevers in five stacked groups of six to nine floors each, groups that Foster called "villages." Elevators stop only on the communal floor of each village, and escalators then connect the remaining floors. All the services, including elevators, are placed in sleek shafts at either end of the building, allowing the interior to be virtually free of obstructions (fig. 30.6). Foster transformed the ground floor into a piazza, opening it up to the surrounding streets and leaving it unlevel since the streets themselves are at different elevations. The piazza has an enormous curved ceiling, penetrated by escalators that ascend to a spectacular atrium, extending ten stories and 170 feet high, as seen in our reproduction, off which are balconies of workspace. On the south side of the building, computer-driven mirrors, called "sun scoops," track the sun and reflect light onto a second set of

30.5 Norman Foster. Hong Kong and Shanghai Bank, Hong Kong, China. 1979–86

30.6 Norman Foster. Interior of the Hong Kong and Shanghai Bank

mirrors that in turn direct it down into the piazza, which becomes filled with spectacular natural light strong enough to cast shadows. Inside and out, machines, mechanics, a megastructure of trusswork, rooftop maintenance hoists, and sleek service shafts define the building, giving it an appearance of industrial strength, efficiency, and functionalism.

Deconstructivism: Countering Modernist Authority

In 1988, the Museum of Modern Art in New York mounted an exhibition titled Deconstructivism. The show included seven architects whose work displayed a Constructivist geometry (see page 1003) and planarity that created an architecture of "disruption, dislocation, deviation, and distortion," as Mark Wigley, who cocurated the exhibition with architect Philip Johnson, wrote in the accompanying catalogue. Originally the show was to have been called "Violated Perfection," which would have spared everyone from struggling to determine what Deconstructivism actually is. The label caught on, however, with none of its advocates agreeing on a definition or even who the core Deconstructivists were. The show's curators derived the term from Derrida's theory of Deconstruction. Essentially, Derrida posits that there are no firm meanings to any written text; outside of the text there are infinite forces that continually restructure its meaning and provide endless readings and interpretations. Similarly, Deconstructivist architecture had no fixed meaning. Wigley linked architectural Deconstructivism with Russian Constructivism. This connection is based on style and not theory, since Constructivism was about establishing a new order and a utopian perfection, whereas Deconstructivism focused on denying any fixed structure or logic.

30.7 Coop Himmelblau. Rooftop Office, Vienna. 1983–88

Ironically, most of the architects in the show had no or little interest in Derrida, and if they did, it was through indirect associations rather than a reading of his abstruse writings. That said, a major trend emerged in the 1980s that challenged the idea that architecture had to adhere to any single concept or ideal. These architects rebelled against the notion that architecture had to aspire to some kind of perfection, order, or logic.

COOP HIMMELBLAU Early advocates of this movement are Wolf Prix (b. 1942) and Helmut Swiczinsky (b. 1944), whose Viennese firm Coop Himmelblau was included in the 1988 *Deconstructivism* exhibition. Their aesthetic is prominently displayed in the rooftop conference room (fig. 30.7) they designed in 1983 for a law firm in Vienna. No explanation or logic can be applied to this architectural phenomenon, in which the roof seems to explode, creating a sense of catastrophe wholly at odds with the staid conservatism usually associated with the legal profession. Even the materials are jarring, conflicting violently with the nineteenth-century apartment building below. The planarity of the forms may suggest Constructivist sculpture, but the design lacks the clarity, structure, and logic of the Russian movement. The project is devoid of historicist and architectural references. Replacing order and logic is a sense of slashing, thrusting, tilting, fragmentation, and skewing. Yet these attributes are not about destruction, demolition, dismantling, or disaster. Rather, the architects aspired to disrupt preconceived notions of architecture.

ZAHA HADID Zaha Hadid (b. 1950) is the one artist who is on everyone's list of Deconstructivist architects, although she has little interest in Derrida and claims her work is not based in theory, but instead is intuitive. Born in Iraq and trained and based in London, she was heavily influenced by the energized geometric forms of Suprematism (see pages 966–69). Hadid's projects generally show her concern for creating easily perceived fluid spaces that encourage people to come into and move about her structures.

In the Lois and Richard Rosenthal Center for Contemporary Art in Cincinnati (fig. **30.8**), which opened in 2003, broad shifting Suprematist-like planes and Constructivist-like boxes move up

30.8 Zaha Hadid. Lois and Richard Rosenthal Center for Contemporary Art, Cincinnati. Opened 2003

and down and in and out on the museum's façade. Hadid describes the façade as an "Urban Carpet," and in fact, the sidewalk curves slowly upward into the building, encouraging people to enter. The ground floor is a landscaped lobby, serving as an enclosed park, further attracting visitors. It is dominated by a dramatic series of lobby ramps that run the length of the entire space. The ramps lead to a mezzanine that opens onto galleries. The galleries and their shapes are visible from the street, further enticing the public to enter the museum. Because the museum does not have a permanent collection and only mounts temporary exhibits, Hadid designed a wide range of spaces to accommodate all kinds of art objects. The galleries appear to be suspended in space, floating on a variety of levels. This sense of energized fluidity, not only within the museum but also in the relationship of the street and sidewalk with the building, is one of the hallmarks of Hadid's work.

FRANK GEHRY Frank Gehry (b. 1929) was also one of the seven architects included in the 1988 *Deconstructivism* show, but he views himself as an independent, refusing to be associated with any style or group. Nevertheless, his projects share with Coop Himmelblau's rooftop office a sense of disorder, fragmentation, and energy, as seen in his most famous project, the Guggenheim Museum, Bilbao (fig. 30.9). Its unique forms and vocabulary make it impossible to establish any specific meaning or architectural references. People have described the building's forms as a boat, a fish, and a blossoming flower—Gehry's own description—but ultimately the structure is an exploration of the abstract

sculptural play of enormous volumes, and it shows clearly the architect's pure delight in architectural freedom.

The building's curvilinear masses are contrary to orthodox Deconstructivism, which emphasizes flat planes and angularity. Gehry designed their complex forms using computer technology, an integral tool in the fabrication of the building as well. (See Materials and Techniques, page 1085.) The museum even feels Hi-Tech, for covering the steel skeleton is a thin skin made up of thousands of tiny titanium shingles. These shimmer in the light, changing color-silver, blue, gold-as the time of day or the weather changes. The interior is equally spectacular. A handful of conventional, rectilinear rooms containing modern art (that is, art made before 1960) contrast with large, irregularly shaped galleries that accommodate contemporary works. One such space is the so-called boat gallery, a long corridor created by two massive concave walls. Perhaps the most sensational area is the vast entrance atrium. Crisscrossed by catwalks and lined with elevator cages, it contains spiraling ribbons of piers and opens up to a sea of windows and skylights.

The Guggenheim, Bilbao is an example of the architectural diversity that had emerged by the end of the twentieth century, when all rules about design were suspended. As important, it reflects how architecture has moved beyond just being about designing buildings. Architects have, once again, begun to create prominent symbols for a city. From its conception, the museum was intended to be more than just a museum; it was meant to change the image of this Spanish industrial port, giving it cultural cachet and transforming it into a tourist destination. That is

30.9 Frank Gehry. Guggenheim Museum, Bilbao, Spain. 1992–97

Computer-Aided Design in Architecture

n the early 1990s, architects began using CAD (computer-aided design) to create their buildings. In the "paperless studio," plans were developed using computer programs. This approach to design was initially quite controversial, since it forsook the age-old intuitive process of creating by putting hand to paper or modeling with wood or cardboard.

Frank Gehry used a CAD program to produce the extremely complicated forms of the Guggenheim, Bilbao, and without this advanced technology, the structure and its titanium veneer probably would have been difficult to achieve, or at least the building would have been prohibitively expensive. The CAD program that Gehry, with his associate Him Glymph, selected is called CATIA, originally developed by Dessault Systems of France to digitally design and precisely produce extremely complicated products, such as airplane wings and fuselages for the French aerospace industry.

Perhaps more important for Gehry and Glymph than facilitating the design, CATIA made the fabrication possible. Without CATIA, Gehry would have had to hand his plans over to artisans and workers, who then would have been challenged to translate them precisely into three-dimensional forms, a daunting if not impossible task. (Frank Lloyd Wright had tremendous difficulty finding a contractor willing to build his highly irregular, organic Solomon R. Guggenheim Museum in New York.) Instead, Gehry and Glymph sent computer files to fabricators, who fed the digitized information into computer-robotic equipment that then manufactured the forms. Every detailed component of the building could be produced this way, from each unique, oddly

precisely what happened: Gehry designed one of the seminal buildings of the twentieth century, a satellite of Frank Lloyd Wright's sensational 1950s Solomon R. Guggenheim Museum in New York (see figs. I.16 and I.17), which it rivals in audacity and individuality.

POST-MINIMALISM AND PLURALISM: LIMITLESS POSSIBILITIES IN FINE ART

Beginning in the late 1960s, the Post-Minimalists had rejected the austerity of Minimalism (see pages 1058–69) and once again returned the human figure, the artist's hand, subjectivity, and references back to art. The reaction to Minimalism was accompanied by the rise of a broad range of issues, styles, and mediums in the 1970s. During the 1980s, this pluralism began to gain widespread acceptance as it moved from marginalized art to the mainstream. At the same time, Postmodern theory provided a philosophical basis for pluralism, as it argued against all authoritative aesthetics and philosophical positions. The Modernist notion that one and only one style was correct and could move art forward at any given moment was dead. Indeed, if a single word could encapsulate the art made since the 1980s, it would be "diverse." The art market, too, became truly global, with artists from every continent

Computer-generated diagram of the Guggenheim Museum, Bilbao, Spain

shaped window to each irregular titanium slate. CATIA also kept costs down. It no longer mattered that large segments of the building were uniquely sized and shaped and therefore could not be cost-effectively mass-produced. The computer program could manufacture each unique product with virtually the same expediency and cost as those of a Modernist building that has thousands of uniform windows and I-beams.

developing individual styles expressing a wide range of subjects in almost limitless mediums. Art's complexity now made it difficult to comfortably place an artist in a single category or hang a label on her or him.

Among the many developments of the last 30 years are a revival of interest in painting and the ascendance of installation art, photography, and video as leading mediums. Among the more popular themes are racial, ethnic, and gender identity, a preoccupation with the body and death, and a Postmodern analysis, or Deconstruction, of how images and art take on meaning. But if there is anything that unites this period, it is the belief that Modernism with its authoritarian posturing is dead, and that the possibilities of what art can be and be about are limitless.

The Return of Painting

Painting was back by 1980. Not that it had ever disappeared, but in the late 1960s and 1970s it had been overshadowed by Conceptual, Video, Performance, and Earth Art, for example. The Postmodern art critics of the late 1970s associated painting with Modernism and were talking about "the death of painting," even though a stream of shows featuring the medium opened in London, New York, Germany, and Italy in the period. In the introduction to his book about painting's revival, *The* International Trans-avantgarde (1982), critic Achille Bonito Oliva wrote, "The dematerialization of the work and the impersonality of execution which characterized the art of the seventies, along strictly Duchampian lines, are being overcome by the reestablishment of manual skill through a pleasure of execution which brings the tradition of painting back into art." Another staunch advocate of painting, Christos Joachimides, in the introduction to the catalogue for his 1981 London show, A New Spirit in Painting, lauded the medium because now "Subjectivity, the visionary, myth, suffering and grace have all been rehabilitated." The demand for painting was fueled by an explosion of personal and corporate wealth in the 1980s in America, western Europe, and Japan, especially driven in America by the takeovers and mergers encouraged by Reaganomics. As the recession of the 1970s and early 1980s ended, demand grew for art that could be bought and hung on a collector's wall or in a corporate lobby.

The new type of painting that emerged came to be known as Neo-Expressionism, an appropriate label for works that are often both painterly and expressionistic, although not always, which makes the term problematic, along with the fact that the range of issues these artists deal with are quite broad in range and unrelated. The painting labeled Neo-Expressionist appeared first in Germany and Italy in the 1970s and then migrated to New York. In Germany, painters self-consciously recalled the Northern Romanticism and Expressionism so deeply ingrained in that nation's culture. Joseph Beuys (see page 1063), through his mystical performances, was the catalyst for this resurrection of the German past. Among the themes he and other artists began to explore was the legacy of Hitler's Third Reich.

ANSELM KIEFER Among Beuys's students at the Düsseldorf Art Academy was Anselm Kiefer (b. 1945). Kiefer created images of mythical themes and epic scope that evoke centuries of German history, as seen in his enormous painting To the Unknown Painter (fig. 30.10). The picture explodes with the energy of flailed paint and the dramatic perspective of crop furrows rushing toward an eerie monumental tomb. Cold, bleak, and lifeless, this largely colorless image, except for shots of blood-red, seems to exude an atmosphere of death. Or does it? Crops lying fallow in the winter will be reborn in the spring, and the cycle of life continues. Kiefer's expressive use of paint and dramatic composition can be interpreted as a metaphor for the constant movement and forces of nature. Inspired by Beuys's use of symbolic objects, Kiefer often incorporated real materials into his paintings, imbuing them with a similar ritualistic magic. In this work, he embedded straw into the paint, and viewers could smell its scent for years. Nature is not just illustrated, it is physically present.

The focus of the image is the tomb, a mausoleum for painters, as suggested by the title. We can assume the painters are German because the tomb is not painted but rendered in a large woodcut,

30.10 Anselm Kiefer, *To the Unknown Painter*. 1983. Oil, emulsions, woodcut, shellac, latex, and straw on canvas, $9'2" \times 9' \times 2" (2.79 \times 2.79 \times$ 0.05 m). The Carnegie Museum of Art, Pittsburgh. Richard M. Scaife Fund; a. w. Mellon Acquisition Endowment Fund. 83.53

30.11 Julian Schnabel, *The Exile.* 1980. Oil, antlers, gold pigment, and mixed media on wood, $90 \times 120 \ge 24\%''$ (229 \times 305 \times 63 cm). Bischofberger Collection, Switzerland

a medium associated with German art since being widely used by northern European artists during the Renaissance as well as by the Expressionists in the early twentieth century (see page 958). The bunkerlike shape suggests a shelter, and the isolated but wellanchored monument seems to be surrounded by the swirling forces of nature, representing not only the German mythical past but also the Romantic spirit that has driven German artists for centuries. We know from other works by Kiefer that these destructive forces are meant to symbolize Hitler's perversion of the German Romantic tradition, which he manipulated to serve his racist agenda and justify the suppression of avant-garde German artists, whom the Nazis labeled "Degenerates" (see page 1031).

In a painting about national identity, Kiefer's Expressionist style and use of Romantic themes proclaim his place within the northern European Romantic tradition. He assures us that this tradition is once again in safe hands. With its wealth of symbols, metaphors, and overlapping and interlocking interpretations, the resulting image is varied and complex, reflecting the epic scale Kiefer covers and the mythical themes he evokes.

JULIAN SCHNABEL The artist who became emblematic of Neo-Expressionism in America is Julian Schnabel (b. 1953), a New Yorker raised in Texas, where he went to the University of Houston. While today perhaps better known by the general public for his films, such as *The Diving Bell and the Butterfly* (2007), Schnabel dominated the New York art world in the 1980s, or, as one critic put it, he "created a bonfire over Manhattan," which he ignited with a 1981 exhibition that was so large it was held at both the Leo Castelli Gallery, the premier blue-chip gallery, and the Mary Boone Gallery, the hottest new gallery in town. Everything about Schnabel was oversize, including his ego, reflected in such statements as "I'm the closest thing to Picasso." His paint surfaces are enormous, 16 feet in one direction not being unusual, and range from traditional canvas, to Kabuki backdrops, to tarpaulins, to animal skins, to the disreputable black velvet found in gasstation art. Often, his pictures are encased in extremely ornate and wide baroque frames. He covers his surfaces with violent, crudelooking, and dramatic slathers of paint, as well as with objects of all kinds, including broken crockery, for which he became especially renowned, the skeleton of a fir tree, and antlers, as seen here in his 1980 painting The Exile (fig. 30.11). Demonstrating a Postmodern penchant to raid the art of the past and present, as well as popular culture, his motifs are often appropriated, as is the figure holding a fruit basket in Exile, which was taken from a painting by Caravaggio. Despite the bombast, there is no point in trying to interpret Schnabel's picture, since there is no narrative to be found in the Caravaggio figure, the spool-like diagrammatic doll, the bearded man, the antlers, and the often odd trailings of paint. The inspiration for Schnabel's appropriation of objects and images that are juxtaposed in no particular narrative is Sigmar Polke (see fig. 29.17), whose work Schnabel saw in Europe in the 1970s. Like Polke, Schnabel's painting exudes a mood, rather than a story. In The Exile, we can sense the eruptive gestures and vitality of the artist locking horns with death, as evoked by the lifelessness of the appropriated figures and the sad, one-eyed doll, and, of course, the antlers themselves, the remains of once-living animals. As expressed by the artist, his paintings "are icons that present life in terms of our death." Although he is Jewish, his

imagery is often Catholic, the crucified Christ being one favorite motif. While reflecting his personal experience as a student at a Catholic school in Brownsville, Texas, this kind of imagery is hardly spiritual, instead reinforcing a sense of physical suffering, loss, and isolation that haunts his baroque pictures.

JEAN-MICHEL BASQUIAT AND GRAFFITI ART Of the many American Neo-Expressionists to emerge in the 1980s, among the most exciting was Jean-Michel Basquiat (1960–1988). Born in New York to a middle-class family, Basquiat's father was Haitian and his mother was of Puerto Rican descent. He dropped out of school at age 17, first writing poetry and then becoming a street artist using the tag name SAMO, suggesting the phrase "same old." By studying art books, he became knowledgeable about art history and began painting. By the time he was 22, he had achieved international stardom. He died of a drug overdose at age 27.

In *Horn Players* (fig. 30.12) of 1983, Basquiat combines both poetry and graffiti. More important, he draws upon the lessons of

the pluralistic 1970s by brilliantly incorporating the era's strategies of using texts, making process art, working with narratives, and dealing with social politics, here racial identity. Basquiat also owes a debt to Abstract Expressionism, seen in his dynamic handling of paint, and to Pop Art, visible in his cartoonlike imagery and popular-culture references.

Basquiat was prolific, working quickly and with the streamof-consciousness intensity sensed here. We can feel him painting, writing, crossing out. He draws us into the canvas by forcing us to read and piece it together. He makes us experience the sounds coming out of the saxophone, think about the repetition of words and the rhythms they make, and analyze his masterful use of color—a brilliant pink and blue here, yellow and green there. Because they are so powerfully presented, we cannot dismiss Basquiat's use of words such as "alchemy," a reference to the alchemy of jazz, "ornithology," a nod to jazz musician Charlie Parker, nicknamed "Bird,", and "ear," an allusion to musical instinct. His works evoke the raw energy of the 1950s— Beat poetry, improvisational jazz, and Abstract Expressionism.

30.12 Jean-Michel Basquiat, *Horn Players*. 1983. Acrylic and oil paintstick on canvas, three panels, overall $8' \times 6'5"$ (2.44 × 1.91 m). Broad Art Foundation, Santa Monica, CA

30.13 Elizabeth Murray, *More Than You Know*. 1983. Oil on ten canvases, $9'3" \times 9' \times 8"$ (2.82 × 2.74 × 0.20 m). Estate of Elizabeth Murray. Courtesy PaceWildenstein Gallery, New York

But 1980s hip-hop also comes to mind. Like Schnabel, Basquiat appropriates motifs, styles, and ideas from different periods a hallmark of Postermodernism. This approach allows him to create a powerful, sensuous experience as he shares his passionate feelings about the black musicians Dizzy Gillespie and Charlie Parker, with whom he clearly identifies. Much of his work features African-American musicians, singers, and athletes, and is a reflection of the importance artists were increasingly giving to racial, ethnic, and gender identifies, as will be discussed below.

ELIZABETH MURRAY AND NEW IMAGE PAINTING In 1978, the Whitney Museum of American Art in New York mounted an exhibition of American artists entitled *New Image Painting*. The show not only claimed that painting was alive and well, it heralded the arrival of a new kind of painting, one that had representational objects embedded within seemingly abstract paintings. At the time, Elizabeth Murray (1940–2007) was producing totally abstract work and was not included in the exhibition. But within a few years, she had begun adding representational components to her abstractions. Because of their associations, these recognizable elements served as metaphors for a psychological state. Murray's evolution to referential abstraction can be seen in *More Than You Know* (fig. 30.13) of 1983. At a glance, the painting appears to consist of entirely abstract shapes. But we soon realize that the

sweeping organic curve playing off a blue-gray Constructivist rectangle is the back of a spindleback chair. We then recognize the mostly gray rectangle as a painting hanging on a yellow wall. Finally, the green anthropomorphic shape evolves into a table with collapsed legs. On the table lie a white form resembling a piece of paper and a disturbing biomorphic shape that recalls the skull in Munch's The Scream (see fig. 26.19). Tension dominates the image, symbolized by the collapsed table as well as the strident colors, the unfinished-looking paint handling, and the violent tilt of the floor. Even the shape of the painting is frenzied. Murray combines ten canvases, overlapping them and producing a ragged profile that transforms the painting into a wildly spinning pinwheel. Nothing seems to be anchored in this composition as objects shift like detritus adrift in a stormy sea. In her threedimensional, heaving paintings, Murray continually focuses on the psychological tension of daily life, the edgy reality that lies beneath the façade of domestic harmony. Because her work often deals with the psychology of the home as experienced from a woman's viewpoint, many critics place her within the context of feminist art. In any case, her work reflects the increasing interest in women's issues that characterize the 1980s.

Sculpture

The Post-Minimal aesthetic in sculpture, which combined the geometry of Minimalism with references and emotion that we saw in the work of Eva Hesse and Richard Serra (see pages 1058–59), continued unabated into the 1980s and 1990s. It could appear in such diverse forms as beautifully crafted, mysterious objects, as in the work of Martin Puryear, or readily understood public monuments, as in the *Vietnam Veterans Memorial* by Maya Lin.

MARTIN PURYEAR One of the many outstanding sculptors who made objects rather than installations is Martin Puryear (b. 1941). Puryear fulfills in sculpture "the reestablishment of manual skill through a pleasure of execution," as the critic Oliva had said about painting. After serving in the Peace Corps in the West African nation of Sierra Leone, studying printmaking and woodworking in Sweden, and visiting Japan, Puryear settled in Brooklyn in 1973, where he soon emerged, by the 1980s becoming a leading sculptor of his generation.

One of the first things we notice in his 1985 wood and steel sculpture *The Spell* (fig. 30.14) is his craftsmanship. We marvel at the beauty of the curved shapes, the elegant tapering of the cone, the playful variety of its rectangular openings, and the sensuous texture of the flat, striated wood strips that make up the "webbing" of what looks like a basket. The allusion to basket making suggests crafts and craftsmanship, which in turn implies a human presence—we sense the hand that carefully constructed this object, unlike Minimal Art, which seemed mass-produced and machine-made. We also sense Puryear's background not only in Africa, where he would have seen magnificently crafted utilitarian and ceremonial wooden objects, but also in Sweden, where he

30.14 Martin Puryear, *The Spell.* 1985. Pine, cedar, and steel, $4'8" \times 7' \times 5'5"$ (1.42 × 2.13 × 1.65 m). Collection of the artist. Courtesy of the McKee Gallery, New York

trained in woodworking, and in Japan, a culture with a long tradition of crafting wood into functional and decorative objects. It would be a mistake, however, to interpret Puryear's references to African art as just an acknowledgment of his African-American background. His sculpture is generally not about ethnic identity and politics, although there are exceptions, but instead it reflects his broader experiences in diverse cultures well versed in using wood as an artistic medium.

The Spell defies interpretation. Resembling a trap lying on the floor, the sculpture appears to be utilitarian but is not. Despite its title, suggestive of mystery and sorcery, there is nothing clearly ritualistic or shamanistic about the work. Rather, we sense the essence of the wood itself, and therefore the sculpture evokes nature. Yet it is the human component—the craftsmanship—that prevails. Like Eva Hesse, but working in a radically different style, Puryear transforms the austerity of Minimalist geometry into an enigmatic yet warm organic object loaded with powerful human allusions.

MAYA LIN One of the best-known Post-Minimal sculptures of the 1980s is the *Vietnam Veterans Memorial* (fig. 30.15) by Maya Lin (b. 1959). Lin received the commission while still a student in the architecture program at Yale University. A daunting project because of the strong emotions and opinions surrounding the Vietnam War, Lin's solution proved beautiful in its simplicity, ingenious in its neutrality, and sublime in its emotional impact. Lin presents

30.15 Maya Lin, *Vietnam Veterans Memorial.* 1982. Two black granite walls, length of each 246'9" (75m). The Mall, Washington, D.C.

Cindy Sherman (b. 1954)

From an interview

In these excerpts from a 1988 interview with Jeanne Siegel, Sherman discusses the role-playing in her photographs.

CINDY SHERMAN: I still wanted to make a filmic sort of image, but I wanted to work alone. I realized that I could make a picture of a character reacting to something outside the frame so that the viewer would assume another person.

Actually, the moment that I realized how to solve this problem was when Robert [Longo] and I visited David Salle, who had been working for some sleazy detective magazine. Bored as I was, waiting for Robert and David to get their "art talk" over with, I noticed all these 8 by 10 glossies from the magazine which triggered something in me. (I was never one to discuss issues—after all, at that time I was "the girlfriend.")

- JEANNE SIEGEL: In the "Untitled Film Stills," what was the influence of real film stars? It seems that you had a fascination with European stars. You mentioned Jeanne Moreau, Brigitte Bardot, and Sophia Loren in some of your statements. Why were you attracted to them?
- CS: I guess because they weren't glamorized like American starlets. When I think of American actresses from the same period, I think of bleached blonde, bejeweled, and furred sex bombs. But, when I think of Jeanne Moreau and Sophia Loren, I think of more vulnerable, lower-class types of characters, more identifiable as workingclass women.

At that time I was trying to emulate a lot of different types of characters. I didn't want to stick to just one. I'd seen a lot of the movies that these women had been in but it wasn't so much that I

the names of the dead and missing in action in a chronological list from 1959 to 1975. The names are etched into slabs of black granite that carve out a V-shaped gash in the earth. Viewers start reading from the left, representing the year 1959, where the first killed are listed and the granite rises out of the ground. The nameladen stone gradually rises along its 247-foot (75.2-m) length as more and more Americans die. The names keep coming, and the viewer soon becomes emotionally overwhelmed by their number.

At its 10-foot peak, the granite turns at a 130-degree angle and then descends along another 247-foot length, with fewer soldiers listed as the 1973 withdrawal from Vietnam approaches. At the end, as the granite again disappears into the ground, many viewers are left with a feeling of existential nothingness. Adding to this sense of loss is the impact of the granite's polished surface, which acts like a mirror casting reflections of the living onto the names of the dead. This memorial is a sharp departure from traditional representational monuments to heroism, like Rude's *La Marseillaise* (see fig. 24.27), which glorified nationalistic spirit and dedication. In a sense, the granite wall acts as an enormous tombstone. While the monument takes the form of Minimal sculpture, and like Minimal sculpture was manufactured, it has was inspired by the women as by the films themselves and the feelings in the films.

JS: And what is the relationship between your "Untitled Film Stills" and the real film stills?

cs: In real publicity film stills from the 40s and 50s something usually sexy/cute is portrayed to get people to go see the movie. Or the woman could be shown screaming in terror to publicize a horror film.

My favorite film images (where obviously my work took its inspiration) didn't have that. They're closer to my own work for that reason, because both are about a sort of brooding character caught between the potential violence and sex. However, I've realized it is a mistake to make that kind of literal connection because my work loses in the comparison. I think my characters are not quite taken in by their roles so that they couldn't really exist in any of their socalled "films," which, next to a real still, looks unconvincing. They are too aware of the irony of their role and perhaps that's why many have puzzled expressions. My "stills" were about the fakeness of role-playing as well as contempt for the domineering "male" audience who would mistakenly read the images as sexy. ...

- JS: Another critical issue attached to the work was the notion that the stereotypical view was exclusively determined by the "male" gaze. Did you see it only in this light or did it include the woman seeing herself as well?
- CS: Because I'm a woman I automatically assume other women would have an immediate identification with the roles. And I hoped men would feel empathy for the characters as well as shedding light on their role-playing. What I didn't anticipate was that some people would assume that I was playing up to the male gaze. I can understand the criticism of feminists who therefore assumed I was reinforcing the stereotype of woman as victim or as sex object.

Source: Artwords, II, ed. Jeanne Siegel (NY: Da Capo Press, 1990). Copyright $\textcircled{$\otimes$}$ 1988 by Jeanne Siegel. Reprinted by permission of Jeanne Siegel

been transformed through references into a brilliant Postmodern monument of powerful emotions.

APPROPRIATION ART: DECONSTRUCTING IMAGES

While painting and sculpture were exciting the art world in the first half of the 1980s and garnering the bulk of the attention, more and more artists came under the spell of Postmodern ideas. These artists turned to photography, video, film, billboards, and LED (light-emitting diode) boards, that is, mediums associated with the mass media. Rarely did they make paintings, which were identified with Modernism, although Julian Schnabel's appropriated images that he put into a new context, thus changing their meaning, could just as easily be discussed in this section as under Neo-Expressionism. This new generation of artists began to deconstruct the visual world, exploring how images, which include three-dimensional objects, function largely to establish power, prestige, and value, but also demonstrating how objects take on meaning in general. This Postmodern questioning parsed image making, exposing hidden agendas or hierarchies, and demystifying the authority of the image. Feminist theory especially propelled this Postmodernist art, as large numbers of women artist explored how women were presented in the media, and for whom.

Photography and LED Signs

While October magazine played a major role in introducing Postmodern theory to American artists, an exhibition titled Pictures, presented in 1977 at Artists Space, an alternative gallery in lower Manhattan, was also instrumental in bringing Postmodernism to the art world's attention. The art in the show consisted largely of pictures, both paintings and photographs, that were appropriations of preexisting images, thus demonstrating how all pictures, to varying degrees, are based on earlier art and calling into question such issues as originality, uniqueness, and authorship in art. Sherrie Levine, one of the artists in the exhibition, soon after became notorious for making photographs of photographs by such major male artists as Edward Weston and Walker Evans (see pages 1023 and 1029) and drawings of drawings by Joan Miró and Piet Mondrian (see pages 996 and 1005). Her copies, or re-presentations, called into question how art takes on value and the importance granted to the original artist, who, himself, was always borrowing from predecessors. In effect, Levine was declaring that no art was new. Furthermore, Levine re-presented the work of men, her appropriations underlining the status accorded male artists. Not only did many of the early appropriation artists work in photography, but many, such as Cindy Sherman, Louise Lawler, Barbara Kruger, and Laurie Simmons, were women, who often dealt with women's issues. By the end of the 1980s, Neo-Expressionism was on the wane, overtaken by Deconstruction, much of which was photography.

BARBARA KRUGER If anyone knows how the mass media operates, it is Barbara Kruger (b. 1945), who has a background in graphic design at the magazines Mademoiselle and House and Garden. Kruger appropriates photographs from magazines, which she re-presents in gelatin silver prints, often quite large, with wording across the image, similar to the wording in advertising. Over the frontally presented head of an attractive woman, for example, she put "Your body is a battleground," a reference to the abortion debate engulfing the nation in the 1980s as Jerry Falwell's Moral Majority ramped up the attack on Roe vs. Wade, the 1973 supreme court decision upholding the right to abortion. Over the image of a stone sculpture bust of a woman seen in profile she placed "Your gaze hits the side of my head," a reference to art being made specifically for the male gaze, as described in Jacques Lacan's psychoanalytic theories, with women being presented for male pleasure. This same theme is presented in Untitled (We Won't Play Nature to Your Culture) (fig. 30.16). The woman does not have the power of the gaze for she is blinded, not because she is stone, but here because her eyes are covered with leaves. By using words such as "we" and "our" versus "you" and "your,"

30.16 Barbara Kruger, *Untitled (We Won't Play Nature to Your Culture).* 1983. Photograph, 73 × 49" (185 × 124 cm.) Courtesy Mary Boone Gallery, NY

Kruger sets up a dichotomy between the maker/manipulator of the image on the one hand, and the target/manipulated on the other. Besides the male/female dichotomy, Kruger sets up a nature/culture opposition, "nature" referring to the neutral state of nature, and "culture" to the two-dimensional visual image in which one person's agenda is imposed on another.

Kruger's deconstruction not only reflects European Postmodernism, it is also driven by a dramatic increase in feminist theory in general, which appeared in such journals as *Camera Obscura* and *Differences*. The feminist movement also produced a journal specifically for feminist art, *Heresies*, started in 1976. The late 1970s and 1980s saw an enormous increase in women artists dealing with feminist issues. Among the most vociferous and effective was a collaborative called the Guerrilla Girls, founded in New York in 1985 and with cells throughout the United States. They produced printed matter, especially posters, and gave presentations, wearing gorilla masks, a feminist ploy meant to undermine the Modernist emphasis on the individual artist and shift focus to the issues. They especially spotlighted how women were marginalized by the art establishment. Among their more famous posters is one made in 1989 presenting Ingres's *Grande Odalisque* (see fig. 24.13) wearing a gorilla mask, above which is printed "Do women have to be naked to get into the Met. Museum? Less than 5% of the artists in the Modern Art sections are women, but 85% of the nudes are female." The Guerilla Girls are confrontational interventionists, taking their art out of the gallery and to the public by plastering their posters and billboards in public places, often around museums and galleries that they were viciously critiquing. Kruger as well on occasion has worked in the public domain, using billboards.

CINDY SHERMAN AND THE UNTITLED FILM STILL

While Kruger and the Gorilla Girls appropriate the propagandistic look and power of advertising, Cindy Sherman (b. 1954) focuses more on how film structures identity and sexuality. She is also interested in revealing how viewers impose meaning on images. Beginning in 1977, Sherman began a series called *Untitled Film Stills*, in which she photographed herself in situations that resemble stills from B movies. For each, she created a set and a female character that she played herself, wearing different clothes, wigs, and accouterments so that she is unrecognizable as the same

person from one 10-by-8-inch still to the next. It is conceptually important that she is always the actress, for her metamorphosis represents the transformation women undergo subliminally as they conform to societal stereotypes reinforced, if not actually determined, by the mass media. In Untitled Film Still # 15, Sherman plays the "sexy babe" who seems to be anxiously awaiting the arrival of a date or lover (fig. 30.17). But is this really what is happening? Sherman leaves the viewer guessing. She may suggest a narrative, but in her untitled works, she never provides enough information to securely determine one. In effect, the story a viewer imagines says more about their own backgrounds, experiences, and attitudes than it does about the picture itself, which remains ambiguous. Her "babe" could very well be dressed for a costume party instead of a date, and her look of concern could be for something occurring on the street below. Innumerable stories can be spun from this image, taking into account such details as her cross pendant or the spindleback chair and exposed-brick wall, which seem to conflict with her youth and the lifestyle her clothing suggests. Remove any one of these motifs, and the story would change. Through what seems a simple strategy, Sherman brilliantly reveals the complex ways in which images become invested with meaning and how we are programmed by the media to interpret them. (See Primary Source, page 1091.)

JENNY HOLZER AND LED BOARDS Like Kruger and Sherman, Jenny Holzer (b. 1950) works in the very medium she wants to expose. For Holzer, the target is the advertising slogan that passes as truth. In 1977, she began writing what she calls "truisms," which she printed on posters, flyers, T-shirts, and hats. Eventually, she moved on to electronic signs, even using the big electronic board in New York's Times Square in 1982. In the mid-1980s, she began working with LED boards, the medium with which she is now most associated. Holzer's truisms were homespun aphorisms, one-liners that express a broad range of attitudes and biases, such as "Murder has its sexual side," "Raise boys and girls the same way," "Any surplus is immoral," and "Morality is for little people." In effect, she presents either side of the "us versus you" conflict exposed by Kruger, but the impact is the same. Her works provoke an awareness that one person is trying to impose a position on another. Holzer created the installation of truisms reproduced here (fig. 30.18) for the Solomon R. Guggenheim Museum in 1989. LED boards run up the side of museum's spiral ramp, while below, arranged in a ritualistic circle, are benches with truisms etched on their seats. Wherever visitors turn, they are being talked to, and in a sense, manipulated, harangued, preached to, and controlled. Left unanswered, however, are such questions as: What is the truth? And who is talking, and for whom?

30.17 Cindy Sherman, *Untitled Film Still* #15. 1978. Gelatin silver print, 10×8 " (25.4 × 20.3 cm). Courtesy of the artist and Metro Pictures, New York

30.18 Jenny Holzer, Untitled (selections from Truisms, Inflammatory Essays, The Living Series, The Survival Series, Under a Rock, Laments, and Child Text). 1989. Extended helical tricolor LED electronic display signboard, 16" × 162' × 6" (40.6 × 4,937.8 × 15.2 cm). Site-specific dimensions. Solomon R. Guggenheim Museum, New York. Partial gift of the artist, 1989. 89.3626

Context and Meaning in Art: The Institutional Critique and Art as Commodity

Not all Postmodern artists deconstructed the mass media. Some, such as Fred Wilson, used appropriation to explore how museums control meaning and manipulate visitors, which we have already seen the Guerrilla Girls doing as well. Others, such as Jeff Koons, scavenged images from mass culture, especially nonart kitsch objects, and transformed them into high art. By putting the work in a high-art context, Koons demonstrates how art functions, how it differs from popular culture, and how taste is fashioned.

THE INSTITUTIONAL CRITIQUE: FRED WILSON Fred Wilson (b. 1954) is a New York Conceptual artist who generally works with found objects that he puts into new contexts in order to reveal the hidden meanings or agendas of their previous uses. Or, as he himself said, "I get everything that satisfies my soul from bringing together objects that are in the world, manipulating them, working with spatial arrangements, and having things presented in the way I want to see them." He is especially renowned for deconstructing museums, that is, reinstalling collections to reveal how museums have an agenda when they present art and how the interpretation of this art can change when it is put into a new context. His most famous work is titled Mining the Museum (fig. 30.19), a commission from the Museum of Contemporary Art in Baltimore. For this project, Wilson "mined" the collection of the nearby Maryland Historical Society, pulling works out of storage that probably had not seen the light of day in decades, and then inserting them into existing installations, the new item creating a new context for the display and powerfully deconstructing the original objects. Wilson, for example, uncovered slave manacles in storage, which he then inserted in a case of fine silver. Silver pitchers, teapots, and goblets, which had been presented as examples of superb craftsmanship and design, were now seen as valuable commodities, their production and acquisition made possible by the proceeds of slave labor. The manacles also raised a second issue, which is that without the manacles, African Americans, who constitute as large portion of

30.19 Fred Wilson, 'Metal Work, 1793–1880,' from *Mining the Museum: An Installation by Fred Wilson.* The Contemporary Museum and Maryland Historical Society, Baltimore, 4 April 1992–8 February 1993. Photograph courtesy PaceWildenstein, New York

Baltimore's populace, would not be represented at all in the museum. The unadorned, painfully functional manacles sit in powerful contrast to the glistening polished silver, creating a new context that radically undermines the story formerly told by the historical society.

ART AS COMMODITY: JEFF KOONS Unlike Wilson, Jeff Koons (b. 1955) makes objects, although he does not do the work himself, preferring to contract out the actual labor. But he likewise scavenges objects and images in order to explore the

relationship of fine art, often sculpture, to mass culture. He is particularly interested in issues of taste and how art functions as a commodity. Despite making objects, Koons is basically a Conceptual artist, and the wealth of his ideas drives the diverse styles and mediums in which he works. He continuously pushes the limits of sculpture, creating objects that range from Hoover vacuum cleaners presented in Plexiglas boxes to stainless-steel train cars filled with bourbon based on actual Jim Beam train cars, and from a rabbit-shaped chrome balloon to a 43-foot-tall puppy made of flowers.

Entirely different is the ceramic sculpture Michael Jackson and Bubbles (fig. 30.20) of 1988. Like a Warhol print, the sculpture was factory-produced, made to Koons's specifications in a limited edition by craftsmen in Italy. The image was not drawn or designed by the artist but rather chosen by him, in Duchampian fashion, from a publicity photograph of the singer with his pet chimpanzee, a process that on another occasion resulted in a copyright lawsuit against him. Its ornateness recalls seventeenthcentury Italian Baroque sculpture (see Chapter 19) and eighteenthcentury French porcelain, while the tawdry gold paint and rouged lips, along with the pop-culture imagery, give the work a crass look associated with mass-produced gift-shop figurines. Koons realized that by presenting his subject life-size, like a Classical sculpture of a Greek god, he was placing a mass-media image in the context of fine art, and giving it a new meaning. He transformed it from a kitsch souvenir into a compelling statement about what constitutes art, exploring the differences between fine art and "low" art. And because souvenirs are commodities, Koons reminds us that art, too, is merchandise. Again, with a hint of Warhol, Koons captures and parodies the glitz of celebrity promotion. But the tawdriness of the image and the porcelain medium give the sculpture a poignant sense of fragility and impermanence, suggesting

30.20 Jeff Koons, *Michael Jackson and Bubbles*. 1988. Porcelain, $42 \times 70\frac{1}{2} \times 32\frac{1}{2}$ " (107 × 179 × 83 cm). Courtesy Sonnabend Gallery, New York

the temporary nature of life and fame. Koons rolls the influences of Duchamp, Warhol, and Postmodern deconstruction into one package and updates it for the consumption-oriented 1980s.

MULTICULTURALISM AND POLITICAL ART

We have looked at Fred Wilson within the context of appropriation, deconstruction, and the institutional critique, but we could have just as easily incorporated him in a section devoted to racial identity. Part and parcel of the Postmodern 1980s is the tremendous surge in art dealing with issues of race, ethnicity, gender, and sexual orientation, as well as a full range of social and economic issues. Goading many artists was the adversarial position of the neoconservativism of Ronald Reagan's administration (1981–89) and Jerry Falwell's Moral Majority, founded in 1979. Their extreme-right philosophy defeated the women's Equal Rights Amendment in 1982, sought to outlaw abortion, reduced funding for social welfare, and ignored the AIDS epidemic, which struck mostly gays, blacks, and Latinos.

African-American Identity

There are almost as many approaches to dealing with racial issues as there are artists. While Fred Wilson uses site-specific installation, others, like Lorna Simpson and Carrie-Mae Weems, use photography with text, like Kruger. In one of her best-known works, Cornered (1988), the Conceptual artist Adrien Piper used video installation. She barricaded a television monitor, draped in black cloth, in a corner of a room behind an upturned table. Above the monitor on the wall were two death certificates for her father, one describing him as white, the other as octoroon, that is, one-eight African-American. On the screen, Piper, well dressed and softly spoken, gives a 20-minute monologue describing how people become cornered due to stereotyping and labeling. Radically different is Conceptual artist David Hammons, whose work is often imbued with humor and takes place in the community. In contrast again, Kara Walker's cut-paper silhouette wall drawings are charged with horror, exposing the conflicting feelings of hatred, lust, sadism, and fascination that lie beneath racial tensions.

DAVID HAMMONS Emerging in the late 1960s, David Hammons (b. 1943) is a wonderfully quirky Conceptual artist who, for most of his career, shunned showing in prestigious galleries (he does now), often presenting his art surreptitiously in New York shops owned by friends, where customers would chance upon it while looking at the store's regular nonart merchandise. Or he creates work specifically for African-American communities, as is the case with *Higher Goals* (fig. **30.21**) of 1982, originally installed in his Harlem neighborhood and here photographed at a Brooklyn site. The sculpture was provoked by a group of neighborhood teenagers, who were playing basketball when they should have been attending school and who told the artist that the road to success lay in sports, not education.

Hammons' response was to design 40-foot-high basketball hoops decorated with wind chimes (which suggest native American spirit catchers meant to filter out bad dreams) and bottle caps, often associated with winos and thus wasted lives and arranged in colorful geometric patterns suggesting African motifs, designs, textiles, and beadwork. As stated in the title, the work is about setting realistic higher goals, such as getting an education, as opposed to unrealistic objectives, such as becoming a professional basketball player, as suggested by the unreachable 40-foothigh baskets. Its brightly decorated objects have a ritualistic, even totemic quality, and they raise the issue of what is to be revered and where ancestral spirit is to be placed. While clearly humorous, Hammons's works are extremely intellectual, although they communicate at a "cool" accessible level with the neighborhood and in the neighborhood.

30.21 David Hammons, *Higher Goals*. 1982. Wood poles, basketball hoops, bottle caps, and other objects, height 40' (12.19 m). Shown installed in Brooklyn, New York, 1986

KARA WALKER Among the most sensational, and perhaps the most controversial, African-American artists to appear in recent years is Kara Walker (b. 1969), who emerged in 1994 fresh out of the M.F.A. program at the Rhode Island School of Design. Heavily influenced by her readings of such black feminist writers as Michele Wallace, Octavia Butler, and Toni Morrison, and especially the latter's *Tar Baby*, Walker found her subject matter in African-American history and, often, in her feelings as a black woman living in racist America. Simultaneously, her research led her to nineteenth-century silhouette portraits, simple black cut-paper silhouettes of the sitter, made by privileged white girls as part of their education and by itinerant portraitists for clients who could not afford full-blown portraits, whether on paper or canvas.

Walker exploded onto the New York art world in 1994 with a 13-by-50-foot installation of life-size black cutouts titled *Gone*, *An Historical Romance of a Civil War As It Occurred Between the Dusky Thighs of One Young Negress and Her Heart*, presented at the Drawing Center, a not-for-profit space. The scene is set in the antebellum South, filled with moss-laden oaks that frame such vignettes as white lovers leaning together to kiss, a small male slave mysteriously strangling a bird that appears to emerge from the opened legs of a female slave while the sword of a white gentleman appears to pierce the backside of the boy, and a slave girl performing fellatio on a white man. By 2000, Walker was adding projected silhouettes and colored lighting to her cut-paper installations, as can be seen in *Insurrection (Our Tools Were* Rudimentary, Yet We Pressed On) (fig. 30.22), containing such lurid or unseemly events as a plantation owner surreptitiously propositioning a naked female slave behind a tree, a group of whites torturing a black, and a female slave, with a tiny baby on her head, trying to escape a lynching. Everything is exaggerated and caricatured, playing to stereotypes; many of the figures in her works are outright grotesques, having, for example, four legs or giant phalluses, thus hammering home the perversion and abnormality driving the emotions in her anecdotal, chimerical world. The cut paper is executed in unmitigated black, and the scene has the quality of a dream, actually a nightmare, its sense of violence, hysteria, and horror pushed to a feverish pitch by Walker's contours, which are jagged, spiky, and erupting with piercing swordor daggerlike projections. This simple, detailless, flat, dark world seems to penetrate beneath the visual overload and superficiality of the fact-filled real world to expose the essence of human relations-a frightening psychological realm where the basic human urges and emotions of sex, desire, hatred, cruelty, love, sodomy, masochism, bestiality, castration, murder, and lust are played out. Walker's world is not just that of the antebellum South, it is also the world of today, where fraught race relations still plague American society and racial, ethnic, and religious conflict steeps the world in perpetual conflict. For besides giving Insurrection an oneiric quality, the projections pull Walker's antebellum scene into the present, for the light casts shadows of the viewers on the wall, thereby integrating the present, us, into Walker's nightmare and making us complicit in this horrific timeless occurrence.

30.22 Kara Walker, *Insurrection (Our Tools Were Rudimentary, Yet We Pressed On).* 2000. Cut paper silhouettes and light projections, dimensions variable. Solomon R. Guggenheim Museum, New York. Purchased with funds contributed by the International Director's Council and Executive Committee Members, 2000. 200.68

The AIDS Pandemic and a Preoccupation with the Body

One of the most embattled fronts in the 1980s artistic war with right-wing politics was the struggle to bring about government support to deal with the AIDS epidemic, a disease of the immune system first identified in 1981 that to date has affected over 33 million people worldwide. Triggered by ACT-UP, the acronym for the AIDS Coalition to Unleash Power, artists, many gay, began making art dealing with the crisis of thousands of people dying while the government did nothing. Much of the art was made by groups, such as Gran Fury and Group Material, these collaborative artists being a reflection of the Postmodern rejection

30.23 Felix Gonzalez-Torres, *Untitled* (billboard of an empty unmade bed). 1991. Billboard, overall dimensions vary with installation. The Felix Gonzalez-Torres Foundation. Courtesy of Andrea Rosen Gallery, New York and Museum of Modern Art, New York

of the importance placed on the individual in the production of art. Gran Fury, a spin-off of ACT-UP, its name taken from the Plymouth automobile used by the then-repressive New York Police Department, made posters, such as the 1988 *The Government Has Blood on Its Hands*, the bold type of the title appearing above and below a large blood-red handprint.

THE AIDS CRISIS: FELIX GONZALEZ-TORRES Felix Gonzalez-Torres (1957-1996), a founding member of the collaborative Group Material in 1980, produced some of the most powerful AIDS-related art, although his work encompasses a wide range of social issues. Gonzalez-Torres, who was born in Cuba and came to Florida in the 1981 in the mass-exodus called the Mariel boatlift, can best be described as a Conceptual artist working in a Minimalist mode. He is the quintessential Postmodern artist, since his art is issue-drive and seemingly oblivious to the concept of style. His mediums include, for example, two identical wall clocks hung side by side, which can be viewed as lovers who fade and die as the batteries wear out; a string of lightbulbs hanging from the ceiling, the lights evoking tears, or even souls, and like the clocks, eventually burning out; and a pile of brightly wrapped candy, the weight of the artist's lover, which visitors may take and eat, the gradual disappearance of the candy reflecting, among other things, the lover's body being consumed by AIDS.

Like so many artists of the 1980s, Gonzalez-Torres took his work out of a specifically art context and into the public domain. As part of a 1991 exhibition at the Museum of Modern Art in New York, he arranged for a black-and-white photograph of an empty, unmade bed, in which two people had slept, to be installed on 24 billboards around the city (fig. 30.23). A classic Postmodern picture, it was highly suggestive and subject to broad interpretation. Despite being devoid of text, the simple image of an unmade bed spoke volumes. It conjured thoughts of intimacy, relationships, and love, as well as of loss, absence, and death. For some viewers, the image of the empty bed evoked the thousands of men, women, and children who had become victims of the AIDS epidemic, creating public awareness and discussion of the disease. In contrast to the overt propaganda of Gran Fury, Gonzalez-Torres's work is poetic and understated. Gonzalez-Torres died of AIDS at the age of 38.

A PREOCCUPATION WITH THE BODY: KIKI SMITH The death and suffering of AIDS victims brought about a new awareness of the body, especially its vulnerability and frailty. One artist to explore the vincibility of the body and the brevity of life is New Yorker Kiki Smith (b. 1954). In the 1980s, she created a work consisting of eight identical jars of blood, and another presenting silver-coated watercooler bottles etched with the names of bodily fluids such as tears, milk, saliva, vomit, semen, urine, and sweat that a viewer is led to believe is in the jars. Because these works contain repeated elements, they resemble Minimal Art. Yet the Conceptual component—the thoughts we have when confronting any of these bodily fluids—packs a powerful, visceral

30.24 Kiki Smith, *Untitled.* 1990. Beeswax and micro-crystalline wax figures on metal stands, female figure installed height 6'4¹⁵/₁₆" (1.95 m). Collection Whitney Museum of American Art, New York. Purchase, with funds from the Painting and Sculpture committee. 91.13 (a–d)

response and emotional punch. Smith has reduced existence to an elemental essence, stripping away individuality and uniqueness to reveal the basic elements of life.

Toward 1990, Smith began constructing entire figures, usually using such impermanent materials as paper, papier-mâché, and wax, which served as a metaphor for the fragility of the body and the transience of life. In the untitled 1990 work reproduced here (fig. **30.24**), Smith cleverly revives the Classical tradition of the nude figure. However, we are viewing neither Greek gods and goddesses nor heroic athletes and soldiers. Rather, Smith portrays flesh-and-blood mortals. The woman oozes milk from her breast and the man semen from his penis, attributes of nourishment, procreation, and life. But death prevails, seen in the form of the limp figures slumped on their poles and the repulsive discoloration of the skin. Smith presents the entire life cycle, but it is the sadness of deterioration and our ultimate fate of death that prevail.

THE FUTILITY OF PRESERVING LIFE: DAMIEN HIRST

One of the most powerful statements about death, decay, and impermanence comes from the British artist Damien Hirst (b. 1965). Hirst, who has a flamboyant personality and is often

accused of being a publicity hound, headed a group of London artists who came to the fore in 1988, when Hirst organized a student exhibition entitled Freeze in a London warehouse. The group created a public sensation and a critical storm due to their outrageous subject matter. Their imagery got even more outrageous in the 1990s, highlighted by Hirst's The Physical Impossibility of Death in the Mind of Someone Living, consisting of a dead shark floating in a tank of formaldehyde and shown in a 1992 Saatchi Gallery exhibition titled Young British Artists. The show also included Hirst's 1990 One Thousand Years, a glass case filled with flies and maggots feeding off a rotting cow's head. In addition, Hirst has made beautiful, ethereal paintings incorporating dead butterflies and abstractions using dead flies stuck to an enormous canvas. In Mother and Child Divided (fig. 30.25), shown at the Venice Biennale in 1993, a cow and a calf, each divided in two, float in four tanks of formaldehyde. Using a Minimalist seriality, Hirst placed the bisected cows into identical tanks, thus creating a feeling of scientific objectivity. Even the nearly identical halves of each cow are multiples, that is, a repetition of the same form. The Minimalist tanks function as frames, the cow and calf as "realist pictures." The beauty and repulsiveness of this daring

30.25 Damien Hirst, *Mother and Child Divided*. 1993. Steel, GRP composites, glass, silicone, cow, calf, and formaldehyde solution, two tanks at $74\% \times 126\% \times 43$ " ($190 \times 322 \times 109$ cm) and two tanks at $40\% \times 66\% \times 245\%$ " ($102.5 \times 169 \times 62.5$ cm). Astrup Fearnley Museet for Moderne Kunst

presentation is fascinating. And because we are looking at real objects, we are literally confronting death, which is a powerful experience. We are also witnessing a vain attempt to prolong the physical existence of the animals. An especially poignant aspect of this work is the separation of mother from calf, a reminder of the life that once was and the emotional attachment of mother and child. While Hirst's subject matter may seem sensational, the animals he displays in formaldehyde tanks are powerful and 'unforgettable metaphors of life and death.

The Power of Installation, Video, and Large-Scale Photography

As we saw in the last chapter, installation art had existed since the late 1950s, when introduced by Alan Kaprow and called Environments. And by the early 1960s, we saw Robert Whitman integrating film into installation, thus anticipating video installation, and Nam June Paik taking a lead role in popularizing Video Art. At the same time, avant-garde artists, such as Joseph Kosuth, redefined photography, using the medium on a large scale and integrating it with other mediums. But in the 1980s, installation, video, and large-scale photography entered a new stage, their popularity exploding to new heights again in the 1990s. Not only did all three art forms become more popular, they got bigger, more sophisticated, and more refined, moving away from the more experimental, tentative, or temporary look of these mediums in the 1960s and 1970s. And now artists often worked primarily in these mediums, not being part-time practitioners as before. And like art in the Postmodern era, the work often drew heavily on earlier styles and historical periods, and showed no fear of being anecdotal, often having elaborate narratives as opposed to being abstract.

ILYA KABAKOV Of the legions of installation artists who emerged in the 1980s, one of the most engaging is the Russian Ilya Kabakov (b. 1933), who emigrated from Moscow to New York in 1988. In Russia from 1981 to 1988, he made a series of rooms he called *Ten Characters* that replicated the types of seedy communal apartments assigned to people by the Russian state under the Communist regime. Each was inhabited by an imaginary person with an "unusual idea, one all-absorbing passion belonging to him alone." One spectacular cubicle was *The Man Who Flew into Space from His Apartment* (fig. **30.26**). We see the room after its occupant has achieved his dream of being ejected into outer space, hurled through the ceiling from a catapult suspended by springs

30.26 Ilya Kabakov, *The Man Who Flew into Space from His Apartment*, from *Ten Characters*. 1981–88. Mixed-media installation, life-size

Ilya Kabakov (b. 1933)

On installations

Kabakov discusses his installations entitled Ten Rooms, which deal with life in Soviet Russia. He especially emphasizes the importance of the space in his installations, claiming the rooms have a spirit that establishes the mood and meaning of the work.

How does this "spirit of the place" seize you? In the first place, the rooms are always deconstructive, asymmetrical to the point of absurdity or, on the contrary, insanely symmetrical. In the second place, they look dull, oppressing, semidark, but this is not so because the windows are small or weak lamps are on. The main thing is the light both during the day and at night is arranged so excruciatingly, so awkwardly that it creates a peculiar discomfort distinctive to that place alone. The third important feature of our rooms' effect is their wretched, ridiculous preparation from the planning stage to the realization: everything is crooked, unfinished, full of stains, cracks; even in the most durable materials, there is something temporary, strange, made haphazardly, just to "pass."

What is especially depressing is the fact that everything is old, but at the same time it isn't clear when it was made, it doesn't have all the noble "patina of time," the marks of "wonderful days of old"; it is old in the sense of being decrepit and useless. All of this is despite the fact that it might have been made and painted only yesterday—it already appears outdated, marked for disposal. There is an impression of dust and dirt in every place and in everything—on the walls, at the ceiling, on the floor, in the corners. But the sensation is even stronger that these rooms, including private apartments, do not belong to anyone, that they are no-one's and that, in essence, no-one cares in the least about them. No-one loves them, people live in them temporarily and will leave not remembering them at all, like a train station, an underground crosswalk or a toilet at the bus station. ...

Sociality, being completely interlinked, was the natural means of survival, the very same traditional Russian "commune" which later also entered Soviet reality, in which you as a voluntary or subordinated participant were forever drowned, dissolved. But on the other hand, the commune saved you, supported you, didn't let you disappear or perish in loneliness, in despair, in a state of material or moral neglect. Every second of your life, you belonged to some kind of community....The atmosphere of the surrounding space was, in essence, its "spirit." ... And you caught this spirit immediately, all you had to do was to enter this or that space.

Source: Ilya Kabakov, *The Text as the Basis of Visual Expression*, ed. Zdenek Felix (Cologne: Oktagon, 2000)

and alluding to the space race between the U.S. and Russia. Like the other rooms, this one is accompanied by a grim story, worthy of the Russian novelist Fyodor Dostoevsky. The text, the collapsed ceiling, limp sling, and clutter become a tableau of life in Communist Russia, where claustrophobic squalor has brought about a hopeless delusional state, and flights of fantasy are the only escape from the drudgery of daily life. The ruin we are witnessing in *The Man Who Flew into Space* is not just the devastation of one man's life, but rather the shattered dream of the utopia in which Tatlin, the Constructivists, the Dadaists, and the Communist world in general had so firmly believed. Kabakov's installation is presented as a relic of an actual event, and like any relic, it possesses a powerful aura, almost impossible to achieve in conventional painting and sculpture. (See *Primary Source*, above.)

BILL VIOLA An especially popular form of installation is video or film installation. Among the best-known video artists is Bill Viola (b. 1951), who was also one of the first to specialize in video, coming at the tail end of the first generation of video artists. He started working with the medium in the 1970s after graduating from Syracuse University, his earliest work being primarily singlechannel video presented on a television monitor. By the early 1980s, he was projecting video onto large walls and incorporating

^{30.27} Bill Viola, *The Crossing*. 1996. Video/sound installation with two channels of color video projected onto 6-foot-high (1.83 m) screens, 10¹/₂ minutes. View of one screen at 1997 installation at Grand Central Market, Los Angeles. Courtesy of the Artist

it into installations or environments containing real objects. Although Viola's work does not always have a clear sequential narrative, it always has a theme, usually an unsettling, intense questioning of the meaning of existence that in part is brought about through intense sensory experience for a viewer.

One of Viola's best-known-and simplest-video projections is The Crossing (fig. 30.27). In two simultaneous, approximately ten-minute projections, shown side by side, or on either side of a single screen, a plainly dressed man approaches from the distance, passing through an empty, darkened space and stopping when his body, now nearly 12 feet tall, fills the screen. In one projection, water begins to drip on him, eventually becoming a deluge that washes him away. In the other, a small fire erupts at his feet, increasingly swelling into a bonfire that ultimately consumes him. The projections end with water hauntingly dripping in one, and a fire mysteriously smoldering in the other. Both videos are accompanied by a deafening soundtrack of pouring water and crackling fire, which intensifies the force of the imagery and heightens its visceral impact. Viola's elemental symbols of fire and water seem to have destroyed the figure. Or perhaps the two forces have brought about a transformative process, as the body dissolves into a spiritual state, crossing into a higher reality and becoming one with the unseen universal forces. We do not know. The video relentlessly instills a sense of the physical and sensory, and then suddenly leaves us in an existential void. Viola's work is a quest for the spiritual, reflecting the influence of Zen Buddhism, Islamic Sufism, and Christian mysticism. Viola summed up the thrust of much of his work when he said, "And those two realizations: that you are connected deeply to the entire cosmos and at the same time you are mortal and you are fragile and inconsequential; the search for meaning that human beings have been engaged with since the beginning of time is part of the reconciliation of those two things."

LARGE-SCALE PHOTOGRAPHY: ANDREAS GURSKY As we have already seen when discussing Joseph Kosuth in the last chapter (see page 1062), photography underwent a dramatic change beginning in the late 1960s as the medium was appropriated by visual artists who, because they were not trained as photographers, broke all of photography's traditions. These new photographers worked on a large scale, often did not take their own photographs, generally did not print their own work, and occasionally integrated photography into other mediums. Beginning in the 1980s, large-scale photography entered a new stage. For one thing, by the end of the 1980s, it became more prevalent, to the point that it may very well have superseded painting for the art world's attention. Second, it got bigger, with more and more artists working on a larger and larger scale. Cindy Sherman and Barbara Kruger, for example, made 6- and 8-foot pictures, while the Canadian Jeff Wall worked on a billboard scale, backlighting his images, which were transparencies in lightboxes. And third, it was increasingly being made by artists for whom it was their primary medium. Düsseldorf especially produced a large number of major photographers, mainly due to the

30.28 Andreas Gursky, *Shanghai*. 2000. Chromogenic color print, $9'1/_{6}'' \times 6'91/_{2}'''$ (2.80 × 2.00 m). Courtesy: Monika Sprueth/Philomene Magers, Cologne

innovative black-and-white photography of Bernd (1931–2007) and Hílla (b. 1934) Becher, and because Bernd, like Joseph Beuys, taught at the Art Academy. Becher's students included such renowned photographers as Thomas Struth, Thomas Ruff, Candida Höffer, and Elger Esser.

They also included Andreas Gursky (b. 1955). We can get a sense of his scale from his 2000 Chromogenic color print *Shanghai* (fig **30.28**), which is over 9½ feet high. Looking at this work, we get the impression that Gursky has an exceptional eye that has allowed him to discover remarkable compositions in the real world. Here, as in so many of his works, he seems to have discovered a wonderful geometry, which gives his image the look of Minimalist Art (see page 1056), yet another example of a Postmodern appropriation of an earlier style. But in fact he has digitally manipulated his images—sharpening lines, emphasizing certain colors while suppressing others, heightening value contrasts or minimizing them, and, on occasion, removing

The Changing Art Market

The world of contemporary art is as complex and varied as the art itself. Museums, commercial galleries, private dealers, auction houses, art fairs, international exhibitions, collectors from all strata of society, critics, curators, art historians, books, and a vast mass media that includes the Internet are some of the pieces that form the kaleidoscopic art market of the twenty-first century.

How different this conglomerate of influences is from the late medieval and Early Renaissance world that was largely defined by artists' guilds, the apprentice system, and a patronage system dominated by aristocrats and the Church. The rise of academies in the sixteenth and seventeenth centuries, especially the French Royal Academy in 1648, marked a shift of power to the academy system and its accompanying exhibitions (called Salons in Paris) which showcased the work of members and students. Historians published the first books on artists during this period. The eighteenth century witnessed the rise of prominent art auctions in Paris and London, the opening of the first public art museums in those cities, and the beginning of what many consider to be the first art criticism (see pages 811-12). In the nineteenth century, the French Salon changed from a members' exhibition into an open show that was juried and that presented hundreds of artists and thousands of works. Artists from all over Europe and the Americas aspired to exhibit at the Paris Salon, which, although dominated by the French, in effect became the first international showcase and an important venue for attracting patrons and commercial success. By the end of the nineteenth century, art dealers, who had virtually always been around, became a major force in the art world, especially in Paris.

Today, one of the strongest influences on an artist's career is representation by a prestigious dealer with a reputation for selecting "important" artists. Also significant is exhibiting and being collected by major museums, such as the Museum of Modern Art in New York, the Museum of Contemporary Art in Los Angeles, the Tate Gallery in London, the Ludwig Museum in Cologne, and the National Museum of Modern Art in Paris. These are just a few of the many museums known for presenting prestigious exhibitions and collecting contemporary art.

Artists also aspire to be included in the big international exhibitions, the twentieth- and twenty-first-century equivalent of the nineteenth-century French Salons, although the artists are generally invited by curators and do not submit work to a jury. One of the oldest international exhibitions is the Venice Biennale, established in 1903 and located in a park in Venice. Today, the show occurs once every two years and takes place in permanent pavilions owned by the various countries which present their own artists. Such international shows were often conceived to promote the host cities and to encourage their economic development. For example, Andrew Carnegie founded the Carnegie Museum of Art in Pittsburgh in 1895, and the following year he established what is now known as the Carnegie International in

objects. In some respects, he colors and draws like a painter. And his extremely realistic-looking images, which *have* to be fact since after all they are photographs, are a deconstruction of photography since they serve as evidence of how all images are order to draw international attention to Pittsburgh. Both the Venice Biennale and the Carnegie International, however, only gained their current prestige after World War II, when they were joined by other major international shows, such as the Documenta in Kassel, Germany, which is held every four years, and the São Paulo Biennale in Brazil. In the last few decades, many other international biennials have joined the art scene, including those in Istanbul, Havana, Cairo, and Johannesburg. A major venue for American artists has been New York's Whitney Museum of American Art, which was founded in 1930 and has always held an annual or biennial exhibition.

Despite the excitement generated by fairs and galleries, however, contemporary art has largely lived in the shadow of Old Masters and Impressionism, and, as the twentieth century progressed, early European Modernism. It was not until the 1970s that contemporary art became fashionable. Triggering the stampede to buy work by living artists was the sensationally successful auction of the Pop Art collection of Robert and Ethel Scull at Sotheby's in New York in 1973. Such major auction houses as Sotheby's and Christie's, both dating to eighteenth-century London, had long sold contemporary art, but in small quantities and with little fanfare. But after the Scull auction, countless collectors rushed into the contemporary arena, and in the last 25 years, auctions of contemporary art have shared the limelight with sales of Impressionism and European Modernism. This collecting fever spurred the appearance of numerous international art fairs, including Art Basel in Basel, Switzerland; Art Basel Miami in Miami Beach; the Frieze Art Fair in London; the Armory Show in New York; and the Foire Internationale d'Art Contemporain or FIAC (International Fair of Contemporary Art) in Paris. Every year, these high-end art fairs are flooded with tens of thousands of collectors and visitors scouting for new work and new artists.

International Art Fair. Art/Basel/Miami Beach/1-4/Dec/05

artificial and reflect what Derrida would describe as one person's hierarchy.

If it were not for the title, *Shanghai*, we would have no idea where Gursky's photograph was shot, for there is nothing to give **30.29** El Anatsui, *Dzesi II*. 2006. Aluminum liquor bottle caps and copper wire, 9'9" \times 16'3" \times 8" (2.97 \times 4.95 \times 0.20 m). Collection of the Akron Art Museum, Akron Ohio. Courtesy Artist and Jack Shainman Gallery, New York

this building a sense of place. And that is the point. From a deconstruction standpoint, the title is in a sense an integral part of the visual work, underscoring how the title affects meaning. As social commentary, the work points up how global all cultures have become. Gursky travels the world to acquire his images, photographing such motifs as hotel lobbies, stock exchanges, office towers, department stores, and crowds at rock concerts: The latter, instead of appearing Minimalist, have the allover look of a Jackson Pollock painting, another stylistic appropriation. In every instance, if it were not for the title, we would be clueless not only about the locale but even the nation or hemisphere featured in Gursky's highly objective and unemotional images, which suggest how homogeneous the world has become.

GLOBAL ART

The closing decade of the twentieth century marked the rise of a world art. With the arrival of the Internet and satellite communications, artists in even the most remote areas no longer operate in isolation. More artists than ever have access to what is being produced in New York, London, Paris, Düsseldorf, Beijing, and Tokyo. Jet travel circulates artists from Korea to Cairo, from Johannesburg to São Paulo, and from Basel to Dubai, for exhibitions and art fairs. (See *The Art Historian's Lens*, page 1104.) The entire world is artistically bound together, transforming it into one large art gallery and making it nearly impossible to talk about art in one hemisphere without talking about developments occurring everywhere else. Now, artists worldwide use the same art language, deal with similar issues, and avidly follow each other's work.

Many critics predicted that the rise of a global art world would result in a global art, art that is basically homogeneous. But this is hardly the case. Since Postmodernism emphasizes issues and not style, artists often make work that is very personal and that reflects their personal experience. As we have seen, gender, race, ethnicity, sexual orientation, politics, and economics have been dominant themes in Western culture since the 1980s, and the same holds true worldwide, with contemporary art from Lebanon, Vietnam, India, Iran, and Colombia, for example, embracing issues specific to these countries. Or, as expressed by the Ghanaian artist El Anatsui, "Art is something that is environment-based. It takes its roots from a certain soil."

El Anatsui, Adinkra Signs, and Postmodern Ambiguity

El Anatsui (b. 1944) was born in Ghana, and studied art at the University of Science and Technology in Kumasi, his education focusing on contemporary art, largely made in a formalist, Modernist tradition. In 1975, he began teaching at the University of Nigeria in Nsukka, where he lives today. Initially working in clay and wood and reflecting traditional Ghanaian and Nigerian art and themes, he now works with the flattened metal caps and bottleneck foil of liquor bottles, weaving this metal together with copper wire to create what look like enormous, luxurious tapestries or fabrics. These brightly colored aluminum mosaics, such as Dzesi II (fig. 30.29), evoke Nigerian and Ghanaian textiles and designs, the hard metal being visually transformed into something soft. For Anatsui, these caps are a reminder of the liquor that European traders brought to Africa as barter and therefore could be seen as a reference to trade, commodity, and even the beginning of globalization. The artist has also said that "metals and liquor in many cultures, especially African, have this association with the spiritual, with healing. Just think about the many ways a hand must open metal caps to pour out schnapps for prayers and libations."

In *Dzesi II*, the protrusion of concentric circles placed within a square suggests something ritualistic. According to the artist, this form came about "with thoughts about the zero sign, \emptyset which can mean a lot or nothing. And I think is a kind of harking to Adinkra symbols I had worked with earlier." Adinkra, which translates as saying farewell, are West African symbols, printed on fabric originally worn at funerals, although they have wider uses now. The symbols encapsulate aphorisms that help mourners meditate on life, and the concentric circles, according to Antasui, are the "king of these signs, the most conspicuous and attentiongrabbing, which I think has focus-inducing properties." The central zero is thus a form upon which to mediate. And it is also a Postmodern void to which viewers can assign meaning. Not only does the meaning of the work have a Postmodern ambiguity, but so does the form of the sculpture itself. For travel, the artist folds these enormous reliefs until they are small enough to fit into a box; when unfurled, they do not automatically resume their original shape, allowing curators and collectors in the artist's absence, and with his blessing, to restructure the work, implementing what Anastui calls a "nomadic aesthetic."

Cai Guo-Qiang: Projects for Extraterrestrials

It seems only fitting to end this book with Cai Guo-Qiang (b. 1957), a Chinese artist living in New York since 1995, with a second house in Beijing, which he needed as the director of Visual and Special Effects for the 2008 Olympics. With the adoption of capitalism, China has become a powerhouse in art, not only saturating the art world with artists but becoming a major art center and market for art itself. Cai is among the most visible artists working today, and he brings to the new global art a Chinese background and perspective. Like Gonzalez-Torres, Cai is primarily a Conceptual artist working in a broad range of mediums. His oeuvre, however, is dominated by installation art and the use of explosions, namely fireworks, which he used so effectively in the opening ceremonies at the 2008 Olympics and which have become his signature style. By using gunpowder, a Chinese invention, Cai is able to underscore his cultural identity, which he does as well by working with Chinese calligraphy, dragons, Chinese medicine, and feng shui, an ancient art and science that reveals how to balance the energy of any given space to assure health and good fortune. He started working with explosives while living in Japan between 1986 and 1995, reveling in the spontaneity and chance of the medium and finding it an emotional release from the stifling artistic and social environment of precapitalist 1980s China. As the artist explains: "Explosions make you feel something intense at the very core of your being because, while you can arrange explosives as you please, you cannot control the explosion itself. And this fills you with a great deal of freedom." Cai "draws" with explosives, on a small scale by drawing with gunpowder on large sheets of paper that he then ignites, and on a large scale with fireworks, which sometimes resemble Chinese calligraphy.

In 2003, Cai was commissioned by New York City and the Central Park Conservancy to create an explosion piece in Central Park. Titled *Light Cycle: Explosion Project for Central Park* (fig. **30.30**), the work lasted four minutes and was divided into three parts: "Signal towers" (pillars of light), "The Light Cycle" (a series of haloes), and "White Night" (small-shell explosions of brilliant white light). The degree to which Cai controls the explosions is remarkable. He draws and paints with the medium. Through his work, Cai seeks to capture a spiritual essence. He has said that his work is for extraterrestrials, and he has subtitled many of his explosions "Project for Extraterrestrials." Just as the art world has become global, so Cai, perhaps with a little wink, is looking beyond earth, seeking to create art for the universe.

30.30 Cai Guo-Qiang, *Light Cycle: Explosion Project for Central Park*. Tiger tails, titanium solutes fitted with computer chips, shells with descending stars, 4 minutes. Realized at Central Park, New York, 7:45 p.m. September 15, 2003.

1980-82 Michael Graves's Public Services Building, Portland, Oregon

1982 Maya Lin's Vietnam Veterans Memorial

1983 Elizabeth Murrav's More Than You Know

1983 Anselm Kiefer's To the Unknown Painter

to Your Culture

1991 Felix Gonzalez-Torres's Untitled (billboard of an empty bed)

992-97 Frank Gehry's Juggenheim Museum, Bilbao, spain

1992 Fred Wilson's Mining the Museum

2003 Cai Guo-Qiang's Light Cycle: Explosion Project for Central Park

1979-89 Soviet-Afghan War

- 1979-90 Margaret Thatcher, leader of the Conservative Party, is Prime Minister of the United Kingdom
- 1979 Jerry Falwell forms Moral Majority

1981-89 Ronald Reagan is President of the USA 1981 Sandra Day O'Connor is the first woman appointed to the Supreme Court

- 1981 First AIDS cases reported 1981 A New Spirit in Painting, a painting exhibition at the Royal Academy of Arts, London
- 1982 Equal Rights Amendment defeated

1986 Chernobyl Nuclear Power Plant disaster

- 1986 Ivan Boesky, an arbitrageur specializing in corporate takeovers and mergers, is on the cover of Time December 1
- 1987 The Intermediate-Range Nuclear Forces Treaty between the U.S. and the Soviet Union

1988 Magiciens de la Terre, an exhibition dedicated to global art, presented at the Pompidou Center,

1991-92 Republic of South Africa repeals apartheid 1992 Saatchi Gallery, London mounts exhibition

1994 Nelson Mandela elected president of South Africa

1994 North American Free Trade Agreement

 1989 Berlin Wall torn down 1989 Student protests in Tiananmen Square, Beijing

Young British Artists

1994 World Wide Web launched

 1990 Germany Reunited 1990-91 Persian Gulf War 1991 U.S.S.R. is dissolved

1990

1980

1985

1995

2000

2001 Al Qaeda terrorists attack the United States

2003 United States invades Iraq

2008 Beijing hosts Olympics; Cai Guo-Qiang artistic director of opening and closing ceremonies

2008 Barack Obama is elected the first African-American President of the United States

2010

1107

Glossary

ABACUS. A slab of stone at the top of a Classical capital just beneath the architrave.

ABBEY. (1) A religious community headed by an abbot or abbess. (2) The buildings that house the community. An abbey church often has an especially large choir to provide space for the monks or nuns.

ACROTERION (pl. **ACROTERIA**). Decorative ornaments placed at the apex and the corners of a pediment.

ACTION PAINTING. In Abstract art, the spontaneous and uninhibited application of paint, as practiced by the avant-garde from the 1930s through the 1950s.

AEDICULA. A small shrine or altar that dates to ancient Rome.

AEOLIC. An early style of Greek architecture, found in northwestern Asia Minor. The Aeolic style is often considered a precursor to the Ionic style.

AISLE. The passageway or corridor of a church that runs parallel to the length of the building. It often flanks the nave of the church but is sometimes set off from it by rows of piers or columns.

ALABASTRON. A perfume container, similar to an aryballos, crafted by Greek vase-painters and often imported into Etruria.

ALBUMEN PRINT. A process in photography that uses the proteins found in eggs to produce a photographic plate.

ALLEGORY. A representation in which figures or events stand for ideas beyond themselves as symbols or metaphors, to create a moral or message for the viewer.

ALLOVER PAINTING. A painting in which the texture tends to be consistent throughout and which has no traditional compositional structure with a dominant focus of interest but, rather, even stresses throughout the image, as in Jackson Pollock's Abstract Expressionist action paintings.

ALTAR. A mound or structure on which sacrifices or offerings are made in the worship of a deity. In a Catholic church, a tablelike structure used in celebrating the Mass.

ALTARPIECE. A painted or carved work of art placed behind and above the altar of a Christian church. It may be a single panel or a *triptych* or a *polytych*, both having hinged wings painted on both sides. Also called a reredos or retablo.

AMBULATORY. A covered walkway. (1) In a basilican church, the semicircular passage around the apse. (2) In a central-plan church, the ring-shaped aisle around the central space. (3) In a cloister, the covered colonnaded or arcaded walk around the open courtyard.

ANAMORPHIC. Refers to a special form of perspective, which represents an object from an unusual or extreme viewpoint, so that it can only be understood from that viewpoint, or with the aid of a special device or mirror. **ANDACHTSBILD**. German for "devotional image." A picture or sculpture with imagery intended for private devotion. It was first developed in Northern Europe.

ANIMAL STYLE. A style that appears to have originated in ancient Iran and is characterized by stylized or abstracted images of animals.

ANNULAR. From the Latin word for "ring." Signifies a ring-shaped form, especially an annular barrel vault.

APOTROPAIC DEVICE. An object deployed as a means of warding off evil. Often a figural image (such as a Medusa head) or a composite image (like a Near Eastern lamassu), inserted into an architectural setting.

APSE. A semicircular or polygonal niche terminating one or both ends of the nave in a Roman basilica. In a Christian church, it is usually placed at the east end of the nave beyond the transept or choir. It is also sometimes used at the end of transept arms.

APSIDIOLE. A small apse or chapel connected to the main apse of a church.

ARCADE. A series of arches supported by piers or columns. When attached to a wall, these form a blind arcade.

ARCH. A curved structure used to span an opening. Masonry arches are generally built of wedge-shaped blocks, called *voussoirs*, set with their narrow sides toward the opening so that they lock together. The topmost *voussoir* is called the *keystone*. Arches may take different shapes, such as the pointed Gothic arch or the rounded Classical arch.

ARCHAIC SMILE. A fixed, unnaturalistic smile characteristic of many archaic Greek sculpted images. Artists ceased to depict figures smiling in this way once they began to explore greater naturalism.

ARCHITRAVE. The lowermost member of a classical entablature, such as a series of stone blocks that rest directly on the columns.

ARCHIVOLT. A molded band framing an arch, or a series of such bands framing a tympanum, often decorated with sculpture.

ARCUATION. The use of arches or a series of arches in building.

ART BRUT. Meaning "raw art" in French, *art brut* is the direct and highly emotional art of children and the mentally ill that served as an inspiration for some artistic movements in Modern art.

ARYBALLOS. A perfume jar, generally small in size, and often minutely decorated. This was a favorite type of vessel for Corinthian vase-painters.

ASHLAR MASONRY. Carefully finished stone that is set in fine joints to create an even surface.

ASSOCIATIONISM. A 20th-century art historical term that refers to the concept that architecture and landscape design can have motifs or aspects that associate them with earlier architecture, art, history, or literature.

ATMOSPHERIC PERSPECTIVE. Creates the illusion of depth by reducing the local color and clarity of objects in the distance, to imply a layer of atmosphere between the viewer and the horizon.

ATRIUM. (1) The central court or open entrance court of a Roman house. (2) An open court, sometimes colonnaded or arcaded, in front of a church.

AVANT-GARDE. Meaning "advance force" in French, the artists of the avant-garde in 19th- and 20th-century Europe led the way in innovation in both subject matter and technique, rebelling against the established conventions of the art world.

BALDACCHINO. A canopy usually built over an altar. The most important one is Bernini's construction for St. Peter's in Rome.

BAROQUE. A style of Hellenistic Greek sculpture, characterized by extreme emotions and extravagant gestures, as seen on the Great Altar of Zeus at Pergamon. The term is usually used to describe a style of 17th-century CE art, and scholars of ancient art coin it in recognition of similarities of style.

BARREL VAULT. A vault formed by a continuous semicircular arch so that it is shaped like a half-cylinder.

BAR TRACERY. A style of tracery in which glass is held in place by relatively thin membranes.

BAS-DE-PAGE. Literally "bottom of the page." An illustration or decoration that is placed below a block of text in an illuminated manuscript.

BASILICA. (1) In ancient Roman architecture, a large, oblong building used as a public meeting place and hall of justice. It generally includes a nave, side aisles, and one or more apses. (2) In Christian architecture, a longitudinal church derived from the Roman basilica and having a nave, an apse, two or four side aisles or side chapels, and sometimes a narthex. (3) Any one of the seven original churches of Rome or other churches accorded the same religious privileges.

BATTLEMENT. A parapet consisting of alternating solid parts and open spaces designed originally for defense and later used for decoration. See *crenelated*.

BAY. A subdivision of the interior space of a building. Usually a series of bays is formed by consecutive architectural supports.

BELVEDERE. A structure made for the purpose of viewing the surroundings, either above the roof of a building or free-standing in a garden or other natural setting.

BLACK-FIGURED. A style of ancient Greek pottery decoration characterized by black figures against a red background. The black-figured style preceded the red-figured style.

BLIND ARCADE. An arcade with no openings. The arches and supports are attached decoratively to the surface of a wall.

BLOCK BOOKS. Books, often religious, of the 15th century containing woodcut prints in which picture and text were usually cut into the same block.

BOOK OF HOURS. A private prayer book containing the devotions for the seven canonical hours of the Roman Catholic church (matins, vespers, etc.), liturgies for local saints, and sometimes a calendar. They were often elaborately illuminated for persons of high rank, whose names are attached to certain extant examples.

BUON FRESCO. See fresco.

BURIN. A pointed metal tool with a wedged-shaped tip used for engraving.

BUTTRESS. A projecting support built against an external wall, usually to counteract the lateral thrust of a vault or arch within. In Gothic church architecture, a *flying buttress* is an arched bridge above the aisle roof that extends from the upper nave wall, where the lateral thrust of the main vault is greatest, down to a solid pier.

CALOTYPE. Invented in the 1830s, calotype was the first photographic process to use negatives and positive prints on paper.

CAMEO. A low relief carving made on agate, seashell, or other multilayered material in which the subject, often in profile view, is rendered in one color while the background appears in another, darker color.

CAMES. Strips of lead in stained-glass windows that hold the pieces of glass together.

CAMPANILE. From the Italian word *campana*, meaning "bell." A bell tower that is either round or square and is sometimes free-standing.

CANON. A law, rule, or standard.

CAPITAL. The uppermost member of a column or pillar supporting the architrave.

CARAVANSARAY. A wayside inn along the main caravan routes linking the cities of Asia Minor, usually containing a warehouse, stables, and a courtyard.

CARTE-DE-VISITE. A photographic portrait mounted on thicker card stock measuring 2½ x 4 inches (6 x 10 cm) that people commissioned and distributed to friends and acquaintances. They were developed in 1854 by the French photographer Adolphe-Eugène Disdéri, and by the end of the decade were so popular that they were widely collected in Europe and America, a phenomenon called "cardomania."

CARTOON. From the Italian word *cartone*, meaning "large paper." (1) A full-scale drawing for a picture or design intended to be transferred to a wall, panel, tapestry, etc. (2) A drawing or print, usually humorous or satirical, calling attention to some action or person of popular interest.

CARYATID. A sculptured female figure used in place of a column as an architectural support. A similar male figure is an *atlas* (pl. *atlantes*).

CASEMATE. A chamber or compartment within a fortified wall, usually used for the storage of artillery and munitions.

CASSONE (pl. **CASSONI**). An Italian dowry chest often highly decorated with carvings, paintings, inlaid designs, and gilt embellishments.

CATACOMBS. The underground burial places of the early Christians, consisting of passages with niches for tombs and small chapels for commemorative services.

CATALOGUE RAISONNÉ. A complete list of an artist's works of art, with a comprehensive chronology and a discussion of the artist's style.

CATHEDRAL. The church of a bishop; his administrative headquarters. The location of his *cathedra* or throne.

CAVEA. The seating area in an ancient theater. In a Greek theater, it was just over semicircular; in a Roman theater, it was semicircular. Access corridors divided the seating into wedges (*cunei*).

CELLA. (1) The principal enclosed room of a temple used to house an image. Also called the *naos*. (2) The entire body of a temple as distinct from its external parts.

CENOTAPH. A memorial monument to honor a person or persons whose remains lie elsewhere.

CENTERING. A wooden framework built to support an arch, vault, or dome during its construction.

CHAMPLEVÉ. An enameling method in which hollows are etched into a metal surface and filled with enamel.

CHANCEL. The area of a church around the altar, sometimes set off by a screen. It is used by the clergy and the choir.

CHIAROSCURO. Italian word for "light and dark." In painting, a method of modeling form primarily by the use of light and shade.

CHIASTIC POSE. From the Greek letter chi: an asymmetrical stance, where the body carries the weight on one leg (and often bears a weight with the opposite arm). Also described as *contrapposto*.

CHINOISERIE. Objects, usually in the decorative arts (screens, furniture, lacquerware) made in a Chinese or pseudo-Chinese style, most popular in the 18th century.

CHITON. A woman's garment made out of a rectangle of fabric draped and fastened at the shoulders by pins. The garment is worn by some Archaic Greek *korai*, where it provides a decorative effect.

CHRYSELEPHANTINE. Usually refering to a sculpture in Classical Greece, signifying that it is made of gold and ivory. Pheidias' cult statues of Athena in the Parthenon, and Zeus at Olympia, were chryselephantine.

CLASSICISM. Art or architecture that harkens back to and relies upon the style and canons of the art and architecture of ancient Greece or Rome, which emphasize certain standards of balance, order, and beauty.

CLASSICIZING. To refer to the forms and ideals of the Classical world, principally Greece and Rome.

CLERESTORY. A row of windows in the upper part of a wall that rises above an adjoining roof. Its purpose is to provide direct lighting, as in a basilica or church.

CLOISONNÉ. An enameling method in which the hollows created by wires joined to a metal plate are filled with enamel to create a design.

CLOISTER. (1) A place of religious seclusion such as a monastery or nunnery. (2) An open court attached to a church or monastery and surrounded by an ambulatory. Used for study, meditation, and exercise.

COFFER. (1) A small chest or casket. (2) A recessed, geometrically shaped panel in a ceiling. A ceiling decorated with these panels is said to be coffered.

COLONNETTE. A small, often decorative, column that is connected to a wall or pier.

COLOPHON. (1) The production information given at the end of a book. (2) The printed emblem of a book's publisher.

COLOR-FIELD PAINTING. A technique of Abstract painting in which thinned paints are spread onto an unprimed canvas and allowed to soak in with minimal control by the artist.

COLOSSAL ORDER. Columns, piers, or pilasters in the shape of the Greek or Roman orders but that extend through two or more stories rather than following the Classical proportions.

COMBINES. The label the American artist Robert Rauschenberg gave to his paintings of the mid-1950s that combined painting, sculpture, collage, and found objects.

COMPOSITE CAPITAL. A capital that combines the volutes of an Ionic capital with the acanthus leaves of the Corinthian capital. Roman architects developed the style as a substitute for the Ionic style, for use on secular buildings.

COMPOSITE IMAGE. An image formed by combining different images or different views of the subject.

COMPOUND PIER. A pier with attached pilasters or shafts.

CONSTRUCTION. A type of sculpture, developed by Picasso and Braque toward 1912, and popularized by the Russian Constructivists later in the decade. It is made by assembling such materials as metal or wood.

CONTINUOUS NARRATION. Portrayal of the same figure or character at different stages in a story that is depicted in a single artistic space.

CONTRAPPOSTO. Italian word for "set against." A composition developed by the Greeks to represent movement in a figure. The parts of the body are placed asymmetrically in opposition to each other around a central axis, and careful attention is paid to the distribution of weight.

CORBEL. (1) A bracket that projects from a wall to aid in supporting weight. (2) The projection of one course, or horizontal row, of a building material beyond the course below it.

CORBEL VAULT. A vault formed by progressively projecting courses of stone or brick, which eventually meet to form the highest point of the vault.

CORINTHIAN CAPITAL. A column capital ornamented with acanthus leaves, introduced in Greece in the late fifth century BCE, and used by Roman architects throughout the Empire.

CORNICE. (1) The projecting, framing members of a classical pediment, including the horizontal one beneath and the two sloping or "raking" ones above. (2) Any projecting, horizontal element surmounting a wall or other structure or dividing it horizontally for decorative purposes.

CORPUS. In carved medieval altarpieces, the corpus is the central section which usually holds a sculpted figure or design.

COURT STYLE. See Rayonnant.

CRENELATIONS. A sequence of solid parts, and the intervals between them, along the top of a parapet, allowing for defense and to facilitate firing weapons. The effect is of a notched termination of a wall. Generally used in military architecture.

CROSSING. The area in a church where the transept crosses the nave, frequently emphasized by a dome or crossing tower.

CRYPT. A space, usually vaulted, in a church that sometimes causes the floor of the choir to be raised above that of the nave; often used as a place for tombs and small chapels.

CUBICULUM (pl. **CUBICULA**) A bedroom in a Roman house. A cubiculum usually opened onto the atrium. Most were small; some contained wall-paintings.

CUNEUS (pl. **CUNEI**). A wedgelike group of seats in a Greek or Roman theater.

CUNEIFORM. The wedge-shaped characters made in clay by the ancient Mesopotamians as a writing system.

CURTAIN WALL. A wall of a modern building that does not support the building; the building is supported by an underlying steel structure rather than by the wall itself, which serves the purpose of a façade.

DADO. The lower part of an interior wall. In a Roman house, the dado was often decorated with paintings imitating costly marbles.

DAGUERREOTYPE. Originally, a photograph on a silver-plated sheet of copper, which had been treated with fumes of iodine to form silver iodide on its surface and then after exposure developed by fumes of mercury. The process, invented by L. J. M. Daguerre and made public in 1839, was modified and accelerated as daguerreotypes gained popularity.

DEËSIS. From the Greek word for "entreaty." The representation of Christ enthroned between the Virgin Mary and St. John the Baptist, frequent in Byzantine mosaics and depictions of the Last Judgment. It refers to the roles of the Virgin Mary and St. John the Baptist as intercessors for humankind.

 ${\sf DIKKA}.$ An elevated, flat-topped platform in a mosque used by the muezzin or cantor.

DIPTERAL. Term used to describe a Greek or Roman building—often a temple or a stoa—with a double colonnade.

DIPTYCH. (1) Originally a hinged, two-leaved tablet used for writing. (2) A pair of ivory carvings or panel paintings, usually hinged together.

DOLMEN. A structure formed by two or more large, upright stones capped by a horizontal slab. Thought to be a prehistoric tomb.

DOME. A true dome is a vaulted roof of circular, polygonal, or elliptical plan, formed with hemispherical or ovoidal curvature. May be supported by a circular wall or drum and by pendentives or related constructions. Domical coverings of many other sorts have been devised.

DOMUS. Latin word for "house." A detached, onefamily Roman house with rooms frequently grouped around two open courts. The first court, called the *atrium*, was used for entertaining and conducting business. The second court, usually with a garden and surrounded by a *peristyle* or colonnade, was for the private use of the family.

DORIC COLUMN. A column characterized by a simple cushionlike abacus and the absence of a base. One of three styles of column consistently used by Greek and Roman architects.

DRÔLERIES. French word for "jests." Used to describe the lively animals and small figures in the margins of late medieval manuscripts and in wood carvings on furniture.

DROMOS. A pathway, found, for instance, in Bronze Age, Aegean and Etruscan tomb structures.

DRUM. (1) A section of the shaft of a column. (2) A circular-shaped wall supporting a dome.

DRYPOINT. A type of *intaglio* printmaking in which a sharp metal needle is use to carve lines and a design into a (usually) copper plate. The act of drawing pushes up a burr of metal filings, and so, when the plate is inked, ink will be retained by the burr to create a soft and deep tone that will be unique to each print. The burr can only last for a few printings. Both the print and the process are called drypoint.

EARLY ENGLISH STYLE. A term used to describe Gothic architecture in England during the early- and mid-13th century. The style demonstrates the influence of architectural features developed during the Early Gothic period in France, which are combined with Anglo-Norman Romanesque features.

EARTHWORKS. Usually very large scale, outdoor artwork that is produced by altering the natural environment.

ECHINUS. In the Doric or Tuscan Order, the round, cushionlike element between the top of the shaft and the abacus.

ENCAUSTIC. A technique of painting with pigments dissolved in hot wax.

ENGAGED COLUMN. A column that is joined to a wall, usually appearing as a half-rounded vertical shape.

ENGRAVING. (1) A means of embellishing metal surfaces or gemstones by incising a design on the surface. (2) A print made by cutting a design into a metal plate (usually copper) with a pointed steel tool known as a burin. The burr raised on either side of the incised line is removed. Ink is then rubbed into the V-shaped grooves and wiped off the surface. The plate, covered with a damp sheet of paper, is run through a heavy press. The image on the paper is the reverse of that on the plate. When a fine steel needle is used instead of a burin and the burr is retained, a drypoint engraving results, characterized by a softer line. These techniques are called, respectively, engraving and drypoint.

ENNEASTYLE. A term used to describe the façade of a Greek or Roman temple, meaning that it has nine columns.

ENTABLATURE. (1) In a classical order, the entire structure above the columns; this usually includes architrave, frieze, and cornice. (2) The same structure in any building of a classical style.

ENTASIS. A swelling of the shaft of a column.

ENVIRONMENT. In art, environment refers to the Earth itself as a stage for Environmental art, works that can be enormously large yet very minimal and abstract. These works can be permanent or transitory. The term Earth art is also used to describe these art-works.

EVENTS. A term first used by John Cage in the early 1950s to refer to his multimedia events at Black Mount College in North Carolina that included dance, painting, music, and sculpture. The term was appropriated by the conceptual artist George Brecht in 1959 for his performance projects, and shortly thereafter by the conceptual and performance group Fluxus, which included Brecht.

EXEDRA (pl. **EXEDRAE**). In Classical architecture, an alcove, often semicircular, and often defined with columns. Sometimes, exedrae framed sculptures.

FAIENCE. (1) A glass paste fired to a shiny opaque finish, used in Egypt and the Aegean. (2) A type of earthenware that is covered with a colorful opaque glaze and is often decorated with elaborate designs.

FIBULA. A clasp, buckle, or brooch, often ornamented.

FILIGREE. Delicate decorative work made of intertwining wires.

FLAMBOYANT. Literally meaning "flamelike" in French, describes a late phase of Gothic architecture where undulating curves and reverse curves were a main feature.

FLUTES. The vertical channels or grooves in Classical column shafts, sometimes thought to imitate the faceting of a hewn log.

FLYING BUTTRESS. An arch or series of arches on the exterior of a building, connecting the building to detached pier buttresses so that the thrust from the roof vaults is offset. See also *Buttress*

FOLIO. A leaf of a manuscript or a book, identified so that the front and the back have the same number, the front being labeled *recto* and the back *verso*.

FORESHORTENING. A method of reducing or distorting the parts of a represented object that are not parallel to the picture plane in order to convey the impression of three dimensions as perceived by the human eye.

FRESCO. Italian word for "fresh." Fresco is the technique of painting on plaster with pigments ground in water so that the paint is absorbed by the plaster and becomes part of the wall itself. *Buon fresco* is the technique of painting on wet plaster; *fresco secco* is the technique of painting on dry plaster.

FRIEZE. (1) A continuous band of painted or sculptured decoration. (2) In a Classical building, the

part of the entablature between the architrave and the cornice. A Doric frieze consists of alternating triglyphs and metopes, the latter often sculptured. An Ionic frieze is usually decorated with continuous relief sculpture.

FRONTALITY. Representation of a subject in a full frontal view.

FROTTAGE. The technique of rubbing a drawing medium, such as a crayon, over paper that is placed over a textured surface in order to transfer the underlying pattern to the paper.

GABLE. (1) The triangular area framed by the cornice or eaves of a building and the sloping sides of a pitched roof. In Classical architecture, it is called a *pediment*. (2) A decorative element of similar shape, such as the triangular structures above the portals of a Gothic church and sometimes at the top of a Gothic picture frame.

GALLERY. A second story placed over the side aisles of a church and below the clerestory. In a church with a four-part elevation, it is placed below the triforium and above the nave arcade.

GEISON. A projecting horizontal cornice. On a Greek or Roman temple, the geison will often be decorated.

GENRE PAINTING. Based on the French word for type or kind, the term sometimes refers to a category of style or subject matter. But it usually refers to depictions of common activities performed by contemporary people, often of the lower or middle classes. This contrasts with grand historical themes or mythologies, narratives or portraits.

GEOMETRIC ARABESQUE. Complex patterns and designs usually composed of polygonal geometric forms, rather than organic flowing shapes; often used as ornamentation in Islamic art.

GESTURE PAINTING. A technique in painting and drawing where the actual physical movement of the artist is reflected in the brushstroke or line as it is seen in the artwork. The artist Jackson Pollock is particularly associated with this technique.

GISANT. In a tomb sculpture, a recumbent effigy or representation of the deceased. At times, the gisant may be represented in a state of decay.

GLAZE. (1) A thin layer of translucent oil color applied to a painted surface or to parts of it in order to modify the tone. (2) A glassy coating applied to a piece of ceramic work before firing in the kiln as a protective seal and often as decoration.

GLAZED BRICK. Brick that is baked in a kiln after being painted.

GOTHIC. A style of art developed in France during the 12th century that spread throughout Europe. The style is characterized by daring architectural achievements, for example, the opening up of wall surfaces and the reaching of great heights, particularly in cathedral construction. Pointed arches and ribbed groin vaults allow for a lightness of construction that permits maximum light to enter buildings through stained-glass windows. Increasing naturalism and elegance characterize Gothic sculpture and painting.

GRANULATION. A technique of decoration in which metal granules, or tiny metal balls, are fused to a metal surface.

GRATTAGE. A technique in painting whereby an image is produced by scraping off paint from a canvas that has been placed over a textured surface.

GREEK CROSS. A cross with four arms of equal length arranged at right angles.

GRISAILLE. A monochrome drawing or painting in which only values of black, gray, and white are used.

GRISAILLE GLASS. White glass painted with gray designs.

GROIN VAULT. A vault formed by the intersection of two barrel vaults at right angles to each other. A groin is the ridge resulting from the intersection of two vaults.

GUILLOCHE PATTERN. A repeating pattern made up of two ribbons spiraling around a series of central points. A guilloche pattern is often used as a decorative device in Classical vase-painting.

GUILDS. Economic and social organizations that control the making and marketing of given products in a medieval city. To work as a painter or sculptor in a city, an individual had to belong to a guild, which established standards for the craft. First mentioned on p.211. Emboldened entry on p.258

GUTTAE. In a Doric entablature, small peglike projections above the frieze; possibly derived from pegs originally used in wooden construction.

HALL CHURCH. See hallenkirche.

HALLENKIRCHE. German word for "hall church." A church in which the nave and the side aisles are of the same height. The type was developed in Romanesque architecture and occurs especially frequently in German Gothic churches.

HAN. In Turkish, an establishment where travelers can procure lodging, food, and drink. Also called a *caravansaray*.

HAPPENING. A type of art that involves visual images, audience participation, and improvised performance, usually in a public setting and under the loose direction of an artist.

HARMONY. In medieval architecture, the perfect relationship among parts in terms of mathematical proportions or ratios. Thought to be the source of all beauty, since it exemplifies the laws by which divine reason made the universe.

HATAYI. A style of ornament originated by the Ottomans and characterized by curved leaves and complex floral palmettes linked by vines, sometimes embellished with birds or animals.

HATCHING. A series of parallel lines used as shading in prints and drawings. When two sets of crossing parallel lines are used, it is called *crosshatching*.

HERALDIC POSE. A pose where two figures are mirror images of one another, sometimes flanking a central object, as in the relieving triangle above the Lioness Gate at Mycenae.

HEROÖN. The center of a hero cult, where Classical Greeks venerated mythological or historical heroes.

HEXASTYLE. A term used to describe the façade of a Greek or Roman temple, meaning that it has six columns.

HIERATIC SCALE. An artistic technique in which the importance of figures is indicated by size, so that the most important figure is depicted as the largest.

HIEROGLYPH. A symbol, often based on a figure, animal, or object, standing for a word, syllable, or sound. These symbols form the early Egyptian writing system, and are found on ancient Egyptian monuments as well as in Egyptian written records.

HOUSE CHURCH. A place for private worship within a house; the first Christian churches were located in private homes that were modified for religious ceremonies.

HUMANISM. A philosophy emphasizing the worth of the individual, the rational abilities of humankind, and the human potential for good. During the Italian Renaissance, humanism was part of a movement that encouraged study of the classical cultures of Greece and Rome; often it came into conflict with the doctrines of the Catholic church.

HYDRIA. A type of jar used by ancient Greeks to carry water. Some examples were highly decorated.

HYPOSTYLE. A hall whose roof is supported by columns.

ICON. From the Greek word for "image." A panel painting of one or more sacred personages, such as Christ, the Virgin, or a saint, particularly venerated in the Orthodox Christian church.

ICONOCLASM. The doctrine of the Christian church in the 8th and 9th centuries that forbade the worship or production of religious images. This doctrine led to the destruction of many works of art. The iconoclastic controversy over the validity of this doctrine led to a division of the church. Protestant churches of the 16th and 17th centuries also practiced iconoclasm.

ICONOGRAPHY. (1) The depicting of images in art in order to convey certain meanings. (2) The study of the meaning of images depicted in art, whether they be inanimate objects, events, or personages. (3) The content or subject matter of a work of art.

IMPASTO. From the Italian word meaning "to make into a paste"; it describes paint, usually oil paint, applied very thickly.

IMPLUVIUM. A shallow pool in a Roman house, for collecting rain water. The impluvium was usually in the atrium, and stood beneath a large opening in the roof, known as a compluvium.

INFRARED LIGHT. Light on the spectrum beyond the comprehension of the naked eye is referred to as infrared. Special filters are needed to perceive it.

INFRARED REFLECTOGRAPHY. A technique for scientifically examining works of art. Special cameras equipped with infrared filters can look below the top layer of paintings to record the darker materials, such as carbon, which artists used to create drawings on panels or other supports.

INLAID NIELLO. See niello.

INSULA (pl. **INSULAE**). Latin word for "island." (1) An ancient Roman city block. (2) A Roman "apartment house": a concrete and brick building or chain of buildings around a central court, up to five stories high. The ground floor had shops, and above were living quarters.

INTAGLIO. A printing technique in which the design is formed from ink-filled lines cut into a surface. Engraving, etching, and drypoint are examples of intaglio.

INTERCOLUMNIATION. The space between two columns, measured from the edge of the column shafts. The term is often used in describing Greek and Roman temples.

INVERTED PERSPECTIVE. The technique, in some 16th- and 17th-century paintings, of placing the main theme or narrative of a work in the background and placing a still life or other representation in the foreground.

IONIC COLUMN. A column characterized by a base and a capital with two volutes. One of three styles of column consistently used by Greek and Roman architects.

IWAN. A vaulted chamber in a mosque or other Islamic structure, open on one side and usually opening onto an interior courtyard.

JAMBS. The vertical sides of an opening: In Romanesque and Gothic churches, the jambs of doors and windows are often cut on a slant outward, or "splayed," thus providing a broader surface for sculptural decoration.

JAPONISME. In 19th-century French and American art, a style of painting and drawing that reflected the influence of the Japanese artworks, particularly prints, that were then reaching the West.

JASPERWARE. A durable, unglazed porcelain developed by the firm of Josiah Wedgwood in the 18th century. It is decorated with Classically inspired bas relief or cameo figures, and ornamented in white relief on a colored ground, especially blue and sage green.

KORE (pl. KORAI). Greek word for "maiden." An Archaic Greek statue of a standing, draped female.

KOUROS (pl. KOUROI). Greek word for "male youth." An Archaic Greek statue of a standing, nude youth.

KRATER. A Greek vessel, of assorted shapes, in which wine and water are mixed. A *calyx krater* is a bell-shaped vessel with handles near the base; a *volute krater* is a vessel with handles shaped like scrolls.

KUFIC. One of the first general forms of Arabic script to be developed, distinguished by its angularity; distinctive variants occur in various parts of the Islamic worlds.

KYLIX. In Greek and Roman antiquity, a shallow drinking cup with two horizontal handles, often set on a stem terminating in a foot.

LAMASSU. An ancient Near Eastern guardian of a palace; often shown in sculpture as a human-headed bull or lion with wings.

LANCET. A tall, pointed window common in Gothic architecture.

LANTERN. A relatively small structure crowning a dome, roof, or tower, frequently open to admit light to an enclosed area below.

LATIN CROSS. A cross in which three arms are of equal length and one arm is longer.

LEKYTHOS (pl. LEKYTHOI). A Greek oil jug with an ellipsoidal body, a narrow neck, a flanged mouth, a curved handle extending from below the lip to the shoulder, and a narrow base terminating in a foot. It was used chiefly for ointments and funerary offerings.

LIGHT WELLS. Open shafts that allow light to penetrate into a building from the roof. These were a major source of light and ventilation in Minoan "palaces."

LIMINAL SPACE. A transitional area, such as a doorway or archway. In Roman architecture, liminal spaces were often decorated with apotropaic devices.

LINEARITY. A term used to refer to images that have a strong sense of line that provides sharp contours to figures and objects.

LITURGY. A body of rites or rituals prescribed for public worship.

LOGGIA. A covered gallery or arcade open to the air on at least one side. It may stand alone or be part of a building.

LUNETTE. (1) A semicircular or pointed wall area, as under a vault, or above a door or window. When it is above the portal of a medieval church, it is called a *tympanum*. (2) A painting, relief sculpture, or window of the same shape.

LUSTER. A metallic pigment fired over glazed ceramic, which creates an iridescent effect.

MACHICOLATIONS. A gallery projecting from the walls of a castle or tower with holes in the floor in order to allow liquid, stones, or other projectiles to be dropped on an enemy.

MAIDAN. In parts of the Near East and Asia a large open space or square.

MANDORLA. A representation of light surrounding the body of a holy figure.

MANUSCRIPT ILLUMINATION. Decoration of handwritten documents, scrolls, or books with drawings or paintings. Illuminated manuscripts were often produced during the Middle Ages.

MAQSURA. A screened enclosure, reserved for the ruler, often located before the *mihrab* in certain important royal Islamic mosques.

MARTYRIUM (pl. MARTYRIA). A church, chapel, or shrine built over the grave of a Christian martyr or at the site of an important miracle.

MASTABA. An ancient Egyptian tomb, rectangular in shape, with sloping sides and a flat roof. It covered a chapel for offerings and a shaft to the burial chamber.

MATRIX. (1) A mold or die used for shaping a ceramic object before casting. (2) In printmaking, any surface on which an image is incised, carved, or applied and from which a print may be pulled.

MEANDER PATTERN. A decorative motif of intricate, rectilinear character applied to architecture and sculpture.

MEGALITH. From the Greek *mega*, meaning "big," and *lithos*, meaning "stone."A huge stone such as those used in cromlechs and dolmens.

MEGARON (pl. **MEGARONS** or **MEGARA**). From the Greek word for "large." The central audience hall in a Minoan or Mycenaean palace or home.

MENHIR. A megalithic upright slab of stone, sometimes placed in rows by prehistoric peoples.

METOPE. The element of a Doric frieze between two consecutive triglyphs, sometimes left plain but often decorated with paint or relief sculpture.

MEZZOTINT. Printmaking technique developed in the late 17th century where the plate is roughened or "rocked" to better retain the ink and create dark images.

MIHRAB. A niche, often highly decorated, usually found in the center of the *qibla* wall of a mosque, indicating the direction of prayer toward Mecca.

MINA'I. From the Persian meaning "enameled," polychrome overglaze-decorated ceramic ware produced in Iran.

MINARET. A tower on or near a mosque, varying extensively in form throughout the Islamic world, from which the faithful are called to prayer five times a day.

MINBAR. A type of staircase pulpit, found in more important mosques to the right of the mihrab, from which the Sabbath sermon is given on Fridays after the noonday prayer.

MINIATURIST. An artist trained in the painting of miniature figures or scenes to decorate manuscripts.

MODULE. (1) A segment of a pattern. (2) A basic unit, such as the measure of an architectural member. Multiples of the basic unit are used to determine proportionate construction of other parts of a building.

MONOTYPE. A unique print made from a copper plate or other type of plate from which no other copies of the artwork are made.

MOSQUE. A building used as a center for community prayers in Islamic worship; it often serves other functions including religious education and public assembly.

MOZARAB. Term used for the Spanish Christian culture of the Middle Ages that developed while Muslims were the dominant culture and political power on the Iberian peninsula.

MUQARNAS. A distinctive type of Islamic decoration consisting of multiple nichelike forms usually arranged in superimposed rows, often used in zones of architectural transition.

NAOS. See cella.

1

NARTHEX. The transverse entrance hall of a church, sometimes enclosed but often open on one side to a preceding atrium.

NATURALISM. A style of art that aims to depict the natural world as it appears.

NAVE. (1) The central aisle of a Roman basilica, as distinguished from the side aisles. (2) The same section of a Christian basilican church extending from the entrance to the apse or transept.

NECROPOLIS. Greek for "city of the dead." A burial ground or cemetery.

NEMES HEADDRESS. The striped cloth headdress worn by Egyptian kings, and frequently represented in their sculpted and painted images.

NEOCLASSICISM. An 18th-century style that emphasizes Classical themes, sometimes with strong moral overtones, executed in a way that places a strong emphasis on line, with figures and objects running parallel to the picture plane. Paintings and drawings are typically executed with sharp clarity, by way of tight handling of paint and clearly defined line and light.

NIELLO. Dark metal alloys applied to the engraved lines in a precious metal plate (usually made of gold or silver) to create a design.

NIKE. The ancient Greek goddess of victory, often identified with Athena and by the Romans with Victoria. She is usually represented as a winged woman with windblown draperies.

NOCTURNE. A painting that depicts a nighttime scene, often emphasizing the effects of artificial light.

NOMAD'S GEAR. Portable objects, including weaponry, tackle for horses, jewelry and vessels, crafted by nomadic groups such as the tribes of early Iran, and sometimes buried with their dead.

OBELISK. A tall, tapering, four-sided stone shaft with a pyramidal top. First constructed as *megaliths* in ancient Egypt, certain examples have since been exported to other countries.

OCTASTYLE. A term used to describe the façade of a Greek or Roman temple, meaning that it has eight columns.

OCULUS. The Latin word for "eye." (1) A circular opening at the top of a dome used to admit light. (2) A round window.

OPISTHONAOS. A rear chamber in a Greek temple, often mirroring the porch at the front. The opisthonaos was sometimes used to house valuable objects. Access to the chamber was usually from the peristyle rather than the cella.

OPTICAL IMAGES. An image created from what the eye sees, rather than from memory.

ORANT. A standing figure with arms upraised in a gesture of prayer.

ORCHESTRA. (1) In an ancient Greek theater, the round space in front of the stage and below the tiers of seats, reserved for the chorus. (2) In a Roman theater, a similar space reserved for important guests.

ORIEL. A bay window that projects from a wall.

ORIENTALISM. The fascination of Western culture, especially as expressed in art and literature, with Eastern cultures. In the 19th-century, this fascination was especially focused on North Africa and the Near East, that is, the Arab world.

ORTHOGONAL. In a perspective construction, an imagined line in a painting that runs perpendicular to the picture plane and recedes to a vanishing point.

ORTHOSTATS. Upright slabs of stone constituting or lining the lowest courses of a wall, often in order to protect a vulnerable material such as mudbrick.

POUSSINISTES. Those artists of the French Academy at the end of the 17th century and the beginning of the 18th century who favored "drawing," which they believed appealed to the mind rather than the senses. The term derived from admiration for the French artist Nicolas Poussin. See *Rubénistes*.

PALETTE. (1) A thin, usually oval or oblong board with a thumbhole at one end, used by painters to hold and mix their colors. (2) The range of colors used by a particular painter. (3) In Egyptian art, a slate slab, usually decorated with sculpture in low relief. The

small ones with a recessed circular area on one side are thought to have been used for eye makeup. The larger ones were commemorative objects.

PARCHMENT. From Pergamon, the name of a Greek city in Asia Minor where parchment was invented in the 2nd century BCE. (1) A paperlike material made from bleached animal hides used extensively in the Middle Ages for manuscripts. Vellum is a superior type of parchment made from calfskin. (2) A document or miniature on this material.

PEDIMENT. (1) In Classical architecture, a low gable, typically triangular, framed by a horizontal cornice below and two raking cornices above; frequently filled with sculpture. (2) A similar architectural member used over a door, window, or niche. When pieces of the cornice are either turned at an angle or interrupted, it is called a *broken pediment*.

PENDENTIVE. One of the concave triangles that achieves the transition from a square or polygonal opening to the round base of a dome or the supporting drum.

PERFORMANCE ART. A type of art in which performance by actors or artists, often interacting with the audience in an improvisational manner, is the primary aim over a certain time period. These artworks are transitory, perhaps with only a photographic record of some of the events.

PERIPTERAL TEMPLE. In Classical architecture, a temple with a single colonnade on all sides, providing shelter.

PERISTYLE. (1) In a Roman house or *domus*, an open garden court surrounded by a colonnade. (2) A colonnade around a building or court.

PERPENDICULAR GOTHIC STYLE. Describes Late Gothic architecture in England, characterized by dominant vertical accents.

PERSPECTIVE. A system for representing spatial relationships and three-dimensional objects on a flat two-dimensional surface so as to produce an effect similar to that perceived by the human eye. In atmospheric or aerial perspective, this is accomplished by a gradual decrease in the intensity of color and value and in the contrast of light and dark as objects are depicted as farther and farther away in the picture. In color artwork, as objects recede into the distance, all colors tend toward a light bluish-gray tone. In scientific or linear perspective, developed in Italy in the 15th century, a mathematical system is used based on orthogonals receding to vanishing points on the horizon. Transversals intersect the orthogonals at right angles at distances derived mathematically. Since this presupposes an absolutely stationary viewer and imposes rigid restrictions on the artist, it is seldom applied with complete consistency. Although traditionally ascribed to Brunelleschi, the first theoretical text on perspective was Leon Battista Alberti's On Painting (1435).

PHOTOGRAM. A shadowlike photograph made without a camera by placing objects on light-sensitive paper and exposing them to a light source.

PHOTOMONTAGE. A photograph in which prints in whole or in part are combined to form a new image. A technique much practiced by the Dada group in the 1920s.

PICTOGRAPH. A pictorial representation of a concept or object, frequently used by Egyptian artists, sometimes in conjunction with hieroglyphs.

PICTURESQUE. Visually interesting or pleasing, as if resembling a picture.

PIER. An upright architectural support, usually rectangular and sometimes with capital and base. When columns, pilasters, or shafts are attached to it, as in many Romanesque and Gothic churches, it is called a compound pier.

PIETÀ. Italian word for both "pity" and "piety." A representation of the Virgin grieving over the dead Christ. When used in a scene recording a specific moment after the Crucifixion, it is usually called a Lamentation.

PILE CARPET. A weaving made on a loom in which rows of individual knots of colored wool are tied so that the ends of each knot protrude to form a thick pile surface.

PILGRIMAGE PLAN. The general design used in Christian churches that were stops on the pilgrimage routes throughout medieval Europe, characterized by having side aisles that allowed pilgrims to ambulate around the church. See *pilgrimage choir*.

PILOTIS. Pillars that are constructed from *reinforced concrete (ferroconcrete)*.

PINAKOTHEKE. A museum for paintings. The first known example may have been in the Propylaia on the Athenian Akropolis.

PINNACLE. A small, decorative structure capping a tower, pier, buttress, or other architectural member. It is used especially in Gothic buildings.

PISÉ. A construction material consisting of packed earth, similar to wattle and daub. Etruscan architects used pisé for houses, with the result that little survives of them.

PLANARITY. A term used to described a composition where figures and objects are arranged parallel to the picture plane.

PLATE TRACERY. A style of tracery in which pierced openings in an otherwise solid wall of stonework are filled with glass.

PLEIN-AIR. Sketching outdoors, often using paints, in order to capture the immediate effects of light on landscape and other subjects. Much encouraged by the Impressionists, their *plein-air* sketches were often taken back to the studio to produce finished paintings, but many *plein-air* sketches are considered masterworks.

POCHADES. Small outdoor oil paintings made by landscape painters, serving as models for large-scale pictures that would be developed in the artist's studio.

POLIS. A city-state, in the Classical Greek world. City-states began to develop in the course of the 7th and 6th centuries BCE, and were governed in a variety of different ways, including monarchy and oligarchy.

POLYPTYCH. An altarpiece or devotional work of art made of several panels joined together, often hinged.

PORTRAIT BUST. A sculpted representation of an individual which includes not only the head but some portion of the upper torso. Popular during the Roman period, it was revived during the Renaissance.

POST AND LINTEL. A basic system of construction in which two or more uprights, the posts, support a horizontal member, the lintel. The lintel may be the topmost element or support a wall or roof.

POUNCING. A technique for transferring a drawing from a cartoon to a wall or other surface by pricking holes along the principal lines of the drawing and forcing fine charcoal powder through them onto the surface of the wall, thus reproducing the design on the wall.

PREDELLA. The base of an altarpiece, often decorated with small scenes that are related in subject to that of the main panel or panels.

PREFIGURATION. The representation of Old Testament figures and stories as forerunners and fore-shadowers of those in the New Testament.

PRIMITIVISM. The appropriation of non-Western (e.g., African, tribal, Polynesian) art styles, forms, and techniques by Modern era artists as part of innovative

and avant-garde artistic movements; other sources were also used, including the work of children and the mentally ill.

PROCESS ART. Art in which the process is the art, as when Richard Serra hurled molten lead where a wall meets the floor, or Hans Haacke put water in a hermetic acrylic cube, which resulted in condensation forming on it.

PRONAOS. In a Greek or Roman temple, an open vestibule in front of the *cella*.

PRONK. A word meaning ostentatious or sumptuous; it is used to refer to a still life of luxurious objects.

PROPYLON. A monumental gateway, often leading into a citadel or a precinct, such as the Akropolis of Mycenae or Athens.

PROTOME. A decorative, protruding attachment, often on a vessel. Greek bronze-workers attached griffin-shaped protomes to tripod cauldrons in the 7th century BCE.

PROVENANCE. The place of origin of a work of art and related information.

PSALTER. (1) The book of Psalms in the Old Testament, thought to have been written in part by David, king of ancient Israel. (2) A copy of the Psalms, sometimes arranged for liturgical or devotional use and often richly illuminated.

PYLON. Greek word for "gateway." (1) The monumental entrance building to an Egyptian temple or forecourt consisting either of a massive wall with sloping sides pierced by a doorway or of two such walls flanking a central gateway. (2) A tall structure at either side of a gate, bridge, or avenue marking an approach or entrance.

PYXIS. A lidded box, often made of ivory, to hold jewelry or cosmetics in daily life, and, in the context of the Christian church, used on altars to contain the Host (Communion wafer).

QIBLA. The direction toward Mecca, which Muslims face during prayer. The gibla wall in a mosque identifies this direction.

QUADRANT VAULT. A half-barrel vault designed so that instead of being semicircular in cross-section, the arch is one-quarter of a circle.

QUATREFOIL. An ornamental element composed of four lobes radiating from a common center.

RAYONNANT. The style of Gothic architecture, described as "radiant," developed at the Parisian court of Louis IX in the mid-13th century. Also referred to as *court style*.

READYMADE. An ordinary object that, when an artist gives it a new context and title, is transformed into an art object. Readymades were important features of the Dada and Surrealism movements of the early 20th century.

RED-FIGURED. A style of ancient Greek ceramic decoration characterized by red figures against a black background. This style of decoration developed toward the end of the 6th century BCE and replaced the earlier *black-figured* style.

REGISTER. A horizontal band containing decoration, such as a relief sculpture or a fresco painting. When multiple horizontal layers are used, registers are useful in distinguishing between different visual planes and different time periods in visual narration.

RELIEF. (1) The projection of a figure or part of a design from the background or plane on which it is carved or modeled. Sculpture done in this manner is described as "high relief" or "low relief" depending on the height of the projection. When it is very shallow, it is called *schiacciato*, the Italian word for "flattened out." (2) The apparent projection of forms represented in a painting or drawing. (3) A category of printmaking in which lines raised from the surface are inked and printed.

RELIEVING TRIANGLE. A space left open above a lintel to relieve it of the weight of masonry. This device was used by Bronze Age architects in gate and tomb construction.

RELIQUARY. A container used for storing or displaying relics.

RENAISSANCE. Literally, rebirth. During the 14th and 15th centuries, Italian writers, artists, and intellectuals aimed to revive the arts of the ancient world. From their accomplishments, the term has been applied to the period, and is used generally to refer to a cultural flowering.

REPOUSSÉ. A metalworking technique where a design is hammered onto an object from the wrong side. Sasanian craftsmen used this techniques for silver vessels.

RESPOND. (1) A half-pier, pilaster, or similar element projecting from a wall to support a lintel or an arch whose other side is supported by a free-standing column or pier, as at the end of an arcade. (2) One of several pilasters on a wall behind a colonnade that echoes or "responds to" the columns but is largely decorative. (3) One of the slender shafts of a compound pier in a medieval church that seems to carry the weight of the vault.

RHYTON. An ancient drinking or pouring vessel made from pottery, metal, or stone, and sometimes designed in a human or animal form.

RIBBED GROIN VAULTS. A vault is a stone or brick roof. Groin vaults result from the intersection of two barrel vaults; the places where the arched surfaces meet is called the groin. Adding ribs or thickenings of the groins increases the strength of the roof.

RIBBED VAULT. A style of vault in which projecting surface arches, known as ribs, are raised along the intersections of segments of the vault. Ribs may provide architectural support as well as decoration to the vault's surface.

ROCOCO. The ornate, elegant style most associated with the early-18th-century in France, and which later spread throughout Europe, generally using pastel colors and the decorative arts to emphasize the notion of fantasy.

ROMANESQUE. (1) The style of medieval architecture from the 11th to the 13th centuries that was based upon the Roman model and that used the Roman rounded arch, thick walls for structural support, and relatively small windows. (2) Any culture or its artifacts that are "Roman-like."

ROMANTICISM. A cultural movement that surfaced in the second half of the 18th century and peaked in the first half of the 19th century. The movement was based on a belief in individual genius and originality and the expression of powerful emotions, as well as preference for exotic themes and the omnipotent force of nature, often viewed as manifestation of God.

ROSE WINDOW. A large, circular window with stained glass and stone tracery, frequently used on facades and at the ends of transepts in Gothic churches.

ROSTRUM (pl. **ROSTRA**). (1) A beaklike projection from the prow of an ancient warship used for ramming the enemy. (2) In the Roman forum, the raised platform decorated with the beaks of captured ships from which speeches were delivered. (3) A platform, stage, or the like used for public speaking.

ROTULUS (pl. **ROTULI**). The Latin word for scroll, a rolled written text.

RUBÉNISTES. Those artists of the French Academy at the end of the 17th century and the beginning of the 18th century who favored "color" in painting because it appealed to the senses and was thought to be true to nature. The term derived from admiration for the work of the Flemish artist Peter Paul Rubens. See *Poussinistes*.

RUSTICATION. A masonry technique of laying rough-faced stones with sharply indented joints.

SALON. (1) A large, elegant drawing or reception room in a palace or a private house. (2) Official government-sponsored exhibition of paintings and sculpture by living artists held at the Louvre in Paris, first biennially, then annually. (3) Any large public exhibition patterned after the Paris Salon.

SARCOPHAGUS (pl. **SARCOPHAGI**). A large coffin, generally of stone, and often decorated with sculpture or inscriptions. The term is derived from two Greek words meaning "flesh" and "eating."

SAZ. Meaning literally "enchanted forest," this term describes the sinuous leaves and twining stems that are a major component of the *hatayi* style under the Ottoman Turks.

SCHIACCIATO. Italian for "flattened out." Describes low relief sculpture used by Donatello and some of his contemporaries.

SCHOLASTICISM. A school of medieval thought that tries to reconcile faith and reason by combining ancient philosophy with Christian theology.

SCIENTIFIC PERSPECTIVE. See perspective.

SCRIPTORIUM (pl. **SCRIPTORIA**). A workroom in a monastery reserved for copying and illustrating manuscripts.

SECTION. An architectural drawing presenting a building as if cut across the vertical plane at right angles to the horizontal plane. A *cross section* is a cut along the transverse axis. A *longitudinal section* is a cut along the longitudinal axis.

SELECTIVE WIPING. The planned removal of certain areas of ink during the etching process to produce changes in value on the finished print.

SEPTPARTITE VAULT. A type of vault divided into seven sections.

SERDAB. In Egyptian architecture, an enclosed room without an entrance, often found in a funerary context. A sculpture of the dead king might be enclosed within it, as at Saqqara.

SEXPARTITE VAULT. See vault.

SFUMATO. Italian word meaning "smoky." Used to describe very delicate gradations of light and shade in the modeling of figures. It is applied especially to the work of Leonardo da Vinci.

SGRAFFITO ORNAMENT. A decorative technique in which a design is made by scratching away the surface layer of a material to produce a form in contrasting colors.

SHADING. The modulation of volume by means of contrasting light and shade. Prehistoric cave-painters used this device, as did Greek tomb-painters in the Hellenistic period.

SILKSCREEN PRINTING. A technique of printing in which paint or ink is pressed through a stencil and specially prepared cloth to produce a previously designed image. Also called serigraphy.

SILVERPOINT. A drawing instrument (stylus) of the 14th and 15th centuries made from silver; it produced a fine line and maintained a sharp point.

SIMULTANEOUS CONTRAST. The theory, first expressed by Michel-Eugène Chevreul (1786–1889), that complementary colors, when placed next to one another, increase the intensity of each other (e.g., red becoming more red and green more green.)

SITE-SPECIFIC ART. Art that is produced in only one location, a location that is an integral part of the work and essential to its production and meaning.

SKENE. A building erected on a Greek or Roman stage, as a backdrop against which some of the action took place. It usually consisted of a screen of columns, arranged in several storeys.

SOCLE. A portion of the foundation of a building that projects outward as a base for a column or some other device.

SPANDREL. The area between the exterior curves of two adjoining arches or, in the case of a single arch, the area around its outside curve from its springing to its keystone.

SPATIAL PERSPECTIVE. The exploration of the spatial relationships between objects. Painters were especially interested in spatial perspective in the Hellenistic period in Greece.

SPIRE. A tall tower that rises high above a roof. Spires are commonly associated with church architecture and are frequently found on Gothic structures.

SPOLIA. Latin for "hide stripped from an animal." Term used for (1) spoils of war and (2) fragments of architecture or sculpture reused in a secondary context.

SPRINGING. The part of an arch in contact with its base.

SQUINCHES. Arches set diagonally at the corners of a square or rectangle to establish a transition to the round shape of the dome above.

STAIN PAINTING. A type of painting where the artist works on unprimed canvas, allowing the paint to seep into the canvas, thus staining it.

STELE. From the Greek word for "standing block." An upright stone slab or pillar, sometimes with a carved design or inscription.

STEREOBATE. The substructure of a Classical building, especially a Greek temple.

STEREOCARDS. Side-by-side photographs of the same image taken by a camera with two lenses, replicating human binocular vision. When put into a special viewer, the twin flat pictures appear as a single three-dimensional image.

STILL LIFE. A term used to describe paintings (and sometimes sculpture) that depict familiar objects such as household items and food.

STIPPLES. In drawing or printmaking, stippling is a technique to create tone or shading in an image with small dots rather than lines.

STREET PHOTOGRAPHY. A term applied to American documentary photographers such as Walker Evans, who emerged in the 1930s, and Robert Frank, who surfaced in the 1950s, who took to the streets to find their subject matter, often traveling extensively.

STYLOBATE. A platform or masonry floor above the stereobate forming the foundation for the columns of a Greek temple.

SUBLIME. In 19th-century art, the ideal and goal that art should inspire awe in a viewer and engender feelings of high religious, moral, ethical, and intellectual purpose.

SUNKEN RELIEF. Relief sculpture in which the figures or designs are modeled beneath the surface of the stone, within a sharp outline.

SYMPOSIUM. In ancient Greece, a gathering, sometimes of intellectuals and philosophers to discuss ideas, often in an informal social setting, such as at a dinner party.

SYNCRETISM. The act of bringing together disparate customs or beliefs. Historians usually describe Roman culture as syncretistic, because Romans embraced many of the the practices of those they conquered.

SYNOPTIC NARRATIVE. A narrative with different moments presented simultaneously, in order to encapsulate the entire story in a single scene. The device appears in early Greek pediment sculpture. **TEMPERA**. Medium for painting in which pigments are suspended in egg yolk tempered with water or chemicals; this mixture dries quickly, reducing the possibility of changes in the finished painting.

TENEBRISM. The intense contrast of light and dark in painting.

TESSERA (pl. **TESSERAE**). A small piece of colored stone, marble, glass, or gold-backed glass used in a mosaic.

THOLOS. A building with a circular plan, often with a sacred nature.

TONDO. A circular painting or relief sculpture.

TRANSEPT. A cross arm in a basilican church placed at right angles to the nave and usually separating it from the choir or apse.

TRANSVERSALS. In a perspective construction, transversals are the lines parallel to the picture plane (horizontally) that denote distances. They intersect orthogonals to make a grid that guides the arrangement of elements to suggest space.

TRIBUNE. A platform or walkway in a church constructed overlooking the *aisle* and above the *nave*.

TRIFORIUM. The section of a nave wall above the arcade and below the clerestory. It frequently consists of a blind arcade with three openings in each bay. When the gallery is also present, a four-story elevation results, the triforium being between the gallery and clerestory. It may also occur in the transept and the choir walls.

TRIGLYPH. The element of a Doric frieze separating two consecutive metopes and divided by grooves into three sections.

TRILITHIC. A form of construction using three stones—two uprights and a lintel—found frequently in Neolithic tomb and ritual architecture.

TRIPTYCH. An altarpiece or devotional picture, either carved or painted, with one central panel and two hinged wings.

TRIUMPHAL ARCH. (1) A monumental arch, sometimes a combination of three arches, erected by a Roman emperor in commemoration of his military exploits and usually decorated with scenes of these deeds in relief sculpture. (2) The great transverse arch at the eastern end of a church that frames altar and apse and separates them from the main body of the church. It is frequently decorated with mosaics or mural paintings.

TROIS CRAYONS. The use of three colors, usually red, black, and white, in a drawing; a technique popular in the 17th and 18th centuries.

TROMPE L'OEIL. Meaning "trick of the eye" in French, it is a work of art designed to deceive a viewer into believing that the work of art is reality, an actual three-dimensional object or scene in space.

TRUMEAU. A central post supporting the lintel of a large doorway, as in a Romanesque or Gothic portal, where it is frequently decorated with sculpture.

TRUSS. A triangular wooden or metal support for a roof that may be left exposed in the interior or be covered by a ceiling.

TUMULUS (pl. **TUMULI**) A monumental earth mound, often raised over a tomb. Etruscan builders constructed tumuli with internal chambers for burials.

TURRET. (1) A small tower that is part of a larger structure. (2) A small tower at a corner of a building, often beginning some distance from the ground.

TUSCAN STYLE. An architectural style typical of ancient Italy. The style is similar to the Doric style, but the column shafts have bases.

TUSCHE. An inklike liquid containing crayon that is used to produce solid black (or solid color) areas in prints.

TYMPANUM. (1) In Classical architecture, a recessed, usually triangular area often decorated with sculpture. Also called a pediment. (2) In medieval architecture, an arched area between an arch and the lintel of a door or window, frequently carved with relief sculpture.

TYPOLOGY. The matching or pairing of pre-Christian figures, persons, and symbols with their Christian counterparts.

VANISHING POINT. The point at which the orthogonals meet and disappear in a composition done with scientific perspective.

VANITAS. The term derives from the book of Ecclesiastes I:2 ("Vanities of vanities, ...") that refers to the passing of time and the notion of life's brevity and the inevitability of death. The vanitas theme found expression especially in the Northern European art of the 17th century.

VAULT. An arched roof or ceiling usually made of stone, brick, or concrete. Several distinct varieties have been developed; all need buttressing at the point where the lateral thrust is concentrated. (1) A barrel vault is a semicircular structure made up of successive arches. It may be straight or annular in plan. (2) A groin vault is the result of the intersection of two barrel vaults of equal size that produces a bay of four compartments with sharp edges, or groins, where the two meet. (3) A ribbed groin vault is one in which ribs are added to the groins for structural strength and for decoration. When the diagonal ribs are constructed as half-circles, the resulting form is a domical ribbed vault. (4) A sexpartite vault is a ribbed groin

vault in which each bay is divided into six compartments by the addition of a transverse rib across the center. (5) The normal Gothic vault is quadripartite with all the arches pointed to some degree. (6) A fan vault is an elaboration of a ribbed groin vault, with elements of tracery using conelike forms. It was developed by the English in the 15th century and was employed for decorative purposes.

VELLUM. See *parchment*.

VERISTIC. From the Latin *verus*, meaning "true." Describes a hyperrealistic style of portraiture that emphasizes individual characteristics.

VIGNETTE. A decorative design often used in manuscripts or books to separate sections or to decorate borders.

VOLUTE. A spiraling architectural element found notably on Ionic and Composite capitals but also used decoratively on building façades and interiors.

VOUSSOIR. A wedge-shaped piece of stone used in arch construction.

WARP. The vertical threads used in a weaver's loom through which the weft is woven.

WEBS. Masonry construction of brick, concrete, stone, etc. that is used to fill in the spaces between groin vault ribs.

WEFT. The horizontal threads that are interlaced through the vertical threads (the warp) in a woven fabric. Weft yarns run perpendicular to the warp.

WESTWORK. From the German word *Westwerk*. In Carolingian, Ottonian, and German Romanesque

architecture, a monumental western front of a church, treated as a tower or combination of towers and containing an entrance and vestibule below and a chapel and galleries above. Later examples often added a transept and a crossing tower.

WET-COLLODION PROCESS. A 19th-century photographic technique that uses a very sensitive emulsion called collodion (gun-cotton dissolved in alcohol ether), that reduces exposure time to under a second and produces a sharp, easily reproducible negative.

WHITE-GROUND. Vase-painting technique in which artists painted a wide range of colors onto a white background. This was a favorite technique for decorating lekythoi (vases used in a funerary context in ancient Greece.)

WOODCUT. A print made by carving out a design on a wooden block cut along the grain, applying ink to the raised surfaces that remain, and printing from those.

X-RADIOGRAPHIC. Using a form of electromagnetic radiation called X-rays, researchers can examine the layers of paint or other materials used by artists to construct works of art.

ZIGGURAT. From the Assyrian word *ziqquratu*, meaning "mountaintop" or "height." In ancient Assyria and Babylonia, a pyramidal mound or tower built of mud-brick forming the base for a temple. It was often either stepped or had a broad ascent winding around it, which gave it the appearance of being stepped.

Books for Further Reading

This list is intended to be as practical as possible. It is therefore limited to books of general interest that were printed over the past 20 years or have been generally available recently. However, certain indispensable volumes that have yet to be superseded are retained. This restriction means omitting numerous classics long out of print, as well as much specialized material of interest to the serious student. The reader is thus referred to the many specialized bibliographies noted below.

REFERENCE RESOURCES IN ART HISTORY

1. BIBLIOGRAPHIES AND RESEARCH GUIDES

- Arntzen, E., and R. Rainwater. Guide to the Literature of Art History. Chicago: American Library, 1980.
- Barnet, S. A Short Guide to Writing About Art. 8th ed. New York: Longman, 2005.
- Ehresmann, D. Architecture: A Bibliographical Guide to Basic Reference Works, Histories, and Handbooks. Littleton, CO: Libraries Unlimited, 1984. Fine Arts: A Bibliographical Guide to Basic Reference Works, Histories, and Handbooks. 3d ed.
- Littleton, CO: Libraries Unlimited, 1990. Freitag, W. Art Books: A Basic Bibliography of Monographs on Artists. 2d ed. New York: Garland,
- 1997. Goldman, B. Reading and Writing in the Arts: A Handbook. Detroit, MI: Wayne State Press, 1972.
- Kleinbauer, W., and T. Slavens. Research Guide to the History of Western Art. Chicago: American Library, 1982.
- Marmor, M., and A. Ross, eds. Guide to the Literature of Art History 2. Chicago: American Library, 2005
- Sayre, H. M. Writing About Art. New ed. Upper Saddle River, NJ: Pearson Prentice Hall, 2000.

2. DICTIONARIES AND ENCYCLOPEDIAS

- Aghion, I. Gods and Heroes of Classical Antiquity. Flammarion Iconographic Guides. New York: Flammarion, 1996.
- Boström, A., ed. Encyclopedia of Sculpture. 3 vols. New York: Fitzroy Dearborn, 2004.
- Brigstocke, H., ed. The Oxford Companion to Western Art. New York: Oxford University Press, 2001.
- Burden, E. Illustrated Dictionary of Architecture. New York: McGraw-Hill, 2002.
- Carr-Gomm, S. The Hutchinson Dictionary of Symbols in Art. Oxford: Helicon, 1995.
- Chilvers, I., et al., eds. The Oxford Dictionary of Art. 3d ed. New York: Oxford University Press, 2004.
- Congdon, K. G. Artists from Latin American Cultures: A Biographical Dictionary. Westport, CT: Greenwood Press, 2002.
- Cumming, R. Art: A Field Guide. New York: Alfred A. Knopf, 2001.
- Curl, J. A Dictionary of Architecture. New York: Oxford University Press, 1999.
- The Dictionary of Art. 34 vols. New York: Grove's Dictionaries, 1996.
- Duchet-Suchaux, G., and M. Pastoureau. The Bible and the Saints. Flammarion Iconographic Guides. New York: Flammarion, 1994.
- Encyclopedia of World Art. 14 vols., with index and supplements. New York: McGraw-Hill, 1959–1968.
- Fleming, J., and H. Honour. The Penguin Dictionary of Architecture and Landscape Architecture. 5th ed. New York: Penguin, 1998.

-. The Penguin Dictionary of Decorative Arts. New ed. London: Viking, 1989.

- Gascoigne, B. How to Identify Prints: A Complete Guide to Manual and Mechanical Processes from Woodcut to Inkjet. New York: Thames & Hudson, 2004.
- Hall, J. Dictionary of Subjects and Symbols in Art. Rev. ed. London: J. Murray, 1996.

Illustrated Dictionary of Symbols in Eastern and Western Art. New York: HarperCollins, 1995.

- International Dictionary of Architects and Architecture. 2 vols. Detroit, MI: St. James Press, 1993.
- Langmuir, E. Yale Dictionary of Art and Artists. New Haven: Yale University Press, 2000.
- Lever, J., and J. Harris. Illustrated Dictionary of Architecture, 800-1914. 2d ed. Boston: Faber & Faber, 1993.
- Lucie-Smith, E. The Thames & Hudson Dictionary of Art Terms. New York: Thames & Hudson, 2004
- Mayer, R. The Artist's Handbook of Materials and Techniques. 5th ed. New York: Viking, 1991.
- The HarperCollins Dictionary of Art Terms & Techniques. 2d ed. New York: HarperCollins, 1991.
- Murray, P., and L. Murray. A Dictionary of Art and Artists. 7th ed. New York: Penguin, 1998. A Dictionary of Christian Art. New York:
- Oxford University Press, 2004, © 1996. Nelson, R. S., and R. Shiff, eds. Critical Terms for Art
- History. Chicago: University of Chicago Press, 2003. Pierce, J. S. From Abacus to Zeus: A Handbook of Art History. 7th ed. Englewood Cliffs, NJ: Pearson
- Prentice Hall, 2004. Reid, J. D., ed. The Oxford Guide to Classical
- Mythology in the Arts 1300-1990. 2 vols. New York: Oxford University Press, 1993. Shoemaker, C., ed. Encyclopedia of Gardens: History
- and Design. Chicago: Fitzroy Dearborn, 2001.
- Steer, J. Atlas of Western Art History: Artists, Sites, and Movements from Ancient Greece to the Modern Age. New York: Facts on File, 1994.
- West, S., ed. The Bulfinch Guide to Art History. Boston: Little, Brown, 1996.
- Portraiture. Oxford History of Art. New York: Oxford University Press, 2004.

3. INDEXES, PRINTED AND ELECTRONIC

- ARTbibliographies Modern. 1969 to present. A semiannual publication indexing and annotating more than 300 art periodicals, as well as books, exhibition catalogues, and dissertations. Data since 1974 also available electronically.
- Art Index. 1929 to present. A standard quarterly index to more than 200 art periodicals. Also available electronically.
- Avery Index to Architectural Periodicals. 1934 to present. 15 vols., with supplementary vols. Boston: G. K. Hall, 1973. Also available electronically.
- BHA: Bibliography of the History of Art. 1991 to present. The merger of two standard indexes: RILA (Répertoire International de la Littérature de l'Art/ International Repertory of the Literature of Art, vol. 1. 1975) and Répertoire d'Art et d'Archéologie (vol. 1. 1910). Data since 1973 also available electronically.
- Index Islamicus. 1665 to present. Multiple publishers. Data since 1994 also available electronically.
- The Perseus Project: An Evolving Digital Library on Ancient Greece and Rome. Medford, MA: Tufts University, Classics Department, 1994.

4. WORLDWIDE WEBSITES

Visit the following websites for reproductions and information regarding artists, periods, movements, and many more subjects. The art history departments and libraries of many universities and colleges also maintain websites where you can get reading lists and links to other websites, such as those of museums, libraries, and periodicals.

- http://www.aah.org.uk/welcome.html Association of Art Historians
- http://www.amico.org Art Museum Image Consortium http://www.archaeological.org Archaeological Institute
- of America http://archnet.asu.edu/archnet Virtual Library for
- Archaeology http://www.artchive.com
- http://www.art-design.umich.edu/mother/ Mother of all Art History links pages, maintained by the Department of the History of Art at the University of Michigan
- http://www.arthistory.net Art History Network
- http://artlibrary.vassar.edu/ifla-idal International Directory of Art Libraries
- http://www.bbk.ac.uk/lib/hasubject.html Collection of resources maintained by the History of Art Department of Birkbeck College, University of London
- http://classics.mit.edu The Internet Classics Archive
- http://www.collegeart.org College Art Association
- http://www.constable.net
- http://www.cr.nps.gov/habshaer Historic American Buildings Survey
- http://www.getty.edu Including museum, five institutes, and library
- http://www.harmsen.net/ahrc/ Art History Research Centre
- http://icom.museum/ International Council of Museums http://www.icomos.org International Council on
 - Monuments and Sites
- http://www.ilpi.com/artsource
- http://www.siris.si.edu Smithsonian Institution Research Information System

http://whc.unesco.org/ World Heritage Center

5. GENERAL SOURCES ON ART HISTORY, METHOD, AND THEORY

- Andrews, M. Landscape and Western Art. Oxford History of Art. New York: Oxford University Press, 1999.
- Barasch, M. Modern Theories of Art: Vol. 1, From Winckelmann to Baudelaire. Vol. 2, From Impressionism to Kandinsky. New York: 1990-1998. . Theories of Art: From Plato to Winckelmann. New York: Routledge, 2000.
- Battistini, M. Symbols and Allegories in Art. Los Angeles: J. Paul Getty Museum, 2005.
- Baxandall, M. Patterns of Intention: On the Historical Explanation of Pictures. New Haven: Yale University Press, 1985.
- Bois, Y.-A. Painting as Model. Cambridge, MA: MIT Press, 1993.
- Broude, N., and M. Garrard. The Expanding Discourse: Feminism and Art History. New York: Harper & Row, 1992.
- -., eds. Feminism and Art History: Questioning the Litany. New York: Harper & Row, 1982.
- Bryson, N., ed. Vision and Painting: The Logic of the Gaze. New Haven: Yale University Press, 1983.

., et al., eds. Visual Theory: Painting and Interpretation. New York: Cambridge University Press, 1991.

- Chadwick, W. Women, Art, and Society. 3d ed. New York: Thames & Hudson, 2002.
- D'Alleva, A. Methods & Theories of Art History. London: Laurence King, 2005.
- Freedberg, D. The Power of Images: Studies in the History and Theory of Response. Chicago: University of Chicago Press, 1989.
- Gage, J. Color and Culture: Practice and Meaning from Antiquity to Abstraction. Berkeley: University of California Press, 1999.
- Garland Library of the History of Art. New York: Garland, 1976. Collections of essays on specific periods.
- Goldwater, R., and M. Treves, eds. Artists on Art, from the Fourteenth to the Twentieth Century. 3d ed. New York: Pantheon, 1974.
- Gombrich, E. H. Art and Illusion. 6th ed. New York: Phaidon, 2002.
- Harris, A. S., and L. Nochlin. Women Artists, 1550–1950. New York: Random House, 1999.
- Holly, M. A. Panofsky and the Foundations of Art History. Ithaca, NY: Cornell University Press, 1984. Holt, E. G., ed. A Documentary History of Art: Vol. 1,
- The Middle Ages and the Renaissance. Vol. 2, Michelangelo and the Mannerists. The Baroque and the Eighteenth Century. Vol. 3, From the Classicists to the Impressionists. 2d ed. Princeton, NJ: Princeton University Press, 1981. Anthologies of primary sources on specific periods.

Johnson, P. Art: A New History. New York: HarperCollins, 2003.

- Kemal, S., and I. Gaskell. The Language of Art History. Cambridge Studies in Philosophy and the Arts. New York: Cambridge University Press, 1991. Kemp, M., ed. The Oxford History of Western Art. New
- York: Oxford University Press, 2000. Kleinbauer, W. E. Modern Perspectives in Western Art
- History: An Anthology of Twentieth-Century Writings on the Visual Arts. Reprint of 1971 ed. Toronto: University of Toronto Press, 1989. Kostof, S. A. *History of Architecture: Settings and*
- Rituals. 2d ed. New York: Oxford University Press, 1995
- Kruft, H. W. A History of Architectural Theory from Vitruvius to the Present. Princeton, NJ: Princeton Architectural Press, 1994.
- Kultermann, U. The History of Art History. New York: Abaris Books, 1993.
- Langer, C. Feminist Art Criticism: An Annotated Bibliography. Boston: G. K. Hall, 1993.
- Laver, J. Costume and Fashion: A Concise History. 4th ed. The World of Art. London: Thames & Hudson, 2002.
- Lavin, I., ed. Meaning in the Visual Arts: Views from the Outside: A Centennial Commemoration of Erwin Panofsky (1892-1968). Princeton, NJ: Institute for Advanced Study, 1995.
- Minor, V. H. Art History's History. Upper Saddle River, NJ: Pearson Prentice Hall, 2001.
- Nochlin, L. Women, Art, and Power, and Other Essays. New York: HarperCollins, 1989.
- Pächt, O. The Practice of Art History: Reflections on Method. London: Harvey Miller, 1999.
- Panofsky, E. Meaning in the Visual Arts. Reprint of
- 1955 ed. Chicago: University of Chicago Press, 1982. Penny, N. The Materials of Sculpture. New Haven: Yale
- University Press, 1993. Pevsner, N. A History of Building Types. Princeton, NJ: Princeton University Press, 1976.
- Podro, M. The Critical Historians of Art. New Haven: Yale University Press, 1982.
- Pollock, G. Differencing the Canon: Feminist Desire and the Writing of Art's Histories. New York: Routledge, 1999
- Vision and Difference: Femininity, Feminism, and the Histories of Art. New York: Routledge, 1988. Prettejohn, E. Beauty and Art 1750-2000. New York: Oxford University Press, 2005.
- Preziosi, D., ed. The Art of Art History: A Critical Anthology. New York: Oxford University Press, 1998
- Rees, A. L., and F. Borzello. The New Art History. Atlantic Highlands, NJ: Humanities Press International, 1986.

- Roth, L. Understanding Architecture: Its Elements, History, and Meaning. New York: Harper & Row, 1993.
- Sedlmayr, H. Framing Formalism: Riegl's Work. Amsterdam: G+B Arts International, © 2001. Smith, P., and C. Wilde, eds. A Companion to Art
- Theory. Oxford: Blackwell, 2002.
- Sources and Documents in the History of Art Series. General ed. H. W. Janson. Englewood Cliffs, NJ: Prentice Hall. Anthologies of primary sources on specific periods.
- Sutton, I. Western Architecture. New York: Thames & Hudson, 1999.
- Tags, J. Grounds of Dispute: Art History, Cultural Politics, and the Discursive Field. Minneapolis: University of Minnesota Press, 1992.
- Trachtenberg, M., and I. Hyman. Architecture: From Prehistory to Post-Modernism. 2d ed. New York: Harry N. Abrams, 2002.
- Watkin, D. The Rise of Architectural History. Chicago: University of Chicago Press, 1980.
- Wolff, J. The Social Production of Art. 2d ed. New York: New York University Press, 1993.
- Wölfflin, H. Principles of Art History: The Problem of the Development of Style in Later Art. Various eds. New York: Dover.
- Wollheim, R. Art and Its Objects. 2d ed. New York: Cambridge University Press, 1992.

PART ONE: THE ANCIENT WORLD

GENERAL REFERENCES

- Baines, J., ed. Civilizations of the Ancient Near East. 4 vols. New York: Scribner, 1995.
- Boardman, J., ed. The Oxford History of Classical Art. New York: Oxford University Press, 2001.
- De Grummond, N., ed. An Encyclopedia of the History of Classical Archaeology. Westport, CT: Greenwood, 1996.
- Fine, S. Art and Judaism in the Greco-Roman World: Toward a New Jewish Archaeology. New York: Cambridge University Press, 2005.
- Holliday, P. J. Narrative and Event in Ancient Art. New York: Cambridge University Press, 1993.
- Redford, D. B., ed. The Oxford Encyclopedia of Ancient Egypt. 3 vols. New York: Oxford University Press,
- Stillwell, R. The Princeton Encyclopedia of Classical Sites. Princeton, NJ: Princeton University Press, 1976.
- Tadgell, C. Origins: Egypt, West Asia and the Aegean. New York: Whitney Library of Design, 1998.
- Van Keuren, F. Guide to Research in Classical Art and Mythology. Chicago: American Library Association, 1991.
- Wharton, A. J. Refiguring the Post-Classical City: Dura Europos, Jerash, Jerusalem, and Ravenna. New York: Cambridge University Press, 1995.
- Winckelmann, J. J. Essays on the Philosophy and History of Art. 3 vols. Bristol, England: Thoemmes, 2001.
- Wolf, W. The Origins of Western Art: Egypt, Mesopotamia, the Aegean. New York: Universe Books, 1989.
- Yegül, F. K. Baths and Bathing in Classical Antiquity. Architectural History Foundation. Cambridge, MA: MIT Press, 1992.

CHAPTER 1. PREHISTORIC ART

- Bahn, P. G. The Cambridge Illustrated History of Prehistoric Art. New York: Cambridge University Press, 1988.
- Chauvet, J.-M., É. B. Deschamps, and C. Hilaire. Dawn of Art: The Chauvet Cave. New York: Harry N. Abrams, 1995.
- Clottes, J. Chauvet Cave. Salt Lake City: University of Utah Press, 2003.
- The Shamans of Prehistory: Trance and Magic in the Painted Caves. New York: Harry N. Abrams, 1998.
- Cunliffe, B., ed. The Oxford Illustrated Prehistory of Europe. New York: Oxford University Press, 1994.
- Fitton, J. L. Cycladic Art. London: British Museum Press, 1999
- Fowler, P. Images of Prehistory. New York: Cambridge University Press, 1990.

- Leroi-Gourhan, A. The Dawn of European Art: An Introduction to Paleolithic Cave Painting. New York: Cambridge University Press, 1982.
- McCold, C. H., and L. D. McDermott. Toward Decolonizing Gender: Female Vision in the Upper Palaeolithic. American Anthropologist 98, 1996.
- Ruspoli, M. The Cave of Lascaux: The Final Photographs. New York: Harry N. Abrams, 1987.
- Sandars, N. Prehistoric Art in Europe. 2d ed. New Haven: Yale University Press, 1992. Saura Ramos, P. A. The Cave of Altamira. New York:
- Harry N. Abrams, 1999. Twohig, E. S. The Megalithic Art of Western Europe.
- New York: Oxford University Press, 1981. White, R. Prehistoric Art: The Symbolic Journey of
- Mankind. New York: Harry N. Abrams, 2003.

CHAPTER 2. ANCIENT NEAR EASTERN ART

- Amiet, P. Art of the Ancient Near East. New York: Harry N. Abrams, 1980.
- Aruz, J., ed. Art of the First Cities: The Third Millennium B.C. from the Mediterranean to the Indus. Exh. cat. New York: Metropolitan Museum of Art; Yale University Press, 2003.
- Collon, D. Ancient Near Eastern Art. Berkeley:
- University of California Press, 1995. —. First Impressions: Cylinder Seals in the Ancient Near East. Chicago: University of Chicago Press, 1987
- Crawford, H. The Architecture of Iraq in the Third Millennium B.C. Copenhagen: Akademisk Forlag, 1977
- Curtis, J., and N. Tallis. Forgotten Empire: The World of Ancient Persia. Exh. cat. London: British Museum, 2005.
- Frankfort, H. The Art and Architecture of the Ancient Orient. 5th ed. Pelican History of Art. New Haven: Yale University Press, 1997.
- Goldman, B. The Ancient Arts of Western and Central Asia: A Guide to the Literature. Ames: Iowa State University Press, 1991.
- Harper, P. O., ed. The Royal City of Susa: Ancient Near Eastern Treasures in the Louvre. New York: Metropolitan Museum of Art; Dist. by Harry N. Abrams, 1992.
- Leick, G. A Dictionary of Ancient Near Eastern Architecture. New York: Routledge, 1988.
- Lloyd, S. The Archaeology of Mesopotamia: From the Old Stone Age to the Persian Conquest. Rev. ed. New York: Thames & Hudson, 1984.
- Moscati, S. The Phoenicians. New York: Abbeville Press, 1988.
- Oates, J. Babylon. Rev. ed. London: Thames & Hudson, 1986.
- Reade, J. Mesopotamia. 2d ed. London: Published for the Trustees of the British Museum by the British Museum Press, 2000.
- Zettler, R., and L. Horne, eds. Treasures from the Royal Tombs of Ur. Exh. cat. Philadelphia: University of Pennsylvania, Museum of Archaeology and Anthropology, 1998.

CHAPTER 3. EGYPTIAN ART

- Aldred, C. The Development of Ancient Egyptian Art, from 3200 to 1315 B.C. 3 vols. in 1. London: Academy Editions, 1972.
- Egyptian Art. London: Thames & Hudson, 1985.
- Arnold, D., and C. Ziegler. Building in Egypt: Pharaonic Stone Masonry. New York: Oxford University Press, 1991.
- . Egyptian Art in the Age of the Pyramids. New York: Harry N. Abrams, 1999. Bothmer, B. V. Egyptian Art: Selected Writings of
- Bernard V. Bothmer. New York: Oxford University Press, 2004.
- Davis, W. The Canonical Tradition in Ancient Egyptian Art. New York: Cambridge University Press, 1989.
- Edwards, I. E. S. The Pyramids of Egypt. Rev. ed. Harmondsworth, England: Penguin, 1991.
- Egyptian Art in the Age of the Pyramids. New York: Metropolitan Museum of Art; Dist. by Harry N. Abrams, 1999.

BOOKS FOR FURTHER READING

1117

Grimal, N. A History of Ancient Egypt. London: Blackwell, 1992.

- Mahdy, C., ed. The World of the Pharaohs: A Complete Guide to Ancient Egypt. London: Thames & Hudson, 1990.
- Malek, J. Egypt: 4000 Years of Art. London: Phaidon, 2003.

-. Egyptian Art. Art & Ideas. London: Phaidon, 1999.

- Mendelssohn, K. The Riddle of the Pyramids. New York: Thames & Hudson, 1986. Parry, D. Engineering the Pyramids. Stroud, England:
- Sutton, 2004. Robins, G. The Art of Ancient Egypt. Cambridge, MA:
- Harvard University Press, 1997 Schaefer, H. Principles of Egyptian Art. Oxford:
- Clarendon Press, 1986. Schulz, R., and M. Seidel. Egypt: The World of the
- Pharaohs. Cologne: Könemann, 1998. Smith, W., and W. Simpson. The Art and Architecture of Ancient Egypt. Rev. ed. Pelican History of Art. New Haven: Yale University Press, 1999.
- Tiradritti, F. Ancient Egypt: Art, Architecture and History. London: British Museum Press, 2002.
- Walker, S. and P. Higgs, eds. Cleopatra of Egypt: From History to Myth. Exh. cat. Princeton, NJ: Princeton University Press, 2001.
- Wilkinson, R. Reading Egyptian Art: A Hieroglyphic Guide to Ancient Egyptian Painting and Sculpture. New York: Thames & Hudson, 1992.

CHAPTER 4. AEGEAN ART

- Akurgal, E. The Aegean, Birthplace of Western *Civilization: History of East Greek Art and Culture,* 1050–333 B.C. Izmir, Turkey: Metropolitan Municipality of Izmir, 2000. Barber, R. *The Cyclades in the Bronze Age*. Iowa City:
- University of Iowa Press, 1987. Dickinson, O. T. P. K. The Aegean Bronze Age. New
- York: Cambridge University Press, 1994.
- Elytis, O. The Aegean: The Epicenter of Greek Civilization. Athens: Melissa, 1997.
- German, S. C. Performance, Power and the Art of the Aegean Bronze Age. Oxford: Archaeopress, 2005.
- Getz-Preziosi, P. Sculptors of the Cyclades. Ann Arbor: University of Michigan Press, 1987.
- Graham, J. The Palaces of Crete. Rev. ed. Princeton, NJ: Princeton University Press, 1987.
- Hampe, R., and E. Simon. The Birth of Greek Art from the Mycenean to the Archaic Period. New York: Oxford University Press, 1981.
- Higgins, R. Minoan and Mycenaean Art. Rev. ed. The World of Art. New York: Oxford University Press, 1981.
- Hood, S. The Arts in Prehistoric Greece. Pelican History of Art. New Haven: Yale University Press, 1992.
- . The Minoans: The Story of Bronze Age Crete. New York: Praeger, 1981.
- Hurwit, J. The Art and Culture of Early Greece, 1100-480 B.C. Ithaca, NY: Cornell University Press, 1985.
- McDonald, W. Progress into the Past: The Rediscovery of Mycenaean Civilization. 2d ed. Bloomington: Indiana University Press, 1990.
- Preziosi, D., and L. Hitchcock. Aegean Art and Architecture. New York: Oxford University Press, 1999.
- Renfrew, C. The Cycladic Spirit: Masterpieces from the Nicholas P. Goulandris Collection. London: Thames & Hudson, 1991.
- Vermeule, E. Greece in the Bronze Age. Chicago: University of Chicago Press, 1972.

CHAPTER 5. GREEK ART

1118 BOOKS FOR FURTHER READING

- Beard, M. The Parthenon. Cambridge, MA: Harvard University Press, 2003.
- Beazley, J. D. Athenian Red Figure Vases: The Archaic Period: A Handbook. The World of Art. New York: Thames & Hudson, 1991. Athenian Red Figure Vases: The Classical
- Period: A Handbook. The World of Art. New York: Thames & Hudson, 1989.
- The Development of Attic Black-Figure. Rev. ed. Berkeley: University of California Press, 1986.
- Greek Vases: Lectures. Oxford and New York: Clarendon Press and Oxford University Press, 1989.

- Boardman, J. The Archaeology of Nostalgia: How the Greeks Re-created Their Mythical Past. London: Thames & Hudson, 2002.
- Athenian Black Figure Vases: A Handbook. Corrected ed. The World of Art. New York: Thames & Hudson, 1991.
- . Early Greek Vase Painting: 11th-6th Centuries B.C.: A Handbook. The World of Art. New York: Thames & Hudson, 1998.
- Greek Art. 4th ed., rev. and expanded. The World of Art. New York: Thames & Hudson, 1996.
- —. Greek Sculpture: The Archaic Period: A Handbook. Corrected ed. The World of Art. New York: Thames & Hudson, 1991.
- Greek Sculpture: The Classical Period: A Handbook. Corrected ed. New York: Thames & Hudson, 1991.
- The History of Greek Vases: Potters, Painters, and Pictures. New York: Thames & Hudson, 2001. Burn, L. Hellenistic Art: From Alexander the Great to
- Augustus. London: The British Museum, 2004. Carpenter, T. H. Art and Myth in Ancient Greece: A
- Handbook. The World of Art. New York: Thames & Hudson, 1991.
- Carratelli, G. P., ed. The Greek World: Art and Civilization in Magna Graecia and Sicily. Exh. cat. New York: Rizzoli, 1996.
- Fullerton, M. D. Greek Art. New York: Cambridge University Press, 2000.
- Hampe, R., and E. Simon. The Birth of Greek Art. Oxford: Oxford University Press, 1981.
- Haynes, D. E. L. The Technique of Greek Bronze Statuary. Mainz am Rhein: P. von Zabern, 1992.
- Himmelmann, N. Reading Greek Art: Essays. Princeton, NJ: Princeton University Press, 1998.
- Hurwit, J. M. The Acropolis in the Age of Pericles. New
- 1100-480 B.C. Ithaca, NY: Cornell University Press, 1985.
- Lawrence, A. Greek Architecture. Rev. 5th ed. Pelican History of Art. New Haven: Yale University Press, 1996.
- L'Empereur, J. Alexandria Rediscovered. London: British Museum Press, 1998.
- Osborne, R. Archaic and Classical Greek Art. New York: Oxford University Press, 1998.
- Papaioannou, K. The Art of Greece. New York: Harry N. Abrams, 1989.
- Pedley, J. Greek Art and Archaeology. 2d ed. New York: Harry N. Abrams, 1997.
- Pollitt, J. The Ancient View of Greek Art: Criticism, History, and Terminology. New Haven: Yale University Press, 1974.
- . Art in the Hellenistic Age. New York: Cambridge University Press, 1986.
- ., ed. Art of Ancient Greece: Sources and Documents. New York: Cambridge University Press, 1990.
- Potts, A. Flesh and the Ideal: Winckelmann and the Origins of Art History. New Haven: Yale University Press, 1994.
- Rhodes, R. F. Architecture and Meaning on the Athenian Acropolis. New York: Cambridge University Press, 1995.
- ., ed. The Acquisition and Exhibition of Classical Antiquities: Professional, Legal, and Ethical Perspectives. Notre Dame, IN: University of Notre Dame Press, 2007.
- Richter, G. M. A. A Handbook of Greek Art. 9th ed. New York: Da Capo, 1987.
 - Portraits of the Greeks. Ed. R. Smith. New York: Oxford University Press, 1984.
- Ridgway, B. S. Hellenistic Sculpture: Vol. 1, The Styles of ca. 331-200 B.C. Bristol, England: Bristol Classical Press, 1990.
- Robertson, M. The Art of Vase Painting in Classical Athens. New York: Cambridge University Press, 1992.
- Rolley, C. Greek Bronzes. New York: Philip Wilson for Sotheby's Publications; Dist. by Harper & Row, 1986.
- Schefold, K. Gods and Heroes in Late Archaic Greek Art. New York: Cambridge University Press, 1992.
- Smith, R. Hellenistic Sculpture. The World of Art. New York: Thames & Hudson, 1991.
- Spivey, N. Greek Art. London: Phaidon, 1997.

- Stafford, E. Life, Myth, and Art in Ancient Greece. Los Angeles: J. Paul Getty Museum, 2004. Stansbury-O'Donnell, M. Pictorial Narrative in Ancient
- Greek Art. New York: Cambridge University Press, 1999
- Stewart, A. F. Greek Sculpture: An Exploration. New Haven: Yale University Press, 1990.
- Whitley, J. The Archaeology of Ancient Greece. New York: Cambridge University Press, 2001.

CHAPTER 6. ETRUSCAN ART

- Boethius, A. Etruscan and Early Roman Architecture. 2d ed. Pelican History of Art. New Haven: Yale University Press, 1992.
- Bonfante, L., ed. *Etruscan Life and Afterlife: A* Handbook of *Etruscan Studies*. Detroit, MI: Wayne State University, 1986.
- Borrelli, F. The Etruscans: Art, Architecture, and History. Los Angeles: J. Paul Getty Museum, 2004.
- Brendel, O. Etruscan Art. Pelican History of Art. New Haven: Yale University Press, 1995.
- Hall, J. F., ed. Etruscan Italy: Etruscan Influences on the Civilizations of Italy from Antiquity to the Modern Era. Provo, UT: Museum of Art, Brigham Young University, 1996.
- Haynes, Sybille. Etruscan Civilization: A Cultural History. Los Angeles: J. Paul Getty Museum, 2000.
- Richardson, E. The Etruscans: Their Art and Civilization. Reprint of 1964 ed., with corrections. Chicago: University of Chicago Press, 1976.
- Spivey, N. Etruscan Art. The World of Art. New York: Thames & Hudson, 1997.
- Sprenger, M., G. Bartoloni, and M. Hirmer. The *Etruscans: Their History, Art, and Architecture.* New York: Harry N. Abrams, 1983.
- Steingräber, S., ed. Etruscan Painting: Catalogue Raisonné of Etruscan Wall Paintings. New York: Johnson Reprint, 1986.
- Torelli, M., ed. The Etruscans. Exh. cat. Milan: Bompiani, 2000.

CHAPTER 7. ROMAN ART

- Allan, T. Life, Myth and Art in Ancient Rome. Los Angeles: J. Paul Getty Museum, 2005.
- Andreae, B. The Art of Rome. New York: Harry N. Abrams, 1977
- Beard, M., and J. Henderson. Classical Art: From Greece to Rome. New York: Oxford University Press, 2001.
- Bowe, P. Gardens of the Roman World. Los Angeles: J. Paul Getty Museum, 2004.
- Brilliant, R. Commentaries on Roman Art: Selected Studies. London: Pindar Press, 1994.
- -. My Laocoon: Alternative Claims in the Interpretation of Artworks. University of California Press, 2000.
- Claridge, A. Rome: An Oxford Archaeological Guide.
- New York: Oxford University Press, 1998. D'Ambra, E. Roman Art. New York: Cambridge University Press, 1998.
- Davies, P. Death and the Emperor: Roman Imperial Funerary Monuments from Augustus to Marcus Aurelius. Austin: University of Texas Press, 2004.
- Dunbabin, K. M. D. Mosaics of the Greek and Roman World. New York: Cambridge University Press, 1999.
- Elsner, J. Imperial Rome and Christian Triumph: The Art of the Roman Empire, A.D. 100-450. New York: Oxford University Press, 1998.
- Gazda, E. K. Roman Art in the Private Sphere: New Perspectives on the Architecture and Decor of the Domus, Villa, and Insula. Ann Arbor: University of Michigan Press, 1991. Jenkyns, R., ed. The Legacy of Rome: A New Appraisal.

., and S. B. Matheson, eds. I, Claudia: Women in

New York: Oxford University Press, 1992.

Ancient Rome. New Haven: Yale University Art

Ling, R. Ancient Mosaics. London: British Museum

. Roman Painting. New York: Cambridge

Kleiner, D. Roman Sculpture. New Haven: Yale

University Press, 1992.

University Press, 1991.

Gallery, 1996.

Press, 1998.

- Nash, E. Pictorial Dictionary of Ancient Rome. 2 vols. Reprint of 1968 2d ed. New York: Hacker, 1981.
- Pollitt, J. J. The Art of Rome, c. 753 B.C.- A.D. 337: Sources and Documents. New York: Cambridge University Press, 1983.
- Ramage, N., and A. Ramage. The Cambridge Illustrated History of Roman Art. Cambridge: Cambridge University Press, 1991. Roman Art: Romulus to Constantine. 4th ed.
- Upper Saddle River, NJ: Pearson Prentice Hall, 2005. Richardson, L. A New Topographical Dictionary of
- Ancient Rome. Baltimore, MD: Johns Hopkins University Press, 1992.
- Rockwell, P. The Art of Stoneworking: A Reference Guide. Cambridge: Cambridge University Press, 1993
- Strong, D. E. Roman Art. 2d ed. Pelican History of Art. New Haven: Yale University Press, 1992.
- Vitruvius. The Ten Books on Architecture. Trans. I. Rowland. Cambridge: Cambridge University Press, 1999
- Ward-Perkins, J. B. Roman Imperial Architecture. Reprint of 1981 ed. Pelican History of Art. New York: Penguin, 1992.
- Zanker, P. The Power of Images in the Age of Augustus. Ann Arbor: University of Michigan Press, 1988.

PART TWO: THE MIDDLE AGES

GENERAL REFERENCES

- Alexander, J. J. G. Medieval Illuminators and Their Methods of Work. New Haven: Yale University Press, 1992.
- ed. A Survey of Manuscripts Illuminated in the British Isles. 6 vols. London: Harvey Miller, 1975-1996
- Avril, F., and J. J. G. Alexander, eds. A Survey of Manuscripts Illuminated in France. London: Harvey Miller, 1996.
- Bartlett, R., ed. Medieval Panorama. Los Angeles: J. Paul Getty Museum, 2001.
- Cahn, W. Studies in Medieval Art and Interpretation. London: Pindar Press, 2000.
- Calkins, R. G. Medieval Architecture in Western Europe: From A.D. 300 to 1500. New York: Oxford University Press, 1998.
- Cassidy, B., ed. Iconography at the Crossroads. Princeton, NJ: Princeton University Press, 1993.
- Coldstream, N. Medieval Architecture. Oxford History of Art. New York: Oxford University Press, 2002.
- De Hamel, C. The British Library Guide to Manuscript Illumination: History and Techniques. Toronto: University of Toronto Press, 2001.
- A History of Illuminated Manuscripts. Rev. and enl. 2d ed. London: Phaidon Press, 1994.
- Duby, G. Art and Society in the Middle Ages. Polity Press; Malden, MA: Blackwell Publishers, 2000.
- Hamburger, J. Nuns as Artists: The Visual Culture of a Medieval Convent. Berkeley: University of California Press, 1997.
- Katzenellenbogen, A. Allegories of the Virtues and Vices in Medieval Art. Reprint of 1939 ed. Toronto: University of Toronto Press, 1989.
- Kazhdan, A. P. The Oxford Dictionary of Byzantium. 3 vols. New York: Oxford University Press, 1991.
- Kessler, H. L. Seeing Medieval Art. Peterborough, Ont.
- and Orchard Park, NY: Broadview Press, 2004. Luttikhuizen, H., and D. Verkerk. Snyder's Medieval Art. 2d ed. Upper Saddle River, NJ: Prentice Hall, 2006.
- Pächt, O. Book Illumination in the Middle Ages: An Introduction. London: Harvey Miller, 1986.
- Pelikan, J. Mary Through the Centuries: Her Place in the History of Culture. New Haven: Yale University Press, 1996.
- Ross, L. Artists of the Middle Ages. Westport, CT: Greenwood Press, 2003.
- . Medieval Art: A Topical Dictionary. Westport, CT: Greenwood Press, 1996. Schütz, B. Great Cathedrals. New York: Harry N.
- Abrams, 2002.
- Sears, E., and T. K. Thomas, eds. Reading Medieval Images: The Art Historian and the Object. Ann Arbor: University of Michigan Press, 2002.
- Sekules, V. Medieval Art. New York: Oxford University Press, 2001.

- Stokstad, M. Medieval Art. Boulder, CO: Westview Press, 2004.
- Tasker, E. Encyclopedia of Medieval Church Art. London: Batsford, 1993.
- Watson, R. Illuminated Manuscripts and Their Makers: An Account Based on the Collection of the Victoria and Albert Museum. London and New York: V & A Publications; Dist. by Harry N. Abrams, 2003
- Wieck, R. S. Painted Prayers: The Book of Hours in Medieval and Renaissance Art. New York: George Braziller in association with the Pierpont Morgan Library, 1997.
- Wixom, W. D. Mirror of the Medieval World. Exh. cat. New York: Metropolitan Museum of Art; Dist. by Harry N. Abrams, 1999.

CHAPTER 8. EARLY JEWISH, EARLY CHRISTIAN, AND BYZANTINE ART

- Beckwith, J. Studies in Byzantine and Medieval Western Art. London: Pindar Press, 1989.
- Bowersock, G. W., ed. Late Antiquity: A Guide to the Postclassical World. Cambridge, MA: Belknap Press of Harvard University Press, 1999.
- Cormack, R. Icons. London: British Museum Press, 2007
- Demus, O. Studies in Byzantium, Venice and the West. 2 vols. London: Pindar Press, 1998.

Drury, J. Painting the Word: Christian Pictures and Their Meanings. New Haven and London: Yale University Press in association with National Gallery Publications, 1999.

- Durand, J. Byzantine Art. Paris: Terrail, 1999. Evans, H. C., ed. Byzantium: Faith and Power, 1261–1557. Exh. cat. New York: Metropolitan Museum of Art; New Haven: Yale University Press, 2004.
- Evans, H. C., and W. D. Wixom, eds. The Glory of Byzantium: Art and Culture of the Middle Byzantine Era, A. D. 843-1261. Exh. cat. New York: Metropolitan Museum of Art; New Haven: Yale University Press, 1997.
- Galavaris, G. Colours, Symbols, Worship: The Mission of the Byzantine Artist. London: Pindar, 2005.
- Grabar, A. Christian Iconography: A Study of Its Origins. Princeton, NJ: Princeton University Press, 1968.
- Henderson, G. Vision and Image in Early Christian England. New York: Cambridge University Press, 1999
- Kalavrezou, I. Byzantine Women and Their World. Exh. cat. Cambridge, MA and New Haven: Harvard University Art Museums; Yale University Press, © 2003.
- Kleinbauer, W. Early Christian and Byzantine Architecture: An Annotated Bibliography and Historiography. Boston: G. K. Hall, 1993.

Krautheimer, R., and S. Curcic. Early Christian and Byzantine Architecture. 4th ed. Pelican History of Art. New Haven: Yale University Press, 1992.

Lowden, J. Early Christian and Byzantine Art. London: Phaidon Press, 1997.

Maguire, H. Art and Eloquence in Byzantium.

Princeton, NJ: Princeton University Press, 1981. Mango, C. The Art of the Byzantine Empire, 312-1453: Sources and Documents. Reprint of 1972 ed. Toronto: University of Toronto Press, 1986.

- Mark, R., and A. S. Çakmak, eds. Hagia Sophia from the Age of Justinian to the Present. New York: Cambridge University Press, 1992.
- Matthews, T. Byzantium from Antiquity to the Renaissance. New York: Harry N. Abrams, 1998.
- The Clash of Gods: A Reinterpretation of Early Christian Art. Princeton, NJ: Princeton University Press, 1993.
- Milburn, R. Early Christian Art and Architecture. Berkeley: University of California Press, 1988.
- Rodley, L. Byzantine Art and Architecture: An Introduction. New York: Cambridge University Press, 1994.
- Simson, O. G. von. Sacred Fortress: Byzantine Art and Statecraft in Ravenna. Reprint of 1948 ed. Princeton, NJ: Princeton University Press, 1987.
- Webster, L., and M. Brown, eds. The Transformation of the Roman World A.D. 400-900. Berkeley: University of California Press, 1997.

Weitzmann, K. Late Antique and Early Christian Book Illumination. New York: Braziller, 1977.

CHAPTER 9. ISLAMIC ART

- Asher, C.-E. B. Architecture of Mughal India. New Cambridge History of India, Cambridge, England. New York: Cambridge University Press, 1992
- Atil, E. The Age of Sultan Süleyman the Magnificent. Exh. cat. Washington, DC: National Gallery of Art; New York: Harry N. Abrams, 1987.
- Renaissance of Islam: Art of the Mamluks. Exh. cat. Washington, DC: Smithsonian Institution Press, 1981.
- Behrens-Abouseif, D. Beauty in Arabic Culture. Princeton, NJ: Markus Wiener, 1998. Bierman, I., ed. The Experience of Islamic Art on the
- Margins of Islam. Reading, England: Ithaca Press, 2005.
- Blair, S., and J. Bloom. The Art and Architecture of Islam 1250–1800. Pelican History of Art. New Haven: Yale University Press, 1996.
- Brookes, J. Gardens of Paradise: The History and Design of the Great Islamic Gardens. New York: New Amsterdam, 1987.
- Burckhardt, T. Art of Islam: Language and Meaning. London: World of Islam Festival, 1976.
- Creswell, K. A. C. A Bibliography of the Architecture, Arts, and Crafts of Islam. Cairo: American University in Cairo Press, 1984.
- Denny, W. B. The Classical Tradition in Anatolian Carpets. Washington, DC: Textile Museum, 2002.
- Dodds, J. D., ed. al-Andalus: The Art of Islamic Spain. Exh. cat. New York: Metropolitan Museum of Art; Dist. by Harry N. Abrams, 1992.
- Erdmann, K. Oriental Carpets: An Essay on Their History. Fishguard, Wales: Crosby Press, 1976, © 1960.
- Ettinghausen, R., O. Grabar, and M. Jenkins-Madina. Islamic Art and Architecture, 650–1250. 2d ed. Pelican History of Art. New Haven: Yale University Press, 2002.
- Frishman, M., and H. Khan. The Mosque: History, Architectural Development and Regional Diversity. London: Thames & Hudson, 2002, © 1994.
- Goodwin, G. A History of Ottoman Architecture. New York: Thames & Hudson, 2003, © 1971.
- Grabar, O. The Formation of Islamic Art. Rev. and enl. ed. New Haven: Yale University Press, 1987.
- Hillenbrand, R. Islamic Architecture: Form, Function, and Meaning. New ed. New York: Columbia University Press, 2004.
- Komaroff, L., and S. Carboni, eds. The Legacy of Genghis Khan: Courtly Art and Culture in Western Asia, 1256-1353. Exh. cat. New York: Metropolitan Museum of Art; New Haven: Yale University Press, 2002.
- Lentz, T., and G. Lowry. Timur and the Princely Vision: Persian Art and Culture in the Fifteenth Century. Exh. cat. Los Angeles: Los Angeles County Museum of Art; Washington, DC: Arthur M. Sackler Gallery; Smithsonian Institution Press, 1989.
- Lings, M. The Quranic Art of Calligraphy and Illumination. 1st American ed. New York: Interlink Books, 1987, © 1976.
- Necipolu, G. The Age of Sinan: Architectural Culture in the Ottoman Empire. Princeton, NJ: Princeton University Press, 2005.
- The Topkapı Scroll: Geometry and Ornament in Islamic Architecture. Topkapı Palace Museum Library MS H. 1956. Santa Monica, CA: Getty Center for the History of Art and the Humanities, 1995.
- Pope, A. U. Persian Architecture: The Triumph of Form and Color. New York: Braziller, 1965.
- Robinson, F. Atlas of the Islamic World Since 1500. New York: Facts on File, 1982.
- Ruggles, D. F. Gardens, Landscape, and Vision in the Palaces of Islamic Spain. University Park: Pennsylvania State University Press, 2000.
- , ed. Women, Patronage, and Self-Representation in Islamic Societies. Albany: State University of New York Press, 2000.
- Tabbaa, Y. The Transformation of Islamic Art During the Sunni Revival. Seattle: University of Washington Press, 2001.

- Thompson, J., ed. Hunt for Paradise: Court Arts of Safavid Iran, 1501-1576. Milan: Skira; New York: Dist. in North America and Latin America by Rizzoli, 2003.
- . Oriental Carpets from the Tents, Cottages, and Workshops of Asia. New York: Dutton, 1988.
- Vernoit, S., ed. Discovering Islamic Art: Scholars, Collectors and Collections, 1850-1950. London and New York: I. B. Tauris; Dist. by St. Martin's Press, 2000.
- Welch, S. C. Imperial Mughal Painting. New York: Braziller, 1978.
- -. A King's Book of Kings: The Shah-nameh of Shah Tahmasp. New York: Metropolitan Museum of Art; Dist. by New York Graphic Society, 1972.

CHAPTER 10. EARLY MEDIEVAL ART

- Backhouse, J. The Golden Age of Anglo-Saxon Art, 966–1066. Bloomington: Indiana University Press, 1984.
- The Lindisfarne Gospels: A Masterpiece of Book Painting. London: British Library, 1995.
- Barral i Altet, X. The Early Middle Ages: From Late Antiquity to A.D. 1000. Taschen's World Architecture. Köln and New York: Taschen, © 1997.
- Conant, K. Carolingian and Romanesque Architecture, 800–1200. 4th ed. Pelican History of Art. New Haven: Yale University Press, 1992.
- Davis-Weyer, C. Early Medieval Art, 300-1150: Sources and Documents. Reprint of 1971 ed. Toronto: University of Toronto Press, 1986.
- Diebold, W. J. Word and Image: An Introduction to Early Medieval Art. Boulder, CO: Westview Press, 2000.
- Dodwell, C. R. Anglo-Saxon Art: A New Perspective. Ithaca, NY: Cornell University Press, 1982. The Pictorial Arts of the West, 800-1200. New ed. Pelican History of Art. New Haven: Yale
- University Press, 1993. Graham-Campbell, J. The Viking-age Gold and Silver of Scotland, A.D. 850-1100. Exh. cat. Edinburgh: National Museums of Scotland, 1995.
- Harbison, P. The Golden Age of Irish Art: The Medieval Achievement, 600–1200. New York: Thames & Hudson, 1999.
- Henderson, G. The Art of the Picts: Sculpture and Metalwork in Early Medieval Scotland. New York: Thames & Hudson, 2004.
- Kitzinger, E. Early Medieval Art, with Illustrations from the British Museum. Rev. ed. Bloomington: Indiana University Press, 1983.
- Lasko, P. Ars Sacra, 800-1200. 2d ed. Pelican History of Art. New Haven: Yale University Press, 1995.
- Mayr-Harting, M. Ottonian Book Illumination: An Historical Study. 2 vols. London: Harvey Miller, 1991-1993.
- Megaw, M. R. Celtic Art: From Its Beginnings to the Book of Kells. New York: Thames & Hudson, 2001.
- Mosacati, S., ed. The Celts. Exh. cat. New York: Rizzoli, 1999.
- Nees, L. Early Medieval Art. Oxford History of Art. New York: Oxford University Press, 2002.
- Ohlgren, T. H., comp. Insular and Anglo-Saxon Illuminated Manuscripts: An Iconographic Catalogue, c. A.D. 625 to 1100. New York: Garland, 1986.
- Rickert, M. Painting in Britain: The Middle Ages. 2d ed. Pelican History of Art. Harmondsworth, England: Penguin, 1965.
- Stalley, R. A. Early Medieval Architecture. Oxford History of Art. New York: Oxford University Press,
- Stone, L. Sculpture in Britain: The Middle Ages. 2d ed. Pelican History of Art. Harmondsworth, England: Penguin, 1972.
- Webster, L., and J. Backhouse, eds. The Making of England: Anglo-Saxon Art and Culture, A.D. 600-900. Exh. cat. London: Published for the Trustees of the British Museum and the British Library Board by British Museum Press, 1991.

CHAPTER 11. ROMANESQUE ART

- Barral i. Altet, X. The Romanesque: Towns, Cathedrals, and Monasteries. Cologne: Taschen, 1998.
- Bizzarro, T. Romanesque Architectural Criticism: A Prehistory. New York: Cambridge University Press, 1992.

- Boase, T. S. R. English Art, 1100-1216. Oxford History of English Art. Oxford: Clarendon Press, 1953.
- Cahn, W. Romanesque Bible Illumination. Ithaca, NY: Cornell University Press, 1982.
 - Davies, M. Romanesque Architecture: A Bibliography. Boston: G. K. Hall, 1993.
- Focillon, H. The Art of the West in the Middle Ages. Ed. J. Bony. 2 vols. Reprint of 1963 ed. Ithaca, NY Cornell University Press, 1980.
- Hearn, M. F. Romanesque Sculpture: The Revival of Monumental Stone Sculpture. Ithaca, NY: Cornell University Press, 1981.
- Mâle, E. Religious Art in France, the Twelfth Century: A Study of the Origins of Medieval Iconography. Bollingen series, 90:1. Princeton, NJ: Princeton University Press, 1978.
- Minne-Sève, V. Romanesque and Gothic France: Architecture and Sculpture. New York: Harry N. Abrams, 2000.
- Nichols, S. Romanesque Signs: Early Medieval Narrative and Iconography. New Haven: Yale University Press, 1983.
- O'Keeffe, T. Romanesque Ireland: Architecture and Ideology in the Twelfth Century. Dublin and Portland, OR: Four Courts, 2003.
- Petzold, A. *Romanesque Art.* Perspectives. Upper Saddle River, NJ: Prentice Hall, 1996.
- Platt, C. The Architecture of Medieval Britain: A Social History. New Haven: Yale University Press, 1990.
- Sauerländer, W. Romanesque Art: Problems and Monuments. 2 vols. London: Pindar, 2004.
- Schapiro, M. Romanesque Art. New York: Braziller, 1977. Stoddard, W. Art and Architecture in Medieval France.
- New York: Harper & Row, 1972, © 1966. Stones, A., J. Krochalis, P. Gerson, and A. Shaver-

Crandell. The Pilgrim's Guide to Santiago de Compostela: A Critical Edition. 2 vols. London: Harvey Miller, 1998.

Toman, R., and A. Bednorz. Romanesque Architecture, Sculpture, Painting. Cologne: Könemann, 2008.

Zarnecki, G. Further Studies in Romanesque Sculpture. London: Pindar, 1992.

CHAPTER 12. GOTHIC ART

- Barnes, C. F. Villard de Honnecourt, the Artist and His Drawings: A Critical Bibliography. Boston: G. K. Hall, 1982
- Belting, H. The Image and Its Public: Form and Function of Early Paintings of the Passion. New Rochelle, NY: Caratzas, 1990.
- Blum, P. Early Gothic Saint-Denis: Restorations and Survivals. Berkeley: University of California Press, 1992.
- Bony, J. French Gothic Architecture of the Twelfth and Thirteenth Centuries. Berkeley: University of California Press, 1983.
- Camille, M. Gothic Art: Glorious Visions. Perspectives. New York: Harry N. Abrams, 1997.
- The Gothic Idol: Ideology and Image Making in Medieval Art. New York: Cambridge University Press, 1989.
- . Sumptuous Arts at the Royal Abbeys of Reims and Braine. Princeton, NJ: Princeton University Press, 1990.
- Cennini, C. The Craftsman's Handbook (Il Libro dell'Arte). New York: Dover, 1954.
- Coldstream, N. Medieval Architecture. Oxford History of Art. New York: Oxford University Press, 2002.
- Erlande-Brandenburg, A. Gothic Art. New York: Harry N. Abrams, 1989.
- Frankl, P. Gothic Architecture. Rev. by P. Crossley. Pelican History of Art. New Haven, CT: Yale University Press, 2001.
- Frisch, T. G. Gothic Art, 1140-c. 1450: Sources and Documents. Reprint of 1971 ed. Toronto: University of Toronto Press, 1987.
- Grodecki, L. Gothic Architecture. New York:
- Electa/Rizzoli, 1985. Gothic Stained Glass, 1200-1300. Ithaca, NY: Cornell University Press, 1985.
- Hamburger, J. F. The Visual and the Visionary: Art and Female Spirituality in Late Medieval Germany. Zone Books. Cambridge, MA: MIT Press, 1998.
- Jantzen, H. High Gothic: The Classic Cathedrals of Chartres, Reims, Amiens. Reprint of 1962 ed. Princeton, NJ: Princeton University Press, 1984.

- Kemp, W. The Narratives of Gothic Stained Glass. New York: Cambridge University Press, 1997
- Limentani Virdis, C. Great Altarpieces: Gothic and Renaissance. New York: Vendome Press; Dist. by Rizzoli, 2002.
- Mâle, E. Religious Art in France, the Thirteenth Century: A Study of Medieval Iconography and Its Sources. Ed. H. Bober. Princeton, NJ: Princeton University Press, 1984.
- Marks, R., and P. Williamson, eds. Gothic: Art for England 1400-1547. Exh. cat. London and New York: Victoria & Albert Museum; Dist. by Harry N. Abrams, 2003.
- Murray, S. Beauvais Cathedral: Architecture of Transcendence. Princeton, NJ: Princeton University Press, 1989.
- Panofsky, E. ed. and trans. Abbot Suger on the Abbey Church of Saint-Denis and Its Art Treasures. 2d ed. Princeton, NJ: Princeton University Press, 1979. Gothic Architecture and Scholasticism. Reprint
- of 1951 ed. New York: New American Library, 1985.
- Parnet, P., ed. Images in Ivory: Precious Objects of the Gothic Age. Exh. cat. Detroit, MI: Detroit Institute of Arts, © 1997.
- Sandler, L. Gothic Manuscripts, 1285-1385. Survey of Manuscripts Illuminated in the British Isles. London: Harvey Miller, 1986.
- Scott, R. A. The Gothic Enterprise: A Guide to Understanding the Medieval Cathedral. Berkeley: University of California Press, 2003.
- Simson, O. von. The Gothic Cathedral: Origins of Gothic Architecture and the Medieval Concept of Order. 3d ed. Princeton, NJ: Princeton University Press, 1988.
- Toman, R., and A. Bednorz. The Art of Gothic: Architecture, Sculpture, Painting. Cologne: Könemann, 1999.
- Williamson, P. Gothic Sculpture, 1140-1300. New Haven: Yale University Press, 1995.
- Wilson, C. The Gothic Cathedral: The Architecture of the Great Church, 1130-1530. 2d rev. ed. London: Thames & Hudson, 2005.

PART THREE: THE RENAISSANCE THROUGH THE ROCOCO

GENERAL REFERENCES AND SOURCES

- Campbell, L. Renaissance Portraits: European Portrait-Painting in the 14th, 15th, and 16th Centuries. New Haven: Yale University Press, 1990.
- Chastel, A., et al. The Renaissance: Essays in Interpretation. London: Methuen, 1982.
- Cloulas, I. Treasures of the French Renaissance. New York: Harry N. Abrams, 1998.
- Cole, A. Art of the Italian Renaissance Courts: Virtue and Magnificence. London: Weidenfeld & Nicolson, 1995.
- Gascoigne, B. How to Identify Prints: A Complete Guide to Manual and Mechanical Processes from Woodcut to Inkjet. New York: Thames & Hudson, 2004.
- Grendler, P. F., ed. Encyclopedia of the Renaissance. 6 vols. New York: Scribner's, published in association with the Renaissance Society of America, 1999.
- Gruber, A., ed. The History of Decorative Arts: Vol. 1, The Renaissance and Mannerism in Europe. Vol. 2, Classicism and the Baroque in Europe. New York: Abbeville Press, 1994.
- Harbison, C. The Mirror of the Artist: Northern Renaissance Art in its Historical Context. New York: Harry N. Abrams, 1995.
- Harris, A. S. Seventeenth-Century Art and Architecture. 2d ed. Upper Saddle River, NJ: Pearson Education, 2008.
- Hartt, F., and D. Wilkins. History of Italian Renaissance Art. 6th ed. Upper Saddle River, NJ: Pearson Prentice Hall, 2007.
- Hopkins, A. Italian Architecture: from Michelangelo to *Borromini.* World of Art. New York: Thames & Hudson, 2002.
- Hults, L. The Print in the Western World. Madison:
- University of Wisconsin Press, 1996.
 Impey, O., and A. MacGregor, eds. The Origins of Museums: The Cabinet of Curiosities in Sixteenthand Seventeenth-Century Europe. New York: Clarendon Press, 1985.

- Ivins, W. M., Jr. *How Prints Look: Photographs with a Commentary*. Boston: Beacon Press, 1987.
- Landau, D., and P. Parshall. *The Renaissance Print*. New Haven: Yale University Press, 1994.
- Lincoln, E. The Invention of the Italian Renaissance Printmaker. New Haven: Yale University Press, 2000.
- Martin, J. R. *Baroque*. Harmondsworth, England: Penguin, 1989.
- Millon, H. A., ed. *The Triumph of the Baroque:* Architecture in Europe, 1600–1750. New York: Rizzoli, 1999.
- Minor, V. H. Baroque & Rococo: Art & Culture. New York: Harry N. Abrams, 1999.

Norberg-Schultz, C. Late Baroque and Rococo Architecture. New York: Harry N. Abrams, 1983.

- Olson, R. J. M. *Italian Renaissance Sculpture*. The World of Art. New York: Thames & Hudson, 1992 Paoletti, J., and G. Radke. *Art in Renaissance Italy*. 3d
- Paoletti, J., and G. Radke. *Art in Renaissance Italy*. 3d ed. Upper Saddle River, NJ: Pearson Prentice Hall, 2006.
- Payne, A. Antiquity and Its Interpreters. New York: Cambridge University Press, 2000.
- Pope-Hennessy, J. An Introduction to Italian Sculpture: Vol. 1, Italian Gothic Sculpture. Vol. 2, Italian Renaissance Sculpture. Vol. 3, Italian High Renaissance and Baroque Sculpture. 4th ed. London: Phaidon Press, 1996.
- Richardson, C. M., K. W. Woods, and M. W. Franklin, eds. *Renaissance Art Reconsidered: An Anthology of Primary Sources.* Wiley-Blackwell, 2007.

Smith, J. C. The Northern Renaissance. Art & Ideas. London: Phaidon Press, 2004.

- Snyder, J. Northern Renaissance Art: Painting, Sculpture, the Graphic Arts, from 1350–1575. 2d ed. New York: Harry N. Abrams, 2005.
- Strinati, E., and J. Pomeroy. Italian Women Artists of the Renaissance and Baroque. Exh. cat. Washington, DC: National Museum of Women in the Arts; New York: Rizzoli, 2007.
- Tomlinson, J. From El Greco to Goya: Painting in Spain 1561–1828. Perspectives. New York: Harry N. Abrams, 1997.
- Turner, J. Encyclopedia of Italian Renaissance & Mannerist Art. 2 vols. New York: Grove's Dictionaries, 2000.
- Vasari, G. *The Lives of the Artists*. Trans. with an introduction and notes by J. C. Bondanella and P. Bondanella. New York: Oxford University Press, 1998.
- Welch, E. Art in Renaissance Italy, 1350–1500. New ed. Oxford: Oxford University Press, 2000.
- Wiebenson, D., ed. Architectural Theory and Practice from Alberti to Ledoux. 2d ed. Chicago: University of Chicago Press, 1983.
- Wittkower, R. Architectural Principles in the Age of Humanism. 5th ed. New York: St. Martin's Press, 1998.

CHAPTER 13. ART IN THIRTEENTH-AND FOURTEENTH-CENTURY ITALY

- Bellosi, L. *Duccio, the Maestà*. New York: Thames & Hudson, 1999.
- Bomford, D. Art in the Making: Italian Painting Before 1400. Exh. cat. London: National Gallery of Art, 1989.
- Christiansen, K. Duccio and the Origins of Western Painting. New York: Metropolitan Museum of Art and Yale University Press, 2009.
- Derbes, A. The Cambridge Companion to Giotto. New York: Cambridge University Press, 2004.
- ——, and M. Sandona. The Usurer's Heart: Giotto, Enrico Scrovegni, and the Arena Chapel in Padua. University Park: Pennsylvania State University Press, 2008.
- Kemp, M. Behind the Picture: Art and Evidence in the Italian Renaissance. New Haven: Yale University Press, 1997.
- Maginnis, H. B. J. *The World of the Early Sienese Painter*. With a translation of the Sienese Breve dell'Arte del pittori by Gabriele Erasmi. University Park: Pennsylvania State University Press, 2001.
- Meiss, M. Painting in Florence and Siena after the Black Death: The Arts, Religion, and Society in the Mid-Fourteenth Century. Princeton, NJ: Princeton University Press, 1978, © 1951.

- Nevola, F. Siena: Constructing the Renaissance City. New Haven and London: Yale University Press, 2008.
- Norman, D., ed. Siena, Florence, and Padua: Art, Society, and Religion 1280–1400. New Haven: Yale University Press in association with the Open University, 1995.
- Schmidt, V., ed. Italian Panel Painting of the Duecento and Trecento. Washington, DC: National Gallery of Art; New Haven: Dist. by Yale University Press, 2002.
- Stubblebine, J. H. Assisi and the Rise of Vernacular Art. New York: Harper & Row, 1985.
- ———. Dugento Painting: An Annotated Bibliography. Boston: G. K. Hall, 1983.
- Trachtenberg, M. Dominion of the Eye: Urbanism, Art, and Power in Early Modern Florence. New York: Cambridge University Press, 2008.
- White, J. Art and Architecture in Italy, 1250–1400. 3d ed. Pelican History of Art. New Haven: Yale University Press, 1993.

CHAPTER 14. ARTISTIC INNOVATIONS IN FIFTEENTH-CENTURY NORTHERN EUROPE

- Ainsworth, M. W., and K. Christiansen. From Van Eyck to Bruegel: Early Netherlandish Painting in the Metropolitan Museum of Art. New York: Metropolitan Museum of Art, 1998.
- Borchert, T., ed. The Age of van Eyck: the Mediterranean World and Early Netherlandish Painting, 1430–1530. New York: Thames & Hudson, 2002.
- Chapuis, J., ed. *Tilman Riemenschneider, Master Sculptor of the Late Middle Ages.* Washington, DC: National Gallery of Art; New York: Metropolitan Museum of Art; New Haven: Dist. by Yale University Press, 1999.
- Cuttler, C. Northern Painting from Pucelle to Bruegel. Fort Worth: Holt, Rinehart & Winston, 1991, © 1972.
- De Vos, D. Rogier van der Weyden: The Complete Works. New York: Harry N. Abrams, 1999.
- Dhanens, E. *Hubert and Jan van Eyck*. New York: Alpine Fine Arts Collection, 1980.
- Dixon, L. Bosch. Art & Ideas. London: Phaidon Press, 2003.
- Friedländer, M. Early Netherlandish Painting. 14 vols. New York: Praeger, 1967–1973.
- Hand, J. O., C. Metzger, and R. Spronk. *Prayers and Portraits: Unfolding the Netherlandish Diptych.* Exh. cat. Washington DC, National Gallery of Art; New Haven: Yale University Press, 2006.
- Koldeweij, J., ed. Hieronymus Bosch: New Insights into His Life and Work. Rotterdam: Museum Boijmans Van Beuningen: NAi; Ghent: Ludion, 2001.
- Muller, T. Sculpture in the Netherlands, Germany, France, and Spain, 1400–1500. Pelican History of
- Art. Harmondsworth, England: Penguin, 1966.
 Nuttall, P. From Flanders to Florence: The Impact of Netherlandish Painting, 1400–1500. New Haven: Yale University Press, 2004.
- Pächt, O. Van Eyck and the Founders of Early Netherlandish Painting. London: Harvey Miller, 1994.
- Panofsky, E. *Early Netherlandish Painting*. 2 vols. New York: Harper & Row, 1971. Orig. published Cambridge, MA: Harvard University Press, 1958.
- Rothstein, B. L. Sight and Spirituality in Early Netherlandish Painting. Cambridge: Cambridge University Press, 2005.
- Van der Velden, H. The Donor's Image: Gérard Loyet and the Votive Portraits of Charles the Bold. Turnhout: Brepols, 2000.
- Williamson, P. *Netherlandish Sculpture 1450–1550.* London: V & A; New York: Dist. by Harry N. Abrams, 2002.

CHAPTER 15. THE EARLY RENAISSANCE IN ITALY

- Ahl, D. C. *The Cambridge Companion to Masaccio*. New York: Cambridge University Press, 2002. Aikema, B. *Renaissance Venice and the North:*
- Crosscurrents in the Time of Bellini, Dürer and Titian. Exh. cat. Milan: Bompiani, 2000.
- Ajmar-Wollheim, M., and F. Dennis, eds. At Home in Renaissance Italy. Exh. cat. London: Victoria & Albert Museum; V&A Publications, 2006.

- Alberti, L. B. On Painting. Trans. C. Grayson, introduction and notes M. Kemp. New York: Penguin, 1991.
- On the Art of Building, in Ten Books. Trans.
 J. Rykwert, et al. Cambridge, MA: MIT Press, 1991.
 Ames-Lewis, F. Drawing in Early Renaissance Italy.
- 2d ed. New Haven: Yale University Press, 2000. Baxandall, M. Painting and Experience in Fifteenth-Century Italy: A Primer in the Social History of Pictorial Style. 2d ed. New York: Oxford University Press, 1988.
- Blunt, A. Artistic Theory in Italy, 1450–1600. Reprint of 1940 ed. New York: Oxford University Press, 1983.
- And R. Rubinstein. Renaissance Artists and Antique Sculpture: A Handbook of Sources. New York: Oxford University Press, 1986.
- Borsook, E. The Mural Painters of Tuscany: From Cimabue to Andrea del Sarto. 2d ed. New York: Oxford University Press, 1980.
- Cole, B. The Renaissance Artist at Work: From Pisano to Titian. New York: Harper & Row, © 1983.
- Fejfer, J. The Rediscovery of Antiquity: The Role of the Artist. Copenhagen: Museum Tusculanum Press, University of Copenhagen, 2003.
- Gilbert, C. E. Italian Art, 1400–1500: Sources and Documents. Englewood Cliffs, NJ: Prentice Hall, 1980.
- Goldthwaite, R. Wealth and the Demand for Art in Italy, 1300–1600. Baltimore, MD: Johns Hopkins University Press, 1993.
- University Press, 1993. Gombrich, E. H. *New Light on Old Masters*. New ed. London: Phaidon Press, 1994.
- Heydenreich, L., and W. Lotz. Architecture in Italy, 1400–1500: Rev. ed. Pelican History of Art. New Haven: Yale University Press, 1996.
- Humfreys, P., and M. Kemp, eds. *The Altarpiece in the Renaissance*. New York: Cambridge University Press, 1990.
- Huse, N., and W. Wolters. The Art of Renaissance Venice: Architecture, Sculpture, and Painting, 1460–1590. Chicago: University of Chicago Press, 1990.
- Janson, H. W. The Sculpture of Donatello. 2 vols.
- Princeton, NJ: Princeton University Press, 1979. Kempers, B. Painting, Power, and Patronage: The Rise of the Professional Artist in the Italian Renaissance. New York: Penguin, 1992. Kent, D. V. Cosimo de' Medici and the Florentine
- Kent, D. V. Cosimo de' Medici and the Florentine Renaissance: The Patron's Oeuvre. New Haven: Yale University Press, © 2000.
- Krautheimer, R., and T. Krautheimer-Hess. Lorenzo Ghiberti. Princeton, NJ: Princeton University Press, 1982.
- Lavin, M. A. *Piero della Francesca*. Art & Ideas. New York: Phaidon Press, 2002.
- Murray, P. *The Architecture of the Italian Renaissance*. New rev. ed. The World of Art. New York: Random House, 1997.
- Musacchio, J. M. Art, Marriage, and Family in the Florentine Renaissance Palace. New Haven: Yale University Press, 2009.
- Pächt, O. Venetian Painting in the 15th Century: Jacopo, Gentile and Giovanni Bellini and Andrea Mantegna. London: Harvey Miller, 2003.
- Panofsky, E. Perspective as Symbolic Form. New York: Zone Books, 1997.
- ——. Renaissance and Renascences in Western Art. Trans. C. S. Wood. New York: Humanities Press, 1970.
- Pope-Hennessy, J. Italian Renaissance Sculpture. 4th ed. London: Phaidon Press, 2000.
- Randolph, A. Engaging Symbols: Gender, Politics, and Public Art in Fifteenth-Century Florence. New Haven: Yale University Press, 2002.
- Saalman, H. *Filippo Brunelleschi: The Buildings.* University Park: Pennsylvania State University Press,
- 1993. Seymour, C. *Sculpture in Italy, 1400–1500*. Pelican History of Art. Harmondsworth, England: Penguin,
- 1966. Turner, A. R. *Renaissance Florence*. Perspectives. New York: Harry N. Abrams, 1997.
- Wackernagel, M. The World of the Florentine Renaissance Artist: Projects and Patrons, Workshop and Art Market. Princeton, NJ: Princeton University Press, 1981.

Wood, J. M., ed. *The Cambridge Companion to Piero della Francesca*. New York: Cambridge University Press, 2002.

CHAPTER 16. THE HIGH RENAISSANCE IN ITALY, 1495-1520

- Ackerman, J., *The Architecture of Michelangelo*. 2d ed. Chicago: University of Chicago Press, 1986. Beck, J. H. *Three Worlds of Michelangelo*. New York:
- W. W. Norton, 1999. Boase, T. S. R. Giorgio Vasari: The Man and the Book.
- Princeton, NJ: Princeton University Press, 1979. Brown, P. F. Art and Life in Renaissance Venice.
- Perspectives. New York: Harry N. Abrams, 1997. ——. Venice and Antiquity: The Venetian Sense of the Past. New Haven: Yale University Press, 1997.
- Chapman, H. *Raphael: From Urbino to Rome*. London: National Gallery; New Haven: Dist. by Yale University Press, 2004.
- Clark, K. *Leonardo da Vinci*. Rev. and introduced by M. Kemp. New York: Penguin, 1993, © 1988.
- Cole, A. Virtue and Magnificence: Art of the Italian Renaissance Courts. Perspectives. New York: Harry N. Abrams, 1995.
- De Tolnay, C. *Michelangelo*. 5 vols. Some vols. rev. Princeton, NJ: Princeton University Press, 1969–1971.
- Freedberg, S. *Painting in Italy, 1500–1600.* 3d ed. Pelican History of Art. New Haven: Yale University Press, 1993.
- Goffen, R. *Renaissance Rivals: Michelangelo, Leonardo, Raphael, Titian.* New Haven: Yale University Press, 2002.
- Hall, M. B. *The Cambridge Companion to Raphael.* New York: Cambridge University Press, 2005.
- Hersey, G. L. High Renaissance Art in St. Peter's and the Vatican: An Interpretive Guide. Chicago: University of Chicago Press, 1993.
- Hibbard, H. *Michelangelo*. 2d ed. Boulder, CO: Westview Press, 1998, © 1974.
- Kemp, M. Leonardo. New York: Oxford University Press, 2004.
- —, ed. Leonardo on Painting: An Anthology of Writings. New Haven: Yale University Press, 1989.
- Nicholl, C. Leonardo da Vinci: Flights of the Mind. New York: Viking Penguin, 2004.
- Panofsky, E. Studies in Iconology: Humanist Themes in the Art of the Renaissance. New York: Harper & Row, 1972.
- Partridge, L. *The Art of Renaissance Rome*. Perspectives. New York: Harry N. Abrams, 1996.
- Rowland, I. The Culture of the High Renaissance: Ancients and Moderns in Sixteenth Century Rome. Cambridge: 1998.
- Rubin, P. L. *Giorgio Vasari: Art and History*. New Haven: Yale University Press, 1995.
- Steinberg, L. Leonardo's Incessant Last Supper. New York: Zone Books, 2001.
- Wallace, W. Michelangelo: The Complete Sculpture, Painting, Architecture. Southport, CT: Hugh Lauter Levin, 1998.
- Wölfflin, H. Classic Art: An Introduction to the High Renaissance. 5th ed. London: Phaidon Press, 1994.

CHAPTER 17. THE LATE RENAISSANCE AND MANNERISM

- Ackerman, J. *Palladio*. Reprint of the 2d ed. Harmondsworth, England: Penguin, 1991, © 1966.
- Barkan, L. Unearthing the Past: Archaeology and Aesthetics in the Making of Renaissance Culture.
- New Haven: Yale University Press, 1999. Beltramini, G., and A. Padoan. Andrea Palladio: The Complete Illustrated Works. New York: Universe;
- Dist. by St. Martin's Press, 2001. Cole, M., ed. *Sixteenth-Century Italian Art*. Oxford: Blackwell, 2006.
- Ekserdjian, D. Correggio. New Haven: Yale University Press, 1997.
- Fortini Bown, P. Private Lives in Renaissance Venice: Art, Architecture, and the Family. New Haven: Yale University Press, 2004.

- Friedlaender, W. Mannerism and Anti-Mannerism in Italian Painting. Reprint of 1957 ed. Interpretations in Art. New York: Columbia University Press, 1990.
- Furlotti, B., and G. Rebecchini. The Art and Architecture of Mantua: Eight Centuries of Patronage and Collecting. London: Thames & Hudson, 2008. Goffen, R. Titian's Women. New Haven: Yale
- University Press, 1997.
- Jacobs, F. H. Defining the Renaissance "Virtuosa": Women Artists and the Language of Art History and Criticism. New York: Cambridge University Press, 1997.
- Klein, R., and H. Zerner. Italian Art, 1500–1600: Sources and Documents. Reprint of 1966 ed. Evanston, IL: Northwestern University Press, 1989.
- Kliemann, J., and M. Rohlmann. *Italian Frescoes: High Renaissance and Mannerism, 1510–1600.* New York: Abbeville Press, 2004.
- Partridge, L. Michelangelo—The Last Judgment: A Glorious Restoration. New York: Harry N. Abrams, 1997.
- Rearick, W. R. *The Art of Paolo Veronese*, *1528–1588*. Cambridge: Cambridge University Press, 1988.
- Rosand, D. Painting in Sixteenth-Century Venice: Titian, Veronese, Tintoretto. New York: Cambridge University Press, 1997.
- Shearman, J. K. G. Mannerism. New York: Penguin Books, 1990, © 1967.
- Smyth, C. H. *Mannerism and Maniera*. 2d ed. Bibliotheca artibus et historiae. Vienna: IRSA, 1992.
- Tavernor, R. *Palladio and Palladianism*. The World of Art. New York: Thames & Hudson, 1991.
- Valcanover, F., and T. Pignatti. *Tintoretto*. New York: Harry N. Abrams, 1984.
- Wundram, M. Palladio: The Complete Buildings. Köln and London: Taschen, 2004.

CHAPTER 18. EUROPEAN ART OF THE SIXTEENTH CENTURY: RENAISSANCE AND REFORMATION

- Bartrum, G. Albrecht Dürer and His Legacy: The Graphic Work of a Renaissance Artist. Princeton, NJ: Princeton University Press, 2002.
- Baxandall, M. The Limewood Sculptors of Renaissance Germany. New Haven: Yale University Press, 1980.
- Campbell, T. P. Tapestry in the Renaissance: Art and Magnificence. Exh. cat. New York: Metropolitan Museum of Art; New Haven: Yale University Press, 2006.
- Eichberger, D., ed. *Durer and His Culture*. New York: Cambridge University Press, 1998.
- Hayum, A. The Isenheim Altarpiece: God's Medicine and the Painter's Vision. Princeton, NJ: Princeton University Press, 1989.
- Hitchcock, H.-R. German Renaissance Architecture. Princeton, NJ: Princeton University Press, 1981.
- Honig, E. A. Painting and the Market in Early Modern Antwerp. New Haven: Yale University Press, 1998.
- Hulse, C. *Elizabeth I: Ruler and Legend*. Urbana: Published for the Newberry Library by the University of Illinois Press, 2003.
- Hutchison, J. C. Albrecht Dürer: A Biography. Princeton, NJ: Princeton University Press, 1990.
- Jopek, N. German Sculpture, 1430–1540: A Catalogue of the Collection in the Victoria and Albert Museum. London: V & A, 2002.
- Kavaler, E. M. Pieter Bruegel: Parables of Order and Enterprise. New York: Cambridge University Press, 1999.
- Koerner, J. The Moment of Self-Portraiture in German Renaissance Art. Chicago: University of Chicago Press, 1993.
- Mann, R. El Greco and His Patrons: Three Major Projects. New York: Cambridge University Press, 1986.
- Melion, W. Shaping the Netherlandish Canon: Karel van Mander's Schilder-Boeck. Chicago: University of Chicago Press, 1991.
- Moxey, K. Peasants, Warriors, and Wives: Popular Imagery in the Reformation. Chicago: University of Chicago Press, 1989.
- Osten, G. von der, and H. Vey. *Painting and Sculpture in Germany and the Netherlands, 1500–1600.* Pelican History of Art. Harmondsworth, England: Penguin, 1969.

- Panofsky, E. *The Life and Art of Albrecht Dürer*. 4th ed. Princeton, NJ: Princeton University Press, 1971.
- Smith, J. C. Nuremberg: A Renaissance City, 1500–1618. Austin: Published for the Archer M. Huntington Art Gallery by the University of Texas Press, 1983.
- Stechow, W. Northern Renaissance Art, 1400–1600: Sources and Documents. Evanston, IL: Northwestern University Press, 1989, © 1966.
- Van Mander, K. Lives of the Illustrious Netherlandish and German Painters. Ed. H. Miedema. 6 vols. Doornspijk, Netherlands: Davaco, 1993–1999.
- Wood, C. Albrecht Altdorfer and the Origins of Landscape. Chicago: University of Chicago Press, 1993. Zerner, H. Renaissance Art in France: The Invention of
- *Classicism*. Paris: Flammarion; London: Thames & Hudson, 2003.

CHAPTER 19. THE BAROQUE IN ITALY AND SPAIN

Avery, C. Bernini: Genius of the Baroque. London: Thames & Hudson, 1997.

- Bissell, R. W. Masters of Italian Baroque Painting: The Detroit Institute of Arts. Detroit, MI: Detroit Institute of Arts in association with D. Giles Ltd., London, 2005.
- Brown, B. L., ed. *The Genius of Rome, 1592–1623*. Exh. cat. London: Royal Academy of Arts; New York: Dist. in the United States and Canada by Harry N. Abrams, 2001.
- Brown, J. Francisco de Zurbaran. New York: Harry N. Abrams, 1991.
- *Painting in Spain, 1500–1700.* Pelican History of Art. New Haven: Yale University Press, 1998.
- Dempsey, C. Annibale Carracci and the Beginnings of Baroque Style. 2d ed. Fiesole, Italy: Cadmo, 2000.
- Enggass, R., and J. Brown. *Italy and Spain, 1600–1750: Sources and Documents.* Reprint of 1970 ed. Evanston, IL: Northwestern University Press, 1992.
- Evanston, IL: Northwestern University Press, 1992 Freedberg, S. Circa 1600: A Revolution of Style in Italian Painting. Cambridge, MA: Harvard University Press, 1983.
- Garrard, M. D. Artemisia Gentileschi: The Image of the Female Hero in Italian Baroque Art. Princeton, NJ: Princeton University Press, 1989.
- Marder, T. A. *Bernini and the Art of Architecture*. New York: Abbeville Press, 1998.
- Montagu, J. Roman Baroque Sculpture: The Industry of Art. New Haven: Yale University Press, 1989.
- Nicolson, B. Caravaggism in Europe. Ed. L. Vertova. 3 vols. 2d ed., rev. and enl. Turin, Italy: Allemandi, 1989.
- Schroth, S., R. Baer, et al. El Greco to Velázquez: Art During the Reign of Philip III. Exh. cat. Boston: Museum of Fine Arts; MFA Publications, 2008.
- Smith, G. Architectural Diplomacy: Rome and Paris in the Late Baroque. Cambridge, MA: MIT Press, 1993.
- Spear, R. E. From Caravaggio to Artemisia: Essays on Painting in Seventeenth-Century Italy and France. London: Pindar Press, 2002.
- Spike, J. T. Caravaggio. Includes CD-ROM of all the known paintings of Caravaggio, including attributed and lost works. New York: Abbeville Press, © 2001.
- Varriano, J. Italian Baroque and Rococo Architecture. New York: Oxford University Press, 1986. Wittkower, R. Art and Architecture in Italy, 1600–1750.
- 4th ed. Pelican History of Art. New Haven: Yale University Press, 2000. ———. Bernini: The Sculptor of the Roman Baroque.
- 4th ed. London: Phaidon Press, 1997.

CHAPTER 20. THE BAROQUE IN FLANDERS AND HOLLAND

- Alpers, S. The Art of Describing: Dutch Art in the Seventeenth Century. Chicago: University of Chicago Press, 1983.
- ——. The Making of Rubens. New Haven: Yale University Press, 1995.
- Chapman, H. P. Rembrandt's Self-Portraits: A Study in Seventeenth-Century Identity. Princeton, NJ: Princeton University Press, 1990.
- Fleischer, R., ed. *Rembrandt, Rubens, and the Art of Their Time: Recent Perspectives.* University Park: Pennsylvania State University, 1997.

- Franits, W. E. Dutch Seventeenth-Century Genre Painting: Its Stylistic and Thematic Evolution. New Haven: Yale University Press, 2004.
- Grijzenhout, F., ed. The Golden Age of Dutch Painting in Historical Perspective. New York: Cambridge University Press, 1999.
- Kiers, J. and E. Runia, eds. The Glory of the Golden Age: Dutch Art of the 17th Century. 2 vols. Exh. cat. Rijksmuseum, Amsterdam: Waanders: 2000.
- Logan, A. S. Peter Paul Rubens: The Drawings. Exh. cat. New York: Metropolitan Museum of Art; New Haven: Yale University Press, 2004.
- Salvesen, S., ed. Rembrandt: The Master and His Workshop. 2 vols. Exh. cat. New Haven: Yale University Press, 1991.
- Schama, S. The Embarrassment of Riches: An Interpretation of Dutch Culture in the Golden Age. New York: Alfred A. Knopf, 1987.
- Schwartz, G. Rembrandt: His Life, His Paintings. New York: Viking, 1985.
- Slive, S. Dutch Painting, 1600-1800. Pelican History of Art. New Haven: Yale University Press, 1995. Frans Hals. Exh. cat. Munich: Prestel-Verlag, 1989.
- -. Jacob van Ruisdael: Master of Landscape. London: Royal Academy of Arts, 2005.
- Sluijter, E. J. Rembrandt and the Female Nude. Amsterdam University Press, 2006.

Sutton, P. The Age of Rubens. Exh. cat. Boston: Museum of Fine Arts, 1993.

- Vlieghe, H. Flemish Art and Architecture, 1585-1700. Pelican History of Art. New Haven: Yale University Press, © 1998.
- Westermann, M. Art and Home: Dutch Interiors in the Age of Rembrandt. Exh. cat. Zwolle: Waanders, 2001. Rembrandt. Art & Ideas. London: Phaidon Press, 2000.
- -. A Worldly Art: The Dutch Republic 1585–1718. Perspectives. New York: Harry N. Abrams, 1996.
- Wheelock, A. K., ed. Johannes Vermeer. Exh. cat. New Haven: Yale University Press, 1995.
- ., et al. Anthony van Dyck. Exh. cat. New York: Harry N. Abrams, 1990.
- White, C. Peter Paul Rubens. New Haven: Yale University Press, 1987.

CHAPTER 21. THE BAROQUE IN FRANCE AND ENGLAND

- Blunt, A. Art and Architecture in France, 1500-1700. 5th ed. Pelican History of Art. New Haven: Yale University Press, 1999.
- Brusatin, M., et al. The Baroque in Central Europe: Places, Architecture, and Art. Venice: Marsilio, 1992.
- Donovan, F. Rubens and England. New Haven: Published for The Paul Mellon Centre for Studies in
- British Art by Yale University Press, 2004. Downes, K. The Architecture of Wren. Rev. ed. Reading,
- England: Redhedge, 1988. Garreau, M. Charles Le Brun: First Painter to King Louis XIV. New York: Harry N. Abrams, 1992.
- Kitson, M. Studies on Claude and Poussin. London: Pindar, 2000.
- Lagerlöf, M. R. Ideal Landscape: Annibale Carracci, Nicolas Poussin, and Claude Lorrain. New Haven: Yale University Press, 1990.
- Mérot, A. French Painting in the Seventeenth Century. New Haven: Yale University Press, 1995.
- Nicolas Poussin. New York: Abbeville Press, 1990. Porter, R. London: A Social History. Cambridge, MA:
- Harvard University Press, 1995. Rosenberg, P., and K. Christiansen, eds. Poussin and
- Nature: Arcadian Visions. Exh. cat. New York: Metropolitan Museum of Art; New Haven: Yale University Press, 2008.
- Summerson, J. Architecture in Britain, 1530-1830. Rev. 9th ed. Pelican History of Art. New Haven: Yale University Press, 1993.
- Tinniswood, A. His Invention So Fertile: A Life of Christopher Wren. New York: Oxford University Press, 2001.
- Verdi, R. Nicolas Poussin 1594-1665. London: Zwemmer in association with the Royal Academy of Arts, 1995.
- Vlnas, V., ed. The Glory of the Baroque in Bohemia: Essays on Art, Culture and Society in the 17th and 18th Centuries. Prague: National Gallery, 2001.

- Waterhouse, E. K. The Dictionary of Sixteenth and Seventeenth Century British Painters. Woodbridge, Suffolk, England: Antique Collectors' Club, 1988. Painting in Britain, 1530-1790. 5th ed. Pelican History of Art. New Haven: Yale University Press, 1993.
- Whinney, M. D. Wren. World of Art. New York: Thames & Hudson, 1998.

CHAPTER 22. THE ROCOCO

- Bailey, C. B. The Age of Watteau, Chardin, and Fragonard: Masterpieces of French Genre Painting. New Haven: Yale University Press in association with the National Gallery of Canada, 2003.
- Brunel, G. Boucher. New York: Vendome, 1986. . Painting in Eighteenth-Century France. Ithaca, NY: Cornell University Press, 1981.
- Cuzin, J. P. Jean-Honoré Fragonard: Life and Work: Complete Catalogue of the Oil Paintings. New York: Harry N. Abrams, 1988.
- François Boucher, 1703–1770. Exh. cat. New York: Metropolitan Museum of Art, © 1986.
- Gaunt, W. The Great Century of British Painting: Hogarth to Turner. 2d ed. London: Phaidon Press, 1978.
- Kalnein, W. von. Architecture in France in the Eighteenth Century. Pelican History of Art. New Haven: Yale University Press, 1995.
- Levey, M. Giambattista Tiepolo: His Life and Art. New Haven: Yale University Press, 1986.
- -. Painting and Sculpture in France, 1700–1789. New ed. Pelican History of Art. New Haven: Yale University Press, 1993.
- Painting in Eighteenth-Century Venice. 3d ed. Pelican History of Art. New Haven: Yale University Press, 1993.
- -. Rococo to Revolution: Major Trends in Eighteenth-Century Painting. Reprint of 1966 ed. The World of Art. New York: Thames & Hudson, 1985.
- Links, J. G. Canaletto. Completely rev., updated, and enl. ed. London: Phaidon Press, 1994. Paulson, R. *Hogarth.* 3 vols. New Brunswick: Rutgers
- University Press, 1991–1993.
- Pointon, M. Hanging the Head: Portraiture and Social Formation in Eighteenth-Century England. New Haven: Yale University Press, 1993.
- Posner, D. Antoine Watteau. Ithaca, NY: Cornell University Press, 1984.
- Rococo to Romanticism: Art and Architecture, 1700-1850. Garland Library of the History of Art. New York: Garland, 1976.
- Rosenberg, P. Chardin. Exh. cat. London: Royal Academy of Art; New York: Metropolitan Museum of Art, 2000.
- . From Drawing to Painting: Poussin, Watteau, Fragonard, David & Ingres. Princeton, NJ: Princeton University Press, 2000.
- Scott, K. The Rococo Interior: Decoration and Social Spaces in Early Eighteenth-Century Paris. New Haven: Yale University Press, 1995.

Sheriff, M. D. The Exceptional Woman: Elisabeth Vigée-Lebrun and the Cultural Politics of Art. Chicago: University of Chicago Press, 1996.

Wintermute, A. Watteau and His World: French Drawing from 1700 to 1750. Exh. cat. London: Merrell Holberton; New York: American Federation of Arts, 1999.

PART FOUR: THE MODERN WORLD

GENERAL REFERENCES

- Arnason, H. H. History of Modern Art: Painting, Sculpture, Architecture, Photography. 5th ed. Upper Saddle River, NJ: Pearson Prentice Hall, 2004.
- Atkins, R. Artspoke: A Guide to Modern Ideas, Movements, and Buzzwords, 1848-1944. New York: Abbeville Press, 1993.
- Baigell, M. A Concise History of American Painting and Sculpture. Rev. ed. New York: Icon Editions, 1996.
- Banham, R. Theory and Design in the First Machine Age. 2d ed. Cambridge, MA: MIT Press, 1980, © 1960.
- Bearden, R., and H. Henderson. A History of African-American Artists from 1792 to the Present. New York: Pantheon, 1993.

- Bergdoll, B. European Architecture 1750-1890. Oxford History of Art. New York: Oxford University Press, 2000.
- Bjelajac, D. American Art: A Cultural History. Upper Saddle River, NJ: Pearson Prentice Hall, 2005.
- Boime, A. A Social History of Modern Art. Vol. 1, Art in the Age of Revolution, 1750–1800. Vol. 2, Art in the Age of Bonapartism, 1800–1815. Vol. 3, Art in the Age of Counterrevolution, 1815-1848. Chicago: University of Chicago Press, 1987-2004.
- Bown, M. C. A Dictionary of Twentieth Century Russian and Soviet Painters 1900-1980s. London: Izomar, 1998.
- Campany, D., ed. Art and Photography. Themes and Movements. London: Phaidon Press, 2003.
- Castelman, R. Prints of the Twentieth Century: A History. Rev. ed. London: Thames & Hudson, 1988. Chiarmonte, P. Women Artists in the United States: A
- Selective Bibliography and Resource Guide to the Fine and Decorative Arts, 1750-1986. Boston: G. K. Hall, 1990.
- Chilvers, I. A Dictionary of Twentieth-Century Art. New York: Oxford University Press, 1998.
- Chipp, H., ed. Theories of Modern Art: A Source Book by Artists and Critics. Berkeley: University of California Press, 1968.
- Colquhoun, A. Modern Architecture. New York: Oxford University Press, 2002.
- Crary, J. Techniques of the Observer: On Vision and Modernity in the Nineteenth Century. Cambridge, MA: MIT Press, 1990.
- Craven, W. American Art: History and Culture. New York: Harry N. Abrams, 1994.
- Crook, J. The Dilemma of Style: Architectural Ideas from the Picturesque to the Post Modern. Chicago: University of Chicago Press, 1987.
- Crow, T. Modern Art in the Common Culture, New Haven: Yale University Press, 1996.
- Cummings, P. Dictionary of Contemporary American Artists. New York: St. Martin's Press, 1988.
- Documents of Modern Art. 14 vols. New York: Wittenborn, 1944–1961. Anthologies of primary source material. Selected titles listed individually, below.
- The Documents of Twentieth-Century Art. Boston: G. K. Hall, Anthologies of primary source material. Selected titles listed individually, below.
- Doss, E. Twentieth-Century American Art. Oxford History of Art. New York: Oxford University Press, 2002.
- Drucker, J. The Century of Artists' Books. New York: Granary Books, 2004.
- Eisenman, S. Nineteenth Century Art: A Critical History. New York: Thames & Hudson, 2002.
- Eitner, L. An Outline of Nineteenth-Century European Painting: From David Through Cézanne. 2 vols. New York: Harper & Row, 1986.
- Elderfield, J., ed. Modern Painting and Sculpture: 1880 to the Present at the Museum of Modern Art. New York: Museum of Modern Art; Dist. by D.A.P./Distributed Art Publishers, 2004.
- Evans, M. M., ed. Contemporary Photographers. 3d ed. New York: St. James Press, 1995.
- Farrington, L. E. Creating Their Own Image: The History of African-American Women Artists. New York: Oxford University Press, 2005.
- Frampton, K. Modern Architecture: A Critical History. 3d ed. New York: Thames & Hudson, 1992.
- Frascina, F. and J. Harris, eds. Art in Modern Culture: An Anthology of Critical Texts. New York: Harper & Row, 1992.
- Gaiger, J., ed. Art of the Twentieth Century: A Reader. New Haven: Yale University Press in association with the Open University, 2003.
- . Frameworks for Modern Art. New Haven: Yale University Press in association with the Open University, 2003.
- Goldberg, R. Performance Art: From Futurism to the Present. Rev. and exp. ed. The World of Art. New York: Thames & Hudson, 2001.
- Goldwater, R. Primitivism in Modern Art. Enl. ed. Cambridge: Harvard University Press, 1986.
- Gray, J. Action Art: A Bibliography of Artists' Performance from Futurism to Fluxus and Beyond. Westport, CT: Greenwood Press, 1993.
- Harrison, C., and P. Wood, eds. Art in Theory, 1815–1900: An Anthology of Changing Ideas. Malden, MA: Blackwell, 1998.

- Heller, N. Women Artists: An Illustrated History. New York: Abbeville Press, 2003.
- Hertz, R., ed. Theories of Contemporary Art. 2d ed.
 Englewood Cliffs, NJ: Prentice Hall, 1993.
 —, and N. Klein, eds. Twentieth-Century Art Theory: Urbanism, Politics, and Mass Culture.
 Englewood Cliffs, NJ: Prentice Hall, 1990.
- Hitchcock, H. R. Architecture: Nineteenth and Twentieth Centuries. 4th rev. ed. Pelican History of Art. New Haven: Yale University Press, 1987, © 1977.
- Hughes, R. American Visions: The Epic History of Art in America. New York: Alfred A. Knopf, 1997.
- Hunter, S., and J. Jacobus. *Modern Art: Painting, Sculpture, Architecture.* 3d rev. ed. New York: Harry N. Abrams, 2000.
- Igoe, L. 250 Years of Afro-American Art: An Annotated Bibliography. New York: Bowker, 1981.
- Joachimides, C., et al. American Art in the Twentieth Century: Painting and Sculpture, 1913–1933. Exh. cat. Munich: Prestel, 1993.
- Johnson, W. Nineteenth-Century Photography: An Annotated Bibliography, 1839–1879. Boston: G. K. Hall, 1990.
- Kostelanetz, R. A Dictionary of the Avant-Gardes. New York: Routledge, 2001.
- Lewis, S. African American Art and Artists. Berkeley: University of California Press, 1990.
- Marien, M. *Photography: A Cultural History*. Upper Saddle River, NJ: Pearson Prentice Hall, 2002.
- McCoubrey, J. American Art, 1700–1960: Sources and Documents. Englewood Cliffs, NJ: Prentice Hall, 1965.
- Meikle, J. L. *Design in the USA*. Oxford History of Art. New York: Oxford University Press, 2005. *Modern Arts Criticism.* 4 vols. Detroit, MI: Gale
- Research, 1991–1994. Newhall, B. *The History of Photography from 1830 to the Present.* Rev. and enl. 5th ed. New York: Museum
- of Modern Art; Dist. by Bulfinch Press/Little, Brown, 1999. Nochlin, L. *The Politics of Vision: Essays on Nineteenth*-
- *Century Art and Society*. New York: Harper & Row, 1989.
- Osborne, H., ed. Oxford Companion to Twentieth-Century Art. Reprint. New York: Oxford University Press, 1990.
- Patton, S. F. African-American Art. Oxford History of Art. New York: Oxford University Press, 1998.
- Pevsner, N. Pioneers of Modern Design: From William Morris to Walter Gropius. 4th ed. New Haven: Yale University Press, 2005.
- Piland, S. Women Artists: An Historical, Contemporary, and Feminist Bibliography. Metuchen, NJ: Scarecrow Press, 1994.
- Powell, R. J. Black Art and Culture in the 20th Century. New York: Thames & Hudson, 1997.
- Robinson, Hilary. Feminism-Art-Theory: An Anthology, 1968–2000. Oxford and Malden, MA: Blackwell, 2001.
- Rose, B. American Art Since 1900. Rev. ed. New York: Praeger, 1975.
- Rosenblum, N. A World History of Photography. 3rd ed. New York: Abbeville Press, 1997.
- Rosenblum, R., and H. W. Janson. *19th Century Art*. Rev. and updated ed. Upper Saddle River, NJ: Pearson Prentice Hall, 2005.
- Schapiro, M. Modern Art: Nineteenth and Twentieth Centuries. New York: Braziller, 1982.
- Scharf, A. Art and Photography. Reprint. Harmondsworth, England: Penguin, 1995. Sennott, S., ed. Encyclopedia of 20th Century
- Architecture. 3 vols. New York: Fitzroy Dearborn, 2004.
- Stiles, K., and P. Selz. Theories and Documents of Contemporary Art. Berkeley: University of California Press, 1996.
- Tafuri, M. *Modern Architecture*. 2 vols. New York: Rizzoli, 1986.

BOOKS FOR FURTHER READING

1124

Taylor, J. *The Fine Arts in America*. Chicago: University of Chicago Press, 1979.

- Tomlinson, J. Readings in Nineteenth-Century Art. Upper Saddle River, NJ: Prentice Hall, 1995.
- Upton, D. Architecture in the United States. New York: Oxford University Press, 1998.
- Varnedoe, K., and A. Gopnik, eds. Modern Art and Popular Culture: Readings in High and Low. New York: Harry N. Abrams, 1990.
- Waldman, D. Collage, Assemblage, and the Found Object. New York: Harry N. Abrams, 1992.
- Weaver, M. The Art of Photography, 1839–1989. Exh. cat. New Haven: Yale University Press, 1989.
- Wilmerding, J. American Views: Essays on American Art. Princeton, NJ: Princeton University Press, 1991.Witzling, M., ed. Voicing Our Visions: Writings by
- CHAPTER 23. ART IN THE AGE OF THE ENLIGHTENMENT, 1750-1789

Women Artists. New York: Universe, 1991.

- Bryson, N. Tradition and Desire: From David to Delacroix. Cambridge: Cambridge University Press, 1984.
- . Word and Image: French Painting in the Ancient Régime. Cambridge: Cambridge University Press, 1981.
- Crow, T. Painters and Public Life in Eighteenth-Century Paris. New Haven: Yale University Press, 1985.
- Eitner, L. E. A. Neoclassicism and Romanticism, 1750–1850: Sources and Documents. Reprint of 1970 ed. New York: Harper & Row, 1989.
- Fried, M. Absorption and Theatricality: Painting and Beholder in the Age of Diderot. Chicago: University of Chicago Press, 1980.
- Friedlaender, W. *David to Delacroix*. Reprint of 1952 ed. New York: Schocken Books, 1968.
- Goncourt, E. de, and J. de Goncourt. French Eighteenth-Century Painters. Reprint of 1948 ed. Ithaca, NY: Cornell University Press, 1981.
- Honour, H. *Neoclassicism*. Reprint of 1968 ed. London: Penguin, 1991.
- Irwin, D. G. *Neoclassicism*. Art & Ideas. London: Phaidon Press, 1997.
- Licht, F. Canova. New York: Abbeville Press, 1983. Miles, E. G., ed. The Portrait in Eighteenth-Century
- America. Newark: University of Delaware Press, 1993. Ottani Cavina, A. Geometries of Silence: Three
- Approaches to Neoclassical Art. New York: Columbia University Press, 2004.
- Picon, A. French Architects and Engineers in the Age of Enlightenment. New York: Cambridge University Press, 1992.
- Rebora, C., et al. *John Singleton Copley in America*. Exh. cat. New York: The Metropolitan Museum of Art, 1995.
- Rosenblum, R. *Transformations in Late Eighteenth Century Art.* Princeton, NJ: Princeton University Press, 1967.
- Rosenthal, M., ed. Prospects for the Nation: Recent Essays in British Landscape, 1750–1880. Studies in British Art. New Haven: Yale University Press, © 1997.
- Saisselin, R. G. *The Enlightenment Against the Baroque: Economics and Aesthetics in the Eighteenth Century.* Berkeley: University of California Press, 1992.
- Solkin, D. Painting for Money: The Visual Arts and the Public Sphere in Eighteenth-Century England. New Haven: Yale University Press, 1993.
- Vidler, A. The Writing of the Walls: Architectural Theory in the Late Enlightenment. Princeton, NJ: Princeton Architectural Press, 1987.
- Watkin, D., and T. Mellinghoff. German Architecture and the Classical Ideal. Cambridge: MIT Press, 1987.

CHAPTER 24. ART IN THE AGE OF ROMANTICISM, 1789-1848

- Boime, A. *The Academy and French Painting in the Nineteenth Century*. New ed. New Haven: Yale University Press, 1986.
- Brown, D. B. *Romanticism*. Art & Ideas. New York: Phaidon Press, 2001.
- Chu, P. Nineteenth-Century European Art. Upper Saddle River, NJ: Pearson Prentice Hall, 2002.

- Eitner, L. E. A. *Géricault: His Life and Work*. Ithaca, NY: Cornell University Press, 1982.
- Hartley, K. The Romantic Spirit in German Art, 1790–1990. Exh. cat. London: South Bank Centre, © 1994.
- Herrmann, L. Nineteenth Century British Painting. London: Giles de la Mare, 2000.
- Honour, H. *Romanticism*. New York: Harper & Row, 1979.
- Johnson, E. The Paintings of Eugène Delacroix: A Critical Catalogue, 1816–1863. 6 vols. Oxford: Clarendon Press, 1981–1989.
- ——. The Paintings of Eugène Delacroix: A Critical Catalogue. 4th supp. and reprint of 3d supp. New York: Oxford University Press, 2002.
- Joll, E. The Oxford Companion to J. M. W. Turner. Oxford: Oxford University Press, 2001.
- Koerner, J. Caspar David Friedrich and the Subject of Landscape. New Haven: Yale University Press, 1990.
- Licht, F. Goya: The Origins of the Modern Temper in Art. New York: Harper & Row, 1983.
- Middleton, R. Architecture of the Nineteenth Century. Milan: Electa, © 2003.
- Noon, P. J. Crossing the Channel: British and French Painting in the Age of Romanticism. Exh. cat. London: Tate, 2003.
- Novak, B. Nature and Culture: American Landscape and Painting, 1825–1875. Rev. ed. New York: Oxford University Press, 1995.
- Novotny, F. Painting and Sculpture in Europe, 1780–1880. 3d ed. Pelican History of Art. New Haven: Yale University Press, 1992.
- Pérez Sánchez, A., and E. A. Sayre. Goya and the Spirit of Enlightenment. Exh. cat. Boston: Bulfinch Press, 1989.
- Rosenblum, R. Jean-Auguste-Dominique Ingres. New York: Harry N. Abrams, 1990.
- Tomlinson, J. *Goya in the Twilight of Enlightenment*. New Haven: Yale University Press, 1992.

Vaughn, W. *Romanticism and Art*. World of Art. London: Thames & Hudson, © 1994.

CHAPTER 25. THE AGE OF POSITIVISM: REALISM, IMPRESSIONISM, AND THE PRE-RAPHAELITES, 1848-1885

- Adriani, G. *Renoir*. Cologne: Dumont; Dist. by Yale University Press, 1999.
- Broude, N. *İmpressionism: A Feminist Reading*. New York: Rizzoli, 1991.
- Cachin, F., et al. *Cézanne*. Exh. cat. New York: Harry N. Abrams, 1995.
- Cikovsky, N., and F. Kelly. *Winslow Homer*. Exh. cat. New Haven: Yale University Press, 1995.
- Clark, T. J. The Absolute Bourgeois: Artists and Politics in France, 1848–1851. Berkeley: University of California Press, 1999, © 1973.
- Denvir, B. The Chronicle of Impressionism: A Timeline History of Impressionist Art. London: Thames & Hudson, 2000, © 1993.
- Elsen, A. Origins of Modern Sculpture. New York: Braziller, 1974.
- Fried, M. Courbet's Realism. Chicago: University of Chicago Press, 1990.
- Goodrich, L. *Thomas Eakins*. 2 vols. Exh. cat. Cambridge, MA: Harvard University Press, 1982.
- Gray, C. The Russian Experiment in Art, 1863–1922. Rev. ed. The World of Art. New York: Thames & Hudson, 1986.
- Hamilton, G. H. *Manet and His Critics*. Reprint of 1954 ed. New Haven, CT: Yale University Press, 1986.
- Hares-Stryker, C., ed. An Anthology of Pre-Raphaelite Writings. New York: New York University Press, 1997.
- Herbert, R. Impressionism: Art, Leisure, and Parisian Society. New Haven: Yale University Press, 1988.

Yale University Press, 2004.

Higonnet, A. *Berthe Morisot*. New York: Harper & Row, 1990. House, J. *Impressionism: Paint and Politics*. New Haven: *——. Monet: Nature into Art.* New Haven: Yale University Press, 1986.

- Jenkyns, R. Dignity and Decadence: Victorian Art and the Classical Inheritance. Cambridge, MA: Harvard University Press, 1991.
- Kendall, R., and G. Pollock, eds. Dealing with Degas: Representations of Women and the Politics of Vision. New York: Universe, 1992.
- Krell, A. Manet and the Painters of Contemporary Life The World of Art. New York: Thames & Hudson, 1996.
- Lipton, E. Looking into Degas. Berkeley: University of California Press, 1986.
- Mainardi, P. Art and Politics of the Second Empire: The Universal Expositions of 1855 and 1867. New Haven: Yale University Press, 1987.
- Miller, D., ed. American Iconology: New Approaches to Nineteenth-Century Art and Literature. New Haven: Yale University Press, 1993.
- Needham, G. Nineteenth-Century Realist Art. New York: Harper & Row, 1988.
- Nochlin, L., ed. Impressionism and Post-Impressionism, 1874–1904: Sources and Documents. Englewood Cliffs, NJ: Prentice Hall, 1976.
- Novak, B. American Painting of the Nineteenth Century: Realism and the American Experience. 2d ed. New York: Harper & Row, 1979.
- Pollock, G. Mary Cassatt: Painter of Modern Women. New York: Thames & Hudson, 1998.
- Prettejohn, E. *The Art of the Pre-Raphaelites*. Princeton, NJ: Princeton University Press, 2000.
- Reff, T. Manet and Modern Paris. Exh. cat. Washington, DC: National Gallery of Art, 1982.
- Rewald, J. Studies in Impressionism. New York: Harry N. Abrams, 1986, © 1985.
- Rubin, J. H. *Impressionism*. Art & Ideas. London: Phaidon Press, 1999.
- Spate, V. Claude Monet: Life and Work. New York: Rizzoli, 1992.
- Tucker, P. H. Claude Monet: Life and Art. New Haven: Yale University Press, 1995.
- -------. Monet in the '90s: The Series Paintings. Exh. cat. New Haven: Yale University Press, 1989.
- Walther, I., ed. Impressionist Art, 1860–1920. 2 vols. Cologne: Taschen, 1996.
- Weisberg, G. Beyond Impressionism: The Naturalist Impulse. New York: Harry N. Abrams, 1992.
- Werner, M. Pre-Raphaelite Painting and Nineteenth-Century Realism. New York: Cambridge University Press, 2005.

CHAPTER 26. PROGRESS AND ITS DISCONTENTS: POST-IMPRESSIONISM, SYMBOLISM, AND ART NOUVEAU, 1880-1905

- Brettell, R., et al. *The Art of Paul Gauguin*. Exh. cat. Boston: Little, Brown, 1988.
- Broude, N. Georges Seurat. New York: Rizzoli, 1992.
- Denvir, B. Post-Impressionism. The World of Art. New York: Thames & Hudson, 1992.
- Dorra, H., ed. Symbolist Art Theories: A Critical Anthology. Berkeley: University of California Press, 1994.
- Gibson, M. *The Symbolists*. New York: Harry N. Abrams, 1988.
- Hamilton, G. H. Painting and Sculpture in Europe, 1880–1940. 6th ed. Pelican History of Art. New Haven: Yale University Press, 1993.
- Herbert, R. L. *Georges Seurat*, *1859–1891*. New York: Metropolitan Museum of Art; Dist. by Harry N. Abrams, 1991.

- Hulsker, J. The New Complete Van Gogh: Paintings, Drawings, Sketches: Revised and Enlarged Edition of the Catalogue Raisonné of the Works of Vincent van Gogh. Amsterdam: J. M. Meulenhoff, 1996.
- Mosby, D. Henry Ossawa Tanner. Exh. cat. New York: Rizzoli, 1991.
- Schapiro, M. Paul Cézanne. New York: Harry N. Abrams, 1988.
- Shiff, R. Cézanne and the End of Impressionism: A Study of the Theory, Technique, and Critical Evaluation of Modern Art. Chicago: University of Chicago Press, 1984.
- Silverman, D. Art Nouveau in Fin-de-Siècle France. Berkeley: University of California Press, 1989.
- Théberge, P. Lost Paradise, Symbolist Europe. Exh. cat. Montreal: Montreal Museum of Fine Arts, 1995. Troy, N. J. Modernism and the Decorative Arts in
- France: Art Nouveau to Le Corbusier. New Haven: Yale University Press, 1991.
- Varnedoe, K. Vienna 1900: Art, Architecture, and Design. Exh. cat. New York: Museum of Modern Art, 1986.

CHAPTER 27. TOWARD ABSTRACTION: THE MODERNIST REVOLUTION, 1904-1914

- Bach, F., T. Bach, and A. Temkin. Constantin Brancusi.
 Exh. cat. Cambridge: MIT Press, 1995.
 Behr, S. Expressionism. Movements in Modern Art.
- Cambridge: Cambridge University Press, 1999. Bowlt, J. E., ed. *Russian Art of the Avant-Garde:*
- Theory and Criticism, 1902–1934. New York: Thames & Hudson, 1988.
- Brown, M. *The Story of the Armory Show*. 2d ed. New York: Abbeville Press, 1988.
- Duchamp, M. *Marcel Duchamp*, *Notes*. The Documents of Twentieth-Century Art. Boston: G. K. Hall, 1983.
- Edwards, S. Art of the Avant-Gardes. New Haven: Yale University Press in association with the Open
- University, 2004.
- Elderfield, J. *Henri Matisse: A Retrospective.* Exh. cat. New York: Museum of Modern Art; Dist. by Harry N. Abrams, 1992.
- Golding, J. Cubism: A History and an Analysis, 1907–1914. 3d ed. Cambridge, MA: Harvard University Press, 1988.
- Goldwater, R. *Primitivism in Modern Art*. Enl. ed. Cambridge, MA: Belknap Press, 1986.
- Gordon, D. *Expressionism: Art and Idea*. New Haven: Yale University Press, 1987.
- Green, C. Cubism and Its Enemies. New Haven: Yale University Press, 1987.
- Herbert, J. Fauve Painting: The Making of Cultural
- Politics. New Haven: Yale University Press, 1992. Hoffman, K., ed. Collage: Critical Views. Ann Arbor,
- MI: UMI Research Press, 1989. Kallir, J. Egon Schiele: The Complete Works. Exp. ed.
- New York: Harry N. Abrams, 1998. Krauss, R. The Originality of the Avant-Garde and Other Modernist Myths. Cambridge: MIT Press, 1986.
- Kuspit, D. The Cult of the Avant-Garde Artist. New York: Cambridge University Press, 1993.
- Rosenblum, R. Cubism and Twentieth-Century Art. New York: Harry N. Abrams, 2001.
- Rubin, W. S. Picasso and Braque: Pioneering Cubism. Exh. cat. New York: Museum of Modern Art, 1989. Taylor, B. Collage: The Making of Modern Art. London:
- Thames & Hudson, 2004.
- Washton, R.-C., ed. German Expressionism: Documents from the End of the Wilhelmine Empire to the Rise of National Socialism. The Documents of Twentieth-Century Art. Boston: G. K. Hall, 1993.
- Weiss, J. The Popular Culture of Modern Art: Picasso, Duchamp and Avant Gardism. New Haven: Yale University Press, 1994.

CHAPTER 28. ART BETWEEN THE WARS, 1914-1940

- Ades, D. *Photomontage*. Rev. and enl. ed. London: Thames & Hudson, 1986.
- Arbaïzar, P. Henri Cartier-Bresson: The Man, the Image and the World: A Retrospective. New York: Thames & Hudson, 2003.

- Bayer, H., et al., eds. *Baubaus*, 1919–1928. Reprint of 1938 ed. Boston: New York Graphic Society, 1986.
- Blaser, W. *Mies van der Rohe*. 6th exp. and rev. ed. Boston: Birkhauser Verlag, 1997.
- Campbell, M., et al. *Harlem Renaissance: Art of Black America*. New York: Harry N. Abrams, 1987.
- Chadwick, W., ed. Mirror Images: Women, Surrealism, and Self-Representation. Cambridge, MA: MIT Press, 1998.
- Corn, W. The Great American Thing: Modern Art and National Identity, 1915–1935. Berkeley: University of California Press, 2001.
- Curtis, W. *Modern Architecture Since 1900.* 3rd ed. New York: Phaidon Press, 1996.
- Durozoi, G. *History of the Surrealist Movement*. Chicago: University of Chicago Press, 2002.
- Fer, B., et al. Realism, Rationalism, Surrealism: Art Between the Wars. Modern Art—Practices and Debates. New Haven: Yale University Press, 1993.
- Fiedler, J., ed. *Photography at the Bauhaus*. Cambridge, MA: MIT Press, 1990.
- Foster, S. C., ed. Crisis and the Arts: The History of Dada. 10 vols. New York: G. K. Hall, 1996–2005.
- Gale, M. *Dada & Surrealism*. Art & Ideas. London: Phaidon Press, 1997.
- Gössel, P., and G. Leuthäuser. Architecture in the Twentieth Century. Cologne: Taschen, 1991.
- Greenough, S., and J. Hamilton. Alfred Stieglitz: Photographs and Writings. New York: Little, Brown, 1999.
- Haskell, B. The American Century: Art & Culture, 1900–1950. New York: W. W. Norton, 1999.
- Hight, E. M. Picturing Modernism: Moholy-Nagy and Photography in Weimar Germany. Cambridge, MA: MIT Press, 1995.
- Hitchcock, H. R., and P. Johnson. *The International Style*. With a new forward. New York: W. W. Norton, 1996.
- Hochman, E. S. Bauhaus: Crucible of Modernism.
- New York: Fromm International, © 1997. Hopkins, D. *Dada and Surrealism: A Very Short Introduction*. New York: Oxford University Press,

2004.

- Kandinsky, W. Kandinsky: Complete Writings on Art. Orig. pub. in The Documents of Twentieth-Century Art. New York: Da Capo Press, 1994.
- Krauss, R. L'Amour Fou: Photography and Surrealism. New York: Abbeville Press, 1985.
- Kultermann, U. Architecture in the Twentieth Century. New York: Van Nostrand Reinhold, 1993.
- Lane, B. Architecture and Politics in Germany, 1918–1945. New ed. Cambridge, MA: Harvard University Press, 1985.
- Le Corbusier. Towards a New Architecture. Oxford: Architectural Press, 1997, © 1989.
- Lodder, C. Russian Constructivism. New Haven: Yale University Press, 1983.
- McEuen, M. A. Seeing America: Women Photographers Between the Wars. Lexington, KY: University Press of Kentucky, 2000.
- Miró, J. Joan Miró: Selected Writings and Interviews. The Documents of Twentieth-Century Art. Boston: G. K. Hall, 1986.
- Mondrian, P. The New Art, the New Life: The Complete Writings. Eds. and trans. H. Holtzmann and M. James. Orig. pub. in The Documents of Twentieth-Century Art. New York: Da Capo, 1993.
- Motherwell, R., ed. *The Dada Painters and Poets: An Anthology.* 2d ed. Cambridge, MA: Harvard University Press, 1989.
- Nadeau, M. *History of Surrealism*. Cambridge, MA: Harvard University Press, 1989.
- Phillips, C., ed. Photography in the Modern Era: European Documents and Critical Writings, 1913–1940. New York: Metropolitan Museum of Art; Aperture, 1989.

Roskill, M. Klee, Kandinsky, and the Thought of Their

Silver, K. E. Esprit de Corps: The Art of the Parisian

Spiteri, R., ed. Surrealism, Politics and Culture.

Illinois Press, 1992.

Ashgate, 2003.

University, 2004.

Time: A Critical Perspective. Urbana: University of

Avant-Garde and the First World War, 1914–1925.

Princeton, NJ: Princeton University Press, 1989.

Aldershot, Hants., England and Burlington, VT:

Wood, P., ed. Varieties of Modernism. New Haven: Yale

BOOKS FOR FURTHER READING

1125

University Press in association with the Open

Wright, F. L. Frank Lloyd Wright, Collected Writings. 5 vols. New York: Rizzoli, 1992-1995.

CHAPTER 29. POST-WORLD WAR II **TO POSTMODERN, 1945-1980**

- Archer, M. Art Since 1960. World of Art. New York: Thames & Hudson, 2002.
- Ashton, D. American Art Since 1945. New York: Oxford University Press, 1982.
- Atkins, R. Artspeak: A Guide to Contemporary Ideas, Movements, and Buzzwords, 1945 to the Present. New York: Abbeville Press, 1997.
- Baker, K. Minimalism: Art of Circumstance. New York: Abbeville Press, 1989.
- Battcock, G., comp. Idea Art: A Critical Anthology. New ed. New York: Dutton, 1973.
- , ed. Minimal Art: A Critical Anthology Berkeley: University of California Press, 1995. , and R. Nickas, eds. The Art of Performance: A Critical Anthology. New York: Dutton, 1984.
- Beardsley, J. Earthworks and Beyond: Contemporar Art in the Landscape. 3d ed. New York: Abbeville Press, 1998.
- ., and J. Livingston. Hispanic Art in the United States: Thirty Contemporary Painters and Sculptors. Exh. cat. New York: Abbeville Press, 1987
- Burgin, V., ed. Thinking Photography. Communications and Culture. Houndsmills, England: Macmillan Education, 1990.
- Carlson, M. A. Performance: A Critical Introduction. 2d ed. New York: Routledge, 2004.
- Causey, A. Sculpture Since 1945. Oxford History of Art. New York: Oxford University Press, 1998.
- Crane, D. The Transformation of the Avant-Garde: The New York Art World, 1940-1985. Chicago: University of Chicago Press, 1987.
- Crow, T. The Rise of the Sixties: American and European Art in the Era of Dissent. London: Laurence King, 2005, © 1996.
- Frascina, F. Pollock and After: The Critical Debate. 2d ed. New York: Routledge, 2001.
- Gilbaut, S. How New York Stole the Idea of Modern Art. Chicago: University of Chicago Press, 1983. ., ed. Reconstructing Modernism: Art in New York, Paris, and Montreal, 1945-1964. Cambridge:
- MIT Press, 1990. Greenberg, C. Clement Greenberg: The Collected Essays and Criticism. 4 vols. Chicago: University of Chicago
- Press, 1986-1993. Griswold del Castillo, R., ed. Chicano Art: Resistance and Affirmation, 1965-1985. Exh. cat. Los Angeles: Wight Art Gallery, University of California, 1991.
- Hopkins, D. After Modern Art: 1945-2000. New York: Oxford University Press, 2000.
- Joselit, D. American Art Since 1945. The World of Art. London: Thames & Hudson, 2003.
- Landau, E. G., ed. Reading Abstract Expressionism: Context and Critique. New Haven: Yale University Press, 2005.

- Leggio, J., and S. Weiley, eds. American Art of the 1960s. Studies in Modern Art, 1. New York: Museum of Modern Art, 1991.
- Leja, M. Reframing Abstract Expressionism: Subjectivity and Painting in the 1940s. New Haven: Yale University Press, 1993.
- Linder, M. Nothing Less Than Literal: Architecture After Minimalism. Cambridge, MA: MIT Press, 2004
- Lippard, L. R, ed. From the Center: Feminist Essays on Women's Art. New York: Dutton, 1976. Overlay: Contemporary Art and the Art of
- Prehistory. New York: Pantheon, 1983. Livingstone, M. Pop Art: A Continuing History. New
- York: Thames & Hudson, 2000. Lucie-Smith, E. Movements in Art Since 1945. The World of Art. New York: Thames & Hudson, 2001
- McCarthy, D. Pop Art. Movements in Modern Art. New York: Cambridge University Press, 2000
- McEvilley, T. Sculpture in the Age of Doubt. New York: School of Visual Arts; Allworth Press, 1999.
- Meisel, L. K. Photorealism at the Millennium. New York: Harry N. Abrams, 2002.
- Ockman, J., ed. Architecture Culture, 1943-1968: A Documentary Anthology. New York: Rizzoli, 1993. Orvell, M. American Photography. The World of Art.
- New York: Oxford University Press, 2003.

Pincus-Witten, R. Postminimalism into Maximalism: American Art, 1966–1986. Ann Arbor, MI: UMI Research Press, 1987.

- Polcari, S. Abstract Expressionism and the Modern Experience. New York: Cambridge University Press, 1991.
- Rosen, R., and C. Brawer, eds. Making Their Mark: Women Artists Move into the Mainstream, 1970-85. Exh. cat. New York: Abbeville Press, 1989.
- Ross, C. Abstract Expressionism: Creators and Critics: An Anthology. New York: Harry N. Abrams, 1990.
- Sandler, I. Art of the Postmodern Era: From the Late 1960s to the Early 1990s. New York: Icon Editions, 1996.
- The New York School: The Painters and Sculptors of the Fifties. New York: Harper & Row, 1978.
- . The Triumph of American Painting: A History of Abstract Expressionism. New York: Praeger, 1970.
- Sayre, H. The Object of Performance: The American Avant-Garde Since 1970. Chicago: University of
- Chicago Press, 1990. Seitz, W. Abstract Expressionist Painting in America. Cambridge, MA: Harvard University Press, 1983.
- Self-Taught Artists of the 20th Century: An American Anthology. Exh. cat. San Franciso: Chronicle Books, 1998.
- Sontag, S. *On Photography*. New York: Picador; Farrar, Straus & Giroux, 2001, © 1977.
- Weintraub, L. Art on the Edge and Over. Litchfield, CT: Art Insights; Dist. by D.A.P., 1997.
- Wood, P., et al. Modernism in Dispute: Art Since the Forties. New Haven: Yale University Press, 1993.

CHAPTER 30. THE POSTMODERN ERA: **ART SINCE 1980**

- Barthes, R. The Pleasure of the Text. Oxford: Blackwell, 1990.
- Belting, H. Art History After Modernism. Chicago: University of Chicago Press, 2003.
- Broude, N., and M. Garrad., eds. Reclaiming Female Agency: Feminist Art History After Postmodernism. Berkeley: University of California Press, 2005.
- Brunette, P., and D. Wills, eds. Deconstruction and the Visual Arts: Art, Media, Architecture. New York: Cambridge University Press, 1994.
- Capozzi, R., ed. Reading Eco: An Anthology Bloomington: Indiana University Press, © 1997
- Derrida, J. Writing and Difference. London: Routledge Classics, 2001.
- Eco, U. A Theory of Semiotics. Bloomington: Indiana University Press, 1976.
- Foster, H., ed. The Anti-Aesthetic: Essays on Postmodern Culture. New York: New Press; Dist. by W. W. Norton, 1998.
- Ghirardo, D. Architecture After Modernism. New York: Thames & Hudson, 1996.
- Harris, J. P. The New Art History: A Critical Introduction. New York: Routledge, 2001.
- Jencks, C. New Paradigm in Architecture: The Language of Post-Modernism. New Haven: Yale University Press, 2002.
- -., ed. The Post-Modern Reader. London: Academy Editions; New York: St. Martin's Press, 1992. -. What Is Post-Modernism? 4th rev. ed. London:
- Academy Editions, 1996.
- Lucie-Smith, E. Art Today. London: Phaidon Press, 1995
- Mitchell, W. J. T. The Reconfigured Eye: Visual Truth in the Post-Photographic Era. Cambridge, MA: MIT Press, 1992.
- Norris, C., and A. Benjamin. What Is Deconstruction? New York: St. Martin's Press, 1988.
- Papadakes, A., et al., eds. Deconstruction: The Omnibus Volume. New York: Rizzoli, 1989.
- Paul, C. Digital Art. New York: Thames & Hudson, © 2003.
- Pearman, H. Contemporary World Architecture.
- London: Phaidon Press, © 1998. Risatti, H., ed. *Postmodern Perspectives*. Englewood Cliffs, NJ: Prentice Hall, 1990.
- Senie, H. Contemporary Public Sculpture: Tradition, Transformation, and Controversy. New York: Oxford University Press, 1992.
- Steele, J. Architecture Today. New York: Phaidon Press, 2001.
- Thody, P. Introducing Barthes. New York: Totem Books; Lanham, MD: National Book Network, 1997.
- Tomkins, C. Post to Neo: The Art World of the 1980s. New York: Holt, 1988.
- Wallis, B., ed. Art After Modernism: Rethinking Representation. Documentary Sources in Contemporary Art, 1. Boston: Godine, 1984.

Index

A.E.G. Turbinenfabrik (Turbine Factory) (Behrens), Berlin, 977–978, 977 Abbatini, Guidobaldo, 687 Abbey in an Oak Forest (Friedrich), 831-832, 832 Abduction of the Sabine Women (Poussin), 742-743, 742, 743 Absolutism, 662 Abstract Expressionism, 1035, 1036-1037, 1037 action painting, 1038–1040, 1038–1039 Abstraction and Empathy (Worringer), 979 Abstraction-Création, 1001, 1002 Academies, art Academy of Copenhagen, 831 Academy of Fine Art, Antwerp, 913 Academy of St. Luke, France, 816 École des Beaux-Arts, 866 Pennsylvania Academy of the Fine Arts, 832. 879 Royal Academy of Art (England), 789, 791, 794, 802, 805, 826 Royal Academy of Art, Madrid, 823 Royal Academy of Painting and Sculpture (French Academy) 745-746, 761, 763, 806, 810, 815, 835, 866 Accademia del Disegno (Academy of Design), Florence, 601 Action paintings, 1039 ACT-UP (Aids Coalition to Unleash Power), 1098 Adam and Eve (Dürer), 639, 639 Adam and Eve, from the Ghent Altarpiece (Jan and Hubert van Eyck), 482, 482 Adam, Robert Kenwood House library, England, 797-798, 799 turret at Strawberry hill, Twickenham, 801.801 Adams, Ansel, 1023 Adinkra symbols, 1105-1106 Adoration of the Magi (Gentile da Fabriano), 525–527, 526 Advertisement: "Books!" (Rodchenko), 1005, 1005 Aedicula, 930 Aertson, Pieter, The Meat Stall, 654, 655 Aesthetic Movement, 884-887, 884, 886, 887 African American artists Bearden, Romare, 1065–1067, *1066* Edwards, Melvin, 1067, *1067* Hammons, David, 1096, 1096 Harlem Renaissance, 1024-1025, 1024 Piper, Adrien, 1096 Puryear, Martin, 1089–1090, *1090* Saar, Betye, 1067–1068, *1068* Simpson, Lorna, 1096 Tanner, Henry Ossawa, 924, 924 Walker, Kara, 1097, 1097 Weems, Carrie-Mae, 1096 Wilson, Fred, 1075, 1094-1095, 1095, 1096 African-American identity, 1096-1097, 1096-1097 Against Nature (À Rebours) (Huysmans), 918 AIDS-related art, 1096, 1098-1099, 1098-1099

Aisles, 439 Alba Madonna (Raphael), xix Albani, cardinal Alessandro, 788 Albers, Anni, 1008, 1045

Albers, Josef, 1008, 1045 Alberti, Leon Battista, 509, 543, 617 Santa Maria Novella church, Florence, 514-515, 515 on portraits, 542 Sant'Antrea church, Mantua, 546-547, 546, 547 Ten Books on Architecture, 514, 546 Treatise on Architecture, 511 Treatise on Painting, 514, 516, 527 Albumen print, 891 Albuquerque (Friedlander), xxv, xxv Alexander VI, pope, 565 Alexander VII, pope, 678, 696 Algardi, Alessandro, Meeting of Pope Leo I and Attila, 687-689, 689 Alice in Wonderland (Polke), 1052, 1053 Allegory in court portraiture, 599–600, 599 Allegory of Divine Providence (Cortona), Palazzo Barberini, Rome, 672-675, 673 Allegory of Good Government (A. Lorenzetti), 459-461, 460, 461 Allegory of Love and Grace (Cranach the Elder), 643–644, 643 Allegory of Sight (Jan Brueghel the Elder and Rubens), 709–710, 709 Allegory of Venus (Bronzino), 599-600, 599 Allover paintings, 1039 Alloway, Lawrence, 1051 Altarpiece of St. Clare, Convent of Santa Chiara, Assisi, 440–441, 440 Altarpieces, 441 See also Maestà Altarpiece Adoration of the Magi (Gentile da Fabriano), 525-527, 526 Assumption of the Virgin (Egid Quirin Asam), Benedictine abbey, Rohr, Germany, 778, 779 Birth of the Virgin (P. Lorenzetti), 458-459, 459 at Chartreuse de Champmol, Dijon, France, 472-473, 472 Descent from the Cross (Rosso Fiorentino), 593, 593 *Ghent Altarpiece* (Jan and Hubert van Eyck), 480–482, *480*, *481*, *482* Isenheim Altarpiece (Grünewald), 635-637, 636, 637 Madonna and Saints (Bellini), 552-553, 552 Madonna with Members of the Pesaro Family (Titian), 556, 586–588, 587 Melun Diptych (Fouquet), 494–495, 495 Mérode Triptych (Campin), 477–479, 478 Portinari Altarpiece (Goes), 490-491, 490 of St. Clare, 440, 440 Raising of the Cross (Rubens), 698, 700, 701-702 St. Wolfgang Altarpiece (Pacher), 497–499, 498 Altdorfer, Albrecht, Battle of Issos, 644, 645 Altes Museum (Schinkel), Berlin, 854, 854 American Gothic (Wood), xix-xx, xx, 1023-1024, 1023 American Moon (Whitman), 1047 Americans, The (Frank), 1065 Ammanati, Bartolommeo Laurentian Library vestibule stairway, 596, 597 Palazzo Pitti, 598, 598

Amsterdam, painting in, 718–724, 719–721, 723–724

Anamorphic, 547

Anatomy of a Horse (Stubbs), 802 Anatsui, El, Dzesi II, 1105-1106, 1105 Andalusion Dog (Dali and Buñel), 998-999, 998 Andrea da Firenze/Andrea Bonaiuti, The Way of Salvation, Santa Maria Novella, Florence, 463, 463 Andromache Bewailing the Death of Hector (Hamilton), 788–789, 789 Androuet du Cerceau, Jean, 626 Angelico, Fra (Giovanni da Fiesole), Annunciation, 531, 531 Angels Appearing before the Shepherds (Tanner), 924, 924 Anguissola, Sofonisba, Self-Portrait, 613, 613 Animal Destinies (The Trees Showed Their Rings, The Animals Their Arteries) (Marc), 960-961, 960 Animal Locomotion (Muybridge), 940 Anne of Bohemia, 476 Annunciation (Simone Martini), 458, 458, 479, 479 Annunciation, Isenheim Altarpiece (Grünewald), 636, 637 Antonello da Messina, 551 Antwerp Baroque, 699, 701 Renaissance, 650 Town Hall, (Floris and van den Brock), 652-653, 653 Apollinaire, Guillaume, 950, 964 Apollonio di Giovanni di Tomaso, Strozzi cassone with the Conquest of Trebizond, 537, 537 Apoxyomenos (Scraper), xxi, xxii, xxiii Apparition (Moreau), 918, 918 Appropriation Art, 1091 Apse, 441 Aragon, Louis, 992, 993 Arc de Triomphe, Paris, 850 Arch of Titus, Forum Romanum, Rome, xix, xix Architectural painting, Dutch Baroque, 728-729, 728 Architectural Works (Peyre), 808 Architecture American Classical Revival, 854–855, 855 American Modern, 932–935, 932–935, 976-979, 976-978 as art, xxv–xxvii Art Deco, 1020, 1021 Art Nouveau, 927–931, 928–930 Austrian Rococo, 777–779, 777 Baroque, English, 754–758, 754–758 Baroque, French, 748–752, 748–752 Baroque, Italian, 675-684, 676-684 Bauhaus, 107-1011, 1008-1011 Classical Revival, American, 854-855, 855 Classical Revival, English, 853, 853 Classical Revival, German, 854, 854 computer aided design in, De Stijl, 1006-1007, 1006-1007 English Baroque, 754–758, 754–758 English Classical Revival, 853, 853 English Gothic Revival, 800, 801. 851-852, 852 English Neoclassicism, 796-798, 797-799 Expressionist, German, 979-980, 979-980 ferrovitreous structures, 898–899, *898* French Baroque, 748–752, *748–752* French Neoclassicism, *784*, 806–810, 807-810

French Renaissance, 626–628, 626, 628 German Classical Revival, 854, 854

German Expressionist, 979–980, *979–980* German Rococo, 778, 779-781, 779-781 Gothic, Italian, 438-439, 439, 441-442, 442, 445-448, 445, 446, 453-454, 453, 464 465 Gothic Revival, 800, *801*, 851–852, *852* International Style, 1020–1021, *1021* Italian Baroque, 675–684, *676–684* Italian Gothic, 438-439, 439, 441-442. 442, 445-448, 445, 446, 453-454, 453, 464, 465 Italian Renaissance (early), 509-515, *510–513*, *515*, 533–534, *533*, *534*, 546–547, *546–547*, *550*, *550* Italian Renaissance (High), 565-568, 566, 567 Italian Renaissance (Late), 595-599, 595-598, 605-609, 605-609, 613-617, 614–616 Mannerist, 595–599, *595–598* Mannenst, 595–599, 797–598 Modernism, Early, 932–935, 932–935, 976–979, 976–978 Modernism, High, 1006–1014, 1006–1013 Modernism, Late, 1069-1072, 1070-1072 Neoclassicism, English, 796-798, 797-799 Neoclassicism, French, 784, 806-810, 807-810 Netherlands Renaissance, 652–653, 653 nineteenth century use of new materials and methods, 897–900, 897–900 Postmodern/Deconstruction, 1082-1085, 1083-1085 Rational Classicism, 806-807, 807 Renaissance, French, 626–628, 626, 628 Renaissance (early), Italian, 509–515, 510-513, 515, 533-534, 533, 534, 546-547, 546-547, 550, 550 Renaissance (High), Italian, 565-568, 566, 567 Renaissance (Late), Italian, 595–599, 595–598, 605–609, 605–609, 613–617, 614-616 Renaissance, Netherlands, 652-653, 653 Renaissance, Spanish, 632-633, 632 Rococo, Austrian, 777-779, 777 Rococo, German, 778, 779–781, 779–781 Romantic, American, 854–855, *854* skyscrapers, 932–933, *932–933* Spanish Renaissance, 632–633, *632* Arena (Scrovegni) Chapel, Padua, 450-453, 450-452 Arensberg, Walter and Louise, 986 Armory show, 974, 1019 *"Armoflini Portrait"* (Jan van Eyck), 483–485, *484* Arnolfini, Giovanni, "Arnolfini Portrait" (Jan van Eyck), 483–485, 484 Arnolofo di Cambio Santa Croce, Florence, 441–441, 442 Florence Cathedral, 445–446, 445, 446 Palazzo della Signoria (Palzzo Vecchio), Florence, 448, 448 Arp, Jean (Hans), Entombment of the Birds and Butterflies (Head of Tzara) (Arp), 985–986, 986 Art Brut, 1042 Art criticism, Diderot and the beginnings of, 812 Art Deco, 1020, 1021 Art fairs, 1104 Art market economics of in Renaissance period, 651 religious conflict, effect of, 625 twenty-first century, changes in, 1104

1127

Art Nouveau, 927-931, 928-930 Art aesthetics and, xxiii-xxiv architecture as, xxv-xxvii power of, xix-xxi context, changing, xxi context, impact of, xix-xxi defining, xxi-xxiii illusionism in, xxiv meaning in, xxiv photography as, xxv power of, xix-xxi Art history the absent object, 1059 methodology, changes in, 889 Artists, Inc., 871, 877, 908 Artists' reputations, changing fashions in, 889 Arts and Crafts Movement, 883-884, 883 As in the Middle Ages, So in the Third Reich (Heartfield), 1031, 1031 Asam, Cosmas Damian, 779 Asam, Egid Quirin, Assumption of the Virgin, Benedictine abbey altar, Rohr, Germany, 778, 779 Aspdin, Joseph, 1013 Assisi San Francesco basilica, 438–440, 439, 440 Santa Chiara (St. Clare) convent, 440, 440 Associationism, 799 Assumption of the Virgin (Correggio), 611-612, 611 Assumption of the Virgin (Egid Quirin Asam), Benedictine abbey altar, Rohr, Germany, 778, 779 Atmospheric (aerial) perspective, 491 Aurier, Georges-Albert, 917 Aurora (Guercino and Tassi), Villa Ludovisi, Rome, 672, 673 Aurora (Guido Reni), 672, 672 Austria architecture, Rococo, 777-779, 777 painting, Expressionism, 962–963, 962–963 painting, fifteenth century, 497-499, 498 painting, Symbolism, 921-922, 922 Steiner House (Loos), 976-977, 976 Authenticity, workshops of Rubens and Rembrandt, 718 Autumn Rhythm: Number 30 (Pollock), 1034, 1038, 1039 Autumn Salon, 908, 946, 947 Avant-garde, 860 Aventinus of Regensburg, 644 Avenue du Bois de Bologne (Lartigue), 939-940, 940 Awakening Conscience, The (Hunt), 882-883, 882 Awakening Prisoner (Michelangelo), 572, 572 Baargeld, Johannes, 991 Bacchanal (Titian), 585–586, 586 Bach, Johann Sebastian, 762 Back from the Market (Chardin), 770, 770 Bacon, Francis (20th century artist), 1041 Head Surrounded by Sides of Beef, 1043-1044, 1043 Baerze, Jacques de, 471 Baldacchino (Bernini), 676-678, 677 Baldinucci, Filippo, 747 Baldung Grien, Hans, The Bewitched Groom, 646, 646 Ball, Hugo, 985 Baltimore Cathedral (Latrobe), Maryland, 855, 855 Bank of England (Soane), 853, 853 Banks, Thomas, Death of Germanicus, 791, Banquet of the Officers of the St. George Civic Guard (Frans Hals), 715, 716 Baptism of Christ (A. Pisano), bronze doors, baptistery of San Giovanni, Florence, 447-448, 448 Bar at the Folies-Bergère (Manet), 877-878, 877 Barbara of Brandenburg, 546 Barberini ceiling fresco (Cortona), 672–675, 673 Barbizon School, 849, 863, 877 Barcelona, Casa Milà (Gaudí), 929-930, 929

Baroncelli, Maria Maddelena, 491 Baroque architecture English, 754–758, 754–758 French, 748–752, 748–752 Italian, 675–684, 676–684 Baroque painting Dutch, 713–734, 715–717, 719–721, 723-734 Flemish, 700, 701–712, 703–712 French, 739-748, 740–742, 744–746 Italian, 663–675, 664–674 Spanish, 689-696, 690-696 Baroque sculpture French, 753, 753 Italian, 660, 684-689, 685, 686, 688, 689 Baroque decorative arts, Italian, 678-679, 678 decorative style, French, 740 defined, 661-663 difference between Rococo and, 761 engraving/etchings, 713, 713, 739, 739 gardens, 749, 751-752 maps of Europe, 662 patrons of art, 663, 725 science, 663 use of term, 761 Barry, Sir Charles, Houses of Parliament, London, 852-853, 852 Barthes, Roland, 1075 Barye, Antoine-Louis, Tiger Devouring a Gavial of the Ganges, 850, 850 Basel Council of, 496 as a printing center, 501-502, 502 Reformation in, 646 Basic Collection on Architecture (Neufforge), 806 Basilica, 441 Basquiat, Jean-Michel, Horn Players, 1088–1089, 1088 Bath, England, Classical-revival architecture, 797-798, 798 Bathing Place, Asnières (Seurat), 908 Bathsheba with King David's Letter (Rembrandt), 722–724, 723 Battle of Issos (Altdorfer), 644, 645 Battle of San Romano (Uccello), 538, 539 Battle of the Nudes (Pollaiuolo), engraving, 536, 536 Battlements, 448 Battleship Potemkin (Eisenstein), 1044 Baudelaire, Charles, 843, 859, 861, 869, 896, 917 Baudrillard, Jean, 1075 Bauhaus Shop Block (Gropius), Dessau, 1009–1010, *1009* Bauhous art, 1007–1011, *1008–1011* Bautista de Toledo, Juan, Escorial, Madrid, Spain, 632–633, 632 Bayeu, Francisco, 823 Beals, Jessie Tarbox, 939 Bearden, Romare, 1065, 1066 Prevalence of Ritual: Baptism, 1065-1067, 1066 Beardsley, Aubrey, Salomé, 921, 922 Becker, Bernd and Hilla, 1103 Beckford, William, 851 Beckmann, Max, Departure, 1030-1031, 1030 Bedroom of Empress Josephine Bonaparte (Percier and Fontaine), 856, 856 Beethoven, Ludwig van, 822 Behind the Gare Saint-Lazare (Cartier-Bresson), 999, 999 Behrens, Peter, A.E.G. Turbinenfabrik (Turbine Factory), Berlin, 977-978, 977 Belgium metalwork, 487-488, 488 painting, Symbolism (Synthetism), 920, 920 panel painting in tempera and oil, 477–486, 478–487 tapestry, 489–490, 490 Bellini, Giovanni, 543, 549, 584 Madonna and Saints, 552-553, 552 St. Francis in the Desert, 551–552, 551 Bentley, Thomas, 792 Benton, Thomas Hart, 1023 Berg, Max, Jahrhunderhalle (Centennial Hall), Breslau, 980, 980 Berger, John, 923 Bergson, Henri, 945

Berlin A.E.G. Turbinenfabrik (Turbine Factory) (Behrens), 977-978, 977 Altes Museum (Schinkel), 854, 854 Dadaism, 987–990, *988–990* Berlioz, Hector, 843 Bermejo, Bartolomé, Pietà, 495, 496 Bernard, Émile, 907, 915 Bernini, Gianlorenzo, 675 Baldacchino, 676-678, 677 Cornaro Chapel, Santa Maria della Vittoria, Rome, 686, 687 David, 685-686, 685 Ecstasy of St. Teresa, 660, 686, 687 Head of St. Jerome, 688, 688 St. Peter's design, 676–678, 676 sculptural sketches of, 688 Bernini, Gianlorenzo, xxv-xxvi, xxvi Bernini, Pietro, 684 Bertoldo di Giovanni, 568 Beuys, Joseph, 1051 How to Explain Pictures to a Dead Hare, 1063, 1063 Bewitched Groom (Baldung Grien), 646, 646 Bibliothèque Sainte-Geneviève (Labrouste), Paris, 900, 900 *Bicycle Wheel* (Duchamp), 972, 972 Bing, Siegfried, 927 Bird in Space (Brancusi), 973–974, 973 Newborn, The (Brancusi), 972–973, 973, 974 Birth of the Virgin (P. Lorenzetti), 458-459, 459 Birth of Venus (Botticelli), 540-541, 541 Bismarck, Otto von, 859 Black Death, 299, 462, 463 map of spread in Europe, 464 Black Iris III (O'Keeffe), 1022, 1022 Blake, William, 825 Elohim Creating Adam, 826-827, 826 printing technique used by, 827 Blanc, Charles, 874 Blavatsky, Helena, 946 Bleaching Grounds Near Haarlem (Ruisdael), 726, 726 Blenheim Palace (Vanbrugh and Hawksmoor), 758, 758 Blériot, Louis, 964 Blessed Art Thou Among Women (Käsebier), 937–938, 937 Blind Leading the Blind (Bruegel the Elder), 658, 658 Blind Man, The (Duchamp and Wood), 987 Blinding of Samson (Rembrandt), 719-720, 719 Block books, 500 Blondel, Jacque-François, 806 Boboli Gardens, Florence (Triboli), 598, 599 Boccaccio, Giovanni, 438 Decameron, 462 Boccioni, Umberto States Of Mind I: Farewells, 965–966, 965 Unique Forms of Continuity in Space, 966, 966 Bodmer, Johann Jacob, 803 Bohr, Niels, 945 Bologna, Giovanni (Jean Bologne), Rape of the Sabine Women, 601-602, 601 Bologne, Valentin de, 813 Bonaparte, Joseph, 825 Bonheur de Vivre, Le (The Joy of Life) (Matisse), 947-949, 948 Bonheur, Rosa, Plowing in the Nivernais: The Dressing of Vines, 865-866, 865 Bonino da Campione, Tomb of Bernabò Visconti, 465–466, *465* Bonnard, Pierre, 917 Book of Hours of Giangaleazzo Visconti (Giovannino dei Grassi), 466, 466 Book of Truth (Liber Veritas) (Claude Lorrain), 744, 747 Books of Hours Flemish, 488-489, 489 French, 473-474, 473, 474, 474 Borgia, Cesare, 565 Borgia, Lucrezia, 565 Borgo San Sepolcro, 543, 545 Borluut, Elizabeth, 480 Borromini, Francesco Four Rivers Fountain, Piazza Navona,

681-682, 682

San Carlo alle Quattro Fontane church, 679-689, 679, 680 Sant'Agnese church, 681-682, 682 Sant'Ivo church, 680–681, 680–681 Bosch, Hieronymus, Garden of Earthly Delights (Bosch), 492–493, 492, 493 Boston Atheneum, 832 Botticelli, 553 Botticelli, Sandro, 558 Birth of Venus, 540–541, 541 Primavera, 540, 540 Boucher, François, Portrait of Madame de Pompadour, 766, 767 Boudin, Eugène, 871 Bouguereau, Adolphe-William, Nymphs and Satyr, 866–867, 866 Boullée, Étienne-Louis, Project for a Tomb to Isaac Newton, 810, 810 Bourdon, Sébastien, 747 Bourke-White, Margaret, Fort Peck Dam, *Montana*, 1018, *1018* Brady, Matthew, 894 Bramante, Donato St. Peter's basilica, plan for, 567-568, 567 Tempietto, San Pietro church, Rome, 565-567, 566, 567 Brancacci Chapel frescoes, Santa Maria del Carmine, Florence, 528, 529-530, 529, 530 Brancacci, Felice, 529, 530 Brancusi, Constantin Bird in Space, 973-974, 973 Newborn, 972-973, 973, 974 Brant, Sebastian, Ship of Fools, 502, 502 Braque, Georges, The Portuguese, 952-953, 952 Bravo, Manuel Álvarez, La Buena Fama Durmiendo (Good Reputation Sleeping), 1026-1028, 1027 Brecht, George Drip Music, 1048 Motor Vehicle Sunset Event, 1047 *Three Aqueous Events*, 1048 Breton, André, 991–992, 993, 1000, 1037 Breuer, Marcel, Werkbund housing, furniture and lighting, 1008–1009, *1008* Bride of the Wind (Kokoschka), 962–963, 962 Bridges Brooklyn Bridge (John and Washington Roebling), New York, 899, *899* early iron, 786, 897 Brig on the Water (Le Gray), 896-897, 897 Brioche (The Dessert) (Chardin), 770-771, 771 Britain. See under England British Museum, 792 Broederlam, Melchior, Infancy of Christ, altarpiece, 472–473, 472 Bronze doors, San Giovanni baptistery, Florence Gates of Paradise (Story of Jacob and Esau) (Ghiberti), 521-523, 522, 523 A. Pisano, 446–448, 447, 448 Sacrifice of Isaac (Brunelleschi), 507-508, 508 Sacrifice of Isaac (Ghiberti), 507-509, 508 Bronze work doors, San Giovanni baptistery, Florence, 446-448, 447, 448, 507-509, 508, 521-523, 522, 523 Italian Renaissance, 507–509, 508, 519–521, 520, 521–523, 522, 523, 534-536, 535 Bronzino, Agnolo Allegory of Venus, 599-600, 599 Brooklyn Bridge (John and Washington Roebling), 899, 899 Brown, Denise Scott, 1077 Bruegel the Elder, Pieter, 655, 656 Blind Leading the Blind, 658, 658 Peasant Wedding, 657-658, 657 Return of the Hunters, 655–656, 636 Brueghel the Elder, Jan, Allegory of Sight, from The five Senses, 709–710, 709 Bruges, Belgium panel painting, 479-485, 480-484 Renaissance, 651 Town Hall, 476–477, 477 Brunelleschi, Filippo, 515, 527 Florence Cathedral dome, 509–510, *510*, 512, 512 Hospital of the Innocents (Ospedale degli Innocenti), Florence, 510-512, 511

and perspective, development of, 516 San Giovanni baptistery, bronze doors, Sacrifice of Isaac (Brunelleschi), 507-508, 508 San Lorenzo church, Florence, 512-514, 512, 513, 527 Bruni, Leonardo In Praise of the City of Florence, 507 Tomb of Leonardo Bruni (Rossellino), 523-524, 523 Brussels, Belgium panel painting, *468*, 485–486, *486*, *487* stairwell (Horta), Tassel House, *902*, 928, 979 928 879 Bryant, William Cullen, 833 Bubonic Plague, 299, 462, 463 map of spread in Europe, 464 Bucintoro at the Molo, The (Canaletto), 775-776, 776 Buñel, Louis, Andalusion Dog, 998-999, 998 Bunnies (Polke), 1053 Buono Giamberti, Marco del, Strozzi Catholicism cassone with the Conquest of Trebizond, 537, 537 Burden, Jane, 884, 884 Burghers of Calais (Rodin), 926-927, 927 Burial at Ornans (Courbet), 861-863, 862 Burial of Count Orgaz (El Greco), 633-634, *633*, *634* Burke, Edmund, 790, 799, 801 Burlington, Lord (Richard Boyle), 1085 Chiswick House, England, 796-797, 797, 799 Ceiling painting Burne-Jones, Edward, 883, 884, 885 Butler, Octavia, 1097 Buxheim St. Christopher, woodcut, 500, 500 Byron, Lord, 837, 845 Ca' d'Oro, Venice, 550, 550 Cage, John, 1045, 1046, 1047 Calder, Alexander, 1000 Lobster Trap and Fish Tail, 1001, 1001 Calling of St. Matthew (Caravaggio), 664–665, 665 Callot, Jacques, Hangman's Tree, from The Great Miseries of War, etching, 739, 739 Calotype, 891 Calvin, John, 591, 635 Cameos, 648 Camera clubs, 936 907 Camera obscura, 890 Camera Picta (Andrea Mantegna), Ducal Palace, Mantua, 548, 549 969 Camera Work (Stieglitz), 1022 Cameron, Julia Margaret, Sister Spirits, 895-896, 895 Campanile, 446 Campbell, Colin, 796 Campbell's Soup Cans (Warhol), 1049-1051, 1050 Campidoglio, Rome (Michelangelo), 605, 605,606 Campin, Robert, Mérode Triptych, 477–479, 478, 479 Campini, Pier Tommaso, Nocturnal Clock, 678-679, 678 Canaletto (Giovanni Antonio Canal), 762 The Bucintoro at the Molo, 775-776, 776 Canova, Antonio, 787 Cupid and Psyche, 817–818, 817 Theseus Vanquishing the Minotaur, 817 Tomb of the Archduchess Maria 476 Christina, Augustinerkirche, Vienna, 818, 818 Capponi family, 593–594 Caprichos (Caprices) (Goya), 823 Caradosso, Cristoforo Foppa, medal, Bramante's design for St. Peter's, 567, 567 Caravaggio (Michelangelo Merisi) Calling of St. Matthew, 664–665, 665 Contarelli Chapel, San Luigi dei Francesi, Rome, 664–665, 664, 665 Conversion of St. Paul, 666-667, 666 471 The Musician, 667, 667 Caravaggisti, 713 Carleton, Sir Dudley, 704 Chaux Carnegie, Andrew, 1104 Carol, Lewis, 1053 Carpeaux, Jean-Baptiste, The Dance, Paris Opéra façade, 867, 867 809-810, 809

Carracci, Annibale, 666 Landscape with the Flight into Egypt, 671–672, 671 Loves of the Gods, 670, 671 Carriera, Rosalba, Charles Sackville, Second duke of Dorset, 769, 769 Carte-de-visite, 892 Cartier-Bresson, Henri, Behind the Gare Saint-Lazare, 999, 999 Cartoons, Renaissance artists, 575, 581 Casa Milà (Gaudí), Barcelona, 929-930, Cassatt, Mary, The Child's Bath, 879-880, Cassoni (cassone), 537 Castagnary, Jules-Antoine, 859 Castagno, Andrea del, The Last Supper, 531–532, 532 Castle of Otranto: A Gothic Story (Walpole), 800 Catalogue raisonné, 747 Catholic Reform. See Counter Reformation during the Baroque period, 661-663, 689, 699, 737 Canon and Decrees, Council of Trent, Counter Reformation, 592, 604, 607, 622, 633, 661, 689 during the Renaissance period, 591, 592, 603, 625, 635 CATIA computer-aided design program, Cavallini, Pietro, 440 See also Sistine Chapel, Vatican Baroque, 670-675, 670, 672-674 Neoclassicism, 788–789, 788 Rococo, 780, 781-782 Cellini, Benvenuto My Life (Vita), 600 Saltcellar of Francis I, 600–601, 600 Cenami, Giovanna, "Arnolfini Portrait" (Jan van Eyck), 483–485, 484 Centre National d'Art et Culture Georges Pompidou (Rogers and Piano), Paris, 1080, 1081 Cézanne, Paul, 877 letter to Émile Bernard, 907 Mont Saint-Victoire, 905-906, 906 Mont Saint-Victoire Seen from Bibemus Quarry, 908, 908 Still Life with Apples in a Bowl, 906-908, Chagall, Marc, I and the Village, 969, Chamisso, Adelbert von, 957 Champfleury (Jules-François-Félix Husson), 861 Champs délicieux (Man Ray), 992, 992 Chants de Maldoror (Lautréamont), 993 Chardin, Jean-Siméon, 769 Back from the Market, 770, 770 The Brioche (The Dessert), 770-771, 771 Soap Bubbles, 770, 770 Charging Chasseur (Géricault), 841, 841 Charles I Hunting, Portrait of (Van Dyke), 707–708, 707 Charles I, king of England, 707, 737, 754 Charles II, king of England, 737 Charles III, king of Spain, 781, 823 Charles IV, Holy Roman emperor, 475, 476 Charles IV, king of France, 475 Charles IV, king of Spain, 823, 824, 825 Charles Le Brun (Coysevox), 753, 753 Charles Sackville, Second duke of Dorset (Carriera), 769, 769 Charles V, Holy Roman emperor, 591, 593, 603, 609, 634 Charles V, king of France, 471 Charles VI, Holy Roman emperor, 778 Charles VII, king of France, 494 Charles X, king of France, 850 Chartists, 861, 881 Chartreuse de Champmol, Dijon, France, altarpiece (Broederlam), 472–473, 472 Well of Moses (Sluter), 471-472, 471 entrance portico (Ledoux), saltworks, Arc-et-Senans, 784, 808-809, 809 house plan for the ideal city of (Ledoux),

Chavannes, Puvis de, The Sacred Grove, Beloved of the Arts and Muses, 909-910 909 Chevalier, Étienne, 494, 495 Chevreul, Michel-Eugène, 874 Chiaroscuro, 559, 582, 584, 588, 591, 593, 722, 734, 835, 836, 837 Chicago Marshall Field Wholesale Store (Richardson), 931-932, 931 Robie House (Wright), 934–935, 934, 935 Schlesinger and Meyer Store (Sullivan), 933.933 Chicago, Judy, *The Dinner Party*, 1068–1069, *1069* Chigi family, 681 Chigi, Agnostino, 582 Child's Bath, The (Cassatt), 879–880, 879 Chinoiserie, 771–772 Chiswick House (Lord Burlington and William Kent), England, 796–797, 797, 799,800 Christ Entering Jerusalem (Giotto di Bondone), Arena (Scrovegni) Chapel, Padua, 451-452, 451 Christ in the Carpenter's Shop (Christ in the House of His Parents) (Millais), 882, 883 Christ's Entry into Brussels in 1889 (Ensor), 920, 920 Christo (Christo Javacheff), Running Fence, 1060-1061, 106 Chromoluminarism, 910 Chrysler Building (Van Alen), New York City, 1020, *1021* Church, Frederic Edwin The Heart of the Andes, 834 Icebergs, 834 Twilight in the Wilderness, 834–835, 835 Cimabue, Madonna Enthroned, 449, 449 City of Ambition (Stieglitz), 938–939, 939 Civil Rights Movement in US, 1036, 1065, 1067 Civil War, American, 887, 890, 894, 894 Civil War, Spanish, 1031-1032 Classical Revival, American, 854–855, *855* English/British, 796–797, *797*, *799*, 853, 853 French, 806-807, 807, 856, 856 German, 854, 854 Classicism Baroque, 661, 672, 675, 689, 738, 741, 745 Rational, 806-807, 807 use of term, 739 Classicizing, 617, 632, 643 Claude. See under Lorrain, Claude Cleaning works of art, 578 Clement VII, pope, 581, 595, 597, 603 Clement VIII, pope, 675 Clerestory, 446 Climbing Path, L'Hermitage Pontoise (Pissarro), 876-877, 876 Clodion (Claude Michel), Nymph and Satyr Carousing, 774, 774 Club-Footed Boy (Ribera), 690–691, 690 Cobb, Henry N., 1070 Colbert, Jean-Baptiste, 738, 745, 748 Cold War, 1035 end of, 1076 map of alliances, 1036 Cole, Thomas The Course of Empire, 834 The Oxbow (View from Mount Holyoke, Northampton, Massachusetts, after a Thunderstorm), 833-834, 833 Collage, 953-954, 953, 988, 989 Collection of Etruscan, Greek and Roman Antiquities from the Cabinet of the Honorable William Hamilton (Hugues d'Hancarville), 792 Colleoni, Bartolommeo, 550, 550 Colmar, as a printing center, 501-502, 502 Cologne Dadaism in, 991–992, *991* Glass Pavilion (Taut), Werkbund Exhibition, 979-980, 980 Werkbund Theater (Van de Velde), 979, 979 Colonialism, 903-904

Colonialism, 903–904 Color theory, Impressionist, 874 Color wheel, *874*

Color, emotional meanings of, 910-911 Color-field painting, 1040 Colossal order, 546 Coltrane, John, 1067 Columbus, Christopher, 470 Combines, 1045 Commedia dell'arte, 739, 763 Communist Manifesto (Marx and Engels), 821, 861, 881 Company of the Cross of the Day, 593 Complexity and Contradiction (Venturi), 1077 Composition (Miró), 996, 997 Composition with Red, Blue, and Yellow (Mondrian), 1006, 1006 Computer-aided design in architecture, 1085 Comte, August, 859 Conceptual Art, 987, 1044–1046, 1044, 1046, 1062–1063, 1062–1063 Concerning the Spiritual in Art (Kandinsky), 959, 960 Concrete, reinforced, 1013 Condivi, Ascanio, Life of Michelangelo Buonarotti, 568, 569 Conservation of frescoes, 441 of tapestries, 629 Constable, John, 827 on beauty of the English landscape, 829 The Haywain (Landscape Noon), 828-829, 828 Construction, 954, 954 Constructivism, 1003–1005, 1004–1005 Consumer culture, 1035 Contarini, Marino, 550 Contrapposto, 519 Conversion of St. Paul (Caravaggio), 666-667, 666 Coop Himmelblau, Rooftop Office, Vienna, 1082, 1083 Cooper, James Fennimore, 834 Copernicus, Nicolaus, 663 Copley, John Singleton, Mrs Joseph Scott, xvii-xviii, xviii Corday, Charlotte, 816 Cornaro Chapel (Bernini), Santa Maria della Vittoria, Rome, 686, 687 Cornelia Presenting Her Children as Her Treasures (Mother of the Gracchi) (Kauffmann), 791-793, 793 Cornell, Joseph, 1067 Corner Counterrelief (Tatlin), 1004, 1004 Corner Prop (Serra), 1058–1059, 1059 Cornered (Piper), 1096 Corot, Jean-Baptiste-Camille Hagar in the Wilderness, 848 Souvenir de Mortefontaine (Oise), 820, 848-849, 848 View of Rome: The Bridge and Castel Sant'Angelo with the Cupola of St. Peter's, 847–848, 847 Corpus of Rembrandt Paintings, The, 718 Corpus, 497 Correggio, Antonio Allegri da Assumption of the Virgin, 611-612, 611 Jupiter and Io, 610-611, 610 Correspondence littéraire, 811, 812 Corsair, The (Byron), 837 Cortona, Pietro da, Allegory of Divine Providence, 672–675, 673 Cosmos (Humboldt), 834 Council of Trent, 603, 607 Counter Reformation, 592, 604, 607, 622, 633, 661, 689 Cour du Cheval Blanc (Court of the White Horse) (Gilles Le Breton), Fontainebleau, 626-627, 626 Courbet, Gustave Burial at Ornans, 861–863, 862 one-person show (On Realism), 863 rejection of Salons, 866 The Stone Breakers, 862–863, 862 Course of Empire, The (Cole), 834 Couture, Thomas, 868 Coysevox, Antoine Charles Le Brun, 753, 753 The Triumph of Louis XIV, 751, 751 Cranach the Elder, Lucas Allegory of Love and Grace, 643–644, 643 Judgment of Paris, 644, 644 Crawlers, The (Thomson), 893–894, 894

Creation of Adam (Michelangelo), 575-576, 576 Cremona, 611, 613 Cromwell, Oliver, 737 Crossing, 446 Crossing, The (Viola), 1102–1103, 1102 Crucifixion, Isenheim Altarpiece (Grünewald), 636, 637 Crucifixion, The (Grünewald), xxiv Crystal Day (Heckel), 957, 957 Crystal Palace (Paxton), London, 898-899, 898 Cubi series (Smith), 1041-1042, 1041 Cubism analytic, 952–953, 952 fantasy and, 969-970, 969-970 impact of, 955 Picasso, work of, 950-954, 950, 953, 954 synthetic, 953-954, 953-954 Cubo-Futurism and Suprematism, 966-969, 967, 968 Cunningham, Imogen, 1023 Cupid and Psyche (Canova), 817-818, 817 Curry, John Stewart, 1023 Cut with the Kitchen Knife Dada Through the Last Weimar Beer Belly Cultural epoch of Germany (Höch), 988, 989 Cyriacus of Ancona, 485, 486 d'Alembert, Jean, 785, 801 d'Angiviller, Charles-Claude, 813, 814 d'Este, Alfonso, 585 d'Este, Isabella, 609 d'Ètampes, duchess of, 629 *Dada*, 985, 992 Dadaism Berlin, 987–990, *998–990* Cologne, 991–992, *991* New York, 986–987, *986* Paris, 992–993, *992* use of term, 983–984, 985 Zurich, 985–987, *986* Daguerre, Louis-Jacques-Mandé, 891 Daguerreotype, 891 Dalí, Salvador An Andalusion Dog (Un Chien Andalou), 998-999, 998 Persistence of Memory, 998, 999 Damned, The (Signorelli), 554, 554 Dance, The (Carpeaux), 867, 867 Dante Alighieri, 438, 845, 924 Divine Comedy, excerpt from, 453 Danton, Georges-Jacques, 815 Dartet, Jacques, Woodcut of St. Christopher (Annunciation detail), 500, 501 Darwin, Charles, 851, 903 Daubigny, Charles, 876 Daumier, Honoré, 911 It's Safe to Release This One!, 864, 864 The Third-Class Carriage, 864, 865 David (Bernini), 685–686, 685 David (Donatello), 521, 534–535, 535 David (Michelangelo), 569-571, 570 David, Gerard, Virgin Among Virgins, 650, 651 David, Jacques-Louis, 787 and closure of French Royal Academy, 815, 835 Death of Marat, 815–816, 815 Oath of the Horatii, 813–815, 814 Davis, Stuart, Hot Still-Scape for Six Colors-Seventh Avenue Style, 1019–1020, 1020 De Chirico, Giorgio, Mystery and Melancholy of a Street, 969–970, 970 De Heem, Jan Davidsz., Still Life with Exotic Birds, 712, 712 De Kooning, Willem, Woman I, 1039–1040, *1039* De Stijl, 1003, 1005–1007, *1006–1007* Death of General Wolfe (West), 794-795, 794 Death of Germanicus (Banks), 791, 791 Death of Germanicus (Poussin), 736, 741-742, 741 Death of Marat (David), 815–816, 815 Death of Sardanapalus (Delacroix), 845-857, 845 Decadent movement, 903 Decameron (Boccaccio), 462 Deconstruction photography, 1092-1093, 1092-1093

Deconstructionism/Deconstructivism architecture, 1082–1085, *1082–1085* use of term, 1075 Deconstructivism exhibition, 1082 Decorative art Art Nouveau, 927-928, 928, 930, 931 English Neoclassicism, 792, 792, 797-798, 799 French Renaissance, 628-631, 628, 630-631 French Rococo, 772-774, 773, 774 Italian Baroque, 678–679, 678 Degas, Edgar, Orchestra of the Paris Opéra, 858, 870–871, 870 Degenerate Art exhibition, 1028, 1031 Del Monte, cardinal, 664, 667 Delacroix, Eugène, Death of Sardanapalus, 845–857, 845 journal of, 845 Scenes from the Massacre at Chios, 843-844, 844 Women of Algiers, 846, 847 Delaunay, Robert Homage to Blériot, 964, 964 Simultaneous Disks/Contrasts, 964 Delécluze, Étienne-Jean, Louis David, son école et son temps, 813 Delineations of Fonthill Abbey (Rutter), 852 Delivery of the Keys to St. Peter (Perugino), Sistine Chapel, Vatican, 553-554, 553 Della Porta, Giacomo dome of St. Peter's, 606, 607 Il Gesù church, Rome, 607–609, 607, 608 della Robbia, Luca, 511 Madonna and Child, 524, 524 Demoiselles d'Avignon, Les (Picasso), 950-952, 950 Demuth, Charles, My Egypt, 1018-1019, 1019 Denis, Maurice, 917 Departure (Beckmann), 1030-1031, 1030 Departure of the Volunteers of 1792 (La Marseillaise) (Rude), Arc de Triomphe, Paris, 850-851, 851 Der Blaue Reiter Almanac, 961 Der Blaue Reiter, 958–961 Der Sturm, 957 Derain, André, Mountain at Collioure, 947, 948 Derrida, Jacques, 1075, 1082 Descartes, René, 663, 746 Descart from the Cross (Rogier van der Weyden), 485–486, 486 Descent from the Cross (Rosso Fiorentino), 593, 593 Descent of Man (Darwin), 903 Description de l'Égypte, 837 Design for Sportswear (Stepanova), 1005, 1005 Dessault Systems, 1085 Deutsche Werkbund, 977 Devil's Pool, The (Sand), 865 Dickens, Charles, 881 Dickinson, Emily, 1068 Diderot, Denis, 785, 801, 811 and beginnings of art criticism, 812 Die Brücke, 955–958 *"Die Wies"* (Zimmerman), Bavarian pilgrimage church, 779–780, 779 Differences, 1092 Dine, Jim, 1047 Dinner Party, The (Chicago), 1068-1069, 1069 Diptych of Martin van Nieuwenhove (Memling), 491–492, 491 Diptych defined, 476 of Martin van Nieuwenhove (Memling), 491-492, 491 Melun Diptych (Fouquet), 494–495, 495 Wilton Diptych, 476, 476 Discourse on the Arts and Sciences (Rousseau), 787 (Rousseau), 767 Disdéri, Adolphe-Eugène, 892 Ditcheley Portrait (Portrait of Elizabeth I) (Gheeraerts the Younger), 649, 649 Divine Comedy (Dante Alighieri), 453, 924 Diving Bell and the Butterfly, The (Schnabel), 1087 Divisionism, 910

Doge's Palace, Venice, 464, 465, 550, 550

Domenico Veneziano, 543 letter to Piero de' Medici, 534 Madonna and Child with Saints, 532–533, 533 Domes Florence Cathedral (Brunelleschi), 509–510, *510*, 512, *512* Invalides church (Hardouin-Mansart), Paris, 752, 752 Saint Peter's, Rome (Michelangelo and Della Porta), 606, 607 San Carlo alle Quattro Fontane, Rome, 679–689, 680 Dominici, cardinal Giovanni, Rule for the Management of Family Care, 536, 539 Donatello, 509 David, 521, 534–535, 535 Equestrian Monument of Gattamelata, 521, 521 Feast of Herod, 520-521, 520 Mary Magdalen, 521, 521 St. George, 519, 519 St. Mark, 518–519, 518 Donkey's Tail, 966 Donne, John, 738 Double Portrait of Battista Sforza and Frederico da Montefeltro (Piero della Francesca), 545, 545 Douglass, Frederick, 1025 Dove, Arthur Plant Forms, 974, 975 Ten Commandments, 975 Draper, Paul, Reconstruction of Sir Christopher Wren's plan for the city of London, 755 Drawing after Michelangelo's Ignudi from the Sistine Chapel Ceiling (Rubens), 701, 701 Drawings, techniques used during Renaissance, 575 Dream (Rousseau), 919–920, 919 Drip Music (Brecht), 1048 Drowning Girl (Lichtenstein), 1049, 1049 Drug Store, Detroit (Frank), 1065, 1065 Dryden, John, 790 Drypoint, 722 Du Camp, Maxime, 892 Du Cubisme (Gleizes and Metzinger), 963 Dubuffet, Jean, Les Métafisyx, 1042-1043, 1043 Duccio di Buoninsegna, 453 Maestà Altarpiece, Annunciation of the Death of the Virgin, 456, 456 Maestà Altarpiece, Christ Entering Jerusalem, 456, 457 Maestà Altarpiece, Madonna Enthroned, 454-456, 454-455 Duchamp, Marcel, 1037 Bicycle Wheel, xxiii, 972, 972 Fountain, xxiii, 986–987, 986 In Advance of a Broken Arm, 986 Mona Lisa, xxii–xxiii, xix, 987 Nude Descending a Staircase, 970-971, 971 Duchamp-Villon, Raymond, Horse, 971, 971 Dupérac, Étienne, engraving of Campidoglio, Rome, 605 Dürer, Albrecht Adam and Eve, 639, 639 Four Apostles, 642-643, 642 Four Horsemen of the Apocalypse, 638, 639 Hare, 638, 638 journal excerpt, 641 Melencolia I, 641, 641 Self-Portrait, 630-640, 640 Dürer, Albrecht, 480 Dutch Republic, Baroque painting, 713-734, 714-734 Dzesi II (Anatsui), 1105–1106, 1105 Eakins, Thomas, Max Schmitt in a Single Scull (The Champion Single Sculls), 887-888, 888 Early modern period", use of term, 505 Early Sunday Morning (Hopper), 1028, 1029 Earthworks, 1059–1060, 1060

Earthworks, 1059–1060, *1060* École des Beaux-Arts, 866, 878 *Ecstasy of St. Teresa* (Bernini), 660, 686, 687

Edgar A. Poe series (Redon), 918-919, 919

Edison, Thomas, New Brooklyn to New York via Brooklyn Bridge No. 2, 942, 942 Édouard Manet (Nadar), 892, 892 Edward VI, king of England, 648 Edwards, Melvin, Lynch Fragment: Some Bright Morning, 1067, 1067 Egypt, Nubia, Palestine and Syria (Du Camp), 892 Eiffel, Gustave, Eiffel Tower, Paris, 900, 900 18 Happenings in 6 Parts (Kaprow), 1046–1047 Einstein, Albert, 945, 959 Eisenstein, Sergei, 1044 El Greco (Domenikos Theotokopoulos), 621 Burial of Count Orgaz, 633-634, 633, 634 Eleanora of Toledo and Her Son Giovanni de' Medici (Bronzino), 599, 599 Electronic Superhighway: Continental U.S. (Paik), 1063–1064, 1064 Elizabeth I, Portrait of (Ditcheley Portrait) (Gheeraerts the Younger), 649, 649 Elizabeth I, queen of England, 648–649, 649 Elohim Creating Adam (Blake), 826–827, 826 Élouard, Paul, 991–992 Embryo in the Womb (Leonardo da Vinci), 559, 560 Emerson, Peter Henry Life and Landscape on the Norfolk Broads, 937 Poling the Marsh Hay, 936, 937 Emerson, Ralph Waldo, 833 Empire Style, 856, 856 Empress of India (Stella), 1055–1056, 1055 Encyclopédie (Diderot and d'Alembert), 785, 801 Engels, Friedrich, 821, 861, 881 England architecture, Baroque, 754-758, 754-758 architecture, Classical Revival, architecture, Eclecticism, 853-854, 853 architecture, Gothic revival, 800, *801*, 851–852, *852* architecture, Neoclassicism, 796-798, 797-799 architecture of the industrial age, 897-899, 898 decorative art, Neoclassicism, 792, 792, 797–798, 799 Elizabethan, 648-649, 649 landscape garden, 799–800, 800 map of seventeenth-century political unrest, 738 painting, Gothic International, 476, 476 painting, Neoclassicism, 791–796, 793, 794, 796 painting, Realism, 881–883, *882*, 884–887, *884*, *886* painting, Renaissance, 646-649, 647-649 painting, Rococo, 774-775, 775 painting, Romanticism, 801–806, 802–805, 825-830, 826, 828, 830, 831 painting, Symbolism, 921, *922* pictorialism, 895–896, *895* Pop Art, 1051, *1051* Reformation in, 647-649, 647-649 Royal Academy of Art, 789, 791, 794 sculpture, abstract organic, 1000-1003, 1001-1003 sculpture, Neoclassicism, 791, 791 Engravings, 501–502, 501, 502 Enlightenment map of Europe and North America, 786 philosophy and, 785, 786 science and, 786 use of term, 785 Ensor, James, Christ's Entry into Brussels in 1889, 920, 920 Entire City (Die Ganze Stadt) (Ernst), 995–996, 996 Entombment of the Birds and Butterflies (Head of Tzara), 985–986, 986 Environments, 1046–1047, 1047, 1048, 1048 Equestrian Monument of Colleoni (Verrocchio), 550-551, 550 Equestrian Monument of Gattamelata, (Donatello), Padua, 521, 521 Erasmo da Narni ("Gattamelata"), 520, 521 Erasmus, Desiderius, 636

Ernst, Max, 1037 The Entire City (Die Ganze Stadt), 995–996, 996 1 Copper Plate 1 Zinc Plate 1 Rubber Cloth 2 Calipers 1 Drainpipe *Telescope 1 Piping Man*, 991, 991 Eroica symphony (Beethoven), 822 Escorial (Toledo and Herrera), 632-633, 632 Essay on Architecture (Laugier), 806 Esser, Elger, 1103 Etching, techniques of, 722 939 Étienne Chevalier and St. Stephen (Melun Flanders, 699 Diptych) (Fouquet), 494-495, 495 Europe, maps of in Age of Positivism, 860 Bubonic Plague spread, fourteenth century, 464 crafts/manufacturing in fifteenth century, 470 at end of nineteenth century, 904 in the Enlightenment, 786 England and France, political unrest in seventeenth century, 738 Italian fourteenth-century sea trade routes, 438 in the Rococo period, 762 in seventeenth century, 662 Florence in twenty-first century, 1076 Evans, Walker, Graveyard, Houses, and Steel Mill, Bethlehem, 1029, 1029 Evelyn, John, 701 Events, 1047 *Exile, The* (Schnabel), 1087–1088, *1087* Existentialism defined, 1036 in Europe: Figural Expressionism, 1042-1044, 1043 in New York: Abstract Expressionism, 1036-1042, 1037-1042 Expressionism architecture, German, 979–980, 979–980 painting, Austrian, 962-963, 962-963 painting, German, 955-961, 955-961 Expressions (Testelin after Charles Le Brun), 746, 746 Expulsion from the Garden of Eden (Michelangelo), 574–575, 576 Eye Like a Strange Balloon Mounts Toward Infinity (Redon), 918-919, 919 f/64, 1023 Fabriano, Gentile da, 553 Factory, The, xxii Fagus Factory (Gropius and Meyer), Germany, 978–979, *978* Fall of Man (Michelangelo), 574-575, 576 Fall of the Giants (Romano), 609-610, 610 False Mirror (Magritte), 997, 997 Falwell, Jerry, 1096 Famiglia Artistica, 964 Family of Charles IV (Goya), 824–825, 824 Fantastic Art, Dada, and Surrealism exhibition, 1036 Farm Security Administration (FSA), 1029 Farnese Hercules (Goltzius), 713, 713 Farnese, Alessandro, 603 Fauvism, 946–949, *947–949* impact of, 955 Feast in the House of Levi (Veronese), 621, 621 Feast of Herod (Donatello), Siena cathedral, 520-521, 520 Feast of St. Nicholas (Steen), 730-731, 731 Félibien, André, 763 Feminine Mystique (Friedan), 1068 Feminist art history, 923 856 Feminist Art, 1068-1069, 1069, 1089, 1089 Feminist movement, role of, xxi 738 Heresies, 1092 New Woman, 889, 904–905 in postmodern art, 1089, 1092–1093 in postwar art, 1068-1069 Femme au chapeau (Matisse), 946-947, 947 Fénéon, Félix, 910 Ferdinand of Spain, 565, 634 Ferdinand VII, king of Spain, 825 Ferdinand, king of Aragon, 470 1082 Ferrer, Vincent, 554 Ferroconcrete, 1011 Ferrovitreous structures, 898-899, 898 Festum Fluxorum, 1051 Fête Champêtre (Pastoral Concert)

(Giorgione), 584, 585

Fête galante, 761, 763 Ficino, Marsilio, 540, 541, 568 Figaro Littéraire, 917 Film, Surrealism, 993, 997–998, 997, 1017–1018, *1018* Fischer von Erlach, Johann, Karlskirche (church of St. Charles Borromeo), Vienna, 777–779, 777 Five Cents a Spot, Unauthorized Lodgings in a Bayard Street Tenement (Riis), 939, illuminated manuscripts, 488-489, 489 metalwork, 487–488, 488 painting, Baroque, 698, 700, 701–712, 703–712 panel painting in tempera and oil, 477–486, *478–487* tapestries, 489-490, 490 Flavin, Dan, the nominal three (to William of Ockham), 1057, 1057 Flaxman, John, Hercules in the Garden of the Hesperides, Wedgwood Jasperware, 792, 792 Flitcroft, Henry, Stourhead park, Wiltshire, England, 800, 800 Baptistery competition, 507–509, 508 Baptistery of San Giovanni, 445, 446 birth of Renaissance in, 507 Brancacci Chapel frescoes, Santa Maria del bronze doors (A. Pisano), San Giovanni baptistery, 446-448, 447, Carmine, 528, 529-530, 529, 530 Capponi chapel, Santa Felicita church (Brunelleschi and Pontormo), 593-594, 594 Cathedral (Arnolfo di Cambio), 445-446, 445.446 Cathedral dome (Brunelleschi), 509–510, 510, 512, 512 Hospital of the Innocents (Ospedale degli Innocenti) (Brunelleschi), 510–512, map of key Renaissance monuments, 517 Or San Michele, 515–519, *518–519*, 524–525, *524* Palazzo della Signoria (Palzzo Vecchio) (Arnolfo di Cambio), 448, 448 San Giovanni baptistery, 445, 446 San Giovanni baptistery, bronze doors (A. Pisano), 446-448, 447, 448 San Giovanni baptistery, bronze doors, Gates of Paradise (Story of Jacob and Esau) (Ghiberti), 521–523, 522, 523 San Giovanni baptistery, bronze doors, Sacrifice of Isaac (Brunelleschi), 507-508, 508 San Giovanni baptistery, bronze doors, Sacrifice of Isaac (Ghiberti), 507-509, San Lorenzo church (Brunelleschi), 512-514, 512, 513 Santa Croce (Arnolfo di Cambio), Florence, 441-441, 442 Santa Maria Novella church, 463, 463, 514-515. 515 Floris, Cornelis, Town Hall, Antwerp, 652-653, 653 Flower Still Life (Ruysch), 729-730, 730 Flowers of Evil (Baudelaire), 917 Fluxus artists, 1048, 1051, 1063 Fontaine, Pierre-François, Bedroom of Empress Josephine Bonaparte, 856, Fontainebleau, School of, 629-630, 630, Fonthill Abbey (Wyatt), 851–852, 852 Foreshortening, 456 Forgeries, *Book of Truth*, 747 Formalism, 1053–1057, *1054–1057* Fort Peck Dam, Montana (Bourke-White), 1018, 1018 Fortitude pulpit (N. Pisano), 443, 443 Foster, Norman, Hong Kong and Shanghai Bank, Hong Kong, 1081–1082, *1081*, Foucault, Michel, 1075 Fountain (Duchamp), xxiii, 986-987, 986 Fouquet, Jean Étienne Chevalier and St. Stephen Italian Renaissance (Late), 602, 603-604,

448

511

508

(Melun Diptych), 494-495, 495

Madonna and Child (Melun Diptych), 494-495, 495 Four Apostles (Dürer), 642-643, 642 Four Horsemen of the Apocalypse (Dürer), 638 639 Four Rivers Fountain (Borromini), Piazza Navona, Rome, 681-682, 682 Four Studies of the Head of a Negro (Rubens), 704-705, 704 4'33" (Cage), 1045 Fournaise, Alphonese, 876, 875 Fox-Strangways, Lady Susan, 796, 796 Fragonard, Jean-Honoré, The Swing, 767-769, 768 France architecture, Baroque, 748–752, 748–752 architecture, Neoclassicism, 784, 806–810, 807-810 architecture, Renaissance, 626-628, 626, 628 architecture of the industrial age, 900, *900* Classical Revival, 806–807, *807*, 856, *856* Dadaism, 992-993, 992 decorative arts, Renaissance, 628-631, 628, 630-631 decorative arts, Rococo, 772-774, 773, 774 Empire Style, 856, 856 illuminated manuscripts, 473-474, 473, 474, 474 map of seventeenth-century political unrest, 738 painting, Baroque, 739-748, 740-742, 744-746 painting, Fauvism, 946–949, 947–949 painting, fifteenth century, 494-495, 495 painting, Gothic, International, 472-473, 472 painting, Impressionism, 871–881, 872–873, *875–880* painting, Neoclassicism, 810-812, 811, 813-817, 814-816 painting, Neo-Impressionism, 910-911, 910 painting, Post-Impressionism, 905–917, 906–910, 912–916 painting, Realism, 860-866, 862-866, 868-870, 868-870 painting, Rococo, 760, 763–772, 763–765, 767–772 painting, Romanticism, 835-849, 836-849 painting, Symbolism (Synthetism), 917–920, *918–919* sculpture, Baroque, 753, 753 sculpture, Gothic International, 471-472, 471 sculpture, Neoclassicism, 812-813, 812 sculpture, Renaissance, 630-631, 630, 631 sculpture, Rococo, 774, 774 sculpture, Romanticism, 812-813, 812 sculpture, Surrealism, 999-1001, 1000-1001 Surrealism, 995–1001, 996–1001 tapestry, Renaissance, 628–629, *628* Villa Savoye (Le Corbusier), 1012–1014, 1012, 1014 Francis I, king of France, 564, 593, 599, 600, 601, 603, 626, 627 Francis of Assisi, saint, 438, 439 Franciscans, 438–441 Frank, Robert The Americans, 1065 Drug Store, Detroit, 1065, 1065 Frankenthaler, Helen, Mountains and Sea, 1053-1055, 1054 Frankert, Hans, 657 Frazer, James, 904 Freeze exhibition, 1099 French Revolution, 807, 815, 821, 823, 840 Frescoes Arena Chapel (Giotto), Padua, 450–453, 450-452 conservation and techniques, 441 defined, 441 inscriptions on, Palazzo Pubblico, Siena, 461 Italian, Gothic, 439-441, 440 Italian Renaissance (early), 527-533, 527-533 Italian Renaissance (High), 573-577, 573, 574, 576, 578, 579-580, 579, 602, 603-604, 604

604, 609-610, 610

Neoclassicism, 788-789, 788 Palazzo Barberini ceiling fresco (Cortona), 672–675, 673 Palazzo Farnese ceiling fresco (Carracci), Rome, 670, 671 Palazzo Pubblico (Lorenzetti), Siena, 459–461, *460*, *461* Rococo, *780*, 781–782, *781–782* for Sistine Chapel, 573-577, 573, 574, 576, 602, 603-604, 604 for Stanza della Segnatura, 578, 579–580, 579 Villa Albani frescoes (Mengs), Rome, 788, 788 Freud, Sigmund, 904, 945, 984, 993 Friedan, Betty, 1068 Friedlander, Lee, Albuquerque, xxv, xxv Friedrich Wilhelm III, king of Prussia, 854 Friedrich, Caspar David Abbey in an Oak Forest, 831–832, 832 Monk by the Sea, 831 Froebel, Friedrich (blocks), 934 Frottage, 995 Fry, Roger, 905 Fulton, Robert, 786 Furniture Barcelona chair (Mies van der Rohe), 1010, 1011 Red-Blue chair (Rietveld), 1006-1007, 1006 Renaissance Cassoni, 537, 537 Rococo, 772–773, 773 Fuseli, John The Nightmare, 804, 805 Thor Battering the Midgard Serpent, 803-804, 804 Futurism, 964-966, 965, 966 Gabriel, Ange-Jacques, 806 Gainsborough, Thomas, Portrait of Mrs. Richard Sheridan, 805-806, 805 Galatea (Raphael), Villa Farnesina, Rome, 582–583, 582 Galileo Galilei, 663 Garden of Earthly Delights (Bosch), 492-493, 492, 493 Garden of Love (Rubens), 706, 707 Gardener, Alexander, 895 Gardener's Photographic Sketchbook of the War (Gardener), 894, 895 Gardens design for Versailles (Le Nôtre), 751-752 English landscape, 799-800, 800 Gare Saint-Lazare: Arrival of a Train (Monet), 874-875, 875 Garnier, Charles, The Opéra, Paris, 867–868, 867 Garnier, Tony 1011 Gas Station (Segal), 1048, 1048 Gates of Hell (Rodin), 924-926, 925 Gattamelata, Equestrian Monument of Erasmo da Narni (Donatello), Padua, 521, 521*i* Gaudí, Antoni, Casa Milà, Barcelona, 929-930, 929 Gaugin, Paul, 913 Vision after the Sermon (Jacob Wrestling with the Angel), 915-916, 915 Where Do We Come From? What Are We? Where Are We Going?, 916-917, 916 Gaulli, Giovanni Battista, Triumph of the Name of Jesus, 674, 675 Gautier, Théophile, 824, 884, 885 Gay, John, 774 Geffroy, Gustave, 881 Gehry, Frank, Guggenheim Museum, Bilbao, Spain, 1074, 1084–1085, 1084, 1085 Genre painting, use of term, 653 Genre painting Baroque, 663, 693–695, 694, 716, 716, 730–734, 731–734 Neoclassicism, 786, 802, 810, 811 Renaissance Netherlands, 655-658, 655-658 Rococo, 769–770, 770, 774, 775 Romanticism, 828–829, *828* Gentile da Fabriano, Adoration of the Magi, 525-527, 526 Gentileschi, Artemesia, xxi Judith and Her Maidservant with the Head of Holofernes, 668–669, 668

relationships with patrons, 667, 669 Self-Portrait as the Allegory of Painting (La Pittura), 669, 669 Gentileschi, Orazio, 667 George III, king of England, 794, 795 Géricault, Théodore Charging Chasseur, 841, 841 Portrait of an Insane Man (Man Suffering from Delusions of Military Rank), 842_843 843 Raft of the Medusa, 841-842, 842 German Pavilion (Mies van der Rohe), International Exposition, Barcelona, 1010, 1010, 1011 Germany architecture, Classic Revival, 854, 854 architecture, Expressionist, 979–980, 979-980 architecture, Modernist, 977-979, 977-978 architecture, Rococo, 778, 779-781, 779-781 Bauhaus art, 1007–1011, *1008–1011* Conceptual Art, 1063, *1063* Dadaism, 987-992, 988-991 Degenerate Art exhibition, Munich, 1028, 1031 Der Blaue Reiter, 958–961 Die Brücke, 955–958 painting, Expressionism, 955–961, 955–961 painting, Neo-Expressionism, 1085-0188, 1086-1087 painting, Renaissance, 639, 640, 642-643, 642, 644-645, 644, 645, 646-647, 647 painting, Romanticism, 831-832, 832 Pop Art, impact of, 1051–1053, *1052* pre-World War II, 1028 woodcuts/engravings, 638–639, 638–639, 641, 641, 643–644, 643, 957–958, 958 Germany, A Winter's Tale (Grosz), 990, 990 Gérôme, Jean-Léon, 879 Gersaint, Edmé, 765 Gersaint's Signboard (Watteau), 765–766, 765 Gesture paintings, 1038 Gheeraerts the Younger, Marcus, Portrait of Elizabeth I (Ditcheley Portrait), 649, 649 *Ghent Altarpiece* (Jan and Hubert van Eyck), 480–482, *480*, *481*, *482* painting of in Vijd chapel, 482, 482 Ghiberti, Lorenzo, 449 Ghiberti, Lorenzo, 509, 516, 519 Commentaries, excerpt from 509 San Giovanni baptistery, bronze doors, Gates of Paradise (Story of Jacob and Esau), 521–523, 522, 523 San Giovanni baptistery, bronze doors, (Sacrifice of Isaac), 507–509, 508 Ghirlandaio, Domenico, 553 An Old Man and a Young Boy, 541-542, 542 Gift, The (Man Ray), 999, 1000 Gilbert, Cass, 1020 Gilles Le Breton, Cour du Cheval Blanc (Court of the White Horse), Fontainebleau, 626-627, 626 Gillespie, Dizzy, 1089 Gilpin, William 799 Ginevra de' Benci, Portrait of (Leonardo da Vinci), 558, 559 Giorgione (Giorgio da Castelfranco) collaboration with Titian, 584 Fête Champêtre (Pastoral Concert), 584, 585 The Tempest, 584, 584 Giotto di Bondone, 440, 449, 453 *Christ Entering Jerusalem*, 451–452, 451 Florence Cathedral campanile, 445, 446 Lamentation, 452, 452 Last Judgment, 436, 451 Madonna Enthroned, 450, 450 Girdle (Smith), 1068 Girodet, Anne-Louis, 816 Sleep of Endymion, 835-836, 836 Gisants, 630 Giuliani, Rudolph, xx Glasgow, Scotland Salon de Luxe (Mackintosh), Willow Tea Rooms, 930, 931 School of Art (Mackintosh), 930-931, 930

Glass Pavilion (Taut), Werkbund Exhibition, Cologne, 979-980, 980 Glazes, 479 Gleizes, Albert, 963 Gleyre, Charles, 871, 885 Global art, 1105–1106, *1105–1106* Glymph, Him, 1085 Goes, Hugo van der, Portinari Altarpiece (Goes), 490–491, *490* Goethe, Johann Wolfgang von, 787, 803, 832, 845 Gold Marilyn Monroe (Warhol), xvi, xvii, xviii, xxi, xxii Golden Bough (Frazer), 904 Goldwater, Robert, 951 Goltzius, Hendrick, Farnese Hercules, 713, 713 Gone, An Historical Romance of a Civil War As It Occurred Between the Dusky Thighs of One Young Negress and Her Heart (Walker), 1097 Gonzaga family, 609-611 Gonzaga of Mantua, 591 Gonzaga, Federico, 609 Gonzaga, Francesco Il, 609 Gonzaga, Francesco, 548 Gonzaga, Ludovico, marquis, 546, 548 González, Julio, *Head*, 995, 995 Gonzalez-Torres, Felix, 1076 Untitled (billboard of an empty bed), 1098, 1098 Gorky, Arshile, 1039 The Liver Is the Cock's Comb, 1037, 1037 Gossaert, Jan, Neptune and Amphitrite, 651-652, 652 Gothic art architecture, Italian, 438-439, 439. 441-442, 442, 445-448, 445, 446, 453-454, 453, 464, 465 archtitecture, Revival, 800, 801, 851-852, 852 sculpture, Italian, 442-444, 443-444, 465, 465 Gothic International defined, 471 illuminated manuscripts, 473-474, 473, 474 painting, English, 476, 476 painting, French, 472-473, 472 painting, Prague, Bohemia, 474–476, 475 sculpture, French, 471–472, 471 Gothic Revival, 800, 801, 851–852, 852 *Götterämmerung* (Wagner), 923 Goujon, Jean, 627 Government Has Blood on Its Hands, The (Gran Fury), 1098 Gova, Francisco Family of Charles IV, 824–825, 824 Sleep of Reason Produces Monsters, 823-824, 823 Third of May, 825, 825 Gracchus, Cornelia, 793 Graffiti Art, 1088–1089, 1088 Grammar of Painting and Engraving (Blanc), 874 Gran Fury, 1098 Grande Odalisque (Ingres), 837-838, 838 Grassi, Giovannino dei, Book of Hours of Giangaleazzo Visconti, 466, 466 Grattage, 995 Graves, Michael, Public Services Building, Graveyard, Houses, and Steel Mill, Bethlehem (Evans), 1029, 1029 Great Miseries of War (Callot), 739, 739 Green Dining Room (Morris), Victoria and Albert Museum (South Kensington Museum), London, 883-884, 883 Greenberg, Clement, 1053, 1054, 1055 Greuze, Jean-Baptiste Salons, exhibiting at, 810 The Village Bride, 811-812, 811 Grimm brothers, 832 Grisaille, 481 Grooms, Red, 1049 Gropius, Walter Bauhaus Shop Block, Dessau, 1009-1010, 1009 Fagus Factory, Germany, 978–979, 978 Werkbund housing development, 1008, 1008 Gros, Antoine-Jean, Napoleon in the Pest House at Jaffa, 840-841, 840

Grosz, George, 987 Germany, A Winter's Tale, 990, 990 Group Material, 1076, 1098 Grünewald, Matthias, Isenheim Altarpiece, 635-637, 636, 637 Grünewald, Matthias, The Crucifixion, xxiv Guarini, Guarino Palazzo Carignano, 682–683, 682, 683 Turin Cathedral, Chapel of the Holy Shroud, 682–683, 682, 683 Guercino (Giovanni Francesco Barbieri), *Aurora*, 672, 673 *Guernica* (Picasso), 1031–1032, *1032* Guerrilla Girls, 1076, 1092–1093 Guggenheim Museum (Gehry), Bilbao, Spain, 1074, 1084–1085, 1084, 1085 Guggenheim Museum, Solomon R. (Wright), New York City, xxvi-xxvii, xxvii Guggenheim Peggy, 1037, 1039 Guidalotti, Buonamico, 463 Guilds, 485 Renaissance, 506, 507, 515-516, 518, 521, 524 women not permitted in, 507 Guilio de' Medici, *580*, 581 Guimard, Hector, Métro station, Paris, 929, 929 Guitar, Sheet Music, and Wine Glass (Picasso), 953-954, 953 Guo-Qiang, Cai, Light Cycle: Explosion Project for Central Park, 1106, 1106 Gursky, Andreas, Shanghai, 1103-1105, 1103 Gutenberg, Johann, 499 Haarlem academy, 713 engraving and painting in, 713, 713, 713, 714–718, 715–717 Haarlempjes, 726 Hadid, Zaha, Rosenthal Center for Contemporary Art, Cincinnati, 1083-1084, 1083 Hagar in the Wilderness (Corot), 848 Hals, Frans Banquet of the Officers of the St. George Civic Guard, 715, 716 Genre painting, 716, 716 Jolly Toper, 716–717, 716 Married Couple in a Garden: Portrait of Isaac Mass and Beatrix van der Laen, 715-717, 716 Hamilton, Gavin, Andromache Bewailing the Death of Hector, 788–789, 789 Hamilton, Richard, 1049, 1059 Just What Is It That Makes Today's Homes So Different, So Appealing?, 1051, 1051 Hamilton, William, 792 Hammons, David, Higher Goals, 1096, 1096 Hangman's Tree, from The Great Miseries of War (Callot), 739, 739 Hanson, Duane, Man on a Mower, xxiv, xxiv Happenings, 1047 Hard-Edge Abstraction, 1055 Hardouin-Mansart, Jules Church of the Invalides, 752, 752 Palace of Versailles, 749–51, 749–51 Hare (Dürer), 638, 638 Harlem Renaissance, 1024–1025, *1024* Hartley, Marsden, Portrait of a German Officer, 975–976, 975 Harvest of Death, Gettysburg, Pennsylvania, July 1863 (O'Sullivan), 894-895, 894 Hatching, 500, 575 Hausmann, Raoul, 987 Mechanical Head (Spirit of the Age), 988, 988 Haussmann, Georges-Eugène, 861, 867 Hawksmoor, Nicholas, Blenheim Palace, 758, 758 Haywain (Landscape Noon) (Constable), 828-829, 828 Head (González), 995, 995 Head of a Woman (Picasso), 994-995, 994 Head of St. Jerome (Bernini), 688, 688

Head Surrounded by Sides of Beef (Bacon), 1043–1044, 1043

Heartfield, John, 987 As in the Middle Ages, So in the Third Reich, 1031, 1031 Heckel, Erich, A Crystal Day, 957, 957 Heda, Willem Claesz., Still Life with Oysters, 729, 729 Hegel, Georg Wilhelm Friedrich, 851 Helmholtz, Hermann von, 937 Hennebrique, François, 1013 Henry II, king of France Tomb of Henry II and Catherine de' Medici (Primaticcio and Pilon), 630-631, 631 Henry III, count of Nassau, 493 Henry IV, king of France, 705 Henry VIII (Holbein the Younger), 647-648, 648 Henry VIII, king of England, 647–648, 648 Henry, Charles, 910 Hepworth, Barbara, 1000 Sculpture with Color (Deep Blue and Red), 1002-1003, 1003 Hercules and Antaeus (Pollaiuolo), 535-536, 535 Hercules in the Garden of the Hesperides (Flaxman), Wedgwood Jasperware, 792, 792 Hercules in the Garden of the Hesperides, illustration from Collection of Etruscan, Greek and Roman Antiquities from the Cabinet of the Honorable William Hamilton (Hugues d'Hancarville), 792 Herder, Johann Gottfried, 832 Heresies, 1092 Herrera, Juan de, Escorial, Madrid, Spain, 632-633, 632 Hess, Tom, 1039 Hesse, Eva, Untitled, 1058, 1058 Higher Goals (Hammons), 1096, 1096 Hilliard, Nicholas, A Young Man Among Roses, 648–649, 648 Hine, Lewis, 939 Hiroshige, Ando, Plum Estate, Kameido, 871, 871 Hirst, Damien, 1076 Freeze exhibition, 1099 One Thousand Years, 1099 Physical Impossibility of Death in the Mind of Someone Living, The, 1099 Mother and Child Divided, 1099–1100, 1100 History of Greek Art (Winckelmann), 787 History paintings English Neoclassicism, 793–795, 794 French Neoclassicism, 813–816, *814–815* Hitchcock, Henry-Russell, 1010 Hi-Tech architecture, 1077, 1080-1082, 1080-1082 Hitler, Adolf, 983, 984, 1028, 1031, 1087 Hoare, Henry II, Stourhead Park, Wiltshire, England, 800, 800 Höch, Hannah, 987, 991 Cut with the Kitchen Knife Dada Through the Last Weimar Beer Belly Cultural epoch of Germany, 988, 989 Höffer, Candida, 1103 Hogarth, William Harlots' Progress, 774 He Revels, from The Rake's Progress, 774-775. 775 Orgy, from The Rake's Progress, 774-775, Holbein the Younger, Hans Henry VIII, 647-648, 648 Jean de Dinteville and Georges de Selve ("The Ambassadors"), 624, 646-647, 647 Holland, 699 See also Netherlands Baroque painting, 713–734, 714–717, 719–721, 723–734 Schröder House (Rietveld), 1006, 1007, 1007 seventeenth-century schools of painting, 699 Holy Trinity with the Virgin, St. John and Two Donors (Masaccio), 527–529, 527 Holy Virgin Mary (Ofili), xx, xx Holzer, Jenny, Untitled (from Truisms), 1093, 1094 Homage to Blériot (Delaunay), 964, 964 Homer, Hymn to Aphrodite, 541

Homer, Winslow, Snap the Whip, 888-890, 890 Hood, Raymond M., 1020 Hopper, Edward, Early Sunday Morning, 1028, 1029 Horace (Roman poet), 563 Horace (toman poet, 565) Horn Players (Basquiat), 1088–1089, 1088 Horse (Duchamp-Villon), 971, 971 Horta, Victor, interior stairwell, Tassel House, Brussels, 902, 928, 928 Hospital of the Innocents (Ospedale degli Innocenti) (Brunelleschi), Florence, 510-512, 511 Hot Still-Scape for Six Colors—Seventh Avenue Style (Davis), 1019–1020, 1020 Houdon, Jean-Antoine, Voltaire Seated, Italy 812-813, 812 Hours of Mary of Burgundy, 488–489, 489 Houses of Parliament (Barry and Pugin), London, 852–853, 852 How The Other Half Lives (Riis), 939 How to Explain Pictures to a Dead Hare (Beuys), 1063, 1063 Howe, George, Philadelphia Savings Fund Society Building, Philadelphia, 1020–1021, *1021* Hudson River School, 833 Hudson, Thomas, 802 Huelsenbeck, Richard, 985, 987 Hugo, Victor, 800, 822, 843 Humanism, 438, 505-507, 580, 635 themes in art, 646-647, 646, 647 Humboldt, Alexander von, 834 Hundred Guilder Print (Rembrandt), 721-722, 721 Hunt, William Holman, 881 *The Awakening Conscience*, 882–883, 882 Huysmans, Joris-Karl, 918 I and the Village (Chagall), 969, 969 Ibsen, Henrik, 921 Icebergs (Church), 834 Iconoclasm, 635 Ignatius of Loyola, 607, 633, 687, 689 Il Gesù church, Rome (Della Porta), 607–609, 607, 608 ceiling fresco (Gaulli), 674, 675 Imitation of Christ (Thomas à Kempis), 479 Immaculate Conception (Murillo), 696, 696 Immaculates, 1018 Impasto, 479, 619 Impression, Sunrise (Monet), 871, 873-874, 873 Impressionism, 860 color theory, 874 en plein air painting 872, 877 exhibitions, 871, 877, 879, 880, 915 painting, 871-881, 872-873, 875-880 use of term, 871 In the North the Negro Had Better Education Facilities (Lawrence), 1024, 1025 Incredulity of Thomas, The (Verrocchio), 524, 525 Independent Artists exhibition, 908 Independent Group, 1051 Index of Prohibted Books, 603 Industrial Revolution, 786, 792, 802, 821, 849, 861, 881 and architecture, 897-898 Infancy of Christ (Broederlam), altarpiece, 472-473, 472 *Information* exhibition, 1062 Ingalls Building, Cincinnati, 1013 **Ingres, Jean-Auguste-Dominique** Grande Odalisque, 837–838, 838 Portrait of Madame Inès Moitessier, 838, 839 Portrait of Napoleon on His Imperial Throne, 836–837, 837 The Vow of Louis XIII, 838 Ingres, Jean-Auguste-Dominique, 480 Inquisition, 633, 689 tribunal of Veronese, 620, 621 Installation Art, 1085, 1095, *1096*, 1100-1103 Insurrection (Our Tools Were Rudimentary, Yet We Pressed On) (Walker), 1097, 1097 Intaglio, 501

Interior of the Choir of St. Bravo's Church at Haarlem (Saenredam), 728–729, 728

Jasperware, 792, 792

International Congress of Women's Rights (1878), 879 International Gothic. See under Gothic, International International Style, 1020-1021, 1021 International Trans-avantgarde, The (Oliva), 1086 Interpretation of Dreams (Freud), 904 Invalides, church of the (Hardouin-Mansart), Paris, 752, 752 Inverted perspective, 655 Isabella, queen of Castile, 470 Isabella, queen of Spain, 565 It's Safe to Release This One! (Daumier), 864, 864 architecture, of city government, 448, 448, 453-454, 453 architecture, Gothic, 438-439, 439 art, importance to society, 455 frescoes, 439–441, 440, 450–453, 450–452, 459-461, 460, 461 cultural influences, 437-438, 449 geography, effects of, 437 illuminated manuscripts, 466, 466 map of sea trade routes, *438* map of Bubonic Plague spread, *464* mendicant orders, growth of, *439* painting Baroque, *663–675*, *664–674* painting, Gothic, *439–441*, *440*, 450–453, 450-452, 459-461, 460, 461 painting, Rococo, 775–776, 776 sculpture, Gothic, 442–444, 443–444, 465, 465 secular power, 437, 448 trade routes, 437, *438* Italy, Renaissance (early) architecture, 509-515, 510-513, 515, 533-534, 533, 534, 546-547, 546-547, 550, 550 bronze work, 507–509, *508*, 519–521, *520*, 521–523, *522*, *523*, 534–536, *535* map of, 506 Medici family, role of, 512-513, 530-531, 538-541 painting, 525-533, 526-533, 536-542, 537-542, 543-545, 544, 545, 547-550, 548, 549, 551-554, 551-554 sculpture, 507-509, 508, 515-525, 518-524, 534-535, 534, 534, 542-543, 543 Italy, Renaissance (High) architecture, 565–568, 566, 567 description of, 557-558 frescoes for Sistine Chapel, 573-577, 573, 574, 576 frescoes for Stanza della Segnatura, 578, 579-580, 579 and humanism 580 painting, 556, 558, 559–564, 561, 563, 564, 573–588, 573–588 papal and private commissions, 580-582, 580, 581 patrons' influence, 557 sculpture, 569-572, 569-572 use of term, 557 Italy, Renaissance (Late) architecture, 595–599, 595–598, 605–609, 605–609, 613–617, 614–616 description of, 591-592 Mannerism, 592-602, 593-601 map of Italian artists' travels, 592 Medici family, role of, 595–602 painting, 594, 594, 599–600, 599, 602, 603–604, 604, 607–608, 608, 609–613, 610–613, 617–622, 617–619, 621, 622 portraiture and allegory, 599-601, 599, 600 sculpture, 596, 596, 600-602, 600, 601, 604, 604 Jack of diamonds, 966 Jacob, Max, 950 Jacob-Desmalter, François-Honoré, 856 Jacobs, Joseph, 1066 Jahrhunderhalle (Centennial Hall) (Berg), 980, 980 James I, king of England, 737 James II, king of England, 737, 796 James, Henry, 889 James, William, 945 Japonisme, 870–871, *871*

Jean de Dinteville and Georges de Selve ("The Ambassadors") (Holbein the Younger), 624, 646–647, 647 Jean, duke of Berry, 473, 474 Jeanne-Claude (de Guillebon), Running *Fence*, 1060–1061, *1061* Jeanneret, Charles-Édouard. *See* Le Corbusier Jeanneret, Pierre, 1011 Jefferson, Thomas, 617 Jefferson, Thomas, University of Virginia, Charlottesville, 854-855, 855 Jesuits, 607, 633 *Jewish Cemetery* (Ruisdael), 726–727, 727 Joachimides, Christos, 1086 John Brown (Washington), 891-892, 891 John Hancock Center (Pei and Cobb) Johns, Jasper, *Three Flags*, 1045–1046, *1046* Johnson, Philip, 1010, 1082 Seagram Building, New York, 1069–1070, 1070 Johnson, Samuel, 790 Johnson, William, 795 Jolly Toper (Frans Hals), 716-717, 716 Jones, Inigo, 738, 757 Banqueting House, Whitehall Palace, 754, 754 Jonghelink, Niclaes, 657 Jordaens, Jacob, The King Drinks, 708-709, 708 Joseph the Carpenter (La Tour), 739-740, 740 Josephine Bonaparte, 840, 856 Joyce, James, 954 Juan de Pareja (Velasquez), 692–693, 693 Judd, Donald, Untitled, 1056, 1057 Judgment of Paris (Cranach the Elder), 644, 644 Judgment of Paris (Raphael), 583, 583 Judith and Her Maidservant with the Head of Holofernes (Gentileschi), 668–669, 668 Jugenstil (Youth Style), Germany, 927 Julius II, pope, 568, 571, 579 Jullienne, Jean de, 764, 766 Jupiter and Io (Correggio), 610–611, 610 Just What Is It That Makes Today's Homes So Different, So Appealing? (Hamilton), 1051, 1051 Kabakov, Ilya on installations, 1102 Man Who Flew into Space from his Apartment, The, 1100–1102, 1101 Ten Characters, 1100, 1102 Kahlo, Frida, The Two Fridas, 1026, 1027 Kahn, Gustave, 917 Kahn, Louis, National Assembly Building, Dacca, Bangladesh, 1072, 1072 Kaisersaal Residenz (Neumann), Würzburg, 780–781, 780 Kandinsky, Vasily Concerning the Spiritual in Art, 959, 960 Sketch I for "Composition VII", 944, 959-960, 959 Kaprow, Allan 18 Happenings in 6 Parts, 1046–1047
18 Yard, 1046–1047, 1047
Käsebier, Gertrude, Blessed Art Thou Among Women, 937–938, 93
Kauffmann, Angelica, 798 Cornelia Presenting Her Children as Her Treasures (Mother of the Gracchi), 791-793, 793 Kelly, Ellsworth, Red Blue Green, 1054, 1055 Kempis, Thomas à, 479 Kent, William Chiswick House, England, 796-797, 797, 799, 800 garden landscape design, 800 Kenwood House library (Adam), England, 797-798, 799 Kepler, Johannes, 663 Kerouac, Jack, 1065
 Kiefer, Anselm, To the Unknown Painter, 1086–1087, 1086
 King Drinks, The (Jordaens), 708–709, 708 King, Martin Luther Jr., 1065 Kirchner, Ernst Ludwig Peter Schlemihl: Tribulations of Love, 957-958, 958 Street, Dresden, 956, 956

Kiss, The (Klimt), 921-922, 922 Klee, Paul, The Niesen, 961, 961 Klimt, Gustav, The Kiss, 921–922, 922, 923 Kokoschka, Oskar, Bride of the Wind, 962-963, 962 Kollwitz, Käthe, 923 Never Again War!, 988–990, 990 Koons, Jeff, 1076 Michael Jackson and Bubbles, 1095-1096, 1095 Kosegarten, Gotthard Ludwig, 832 Kosuth, Joseph, One and Three Chairs, 1062–1063, 1062 Kruger, Barbara, 1103 Untitled (We Won't Play Nature to Your Culture), 1092–1093, 1092 Kunstkammern, 709 L'Ouverture, Toussaint, 1025 La Belle Jardinière (Beautiful Gardener) (Raphael), 577, 577 La Buena Fama Durmiendo (Good Reputation Sleeping) (Bravo), 1026–1028, 1027 La Goulue (Toulouse-Lautrec), 911-912, 912 La Marseillaise (Rude), 850-851, 851 La Tour, Georges de, Joseph the Carpenter, 739-740, 740 Labille-Guiard, Adélaïd, 791 Labrouste, Henri, Bibliothèque Sainte-Geneviève, Paris, 900, 900 Lady at Her Toilet (Ter Borch), 734, 734 Lady Sarah Bunbury Sacrificing to the Graces (Reynolds), 795–796, 796 Lady with a Bunch of Flowers (Verrocchio), 542-543, 543 Lamentation (Giotto di Bondone), Arena (Scrovegni) Chapel, Padua, 452, 452 Lamentation, Isenheim Altarpiece (Grünewald), 636, 637 Landscape garden, English, 799–800, 800 Landscape painting Baroque, 671–672, 671, 725–727, 725–727 Fauvism, 947, 948 Renaissance, 653–654, *654* Rococo, 767–769, *768*, 775–776, *776* Romanticism, American, 832-835, 833, 835 Romanticism, English, 827-830, 828, 830, 831 Romanticism, French, 847–849, 847–849 Romanticism, German, 831–832, 832 Landscape with St. John on Patmos (Poussin), 743, 744 Landscape with the Flight into Egypt (Carracci), 671-672, 671 Lange, Dorothea, Migrant Mother, California, 1029–1030, 1029 Lartigue, Henri Avenue du Bois de Bologne, 939–940, 940 My Hydroglider with Propeller, 939 Last Judgment (Giotto di Bondone), Arena (Scrovegni) Chapel, Padua, 436, 451 Last Judgment (Michelangelo), 602, 603-604, 604 Last Supper (Castagno), Sant'Apollonia, Florence, 531–532, 532 Last Supper (Leonardo da Vinci), 563-564, 563 Last Supper (Nolde), 956-957, 956 Last Supper (Tintoretto), 622, 622 Latrobe, Benjamin, Baltimore Cathedral, Maryland, 855, 855 Laugier, Abbé Marc-Antoine, 806 Laurentian Library vestibule stairway (Michelangelo and Ammanati), 596, 597 Lautréamont, comte de, 993 Lavater, Johann Kaspar, 803, 843 Lawler, Louise, 1092 Lawrence, D.H., 1022 Lawrence, Jacob In the North the Negro Had Better Education Facilities, 1024, 1025 Migration Series, 1025 Le Brun, Charles creation of French Royal Academy of Painting and Sculpture, 745–746 *Expressions*, 746, 746 Louvre, 748–749, *748* Palace of Versailles, 749–751, *749–751* Le Chabut (Seurat), 910, 911

Le Corbusier, 1011 Dom-Ino, 1011 Notre-Dame-du-Haut, 1070-1071, 1071 and Purism, 1014 Towards a New Architecture, 1012 Villa Savoye, France, 1012–1014, 1012, 1014 Le Fauconnier, Henri, 963 Le Figaro, 964 Le Gray, Gustave, Brig on the Water, 896-897.897 Le Nôtre, André, design for the gardens at Versailles, 751-752 Le Vanneur (The Grain Sifter) (Millet), 863 Le Vau, Louis Louvre, Paris, 748-749, 749 Palace of Versailles, 749-51, 749-50 Learning from Las Vegas (Venturi and Brown), 1077 Lebrun, Jean-Baptiste-Pierre, 816 LED boards, 1093, 1094 Ledoux, Claude-Nicolas Chaux, entrance portico, saltworks, Arc-et-Senans, 808–809, *809* Chaux, house plan for the ideal city of, 809-810, 809 Lee, Sir Henry, 649 Leewenhoek, Antonie van, 663 Léger, Fernand, 1011 Three Women (Le Grand Déjeuner), 1014-1015, 1015 Legs, Walking in Front of a Black Wall (Marey), 940, 941 Lenzi family, 527 Leo X, pope, 577, 581, 593, 595 Leonardo da Vinci, 525 as architect and engineer, 559–561, 560 Embryo in the Womb, 559, 560 Last Supper, 563-564, 563 manuscripts, excerpts from, 562 Mona Lisa, 564, 565 Portrait of Ginevra de' Benci, 558, 559 Project for a Church, 560, 561 Virgin of the Rocks, 561–563, 561 Vitruvian Man, 559, 560 Les Métafisyx (Dubuffet), 1042-1043, 1043 Les Vingt, 920 Lescaze, William E., Philadelphia Savings Fund Society Building, Philadelphia, 1020–1021, 1021 Lescot, Pierre, The Louvre, Paris, 627-628, 628 Letter Concerning Art, or Science of Design (Shaftesbury), 796 Levine, Sherrie, 1092 Leyster, Judith The Proposition, 717–718, 717 Self-Portrait, xxi, xxi, 716, 717 Library of San Marco (Sansovino), 614, 614 Lichtenstein, Roy, 1050 Drowning Girl, 1049, 1049 Liège, Cathedral Treasury, 487 Life and Landscape on the Norfolk Broads (Emerson), 937 Light Cycle: Explosion Project for Central Park (Guo-Qiang), 1106, 1106 Light-Space Modulator (Moholy-Nagy), 1009, 1009 Limbourg Brothers, Les Très Riches Heures du Duc de Berry, 473-474, 473, 474.474 Lin, Maya, Vietnam Veterans Memorial, 1090–1091, 1090 Lincoln, President Abraham, 893, 894 Linear (scientific) perspective, 512, 514, 516 Linearity, 788 Lion Attacking a Horse (Stubbs), 801-802, 802 Liotard, Jean-Étienne, Still-Life Tea Set, Lippi, Filippino, Brancacci Chapel frescoes, Santa Maria del Carmine, Florence, 528, 529–530, 529 Lippi, Fra Filippo, Madonna and Child with the Birth of the Virgin, 537–538, 538 Lipps, Theodor Lithography, 911 Little House (Wright), Minnesota, 935–936, 935 Liver Is the Cock's Comb, The (Gorky),

Liver Is the Cock's Comb, The (Gorky), 1037, 1037

Lobster Trap and Fish Tail (Calder), 1001, 1001 Locke, Alain, 1024 Locke, John, 785, 796 Loggia, 510 London Banqueting House, Whitehall Palace (Inigo Jones), 754, *754* Chiswick House (Lord Burlington and William Kent), 796–797, 797, 799, 800 Crystal Palace (Paxton), 898–899, *898* Great Exhibition, 861, 898–899 Great Fire of 1666, 754, 755-758 Green Dining Room (Morris), Victoria and Albert Museum (South Kensington Museum), 883–884, 883 Houses of Parliament (Barry and Pugin), 852-853, 852 Kenwood House library (Adam), 797-798, 799 St. Mary-le-Bow church steeple (Wren), 757.758 St. Pancras Station train shed, 898, 898 St. Paul's Cathedral (Wren), 756, 757–758, 757 Longhena, Baldassare, Santa Maria della Salute church, Venice, 684, 684 Loos, Adolf, Steiner House, Vienna, 976-977, 976 Lorenzetti, Ambrogio Good Government in the City and Good Government in the Country, 459-461, 460, 461 Lorenzetti, Pietro, Birth of the Virgin, 458-459, 459 Lorrain, Claude (Claude Gellée), 761 Book of Truth (Liber Veritas), 744, 747 influence on English landscape gardens, 799-800 A Pastoral Landscape, 743-745, 745 The Tempest, 747, 747 Louis IX, king of France, 626 Louis Napoleon, 861, 868 Louis XIII, king of France, 705, 738, 739, 751 Louis XIV, king of France, 737, 748, 749, 751, 753, 762 style of 738-753 Louis XIV, Portrait of (Rigaud), 746-748, 746 Louis XV, king of France, 761, 762, 766, 806 Louis XVI, king of France, 761, 817 Louis XVIII, king of France, 841, 842 Louis-Philippe, king of France, 850, 860, 864 Louvre East front (Le Vau, Perrault and Le Brun), *xxvi*, 748, 748 Salon exhibitions, 835 Square Court (Lescot), 627-628, 628 Loves of the Gods (Carracci), 670, 671 Loyer, Gerard, Statuette of Charles the Bold, 487-488, 488 Lully, Jean-Baptiste, 748 Lumière, Louis and Auguste, 942 Luncheon of the Boating Party (Renoir), 874-876, 875 Luncheon on the Grass (Manet), 866, 868-869, 868 Luther, Martin, 591, 603, 642 Ninety-five Theses, 634 Lynch Fragment: Some Bright Morning (Edwards), 1067, 1067 Mach, Ernst, 965 Mackintosh, Charles Rennie, Glasgow School of Art, 930–931, *930* Salon de Luxe, Willow Tea Rooms, *930*, 931 Maderno, Carlo, St. Peter's basilica, Rome, 675-675, 676 Maderno, Stefano, Santa Cecilia, 684, 685 Madonna and Child (della Robbia), Or San Michele, 524, 524 Madonna and Child (Melun Diptych) (Fouquet), 494-495, 495 Madonna and Child (Memling), from Diptych of Martin van Nieuwenhove, 491–492, 491

Madonna and Child with Angels, Isenheim Altarpiece (Grünewald), 636, 637

Madonna and Child with Saints (Domenico), 532–533, 533 Madonna and Child with the Birth of the Virgin (Fra Filippo Lippi), 537–538, 538 Madonna Enthroned (Cimabue), 449, 449 Madonna Enthroned (Giotto di Bondone), 450, 450 Madonna with Members of the Pesaro Family (Titian), 556, 586–588, 587 Madonna with the Long Neck (Parmigianino), 612-613, 612 Maestà Altarpiece (Duccio) Annunciation of the Death of the Virgin, 456, 456 Christ Entering Jerusalem, 456, 457 Madonna Enthroned, 454-456, 454-455 Magiciens de la Terre exhibition, 1076 Magritte, René, The False Mirror, 997, 997 Mahler, Alma, 962, 962 Mahler, Gustav, 962 Maids of Honor (Velasquez), 693–695, 694 Mail Art, 1048 Malevich, Kazimir Non-Objective World, 968 Suprematist Composition: Airplane Flying, 968, 969 Victory over the Sun, 966 0, 10 (Zero-Ten): The Last futurist Exhibition, 968, 968 Mallarmé, Stephen, 917 Malouel, Jean, 472, 473 Man at the Crossroads Looking with Hope and High Vision to a New and Better Future (Rivera), 1025 Man in a Red Turban (Jan van Eyck), 483, 483 Man in Black Suit with White Stripes Down Arms (Marey), 940, 941 Man on a Mower (Hanson), xxiv, xxiv Man Ray Champs délicieux, 992, 992 The Gift, 999, 1000 Return to Reason, The, 993 Man Who Flew into Space from his Apartment, The (Kabakov), 1100–1102, 1101 Man with a Blue Sleeve (Titian), 588, 588 Man, Controller of the Universe (Rivera), 1025-1026, 1026 Manet, Édouard Bar at the Folies-Bergère, 877–878, 877 Luncheon on the Grass, 866, 868–869, 868 Olympia, 869-870, 869 portrait photograph by Nadar, 892, 892 Manhatta (New York the Magnificent) (Strand and Sheeler), 1017-1018, 1018 Manifesto of Futurism (Marinetti), 964 Mannerism architecture, 595–599, 595–598 description of, 592–602, *593–601* origin of term, 592 sculpture, 601–603, *601* Mantegna, Andrea, 543 Camera Picta, 548, 549 St. Sebastian, 548, 548 Mantua, 546-550, 546-549 Manuscripts, illuminated Flemish, 488–489, 489 French Gothic International, 473-474, 473, 474, 474 Italian Gothic, 466, 466 Maps artists' travels, sixteenth-century Italy, 592 Cold War alliances, 1036 Dutch seventeenth-century trade routes, 702 England and France, seventeenth-century political unrest, 738 Europe, August 1914, *946* Europe in Age of Positivism, *860* Europe, Bubonic Plague spread, 464 Europe, crafts/manufacturing in fifteenth century, 470 Europe, end of nineteenth century, 904 Europe in the Enlightenment, 786 Europe, 1920s and 1930s, 984 Europe in the Rococo period, 762 Europe in the Romantic era, 822 Europe in seventeenth century, 662 Europe in twenty-first century, 1076 Florence, key monuments in, 517

Italian fourteenth-century sea trade routes, 438 Italy, Renaissance (early), 506 North America in Age of Positivism, 860 North America, August 1914, 946 North America, end of nineteenth century, 904 North America in the Enlightenment, 786 North America, 1920s and 1930s, 984 North America in the Romantic era, 822 North America twenty-first century, 1076 Rome, key monuments in, 566 Marat, Jean-Paul, 815-816, 815 Marc, Franz, Animal Destinies (The Trees Showed Their Rings, The Animals Their Arteries), 960–961, 960 Marchesa Brigida Spinola Doria (Rubens), 702-704, 703 Marconi, Guglielmo, 903 Marey, Étienne-Jules Legs, Walking in Front of a Black Wall, 940, 941 Man in Black Suit with White Stripes Down Arms, 940, 941 Margaret of Austria, 651 Margaret of Mâle, 471 Margarita, princess of Spain, 693 Maria Anna, queen of Spain, 693 Maria Christina, Archduchess, tomb of, Augustinerkirche, Vienna, 818, 818 Maria Luisa, queen of Spain, 824 Marie de' Medici, Queen of France, Landing in Marseilles (November 3, 1600) (Rubens), 705, 705 Marie-Antoinette, queen of France, 791, 816 Marigny, marquis of, 806 Marinetti, Filippo Tommaso, 964 Marlborough, duke of, 758 Marriage of Frederick Barbarossa (Tiepolo), 782, 782 Married Couple in a Garden: Portrait of Isaac Mass and Beatrix van der Laen (Frans Hals), 715-717, 716 Marshall Field Wholesale Store (Richardson), Chicago, 931-932, 931 Marter, Joan, 1050 Martini, Simone, Annunciation, 458, 458, 479, 479 Martyrium, 565 Marx, Karl, 821, 851, 861, 881 Mary I, queen of England, 648 Mary Magdalen (Donatello), 521, 521 Mary of Burgundy, Hours of Mary of Burgundy, 488-489, 489 Masaccio, 553 Brancacci Chapel frescoes, Santa Maria del Carmine, Florence, 528, 529-530, 529, 530 Expulsion from Paradise, 530, 530 Holy Trinity with the Virgin, St. John and Two Donors, 527–529, 527 real name of, 527 Tribute Money, 529-530, 529 Masolino, Brancacci Chapel frescoes, Santa Maria del Carmine, Florence, 528, 529-530, 529 Massa, Isaac, 714, 715, 716 Masson, André, 995, 1037 "masterpiece", origin of the term, 485 Matisse, Henri Femme au chapeau, 946-947, 947 Bonheur de Vivre, Le, 947-949, 948 The Red Studio, 949, 949 Matrix, 501 Max Schmitt in a Single Scull (The Champion Single Sculls) (Eakins), 887-888, 888 Mazarin, Cardinal, 738, 745 McGraw-Hill Building (Hood), New York City, 1020 Meat Stall (Aertson), 654, 655 Mechanical Head (Spirit of the Age) (Hausmann), 988, 988 Medici, Catherine de', Tomb of Henry II and Catherine de', Medici, 630–631, 631 Medici, Cosimo de', 530–531, 532, 533, 538 Medici, Cosimo I de', 591, 597, 599 Medici, Giovanni di Bicci de', 512, 530 Medici, Giovanni, 531 Medici, Guiliano, 542 Medici, Lorenzo the Magnificent, 531, 538, 540, 543, 558, 568, 577, 595

Medici, Piero de', 531, 534, 542, 543, 564 Meeting of Pope Leo I and Attila (Algardi), 687-689, 689 Melancthon, Philip, 635 Melencolia I (Dürer), 641, 641 Melun Diptych (Fouquet), 494-495, 495 Memling, Hans, Madonna and Child, from Diptych of Martin van Nieuwenhove, 491-492, 491 Memoirs of Louis XIV and His Court and of the Regency by the Duke of Saint-Simon, II, 752 Mengs, Anton Raphael, 782 Parnassus, Villa Albani fresco, 788, 788 Mercedarians (Order of Mercy), 695 Mérode Triptych (Campin), 477–479, 478 Metalwork, Flanders, 487–488, 488 Metzinger, Jean, 963 Mexico, art in interwar years, 1025-1028, 1026-1027 Meyer, Adolf, Fagus Factory, Germany, 978–979, 978 Mezzetin (Watteau), 764, 764 Mezzotint, 722 Micas, Nathalie, 865 Michael Jackson and Bubbles (Koons), 1095-1096, 1095 Michelangelo Buonarroti, 523, 525, 568 Awakening Prisoner, 572, 572 Campidoglio (Capitoline Hill), 605, 605, 606 Creation of Adam, 575-576, 576 David, 569-571, 570 Expulsion from the Garden of Eden, 574-575, 576 Fall of Man, 574-575, 576 *Last Judgment*, 602, 603–604, 604 Laurentian Library, 596, 597 *Moses*, 571–572, 571 New Sacristy, San Lorenzo, 595-596, 595 Palazzo Medici-Riccardi, 533-534, 533, 534 Palazzo dei Conservatori, 605, 606 Pietà, 568, 569, 569, 604–605, 604 poetry by, 572, 603 Sistine Chapel, 573-577, 573, 574, 576, 602, 603-604, 604 tomb of Guiliano de' Medici, 596-597, 596 576 tomb of Pope Julius II, 570, 571 Michelozzo di Bartolomeo, 514 Palazzo Medici-Riccardi, 533–534, 533, 534 Miel, Jan, Urban VIII Visiting Il Gesù, 607-608, 608 Mies van der Rohe, Ludwig Barcelona chair, 1010, *1011* German Pavilion, International Exposition, Barcelona, 1010, 1010, 1011 Seagram Building, New York, 1069-1070, 1070 Migrant Mother, California (Lange), 1029–1030, 1029 Migration Series (Lawrence), 1025 Milan in fourteenth century, 465-466 Visconti, Bernabò, tomb of, 465–466, 465 Milan, duke of, 507 Millais, John Everett, 881 Christ in the Carpenter's Shop (Christ in the House of His Parents), 882, 883 Millet, Jean-François Le Vanneur (The Grain Sifter), 863 The Sower, 863–864, 863 *Milo of Crotona* (Puget), 753, 753 Milton, John, 738, 804 Miniatures, xix Minimalism, 1056–1057, 1056–1057 Mining the Museum (Wilson), 1094-1095, 1095 Miraculous Draught of Fishes (Witz), 495–497, *497* Miró, Joan, 995 Composition, 996, 997 Modern Devotion, 469, 479 Modern Painters (Ruskin), 881 Modernism, 860 American, 974–976, 974–975, 1015–1025, 1016-1024 architecture, 932-935, 932-935, 976-979, 976-978

Art Deco, 1020, 1021

Art Nouveau, 927-931, 928-930 Bauhaus art, 1007–1011, 1008–1011 Conceptual Art, 987 Constructivism, 954, 954, 1003-1005, *1004–1005* Cubism, 950–970 Cubo-Futurism and Suprematism, 966-969, 967, 968 Dadaism, 985-993, 986, 988-992 Der Blaue Reiter, 958–961 De Stijl, 1003, 1005–1007, *1006–1007* Die Brücke, 955–958 Expressionism, Austrian, 962-963, 962-963 Expressionism, German, 955-961, 955-961 Fantasy, 969–970, 969–970 Fauvism, 946-949, 947-949 Futurism, 964-966, 965, 966 Harlem Renaissance, 1024-1025, 1024 International Style, 1020-1021, 1021 Mexican, 1025-1028, 1026-1027 Orphism, 964, 964 Purism, 1014-1015, 1014 sculpture, 971, 971, 972-974, 973 sculpture, organic, 1000–1003, 1001–1003 Surrealism, 993-1000, 994-1000 Modernity, use of term, 903–905 Modersohn-Becker, Paula, 923 Selbstbildnis, Halbakt mit Bernsteinkette (Self-Portrait with an Amber Necklace), 955, 955 Moholy-Nagy, Lázló, Light-Space Modulator, 1009, 1009 Moitessier, Inès, 837-838, 838 Mona Lisa (Duchamp), xxii-xxiii, xix, 987 Mona Lisa (Leonardo da Vinci), 564, 565 Monasteries, development of, 439–41 Mondrian, Piet, 1005, Composition with Red, Blue, and Yellow, 1006, 1006 on Neo-Plastic painting, 1007 Monet, Claude Impression, Sunrise, 871, 873–874, 873 Gare Saint-Lazare: Arrival of a Train, 874-875, 875 On the Bank of the Seine, Bennecourt, 872-873, 872 Wheatstack, Sun in the Mist, 880–881, 880 Monk by the Sea (Friedrich), 831 Mont Saint-Victoire (Cézanne), 905–906, 906 Mont Saint-Victoire Seen from Bibemus Quarry (Cézanne), 908, 908 Montefeltro, Frederico da, duke, 543, 545, 545 "Monument to the Third International" (Tatlin), 1004–1005, 1004 Moore, Henry, 1000 Recumbent Figure, 1002, 1002 More Than You Know (Murray), 1089, 1089 More, Thomas, 635 Moréas, Jean, 917 Moreau, Gustave, The Apparition, 918, 918 Moreisot, Berthe, Summer's Day (The Lake in the Bois de Boulogne), 878–879, 878 Morozov, Ivan, 966 Morris, Robert, 1047 Morris, William, 884, 885 Green Dining Room, Victoria and Albert Museum (South Kensington Museum), London, 883-884, 883 Morrison, Toni, 1097 Morse, Samuel, 891 Moses (Michelangelo), 571–572, 571 Mother and Child Divided (Hirst), 1099–1100, 1100 Motion photography, 940–941, *941* Motor Vehicle Sunset Event (Brecht), 1047 Mountain at Collioure (Derain), 947, 948 Mountains and Sea (Frankenthaler), 1053–1055, 1054 Moving pictures, 941–942, 942 Mr. and Mrs. I.N. Phelps Stokes (Sargent), 889, 889 Mrs Joseph Scott (Copley), xvii-xviii, xviii Mulvey, Laura, 923 Munch, Edvard The Scream, 921, 921

woodcut technique, 958

Münter, Gabriele, 958

Murillo, Bartolomé Esteban, Immaculate Conception, 696, 696 Murray, Elizabeth, More Than You Know, 1089, 1089 Museum of Modern Art, New York City, 1010 Deconstructivism exhibition, 1082 Fantastic Art, Dada, and Surrealism exhibition, 1036 Information exhibition, 1062 Sixteen Americans exhibition, 1055 Musician (Caravaggio), 667, 667 Muthesius, Hermann, 977–978 Muybridge, Eadweard Animal Locomotion, 940 Untitled (trot and gallop sequence) from La Nature, 940, 941 My Egypt (Demuth), 1018–1019, 1019 My Hydroglider with Propeller (Lartigue), 939 Mystery and Melancholy of a Street (De Chirico), 969-970, 970 Nabis, 917, 918 Nadar (Gaspard-Félix Tournachon) Édouard Manet, 892, 892 Le Panthéon Nadar, 892 Nanni di Banco, Quattro Coronati (Four Saints), Or San Michele, 516-517, 517 Napoleon III, emperor of France, 861 Napoleon in the Pest House at Jaffa (Gros), 840-841, 840 Napoleon, 821, 835 Portrait of Napoleon on His Imperial Throne (Ingres), 836-837, 837 Narrative, in William Hogarth's work, 775-776 Nash, John, Royal Pavilion, Brighton, 853–854, 853 Nation, The, 1053 National Assembly Building (Kahn), Dacca, Bangladesh, 1072, 1072 Nativity pulpit (G. Pisano), 444, 444 Nativity pulpit (N. Pisano), 443–444, 444 Nature (Emerson), 833 Nave, 439 Neoclassicism architecture, American, 854-855, 855 architecture, English, 796–798, 797–799 architecture, French, 784, 806–810, 807–810 decorative arts, English, 792, 792, 797–798, 799 development of, 786-787, 817 differences between Romanticism and, 787 painting, English, 791-796, 793, 794, 796 painting, French, 810-812, 811, 813-817, 814-816 porcelain, English, 792, 792 in Rome, 787–789, 788, 789 sculpture, English, 791, 791 sculpture, French, 812-813, 812 sculpture, Italian, 817-818, 817-818 use of term, 786 women artists, 791 Neo-Expressionism, 1085–1089, 1086-1088 Neo-Impressionism, 910-911, 910 Neo-Plasticism, 1007 Neptune and Amphitrite (Gossaert), 651–652, 652 Netherlands See also Flanders; Holland architecture, Renaissance, 652-653, 653 art market, Baroque, 725 De Stijl, 1003, 1005–1007, *1006–1007* map of seventeenth-century trade routes, 702 painting, Baroque, 700, 701-712, 703-712 painting, late fifteenth century, 490-493, 490-492 painting, Renaissance, 650–658, 650, 652–658 Reformation in, 650-651 seventeenth-century division of, 699 trade, 700 Neue Staatsgalerie (Stirling), Stuttgart, Germany, 1079–1080, *1079* Neufforge, Jean-François de, 806 Neumann, Balthasar, Kaisersaal Residenz (Episcopal Palace), Würzburg, 780-781, 780

Nevelson, Louise, 1041 Sky Cathedral-Moon Garden Plus One, 1042, 1042 Never Again War! (Kollwitz), 988–990, 990 New Brooklyn to New York via Brooklyn Bridge No. 2 (Edison), 942, 942 New Image Painting exhibition, 1089 New Industrial Revolution, 903 New Spirit in Painting show, 1086 New Ŵoman, 889, 904–905 New York City Abstract Expressionism, 1036–1042, 1037–1042 Armory Show, 974, 1019 Art of This Century gallery, 1037 Brooklyn Bridge (John and Washington Roebling), 899, *899* Dadaism, 986–987, *986* Deconstructivism exhibition, 1082 Fantastic Art, Dada, and Surrealism exhibition, 1036 Goupil Gallery, 834, 893 Grosvenor Gallery, 885, 887 Guggenheim Museum, Solomon R. (Wright), xxvi–xxvii, xxvii, 1038 Information exhibition, 1062 National Academy of Design, 832, 833, 986 Pop Art, 1949-1051, 1049, 1050 Seagram Building, 1069-1070, 1070 Sixteen Americans exhibition, 1055 291 art gallery, 974 Newman, Barnett, 1040 Newton, Isaac, 663, 755, 785 Project for a Tomb to Isaac Newton (Boullée), 810, 810 Nibelungenlied, 804 Niépce, Joseph-Nicéphore, 891 Niesen, The (Klee), 961, 961 Nietzsche, Friedrich, 955, 979 Night Café (Van Gogh), 913, 914 Night Watch (The Company of Captain Frans Banning Cocq) (Rembrandt), 720–721, 720 Nightmare, The (Fuseli), 804, 805 Nithart, Matthias Gothart. See Grünewald, Matthias No. 61 (Rust and Blue) (Rothko), 1040, 1040 Nochlin, Linda, 923 Nocturnal Clock (Campini and Trevisani), 678-679, 678 Nocturne in Black and Gold: The Falling Rocket (Whistler), 887, 887 Nocturnes, 887 Nolde, Emil, The Last Supper, 956–957, 956 nominal three (to William of Ockham), the (Flavin), 1057, 1057 Non-Objective World (Malevich), 968 Nonsite sculptures, 1060 North America, maps of in the Age of Positivism, 860 in August 1914, 946 at end of nineteenth century, 904 in the Enlightenment, 786 in 1920s and 1930s, 984 in the Romantic era, 822 in twenty-first century, 1076 Notre Dame church (Perret), Le Raincy, 1013, 1013 Notre-Dame de Paris (Hugo), 800 Notre-Dame-du-Haut (Le Corbusier), 1070–1071, *1071 Nude Descending a Staircase* (Duchamp), 970-971, 971 Nymph and Satyr Carousing (Clodion), 774, 774 Nymphs and Satyr (Bouguereau), 866-867, 866 O Gadji Beri Bimba (Ball), 985 O'Keeffe, Georgia, Black Iris III, 1022, 1022 O'Sullivan, Timothy, A Harvest of Death, Gettysburg, Pennsylvania, July 1863, 894–895, 894 Oath of the Horatii (David), 813-815, 814 Object (Luncheon in Fur) (Oppenheim), 1000, 1000 Observation on Architecture (Laugier), 806 October, 1075, 1092 Odalisk (Rauschenberg), 1044, 1045

Officer and Laughing Girl (Vermeer), 732-733, 732 Ofili, Chris, The Holy Virgin Mary, xx, xx Oil painting on canvas, 618 optical reality, 470 panel painting in, 477–486, 478–487, 492–495, 492–493, 495 Renaissance (early), 551–553, 551, 552 Renaissance (High), 558, 559–563, 561, 564, 565, 577-578, 577, 580, 581, 584-588, 584-588 Renaissance (Late), 593, 593, 594, 594, 594, 599–600, 599, 610, 610, 612–613, 612–613, 617–619, 617–618, 621–622, 621-622 Old Man and a Young Boy (Ghirlandaio), 541-542, 542 Old Man and Death (Wright), 802-803, 803 Old Sacristy, San Lorenzo church (Brunelleschi), 512–514, *512*, 527 Oldenburg, Claes, 1047 Oliva, Achille Bonito, 1086 Olympia (Manet), 869-870, 869 On the Bank of the Seine, Bennecourt (Monet), 872–873, 872 1 Copper Plate 1 Zinc Plate 1 Rubber Cloth 2 Calipers 1 Drainpipe Telescope 1 Piping Man (Ernst), 991, 991 One and Three Chairs (Kosuth), 1062-1063, 1062 One Thousand Years (Hirst), 1099 Opéra, The (Garnier), Paris, 867–868, 867 Oppenheim, Meret, Object (Luncheon in *Fur*), 1000, *1000* Or San Michele, Florence, 515–519, 518-519, 524-525, 524 Orchestra of the Paris Opéra (Degas), 858, 870-871, 870 Oriel, 930 Orientalism (Said), 951 Orientalism, 837 Origin of Language (Herder), 832 Origin of Species (Darwin), 903 Orphism, 963–964, 964 Orthagonals, 516 Otis, Elisha, 931 Oxbow (View from Mount Holyoke, Northampton, Massachusetts, after a Thunderstorm) (Cole), 833–834, 833 Ozenfant, Amédée, 1014 Pacher, Michael, St. Wolfgang Altarpiece, 497-499, 498 Padua, Italy Equestrian Monument of Gattamelata, (Donatello), 521, 521 Scrovegni Chapel, 450-453, 450-452 Paik, Nam June, Electronic Superhighway: Continental U.S., 1063-1064, 1064 Painter's Treatise (Het Schilder Boeck) (Van Mander), 656 Painting See also Frescoes; Landscape painting, Abstract Expressionism, 1036-1040, 1037-1040 action, 1038-1040, 1039, 1040 allover, 1039 American Modernism, 974–976, 974–975 American Realism, 885–890, 886–890 American Romanticism, 832-835, 833, 835 American Symbolism (Synthetism), 924, 924 architectural, 728-729, 728 Austrian Expressionism, 962-963, 962-963 Baroque, Dutch, 713-734, 715-717, 719–721, 723–734 Baroque, Flemish, 700, 701–712, 703–712 Baroque, French, 739-748, 740–742, 744-746 Baroque, Italian, 663-675, 664-674 Baroque, Spanish, 689-696, 690-696 on canvas, 618 Central Europe, fifteenth century, 497–498, 498 color field, 1040, *1040* contemporary history, 793–795, 794 Cubism, 950–954, 950, 952–953, 963–964, 964, 970–971, 971

Cubo-Futurism and Suprematism, 966–969, 967, 968 Dadaism, 988-992, 989-991 Dutch, Baroque, 713-734, 715-717, 719–721, 723–734 English Gothic, International, 476, 476 English Neoclassicism, 791–796, 793, 794, English Realism, 881-883, 882, 884-887, 884, 886 English Renaissance, 646–649, 647–649 English Rococo, 774–775, 775 English Romanticism, 801-806, 802-805, 825-830, 826, 828, 830, 831 en plein air, 847-848, 847, 872, 877 Expressionism, Austrian, 962-963, 962-963 Expressionism, German, 955-961, 955-961 Fantasy, 969-970, 969, 970 Fauvism, 946–949, 947–949 Flemish Baroque, 700, 701–712, 703–712 Flemish panel, 479–485, 480–484 Formalism, 1053–1056, *1054–1055* French baroque, 739-748, *740–742*, 744-746 French, fifteenth century, 494-495, 495 French Gothic, International, 472-473, 472 French Impressionism, 871-881, 872-873, 875-880 French Neoclassicism, 810-812, 811, 813-817, 814-816 French Post-Impressionism, 905-917, 906–910, 912–916 French Realism, 860–866, 862–866, 868–870, 868–870 French Rococo, 760, 763-772, 763-765, 767-772 French Romanticism, 835-849, 836-849 French Surrealism, 995-999, 996-998 French Symbolism (Synthetism), 917–920, *918–919* Futurism, 964–966, *965–966* genre, Baroque, 663, 693-695, 694, 716, 716, 730-734, 731-734 genre, Neoclassicism, 810-812, 811 genre, Renaissance Netherlands, 655-658, 655-658 genre, Rococo, 769–770, 770, 774, 775 genre, Romanticism, 827–829, *828* gesture, 1038 German Expressionism, 955–961, 955-961 German Renaissance, 635-637, 636-637, 638, 638, 639, 640, 642-644, 642, 644, 645 German Romanticism, 831-832, 832 Gothic, Italian, 439-441, 440, 450-453, 450-452, 459-461, 460, 461 Gothic, International, English, 476, 476 Gothic, International, French, 472-473, 472 Gothic, International, Prague, Bohemia, 474–476, 475 Harlem Renaissance, 1024-1025, 1024 Impressionism, French, 871-881, 872-873, 875-880 investigative techniques, 488 Italian Baroque, 663–675, 664–674 Italian, Gothic, 439–441, 440, 450–453, 450–452, 459–461, 460, 461 Italian Renaissance (early), 525–533, 526–533, 536–542, 537–542, 543–545, 544, 545, 547-550, 548, 549, 551-554, 551-554 Italian Renaissance (High), 556, 558, 559–564, 561, 563, 564, 573–588, 573-588 Italian Renaissance (Late), 593-594, Rahar Rehassance (Late), 555–574, 593–594, 599–600, 599, 602, 603–604, 604, 607–608, 608, 609–613, 610–613, 617–622, 617–619, 621, 622 Italian Rococo, 775–776, 776 Mannerism, 593-594, 593-594, 599-600, 599 Modernism, American, 974-976, 974-975 Neoclassicism, English, 791-796, 793, 794, 796 Neoclassicism, French, 810-812, 811, 813-817, 814-816 Neo-Expressionism, 1085-1089,

1086-1088

Neo-Impressionism, 910-911, 910 Netherlands, late fifteenth century, 490–493, 490–492 Netherlands, Renaissance, 650-658, 650, 652-658 oil, Renaissance (early), 551-553, 551, 552 oil, Renaissance (High), 558, 559–563, 561, 564, 565, 577–578, 577, 580, 581, 584-588, 584-588 oil, Renaissance (Late), 593, *593*, *593*, 594, *594*, 599–600, *599*, 610, *610*, 612–613, *612–613*, 617–619, *617–618*, 621–622, 621-622 panel painting in tempera and oil, 472–473, 472 477–486, 478–487, 490–493, 490–493, 542, 542, 545, 545, pastel, 769 plein air (open air), 847-848, 847, 872, 877 Pop Art, 1049-1053, 1049-1052 Post-Impressionism, 905-917, 906-910, 912-916 Post-Minimalism, 1085–1089, *1086–1089* Prague, Bohemia, Gothic, International, 474-476, 475 Realism, American, 885–890, 886–890 Realism, English, 881-883, 882, 884-887, 884, 886 oo7, 000 Realism, French, 860–866, *862–866*, 868–870, *868–870* Renaissance (early), Italian, 525–533, *526–533*, 536–542, *537–542*, 543–545, 544, 545, 547-550, 548, 549, 551-554, 551-554 Renaissance (High), Italian, 556, 558, 559-564, 561, 563, 564, 573-588, 573-588 Renaissance (Late), Italian, 594, *594*, 599–600, *599*, *602*, 603–604, *604*, 607–608, *608*, 609–613, *610–613*, 617-622, 617-619, 621, 622 Renaissance, Netherlands, 650-658, 650, 652-658 Renaissance, Spanish, 633–634, *633*, *634* Rococo, English, 774–775, *775* Rococo, French, 760, 763-772, 763-765, 767-772 Rococo, Italian, 775-776, 776 Romanticism, American, 832-835, 833, 835 Romanticism, English, 801–806, *802–805*, 825–830, *826*, *828*, *830*, *831* Romanticism, French, 835-849, 836-849 Romanticism, German, 831-832, 832 Romanticism, Spanish, 823-825, 823-825 Spanish Baroque, 689-696, 690-696 Spanish fifteenth century, 495, 496 Spanish Renaissance, 633–634, 633, 634 Spanish Romanticism, 823-825, 823-825 stain, 1054-1055 Surrealism, 993-994, 994, 995-999, 996-998 Symbolism (Synthetism), 917-924, 918-974 tenebrism, 665, *665* tondo (circular), 537, 538 Palaces Banqueting House, Whitehall Palace (Inigo Jones), 754, 754 Blenheim Palace (Vanbrugh and Hawksmoor), 758, 758 Camera Picta (Andrea Mantegna), Ducal Palace, Mantua, 548, 549 Doge's Palace, 464, 465, 550, 550 Escorial (Toledo and Herrera), 632-633, 632 Fontainebleau, 626-627, 626 Kaisersaal Residenz (Neumann), Würzburg, 780–781, *780* Louvre, 627–628, *628* Medici-Riccardi (Michelozzo), Florence, 533–534, *533*, *534* Palazzo dei Conservatori (Michelangelo), 605,606 Palazzo Farnese, 670, 671 Versailles, 749-751, 749-751 Palazzo Barberini (Cortona), Rome, 672–675, 673 Palazzo dei Conservatori (Michelangelo), 605, 606 Palazzo del Te (Guilio Romano), 609-610, 609,610

Palazzo della Signoria (Palzzo Vecchio) (Arnolfo di Cambio), Florence, 448, 448 Palazzo della Signoria, Florence, 521, 534, 535 Palazzo Farnese ceiling fresco (Carracci), Rome, 670, 671 Palazzo Medici-Riccardi (Michelozzo), Florence, 533–534, 533, 534 Palazzo Pitti (Ammanati), 598, 598 Palazzo Pubblico, Siena, 453-454, 453 Palette of King Narmer, from Hierakonpolis, *xix* Palladian Revival, 754, 796–797, *797*, *799* Palladio, Andrea Four Books on Architecture, 615, 616, 617 San Giorgio Maggiore church, 614-615, 615 Villa Rotonda, 615–616, 616 Palomino, Antonio, 693, on Velasquez, 695 Panel painting in tempera and oil, 472-473, 472 477-486, 478-487 Panthéon (formerly Sainte-Geneviève) (Sufflot), Paris, 806–807, *807* Paolozzi, Eduardo, 1051 Papacy See also under name of pope commissions from, 580–582, 580, 581 as patrons of the arts, 553-554, 557-558, 565, 571–577, 663 schism between France and Rome, 437, 469, 507, 553 Papal States, Renaissance and, 553-554, 553, 554 Paper manufacture, 499 Paradise Lost (Milton), 804 Parallels Between the Ancients and Moderns (Charles Perrault), 749 Paris Arc de Triomphe, 850-851, 851 Bibliothèque Sainte-Geneviève, Paris, 900, 900 Centre National d'Art et Culture Georges Pompidou, Paris, 1080, 1081 Church of the Invalides, 752, 752 Dadaism, 992–993, 992 École des Beaux-Arts, 866, 878 Eiffel Tower, 900, 900 Hôtel de Varengeville room, 773, 773 International Exposition, 900 Louvre, 627–628, 628 Métro station, 929, 929 The Opéra, 867–868, 867 Surrealism, 995–1000, 996–2000 Universal Exposition, 861, 863, 871 Parker, Charlie, 1067, 1088, 1089 Parker, Rozsika, 923 Parma Cathedral, Assumption of the Virgin (Correggio), 611–612, 611 Parmigianino (Girolamo Francesco Maria Mazzola) Madonna with the Long Neck, 612-613, 612 Self-Portrait, 612, 612 Parnassus (Mengs), Villa Albani fresco, 788, 788 Partisan Review, 1053 Pastel painting, 769 Pastoral Landscape (Claude Lorrain), 743-745, 745 Patinir, Joachim, The Penitence of St. Jerome, 653-654, 654 Patrons of art See also under name of in Baroque period, 663–664, 700, 701, 713 Black Death, effects of, 462 changing status of, 650, 651 French royal family as, 471 Gentileschi's description of her relationships with, 669 guilds in Renaissance Italy, 506, 507, 515-516, 518, 521, 524 Holy Roman emperors as, 475 in the Renaissance, 487, 525, 580-582, 625, 651 popes as, 553-554, 557-558, 565, 571-577, 580-582, 580, 581, 663 Renaissance elite families as, 512-513, 521, 525, 530-1, 539-541 Spanish royal family as, 824 study of art using, 525 US government as, 1029

women as, 531, 612

Paul III, pope, 603, 607 Pavlov, Ivan, 904 Paxton, (Sir) Joseph, Crystal Palace, London, 898–899, 898 Peasant Wedding (Bruegel the Elder), 657-658, 657 Peeters, Clara, Still Life with Fruit and Flowers, 710-711, 710 Pei, I.M., 1070 Pelkus Gate Near Utrecht (Van Goyen), 725, 725 Pelli, Cesar, 1013 Pencil of Nature, The (Talbot), 891 Penelope Weaving (Penelope at Her Loom), Flemish tapestry, 489–490, 490 Penitence of St. Jerome (Patinir), 653–654, 654 Pennsylvania Academy of the Fine Arts, 832, 879 Pepper (Weston), 1022, 1023 Percier, Charles, Bedroom of Empress Josephine Bonaparte, 856, 856 Performance Art, 1047, *1047* Perrault, Charles, 749 Perrault, Claude, Louvre, Paris, xxvi, xxvi, 748-749, 749 Perret, Auguste, 1011 Notre Dame church, Le Raincy, 1013, 1013 Perry, Lila Cabot, 872 Persistence of Memory (Dali), 998, 999 Perspective atmospheric (aerial), 491, 516 inverted, 655 scientific (linear), 512, 514, 516 Perugino, Pietro, *The Delivery of the Keys* to St. Peter, Sistine Chapel, Vatican, 553–554, 553 Pesaro Madonna (Titian), 585-586, 586 Pesaro, Jacob, 586, 587 Peter Schlemihl: Tribulations of Love (Kirchner), 957–958, 958 Peter Schlemihl's Wondrous History (Chamisso), 957 Peter the Great, 773 Petrarch, 505 Petronas Towers (Pelli), Kuala Lampur, Malaysia, 1013 Peyre, Marie-Joseph Architectural Works, 808 Théâtre Français (Théâtre de l'Odéon), Paris, 808, 808 Philadelphia Savings Fund Society Building (Howe and Lescaze), Philadelphia, 1020–1021, *1021* Philip II, king of Spain, 492, 494, 613, 617, 631, 632, 655 Philip IV, king of Spain, 689, 691, 693 Philip the Bold, duke of Burgundy, 471, Philip the Good, duke of Burgundy, 470, 480 Philip, duke of Orléans, 762 Philosophical Inquiry into the Origin of Our Ideas on the Sublime and Beautiful (Burke), 790, 799, 801 Photo Secession, 936, 937-939, 937, 938 Photogram, 992 Photography as art, xxv, 895–897, 895, 936 deconstruction, 1092-1093, 1092-1093 documentary, 893–894, *894*, 939–940, *939*, 940 early, 890-891 large-scale, 1103-1105, 1103 motion, 940-941, 941 moving pictures, 941–942, 942 photojournalism, 894–895, *894* pictorialism and combination printing, 895-897, 895, pictorialist and photo secession, 936-939, 936-938 portraiture, 891–892, *891–892* Postmodern, 1092–1093, *1092–1093* postwar, street, 1064-1065, 1065 snapshot/vernacular/found, 939-940, 939, 940 Surrealism and, 999-1000, 999, 1000 Porcelain views, 892-893, 893 Photomontages, 989 Physical Impossibility of Death in the Mind

of Someone Living, The (Hirst), 1099 Physiocrats, 809

Portinari, Tommaso, 491

Piano, Renzo, Centre National d'Art et Culture Georges Pompidou, Paris, 1080, 1081 Picabia, Francis, 992 Picaso, Pablo, 877 Demoiselles d'Avignon, Les, 950–952, 950 Guernica, 1031–1032, 1032 Guitar, Sheet Music, and Wine Glass, 953–954, 953 Head of a Woman, 994–995, 994 Three Dancers, 993–994, 994 Violin, 954, 954 Pictorialism in photography, 895–896, 895 Picture postcards, 936 Pictures exhibition, 1092 Picturesque, 799 Piero della Francesca, 543 Double Portrait of Battista Sforza and Frederico da Montefeltro, 545, 545 Resurrection, 544, 545 Piers, 446 Pietà (Bermejo), 495, 496 Pietà (Michelangelo), 568, 569, 569 Pietà (Titian), 619–620, 619 Pilgrimage to Cythera (Watteau), 763–764, 763 Pilon, Germain, Tomb of Henry II and Catherine de' Medici, 630-631, 631 Pilotis, 1012 Pineau, Nicolas, 771 Hôtel de Varengeville room, Paris, 773, 773 Piper, Adrien, 1096 Piranesi, Giovanni Battista Roman Antiquities, 789 Tomb of the Metalli, from Roman Antiquities, 789–790, 790 Pisano, Andrea, Bronze doors, baptistery of San Giovanni, Florence, 446-448, 447, 448 Pisano, Giovanni, 442, 455 Nativity, pulpit, Pisa, 444, 444 Pisano, Nicola, 442, 445 Fortitude, pulpit, Pisa, 443, 443 Nativity, pulpit, Pisa, 443–444, 444 pulpit, Pisa, 443, 443 Pissarro, Camille, 871 Climbing Path, L'Hermitage Pontoise, 876–877, 876 Pitt, William, 827 Planarity, 788 Planck, Max, 945 Plant Forms (Dove), 974, 975 Plantin Press, 701 Plainin Fress, 701 Plein-air painting, 847–848, 847 Plowing in the Nivernais: The Dressing of Vines (Bonheur), 865–866, 865 Plum Estate, Kameido (Hiroshige), 871, 871 Pochades, 847 Poe, Edgar Allan, 919, 923 Poetry, Elizabethan, 648, 649 Pointillism, 910 *Poling the Marsh Hay* (Emerson), *936*, 937 Political art, 1096–1098, *1096–1098* Poliziano, 541 Polke, Sigmar, 1051–1052 Alice in Wonderland, 1052, 1053 Bunnies, 1053 Pollaiuolo, Antonio del, 533 Battle of the Nudes, engraving, 536, 536 Hercules and Antaeus, 535–536, 535 Pollock, Griselda, 923 Pollock, Jackson, 1038, 1046 Autumn Rhythm: Number 30, 1034, 1038, 1039 Polyptych, 454 Pompadour, Madame de, 766, 767 Pompidou Center. See Centre National d'Art et Culture Georges Pompidou Pont-Aven school, 915 Pontormo, Jacopo da Capponi chapel, Santa Felicita church, Florence, 593–594, *594* Pietà, 594, 594 Pop Art, 1049-1053, 1049-1052 Pope, Alexander, 790 Popova, Lyubov, *The Traveler*, 966, 967 Jasperware, 792, 792 Meissen, 770 Sèvres, 770 Portinari Altarpiece (Goes), 490–491, 490

Portrait bust, 542 Portrait of a German Officer (Hartley), 975-976, 975 Portrait of an Insane Man (Man Suffering from Delusions of Military Rank) (Géricault), 842–843, 843 Portrait of Charles I Hunting (Van Dyke), 707-708, 707 Portrait of Eleanora of Toledo and Her Son Giovanni de' Medici (Bronzino), 599, 599 Portrait of Ginevra de' Benci (Leonardo da Vinci), 558, 559 Portrait of Louis XIV (Rigaud), 746-748, 746 Portrait of Madame de Pompadour (Boucher), 766, 767 Portrait of Madame Inès Moitessier (Ingres), 838, 839 Portrait of Mrs. Richard Sheridan (Gainsborough), 805-806, 805 Portrait of Napoleon on His Imperial Throne (Ingres), 836–837, 837 Portrait of Pope Leo X with Cardinals Guilio de' Medici and Luigi de' Rossi (Raphael), 580, 581 Portrait of Saskia can Uylenburgh, 718-719, 719 Portraiture See also under name of and allegory, 599–600, 599 American, 889, 889 Baroque, 669, 669, 692–695, 693, 694, 702–708, *703–707*, 714–718, *715–717*, 720–721, *720*, 724, *724*, 746–748, *746* Leonardo's reinvention of women's, 565 photography, 891-892, 891-892 pastel painting, 769, 769 Renaissance, 541-543, 542, 543, 648-649, 649 Rococo, French, 766, 767 Portuguese, The (Braque), 952–953, 952 Positive Philosophy (Comte), 859 Positivism, 859 Posters, 1005, *1005*, 911 Post-Impressionism, painting, 905-917, 906-910, 912-916 Post-Minimalism, 1058-1064, 1058-1064, 1085-1091, 1088-1090 Postmodernism Abstract Expressionism, 1036-1042, 1037-1042 African American work, 1065–1068, 1066-1068 architecture, 1077–1085, 1078–1085 Conceptual Art, 1044–1046, 1044, 1046, 1062–1063, description of era, 1075–1077 earthworks, 1059–1060, *1060* Environments, Happenings and Performance Art, 1046-1047, 1047, 1048, 1048 feminist art, postwar, 1068–1069, *1069* feminist art, postwar, 1068–1069, *1069* formalism, 1053–1057, *1054–1057* Installation Art, 1085, 1095, *1096*, 1100–1103 Minimalism, 1056–1057, 1056–1057 Neo-Expressionism, 1085-1089, 1086-1088 Photograph, 1092–1093, *1092–1093* photography, street, 1064–1065, *1065* Pluralism, 1085, 1089, *1089* Pop Art, 1049–1053, *1049–1052* Post-Minimalism, 1058–1064, 1058–1064, 1085-1091, 1088-1090 site-specific, 1060-1061, 1061 television art, 1063-1064, 1064 use of term, 1075 Video Art, Post-Painterly Abstraction, 1055 Post-Structuralism, 1075 Pouncing, 575 Poussin, Nicolas, 687 Abduction of the Sabine Women, 742-743, 742, 743 Death of Germanicus, 736, 741-742, 741 and the ideal landscape, 743 Landscape with St. John on Patmos, 743, 744 views on art, 742, 743 Poussinistes, 763 Prairie Houses (Wright), 934–936, *934–935*

Precisionism, 1018

Predella, 525 Pre-Raphaelite Brotherhood, 881-884 Preservation of frescoes, 441 of tapestries, 629 Prevalence of Ritual: Baptism (Bearden), 1065–1067, 1066 Primaticcio, Francesco Room of the Duchesse d'Ètampes, Fontainebleau, France, 629–630, 630 Tomb of Henry II and Catherine de' Medici, 630–631, 631 Primavera (Botticelli), 540, 540 Primitives, 835-836, 836 Primitivism, 951 Principles of Harmony and Contrast of Colors (Chevreul), 874 Principles of Physiological Psychology (Wundt), 904 Printing, 469 centers in Colmar and Basel, 501-502, 502 development of, 499–501, *500, 501* and humanist ideas, spread of, 505–506, 635 impact on Reformation of, 635, 643 Printmaking techniques, 501, 722, 827 Prix, Wolf, 1083 Process art, 1058-1059 Project for a Church (Leonardo da Vinci), 560, 561 Pronk (flamboyant) still life, 712, 712 Proposition, The (Judith Leyster), 717-718, 717 Proserpine (Rossetti), 884-885, 884 Protestant Reformation, 591, 603, 635, 643 Proudhon, Pierre-Joseph, 861 Prune Flat (Whitman), 1047, 1047 Public Services Building (Graves), Portland, Oregon, 1078, *1079* Puget, Pierre-Paul, Milo of Crotona, 753, 753 Pugin, Augustus Welby Northmore, Houses of Parliament, London, 852–853, 852 Puryear, Martin, The Spell, 1089-1090, 1090 Pythagoras, 511 Quattro Coronati (Four Saints) (Nanni di Banco), Or San Michele, 516-517, 517 Quince, Cabbage, Melon, and Cucumber (Sánchez Cotán), 690, 690 Raft of the Medusa (Géricault), 841-842, 842 Raimondi, Marcantonio, 583, 747 Rainaldi, Carlo, 681 Rainer, Yvonne, 1059 Raising of the Cross (Rubens), 698, 700, 701-702 Rake's Progress, The (Hogarth), 774-775, 775 Rape of Europa (Titian), 617-619, 618 Rape of the Sabine Women (Bologna), 601–602, 601 Raphael (Raffaello Sanzio) Alba Madonna, xix death of, 583 early madonnas, 577, Galatea, 582–583, 582 Judgment of Paris, 583, 583 La Belle Jardinière, 577, 577 Portrait of Pope Leo X with Cardinals Guilio de' Medici and Luigi de' Rossi, 580, 581 School of Athens, 579–580, 579 St. Paul Preaching at Athens, 581–582, 581 Stanza della Segnatura frescoes, 578, 579–580, 579 Rational Classicism, 806-807, 807 Rauschenberg, Robert, 1044 Odalisk, 1044, 1045 White Paintings, 1045 Rayograph, 992 Readymades, 972, 986 Realism development of, 859–860 painting, American, 885–890, *886–890* painting, English, 881–883, *882*, 884–887, *884*, 886 painting, French, 860-866, 862-866, 868-870, 868-870 rejection of academic values, 866

scientific realism painting, 887-888, 888 sculpture, French, 866–867, 867 Recumbent Figure (Moore), 1002, 1002 Red Blue Green (Kelly), 1054, 1055 Red Studio (Matisse), 949, 949 Redon, Odilon, Eye Like a Strange Balloon Mounts Toward Infinity, 918–919, 919 Reflections on the Imitation of Greek Art in Painting and Sculpture (Winckelmann), 787 Reformation, 591-592, 603, 625 art in central Europe, 634-646, 636-646 in Basel, 646 in England, 647–649, 647–649 in the Netherlands, 650–651 Rejlander, Oscar Gustave, 895 Relief prints, 501 Relief, 443 Rembrandt van Rijn Bathsheba with King David's letter, 722-724, 723 Blinding of Samson, 719-720, 719 Hundred Guilder Print, 721-722, 721 Night Watch (The Company of Captain Frans Banning Cocq), 720-721, 720 Portrait of Saskia can Uylenburgh, 718–719, 719 Self-Portrait, 724, 724 workshops, authenticity of, 718 Renaissance architecture, French, 626–628, 626, 628 architecture, Netherlands, 652-653, 653 architecture, Spain, 632-633, 632 artists, changing status of, 639-641, 640, 641, 651 decorative art, French, 628–631, 628, 630-631 humanist themes and religious turmoil, 646-647, 646, 647 Mannerism, 592-602, 593-601 map of Europe in sixteenth century, 627 origin of term, 505 painting, English, 646–649, *647–649* painting, German, 639, 640, 642-643, 642, 644-645, 644, 645, 646-647, 647 painting, Netherlands, 650-658, 650, 652-658 painting, Spanish, 633–634, *633, 634* patronage, 525 sculpture, French, 630–631, *630, 631* tapestry, French, 628–629, 628 woodcuts/engravings, 638-639, 638-639, 641, 641, 643-644, 643, 646, 646 Renaissance (early), Italian architecture, 509–515, *510–513*, *515*, 533–534, *533*, *534*, 546–547, *546–547*, 550, 550 bronze work, 507-509, 508, 519-521, 520, 521-523, 522, 523, 534-536, 535 description of, 505-507 map of Italy, 506 Medici family, role of, 512-513, 530-531, 538-541 painting, 525-533, 526-533, 536-542, 537-542, 543-545, 544, 545, 547-550, 548, 549, 551-554, 551-554 sculpture, 505, 507-509, 508, 515-525, 518-524, 534-535, 534, 542-543, 543 Renaissance (High), Italian architecture, 565–568, *566*, *567* description of, 557–558 frescoes for Sistine Chapel, 573-577, 573, 574, 576 frescoes for Stanza della Segnatura, 578, 579-580, 579 and humanism 580 painting, 556, 558, 559–564, 561, 563, 564, 573–588, 573–588 papal and private commissions, 580-582, 580, 581 patrons' influence, 557 sculpture, 569–572, *569–572* use of term, 557 Renaissance (Late), Italian, architecture, 595–599, 595–598, 605–609, 605–609, 613–617, 614–616 description of, 591–592 Mannerism, 592–602, 593–601 map of Italian artists' travels, 592 Medici family, role of, 595-602 painting, 594, 594, 599-600, 599, 602, 603-604, 604, 607-608, 608, 609-613, 610-613, 617-622, 617-619, 621, 622

portraiture and allegory, 599-601, 599, 600 sculpture, 596, 596, 600-602, 600, 601, 604, 604 Reni, Guido, Aurora, 672, 672 Renoir, Auguste, Luncheon of the Boating Party, 874-876, 875 Representaional Surrealism, 996-999, 997-998 Restoring works of art, 578 Resurrection (Piero della Francesca), 544, 545 Resurrection, Isenheim Altarpiece (Grünewald), 636, 637–638, 638 Return of the Hunters (Bruegel the Elder), 655-656, 656 Return to Reason (Man Ray), The, 993 Reynolds, Joshua, 791, 794, 826 discourse delivered to the Royal Academy, 795 Lady Sarah Bunbury Sacrificing to the Graces, 795–796, 796 Ribbed groin vaults, 446 Ribera, Jusepe de, The Club-Footed Boy, 690–691, 690 Riccardi family, 533 Richard II, king of England, 476 Richardson, Henry Hobson, Marshall Field Wholesale Store, Chicago, 931-932, 931 Richlieu, Cardinal, 738 Richter, Gerhard, 1051-1052 Rietveld, Gerrit, 1005 Red-Blue chair, 1006-1007, 1006 Schröder House, 1006, 1007, 1007 Rigaud, Hyacinthe, Portrait of Louis XIV, 746-748, 746 Riis, Jacob Five Cents a Spot, Unauthorized Lodgings in a Bayard Street Tenement, 939, 939 How The Other Half Lives, 939 Rinaldo and Armida (Van Dyke), 706, 707 Ripa, Cesare, Iconologia, 669 Rite of Spring (Stravinsky), 954 Rivera, Diego Man at the Crossroads Looking with Hope and High Vision to a New and Better Future, 1025 Man, Controller of the Universe, 1025-1026, 1026 Robespierre, 821 Robie House (Wright), Chicago, 934-935, 934, 935 Robinson, Henry Peach, 895 Rockefeller family, 1025 Rockefeller, John D., 1026 Rococo decorative arts, French, 772-774, 773, 774 development of, 761-762 difference between Baroque and, 761 in Germany and Austria, 776–782, 777–782 painting, English, 774-775, 775 painting, French, 760, 763-772, 763-765, 767-772 painting, Italian, 775–776, 776 sculpture, French, 774, 774 use of term, 661, 761 Rodchenko, Aleksandr, Advertisement: "Books!", 1005, 1005 Rodin with His Sculptures "Victor Hugo" and "The Thinker" (Steichen), 938, 938 Rodin, Auguste Burghers of Calais, 926–927, 927 Gates of Hell, 924–926, 925 The Thinker, 924–926, 926 Three Shades, 924–926, 925 Walking Man, 926, 926 Roditi, Édouard, 991 Roebling, John, Brooklyn Bridge, New York, 899, *899* Roebling, Washington, Brooklyn Bridge, New York, 899, 899 Röentgen, Wilhelm Konrad, 965 Rogers, Richard, Centre National d'Art et Culture Georges Pompidou, Paris, 1080, 1081 Rogier van der Weyden, 477 Descent from the Cross, 485–486, 486 St. Luke Drawing the Virgin, 468, 486, 487

Romano, Guilio Fall of the Giants, 609-610, 610 Palazzo del Te, 609-610, 609, 610 Romanticism development of, 821-822 differences between Neoclassicism and, landscape painting, American, 832-835, 833, 835 landscape painting, English, 827–830, 828, 830, 831 landscape painting, French, 847-849, 847-849 landscape painting, German, 831-832, 832 Painting, Cerning, Cerning, 61–652,
 painting, English, 801–806, 802–805,
 825–830, 826, 828, 830, 831
 painting, French, 835–849, 836–849 painting, German, 831-832, 832 painting, Spanish, 823-825, 823-825 in Rome, 789–790, 790 sculpture, French, 850–851, *850–851* use of term, 786, 821, 843 Rome See also Vatican Arch of Titus, Forum Romanum, xix, xix Campidoglio (Capitoline Hill) (Michelangelo), 605, 605, 606 map of key monuments, *566* Il Gesù church, 607–609, *607*, *608*, *674*, 675 Neoclassicism in, 787-789, 788, 789 Palazzo Barberini, 672-675, 673 Palazzo Farnese, *670*, *671* Romanticism in, 789–790, *790* sack of, 591, 592, 603 San Carlo alle Quattro Fontane, *679–689*, 679, 680 Sant'Agnese, 681-682, 682 Sant'Ivo, 680-681, 680-681 St. Peter's basilica, xxvi, 675-678, 676, 677 Tempietto, San Pietro church, 565–567, 566. 567 Villa Ludovisi, 672, 673 Rood, Ogden, 910 Roosevelt, Franklin Delano, 983, 1025 Rosenthal Center for Contemporary Art (Hadid), Cincinnati, 1083–1084, 1083 Rossellino, Bernardo, Tomb of Leonardo Bruni, 523–524, 523 Rossetti, Dante Gabriel, 881 Proserpine, 884-885, 884 Rosso Fiorentino Descent from the Cross, 593, 593 and School of Fontainebleau, 629 Rothko, Mark, No. 61 (Rust and Blue), 1040, 1040 Rousseau, Henri, The Dream, 919-920, 919 Rousseau, Jean-Jacques, 785, 787, 793, 822, 826 Rousseau, Théodore (Pierre-Étienne-), Under the Birches, Evening, 849, 849 Royal Academy of Art (England), 789, 791, 794, 802, 805, 826 Royal Academy of Art, Madrid, 823 Royal Academy of Painting and Sculpture (French Academy), 745-746, 761, 763, 806, 810, 815, 835, 866 Royal Crescent (Wood the Younger), Bath, England, 797, 798 Royal Pavilion (Nash), Brighton, 853-854, 853 Royal School of Architecture (France), 806 Rubénistes, 763 Rubens, Peter Paul, xxii Allegory of Sight (with Jan Brueghel the Elder), 709–710, 709 Drawing after Michelangelo's Ignudi from the Sistine Chapel Ceiling, 701, 701 Four Studies of the Head of a Negro, 704–705, 704 Garden of Love, 706, 707 letter to Sir Dudley Carleton, 704 Marchesa Brigida Spinola Doria, 702–704, 703 Raising of the Cross, 698, 700, 701–702 Marie de' Medici, Queen of France, Landing in Marseilles (November 3, 1600), 705, 705 workshops of, 705, 718 Rucellai, Giovanni, 515, 533

Rude, François, Departure of the Volunteers of 1792 (La Marseillaise), Arc de Triomphe, Paris, 850-851, 851 Ruff, Thomas, 1103 Ruffo, Don Antonio, 669 Ruisdael, Jacob van Bleaching Grounds Near Haarlem, 726, 726 Jewish Cemetery, 726-727, 72 Running Fence (Christo and Jeanne-Claude), 1060-1061, 1061 Ruskin, John, 881, 887 Russia Constructivism, 1003-1005, 1004-1005 Cubism and Futurism, 966-970, 967-970 Revolution, 987, 1003 Rusticated, 448 Rutherford, Ernest, 945, 959 Rutter, John, Delineations of Fonthill Abbey, 852 Ruysch, Rachel, Flower Still Life, 729-730, 730 Ryder, Albert Pinkham, Siegfried and the Rhine Maidens, 923–924, 923 Saar, Betye, Shield of Quality, 1067-1068, 1068 Saatchi Gallery, 1099 Sacchi, Andrea, Urban VIII Visiting Il Gesù, 607-608, 608 Sacred Grove, Beloved of the Arts and Muses (Chavannes), 909-910, 909 Saenredam, Pieter, Interior of the Choir of St. Bravo's Church at Haarlem, 728-729, 728 Said, Edward, 951 Saint Peter's basilica Bramante, 567–568, *567* Michelangelo, 606, 607 Saint-Simon, duke of, 752 Salimbeni, Lionardo Bartolini, 537, 538 Salomé (Beardsley), 921, 922 Salomé (Wilde), 921 Salon d'Automne, 908, 946, 947 Salon des Refusés (Salon of the Refused), 868, 869 Salons, 762, 810 d'Automne, 908, 946, 947 Courbet's rejection of, 866 Diderot's reviews of, 812 des Indépendants, 964, 970 Salsow, James, *Poetry of Michelangelo*, 572 Salutati, Coluccio. 507 San Brizio Chapel, Orvieto, 554, 554 San Carlo alle Quattro Fontane (Borromini), Rome, 679-689, 679, 680 San Francesco, basilica, Assisi, 438-440, 439.440 San Giorgio Maggiore church, Venice (Palladio), 614–615, 615 Last Supper (Tintoretto), 622, 622 San Giovanni baptistery, Florence, 445, 446 bronze doors (A. Pisano), 446-448, 447, 448. 507 bronze doors, Gates of Paradise (Story of Jacob and Esau) (Ghiberti), 521–523, 522, 523 bronze doors, Sacrifice of Isaac (Brunelleschi), 507-508, 508 bronze doors, Sacrifice of Isaac (Ghiberti), 507-508, 508 San Lorenzo church, Florence (Brunelleschi), 512–514, *512*, *513* San Zaccaria convent, altarpiece, 552, 552 Sánchez Cotán, Juan, Quince, Cabbage, Melon, and Cucumber, 690, 690 Sand, George (Amantine Aurore Lucile Dupin), 865 Sangallo the Younger, Antonio da, 607 Sansovino, Jacopo Library of San Marco, 614, 614 Venice Mint, 613-614, 614 Sant'Agnese (Borromini), 681–682, 68 Sant'Antrea church, Mantua (Alberti), 546-547, 546, 547 Sant'Ivo, Rome (Borromini), 680-681, 680-681 Santa Cecilia (Stefano Maderno), 684, 685 Santa Croce (Arnolfo di Cambio), Florence, 441–441, 442 Santa Maria della Salute church (Longhena), Venice, 684, 684

Santa Maria Novella church, Florence, 463, 463 façade (Alberti), 514-515, 515 Holy Trinity with the Virgin, St. John and Two Donors (Masaccio), 527–529, 527 Sardanapalus (Byron), 845 Sargent. John Singer reevaluation of, 889 Mr. and Mrs. I.N. Phelps Stokes, 889, 889 Saskia can Uylenburgh, Portrait of, 718–719, 719 Satie, Erik, 999 Savonarola, friar Girolamo, 543, 554, 558, 568 Scenes from the Massacre at Chios (Delacroix), 843-844, 844 Schapiro, Miriam, 1068 Scheerbart, Paul, 957 Schegel, Friedrich von, 821 Schiacciato, 519 Schiele, Egon, Self-Portrait with Twisted Arm, 963, 963 Schinkel, Karl Friedrich, Altes Museum, Berlin, 854, 854 Schlesinger and Meyer Store (Sullivan), Chicago, 933, *933* Schmitt, Max, 888, *888* Schnabel, Julian The Diving Bell and the Butterfly, 1087 The Exile, 1087-1088, 1087 Scholar in Study, woodcut from Ship of Fools (Brant), 502, 502 Schongauer, Martin, Temptation of St. Anthony, engraving, 501–502, 501, 502 School of Athens (Raphael), 579–580, 579 School of Fontainebleau, 629-630, 630, 738, 850 Schröder House (Rietveld), 1006, 1007, 1007 Science Baroque period and, 663 at beginning of twentieth century, 945 Enlightenment and, 786 Scientific (linear) perspective, 512, 514, 516 Scientific Aesthetic (Henry), 910 Scientific realism, 887 Scientific/technical study of paintings, 488 Scott, Walter, 845 Scream, The (Munch), 921, 921 Scrovegni Chapel, Padua, 450-453, 450-452 Scrovegni, Enrico, 451 Sculpture with Color (Deep Blue and Red) (Hepworth), 1002–1003, 1003 Sculpture Abstract Expressionism, 1041-1042, 1041-1042 Abstract organic, 1000-1003, 1001-1003 Baroque, French, 753, 753 Baroque, Italian, 660, 684-689, 685, 686, 688.689 Central Europe, fifteenth century, 498, 498 Constructivism, 1004, 1004, 1009, 1009 Cubism, 954, 954 Dada, 985-987, 986 English Neoclassicism, 791, 791 Formalism, 1056–1057, *1056–1057* French Baroque, 753, *753* French Gothic, International, 471–472, 471 French Neoclassicism, 812-813, 812 French Renaissance, 630-631, 630, 631 French Rococo, 774, 774 French Romanticism, 850-851, 850-851 French Surrealism, 999-1000, 1000 Futurism, 966, 966 Gothic, French International, 471-472, 471 Gothic, Italian, 442-444, 443-444, 465, 465 Italian Baroque, 660, 684–689, 685, 686, 688, 689 Italian Gothic, 442-444, 443-444, 465, 465 Italian Neoclassicism, 817-818, 817-818 Italian Renaissance (early), *504*, 507–509, *508*, 515–525, *518–524*, 534–535, *534*, 542-543, 543

Italian Renaissance (High), 569-572, 569-572

Italian Renaissance (Late), 596, 596, 600-602, 600, 601, 604, 604

Mannerism, 601-603, 601 Modern, 971-974, 971-973 Neoclassicism, English, 791, 791 Neoclassicism, French, 812–813, 812 Neoclassicism, Italian, 817–818, 817–818 nonsite, 1060 Post-Minimalism, 1058-1059, 1058, 1059 Postmodern, 1089-1091, 1090 Renaissance, French, 630–631, 630, 631 Renaissance (early), Italian, 507–509, 508, 515–525, 518–524, 534–535, 534, 542-543, 543 Renaissance (High), Italian, 569-572, 569-572 Renaissance (Late), Italian, 596, 596, 600–602, 600, 601, 604, 604 Rococo, French, 774, 774 Romanticism, French, 850-851, 850-851 Surrealism, 1000-1003, 1001-1003 Symbolism, 924-927, 925-927 welded, 994-995, 994, 995 Seagram Building (Mies van der Rohe and Johnson), New York, 1069–1070, 1070 Sears Tower (Skidmore, Owens, and Merrill), Chicago, 1070 Seated Young Woman (Watteau), 764, 765 Secession Style, Vienna, 922, 927 Section d'Or and Orphism, 963–964, 964 Secular images, Flemish, 483–485, 483, 484 Segal, George, The Gas Station, 1048, 1048 Selective wiping, 722 Self-Portrait (Anguissola), 613, 613 Self-Portrait (Dürer), 630-640, 640 Self-Portrait (Leyster), xxi, xxi, 716, 717 Self-Portrait (Parmigianino), 612, 612 Self-Portrait (Rembrandt), 724, 724 Self-Portrait as the Allegory of Painting (La Pittura) (Gentileschi), 669, 669 Self-Portrait with an Amber Necklace (Modersohn-Becker), 955, 955 Self-Portrait with Daughter (Vigée-Lebrun), 816–817, 816 Self-Portrait with Twisted Arm (Schiele), 963, 963 Serlio, Sebastiano, 565, 566, 617 Serra, Richard, Corner Prop, 1058-1059, 1059 Seurat, Georges A Bathing Place, Asnières, 908 influence of Puvis de Chavannes, 909-910, 909 Le Chabut, 910, 911 A Sunday Afternoon on the Island of La Grande Jatte, 908–909, 909, 910 Seven Lamps of Architecture (Ruskin), 881 Sforza, Ludovico, duke of Milan, 559, 563 Sfumato, 562 Shaftesbury, Earl (Anthony Ashley Cooper), 796 Shakespeare, William, 738, 845 Sonnet Eighteen, 649 Shanghai (Gursky), 1103–1105, 1103 Shchukin, Sergey, 966 Sheeler, Charles, Manhatta (New York the Magnificent), 1017-1018, 1018 Shelley, Percy Bysshe, 826 Sheridan, Richard 805 Sherman, Cindy, 1091, 1103 Untitled Film Still #1, 1093, 1093 Shield of Quality (Saar), 1067–1068, 1068 Ship of Fools (Brant), 502, 502 Siegel, Jeanne, 1091 Siegfried and the Rhine Maidens (Ryder), 923-924, 923 Siena, Palazzo Pubblico, 453-454, 453 Signorelli, Luca, *The Damned*, 554, *554* Sigüenza, Fray José de, 492, 493 The History of the Order of St. Jerome, excerpt from, 494 Silkscreen, xvii Silverpoint, 486, 575 Simmons, Laurie, 1092 Simpson, Lorna, 1096 Simultaneous contrast, 874 Simultaneous Disks/Contrasts (Delaunay), 964 Singing Lute Player (Terbrugghen), 713-714, 714 Sister Spirits (Cameron), 895-896, 895

Spain Sistine Chapel, Vatican cleaning works of art, 578 Creation of Adam, 575-577, 576 581-582, 581

Delivery of the Keys to St. Peter (Perugino), 553-554, 553 diagram of subjects in, 574 Expulsion form the Garden of Eden, 574–575, 576 Fall of Man, 574-575, 576 Last Judgment, 602, 603-604, 604 Libyan Sibyl, 574, 574 Michelangelo's work on, 573–577, 573, 574, 576, 602, 603–604, 604 Studies for the Libyan Sibyl, 575, 575 Site-specific art, 1059, 1060–1061, 1061, 1094-1095, 1094 Sixteen Americans exhibition, 1055 Sixtus IV della Rovere, pope, 553, 572 Sketch I for "Composition VII" (Kandinsky), 944, 959–960, 959 Sky Cathedral—Moon Garden Plus One (Nevelson), 1042, 1042 Skyscapers, 932-933, 932-933, 1015, 1020-1021, 1021 Slave Ship (Slavers Throwing Overboard the Dead and Dying—Typhoon Coming On) (Turner), 830, 831 Sleep of Endymion (Girodet), 835-836, 836 Sleep of Reason Produces Monsters (Goya), 823-824, 823 Sluter, Claus, Well of Moses, Chartreuse de Champmol, Dijon, France, 471-472, 471 Smith, Adolphe, 893 Smith, David, Cubi series, 1041-1042, 1041 Smith, Kiki, 1076 Untitled, 1098-1099, 1099 Smith, Mimi, Girdle, 1068 Smithson, Robert, Spiral Jetty, 1060, 1060 Snap the Whip (Homer), 888–890, 890 Snapshot (vernacular) photography, 939-940, 939, 940 Snowstorm: Hannibal and His Army Crossing the Alps (Turner), 829, 830 Snyders, Frans, Still Life with Dead Game, Fruits, and Vegetables in the market, 711–712, 711 Soane, Sir John, Consol's Office, Bank of England, 853, 853 Soap Bubbles (Chardin), 770, 770 Société Anonyme des Artistes, 871 Society of Artists, London, 802, 805 Society of Independent Artists, 987 Society of Jesus, 607 Sorel, Agnès, 495, 495 Sorrows of Young Werther, The (Goethe), 787, 803 Soupault, Philippe, 992, 993 Souvenir de Mortefontaine (Oise) (Corot), 820, 848–849, 848 Sower, The (Millet), 863-864, 863 architecture, Renaissance, 632-633, 632 Civil War in, 1031-1032 painting, Baroque, 689-696, 690-696 painting, fifteenth century, 495, 496 painting, Renaissance, 633–634, 633, 634 painting, Romanticism, 823-825, 823-825 religious orthodoxy, 631, 689 Spandrels, 444, 933 Spell, The (Puryear), 1089–1090, 1090 Spenser, Edmund, Sonnet Sixty-four from the Amoretti, 649 Spero, Nancy, 1068 Spiral group, 1065 Spiral Jetty (Smithson), 1060, 1060 St. Anthony Abbot, Isenheim Altarpiece (Grünewald), 636, 637 St. Bridget, Revelations, 635 St. Charles Borromeo church (Fischer von Erlach), Vienna, 777–779, 777
St. Francis Preaching to the Birds, Basilica of San Francesco, Assisi, 439-440, 440 St. Francis, Hymn of the Sun, 551 St. George (Donatello), Or San Michele, Florence, 519, 519 St. Luke Drawing the Virgin (Rogier van der Weyden), 468, 486, 487 St. Mark (Donatello), Or San Michele, Florence, 518-519, 518 St. Matthew and the Angel (Theodric), 475, 475 St. Pancras Station train shed, London, 898,

Strand, Paul 1017-1018, 1018 Struth, Thomas, 1103 801-802, 802 (formerly Sainte-Geneviève), Paris, 806-807, 807 St. Paul Preaching at Athens (Raphael), Suitor, The (Vuillard), 917, 918

St. Peter's basilica, Rome, xxvi, 675-678, 676, 677 St. Sebastian (Andrea Mantegna), 548, 548 St. Sebastian, Isenheim Altarpiece (Grünewald), 636, 637 St. Serapion (Zurbarán), 695–696, 695 St. Wolfgang Altarpiece (Pacher), 497–499, 498 Stamp Art, 1048 Stanza della Segnatura, Vatican Palace, 578, 579-580, 579 Starry Night (Van Gogh), 913–915, 914 States Of Mind I: Farewells (Boccioni), 965-966, 965 Statuette of Charles the Bold (Loyer), 487–488, 488 Steen, Jan, Feast of St. Nicholas, 730-731, 731 Steichen, Edward, Rodin with His Sculptures "Victor Hugo" and "The Thinker", 938, 938 Stein, Gertrude, 954 Stein, Leo, 954 Steiner House (Loos), 976–977, 976 Steiner, Rudolph, 959 Stella, Frank Black Paintings, 1055 Empress of India, 1055-1056, 1055 Pratt Institute Lecture, 1056 Stella, Joseph, Voice of the City (New York Interpreted), 1016, 1016–1007 Stendhal, 841 Stepanova, Varvara Fedorovna, Design for Sportswear, 1005, 1005 Stereocards, 892 Stieglitz, Alfred, 974, 986, 987, 1021–1022 City of Ambition, 938–939, 939 Still Life with Apples in a Bowl (Cézanne), 906-908, 907 Still Life with Dead Game, Fruits, and Vegetables in the market (Snyders), 711-712, 711 Still Life with Exotic Birds (De Heem), 712, 712 Still Life with Fruit and Flowers (Clara Peeters), 710–711, 710 Still Life with Oysters (Heda), 729, 729 Still, Clifford, 1040 Still-life paintings Dutch baroque, 729–730, 729–730 Flemish baroque, 710–712, 710–712 game, 711–712, 711 Post-Impressionist, 906–908, 907 pronk (flamboyant), 712, 712 Rococo, 771, 772 Spanish Baroque, 690, 690 Still-Life Tea Set (Liotard), 771, 772 Stipples, 639 Stirling, James Engineering School, Leicester, England, 1081 Neue Staatsgalerie, Stuttgart, Germany, 1079-1080, 1079 Stoffels, Hendrikje, 723 Stokes, Edith, 889, 889 Stone Breakers (Courbet), 862–863, 862 Stourhead Park (Flitcroft and Hoare), Wiltshire, England, 800, 800 Manhatta (New York the Magnificent), Wire Wheel, 1016-1017, 1017 Stravinsky, Igor, 954 Strawberry Hill (Walpole and others), Twickenham, England, 800–801, 801 Street Life in London (Smith), 893 Street photography, 1064-1065, 1065 Street, Dresden (Kirchner), 956, 956 Strindberg, August, 921 Strozzi cassone with the Conquest of Trebizond (Marco del Buono Giamberti and Apollonio di Giovanni di Tomaso), 537, *537* Strozzi, Palla, 525, 530 Stubbs, George, Lion Attacking a Horse, Sturm und Drang, 787, 803, 822, 832 Sublime, use of term, 790, 799, 808 Sufflot, Jacques-Germain, The Panthéon

Sullivan, Louis ideas of, 932-933 Schlesinger and Meyer Store, Chicago, 933. 933 Wainwright Building, St. Louis, 932-933, 932 Summer's Day (The Lake in the Bois de Boulogne) (Morisot), 878-879, 878 Sunday Afternoon on the Island of La Grande Jatte (Seurat), 908-909, 909, 910 Suprematist Composition: Airplane Flying (Malevich), 968, 969 Surrealism development of, 993 film and, 993, 997–998, *997*, 1017–1018, 1018 French, 995-999, 996-998 Photography and, 999, 999 Picasso and, 993–995, 994 objects, 999–1000, 1000 representational, 996–999, 997–998 Surrealist Manifesto (Breton), 992, 993 Surrender at Breda (Velasquez), 691–692, 692 Swedenborg, Emmanuel, 933 Swiczinsky, Helmut, 1083 Swinburne, Algernon Charles, 884, 885 Swing, The (Fragonard), 767–769, 768 Symbolism (Synthetism) defined, 917 painting, 917-924, 918-924 sculpture, 924-927, 925-927 Symphony in White No. I: The White Girl (Whistler), 885 Symphony in White No. 11: The White Girl (Whistler), 885–887, 886 Synthetic Cubism, 975–976, 975 Synthetism, 917 Talbot, William Henry Fox, 891 Talenti, Francesco, Florence Cathedral, 445-446, 445, 446 Tanner, Henry Ossawa, Angels Appearing before the Shepherds, 924, 924 Tapestry Flemish, 489–490, 490 French Renaissance, 628-629, 628 preserving, 629 techniques used in creating, 629 Tassel House stairwell (Horta), Brussels, 902, 928, 928 Tassi, Agostino, 667 Aurora, 672, 673 Tasso, Torquato, 707 Tatlin, Vladimir Corner Counterrelief, 1004, 1004 Project for "Monument to the Third International", 1004–1005, 1004 Taut, Bruno, Glass Pavilion, Werkbund Exhibition, Cologne, 979-980, 980 Television Art, 1063-1064, 1064 Tempera paints, 441 Tempest, The (Claude Lorrain), 747, 747 Tempest, The (Giorgione), 584, 584 Ten Books on Architecture (Alberti), 514 Ten Characters (Kabakov), 1100, 1102 Ten Commandments (Dove), 975 Tenniel, Sir John, 1053 Tennyson, (Lord) Alfred, 896 Ter Borch, Gerard, Lady at Her Toilet, 734, 734 Terbrugghen, Hendrick, Singing Lute Player, 713-714, 714 Teresa of Ávila, 633, 687, 689 Testelin, Henri, Expressions (after Charles Le Brun), 746, 746 Text as the Basis of Visual Expression (Kabakov), 1102 The Heart of the Andes (Church), 834 The Potato Eaters (Van Gogh), 912-913, 913 Théâtre Français (Théâtre de l'Odéon) (Peyre and Wailly), Paris, 808, 808 Theodric, St. Matthew and the Angel, 475, 475 Theosophie (Steiner), 959 Theosophy, 904, 959, 959, 961, 969, 976 Thinker, The (Rodin), 924–926, 926 Third of May (Goya), 825, 825 Third-Class Carriage (Daumier), 864, 865 Thirty Years' War, 662, 699, 737, 739, 744 Thomson, John, The Crawlers, 893-894, 894

Thor Battering the Midgard Serpent (Fuseli), 803-804, 804 Thoreau, Henry David, 833 Three Aqueous Events (Brecht), 1048 *Three Dancers* (Picasso), 993–994, 994 *Three Flags* (Johns), 1045–1046, *1046 Three Shades* (Rodin), 924–926, 925 Three Women (Le Grand Déjeuner) (Léger), 1014–1015, *1015* Thus Spoke Zarathustra (Nietzsche), 955 Tiepolo, Giovanni Battista, 762 Würzburg frescoes (Kaisersaal Residenz), 780, 781-782, 781 The Marriage of Frederick Barbarossa, 782, 782 Tiffany, Louis Comfort, A Wooded Landscape in Three Panels, 927, 928 Tiger Devouring a Gavial of the Ganges (Barye), 850, 850 Tintoretto (Jacopo Robusti), Last Supper, 622. 622 Titian (Tiziano Vecellio), 584, 591 Bacchanal, 585-586, 586 collaboration with Giorgione, 584 Fête Champêtre (Pastoral Concert), 584, 585 Madonna with Members of the Pesaro Family, 556, 586–588, 587 Man with a Blue Sleeve, 588, 588 Pietà, 619-620, 619 Rape of Europa, 617–619, 618 Venus of Urbino, 617, 617 To the Unknown Painter (Kiefer), 1086-1087, 1086 Toilet of Venus (Vouet), 740-741, 740 Tolentino, Niccolò da, 538 Tomb to Isaac Newton, Project for a (Boullée), 810, 810 Tombs of the Archduchess Maria Christina (Canova), 818, 818 of Bernabò Visconti, 465–466, 465 of Guiliano de' Medici (Michelangelo), 596-597, 596 of Henry II and Catherine de' Medici (Primaticcio and Pilon), 630-631, 631 of Leonardo Bruni (Rossellino), 523-524, 523 Pope Julius II (Michelangelo), *570*, 571 Tondo, 537, *538* Tornabuobi, Lucrezia, 542 Toulouse-Lautrec, Henri de, La Goulue, 911-912, 912 Tournai, Belgium, panel painting in, 477–479, 478, 479 Towards a New Architecture (Le Corbusier), 1012 Traini, Francesco sinopia drawing for *The Triumph of* Death, 441, 441 The Triumph of Death, 462, 462 Trakl, Georg, 963 Transept, 442 Transversals, 516 Traveler, The (Popova), 966, 967 Traversari, Ambrogio, 523 Treatise on Architecture (Alberti), 511 Très Riches Heures du Duc de Berry, Les (Limbourg brothers), 473-474, 473, 474, 474 Trevisani, Francesco, Nocturnal Clock, 678-679, 678 Triboli, Nicolo, Boboli Gardens, Florence, 598. 599 Trinitarians, 679 Triptych, use of term, 458, 480 Triptychs See also Altarpieces Birth of the Virgin (P. Lorenzetti), 458-459, 459 Departure (Beckmann), 1030-1031, 1030 Garden of Earthly Delights (Bosch), 492–493, 492, 493 Ghent Altarpiece, 480-482, 480, 481, 482 Isenheim Altarpiece (Grünewald), 635-637, 636, 637 Mérode Triptych (Campin), 477–479, 478 Penitence of St. Jerome (Patinir), 653–654, 654 Portinari Altarpiece (Goes), 490-491, 490

Trissino, Giangiorgio, count of Vicenza, 614 Triumph of Death (Traini), 441, 441, 462, 462 Triumph of Louis XIV (Coysevox), 751, 751 Triumph of the Name of Jesus (Gaulli), Il Gesù, Rome, 674, 675 Trois crayons, 765 Tubman, Harriet, 1025 Tura del Grasso, Agnolo di, Chronicle, 454 Turin Chapel of the Holy Shroud, Turin cathedral (Guarini), 682-683, 682, 683 Palazzo Carignano (Guarini), 682-683, 682, 683 Turner, Joseph Mallord William The Slave Ship (Slavers Throwing Overboard the Dead and Dying-Typhoon Coming On), 830, 831 Snowstorm: Hannibal and His Army Crossing the Alps, 829, 830 Tuscany, painting in, 449–463, 449–452, 454–463 Tusche, 911 Twain, Mark, 887 Twilight in the Wilderness (Church), 834-835, 835 Two Fridas, The (Kahlo), 1026, 1027 Tzara, Tristan, 985, 992 Uccello, Paolo, Battle of San Romano, 538, 539 Uffizi courtyard, Florence (Vasari), 597-598, 597 Ulysses (Joyce), 954 Under the Birches, Evening (Théodore Rousseau), 849, 849 Unicorn in Captivity, from the Unicorn Tapestries, 628–629, 628 Unicorn Tapestries, 628–629, 628 Unique Forms of Continuity in Space (Boccioni), 966, 966 United States Abstract Expressionism, 1036-1040, 1037-1039 architecture, Classic Revival, 854-855, 855 architecture, historical eclecticism and technology, 899, 899 architecture, Modern, 932-935, 932-935, 976–979, 976–978 architecture, Neoclassicism, 854–855, 855 Armory Show, 974, 1019 Art Deco, 1020, *1021* Art Nouveau, 927, 928 Civil Rights Movement, 1036, 1065, 1067 Conceptual Art, 1044-1046, 1044, 1046 Dadaism, 986–987, *986* earthworks, 1059–1060, *1060* Environments, Happenings and Performance Art, 1046-1047, 1047, 1048, 1048 feminist art, postwar, 1068-1069, 1069, 1089, 1089 Harlem Renaissance, 1024–1025, 1024 iconic imagery in Realism painting, 888–890. 890 International Style, 1020–1021, *1021* Minimalism/Formalism, 1053–1057, 1054-1057 Modernism, 974–976, 974–975 Neo-Expressionism, 1085-1089, 1086-1088 painting, Modernism, 974–976, 974–975, 1016, 1016–1017, 1018–1020, 1019–1020, 1022–1025, 1022–1024, 1028, 1029 painting, Neo-Expressionism, 1085-1089, 1086-1088 painting, Realism, 885–890, 886–890 painting, Romanticism, 832-835, 833, 835 painting, Symbolism (Synthetism), 924, 924 photography, Civil War, 894-895, 894 photography, documentary, 893–894, *894*, 939–940, *939–940* photography, portraiture, 891-892, 891, photography, Postmodern, 1092–1093, 1092-1093 photography, postwar, street, 1064–1065, *1065*

Pop Art, 1049–1051, 1049–1050

Post-Minimalism, 1085–1091, *1086–1090* regionalism and national identity, 1023–1024, *1023*

skyscrapers, 932-933, 932-933, 1015, 1020-1021, 1021 University of Virginia (Jefferson), Charlottesville, 854–855, 855 Untitled (billboard of an empty bed) (Gonzalez-Torres), 1098, 1098 Untitled (from Truisms) (Holzer), 1093, 1094 Unitiled (Hesse), 1058, 1058 Unitiled (Judd), 1056, 1057 Unitiled (Muybridge) (trot and gallop sequence) from La Nature, 940, 941 Untitled (Smith), 1098–1099, 1099 Untitled (We Won't Play Nature to Your Culture) (Kruger), 1092–1093, 1092 Untitled Film Still #1 (Sherman), 1093, 1093 Urban VIII Visiting Il Gesù (Sacchi and Miel), 607-608, 608 Urban VIII, pope, 663, 673, 678, 685 Urbino, duke Guidobaldo Il della Rovere, 617 Valadon, Suzanne, 923 Vallayer-Coster, Anne, 791 Van Alen, William, Chrysler Building, New York City, 1020, 1021 Van de Velde, Henri, Werkbund Theater, Cologne, 979, 979 van den Brock, Willem, Town Hall, Antwerp, 652–653, 653 Van der Laen, Beatrix, 715, 716 Van der Weyden, Rogier, 477 Van Doesburg, Theo, 1005, 1008 Van Dyke, Anthony Portrait of Charles I Hunting, 707–708, 707 Rinaldo and Armida, 706, 707 Van Eyck, Hubert Adam and Eve, from the Ghent Altarpiece, 482, 482 Ghent Altarpiece, 480-482, 480, 481, 482 Van Eyck, Jan, 479–480 Adam and Eve, from the Ghent Altarpiece, 482, 482 "Arnoflini Portrait", 483–485, 484 Ghent Altarpiece, 480-482, 480, 481, 482 Man in a Red Turban, 483, 483 Van Gogh, Vincent Night Café, 913, 914 The Potato Eaters, 912–913, 913 Starry Night, 913–915, 914 Van Goyen, Jan, Pelkus Gate Near Utrecht, 725, 725 Van Mander, Karel, 657 The Painter's Treatise (Het Schilder *Boeck)*, excerpts from, 656 Van Nieuwenhove, Martin, 491, 492 Van Noordt, Adam, 708 Vanbrugh, Sir John Blenheim Palace, 758, 758 and early romantic architecture, 798 Vanishing point, 516 Vanias, 727 Vanna Venturi House (Venturi), Philadelphia, 1077–1078, *1078* Vanucci, Pietro, 553 Vasari, Giorgio, 449, 527, 559, 568, 571, 584 Lives of the Most Eminent Painters, Sculptors and Architects of Italy, 557 Uffizi courtyard, 597-598, 597 Vatican Saint Peter's basilica, 606, 607, 607 Stanza della Segnatura, 578, 579–580, 579 Vatican, Sistine Chapel cleaning works of art, 578 Creation of Adam, 575-577, 576 Delivery of the Keys to St. Peter (Perugino), 553–554, 553 diagram of subjects in, 574 Expulsion form the Garden of Eden, 574-575, 576 Fall of Man, 574–575, 576 Last Judgment, 602, 603–604, 604 Libyan Sibyl, 574, 574 Michelangelo's work on, 573–577, 573, 574, 576, 602, 603-604, 604 Studies for the Libyan Sibyl, 575, 575 Vaxcelles, Louis, 947 Velasquez, Diego Juan de Pareja, 692–693, 693 Maids of Honor, 693-695, 694 Surrender at Breda, 691–692, 692 Water Carrier of Seville, 691, 691

Venice architecture, 613-617, 614-616 Biennale, 1104 Ca' d'Oro, 550, *550* Canaletto's work, *775–776*, *776* Doge's Palace, *464*, 465, 550, *550* fourteenth century, 465 Library of San Marco, 614, 614 Mint, 613-614, 614 Renaissance oil painting, 551–553, 551, 552, 584–588, 584–588, 617–622, 617–619, 621–622 San Giorgio Maggiore, 614-615, 615, 622, 622 Santa Maria della Salute church, 684, 684 Venturi, Robert Complexity and Contradiction, 1077 Learning from Las Vegas, 1077 Vanna Venturi House, 1077–1078, 1078 Venus of Urbino (Titian), 617, 617 Verlaine, Paul, 917 Vermeer, Jan Officer and Laughing Girl, 732–733, 732 Woman Holding a Balance, 733, 733 Vernacular (snapshot) photography, 939-940, 939, 940 Veronese (Paolo Cagliari) Feast in the House of Levi, 621, 621 Inquisition tribunal of, 620, 621 Verrocchio, Andrea del Equestrian Monument of Colleoni, 550-551, 550 Incredulity of Thomas, The, 524, 525 Lady with a Bunch of Flowers, 542-543, 543 Versailles, palace of (Le Vau, Hardouin-Mansart, Le Brun), 738, 749 aerial view, 749 garden front, 750, 751 gardens, 751-752 Hall of Mirrors, 750, 751 Salon de la Guerre, 751, 751 Victoria, queen of England, 881 Victory over the Sun (Malevich), 966 Video Art, 1063, 1096, 1100, 1102–1103, 1102 Vienna architecture, Rococo, 777-779, 777 Camera Club, 936 Kuntschau exhibitions, 962–963, 962 painting, Symbolism, 921–922, 922 Rooftop Office (Coop Himmelblau), 1082, 1083 Secession, 922, 927 Steiner House (Loos), 976–977, 976 Vietnam Veterans Memorial (Lin), 1090–1091, 1090 View of Rome: The Bridge and Castel Sant'Angelo with the Cupola of St. Peter's (Corot), 847-848, 847 Vigée-Lebrun, Marie-Louise-Élizabeth, xxi, 791 Self-Portrait with Daughter, 816–817, 816 Vignola, Giacomo, 607 Vijd chapel painting of Ghent Altarpiece, 482, 482 Vijd, Jodicus, 480 Villa Albani frescoes (Mengs), Rome, 788, 788 Villa Ludovisi, Rome, 672, 673 Villa Savoye (Le Corbusier), France, 1012–1014, *1012*, *1014* Village Bride (Greuze), 811-812, 811 Villars, Duchesse de, 773 Villon, Jacques, 971 Viola, Bill, The Crossing, 1102–1103, 1102 Violin (Picasso), 954, 954 Virgin Among Virgins (David), 650, 651Philip of Burgundy, 651 Virgin Mary in Italian Renaissance painting, 453-459, 454-455, 456-459 in Spanish Baroque painting, 696, 696 Virgin of the Rocks (Leonardo da Vinci),

561-563, 561

Vitruvius Britannicus (Campbell), 796 Vitruvius, 513, 514 Vitruvius, 513, 514 Vivaldi, Antonio, 762 Voice of the City (New York Interpreted) (Stella), 982, 1016, 1016–1007 Vollard, Ambroise, 917 Voltaire Seated (Houdon), 812–813, 812 Voltaire, 761, 785, 786 Vouet, Simon, The Toilet of Venus, 740-741, 740 Vow of Louis XIII (Ingres), 838 Vuillard, Édouard, The Suitor, 917, 918 Wagner, Richard, 917, 923, 963 Wailly, Charles de, Théâtre Français (Théâtre de l'Odéon), Paris, 808, 808 Wainwright Building (Sullivan), St. Louis, 932-933, 932 Walden (Thoreau), 833 Walden, Herwarth, 957 Walker, Kara, 1096 Gone, An Historical Romance of a Civil War As It Occurred Between the Dusky Thighs of One Young Negress and Her Heart, 1097 Insurrection (Our Tools Were Rudimentary, Yet We Pressed On), 1097, 1097 Walking Man (Rodin), 926, 926 Wall, Jeff, 1103 Wallace, Michele, 1097 Walpole, Horace, 821 *Castle of Otranto: A Gothic* Story, 800 Strawberry Hill, Twickenham, England, 800–801, *801* Warhol, Andy Campbell's Soup Cans, 1049–1051, 1050 Gold Marilyn Monroe, xvi, xvii, xviii, xxi, xxii Washington, Augustus, John Brown, 891-892, 891 Water Carrier of Seville (Velasquez), 691, 691 Watkins, Carleton, Yosemite Valley from the Best General View, 893, 893 Watt, James, 786 Watteau, Jean-Antoine, 761 Gersaint's Signboard, 760, 765–766, 765 Jullienne's comments on, 764, 766 Mezzetin, 764, 764 A Pilgrimage to Cythera, 763-764, 763 Seated Young Woman, 764, 765 Way of Salvation (Andrea da Firenze/Andrea Bonaiuti), 463, 463 Ways of Seeing (Berger), 923 Webb, Philip, 884 Weber, Louise (La Goulue), 911 Wedgwood, Josiah, 792 Weems, Carrie-Mae, 1096 Well of Moses (Sluter), Chartreuse de Champmol, Dijon, France, 471-472, 471 Werkbund, 977 housing development (Gropius and Breuer), 1008, 1008 theater (Van de Velde), Cologne, 979, 979 West, Benjamin, The Death of General Wolfe, 794–795, 794 Weston, Edward, Pepper, 1022, 1023 Wet-collodian process, 891 Wheatstack, Sun in the Mist (Monet), 880-881, 880 Where Do We Come From? What Are We? Where Are We Going? (Gaugin), 916-917, 916

Visconti family 465–466

560

Visconti, Bernabò, tomb of (Bonino da

Book of Hours (Giovannino dei Grassi),

466, 466 Vision after the Sermon (Jacob Wrestling with the Angel) (Gaugin), 915–916, 915 Vitruvian Man (Leonardo da Vinci), 559,

Campione), 465-466, 465

Visconti, Giangaleazzo, 465

Whistler, James Abbott McNeill autobiography of, 885 Nocturne in Black and Gold: The Falling Rocket, 887, 887 Symphony in White No. I: The White Girl. 885 Symphony in White No. II: The Little White Girl, 885–887, 886 White Paintings (Rauschenberg), 1045 Whitman, Robert American Moon, 1047 Prune Flat, 1047, 1047 Wigley, Mark 1082 Wilde, Oscar, 903, 921 William III, king of England, 737 William IV, duke of Bavaria Willumsen, J.F., 917
 Wilson, Fred, 1075, 1096
 Mining the Museum, 1094–1095, 1095 Wilton Diptych, 476, 476 Winckelmann, Johann Joachim, 787 Wiping, selective, 722 Wire Wheel (Strand), 1016–1017, 1017 Witz, Conrad, Miraculous Draught of Fishes, 495–497, 497 Woman Holding a Balance (Vermeer), 733, 733 Woman I (De Kooning), 1039-1040, 1039 Women artists Albers, Anni, 1008, 1045 Anguissola, Sofonisba, 613, 613, 632 Bonheur, Rosa, 865–866, *865* Bourke-White, Margaret, 1018, *1018* Cameron, Julia Margaret, 895–896, *895* Carriera, Rosalba, 769, 769 Cassatt, Mary, 879-880, 879, 923 Chicago, Judy, 1068-1069, 1069 Cunningham, Imogen, 1023 Frankenthaler, Helen, 1053–1055, *1054* Gentileschi, Artemesia, xxi, 668–669, *668*, 669 Hadid, Zaha, 1083-1084, 1083 Hepworth, Barbara, 1002–1003, 1003 Hesse, Eva, 1058, 1058 Höch, Hannah, 987, 988, 989 Holzer, Jenny, 1093, 1094 Kahlo, Frida, 1026, 1027 Kauffmann, Angelica, 791-793, 793 Kollwitz, Käthe, 923, 988–990, *990* Kruger, Barbara, 1092–1093, *1092* Labille-Guiard, Adélaïd, 791 Lange, Dorothea, 1029–1030, *1029* Lawler, Louise, 1092 Leyster, Judith, xxi, *xxi* Lin, Maya, 1090–1091, 1090 Modersohn-Becker, Paula, 923, 955, 955 Morisot, Berthe, 878-879, 878, 923 Münter, Gabriele, 958 Murray, Elizabeth, 1089, *1089* O'Keeffe, Georgia, 1022, *1022* Oppenheim, Meret, 1000, *1000* Peeters, Clara, 710-711, 710 Piper, Adrien, 1096 Saar, Betye, 1067-1068, 1068 Sherman, Cindy, 1091, 1093, 1093, 1103 Simmons, Laurie, 1092 Simpson, Lorna, 1096 Smith, Kiki, 1076, 1098–1099, *1099* Stepanova, Varvara Fedorovna, 1005, 1005 Valadon, Suzanne, 923 Vallayer-Coster, Anne, 721 Vigée-Lebrun, Marie-Louise-Élizabeth, xxi, 791, 816–817, *816* Walker, Kara, 1097, *1097* Weems, Carrie-Mae, 1096 Women of Algiers (Delacroix), 846, 847 Women admittance to art academies, 791 Berlin Academy, not permitted at, 988 as collectors, 954 École des Beaux-Arts, not permitted at feminist art, postwar, 1068-1069, 1069, 1089, 1089

C. Samuel

feminist movement, role of, xxi French Royal Academy, not permitted at, 816 guilds, Renaissance women not permitted in, 507 New Woman, 889, 904–905 in numeries, 440–441 as patrons of art, 531, 612 portraits, Leonardo's reinvention of women's, 565 rights, 879, 889 Wood the Elder, John, 797 Wood the Younger, John, 797 Bath, England, 797, 798 Wood, Beatrice, 987 Wood, Grant, American Gothic, xix-xx, xx, 1023-1024, 1023 Woodcut of St. Christopher (Daret) Annunciation detail, 500, 501 Woodcuts/Engravings as copies of Renaissance artists' work, 583, 585 Dürer, work of, 638-639, 638-639, 641, 641 German Expressionism and, 957-958, 958 Grien, work of, 646, 646 Lucas Cranach the Elder, work of, 643-644, 643 technique for making, 500-501, 500, 501, 502 Wooded Landscape in Three Panels (Tiffany), 927, 928 Woolworth Building (Gilbert), New York City, 1020 Wordsworth, William, 826 Workshops, authenticity of, Rubens and Rembrandt 718 World War I, 954, 972, 983–984 World War II, 1035, 1039 Worringer, Wilhelm, 979 Wren, Sir Christopher, 663, 738 Five Tracts, 757 plans for rebuilding city of London, after Great Fire of 1666, 755–758, 755 St. Mary-le-Bow church steeple, London, 757, 758 St. Paul's Cathedral, London, 756, 757–758, 757 Wright, Frank Lloyd Guggenheim Museum, Solomon R., New York City, xxvi–xxvii, xxvii, 1071 Little House, Minnesota, 935–936, 935 Robie House, Chicago, xxvii, 934–935, 934, 935 Wright, Joseph, Old Man and Death, 802–803, 803 Wunderkammern, 709 Wundt, Wilhelm, 904 Würzburg, Germany frescoes (Tiepolo), 780, 781–782, 781, 782 Kaisersaal Residenz (Neumann), 780–781, 780 Wyatt, James, Fonthill Abbey, 851-852, 852 Xavier, Francis, 689 Yard (Kaprow), 1046–1047, 1047 Yosemite Valley from the Best General View (Watkins), 893, 893 Young British Artists exhibition, 1099 Young Man Among Roses (Hilliard), 648-649, 648

0, 10 (Zero–Ten): The Last Futurist Exhibition (Malevich), 968, 968 Zimmerman, Dominikus, "Die Wies" Bavarian pilgrimage church, 779-780, 779 Zimmerman, Johann Baptist, 779–780 Zola, Émile, 868 Zucchi, Antonio, 798 Zurbarán, Francisco de, St. Serapion, 695-696, 695 Zwingli, Ulrich, 591, 635

Credits

CREDITS AND COPYRIGHTS

The Authors and Publisher wish to thank the libraries, museums, galleries, and private collections for permitting the reproduction of works of art in their collections. Sources not included in the captions are gratefully acknowledged below.

INTRODUCTION

I.1 © 2009. Digital Image, The Museum of Modern Art, New York/Scala, Florence, © The Andy Warhol Foundation for the Visual Arts / Artists Rights Society (ARS), New York / DACS, London 2009; I.2 © 2005. Photo The Newark Museum/Art Resource/Scala, Florence; I.3 Image © The Board of Trustees, National Gallery of Art, Washington I.4 akg-images / Erich Lessing; I.5 Werner Forman Archive; I.6 © Grant Wood/ Licensed by VAGA, New York. Photography © The Art Institute of Chicago; I.8 Photograph by Lorene Emerson/Images © The Board of Trustees, National Gallery of Art, Washington; I.9 © 1990. Photo Scala, Florence; I.10 Photograph by Lynn Rosenthal, Philadelphia Museum of Art, © Succession Marcel Duchamp/ADAGP, Paris and DACS, London 2009; I.11 Photo by O. Zimmermann, © Musée d'Unterlinden, Colmar; I.12 © Estate of Duane Hanson/VAGA, New York/DACS, London 2009; I.13 © Lee Friedlander, courtesy Fraenkel Gallery, San Francisco; I.14 © Aerocentro; I.15 akg-images / Erich Lessing; I.16 Ezra Stoller © Esto, © ARS, NY and DACS, London 2009.

CHAPTER 13

13.0 © 1990, Photo Scala, Florence; 13.1 © 1995. Photo Scala, Florence; 13.2 Canali Photobank, Milan Italy; 13.3 © 2004, Photo Scala, Florence; Box p441 akg-images; 13.4 © 1991. Photo Scala, Florence/Fondo Edifici di Culto – Min. dell'Interno; 13.6 © Quattrone, Florence; 13.7 © 1990, Photo Scala, Florence; 13.8 Alinari Archives / Florence; 13.9 © 1990, Photo Scala, Florence; 13.11 © Bednorz-images; 13.13 Tosi, Index, Florence; 13.14 © 1990. Photo Scala, Florence; 13.15 © 2006, Photo Scala, Florence; 13.16 ⊂ Scala, Florence; 13.17 © Quattrone, Florence; 13.15 © 2006, Photo Scala, Florence; 13.16 ⊂ Scala, Florence; 13.17 © Quattrone, Florence; 13.18 © Quattrone, Florence; 13.20 © Quattrone, Florence; 13.21 © Photoservice Electa/Arnaldo Vescovo; 13.22 Canali Photobank, Milan Italy; 13.25 Canali Photobank, Milan Italy; 13.26 Canali Photobank, Milan Italy; 13.27 Canali Photobank, Milan Italy; 13.28 © 1990. Photo Scala, Florence; 13.20 © 1990. Photo Scala, Florence; 13.30 Canali Photobank, Milan Italy; 13.32 © Dorling Kindersley, John Heseltine; 13.33 © 2002. Photo Scala, Florence, 13.34 Biblioteca Nazionale, Firenze/Microfoto.

CHAPTER 14

14.0 Photograph © 2010, Museum of Fine Arts, Boston; 14.1 akg-images / Erich Lessing; 14.2 ©1990. Photo Scala, Florence (left panel) / Musee des Beaux-Arts, Dijon / Bridgeman Art Library (right panel); © Réunion des Musées Nationaux / Rene-Gabriel Ojeda; 14.4 © R. G. Ojeda/Réunion des Musées Nationaux; 14.5 © National Heritage Institute, Prague. Inv. No. V0675/200; 14.6 Photo © The National Gallery, London, 14.7 © Bednorz-images; 14.8 © 2008. Image copyright The Metropolitan Museum of Art/Art Resource/Scala, Florence; **Box p479** Canali Photobank, Milan Italy (left) / © 2008. Image The Metropolitan Museum of Art/Art Resource/Scala, Florence (right); 14.9 akg-images / Erich Lessing; 14.10 Giraudon / The Bridgeman Art Library; 14.11 akg-images / Erich Lessing; 14.13 Photo © The National Gallery, London; 14.14 Photo © The National Gallery, London; 14.16 Photograph © 2010, Museum of Fine Arts, Boston; 14.17 © M. Verpoorten, Liege Tourist Office, 14.18 © Austrian National Library/Picture Archive, Vienna, Cod. 1857, fol. 14v; 14.19 Photograph © 2010, Museum of Fine Arts, Boston; 14.20 © Quattrone, Florence; 14.21 akg-images / Erich Lessing; 14.23 © 1990, Photo Scala, Florence; 14.24 © 2005. Photo Scala, Florence/BPK, Bildagentur fuer Kunst, Kultur und Geschichte, Berlin; 14.26 Oronoz; 14.27 © Musee d'Art et d'Histoire, City of Geneva, Switzerland. Photograph by Bettina Jacot-Descombes; 14.28 © Bednorz-images; 14.29 Courtesy of the Director and Librarian, John Rylands University Library of Manchester; **Box p501** Laurie Platt Winfrey, Inc; 14.31 Laurie Platt Winfrey, Inc.

CHAPTER 15

15.0 Museo dell' Opera del Duomo, Florence, Italy/ The Bridgeman Art Library; 15.1 akgimages / Erich Lessing; 15.2 © Quattrone, Florence; 15.3 Vanni / Art Resource, NY; 15.4 Canali Photobank, Milan Italy; 15.5 © 1990, Photo Scala, Florence; Box p512 Dorling Kindersley media library; 15.6 © Quattrone, Florence; 15.7 Achim Bednorz, Cologne; 15.10 Canali Photobank, Milan Italy; 15.13 Canali Photobank, Milan Italy; 15.14 Piazza del Santo, Padua, Italy / The Bridgeman Art Library; 15.15 akg-images / Erich Lessing; 15.16 The Art Archive / Battistero di San Giovanni, Florence / Alfredo Dagli Orti; 15.17 Museo dell' Opera del Duomo, Florence, Italy / The Bridgeman Art Library; 15.18 Alinari / The Bridgeman Art Library 15.19 © 1990, Photo Scala, Florence; 15.20 © Bednorz-Images; 15.21 © 2005. Photo Scala, Florence - courtesy of the Beni e Att. Culturali; 15.23 Canali Photobank, Milan Italy; 15.24 © Quattrone, Florence; 15.25 © 1991. Photo Scala, Florence/Fondo Edifici di Culto – Min. dell'Interno; 15.26 © Quattrone, Florence; 15.27 akg-images / Erich Lessing; 15.28 akg-images / Erich Lessing; 15.29 Canali Photobank, Milan Italy; 15.30 © Quattrone, Florence; 15.31 © 1998. Photo Scala, Florence; 15.32 © Orsi Battaglini; 15.33 © Quattrone, Florence; 15.31 © 1998. Photo Scala, Florence; 15.32 © Orsi Battaglini; 15.33 © Quattrone, Florence; 15.34 Scala/Art Resource, NY; 15.36 © 2007, Image copyright The Metropolitan Museum of Art/Art Resource/Scala, Florence; 15.37 Canali Photobank, Milan Italy; 15.39 © 1991. Photo Scala, Florence – courtesy of the Ministero Beni e Att. Culturali; 15.40 © Quattrone, Florence; 15.41 © Hervé Lewandowski/Réunion des Musées Nationaux; 15.42 © 1990, Photo Scala, Florence – courtesy of the Ministero Beni e Att. Culturali; 15.43 Canali Photobank, Milan Italy; 15.45 © 2004. Photo Scala, Florence; 15.41 © Levandowski/Réunion des Musées Nationaux; 15.42 © 1990, Photo Scala, Florence – courtesy of the Ministero Beni e Att. Culturali; 15.45 Canali Photobank, Milan Italy; 15.46 © 2004. Photo Scala, Florence + Isi 15.47 Canali Photobank, Milan Italy; 15.48 akg-images / Erich Lessing; 15.49 Canali Photobank, Milan Italy; 15.50 © 1990, Photo Scala, Florence – courtesy of the Ministero Beni e Att. Culturali; 15.51 © Bednorz-images; 15.52 Canali Photobank, Milan Italy; 15.53 Copyright The Frick Collection, New York; 15.54 © CAMERAPHOTO Arte, Venice; 15.55 Canali Photobank, Milan Italy; 15.56 © 2000. Photo Scala, Florence/courtesy by Opera del Duomo of Orvieto.

Ministero Beni e Att. Culturali; 15.22 © 2005. Photo Scala, Florence – courtesy of the Ministero

CHAPTER 16

16.0 © CAMERAPHOTO Arte, Venice; 16.1 Image © The Board of Trustees, National Gallery of Art, Washington; 16.2 © 2005 Photo Ann Ronan/HIP/Scala, Florence; 16.3 Art Resource, NY; 16.4 © Réunion des Musées Nationaux; 16.5 © 1990. Photo Scala, Florence; 16.6 Index, Florence; 16.7 © Lewandowski/Le Mage/Réunion des Musées Nationaux; 16.8 © Vincenzo Pirozzi, Rome fotopirozzi@inwind.it; 16.11 © The Trustees of the British Museum; 16.12 Canali Photobank, Milan Italy; 16.13 © Quattrone, Florence; 16.14 from John T. Paoletti and Gary M. Radke, Art in Renaissance Italy, Harry N Abrams, 2002, fig. 7.22, p. 360; 16.15 © Vincenzo Pirozzi, Rome fotopirozzi@inwind.it; 16.16 Bencini / Index; 16.17 © Photo Vatican Museums; 16.19 © Photo Vatican Museums; 16.20 © Photo Vatican Museums; 16.21 Canali Photobank, Milan Italy; 16.22 © J. G. Berizzi/Réunion des Musées Nationaux; 16.23 © Photo Vatican Museums; 16.24 © Photo Vatican Museums; 16.25 © 1997. Photo Scala, Florence – courtesy of the Ministero Beni e Art. Culturali; 16.26 The Royal Collection / V & A Images; 16.27 Canali Photobank, Milan Italy; 16.30 © 1990 Photo Scala, Florence; 16.31 @ Museo Nacional del Prado; 16.32 © CAMERAPHOTO Arte, Venice; 16.33 © The National Gallery, London.

CHAPTER 17

17.0 © Massimo Listri/CORBIS; 17.1 © Quattrone, Florence; 17.2 Index, Florence; 17.3 Canali Photobank, Milan Italy; 17.4 © 1990, Photo Scala, Florence - courtesy of the Ministero Beni e Att. Culturali; 17.5 © Quattrone, Florence; 17.6 Canali Photobank, Milan Italy; 17.7 Alinari / Art Resource, NY; 17.8 © 2004. Photo Scala, Florence - courtesy of the Ministero Beni e Att. Culturali; 17.9 Dorling Kindersley media library; 17.10 Canali Photobank, Milan Italy; 17.11 Photo © The National Gallery, London; 17.12 Kunsthistorisches Museum. Vienna; 17.13 © Quattrone, Florence; 17.14 © Photo Vatican Museums; 17.15 © Photo Vatican Museums; 17.16 © Bednorz Images; 17.17 Gabinetto Fotografico Nazionale; 17.18 Araldo de Luca, Corbis; 17.19 © James Morris, London; 17.22 Foto Vasari, Rome; 17.23 © 1999. Photo Scala, Florence; 17.24 SuperStock; 17.25 © 2004. Photo Scala, Florence; 17.26 Kunsthistorisches Museum. Vienna; 17.27 © 1990. Photo Scala, Florence; 17.28 Kunsthistorisches Museum. Vienna; 17.31 © Quattrone, Florence; 17.30 Photograph © 2010, Museum of Fine Arts, Boston; 17.31 © 1990. Photo Scala, Florence; 17.34 © Bednorz-images; 17.35 © 1996. Photo Scala, Florence; 17.37 © 1990. Photo Scala, Florence; 17.39 © CAMERAPHOTO Arte, Venice; 17.39 © C

CHAPTER 18

18.0 © The National Gallery, London; 18.1 © age fotostock / SuperStock; 18.2 akg-images / Erich Lessing; 18.3 © 2007. Image copyright The Metropolitan Museum of Art/Art Resource/ Scala, Florence; 18.4 © Centre des Monuments Nationaux, Paris; 18.5 © Bednorz-images; 18.6 Institut Amatller de Arte Hispanico, Barcelona; 18.7 Art Resource, NY; 18.8 Marilyn Stokstad; 18.10 Photo by O. Zimmermann, © Musée d'Unterlinden, Colmar; 18.11 The Art Archive / Unterlinden Museum Colmar; 18.12 akg-images / Erich Lessing; 18.14 Laurie Platt Winfrey, Inc; 18.15 Photograph © 2010, Museum of Fine Arts, Boston; 18.16 © 1990. Photo Scala, Florence; 18.17 © The Trustees of the British Museum; 18.18 Artothek; 18.19 © The Trustees of the British Museum; 18.18 Artothek; 18.19 © The Trustees of the British Museum; 18.20 © 2007, Image copyright The Metropolitan Museum of Art/Art Resource/Scala, Florence. Photo: Schecter Lee; 18.21 © 2008. Photo Scala, Florence/BPK, Bildagentur fuer Kunst, Kultur und Geschichte, Berlin; 18.22 Photograph © The Art Institute of Chicago; 18.23 © The National Gallery, London; 18.24 Canali Photobank, Milan Italy; 18.25 V & A Images,

Victoria and Albert Museum, London; **18.26** National Portrait Gallery, London, Reproduced by Courtesy of the Trustees; **18.27** Giraudon / Art Resource, NY; **18.28** © 2005. Photo Scala, Florence/BPK, Bildagentur fuer Kunst, Kultur und Geschichte, Berlin; **18.29** © Bednorz-images; **18.30** Digital Image 2008 © The Metropolitan Museum of Art/Art Rsource New York/Scala, Florence; **18.32** akg-images / Erich Lessing; **18.33** akg-images / Erich Lessing; **18.34** Canali Photobank, Milan Italy.

CHAPTER 19

19.0 Canali Photobank, Milan ItalY; 19.2 Canali Photobank, Milan Italy; 19.3 Canali Photobank, Milan Italy; 19.4 © 2007. Image copyright The Metropolitan Museum of Artt/Art Resource/Scala, Florence; 19.5 Photograph © 1984 Detroit Institute of Arts; 19.6 © Her Majesty Queen Elizabeth II; 19.7 Canali Photobank, Milan Italy; 19.8 Canali Photobank; 19.9 Canali Photobank, Milan Italy; 19.11 © Vincenzo Pirozzi, Rome fotopirozzi@inwind.it; 19.12 © 1990. Photo Scala, Florence/Fondo Edifici di Culto – Min. dell'Interno; 19.13 © Bednorz-images; 19.14 Aerocentro Varesino; 19.15 © 1990. Photo Scala, Florence; 19.16 Musei Capitolino / Index; 19.17 © Photoservice Electa/Vescovo; 19.19 Alinari Archives / Florence; 19.20 © Bednorz-images; 19.21 © Bednorz-images; 19.23 akg-images / Joseph Martin; 19.26 © 2006. Photo Scala, Florence; 19.27 Seat Archive/Alinari Archives; 19.28 © Bednorz-images; 19.29 © 1990. Photo Scala, Florence; 19.30 © 1990. Photo Scala, Florence; 19.34 V & A Images, Victoria & Albert Museum, London; 19.37 © 2007. Image copyright The Metropolitan Museum of Art/Art Resource/Scala, Florence.

CHAPTER 20

20.0 © Peter Willi / SuperStock; 20.1 © IRPA-KIK, Brussels; 20.2 © The Trustees of the British Museum; 20.3 Image © The Board of Trustees, National Gallery of Art, Washington; 20.4 Bridgeman-Giraudon / Art Resource, NY; 20.5 akg-images / Erich Lessing; 20.6 Giraudon / Art Bridgeman Art Library; 20.8 © Réunion des Musées Nationaux; 20.9 © 1990, Photo Scala, Florence; 20.12 Photography © The Art Institute of Chicago; 20.15 Photograph © The National Gallery, London; 20.19 Photograph by Lorene Emerson/Images © The Board of Trustees, National Gallery of Art, Washington; 20.20 © 1990, Photo Scala, Florence; 20.21 © 20.21 © 20.205. Photo Scala, Florence/BPK, Bildagentur fuer Kunst, Kultur und Geschichte, Berlin; 20.22 akg-images / Erich Lessing; 20.24 Photograph © The Metropolitan Museum of Art; 20.25 © 2005. Photo Ann Ronan/HIP/Scala, Florence; 20.26 Copyright The Frick Collection, New York; 20.27 Photograph © 1996 Detroit Institute of Arts; 20.34 Copyright The Frick Collection, New York; 20.34 Copyright The Frick Collection, New York; 20.37 Photograph © The Strustees, National Gallery of Art, Washington.

CHAPTER 21

21.0 The Minneapolis Institute of Arts. The William Hood Dunwoody Fund; 21.1 [©] The Trustees of the British Museum; 21.2 [©] Gerard Blott/Réunion des Musées Nationaux; 21.3 Photograph [©] Carnegie Museum of Art, Pittsburgh; 21.4 The Minneapolis Institute of Arts. The William Hood Dunwoody Fund; 21.5 [©] 2007. Image copyright The Metropolitan Museum of Art/Art Resource/Scala, Florence; 21.6 [©] Orsi Battaglini; 21.7 Photograph [©] The Art Institute of Chicago; 21.8 [©] 2007. Yale University Art Gallery/Art Resource, NY/Scala, Florence; 21.9 Image [©] The Metropolitan Museum of Art; 21.10 [©] Herve Lewandowski/Réunion des Musées Nationaux; Box p747 [©] The Trustees of the British Museum; 21.11 akg-images / Erich lessing; 21.12 [©] Yann Arthus-Bertrand, Altitude; 21.13 Centre Des Monuments Nationaux, Paris; 21.14 [©] Réunion des Musées Nationaux/Droits reserves; 21.15 Giraudon, Art Resource, NY; 21.16 [©] Werner Otto, SuperStock; 21.18 Reproduced by permission of the Trustees, The Wallace Collection, London; 21.19 Giraudon, Art Resource; 12.20 akg-images / A.F.Kersting; 21.24 [©] News International; 21.22 akg-images / A.F.Kersting; 21.23 [©] Oran Arthus-Bertrand, Altitude; 21.32 Orling Kindersley Media; 21.24 akg-images / A.F.Kersting; 21.25 [©] Yann Arthus-Bertrand, Altitude.

CHAPTER 22

22.0 akg-images / Erich Lessing; 22.1 © Gerard Blot/Réunion des Musées Nationaux, 22.2 © 2007. Image copyright The Metropolitan Museum of Art/Art Resource/Scala, Florence; 22.3 © 2000. Photo Pierpont Morgan Library/Art Resource/Scala, Florence; 22.4 akg-images / Erich Lessing; 22.5 © Blauel/Gnamm/ARTOTHEK; 22.6 © Wallace Collection, London, UK / The Bridgeman Art Library; Box p769 John Hammond, The National Trust Photo Library; 22.7 Image © The Board of Trustees, National Gallery of Art, Washington; 22.8 © Herve Lewandowski/Réunion des Musées Nationaux; 22.9 © Réunion des Musées Nationaux /Herve Lewandowski; 22.10 The J. Paul Getty Museum, Los Angeles; 22.11 © 2007. Image copyright The Metropolitan Museum of Art/Art Resource/Scala, Florence; 22.12 © 2007. Image copyright The Metropolitan Museum of Art/Art Resource/Scala, Florence; 22.16 © Bednorz-images; 22.18 akg-images / Erich Lessing; 22.19 akg-images / Bildarchiv Monheim; 22.2 © Bednorz-images.

CHAPTER 23

23.0 © STOCKFOLIO® / Alamy; 23.1 © Photoservice Electa/Sergio Anelli; 23.3 Image © The Metropolitan Museum of Art; 23.4 By Kind Permission of the Earl of Leicester and the Trustees of the Holkham Estate; Box p792 Photo courtesy of The Potteries Museum & Art Gallery, Stoke-on-Trent (top); Plate 127, The General Research Division, The New York Public Library, Astor, Lenox and Tilden Foundations (bottom); 23.5 Photograph by Katherine Wetzel; 23.6 Photo © National Gallery of Canada, Ottawa Transfer from the Canadian War Memorials, 1921; 23.7 Photograph © The Art Institute of Chicago; 23.8 © Bednorz-images; 23.9 © Graham Trust Photographic Library; 23.12 English Heritage, National Monuments Record; 23.13 akg-images / A.F.Kersting; 23.14 © 2007. Yale University Art Gallery/Art Resource, NY/Scala, Florence; 23.16 Royal Academy of Arts; 23.17 Photograph © 1996 Detroit Institute of Arts; 23.18 Image © The Board of Trustees, National Gallery of Art, Washington; 23.21 © Bednorz-images; 23.22 © STOCKFOLIO® / Alamy; 23.23 Bibliotheque Nationale de France; 23.24 Bibliotheque Nationale de France; 23.25 akg-images / Erich Lessing; 23.27 © Réunion des Musées Nationaux; 23.29 © Réunion des Musées Nationaux / Gerard Blot; 23.30 © C. Jean/Réunion des Musées Nationaux; 23.31 akg-images / Erich Lessing.

CHAPTER 24

24.0 © Réunion des Musées Nationaux / Rene-Gabriel Ojeda; 24.1 © 2007. Image copyright The Metropolitan Museum of Art/Art Resource/Scala; Florence; 24.4 © Tate, London 2008; 24.5 National Gallery, London, UK / The Bridgeman Art Library; 24.6 Tate, London / Art Resource, NY; 24.7 Photograph © 2010, Museum of Fine Arts, Boston; 24.8 © 2005. Photo Scala, Florence/BPK, Bildagentur fuer Kunst, Kultur und Geschichte, Berlin; 24.9 © 2007. Image copyright The Metropolitan Museum of Art/Art Resource/Scala, Florence; 21.1 © The Cleveland Museum of Art, purchase, Mr. and Mrs. William H. Marlatt Fund (1965.233); 24.11 akg-images / Erich Lessing; 24.12 akg-images / Erich Lessing; 24.13 © Herve Lewandowski/Réunion des Musées Nationaux; 24.16 © Réunion des Musées Nationaux; 24.16 © Herve Lewandowski/Réunion des Musées Nationaux; 24.10 © Réunion des Musées Nationaux; 24.20 © Réunion des Musées Nationaux; 24.21 © Réunion des Musées Nationaux; 24.22 © Réunion des Musées Nationaux; 24.21 © Réunion des Musées Nationaux; 24.22 © Réunion des Musées Nationaux; 24.23 © Réunion des Musées Nationaux; 24.24 © Réunion des Musées Nationaux; 24.22 © Réunion des Musées Nationaux; 24.23 © Béunion des Musées Nationaux; 24.23 © Stewart McKnight, Alamy Images; 24.31 The Ancient Art & Architecture Collection Ltd; 24.32 © Bednorz-images; 24.33 © Peter Aaron / Esto; Photograph by Jen Swanson-Seningen, 2009, Property of the Basilica of the Assumption Historic Trust, Inc; 24.35 Giraudon / The Bridgeman Art Library.

CHAPTER 25

25.0 © Herve Lewandowski/Réunion des Musées Nationaux; 25.1 © Herve Lewandowski/ Réunion des Musées Nationaux; 25.2 © Staatliche Kunstammlungen Dresden / The Bridgeman Art Library; 25.3 Photograph © 2010, Museum of Fine Arts, Boston; 25.5 © 2008. Image copyright The Metropolitan Museum of Art/Art Resource/Scala, Florence; 25.6 © Gerard Blot/Réunion des Musées Nationaux; 25.8 akg-images / Erich Lessing; 25.9 © Robert Harding; 25.10 © Réunion des Musées Nationaux; 25.11 © Herve Lewandowski/Réunion des Musées Nationaux; 25.12 © Herve Lewandowski/Réunion des Musées Nationaux; 25.14 © The Art Institute of Chicago, 25.15 akg-images / Erich Lessing; 25.16 © President and Fellows of the Harvard College; 25.20 Photo © The National Gallery, London; 25.21 Photography © The Art Institute of Chicago; 25.23 Tate, London / Art Resource, NY; 25.24 Tate, London / Art Resource, NY; 25.25 V & A Images, Victoria and Albert Museum, London; 25.26 © Tate, London 2008; 25.27 Tate, London / Art Resource, NY; 25.28 The Detroit Institute of Arts / Bridgeman Art Library; 25.29 © 2007. Image copyright The Metropolitan Museum of Art/Art Resource/Scala, Florence; 25.30 Art Resource/The Metropolitan Museum of Art/ Art Resource/Scala, Florence; 25.30 Art Resource/The Metropolitan Museum of Art/Art Resource/Scala, Florence; 25.30 Photographs Division, Washington, D.C; 25.38 Science & Society Picture Library; 25.39 The Royal Collection © 2010 Her Majesty Queen Elizabeth II; 25.40 Fay Torres-Yap, New York; 25.41 Artedia; 25.42 Gerty Images.

CHAPTER 26

26.0 Photograph by C. H. Bastin and J. Evrard, Brussels. © SOFAM Brussles / artist © DACS; **26.4** Photography © The Art Institute of Chicago; **26.5** Photography © The Art Institute of Chicago; **26.6** Photography © The Art Institute of Chicago; **26.6** Photography © The Art Institute of Chicago; **26.10** © 2007. Yale University Art Gallery/Art Resource, NY/Scala, Florence; **26.11** © 2009. Digital image, The Museum of Modern Art, New York/Scala, Florence; **26.13** Photograph © 2010, Museum of Fine Arts, Boston; 26.14 © ADAGP, Paris and DACS, London 2009; 26.15 © J. G. Berizzi/Réunion des Musées Nationaux; 26.16 © 2009. Digital image, The Museum of Modern Art, New York/Scala, Florence; 26.17 © 2009. Digital image, The Museum of Modern Art, New York/Scala, Florence; 26.18 O DACS; 26.19 The Art Archive / O Munch Museum/Munch - Ellingsen Group, BONO, Oslo/DACS, London; 26.20 alkg-images; 26.21 © Austrian National Library/Picture Archive, Vienna, 94.905-E; 26.22 Image © The Board of Trustees, National Gallery of Art, Washington; 26.23 © 2004. Photo Smithsonian American Art Museum/Art Resource/Scala, Florence; 26.24 © Réunion des Musées Nationaux; 26.25 Musee Rodin, Paris / Bridgeman Art Library; 26.26 Image C The Board of Trustees, National Gallery of Art, Washington; 26.27 Photograph by Lee Stalsworth; 26.29 Photograph by C. H. Bastin and J. Evrard, Brussels. © SOFAM Brussles / artist © DACS; 26.30 © Bednorz-images; 26.31 SuperStock, Inc; 26.32 From Henry-Russell Hiitchcock, Architecture Nineteenth and Twentieth Centuries, Penguin Books, Yale University Press, 1968, fig. 35, p. 304; 26.33 akg-images / A.F.Kersting; 26.35 Library of Congress, Prints and Photographs Division, Washington, D.C 26.36 © Art on File, Corbis; 26.37 Marvin Trachtenberg, Chicago Architecture Foundation; 26.39 Photography Heidrich Blessing, Chicago History Museum, © ARS, NY and DACS, London 2009; 26.41 © 2007. Image copyright The Metropolitan Museum of Art/Art Resource/Scala, Florence, © ARS, NY and DACS, London 2009; 26.43 © 2007. Image copyright The Metropolitan Museum of Art/ Art Resource/Scala, Florence; 26.44 © Joanna T. Steichen, George Eastman Hutseum of ArtO Art Resource/Scala, Florence; 26.45 © 2009. Digital image, The Museum of Modern Art, New York/Scala, Florence, © Georgia O'Keeffe Museum; 26.47 Photograph by Jacques Henri Lartigue, © Ministère de la Culture – France / AAJHL; 26.50 Library of Congress, Prints & Photographs Division, Washington DC.

CHAPTER 27

27.0 © ADAGP, Paris and DACS, London 2009; 27.1 © Succession H Matisse/DACS 2009; 27.2 Image © The Board of Trustees, National Gallery of Art, Washington, © ADAGP, Paris and DACS, London 2009; 27.3 Photograph reproduced with the permission of the Barnes Foundation, © Succession H Matisse/DACS 2009; 27.4 Digital image, The Museum of Modern Art, New York/Scala, Florence, © Succession H Matisse/DACS 2009; 27.5 © 2009. Digital image, The Museum of Modern Art, New York/Scala, Florence, © Succession H Matisse/DACS 2009; 27.6 © 2009; 27.6 © ADAGP, Paris and DACS, London 2009; 27.7 © 2008, McNay Art Museum/Art Resource, NY/Scala, Florence, © Succession Picasso/DACS 2009; 27.8 © Réunio des Musées Nationaux / © Succession Picasso/DACS 2009; 27.9 © Paula Modersohn-Becker; 27.10 © Ingeborg and Dr. Wolfgang Henze-Ketterer, Wichtrach/Bern; 27.11 © Nolde-Stiftung, Seebull; 27.12 Artothek, © DACS; 27.13 © Ingeborg and Dr. Wolfgang Henze-Ketterer, Wichtrach/Bern; 27.16 © DACS 2009; 27.20 © 2009. Digital image, The Museum of Modern Art, New York/Scala, Florence, © estate of Boccioni; 27.21 © 2009. Digital image; 27.24 © 2009. Digital image, The Museum of Modern Art, New York/Scala, Florence, © estate of Boccioni; 27.23 © Bednorz-images; 27.24 © 2009. Digital Image, The Museum of Modern Art, New York/Scala, Florence, © attate of Boccioni; 27.23 © Bednorz-images; 27.24 © 2009. Digital Image, The Museum of Modern Art, New York/Scala, Florence; Ø 2009. Digital Image, The Museum of Modern Art, New York/Scala, Florence; Ø 2009. Digital Image, The Museum of Modern Art, New York/Scala, Florence; Ø 2009. Digital Image, The Museum of Modern Art, New York/Scala, Florence; Ø 2009. Digital Image, The Museum of Modern Art, New York/Scala, Florence; Ø 2009. Digital Image, The Museum of Modern Art, New York/Scala, Florence; Ø 2009. Digital Image, The Museum of Modern Art, New York/Scala, Florence; Ø 2009. Digital Image, The Museum of Modern Art, New York/Scala, Florence; Ø 2009. Digital Image, The Museum of Modern Art, New York/Scala,

Duchamp/ADAGP, Paris and DACS, London 2009; **27.28** Photography © The Art Institute of Chicago; **27.29** © 2009. Digital image, The Museum of Modern Art, New York/Scala, Florence, © Succession Marcel Duchamp/ADAGP, Paris and DACS, London 2009; **27.30** © ADAGP, Paris and DACS, London 2009; **27.30** © ADAGP, New York/Scala, Florence, © ADAGP, Paris and DACS, London 2009; **27.31** Image copyright The Metropolitan Museum of Art/Art Resource/Scala, Florence, © Marsden Hartley; **27.34** Gerald Zugmann Fotographie KEG, © DACS; **27.35** Bildarchiv Monheim GmbH, © DACS; **27.36** Vanni, Art Resource, NY, © DACS; **27.39** © Bednorz-images.

CHAPTER 28

28.0 © 2004. Photo The Newark Museum/Art Resource/Scala, Florence; 28.1 © DACS; 28.2 Photograph by Alfred Stieglitz, O Philadelphia Museum of Art / Art Resource, NY / O Succes-Marcel Duchamp/ADAGP, Paris and DACS, London 2009; 28.3 © DACS / CNAC/MNAM/Dist. Réunion des Musées Nationaux; 28.4 Scala / Bildarchiv Preussischer Kulturbesitz, O DACS; 28.5 Photo courtesy Galerie St. Etienne, New York, O DACS; 28.6 © DACS; 28.7 Estate of Hans Arp, © ADAGP, Paris and DACS, London 2009; 28.8 © Man Ray Trust/ADAGP, Paris and DACS, London 2009; 28.9 Tate, London / Art Resource, NY, © Succession Picasso/DACS 2009; 28.10 Photography © Beatrice Hatala/Réunion des Musées Nationaux / © Succession Picasso/DACS 2009; 28.11 © 2009. Digital image, The Museum of Modern Art, New York/Scala, Florence, © ADAGP, Paris and DACS, London 2009; 28.12 © ADAGP, Paris and DACS, London 2009; 28.13 © Succession Miro/ADAGP, Paris and DACS, London 2009; 28.14 © 2009. Digital image, The Museum of Modern Art, New York/Scala, Florence, © ADAGP, Paris and DACS, London 2009; 28.15 Photograph courtesy of BFI Stills, © Salvador Dali, Gala-Salvador Dali Foundation, DACS, London 2009; 28.16 © 2009. Digital image, The Museum of Modern Art, New York/Scala, Florence, © Salvador Dali, Gala-Salvador Dali Foundation, DACS, London 2009; 28.17 © Henri Cartier-Bresson, Magnum Photos; 28.18 © 2009. Digital image, The Museum of Modern Art, New York/Scala, Florence, © Man Ray Trust/ADAGP, Paris and DACS, London 2009; 28.19 © 2009. Digital image, The Museum of Modern Art, New York/Scala, Florence, © DACS; 28.20 © 2009. Digital Image, The Museum of Modern Art, New York/Scala, Florence, © Calder Foundation, New York / DACS London 2009; **28.21** Art Resource, NY, Reproduced by Permission of the Henry Moore Foundation. www.henry-moore.org; 28.22 © Bowness, Hepworth Estate; 28.25 © 1990. Photo Scala, Florence, © Rodchenko & Stepanova Archive, DACS 2009; 28.26 © Rodchenko & Stepanova Archive, DACS 2009; 28.28 © DACS; 28.29 © Bildarchiv Monheim GmbH / Alamy, © DACS; 28.30 Bauhaus Archiv Berlin, © DACS; 28.31 Photo: Junius Beebe © President and Fellows of Harvard College, © Hattula Moholy-Nagy/DACS 2009; 28.32 Vanni, Art Resource, NY, © DACS; 28.35 Chicago Historical Museum, © DACS; 28.34 Chicago Historical Museum, © DACS; 28.35 © 2008. White Images/Scala, Florence, © FLC/ADAGP, Paris and DACS, London 2009; Box p1013 Paul Maeyaert; 28.36 Photography C Adrian Forty/Edifice, Corbis, C FLC/ADAGP, Paris and DACS, London 2009; 28.37 © 2009. Digital image, The Museum of Modern Art, New York/Scala, Florence, © ADAGP, Paris and DACS, London 2009; 28.38 © 2006. Photo The Newark Museum/Art Resource/Scala, Florence, © ARS, NY and DACS, London 2009; 28.39 © Paul Strand estate/Aperture; 28.40 Forene enlagements from 2008 2K digital restoration of Manhatta by Lowry Digital. Courtesy Lowry Digital © 2008 The Museum of Modern Art / Anthology Film Archives; 28.41 Margaret Bourke-White/Time Life Pictures, Getty Images; 28.42 Malcom Varon, N.Y.C; 28.43 Photograph © 2010, Museum of Fine Arts, Boston, © DACS 2009; 28.44 © Nathan Benn, Woodfin Camp & Associates, Inc; 28.45 O Jeff Goldberg / Esto; 28.46 O 2007. Image copyright The Metropolitan Museum of Art/Art Resource/Scala, Florence, © Georgia O'Keeffe Museum; 28:48 Photography © The Art Institute of Chicago, VAGA; 28:49 © 2009. Digital image, The Museum of Modern Art, New York/Scala, Florence, © DACS; 28:50 © Banco de Mexico Trust. Pala / 2005. Photo Art Resource/Scala, Florence, © Year of reproduction, Banco de Mexico Diego Rivera & Frida Kahlo Museums Trust, Mexico D.F. / DACS; 28.51 Photo Art Resource/Scala, Florence, O Year of reproduction, Banco de Mexico Diego Rivera & Frida Kahlo Museums Trust, Mexico D.F. / DACS; 28.52 © Manual Alvarez Bravo, San Diego Museum of Photographic Arts. Photo © Colette Urbaitel; 28.53 Photography by Geoffrey Clements; 28.54 © 2009. Digital Image, The Museum of Modern Art, New York/Scala, Florence; 28.56 © 2009. Digital Image, The Museum of Modern Art, New York/Scala, Florence; © DACS; 28.57 © The Heart-field Community of Heirs/VG Bild-Kunst, Bonn and DACS, London; 28.58 Photo Art Resource/Scala, Florence/John Bigelow Taylor, © Succession Picasso/DACS 2009.

CHAPTER 29

29.0 © 2007. Image copyright The Metropolitan Museum of Art/Art Resource/Scala, Florence.
© The Pollock-Krasner Foundation ARS, NY and DACS, London 2009; 29.1 © ADAGP, Paris and DACS, London 2009; 29.2 © 2007. Image copyright The Metropolitan Museum of Art/Art Resource/Scala, Florence / © The Pollock-Krasner Foundation ARS, NY and DACS, London 2009; 29.3 © 2009. Digital image, The Museum of Modern Art, New York/Scala, Florence, © The Willem de Kooning Foundation, New York/ ARS, NY and DACS, London 2009; 29.4 © 1998 Kate Rothko Prizel & Christopher Rothko ARS, NY and DACS, London; 2009; 29.4 © 1998 Kate Rothko Prizel & Christopher Rothko ARS, NY and DACS, London; 2009; 29.5 The Gallery. © DACS; 29.6 Courtesy Pace Wildenstein, New York, Photograph by Ellen Page Will-son / © ARS, NY and DACS, London 2009; 29.7 Photography © Peter Willi, SuperStock / © ADAGP, Paris and DACS, London 2009; 29.8 Photograph The Art Institute of Chicago,

© The Estate of Francis Bacon. All rights reserved. DACS 2009; 29.9 © The Estate of Francis Bacon. All rights reserved. DACS 2009; 29.10 Photograph by Geoffrey Clements, © Jasper Johns / VAGA, New York / DACS, London; 29.11 Photography. Ken Heyman / Woodfin Camp; 29.12 Photography Babette Mangolte. Courtesy Dia Art Foundation; 29.13 Photo © National Gallery of Canada, Ottawa, © The George and Helen Segal Foundation/DACS, London/ VAGA, New York 2009; 29.14 © 2009. Digital Image, The Museum of Modern Art, New York/Scala, Florence / DACS; 29.15 @ 2009. Digital image, The Museum of Modern Art, New York/Scala, Florence / © The Andy Warhol Foundation for the Visual Arts / Artists Rights Society (ARS), New York / DAGS, London 2009; 29.16 © Richard Hamilton . All Rights Reserved, DACS 2009; 29.18 Image © The Board of Trustees, National Gallery of Art, Washing-ton / © ARS, NY and DACS, London 2009; 29.19 Photography by Philipp Scholz Rittermann / © Ellsworth Kelly 1963, San Diego Museum of Contemporary Art; 29.20 © 2009. Digital image, The Museum of Modern Art, New York/Scala, Florence, © ARS, NY and DACS, London 2009; **29.21** Photograph by David Heald © The Solomon R Guggenheim Foundation, New York / © Judd Foundation. Licensed by VAGA, New York/DACS, London 2009; **29.22** Photo-graph by David Heald © The Solomon R. Guggenheim Foundation, NY / © ARS, NY and DACS, London 2009; **29.23** © Estate of Eva Hesse; **29.24** Contresy Leo Castelli Gallery, New York, DACS; 29.26 Photograph by Wolfgang Volz / © 1976 Christo and Jeanne-Claude; 29.27 © 2009. Digital image, The Museum of Modern Art, New York/Scala, Florence, © ARS, NY and DACS, London 2009; 29.28 © Ute Klophaus, D-Wuppertal / © DACS, 29.29 © estate of Nam June Paik; 29,30 © Robert Frank from the Americans; 20-31 © Romare Bearden Foundation/DACS, London/VAGA, New York 2009; 29,32 © Melvin Edwards; 29.33 Photo courtesy Michael Rosenfeld Gallery LLC; 29.34 Photograph © Donald Woodman / © ARS, NY and DACS, London 2009; 29.35 Ezra Stoller © Esto / © DACS; 29.36 Photography © Bednorzimages / © FLC/ ADAGP, Paris and DACS, London 2009; 29.37 Photography © Bednorzimages / © FLC/ ADAGP, Paris and DACS, London 2009; 29.38 © Kurt Wyss, Switzerland.

CHAPTER 30

30.0 Richard Bryant / Arcaid; 30.1 © Matt Wargo for VSBA; 30.2 © Peter Aaron / Esto; 30.4 © Réunion des Musées Nationaux; 30.5 Gerald Zugmann; 30.8 © Roland Halbe, Artur; 30.9 SuperStock; Box p1085 © FMGB Guggenheim, Bilbao, Museum; 30.10 © Anselm Kiefer / Photo: Carnegie Museum of Art, Pittsburgh; 30.12 Photography Douglas M. Parker Studio, Los Angeles / © ADAGP, Paris and DACS, London 2009; 30.13 © Elizabeth Murray; 30.14 © Martin Puryear; 30.15 © Frank Fournier; 30.16 © Barbara Kruger; 30.17 Metro Pictures, © Cindy Sherman; 30.18 Photograph by David Heald © The Solomon R. Guggenheim Foundation, New York ; 30.20 © Jeff Koons; 30.21 Courtesy Jack Tilton Gallery, New York, © David Hammons; 30.22 Photograph by Ellen Labenski, The Solomon R Guggenheim Foundation, New York ; 30.20 © Jeff Koons; 30.21 Courtesy Jack Tilton Gallery, New York, © David Hammons; 30.24 © Kara Walker; 30.23 © Gonzalez Torres Foundation; 30.24 © Kiki Smith; 30.25 Courtesy Jay Jopling/White Cube, © Damien Hirst. All rights reserved, DACS 2009; 30.26 © DACS 2009; 30.27 Image courtesy of Bill Viola Studio, © Bill Viola; 30.28 Courtesy: Monika Sprueth/Philomene Magers, Cologne / © Andreas Gursky, © DACS, London 2009; Box p1104 Courtesy Art Basel Miami Beach; 30.29 Photography John Berens; 30.30 Courtesy Creative Time, © Cai Studio.

TEXT CREDITS

Page 461 Inscriptions on the Frescoes in the Palazzo Pubblico, Siena from Arts of Power: Three Halls of State in Italy, 1300-1600, edited by Randolph Starn and Loren Partridge (Berkeley: University California Press, 1992), copyright © 1992 The Regents of the University of California. Reprinted by permission of the University of California Press. Page 494 Fray Jose de Siguenza. From Bosch in Perspective, edited by James Snyder (NY: Simon & Schuster, 1973), © 1973 Prentice Hall Inc. Reprinted with permission of Simon & Schuster, Inc. All rights reserved. Page 562 Leonardo da Vinci. From his undated manuscripts from The Literary Works of Leonardo da Vinci, edited by Jean Paul Richter (London: Phaidon Press, 1975), © 1975 Phaidon Press Limited, reprinted by permission of the publisher. Page 568 Michelangelo. From Commentary on his 'Pieta' by Ascanio Condivi from *Life, Letters and Poetry*, edited and translat-ed by George Bull (Oxford: Oxford University Press, 1987). Reprinted by permision of Oxford University Press. Page 572 From The Poetry of Michelangelo, translated by James Saslow (New Haven, CT: Yale University Press, 1991), copyright © 1991 by Yale University Press. Reprinted by permission of the publisher. Page 603 Michelangelo. Sonnet, "The Smith" from Life, Letters and Poetry, edited and translated by George Bull (Oxford: Oxford University Press, 1987). Reprinted by permission of Oxford University Press. Page 620 From a Session of the Inquisition Tribunal in Venice of Paolo Veronese from A Documentary History of Art, volume 2, edited by Elizabeth Gilmore Holt (Princeton, NJ: Princeton University Press, 1982), copyright © 1947, 1958, 1982 Princeton University Press. Reprinted by permission of Princeton University Press. Page 656 Karel van Mander. From Dutch and Flemish Painters, translated by Constant van de Wall (Manchester, NH: Ayer Co, 1978). Reprinted by permission of the bulisher. Page 766 Jean de Jullienne. "A Summary of the Life of Antoine Watteau" from A Documen-tary History of Art, Volume 2, edited by Elizabeth Gilmore Holt (Princeton, NJ: Princeton University Press, 1982), copyright @ 1947, 1958, 1982 by Princeton University Press. Reprinted by permission of Princeton University Press. Page 1050 Roy Lichtenstein. Interview with Joan Marter. From Off Limits: Rutgers University and the Avant-Garde, 1957-1963, edited by Joan Marter (NJ: Rutgers University Press, 1999), copyright © 1999 by Rutgers, the State University and The Newark Museum. Reprinted by permission of Rutgers University Press.